AMERICAN SALONS

AMERICAN SALONS

*Encounters with
European Modernism,
1885–1917*

ROBERT M. CRUNDEN

New York Oxford
OXFORD UNIVERSITY PRESS
1993

Oxford University Press

Oxford New York Toronto
Delhi Bombay Calcutta Madras Karachi
Kuala Lumpur Singapore Hong Kong Tokyo
Nairobi Dar es Salaam Cape Town
Melbourne Auckland Madrid

and associated companies in
Berlin Ibadan

Copyright © 1993 by Robert M. Crunden

Published by Oxford University Press, Inc.,
200 Madison Avenue, New York, New York 10016

Oxford is a registered trademark of Oxford University Press

Library of Congress Cataloging-in-Publication Data
Crunden, Robert Morse.
American salons : encounters with European modernism, 1885–1917
Robert M. Crunden.
p. cm. Includes bibliographical references and index.
ISBN 0-19-506569-7
1. Modernism (Art)—United States. 2. Arts, American.
3. Arts, Modern—19th century—United States.
4. Arts, Modern—20th century—United States.
I. Title. NX503.7.C78 1993 700'.973'09034—dc20 91-26718

2 4 6 8 9 7 5 3 1

Printed in the United States of America
on acid-free paper

Моей русской музе, Сицни

Acknowledgments

This book is the result of enthusiasms sparked as long ago as the 1950s. Shortly before I committed myself to history, I was most interested in European literature, music and art. My chief introduction to the field came from a year-long course which Henri Peyre taught on modernist writing from Rimbaud to Camus. One of the great pleasures which my semester immured in the Beinecke offered was a chance to spend a morning reminiscing with that famous scholar, highly amused that he had spawned someone whose letterhead said "American Studies." I also should pay homage to the work of Jacques Barzun, whose pioneering work on Berlioz and on European cultural history in general provided me with role models; and to Roger Shattuck, for *The Banquet Years,* that Bible for whatever it is that we cultural historians try to do.

I owe the most to members of the Faculty Seminar in Modernism at the University of Texas, Austin, where I presented several sections of work in progress, and received spirited critiques from Elizabeth Butler-Cullingford, Alan W. Friedman, Linda Henderson, Sidney Monas and Seth Wolitz. American Studies colleagues Emily Cutrer, Jeff Meikle and Bill Stott read portions of the work, while Shelley Fisher Fishkin surpassed any normal notions of collegiality by actually going through almost all of the 1200 pages in the original typescript. Russell Rosenberg gave me an extremely detailed discussion of my work on jazz, and Alan Frost gave me numerous editorial suggestions on the portions dealing with literature. I am grateful to them all.

During my semester at Yale, Robin Winks offered me the hospitality of Berkeley College, and I remain grateful to him and to his temporary stand-in, Acting Master Duncan Robinson, and Lisa Robinson, for many gestures of hospitality.

Sheldon Meyer is already a legendary editor; given the task he performed on this book, he should probably qualify as a surgeon as well. If the book is clear and focused he deserves much of the credit, although I remain convinced that if it is too clear it probably distorts what actually happened.

Portions of the work were also delivered to the Faculty Seminar on British Studies, University of Texas, Austin, and to the Second Maple Leaf and Eagle Conference, University of Helsinki.

I owe a great debt to Janice Bradley for wrestling with the manuscript, summer after summer, and putting up with my inability ever to make a machine built since 1917 function properly.

And I must thank Christine Allison for suggesting the title during a delightful dinner when birth was imminent.

Grateful acknowledgment is made to the following for kind permission to quote:

Archives of American Art to quote from the Walt Kuhn Family Papers and the Armory Show records, "Owned by the Archives of American Art, Smithsonian Institution," to quote from Judy Throm to me, 10 June 1991.

Floyd Dell Papers, the Newberry Library, for material from the letters of Floyd Dell.

Harry Ransom Humanities Research Center, the University of Texas at Austin, for material from manuscripts in the Ransom Center's collections.

John Quinn Memorial Collection, Rare Books and Manuscripts Division, the New York Public Library, Astor, Lenox and Tilden Foundations, for quotations from the correspondence of Jacob Epstein to John Quinn.

Calman A. Levin of Levin & Gann, attorney for the Estate of Gertrude Stein, 24 December 1991.

New Directions Publishing Corporation for permission to quote from the following copyrighted works of Ezra Pound: *Collected Early Poems,* copyright © 1976 by the Trustees of the Ezra Pound Literary Property Trust; *Ezra Pound and Dorothy Shakespear,* copyright © 1976, 1984 by the Trustees of the Ezra Pound Literary Property Trust; *Pound/Ford,* copyright © 1971, 1972, 1973, 1982 by the Trustees of the Ezra Pound Literary Property Trust; *Ezra Pound and Music,* copyright © 1977 by the Trustees of the Ezra Pound Literary Property Trust; *Ezra Pound and the Visual Arts,* copyright © 1926, 1935, 1950, 1962, 1970, 1971, and 1980 by the Trustees of the Ezra Pound Literary Property Trust; *Gaudier-Brzeska,* copyright © 1970 by Ezra Pound; *Literary Essays,* copyright 1918, 1920, 1935 by Ezra Pound; *Personae,* copyright 1926 by Ezra Pound; *Selected Letters 1907–1941,* copyright 1950 by Ezra Pound; *Selected Prose 1909–1965,* copyright © 1960, 1962 by Ezra Pound, copyright © 1973 by the Estate of Ezra Pound; *The Spirit of Romance,* copyright © 1968 by Ezra Pound; previously unpublished material by Ezra Pound, copyright © 1992 by the Trustees of the Ezra Pound Literary Property Trust, used by permission of New Directions Publishing Corporation, agents.

Mary de Rachewiltz to quote words of her father, Ezra Pound, 20 November 1991.

University of Chicago Library, Department of Special Collections, for material from the Harriet Monroe Personal Papers and for material from the *Poetry* Magazine Papers.

Dr. W.E. Williams to quote from the papers of William Carlos Williams, 13 November 1991.

Yale Collection of American Literature, Beinecke Rare Book and Manuscript Library, Yale University, for material from the works of Marsden Hartley, Mabel Dodge Luhan, Gertrude Stein, Alfred Stieglitz, and Ezra Pound.

Austin, Texas R.M.C.
May 1991

Contents

Introduction

Modernism in the arts had its first stirrings in France. As romanticism ran its course, various individuals developed certain of its tendencies to extremes. In the 1830s, Théophile Gautier extolled the connections between beauty and uselessness and dismissed much of common existence as unworthy of attention. In the 1840s, Henri Murger first gave shape to the notion that true fulfillment only came in bohemian groups of friends, living for the moment and heedless of bourgeois norms of religion and morality. In the 1850s, Charles Baudelaire made poetry and criticism the central focus. He rejected the assumption that material progress would lead to moral progress, insisted on his right to see beauty in evil and to make art out of corrupt material, defended the use of drugs that would heighten consciousness, and made the artist and his relation to the world a primary theme of art. As both art and artist became detached from the stifling environments in which they were born, they began to have influence in England. An emphasis on aesthetic values for their own sake is visible in the work of Algernon Swinburne and Walter Pater in the 1860s, and became central to the work of Oscar Wilde shortly thereafter.

Small, peripheral countries contributed steadily to modernism, usually by forcing their most talented creative figures to mature in Berlin or Paris. Because he received no support in Oslo, Henrik Ibsen went into exile for twenty-seven years, chiefly in Germany. In the 1860s, he satirized several Norwegian themes, finding both support and enmity at home for his attitudes. In the late 1870s, he began the series of plays that became crucial to modernist growth from Berlin to New York: he exposed the hypocrisies of businessmen and politicians, the tyrannies that husbands visited on their wives, the doom which social diseases could wreak on the unsuspecting. He soon went deeply into neurosis, sexual guilt, hysteria, and the obsessions of the artistic personality, in plays that were increasingly introspective and symbolic.

In developing these themes, these individuals were all precursors of modernism, not themselves modernists. The first true modernist artist was Arthur Rimbaud, the young French poet who flared briefly during the first half of the 1870s. His religious yearnings, his hallucinations, his breaking down the artificial barriers of both language and form, his

development of an implicitly irrational and illogical mode of discourse, all helped to make him the legendary prototype of the modernist artist. For his followers, a great poet was wise by definition; he saw beyond the normal limits of language, reason, and science. They wished to follow him to some new relationship between artist and the world, where the artist and artistic values took precedence over the mundane demands of "reality."

This is not the place to enumerate the rest of the story. It has long been the subject of standard texts, such as Richard Ellmann and Charles Feidelson, Jr., eds., *The Modern Tradition* (New York, 1965), and Malcolm Bradbury and James McFarlane, eds., *Modernism 1890–1930* (New York, 1976). The drama of Strindberg, the philosophy of Nietzsche, the poetry of Yeats, the fiction of Proust, the painting of Picasso—everyone knows the rough shape of the subject and is familiar with the artists and countries involved. What remains is to synthesize the purport of their work in language that transcends disciplinary boundaries and to indicate how America fitted into the picture.

European modernism first of all stressed the disruptions and discontinuities of a modernity which affected time, space, and sound. Evolving out of an evolutionary paradigm based on Darwinian biology, modernists attacked linearity as conveying a false order to the experience of life. In the face of new industrial, technological, and urban problems—the problems of "modernization"—modernists demanded the new in life and art: new forms, new sexual values, new freedoms, new feelings unhindered by old rules. Seeing bourgeois life as a dreary monolith, they elevated individual values and satisfactions over social ones. They often expressed such values ironically, parodically, and vulgarly. Given a choice, they preferred anarchism over socialism, elitism over collectivism. Drawing some of their inspiration from realism in both literature and painting, modernists concluded that consciousness and the dream logic that went with it could be the most real of all. They toyed with myth and symbol in an effort to discuss this consciousness. They found the accidental and the unplanned more suggestive of the true and the real than the logical and the orderly. Convinced that religion had died, modernists made art into a religion. Artists became the new priests, holy figures with perceptions finer than those of ordinary citizens. Modernism became a larger rubric that subsumed such philosophical terms as relativism and pragmatism, and such scientific terms as relativity and the uncertainty principle.

The circumstances in America were in many ways different from those in Europe, and modernism accordingly had a different feel. America had been a predominantly Protestant and puritan country, hostile to the arts. It lacked the strong sense of class that dominated many Europeans. It did not automatically connect art to politics. It went through its industrial revolution later; its political system was more responsive to discontented voters. As a nation of individualists who had built up

one city after another, it had not yet had time to develop many institutions to support the arts or the public attitudes that went with them: no major museums, no trained orchestras, no solid art schools. As a young, developing democracy, America had not felt the need for much by way of artistic expression, and its Protestant traditions left it mistrustful of serious efforts to create art, and hostile to anyone who actually wished to make the arts a full-time career.

While American modernism certainly had a few roots in romanticism, the place of first importance must go to the rebellion which the talented young felt against this newly oppressive bourgeois democracy. The three most important precursors of American modernism, James Whistler, William James, and his brother Henry James, were all born skeptical about many common assumptions which their fellow citizens held. Growing up in highly unusual environments, they became seekers after ideas and emotions that their fellow citizens seemed scarcely to dream of. They questioned anecdotal art, dualistic philosophy, realistic fiction, and provincial values. They set countless examples for the next generation, the first modernist generation; and not least by all becoming influential in the highest circles of Europe.

The typical member of that first modernist generation was, psychologically speaking, an outsider. Modernists did *not* share those presumably universal Protestant values. They did not necessarily even share the assumption that the nation was on a proper political path: they did not always sympathize with the North in the Civil War, with the economically successful in the race toward industrialization, or with the winners in a fair democratic election. They were a collection of the excluded: they were Southern in a Yankee society, Jewish in a Christian society, black in a white society, Catholic in a Protestant society, female in a male society, or homosexual in a heterosexual society. In ways that were central to their self-images, they felt outside normal American life: most often they were artists and intellectuals in a society suspicious of both. Since America excluded them, they felt free to exclude America, that is, to "choose" a heritage with no necessary connection to the one on their birth certificates. This is the source of the paradox that permeates modernist creativity: to be most modern was to be most alienated, and that meant to feel most at home in ancient Greece or China, or in medieval Europe or Japan. A modern artist could make history, especially his history, into anything he wanted it to be.

As the popular idiom had it, these American modernists did not speak the language. They felt they could not communicate with the majority which was satisfied with things as they were. Modernists wanted to escape the "prisonhouse of language" as they received it; they sensed that language shaped the world and the subjects of art, rather than the other way around. Their new languages tried to be precise, ironical, discontinuous, hard, clear, impersonal, classical, and musical. They produced styles that were fragmented, minimalist, atomistic, and economical. In

them, the means (tone, color, words) were often more important than the ends (ideas, objects, stories). One good definition of modernism is thus that it was a collection of various new languages, or means of expression, which outsiders developed to express their sense of alienation.

American modernists swept away many nineteenth-century artistic conventions, preferring to stress the primitive over the genteel, the expert over the amateur, the unknown over the known, the exotic over the familiar. Instead of a certain and stable universe, they saw an indeterminate and relational one. Narrators in modernist novels became unreliable; poets spoke in many voices; musicians in new tonalities or none at all. Modernist artists combined the highest and lowest elements in a culture to escape the bourgeois middle in a spirit of "carnivalization." Conventional perspectives, sounds, forms, values, expectations, and ideas were all at risk, as modernists used parody, hyperbole, irony, sexuality, blasphemy, and anarchy to offend everything from shopkeeper to grammar.

Modernism in both Europe and America included many names such as cubism, imagism, futurism, or fauvism. What these movements shared was a stance rather than a precise platform: realistic, humanistic, self-conscious, iconoclastic, experimental, and libertarian. In its American version, the stance distrusted authority, scorned politics, and feared boredom more than hell. In extreme forms it verged on solipsism. It was openly elitist and socially irresponsible.

Modernism touched many disciplines. It was a religion of art, consciousness, and originality, even when individual modernists denied that it was. It was a new psychology of drives, dreams, consciousness, and extreme mental states. It was a science based on new mathematical and physical ideas: matter was energy, the static was dynamic, and reality was relative. American modernists borrowed most of their ideas from Europe, but in two areas had exports of their own. Modernist works were filmic even before the film spread widely. They used montage, rapid cutting, freezing, variation in speed, long-shots and close-ups, flashbacks and crosscuts. Modernist works were also jazz before jazz spread widely. They were spontaneous and improvisatory and depended on new senses of time. They evoked both primitivism and decadence to make severe criticisms of conventional culture and to share the point of view of an oppressed minority.

I have organized my analysis by cities, because cultural history is almost always the history of cities. A person may create anywhere, but only cities provide the stimulation of publishers, museums, theaters, universities, and authoritative criticism. In this urban context, I have chosen to emphasize the salons through which Americans met each other and talented foreigners. Salons were where artists learned to communicate in a modern way. Alfred Stieglitz led the first salon in New York, focusing on photographers and painters. In Chicago, a small group

formed around Floyd Dell and Margery Currey that stressed experimental ideas in fiction. In London, Ezra Pound led Americans to the salons of William Butler Yeats and Ford Madox Hueffer, all but appropriating them for his own purposes. The two Stein families formed distinct but overlapping salons in Paris that seemed to stress painting but had greatest impact on prose style. In New York just before America entered the war, Mabel Dodge reigned briefly over the widest ranging group, enabling artists to meet anarchists, educators, birth controllers, and psychoanalysts. Finally, Walter and Louise Arensberg brought France and America together over a six-year period in a salon that had an incalculable effect on both the major poets and the major visual artists.

The story stops in 1917 for the obvious reasons: creative life in New York all but ceased for the duration of the war, as it already had in London and Paris. Besides, the book is already too long. Still to come are a study of the 1920s, when Americans became more visible as creative figures, and a final volume on the 1930s, when events in Europe forced so many artists to flee west to a country finally ready to profit from their talents.

AMERICAN SALONS

BOOK I

Three Precursors

Major changes in human attitudes have small beginnings. The prehistory of American modernism began with the unusual childhood of James Whistler and his unwillingness to follow his mother's plan for his career. In his rebellion, he established himself in London and Paris, worked out ideas on the self-sufficiency of art, and took a minor tendency to bohemian behavior among artists and made it into a persona peculiarly his own. His paintings were of such merit, and his personality so charismatic, that he became a mythical being who inspired fictional characters, journalistic anecdotage, and imitative behavior. For young modernists of the next generation, Whistler was the great role model. His clothes, his sayings, his prejudices, and his influence on Europeans all impressed young people desperate for alternatives to conventional American life.

CHAPTER 1

Whistler & the Sufficiency
of Art

The family seemed normally American. In its heritage, religion, business connections, and geographical locations, the Whistler clan and its in-laws gave every indication of producing young pillars of the republic, the women tending to religion and the men to commerce. Yet the accidents of inheritance and the whims of an emperor intervened to nourish an artist whose works and ideas helped free art from decades of convention and too comfortable a place in the homes of the newly rich.

The Whistlers were both Irish and English. John Whistler had been a soldier in Burgoyne's army during the American Revolution. Captured, he later entered the American army and became so patriotic that he named his son George Washington. John settled in the Great Lakes area, helping to found and command Fort Dearborn. Young George thus grew up along the frontier, in a military environment. He went to West Point, then the premier engineering school in the country, and joined the army as a railway engineer. In the early phase of his career, he participated in projects that improved Salem harbor and established the border between Canada and the United States, but the bulk of his work involved the laying out of railway beds. In 1833, he resigned his commission as a major to supervise the construction of the Boston-to-Lowell railway; he was so skilled at his work that he even helped redesign the locomotives that would run on his railway.

George Whistler was an attractive man. He had artistic talent and drew well; his nickname at West Point was "Pipes," in honor of his skill on the flute. He not only had engineering skills, he was a man of equable temperament who liked socializing, parties, and the domestic havoc of large families. He married a woman of comparable temperament named Mary Swift, and they had three children before Mary died. Always on the move from project to project, George desperately needed a wife to take care of his children. One of his West Point friends had been William McNeill, also a man involved in railroading; one of his wife's best friends had been William's sister, Anna. She was a bit on the

plain side, stubborn, religious and humorless, but she was available, eager for the marriage, and appropriate by any social standard. They were married in 1831, and in the next fifteen years she produced five more children. One from the first family and two from the second died young.[1]

Anna McNeill Whistler came from a Scots background in North Carolina. Her father Daniel, an army doctor, had come to America after the revolution. Disliking life under slavery, he had moved his family to New York City at the end of the War of 1812, where he conducted experiments on yellow fever with the help of his daughter. She proved an earnest student; indeed, she was earnest in just about everything. Devoted to the Church of England, disapproving of frivolity, she was an unlikely mate for the fun-loving flute player she had admired for years. Once securely married, she imposed a depressing regime on her step-children that irritated their mother's family. Having no special talent herself, she could not understand it in others, and she was soon in constant conflict with Deborah or "Debo," who had her father's high spirits, musical skills, and love of parties.

Like so many rural Protestant Americans, Anna seemed to have a morbid psychology that expressed itself in an iron self-control, good manners, and censoriousness of others. Such qualities were vital in surviving harsh winters, the deaths of children, and early widowhood, but they cast a pall on the next generation and threatened to blight artistic ability. Her step-children proved too old for her to establish complete authority over, but she held tight rein on her own sons. Her home was a classic of its kind, known to every reader of American biography: the solemn dress, the earnest devotion to duty, the mistrust of pleasure, the memorization of Bible verses at least once a week, and the depressing Sundays devoted to a bleak God who had no noticeable sense of humor. She combined this atmosphere with an approval of slavery as a social system, on the ground that Christianized American slaves would ultimately evangelize Africa.[2]

In later life, James Whistler told a variety of stories that concealed his birth in Lowell, Massachusetts, on 11 July 1834. In this as in so many matters, the pedestrian, bourgeois fact of birth in a Yankee manufacturing town clashed with his self-image. He preferred Baltimore, or St. Petersburg, or almost any place else. Like his mother, he rejected the North and clung to the traces of North Carolina in his heritage. He never went south of Maryland in his life, yet in 1899 could insist in a letter to publisher William Heinemann that he had "a *right* to keep my reputation clear—as shall be that of a Southern gentleman." As far as it went, the pose was not incorrect. He certainly avoided any taint of trade throughout his life, never drew a liberal breath, spoke contemptuously of the "niggers" whom he "hated as much as any Southerner," and insisted that he was capable of nostalgia for "a little healthy American lynching." Nevertheless, his childhood was Yankee: the family val-

ues were Puritan enough for any New Englander, and after three years in Lowell, Whistler lived successively in Stonington, Connecticut and Springfield, Massachusetts as his father accepted railway engineering jobs.[3]

Evidence of George Whistler's skills and fame came to the family in 1842, when a Russian commission seeking the most qualified engineer in the world sought him out. At the time, Russia had no railways; indeed, all of Europe possessed only a few, and experts in constructing them were hard to find. The Russians offered Whistler the job of supervising the construction of the railway from St. Petersburg to Moscow at the then-enormous salary of $12,000 per year. Despite a hatred of political or religious liberalism, and a real fear of anything resembling "progress," Czar Nicholas I had something of an obsession about railways. Legend had it that when confronted with the difficulties of choosing the route between his most important cities he took out a ruler, placed it on the map, and drew a straight line between them. This was probably not true, but like so many stories in the history of modernism it has a poetic truth. The Czar knew what he wanted and he expected nature to get out of the way and men to do what they were told. George Whistler was the man he wanted.

George departed in short order, and in August 1843, Anna sailed for Russia with her children to reconstitute as best she could a proper American home with traditional worship, food, and holidays in the midst of a frozen Babylon. The Whistlers settled in a ten-room flat on the Neva River, a bare three hundred yards from the Winter Palace. Both husband and wife disliked the great gulf between rich and poor in Russia, and the random brutalities that so often went with it. Unlike her husband, however, Anna quickly decided that she loathed the social life of the city, with its alcohol, dancing, and frequent displays of fireworks. She refused to leave her home for long periods of time, except for brief forays out to groups of soldiers who might be wandering by—she loved to pass out religious tracts to them, items they gratefully accepted because the paper was useful in rolling cigarettes and stuffing boots for warmth. She also made it awkward for the family to receive guests. The atmosphere of prim piety was such that Debo especially had to face disapproval every time she wanted to socialize or play secular music on the piano or harp.

No one was exempt from the possessive nest-building that circumscribed family life. Anna encouraged dependence in Jamie and Willie to the point where tutoring in the home was all the education she was willing to permit: one experiment with a school across the city produced so much weeping and skirt-clinging that it was never repeated. Even the local Church of England proved too easy-going for her taste, and she shifted family allegiance to an American, fire-and-brimstone chapel. All the children seemed to respond with real and psychosomatic illnesses. Debo proved especially adept in using her health as a

means of thwarting family discipline; she eventually used it to escape St. Petersburg entirely, staying abroad long enough to find a British husband and to settle down in the more congenial environment of London.[4]

The relationship between mother and son was more complicated. While Jamie was capable of rebellion,and on professional and moral matters soon proved his independence, he was also devoted to his mother in complex ways that puzzled his adult friends. Many of his mature views came straight from her. She had no interest in people who were not a part of her circle. She did not approve of how they lived or what they thought and she felt no sense of responsibility for their welfare. At least once she referred to the lower classes as "slaves" and clearly loathed them. She was patriotic in a Southern, military way, and insofar as she ever had public heroes, they were soldiers like Robert E. Lee and Jefferson Davis. Jamie followed these precedents. Throughout his life he remained a snob, contemptuous of the masses and admiring of rulers. He was always patriotic, military, and Southern, if from a safe, European distance. The influences of St. Petersburg certainly proved more lasting on his behavior than those of his mother, but like the prim, ghostly portrait she became, she was always in the background, holding her lace handkerchief and peering with evident disapproval at the colorful scenes before her eyes.

Although Anna instinctively mistrusted any art if it seemed likely to be other than an aid to religious devotion, she apparently did not object to her son's going off to the Imperial Academy of Fine Arts in April of 1845, when he was only eleven. At the time, the Academy was little more than a playtoy of the Czar, and its administrators spent more time on the decoration of uniforms and instruction in ballroom dancing than they did on art. The building was grandly impressive at a distance and filthy upon close inspection. The chief pedagogue was Alexander Ossipovich Koritsky, one of the many epigones of Karl Brullov, painter of *The Last Day of Pompeii* and the center of a group which emphasized exotic, theatrical, historical, and biblical scene-painting. Such an environment would naturally foster talent in a boy not yet a teenager and unaware of what styles and techniques were outmoded—and the lessons certainly got him out of the house.[5]

Whistler was lucky that circumstances soon took him to a more stimulating environment. In 1847 he was seriously ill with rheumatic fever and Debo brought him a book of Hogarth drawings. While his mother sang hymns at him, he pored over the book, having recognized intuitively the skill behind Hogarth's work. He also admired the work of Pavel Fedotov, sometimes locally called "the Russian Hogarth" for the humor and drama of his works. A year later, cholera threatened St. Petersburg, and the Whistlers sent their children to the safety of London, where they could stay in the luxurious home of Debo and her new husband, Seymour Haden, an etcher and painter as well as a phy-

sician. Jamie quickly became devoted to Haden, and under his influence discovered the elementary principles of art. He devoured Anna Brownell Jameson's *Memoirs of the Early Italian Painters and the Progress of Painting in Italy* (1845); from it he could learn the importance of going back to nature to express character and emotion, and of holding up a mirror to nature as the first step of painting. He could also learn, if he needed to, that a painter had to be self-reliant, innovative and rebellious, heedless of fashion and wary of popularity. The example Jameson used most often was that of Giotto, a man small in size with a joyous temper and a gift for witty repartee—in all three qualities providing Whistler with a role model. Bit by bit, Jamie was becoming James, fashioning his sense of who he was, how he should act, and how he might best express himself.[6]

Back in St. Petersburg, George Whistler was at the height of his career. Despite the Byzantine politics and pervasive corruption of the Court, he managed to ride herd on 60,000 workers, miles of track, a multitude of shops and machines, and the construction of two hundred locomotives and six thousand railway cars. Despite the fuming of the British, who wanted the contracts for themselves, he also managed to hire nearly twenty American assistants and to funnel the technical work on the engines and cars to two American firms. He was as completely in control as a person could have been in a foreign autocracy; the Czar repeatedly demonstrated public approval of his work with decorations and personal attention at social functions. Government officials also habitually consulted him on other projects, such as harbor and bridge construction. But George Whistler had long had a heart problem, although he refused to slow the frenetic pace of his typical workday. He apparently caught a mild case of cholera during the epidemic his children were avoiding; although he recovered from the disease his heart was not up to the strain. He died on 7 April 1849, abruptly terminating his son's exposure to a non-American environment.[7]

The Czar made generous offers to Anna, but she preferred to return to America to bring up her boys in democratic simplicity. As her niece put it to Whistler's first biographers: "The boys were brought up like little princes until their father's death, which changed everything." Whistler certainly retained friends of his father's from his Russian years; he never relinquished a sense of elitism and privilege; his scorn of the masses shifted easily from serfs to ignorant critics and a tasteless public; he always loved pomp and circumstance and wore his own eccentric adaptations of the fancy dress he so loved. But the immediate reality was depressing. Anna settled in Pomfret, Connecticut, where a man after her own heart ran a school she deemed appropriate. The Reverend Dr. Roswell Park, a solemn cleric who had graduated from West Point before entering the ministry, was headmaster of Christ Church Hall. There Whistler embarked on the first of his rebellions, doing whatever he could to mock the headmaster and undercut the discipline

to which he was so unaccustomed. Life at home with his mother was no better. The young man who had commanded servants all his life suddenly found himself shivering in the New England snows, feeding the pig, hauling wood before breakfast, and having to recite a verse of the Bible before he could eat. He took out his frustrations in any number of ways, most of them unrecorded. In one case that was, he took a gun—his mother hated guns—and shot his London hat full of holes. He was never without a sense of drama.[8]

Family tradition was strong in the Whistler family, and Anna reenforced the allure which West Point already had for Whistler with her firm insistence that if her son really did not want to enter the ministry, which was what she preferred, then he ought to train for architecture or engineering. Those were worthy careers and far more capable of supporting a man in a socially acceptable way than painting. Her son displayed no sense of discipline whatever, and in terms of West Point requirements showed ability only in geography, drawing, and French. Nevertheless, when his half-brother George wrote to Secretary of State Daniel Webster and asked for a presidential nomination, the request was granted.

If ever a man and an institution were mismatched, Whistler and West Point were; only the sorry saga of Edgar Allan Poe offers anything comparable. Whatever force George Whistler's memory may have had, whatever Whistler's public approval of military parades and patriotic fustian may have indicated, in practice he was no soldier. He refused to study most of his subjects and proved especially inept at science. He fought his barber about hair length and attempted to evade arduous exercises by remaining safely in bed. He never seemed to have his clothes or his gun in proper order. He maintained an adversary relationship with all horses. In short, the spartan discipline got on his nerves and he courted dismissal. His family could force him into West Point, but they could not force him through it. With evident reluctance, Colonel Robert E. Lee severed the relationship. Hardly downcast, Whistler praised the Point throughout his life and regaled his followers with tales of his misadventures.[9]

Having given up all thought of modeling himself on his father, Whistler spent the next few months working through the pressures and temptations most young men face when their instincts clash with the wishes of their families. He drifted around the Northeast; he dallied with a young woman of whom Anna did not approve. His half-brother George, married to Julia Winans, was a partner in the Winans Locomotive Works, and for a few weeks Whistler reported for work there as an apprentice draftsman. His ability impressed everyone, but he did little more than use up valuable paper making sketches. Secretary of War Jefferson Davis recommended him for work on the Coast Survey, and so for several more months Whistler tried the patience of his superiors as he learned etching and printmaking; he continued to add

little portraits around the edges of his work. His languid habits prevented anything so mundane as the keeping of standard government hours, and stories soon multiplied about his bohemian mode of existence. He seemed in no doubt as to what he wanted, and that was art training in Paris. Having "proven" incompetent at soldiering, commerce, and bureaucracy, he persuaded his brother and mother to supply him with $350 a year as long as he stuck by his studies, and in 1855, at the age of twenty-one, he was off.[10]

II

Having spent much of his youth in Europe and being perfectly fluent in French, Whistler adjusted quickly to Paris. He was soon part of a largely British circle, forming friendships that played conflicting roles in his later life in London and in the development of his image in the world of art. Thomas Armstrong, T.R. Lamont, Edward Poynter, and George du Maurier were, on the whole, serious students there to learn their trade, and for the most part they held aloof from French people and any customs more liberal than those to which they were accustomed at home. Because they could always get money from England, they rarely experienced any of the poverty that was so often the lot of French students. They acquired exotic clothes, imported English beer and Scotch whisky, and recalled for years afterwards meals that included "thick loin chops," fried potatoes, "the best of salads," and "large melons." Even a servant was available to help clean up after the feasts.

Armstrong, author of the most useful memoir of the period, never forgot the exact spot in the Odéon Théâtre where he first caught sight of his American friend. The weather was still in the warmth of early fall, "and he was clothed entirely in white duck (quite clean too!), and on his head he wore a straw hat of an American shape not yet well known in Europe, very low in the crown and stiff in the brim, bound with a black ribbon with long ends hanging down behind." His black hair fell in ringlets and did not yet have the distinctive white lock in the front that became a Whistler hallmark later in London. Armstrong soon realized that Whistler did not share the financial prosperity of his British friends—unable to stick to a budget, he spent carelessly when he could and piled up debts when he could not. Nor did he share many of their values. But for a time, things went reasonably well among the English speakers, and no observer could have suspected the resentments that simmered under the surface of their relationships. Du Maurier's famous novel *Trilby* (1894) remains the best record of those early days and its author's later disenchantment.[11]

Whistler also moved in another circle which more closely matched his finances and his attitudes. He referred to them as his "no shirt" friends, and Armstrong clearly felt them inappropriate company for a gentlemanly painter. These French connections soon proved far more

influential on Whistler's life than his British ones. Aside from a commitment to art, about the only thing the two groups had in common was an admiration for his hats. One day Whistler was copying works in the Louvre, which he frequently did, and Henri Fantin-Latour spotted this *"personnage en chapeau bizarre"*; the two hit it off immediately, and continued talking into the evening at the Café Molière. In time Alphonse Legros made it a threesome, and they styled themselves a *Société des Trois*, bound together by common admiration for the French realist painter Gustave Courbet. Others soon appeared on their periphery: Edouard Manet, Jean Charles Cazin, Emile August Carolus-Duran, Zacharie Astruc, Félix Bracquemond, and Alfred Stevens. All believed in the seriousness of art and were devoted to its creation. As Fantin later summed it up in a private letter: "Art, that is my religion. That is the only ideal, the only pure thing in a man." [12]

Members of the group had more to their philosophy of art than that, however. They were at the heart of a significant rebellion against the romanticism that had dominated the French painting of their childhoods. Realism was all the rage, a realism of low tonalities and a serious devotion to the facts of daily existence. Whistler intuitively sensed what was happening; although he fell in briefly behind the leadership of Courbet, he also had a more serious admiration for the Spanish seventeenth-century painter Velázquez. Admiration for Spanish painters had long been common in France even among the romantics, but Whistler seems to have had an extreme case, something very rare for him throughout his career. He so admired Velázquez that he went all the way to Manchester in 1857 to see a display that included fourteen works attributed to him, and planned a pilgrimage to Spain to fill the gaps in his knowledge. Insofar as any single painter taught Whistler how tonalities could unify a portrait into a single impression, a concept essential to understanding his mature portraits and helpful for understanding his landscapes and seascapes, Velázquez was that painter. [13]

Whistler's introduction to technical aspects of painting began during his brief stay in London before his father's death. Charles Robert Leslie, a man who had grown up in Philadelphia and taught drawing briefly at West Point, was lecturing at the Royal Academy of Arts in 1848, and his comments appeared in the *Athenaeum*. His advice meshed well with Whistler's instincts, which his exposure to Hogarth had reenforced. Leslie advised a painter to be obedient to the laws of nature, but to be selective. Apprentices should practice reproduction of nature at least for a while, and then become more experimental. Nature, of course, was a term that included the human, and Leslie advised painters to travel the streets and absorb everything from clothes to buildings; he had no classical aversion to common folk as subjects, and recommended Hogarth as an appropriate model. Important for Whistler's later development, Leslie also stressed the role of memory in great artists. They could view a scene, take in its essence, and then paint it later. That way the useless

details might disappear, but the essence remain. No one needed models, and no one had to haul his canvas into the streets in order to be accurate.[14]

Whistler brought Leslie's ideas with him to a pedagogical environment that did not seem nourishing—educational principles are often a generation or two behind creative innovations. Parisian teaching in the arts had not yet assimilated Delacroix and the romantics, and seemed dominated by the classical principles of Jean Auguste Ingres. Various *ateliers* took in promising students to prepare them for the Ecole des Beaux-Arts on the rue Bonaparte. Ary Scheffer, Thomas Couture, and Charles Gleyre ran the best of them; they all stressed drawing and the importance of design over color. All of them tended to an unhealthy dogmatism, with aging teachers demanding the obedience and imitation of their younger subjects. Whistler's friend Théodore Duret worked with Couture, for example, and described his master's belief "in the excellence of a fixed ideal" and his horror of realism. He believed that only certain subjects were worthy of art: any scene that depicted the ancient Greeks and Romans was preferable to anything in modern life. Religious subjects were of high importance, "but first and foremost came the nude." Next, but lower on the scale, "came compositions drawn from countries having an exotic charm for the imagination, such as those of the Orient. An Egyptian landscape was worthy of itself; an artist enamoured of the ideal might paint the sands of the desert, but to paint a Normandy pasture with cows and fruit-trees was to be sunk in realism and degraded."[15]

Whistler joined the atelier of Gleyre, a forty-nine-year-old Swiss and a pedantic student of Ingres who emphasized drawing from the antique as the keystone of training. Too independent for an official institutional position, he was nevertheless a good painter and teacher, his pupils including Monet, Sisley, and Renoir. Gleyre was actually more appropriate for Whistler than he seemed, for he did not care about the subject a student chose, leaving Whistler to continue his admiration for Hogarthian lowlife. He was also not opposed to color, although he insisted that black was the appropriate basis of tone. He hated carelessness and valued originality, and like Leslie he thought memory was important. He thus encouraged his students to study live models at the atelier and then paint them later, at home. A more formal version of these ideas was also in the air. Through Fantin-Latour and Legros, Whistler became acquainted with the theories of Lecoq de Boisbaudran. Lecoq was a strong advocate of memory, believing that the literal appearance of the subject was unimportant, and that true originality developed only when memory stimulated the imagination, "thus producing completely new compounds, in the same way as chemistry operates with unknown elements."[16]

Whistler was soon active in both etching and painting. The work of Charles Meryon was already stimulating a revival of etching in France,

and Whistler put his Washington training to good use in the thirteen numbers published as *The French Set,* which in addition to Paris scenes included sketches of Whistler's niece and nephew in London and five memories of a recent trip to the Cologne area. He also produced *At the Piano,* an evocation of the Haden family which provided an excellent example of his early experiments with color. When the 1859 Paris Salon refused it, Whistler joined others who had been rejected in a show at the gallery of François Bonvin. There Courbet saw it, approved it, and thus launched Whistler in the world of Parisian art.[17]

III

Despite this initial progress, Whistler had good personal and financial reasons for leaving Paris and settling in England. His half-sister and her husband were comfortably off and able to offer him a place to live and eat. They had encouraged him and his work and urged him to come. Their social position was secure: Seymour Haden had become a Fellow of the Royal College of Surgeons, and his brother-in-law, John Calcott Horsley, was an Associate of the Royal Academy and seemed at the time one of England's major painters. Unsophisticated businessmen with new wealth were bidding up the prices of paintings, and any young painter hoping to make a living knew that London was the place to be. Whistler had two of his etchings accepted for an exhibition at the Royal Academy and every reason to feel that he properly belonged in London. He even had his British friends from Paris to offer continued conviviality and moral support. By the middle of 1860, Whistler was sharing a studio with an admiring George du Maurier, who wrote his mother that Whistler's etchings were "the finest I *ever* saw" and his conversation exhilarating: "A more enchanting vagabond cannot be conceived."

Whistler had had no reason to doubt his British welcome. His painting had been controversial, to be sure, but his etchings had won and continued to win the approval of his family and many critics. Despite the furor soon surrounding his name, Whistler loved to walk around London as he had walked around Paris, discovering subjects that excited his eye. In particular, he was soon exploring a rather seedy area along the Thames, an activity that disturbed the conventional du Maurier. He informed his mother in October 1860 that Whistler was "working hard & in secret down in Rotherhithe, among a beastly set of cads and every possible annoyance and misery, doing one of the greatest chefs d'oeuvres—no difficulty discourages him." Whistler was producing the *Thames Set,* one of his great achievements in etching, and an almost Dickensian evocation of real life.[18]

Etching was one thing, painting was another. For a variety of reasons, England was less favorable than Paris toward creativity in painting. Much of the problem was the philistine level of taste, since busi-

nessmen controlled the art market. They recognized certain genres: a history painting like Daniel Maclise's "The Death of Nelson" seemed the visual equivalent of an epic poem, and such work had held great prestige since the reign of Joshua Reynolds and Benjamin West late in the eighteenth century. A nature painting like John Martin's "The Plains of Heaven" married heaven and earth in a religiously satisfying way, safely following the precedents of Constable and Turner. Sir Edwin Landseer pandered shamelessly to the British infatuation with animals, sentimentally merging the home with nature. Other categories included sporting paintings, marine paintings, paintings of exotic foreign scenes, paintings of fairies, paintings of the nude so long as they seemed classical and not sensual, and portraiture. As Henry James rightly remarked: "They are subjects addressed to a taste of a particularly unimaginative and unaesthetic order—to the taste of the British merchant and paterfamilias and his excellently regulated family. What this taste appears to demand of a picture is that it shall have a taking title, like a three-volume novel or an article in a magazine: that it shall embody in its lower flights some comfortable incident in the daily life of our period, suggestive more especially of its gentilities and proprieties and familiar moralities.[19]

During the early 1860s, Whistler slowly shed his Paris friends and became a part of the Pre-Raphaelite circle. He lived in an unsettled way for a while, returning to Paris as he did regularly throughout his life, but in 1862 he found a "permanent" home in Chelsea near Battersea Bridge. The area was a British version of the Left Bank in Paris, including both the attractive Cheyne Walk area, which Whistler favored, and areas nearly slums. Being British, it was not as bohemian as the Left Bank, but painters had long preferred it to elsewhere in London, and Whistler was soon in the company of Dante Gabriel Rossetti and the other Pre-Raphaelites.

As painters, the group had an ambiguous relationship to much of the rest of Victorian painting. On the one hand they shared the conventional Victorian attitudes toward nature and morality and were certainly not in rebellion against the subject of the artwork as the core of any aesthetic. On the other hand, they were against the sentimentality of most British art and were uncomfortable with conventional notions of dress, propriety, and behavior. As William Michael Rossetti summarized their platform, they wanted: "1) To have genuine ideas to express; 2) to study Nature attentively, so as to know how to express them; 3) to sympathize with what is direct and serious and heartfelt in previous art, to the exclusion of what is conventional and self-parading and learned by rote; and 4) and most indispensable of all, to produce thoroughly good pictures and statues." The program seemed to be one more call for "truth to nature," with nature viewed with scientific precision.[20]

In practice, the Pre-Raphaelites had only the vaguest of platforms

and their work hardly illustrated much of what they were saying. They agreed on what they disliked more than on what they liked. The earliest work to gain attention divided permissible subjects into three areas: historical works, whether religious, political, or mythological; contemporary works on subjects like love or labor; and literary works, especially if they stressed the noble in man. In William Holman Hunt's "The Awakening Conscience," for example, Pre-Raphaelite painting could appear fully as didactic as any work at the Royal Academy, and modern viewers have difficulty in seeing why Pre-Raphaelites regarded themselves as revolutionaries. Whistler never felt much affinity for this side of Pre-Raphaelite work: he did not like moral subjects and rapidly tired of rendering any subject with obsessive correctness.

Rossetti himself followed another path, one more attractive to Whistler. He approved of the precise rendering of nature, but was much more insistent on technical matters of form, color, and light; he was also willing to detach beauty from nature. "Pictures must first be judged as pictures" was a phrase in the air by 1865, and Rossetti developed an oddly original style which lacked traditional perspective and seemed to flatten people and objects. From this time on, British thought could evolve toward a preference for decorative and ultimately abstract work. Edward Burne-Jones and William Morris soon approved of this development, John Ruskin defended it in public, and for a while the best painters in Britain all seemed to be a part of a significant movement.[21]

Young revolutionaries needed stimulation beyond that which satisfied their more conventional contemporaries, and historical accident was at hand with a solution. Although they were capable of ransacking the Bible or mythology for new subject matter, what really stimulated both Whistler and his new friends was the extraordinary vogue for anything Oriental that developed in both France and England in the 1860s. Commodore Matthew Perry and the Emperor of Japan had signed their treaty in 1854, and Japanese art soon spread into the homes and minds of those who wished to escape from convention. One of the earliest shipments of porcelain, for example, contained as package stuffing a volume of sketches by the Mangwa of Hokusai. Félix Bracquemond found it and for almost two years tried to buy it; successful only after great effort, he was soon showing it to all his friends, among them Whistler. Both Bracquemond and Whistler were soon producing work using Japanese subjects, color schemes, and perspectives; Whistler soon even had the reputation of being the "Japanese artist." London experienced the vogue at an international exhibition, and Farmer & Roger's Oriental Warehouse was soon selling the Japanese art objects to, among others, the Rossettis, Burne-Jones, William Morris, John Ruskin, and Whistler. In Paris, La Porte Chinoise, sometimes described as "an exotic junkshop," opened under the proprietorship of a couple who had just returned from Japan. It too was a great success, selling to Baudelaire, the Goncourts, Manet, Degas, Monet, and, of course, Whistler.

Japanese art helped Whistler and his friends change their emphases from reproduction to suggestion. Oriental art seemed limited to only a few timeless subjects—cranes, mountains, houses, faces—which were neither literary nor historical. The work appeared to be intuitive and spontaneous, and appealed less to the intellect than to the eye. It was especially effective in its use of light, as it played off bridges, illuminated flowers, or was reflected by the snow. By 1864, Whistler had produced the work now known as "Purple and Rose: The Lange Lijzen of the Six Marks," a strangely impressive painting that combines Japanese coloring, Delft porcelains, and a conventional Victorian pose. It won general approval both from the British public and from the Rossetti circle, and Whistler produced several more works demonstrating Japanese influence, of which the most successful was probably "Caprice in Purple and Gold No. 2: The Golden Screen," (1864), now in the Freer Gallery in Washington.[22]

With its Japanese enthusiasms, the Pre-Raphaelite movement had a long-term impact on cultural life, influencing poetry, furniture, wallpaper, china, and book design in ways that seem quite different from the actual paintings. Intellectually, the movement inspired both sides of an important division in British cultural thought. On the one hand, it encouraged an emphasis on truth and decoration in painting and architecture. Ruskin and Morris insisted on the importance of subject, its moral teachings, its impact on the lives of all citizens, and the love with which decorations were applied. Such doctrines seemed to rebel against philistine taste, but in time they tended more to mobilize it in the service of social reform. Art became the servant of socialism in England and progressivism in America. On the other hand, Pre-Raphaelitism also encouraged an emphasis on beauty independent of truth: art had its own values and a true artist worried about line, color, and form. Art existed for the sake of art, and the taste, as well as the economic circumstances of the masses, was irrelevant. Walter Pater, Algernon Swinburne, Oscar Wilde, and Whistler preferred not to compromise with philistines, cutting themselves off from their audiences and from all "relevance," and laying the foundations for modernism in both England and America.

At the same time that Whistler and his friends were deciding between the relative values of truth and beauty, they were wrestling with the closely related problem of the subject. Their attitudes were by no means clear and consistent; Whistler's theoretical position did not always match the canvases he produced. By 1867, he had rebelled against the realism of his early days. In a lengthy letter to Fantin-Latour, he insisted that in his own case "Courbet and his influence has been disgusting. The regret that I feel and the rage—hate even—that I have now for it would perhaps astonish you . . ." He now denied any influence by the man or his work, and insisted that he himself had "a uniquely personal approach" in his painting and was "rich in qualities" which

Courbet did not have. Whistler thought his early training had had "a pernicious effect." "It's simply that that damned realism appealed to my artistic vanity, and scorning all traditions, it cried out with all the assurance of ignorance: '*Vive la nature'!*" That cry Whistler saw as a great misfortune. It was simply too easy to look at nature and paint it. "Oh, that I had been a student of Ingres!"[23]

Part of this, of course, was posing—something Whistler did wonderfully. No one could possibly see much of Ingres in his work, so Ingres was safe enough to acknowledge as an ancestor. Much of Whistler's problem was sheer frustration with the British obsession with the subject, about which he could be very funny, but which had taught critics a great many middle-brow ideas. He was heading toward a new critical vocabulary, one with incalculable influence on the history of art. Not having any special interest in music, he did not think of his work at first in musical terminology, but in 1863 the French critic Paul Mantz had called the painting then known as "The White Girl" a "symphony in white," and Whistler saw immediately the utility of the metaphor. Like a musician, he was blending harmonies that were self-sufficient for a composition but were no more related to subject matter than most symphonies. The point was valid enough, although given the fact that the picture was a portrait of Whistler's attractive mistress, Jo Hiffernan, members of the public might be forgiven at least a passing interest in the beautiful woman before them. Rejected by the official *Salon*, it was the hit of the famous *Salon des Réfusés*. It aroused such controversy that Emile Zola later put it in his novel *L'Oeuvre*. British critics were so inept and so entangled in their own presumptive terminology that Whistler actually received notices complaining that he had not properly created Wilkie Collins' famous heroine from the *Woman in White*. Infuriated but unrepentant, Whistler renamed the picture "Symphony in White No. 1: The White Girl," and it has gone down in history as the first important painting in the development of a modernist aesthetic.

A number of influences came together to form this new terminology. Musical ideas had been in the literary air of Paris since the 1840s, when Henri Murger had one of his characters in *Scenes de la vie de bohème* compose a "*Symphonie sur l'influence du bleu dans les arts.*" Théophile Gautier had written a poem, "*Symphonie en blanc majeur,*" and Edgar Poe was already well known in France for his comparisons of poetry and music. The Japanese vogue played its role, as did the tendency of the Pre-Raphaelites to structure entire aesthetic environments, from chairs to wallpaper. Whistler found the conjunction of these influences felicitous, and in 1868 could write Fantin-Latour that he thought "color ought to be, as it were, embroidered on the canvas, that is to say, the same colors ought to appear in the picture continually here and there, in the same way that a thread appears in an embroidery, and so should all the others, more or less according to their importance; in this way, the whole will form a harmony." The Japanese had understood this: "They

never look for the contrast, on the contrary, they're after repetition." Only a very short distance separated such a position from the position that the subject was unimportant. Whistler publicly accepted the idea that the subject was unimportant, yet never abandoned nature as the inspiration of his works. This clash between theory and practice is one obvious hallmark of an artist who remained a precursor of modernism, and not really a pioneer.[24]

Despite his propaganda, he did not seem to mean an art without subjects. Throughout his life Whistler was a portraitist of considerable talent, and he produced realistic lithographs into the 1890s. Artists could earn money painting portraits, and sitters could introduce artists to wealthy patrons, invite them to parties, and be instrumental in furthering their careers. By and large, Whistler was not comfortable painting portraits. He wasted countless hours posing his subjects, and the work of many days scraping out results that did not meet his high standards. He may simply have lacked the gift for portraiture, or perhaps enough training. He seems to have yearned for the effects of his musical pictures, and portraits that have the effect of a landscape or seascape are hard to produce. Although he ran the risk of a two-dimensional, playing-card effect, he sometimes managed to merge subject and background. Late-afternoon winter light often proved effective, blurring edges, muting tones, darkening the light and lightening the dark. "The buttons are lost but the sitter remains," was his quip.

When he did succeed, the results could be extraordinary, as in the famous picture of his mother. Escaping the inconveniences of the American Civil War, in which she and her sons were pro-South, she arrived in Chelsea, displacing Jo and introducing an odd, Scots-Presbyterian note into the lives of her son and the raffish Pre-Raphaelites. Yet Whistler remained devoted to her—even Swinburne was devoted to her—and in time she did, in fact, become as much a part of Whistler's background as the objects in many of his paintings. Whistler took the opportunity to create his most famous picture. Yet his vocabulary never gave in: he called it "Arrangement in Grey and Black No. 1: The Artist's Mother," and many viewers regard it as representative of his most important work. All along, Whistler pretended that the subject was unimportant. "To me it is interesting as a picture of my mother; but what can or ought the public to care about the identity of the portrait?" Even his friends scoffed, unable to comprehend such a point of view. When Whistler mentioned his mother to Thomas Lamont, Lamont responded:

"Your mother? Who would have thought of you having a mother, Jimmy."

"Yes, indeed, I have a mother, and a very pretty bit of colour she is, I can tell you."

The anecdote, told by Thomas Armstrong, then concludes with a sentence that encapsulates British incomprehension of everything

Whistler was likely to say: "And so she was when I knew her afterwards in Chelsea, much more ruddy than she is represented in the beautiful portrait now in the Luxembourg Gallery."[25]

IV

The conflicts of his life took their toll on Whistler's art and personality. At times he could not paint at all; at other times he failed to live up to his own standards and destroyed his work or left it incomplete. The stupidity of the criticism he received not only irritated him, it reenforced all the unfortunate tendencies which an erratic childhood, great talent, and a censorious mother all seemed to encourage. Under stress, Whistler became a caricature of the whimsical, brutal Russian aristocrat and the Southern, slave-whipping gentleman. He dressed exquisitely, served enchanting meals, and decorated himself, his food, and his home so that guests would experience the complete ensemble. He cultivated quarrels with his friends, his mistresses, and his in-laws. He behaved so badly to those who commissioned work from him that he seemed to be courting disaster. He endured a painful bankruptcy and fourteen months in exile in Venice. Recovering, he returned to London, which he proceeded to dominate artistically for the next twenty years. His fame spread through continental Europe and even reached the United States. Sycophants followed him about, faithfully copying his mannerisms and repeating his jokes. Almost insensibly, the character traits of his childhood, plus those forged in the critical battles of the 1860s and 1870s, had become something which, for an American, was entirely new. Whistler had become The Artist: dressing differently from ordinary mortals, speaking differently, his every word and gesture as much a critique of philistia as his clothes. If they would not accept him, "Ha,ha!" one could hear his famous laugh, well, he preferred to have nothing to do with them. He would attend their parties and perhaps accept their commissions; he might even, if he so deigned, take their money. But he would scorn them, he would make them wait, sometimes for decades, before delivering the picture, if he delivered it at all. On occasion, he would deliver it only to reclaim it later for alterations, and then never return it. He was famous, gifted, notorious, charming and impossible by turns. If you wanted to be an artist, that was the way you behaved.[26]

But while Whistler was cultivating a pose as the temperamental late-Victorian dandy, he was simultaneously a serious, hard-working artist. His most important innovations as a mature painter involved his nocturnes, another musical term which could apply equally well to painting. Whistler developed the habit of going out at dusk; at first he took notes, but later he trusted the memory he had been cultivating since his first days in Paris. He was, in addition, notoriously near-sighted, and what his natural incapacities did not blur and confuse, the increas-

ing dark did. "His method was to . . . stand before his subject and look at it, then turn his back on it and repeat to whoever was with him the arrangement, the scheme of colour, and as much of the detail as he wanted." His companion "corrected errors when they occurred, and, after Whistler had looked long enough, he went to bed with nothing in his head but his subject." The next morning, if he could see the complete picture before him, he painted; if not, he might repeat the whole procedure again that evening. Nature gave him its inspiration, while the Japanese gave him intuitions about what to do with it. Bad eyesight, the dark, and memory filtered out the unnecessary—so prominent in many Pre-Raphaelite works—and only the design, the harmony, remained. When it worked, the process was remarkably effective.

He developed his own method of painting. Devoted followers helped him make his own brushes and mix his colors with linseed oil, copal, or mastic and turpentine. He had a large palette, a board two feet by three with a butterfly inlaid at one corner, on which he laid out his colors, the pure at the top. He then mixed large quantities of the prevailing color in the intended picture, producing results so juicy that he called it "sauce." For noctures he used a highly absorbent canvas, occasionally panels or brown holland. He had to lay his canvas on the ground because the sauce would run if the canvas were in any way tilted—sometimes it did anyway, and he often accepted the accidental results. "He washed the liquid colour on, lightening and darkening the tones as he worked. In the Nocturnes, the sky and water are rendered with great sweeps of the brush of exactly the right tone." If he had mixed the tones to his satisfaction, "he took them off his palette and kept them until the next day, in saucers or gallipots, under water, so that he might carry on his work in the same way with the same tones." He was perfectly capable of laying the paintings out on the garden wall to dry in the sun, and sometimes the drying process produced odd changes. He designed special frames, to make the whole a complete ensemble. He had to invent everything, for no one had ever proceeded in this manner before.[27]

Like most artists, Whistler hated to be pinned down about what he was doing. But on one occasion, a critical assault by John Ruskin provoked him to sue for libel, and severe questioning at the trial forced him toward definition. In the picture "Nocturne in Black and Gold: The Falling Rocket" (1874), what had he meant by the word "nocturne"? "I have, perhaps, meant rather to indicate an artistic interest alone in the work, divesting the picture from any outside sort of interest which might have been otherwise attached to it. It is an arrangement of line, form, and colour first, and I make use of any incident of it which shall bring about a symmetrical result." He had done several paintings of the night, and used the term nocturne "because it generalises and simplifies the whole set of them." His definition lacked any of Ruskin's usual criteria for acceptable art: no truth to nature, no God,

no sympathy for the masses, no tying of good art to good men, and certainly no proper reverence for the subject.[28]

Over the next few years, Whistler fretted about what he was doing, often writing out sentences and paragraphs and trying them out on any friend who would listen. Early in 1885 he was finally ready to make a statement; he asked Mrs. D'Oyly Carte to make the arrangements for Prince's Hall, the affair to begin at ten o'clock in the evening, so that no gentleman would feel rushed for dinner. He even designed the tickets and posters himself, and held a dress rehearsal the night before. Finally, on 20 February 1885, Whistler delivered "The Ten O'Clock" by memory to a crowded hall. Faultlessly attired in evening dress, he was the perfect opposite of the man of nature, appearing to one member of the press as "a jaunty, unabashed, composed, and self-satisfied gentleman, armed with an opera hat and an eyeglass." Repeated a month later at Cambridge and a month after that at Oxford, the speech has gone down in history as the first official statement of modernist attitudes by an American.[29]

"It is with great hesitation and much misgiving that I appear before you, in the character of The Preacher," he began, as if to underline his distaste for Ruskin and the other moralists of art. But art was "upon the town," familiarity was breeding contempt, and the masses were feeling an ominous intimacy with it. The Victorian sentimentalists, the Pre-Raphaelites, and William Morris had all helped to create an environment in which no one could escape art. "The people have been harassed with Art in every guise," and "have been told how they shall love Art, and live with it. Their homes have been invaded, their walls covered with paper, their very dress taken to task," until they have come to resent so much intrusion. Such a situation maligned art and needlessly placed it in a bad light. Art had nothing to do with social uplift: "She is a goddess of dainty thought—reticent of habit, adjuring all obtrusiveness, purposing in no way to better others." Holding that art was "selfishly occupied with her own perfection only—having no desire to teach—seeking and finding the beautiful in all conditions and in all times . . . ," he took his refuge with Rembrandt, Tintoretto, and Veronese. These men were "no reformers," "no improvers of the way of others," and lived instead entirely for their work. Their world "was completely severed from that of their fellow-creatures with whom sentiment is mistaken for poetry; and for whom there is no perfect work that shall not be explained by the benefit conferred upon themselves." No great artist could let humanity take the place of art, confuse beauty with virtue, or ask the most absurd of all questions: "What good shall it do?" Such questions usually boiled down to the role of nature in art, and Whistler faced the question boldly. He ridiculed the notion that nature was always right. "Nature is very rarely right, to such an extent even, that it might almost be said that Nature is usually wrong: that is to say, the condition of things that shall bring about the perfec-

tion of harmony worthy of a picture is rare, and not common at all."[30]

As was usual with Whistler, the views so seriously arranged for and delivered quickly went down into the history of anecdote as well. One day a breathless lady ran up to him and said: "Oh, Mr. Whistler, I have just been up the river, and it reminded me so much of your pictures." "Indeed," Whistler replied. "Then Nature is looking up."[31]

In many ways, London was ready for Whistler's remarks. Literary Englishmen for a generation had been thinking along comparable lines. Priority for most important modernist ideas belonged to Paris, but for English speakers the story probably began with Swinburne and Pater. An acute if erratic sensibility, Swinburne could write, in his study of William Blake (1868): "Art for art's sake first of all, and afterwards we may suppose all the rest shall be added to her . . ." As a friend of both Whistler and Pater, Swinburne was also in an excellent position to carry ideas and attitudes from literature to painting and back again, and if no one could ever recall Whistler reading a book, many could recall Swinburne's devotion to Anna Whistler and his closeness to the painter until they differed too significantly over the meaning of "The Ten O'Clock" ideas to remain intimate. Swinburne's knowledge of Baudelaire, and his feelings of kinship with the early French modernists, made him the vital link with the development of British modernist attitudes. He became the spokesman for the solipsistic tendencies of modernism, the creator of a separate world where society was unwelcome and the imagination had full rein.[32]

With Pater, aestheticism achieved its most notorious formulation. Shy and retiring, Pater hid a multitude of skeptical and cynical attitudes behind the mask of a minor don. Given to wicked quips, like Whistler, he probably did himself out of clerical or professorial eminence with remarks like: "It doesn't matter in the least what is said, as long as it is said beautifully," with clear reference to the theology of the Church of England. Unlike most writers and painters associated with the aesthetic movement, he had a serious interest in philosophy, particularly the problem of the relationship between external objects and the perceptions of individuals, and the way the mind deals with sensuous experience. He could never really answer the questions involved, but he came to believe that people were the prisoners of their sense impressions and that consciousness amounted to single moments that passed so quickly that before anyone could truly apprehend them, they were gone. Far more than religion or morality, a work of art could help a person cope with this apparent chaos of consciousness. A work of art could capture such moments forever, and thus impose a kind of order and permanence on the life of the mind. The conclusion to *The Renaissance*, possibly written as early as 1865 and in print by 1868, became the most quoted serious statement in English on the subject: "Every moment some form grows perfect in hand or face; some tone on the hills or sea is choicer than the rest; some mood of passion or insight or intellectual

excitement is irresistibly real and attractive to us"—but only for that moment. "Not the fruit of experience, but the experience itself, is the end." Life can have only a limited number of worthy sensations, and the problem of living is to focus oneself on where "the greatest number of vital forces unite in their purest energy." "To burn always with this hard, gemlike flame, to maintain this ecstasy, is success in life."[33]

Never a showman, Pater had a tendency to back off from his more provocative positions when challenged, but such reticence was never a problem with his best-known student, Oscar Wilde. Wilde's reputation for homosexuality and his trial and imprisonment have left a blurred image of his importance to cultural history. He was a highly intelligent presence on the late Victorian stage, and his narcissistic sense of his separate selves and his constant observation of them as he wrote made him a precursor of post-modernism as well as an obvious influence on modernism. A good friend of Whistler's for some time, he finally broke with the painter in what was more a clash of egos than any great difference of opinion. Wilde's plays and *The Picture of Dorian Gray* were all important in aestheticism, and when Lord Wotton tells Dorian: "Live! Live the wonderful life that is in you! Let nothing be lost upon you. Be always searching for new sensations," he sounds not only like a pupil of Pater and friend of Whistler, he sounds like Lambert Strether in Henry James' *The Ambassadors*.[34]

V

England attracted artists for many social and commercial reasons, but produced few major ones of its own. Those it had did conventional work or went into exile. Paris was the great breeding ground of the new, and Paris was where Whistler belonged if he belonged anywhere. In Paris, a tradition of artistic unconventionality stretched back almost a century from the time of Whistler's maturity. Even Balzac had paid attention to artists, toying with the way a creative figure could be a success in art yet a failure as a man, and leaving a general impression of artists as irreligious, sensual, erratic, and childlike, the best example being Wenceslas Steinbock in *Les parents pauvres* (1846).

Whether art imitated life or life imitated art, Paris in the 1820s and after had produced a circle of literary figures who behaved in a way outsiders identified as artistic. The circle around Victor Hugo was especially important here, for its members developed eccentric clothes, exotic moustaches, and pointed beards into outward symbols of novel ideas about art, sexual relations, and the bourgeois enemy. Théophile Gautier's *Histoire du romantisme* (1874) later gave the world the picturesque details, but the first important contemporary expression of the attitudes involved came in his preface to *Mademoiselle de Maupin* (1835): "There is nothing truly beautiful but that which can never be of any use whatsoever; everything useful is ugly, for it is the expression of

some need, and man's needs are ignoble and disgusting like his own poor and infirm nature. The most useful place in a house is the water-closet."

For a time, the great role model seemed to be E.T.A. Hoffmann, who as draftsman, caricaturist, and musician appeared in several stories, and whose career inspired writers like Gautier to the articulation of the basic themes of the genre: the artist as an unconventional genius, ambitious yet despairing, fighting the bourgeois; the lack of recognition when a person was actually creative; the hostility of established institutions; the success in unconventional love; and the irony of posthumous fame. By the 1870s, Gautier could insist that the aims of his *"petit cénacle"* were clear: "To develop freely every intellectual fancy, whether or not it shocks taste, conventions, and rules; to hate and repulse to the utmost what Horace called the *profanum vulgus,* and what moustachioed, long-haired *rapins* mean by 'shopkeepers,' 'philistines,' or 'bourgeois'; to celebrate the pleasures of love with a passion capable of scorching the paper on which we record them, insisting upon love as the sole end and sole means of happiness; and to sanctify and deify Art, regarded as second Creator." These were the underlying ideas of the program which each artist, according to his strength, tried to practice—"the ideal and secret ordinances of Romantic youth."[35]

Other figures, especially Alfred de Vigny and Alfred de Musset, filled in the general picture. As a young bohemian student, Whistler had had a mistress named Héloïse who used to walk around with a volume of Musset's poems; as "Fumette" she appeared in *The French Set,* and her temperament earned her the nickname of *"la Tigresse"* among Whistler's friends. But more to the point, Whistler was familiar with the work of the writer Henri Murger, and knew the author casually. Whistler's biographers disagree as to whether he read Murger in Washington before coming to Paris, or discovered the work only after his arrival, but the dispute hardly matters. The point is that the Murger picture of artistic life, in *Scènes de la vie de bohème,* did more to define the type than any other. The book made no great aesthetic point, but it pinpointed the south side of the Seine in the area around the Sorbonne as a "bohemia" in which a new class had developed. Students and artists there had no money, wore poor clothes, lived in shabby quarters, drank when they could, had sexual partners who came and went, delighted in swift repartee and bad puns. Life around the Café Momus was disorderly, but out of such disorder came new ideas and new works of art.[36]

Bohemia fascinated Whistler, if only because it was so different from life with mother in Pomfret, and he certainly approved of the freer sexual atmosphere. But socially he was only half a bohemian, much preferring the comforts of Debo's British home or the grandeur of life among the diplomats who had known his father. He found a comparable figure in Charles Baudelaire, as fashionably elitist in his social and

intellectual views as even Whistler could ask. They shared many mutual friends. On occasion, Baudelaire even commented on Whistler's early work. Whistler discovered that Baudelaire had used the precedents set by Edgar Allan Poe and Gautier to reject all photographic, natural art unless it suggested some topic by association. Poetry for Baudelaire had no other aim than itself, and he permitted nothing moralistic or didactic to sully his verse. By the 1860s, through Swinburne, through Baudelaire's reviews of his work, and through the increased French recognition of Pre-Raphaelite work as well as British recognition of French ideas, Whistler had become a convert to the new aesthetic; he and Baudelaire even patronized the same store in Paris that sold Japanese imports. For all practical purposes, an American had entered French aesthetics and applied to painting ideas chiefly associated with poetry.[37]

By the 1880s, the direction of influence was beginning to run the other way. The delivery of "The Ten O'Clock" in 1885 became known in Paris, and Stéphane Mallarmé offered to translate it. He did so, and in the process he and the painter became good friends who kept in touch until Mallarmé's death. By the 1890s, Whistler's work had impressed Claude Debussy so much that the composer, whose most popular work was probably his *Prélude* to Mallarmé's *"L'Après-midi d'un faune,"* called one of his most important pieces the *Nocturnes for Orchestra,* intentionally using Whistlerian terminology. The most notorious aesthete in all Paris, Count Robert de Montesquiou, sat for a Whistler portrait. Whistler and his work so excited him that he presented Proust with a specially bound copy of Whistler's collected papers, *The Gentle Art of Making Enemies.* Proust already felt an affinity for Ruskin, but found an almost equal enthusiasm for Whistler. Some of the material concerning the Whistler-Ruskin trial formed a backdrop in *Jean Santeuil,* and in the longer work the painter Elstir was clearly a character modeled in many ways on Whistler. At the same time, far off in Barcelona, Whistler's use of tonalities had had a pronounced impact on Ramón Casas and Santiago Rusiñol, and then on the young Pablo Picasso, whose "blue" period may well owe its chief inspiration to Whistler's experiments.[38]

Most Americans scarcely noticed, but those few who did proved more than adequate to the task of keeping Whistler's influence a living presence in cultural history. In the late 1870s, Henry James had gone to one of Whistler's breakfasts and found him "a queer little Londonized Southerner" who "paints abominably" but who served tomatoes and buckwheat cakes in a manner that clearly pleased James. His published reviews of Whistler's work proclaimed that it did not "amuse" him, for he thought that "to be interesting," "a picture should have some relation to life as well as to a painting. Mr. Whistler's experiments have no relation whatever to life, they have only a relation to painting." But James evolved in his tastes and was impressed by Whistler's pictures of Anna Whistler and Lady Archibald Campbell. By the 1890s, James had

sent Whistler tickets to a performance of *The American,* and Whistler had sent an etching in return. James was soon so favorably disposed to Whistler's art that he could exclaim in print about the stupidity of public taste that did not "recognize in Mr. Whistler's work one of the finest of all distillations of the artistic intelligence," capable as it was of giving any place that displayed it "something of the sense, of the illusion, of a great museum."

The book which occasioned the most important contact between Whistler and James was *The Spoils of Poynton.* When James had sent him a copy and Whistler's reaction had been all that he could ask, James responded with a classic example of the shock of recognition, one artist suddenly knowing that another understood. Whistler's words had special comfort for him, James wrote, because they came "as from one who knows." "To have pleased you, to have touched you, to have given you something of the impression of the decent little thing one attempted to do—this is for me, my dear Whistler, a rare and peculiar pleasure." James knew that Whistler had himself "done too much of the exquisite not to have earned more despair than anything else; but don't doubt that something vibrates back when that Exquisite takes the form of recognition of a not utterly indelicate brother," signing himself off to "my dear Master."[39]

Of all the cultural figures whose lives Whistler shaped, often unknowingly, Ezra Pound was the most significant. More than anyone else, Pound took the Whistler persona, adapted it to his own purposes, and became himself "The Poet" just as Whistler had been "The Artist." The hair, the moustache, the clothing, the arrogance, the manners—even the talent—somehow seem to be Whistler in a new incarnation. Even more than James, Pound *knew;* he knew even about James. As a college student, Pound had presented a copy of "The Ten O'Clock" to his companion Hilda Doolittle; in 1912, he informed Harriet Monroe that Whistler was "our only great artist," and that the effort Pound and Monroe together were making for the emergence of a great American poetry was "an endeavor to carry into our American poetry the same sort of life and intensity which he infused into modern painting." Pound's greatest act of fealty to his role model came in 1913, when he published the series of articles called "Patria Mia." There, he proclaimed that America "has given the world two men, Whistler, of the school of master-work, of the school of Dürer, and of Hokusai, and of Velázquez, and Mr. Henry James, in the school of Flaubert and Turgenev." Pound took "deep delight" in James' novels, and from a recent exhibition of Whistler paintings "more courage for living than I have gathered from . . . any other manifest American energy whatsoever." With Whistler, the world had "a man, born American, with all our forces of confusion within him, who has contrived to keep order in his work, who has attained the highest mastery, and this not by a natural facility, but by constant labour and searching." The exhibition covered many

aspects of Whistler's career, so that his "life struggle was set before one. He had tried all means, he had spared himself nothing, he had struggled in one direction until he had either achieved or found it inadequate for his expression. After he had achieved a thing, he never repeated. There were many struggles for the ultimate nocturnes." Pound then summed it up: "What Whistler has proved once and for all, is that being born American does not eternally damn a man or prevent him from the ultimate and highest achievement in the arts."[40]

If Whistler taught aspiring artists how to behave in such a way as to distance themselves from American culture, William James gave them words and concepts to express themselves. Having grown up in a family that was an incubator of neuroses, James managed the difficult task of converting personal misery into scientific theory. He became a cosmopolitan committed to the study of consciousness, a central concern to young modernists not only in itself but in such related areas as the unconscious and the supernormal. In studying consciousness in its philosophical, psychological, and religious contexts he had more influence on American modernists than any other American thinker, and was the most influential American influence on Europeans.

CHAPTER 2

William James & a World
of Pure Experience

Neither of James Whistler's parents had ever intended for him a life of exotic exile devoted to art. The needs of the Czar and the ability of a railway engineer had coincided and the resulting circumstances had provided Whistler enough exposure to cosmopolitan tastes and attitudes for him to remain forever dissatisfied with the teachings of either the Presbyterian Church or the American business ethic. He seemed to know his place in life from an early age and never allowed his devotion to his mother to cause him more than mild inconvenience in living as he chose.

The situation of William James was very different. In his family, the chief rebellion against American values had taken place a generation earlier. His grandfather, also named William, had come to America from Northern Ireland in 1789 as a penniless farmer's son. Beginning as a clerk in Albany, New York, he was soon selling tobacco and produce and involved in a partnership that shipped clover and flax back to Ireland. He speculated in land along the Erie Canal and bought a saltworks in the Syracuse area. A friend of Governor De Witt Clinton and Union College President Eliphalet Nott, William was a major figure in the state. He fathered thirteen children by three wives and appeared happy and successful. Yet his life must have seemed in some ways a mockery. His children died young or showed an alarming tendency to avoid business responsibilities. The fortune he had accumulated proved to be a mixed blessing. He could use it to manipulate his children's lives when they were young, but time was on their side and they all seemed to know it.

Henry James, Sr., was the son of William and his third wife, Catherine Barber, and in time the father of both William James and his novelist brother, Henry, Jr. Henry, Sr., rebelled from an early age against the "formal remorseless dogmatism" of the family religion and the "ordinary paralytic Sunday routine" it entailed. He clearly identified his father on earth with his Father in Heaven, and derided the necessity for an innocent child like himself "to keep a debtor and creditor ac-

count with God." Even in old age, he insisted that "the influences—domestic, ecclesiastical, and secular—to which I was subjected, exerted a most unhappy bearing upon my intellectual development." Home and church agreed "that a profound natural enmity existed from the beginning between man and God, which however Christ had finally allayed, and that I ought therefore gratefully to submit myself to the law of Christ." The child and the philosopher were one in declaring, on the contrary, that human impulses were basically good and that man had "no higher obligation" than "to act according to his nature."

The result was a legal, ethical, and familial conflict of wills. William scarcely knew what to do with his rebellious son. A tragic accident complicated matters even further: when he was thirteen, Henry, Sr., lost a leg that had been burned and was feared gangrenous, and for three years his father could do little but indulge him. The pain, beyond anything imaginable to later generations accustomed to anesthesia, inevitably caused anguished reflections as to why the sufferer had been singled out for such punishment. Yet the amputation hardly altered the pattern of family conflict. Henry was something of an alcoholic at an early age, and not even Eliphalet Nott was able to tame his wildness. Henry fled Union College, showed no interest in salt or other business, and ignored his father's instructions to study law. He spent funds with abandon and only under duress did he finally return to college, graduate, and read law in a desultory way. Mostly, Henry gambled and drank, and his father understandably cut him off from all but token participation in his substantial estate. Henry managed to get money for his own use in 1837, but he and other aggrieved members of the family worked from William's death in 1832 until 1846 to break the will, finally succeeding. By then, Henry had abandoned any pretense of a career, and was spending much of his time on European travel, reading, and writing.

The vocational conflict between Henry, Sr., and his father had reverberations for a century. As Henry, Jr., wrote in his own old age: "The rupture with my grandfather's tradition and attitude was complete; we were never in a single case, I think, for two generations, guilty of a stroke of business." Emotionally, the scars may never have disappeared. Henry, Sr., seemed obsessed with his relationship to "God, the Father" and the need for all humanity to be one happy family, the children indulging their natures as God intended, His will being done with benign approval rather than Calvinistic censure. Psychologically, Henry suffered a nervous breakdown, a *vastation* as he came to call it, from which he finally recovered by seeing himself in Bunyanesque terms as Christian, struggling along his pilgrim's progress and adopting a theology—that of Emanuel Swedenborg—which guaranteed an unconditional love for all of God's children. Politically, Henry became devoted to the socialism of Charles Fourier, which he defined as "the idea of a perfect fellowship or society among men."[1]

The home that Henry, Sr., created for his own family reflected his pain at the way he himself had been brought up. In place of the rigid Presbyterianism that had made his Sundays so bleak, he encouraged his children to sample any church they wished "with a sense of earnest provision for any contemporary challenge," as Henry, Jr., recalled. When asked what church they went to, his father would "reply that we could plead nothing less than the whole privilege of Christendom and there was no communion, even that of the Catholics, even that of the Jews, even that of the Swedenborgians, from which we need find ourselves excluded." In place of a bourgeois home devoted to salt and trade, Henry, Sr., created its opposite: "the word had been passed, all round, that we didn't, that we couldn't and shouldn't understand these things, questions of arithmetic and of fond calculation, questions of the counting-house and the market." In a country where with only a few professional exceptions, "business alone was respectable," the children faced constant queries about their father's function: "What shall we tell them that you *are?*" they would ask, only to receive gnomic reply: "Say I'm a philosopher, say I'm a seeker for truth, say I'm a lover of my kind, say I'm an author of books if you like, or, best of all, just say I'm a Student." In place of domestic stability, the family moved constantly, to Paris or Geneva or elsewhere in Europe; "we were for considerable periods, during our earliest time, nothing less than hotel children."

So great, indeed, was Henry, Sr.'s, aversion to the way his own father had pushed him through college toward business and law, that he seemed averse to any sign of serious vocational interest on the part of his children. If they became too committed to anything, even painting or writing, he suggested a distracting alternative. "What we were to do instead was just to *be* something, something unconnected with specific doing, something free and uncommitted, something finer in short than being *that,* whatever it was, might consist of"—and even the career of art might fail "to uplift the spirit." Instead, young William and Henry were to cultivate the state of being " 'good'—in other words so good that the presumption of our being so would literally operate anywhere and anyhow, would really amount in itself to a sort of situated state, a sufficient prime position, and leave other circumstances comparatively irrelevant." They were all, in short, tainted "with the quality and the effect of detachment. The effect of detachment was the fact of the experience of Europe." In time, such detachment, such stress on one's being or consciousness, such insistence on pure experience, became a central focus of the psychology of one brother and the fiction of the other.[2]

Such a family and such ideas produced an educational environment all but unique in the American experience. The results were both positive and negative. William had enrolled in nine schools in four countries by the time he was eighteen, rarely remaining more than a few months in any of them, and enduring a variety of tutors in the intervening periods. He thus never received anything systematic from

schooling, and never throughout his life recalled any person or institution as having been formative in his growth. Yet such a "rootless and accidental childhood," as his sister Alice called it, also saved him from the deadening effects of the typical American school. He never had to endure the more primitive varieties of patriotic or moralistic indoctrinations which remain endemic to American public education, nor force himself to function at the level of the least intelligent of his democratic classmates. He could, instead, develop a fluency in French and German that was later of inestimable social and scholarly value.

Perhaps most important, he became a genuine cosmopolitan. Few other young Americans could have informed their parents, at age twenty-five, that "there is not the slightest touch of the romantic, picturesque, or even *foreign* about living" in Dresden. "My traveling has been accompanied with hardly more astonishment or excitement than would accompany a journey to Chicago. . . ." Because Germany did not seem foreign, a mature William James was able to criticize it, joke about it, and not feel intimidated by its scholars. Fifteen years later he could meet the well-respected Ernst Mach and Carl Stumpf and inform his wife that they were "not so different from us as we think. Their great thoroughness" was "largely the result of circumstances," and he found that he "had a more *cosmopolitan* knowledge of modern philosophic literature than any of them"; he now felt "much less intimidated by the thought of their like than hitherto."[3]

This wandering from school to school and country to country also reenforced William's neurotic inability to choose a career and to stick to his choice. Henry, Jr., recalled his brother during these years as "always drawing," and William seemed happiest during 1856–57 when he could haunt the Louvre and absorb the Paris art scene, especially the work of Delacroix. But art was a subject on which his father had, as usual, strong and often self-contradictory opinions. Henry, Sr., at times thought of the artist as a great hero expressing divinity. But he never thought of art as limited to painting, insisting: "Art embraces all those products of human genius, which do not confess the parentage either of necessity or duty." William could easily have been pardoned for assuming parental approval of a possible career as an artist, since his father had talked about art in an approving way during William's early adolescence, and insisted that William and his siblings could become anything they wished. But in his passive aggressive way, Henry, Sr., backed off from the results of his talk about art and the freedom to pursue it as soon as William showed any serious interest in it as a career. William had to lobby his reluctant father strongly for the right to study with William Morris Hunt in Newport during 1860–61, only to find that the victory was empty. William found that he would never be a great painter and lacked the will to become a happy if mediocre one. A long series of psychosomatic ailments began: his eyes became inflamed and he quit.[4]

As long as William seemed interested in art, Henry, Sr., thought a career in science would be ideal for him. Science to the older man was an analysis of the presence of God in the life of man, and each technical achievement a firm step on the path toward the obliteration of evil in nature. In 1861, William dutifully registered in the Lawrence Scientific School at Harvard and in one sense or another remained a scientist forever after. Louis Agassiz stirred him briefly and James did satisfactory work under Jeffries Wyman in physiology and Charles W. Eliot in chemistry. His heart must have been in it for a while: Henry, Jr., has left a memorable picture of William as "addicted to 'experiments' and the consumption of chemicals, the transfusion of mysterious liquids from glass under exposure to lambent flame, the cultivation of stained fingers, the establishment and the transport, in our wanderings, of galvanic batteries, the administration to all he could persuade of electric shocks, the maintenance of marine animals in splashy aquaria," and so on. But Harvard on the whole was a dull institution with low standards and many years later Eliot told William's son that he did not feel James had been "wholly devoted to the study of Chemistry." He seemed constantly ill with some nervous condition and was always dabbling in other areas of science: "his mind was excursive, and he liked experimenting, particularly novel experimenting." Eliot "received a distinct impression that he possessed unusual mental powers, remarkable spirituality, and great personal charm." In a classic understatement, he concluded: "This impression became later useful to Harvard University."

But dabbling in science was not the same as having a career and James was acutely aware of the need to make a firm choice. "A year and a half of hard work" in chemistry "has somewhat dulled my ardor," he wrote to a cousin, and he had also sampled comparative anatomy with no sense of a calling. "I have four alternatives: Natural History, Medicine, Printing, Beggary. Much may be said in favor of each." Only medicine seemed likely to pay enough for him to support a family, but the training required seemed daunting: "how much drudgery and of what an unpleasant kind is there!" Still, in January 1864, William entered the Harvard Medical School to prepare for something useful. He had some respect for Wyman and Eliot, who taught there as well, but: "My first impressions are that there is much humbug therein, and that, with the exception of surgery, in which something positive is sometimes accomplished, a doctor does more by the moral effect of his presence on the patient and family, than by anything else. He also extracts money from them." He dawdled as he always did. He took time off to accompany Agassiz on a scientific expedition to Brazil. He took medicinal baths in Germany. He remained ill with indecision and although he took his medical degree in 1869 he never valued it much and made no pretense of opening a practice.[5]

If ever a man went through what modern analysts term an "identity

crisis," William James was that man. His family believed that he should never resolve it, should in fact develop his faculties casually for life as his father had. Two younger brothers fought in the Civil War, lived briefly in the South, and avoided ever doing anything successful. Having never found a husband or a role appropriate to women of that day, sister Alice found her identity as an invalid, as did many women and some men of the era. Henry, Jr., claimed any number of physical problems, especially relating to his lower back, that seemed to be excellent means of avoiding the Civil War and his oppressive family and justifying the expense of European travel, but his identity as a man of letters became clear to him fairly early and he avoided much of his brother's anguish and indecision. With William, the inflamed eyes, the insomnia, the intestinal distress, the weak back and general depression were as mystifying as they were painful. Medical theory of the day insisted that such symptoms had to have a physical and not a mental origin, and to anyone with James' medical training, the prognosis for his future did not seem promising. He described himself to one friend as "a mere wreck," and outlined the negative vocational consequences of his troubles to another: "Of course I can never hope to practise; . . . I can't be a teacher of physiology, pathology, or anatomy; for I can't do laboratory work, much less microscopical or anatomical."

Many of his friends suffered similar symptoms and crises; the Jameses were unusual only in the level of talent needing outlet. Even before his mental breakdown, William wrote a friend: "Much would I give for a constructive passion of some kind," and it is hard to escape the conclusion that lack of such a passion of vocation was one root of his troubles. Other roots were fairly obvious. He chafed at the oppressive warmth of his home, only steps from Harvard Yard. His domineering if gentle father, his banal if caring mother, and his complaining if intelligent sister provided an environment only too suited to invalidism and indecision. Yet in Europe he found mostly other invalids, and his sporadic academic forays never led to anything satisfying. He found the medical theories about mental disease inadequate, and seemed to feel that his problems did not have a solely physical origin. The more he studied science, the less rewarding he found a purely scientific outlook on life and the philosophical materialism that usually accompanied the Darwinism of his colleagues. He needed, in short, to form his own family, to settle into a career, to formulate new theories in the realms of psychology, philosophy, and religion.[6]

First, James had to go through a genuine crisis. In August 1872, President Eliot thought his former student would be the ideal man to initiate a new course. He offered James an instructorship in anatomy and physiology. James' spirits lifted immediately and he told his brother that the appointment was "a perfect God-send to me just now, an external motive to work, which yet does not strain me—a dealing with men instead of my own mind, and a diversion from those introspective

studies which had bred a sort of philosophical hypochondria in me of late and which it will certainly do me good to drop for a year . . ." But the solution to his problem also implied an end to his father's hegemony and the tyranny of the family preference for dilettantism. As the chill of fall settled on Cambridge, he hit bottom.

Years later, he included a disguised account of the crisis in his chapter "The Sick Soul," in *The Varieties of Religious Experience*. While in a state of philosophical pessimism, he had gone to his dressing table one evening, "when suddenly there fell upon me without any warning, just as it came out of the darkness, a horrible fear of my own existence." At the same time, an image appeared to his mind "of an epileptic patient whom I had seen in the asylum, a black-haired youth with greenish skin, entirely idiotic, who used to sit all day on one of the benches, or rather shelves against the wall, with his knees drawn up against his chin, and the coarse gray undershirt, which was his only garment, drawn over them inclosing his entire figure." The creature had sat there "like a sort of sculptured Egyptian cat or Peruvian mummy, moving nothing but his black eyes and looking absolutely non-human." His fear and the image somehow fused in his imagination: *"That shape am I,* I felt, potentially." Nothing could possibly save him from some comparable condition if the fates should decree it. "There was such a horror of him, and such a perception of my own merely momentary discrepancy from him, that it was as if something hitherto solid within my breast gave way entirely, and I became a mass of quivering fear." Nothing seemed the same to him, and he awoke each morning "with a horrible dread at the pit of my stomach, and with a sense of the insecurity of life that I never knew before, and that I have never felt since." The experience made him "sympathetic with the morbid feelings of others ever since." He was afraid of the dark and of being alone, even while recognizing that family members around him seemed to have no suspicion of what he was going through. He acknowledged through footnote references the ways in which his own crisis recalled not only his father's *vastation,* but also Bunyan's *Pilgrim's Progress.* But the crisis was no less painful for being familial, literary, and even traditional.

It also contained the seeds of its own cure. He had his classes to prepare for, and by late fall he described himself as going to the medical school every morning, attending lectures and observing work in one of the laboratories. "It is a noble thing for one's spirits to have some responsible work to do," he informed his brother in late November. Two months into his first semester, his father wrote Henry, Jr., of the change in William, who had come in a day or so before, and after pacing about animatedly had told his father: "Bless my soul, what a difference between me as I am now and as I was last spring at this time! Then so hypochondriacal and now with my mind so cleared up and restored to sanity. It's the difference between death and life."

The recovery, however, was neither smooth nor consistent. Because

William James' teaching had been successful with the students, Eliot wanted him to take on more responsibility—not only to continue his course in physiology and hygiene, but to add to it all responsibility for physiology and anatomy in the college. James was in one of his usual panics of indecision. He still longed for art, he inclined toward biology, he thought himself best fitted for philosophy, he thought psychology preferable to physiology. In short, he dithered, and muttered all the while about his health perhaps not permitting anything so serious as a full teaching load. His parents, as was their custom, advised delay, recuperation, and a trip to Europe. William did return to Europe, chiefly Italy, but even as Henry was luxuriating in the Old World, soaking up impressions for his first important fictions, William found he was no longer much interested. "My old love of art returns, but not in its full force. The years have weakened it, I am afraid." He was instead disgusted by the dirt and decay and his trip became something of a series of unpleasant perceptions. He drew what were apparently his last pictures, and returned to a lifetime of teaching and writing at Harvard.[7]

II

The core of James' contribution to modernism was present even at the start of his professional career. His father's efforts to give his children a "better sensuous education" in Europe than they could get in an America given over to dreary views of religion and business had given William not only a cosmopolitanism uncommon among his colleagues, it had given his mind a theme to pursue profitably in both his professional and private lives. "Pure experience" or "consciousness" was an important focus of research in several disciplines. By stressing it, James could not only obtain professional advancement and a significant European audience, he could also cope better with the physical and mental problems remaining from his upbringing.

Insofar as James could pursue a single discipline for an extended period, he pursued psychology from the late 1860s to the late 1880s. It was not a recognized academic specialty in America until late in his life, but his early work in medicine, anatomy, and physiology was an ideal place from which to begin. Psychology enabled him to analyze the mental life which had been so central to his father, and deal in some way with the religious and ethical problems that were crucial to his own outlook on life. It also enabled him to do so as a detached scientist, and to win professional advancement for work well done in the laboratory. As early as 1867, he could casually tie the two needs together, as when he wrote a friend from Berlin that he thought "perhaps the time has come for psychology to begin to be a science—some measurements have already been made in the region lying between the physical changes in the nerves and the appearance of consciousness—at (in the shape of sense perceptions), and more may come of it." At the same time, and

in a remarkably prescient way, he fell immediately to bewailing the bad habits he had picked up—as yet unaware that "habit" would become one of the most important areas in his own writing. His "habits of mind" had been "so bad" that he felt "as if the greater part of the last ten years had been worse than wasted," and he lamented that he had not "been *drilled* further in mathematics, physics, chemistry, logic, and the history of metaphysics. . . ." It was all "Too late! Too late!" The Germans were not "a remarkably intellectually gifted people," but they seemed so to outsiders because of "their habits of conscientious and plodding work . . . It makes one repine at the way he has been brought up, to come here."[8]

James was familiar enough with the German academic scene to know that Wilhelm Wundt was the man with whom he probably ought to study: "I think I may learn something of the physiology of the senses without too great bodily exertion, and may perhaps apply the knowledge to some use afterwards," as he wrote his brother in May, 1868. James' health prevented any meaningful personal contact for years, however, and he essentially educated himself in German, French, and British psychology. But Wundt, and German work in general, had a special scientific prestige for James and his fellow Americans, and he kept the desirability of at least a visit in mind for some years. In November of 1882 James actually did hear Wundt lecture and had a personal conversation with him. At that time, James reported to his wife that Wundt had made a good personal impression on him, and that his opinion of the German was even higher than it had been. Aside from reading and talking to others about Wundt, this seems to have been the sum of James' contact with the man who, more than any other single figure, personified the ideal of *Wissenschaft,* of the scientific researcher in psychology. This lack of any pedagogical or personal relationship was an important fact of history, for it indicated something about the status of laboratory science not only in Germany but also in James' mind. Regarded almost everywhere as the founder of scientific psychology, Wundt in fact was a philosophical anachronism who impressed academics more by his modus operandi than by his contributions to knowledge. He directed a laboratory, edited a journal, organized scholars, publicized an agenda for research, and represented an ideology, but his own work remained narrow. James, who represented the same scientific ideals to many Americans, became disillusioned. Wundt was an excellent professor but a poor guide for the kind of research James felt the world needed.

James soon discovered that he disliked laboratory work, and that his weak eyes provided him with an excellent excuse for abandoning it. By 1890 he was attacking the "microscopic psychology" that had arisen in Germany, "carried on by experimental methods, asking of course every moment for introspective data, but eliminating their uncertainty by operating on a large scale and taking statistical means. This method taxes

patience to the utmost, and could hardly have arisen in a country whose natives could be *bored.*" Given his artistic temperament, James bored all too easily. Even more important, he knew that this type of "science" would not tell him what he wanted to know about his own mind and its experience in the natural world.[9]

James' ambiguous relationship to Wundt and the scientific psychology he symbolized was part of a larger, somewhat confused chapter in the history of American psychology. A student in James' generation would probably encounter one of two varieties of psychological thought. He learned either that the mind was a mechanism that received sense impressions, sorted them, associated them and developed complex conceptions from them; or that the mind was essentially a collection of faculties programmed to deal with the various demands of life. Associationist psychology had become more prevalent than faculty psychology, but both were antique conceptions left over from the mechanistic physics of the Enlightenment. All too frequently they became the means by which clerical teachers of philosophy inculcated traditional theological ideas into the young, integrating man and nature into a static, deductive picture of Creation that prevented the asking of embarrassing questions. Charles Darwin synthesized the most compelling answers, and psychology under his influence slowly changed its language from a stress on the mechanism and deduction of physics to a stress on the organism and evolution of biology. The new psychology seemed no longer determined, but indeterminate; it constantly presented new and relevant data for scientific consideration; it demanded that individuals adapt to nature and that scientists should study that adaptation. Psychology became not only biological but teleological: it asked about the goals of adaptation, about where men were heading, not where they had come from.

James' generation developed new ideas in most areas of thought, with the word "new" often a part of any attempt to conceptualize what was going on. A new mathematics developed notions of geometry at odds with what even the most advanced thinkers had assumed a generation earlier, and before World War I these ideas, at least in popularized forms, became important to painters, musicians, and writers in Europe. Americans not closely involved with pioneer Europeans were scarcely aware of this turmoil, but in psychology James was only the most eminent of the Americans who brought the "New Psychology" into the universities. Others included European colleagues like Hugo Münsterberg at Harvard and Edward Bradford Titchener at Cornell, who chose to make their careers in America.

Many of those involved with the New Psychology, whether students, professors, or historians, have assumed that it was in essence the adaptation of German psychological *Wissenschaft* to the American context, as if Wundt were its chief progenitor. In fact, the word "new" in this context was more honorific than descriptive and even James himself

was far more a product of domestic traditions of thought than he re-
alized. Like the other emerging social sciences, psychology had many
ties to philosophy, religion, education, and social reform, and was not
so free of traces of the old moral philosophy or such oddities as phre-
nology, mnemonics, and mesmerism as its exponents sometimes thought.
What the New Psychology did do was implant the mystique of science
in one area of academia, without being too specific as to what "science"
was, but assuming it had a close relationship to "facts" and experiments
in a laboratory. It also broadened the focus of psychological investiga-
tion. Psychology became a "social" science: New Psychologists were in-
terested in the scientific analysis of the mind *and* how it behaved, in
consciousness *and* its impact on character. Behind the technical lan-
guage and the academic controversies was a Protestant, democratic in-
terest in reforming both the self and the world. Over the long range,
the New Psychology gave great encouragement to progressivism in its
efforts to improve public schooling, social welfare agencies, and city
governments.[10]

This push toward social science and reform was foreign to the mod-
ernist impulse. Such concerns were part of the America the modernists
disliked, just a politicized version of the traditional puritanical concern
with the affairs of one's neighbors. But with William James, the New
Psychology came with a large admixture of other concerns, concerns
that could get lost in summary judgments of the new work. Along with
his German science and his medical degree, James had in his back-
ground his father's religious concerns, his own neurasthenia, and an
instinctive individualism that made him distrust large institutions and
facile assumptions about government activity whether it directly touched
the professions or not. He was concerned about facts, no man more so,
but facts to him included many intangibles: the facts of dreams, of in-
sanity, of religious crises, of psychosomatic diseases, and even the facts
of human immortality. This interest in intangible facts helped give James
his important place in the history of modernism.

As always with James, his life and his work were so woven together
that merely narrating the details of the life illuminates the intentions
and achievements of the work. On some occasions his interests were
respectable enough, as when on his 1882–83 trip to Europe, he at-
tended the lectures of Jean Martin Charcot, the neurologist whose work
at the Salpêtrière Hospital in Paris had led him into the subject of hys-
teria and the possible use of hypnotism in treating it—lectures that helped
Pierre Janet and Sigmund Freud along the path to psychoanalysis. At
other times, James indulged in experiments that might seem physically
dangerous but that were hardly uncommon among doctors of his ac-
quaintance. Thus as he wrote Henry, he had once had "two days spoiled
by a psychological experiment with *mescal*," which the government had
distributed to certain medical men for experimentation. Dr. S. Weir
Mitchell had put himself "in fairyland" with the Indian cactus buds,

but James was not so lucky: "I took one bud three days ago, was violently sick for 24 hours, and had no other symptom whatever," and feared he would have to "take the vision on trust!"

At least on certain rare occasions, James went beyond his own tolerance, mocking himself even as he conducted the experiment and wrote about it later. Thus the tone of his letter to his sister about his "ten or eleven visits to a mind-cure doctress, a sterling creature, resembling the 'Venus of Medicine,' Mrs. Lydia E. Pinkham, made solid and veracious looking." He would sit down beside her and go to sleep, "whilst she disentangles the snarls out of my mind. She says she never saw a mind with so many, so agitated, so restless, etc." Why to her, his eyes "kept revolving like wheels in front of each other and in front of my face, and it was four or five sittings ere she could get them *fixed.*" He was finally, however, "*unconsciously to myself,* much better than when I first went, etc. I thought it might please you to hear an opinion of my mind so similar to your own." Meanwhile, of course, he still suffered from insomnia and wondered what good it did to be "unconsciously" better. James also pursued Yoga, mental telepathy, and mediums. He seemed to need to investigate everything, even if his colleagues hid their eyes in shame and harrumphed loudly in the quarterlies and common rooms.[11]

Regardless of how unconventional James was in his interests and experiments, he was a genuine scientist in his approach to his field and from 1878 until the early 1890s he proved it by producing the two texts that defined the field for most American and many European scholars: *The Principles of Psychology* (1890) and its revised and condensed version, *Psychology* (1892), which students colloquially referred to as "James" and "Jimmy." Although he never had done laboratory work of any importance himself, James greatly valued the experiments of his peers and the books synthesized everything that was worth knowing in the field. He made it clear that he was leaving associationist and faculty psychology behind, as well as the theological baggage that had impeded most previous syntheses. As he wrote in 1900 in the preface to the Italian translation: "I thought that by frankly putting psychology in the position of a natural science, eliminating certain metaphysical questions from its scope altogether, and confining myself to what could be immediately verified by everyone's own consciousness, a central mass of experience could be described which everyone might accept as certain no matter what the differing ulterior philosophic interpretations of it might be."[12]

No one can measure the impact of a teacher or text. Ideas and impressions go into the air, some students and readers learn, some do not, and many put the ideas they retain to uses undreamed of by the scholar. But insofar as new psychological ideas were in the American air after 1890, they were usually there because of certain key passages in these works. James settled scholarly quarrels, lectured his readers

about how to run their lives, and quoted copiously from so wide a variety of sources as to provide something of a liberal education all by himself. On certain topics he had little to say beyond his sources, but three sections stand out as pregnant with modernist ideas.

The chapter on habit was probably the most popular, destined to be reprinted many times. James' first proposition was that *"the phenomena of habit in living beings are due to the plasticity of the organic materials of which their bodies are composed."* People found themselves in specific environments, their nervous systems became paths through which sensations produced muscular or glandular reactions, and habits resulted appropriate to the circumstances. The habits once formed freed the mind to deal with other stimuli, and functioned automatically. So far so normal. But few alert young novelists, interested in unconscious behavior for their portrayal of character, could fail to learn from James' sometimes whimsical asides. "Who is there that has never wound up his watch on taking off his waistcoat in the daytime, or taken his latch-key out on arriving at the door-step of a friend?" Absent-minded people going up to dress for dinner have been known to take their clothes off and climb right into bed, simply because that was what they usually did under such circumstances. James himself remembered the time when he had returned to Paris after ten years, "and, finding himself in the street in which for one winter he had attended school, he lost himself in a brown study" only to come out of it "upon the stairs which led to the apartment in a house many streets away in which he had lived during that earlier time, and to which his steps from the school had then habitually led." Everyone develops such habits and organized lives depend on them, and in such brief passages James approached novelistic writing himself.

On the whole, however, the chapter was so popular because it brought together in communicable form not only the fictional method of James' contemporaries, but the sort of ethics that any sober clergyman would endorse without a murmur. In this sense, the *Principles* was very much a book of the 1880s, when brother Henry was still writing realistically and both brothers admired the work of William Dean Howells above that of all other American novelists. Habit, James argued, had *"ethical implications"* because "our organs grow to the way in which they have been exercised . . ." Habit was "thus the enormous fly-wheel of society, its most precious conservative agent. It alone is what keeps us all within the bounds of ordinance, and saves the children of fortune from the envious uprisings of the poor." Only habit "prevents the hardest and most repulsive walks of life from being deserted by those up to tread therein." Fishermen and miners would flee their grubby jobs if not trained habitually to find them rewarding. "Already at the age of twenty-five you see the professional mannerism settling down on the young commercial traveller, on the young doctor, on the young minister . . ." He thought it just as well "for the world that in most of us,

by the age of thirty, the character has set like plaster, and will never soften again."

Less popular with the public but of more scientific importance was James' work on the emotions. As early as an 1884 article in *Mind,* James had been thinking about a physiological interpretation of the emotions; in time the similar ideas of Carl Lange also appeared and so the resulting theory received the title of the James-Lange theory of the emotions. It stated that *"bodily changes follow directly the perception of the exciting fact, and that our feeling of the same changes as they occur* IS *the emotion."* Most people believed that they lost their fortune, were sorry and wept; they met a bear, were frightened and ran; they were insulted, were angry and struck. James' hypothesis was that "this order of sequence is incorrect, that the one mental state is not immediately induced by the other, that the bodily manifestations must first be interposed between, and that the more rational statement is that we feel sorry because we cry, angry because we strike, afraid because we tremble, and not that we cry, strike, or tremble, because we are sorry, angry, or fearful . . ." On the surface merely a notion in psychology, the theory proved to have implicit lessons for artists. If as James and Lange argued, we have "absolutely no immediate criterion by which to distinguish between spiritual and corporeal feeling," then a novelist had readymade for him a modern way of portraying emotion. The tired adjectives of external descriptions could disappear and in their place a writer could substitute images of motor behavior that suggested emotions but never actually said an individual was sad, terrified, or lonely. Conveyed to Ernest Hemingway by Gertrude Stein, for example, such notions changed the ways Americans thought, talked, and wrote.

Most important of all for cultural history, James revolutionized thinking about consciousness. He rejected the conventional framework for discussing consciousness that started "with sensations, as the simplest mental facts" and proceeded "synthetically, constructing each higher stage from those below it." Such an approach abandoned empiricism because "no one ever had a simple sensation by itself." From birth, consciousness was "of a teeming multiplicity of objects and relations," and what people called "simple sensations" were "results of discriminative attention, pushed often to a very high degree." Thought was a process with five characteristics: it was "part of a personal consciousness," "always changing," "sensibly continuous," always appeared "to deal with objects independent of itself," and chose some subjects for attention while excluding others. As he elaborated these themes, James paid particular attention to the constant change, the flux of consciousness, and found himself deep in water imagery: "whatever was true of the river of life, of the river of elementary feeling, it would certainly be true to say, like Heraclitus, that we never descend twice into the same stream."

He was soon ready for what might well have been the most impor-

tant paragraph in the book: "Consciousness, then, does not appear to itself chopped in bits. Such words as 'chain' or 'train' do not describe it fitly as it presents itself in the first instance. It is nothing jointed; it flows. A 'river' or a 'stream' are the metaphors by which it is most naturally described. *In talking of it hereafter, let us call it the stream of thought, of consciousness, or of subjective life.*" To go from this formulation to an example for modern novelists one merely had to look at the briefer version: "Thus, for instance, after looking at my clock just now (1879), I found myself thinking of a recent resolution in the Senate about our legal-tender notes. The clock called up the image of the man who had repaired its gong. He suggested the jeweller's shop where I had last seen him; that shop, some shirt-studs which I had bought there; the latter, the equal value of greenbacks, and this, naturally, the question of how long they were to last . . ."

Given these discussions of habit, the emotions and the stream-of-consciousness, and the general acceptance of the *Principles* as the first genuinely scientific synthesis, the modernity of the volumes is perhaps too obvious. James may have been a precursor of modernism, but he was no modernist. He was a product of a Darwinian climate of creativity, and even in America the word "Victorian" often went along with "Darwinian." Few subjects separated the Victorian from the modern more effectively than sexuality, and given the modernity of some of James' insights, it comes as something of a shock to realize that sexuality played almost no role in the book. He mentioned sexuality in one paragraph on animal behavior and promptly, even nervously, launched into one of his ethical sermonettes. "No one need be told how dependent all human social elevation is upon the prevalence of chastity. Hardly any factor measures more than this the difference between civilization and barbarism," he wrote. "In all ages the man whose determinations are swayed by reference to the most distant ends has been held to possess the highest intelligence." He then all but made his peculiarly Bostonian inhibitions into a standard of human measurement: "The tramp who lives from hour to hour; the bohemian whose engagements are from day to day; the bachelor who builds but for a single life; the father who acts for another generation; the patriot who thinks of a whole community and many generations; and finally, the philosopher and saint whose cares are for humanity and for eternity,—these range themselves in an unbroken hierarchy, wherein each successive grade results from an increased manifestation of the special form of action by which the cerebral centres are distinguished from all below them." And that's about it for both sex and chastity.

One final area remained not so much omitted from the book as nascent. Like so many thinkers of his day, James worried about the mind-body problem, a dualism which he and his colleagues assumed to be crucial to both psychological and philosophical analysis. James remained a bit of an agnostic on the issue, feeling that the evidence was

insufficient for any firmly scientific word on it. The *Principles* never tried to define sharply what separated the mental from the physical; if it had it might well have reduced the mental to the physical in ways unacceptable to most Americans in 1890. Writers as shrewd as Charles Peirce and George Santayana thought the book materialist as it was. As James gradually abandoned psychology for philosophy and religion, his position became firmer—and far more compatible with modernism. In the years before his death in 1910, he reduced mind and body to the status of pure experience, both being merely different ways of patterning the only materials that existed. "If you ask what any one bit of pure experience is made of, the answer is always the same: 'It is made of *that*, of just what appears, of space, of intensity, of flatness, brownness, heaviness, or what not.' " The stream-of-consciousness overflowed its banks and reality became the field of consciousness. Few young modernists could possibly have been aware of the drift of James' mind, but he was heading their way.[13]

III

Even as James published his masterpiece, his mind had already turned toward philosophy. The roots of his interest extended back into the 1860s. In the July 1869 issue of *Mind,* he had published an early version of his chapter in the *Principles* on belief; as it appeared in the book version twenty-one years later, he argued that *"The true opposites of belief,* psychologically considered, *are doubt and inquiry, not disbelief."* This emphasis on inquiry and belief marks out clearly the symbiotic relationship he perceived between his psychology and the developing philosophy of pragmatism.[14]

In his account of the origins of pragmatism, Charles Sanders Peirce recalled his membership in "The Metaphysical Club" in Cambridge. The name was ironic in its implications, for its members were generally hostile to metaphysics. They had studied Hegel and Kant, but as a group felt the continental Europeans were asking unimportant questions and coming up with useless answers. British thinkers were more welcome. A few members showed the influence of Bentham, and James himself admitted to an interest in Herbert Spencer that he later regretted. All wished to clear the philosophical air in an appropriately American manner. One member "often urged the importance of applying [Alexander] Bain's definition of belief" as "that upon which a man is prepared to act," and Peirce believed that "from this definition, pragmatism is scarce more than a corollary." By the end of the 1870s, Peirce had thought through his position to the point where he could publish the two articles that formed the basis for subsequent discussions.[15]

In "The Fixation of Belief" and "How to Make Our Ideas Clear," Peirce began in a world of both science and psychology, using words like "habit" and "action" to fight off any metaphysical ideas a reader

might have about the word "belief." He talked about how scientific ideas changed and how no one belief was likely to last long. Even scientific ideas changed over time. He insisted on the importance of understanding what a person really meant when he talked about believing and doubting. If we believe something to be true, he said, then we are basically comfortable with an idea. It becomes a habit for us and we act automatically and do not question our assumptions. But if we doubt something, we become restless and upset. People do not like to be in a state of doubt and will do almost anything to rid themselves of doubt and adopt the habits that go with belief. Thus, if we are in doubt, we are irritated into an attempt to achieve belief so that the irritation will stop. This struggle to attain belief was what he called inquiry. People looked around and tried to find answers, and when they did, they relaxed and felt better. Inquiry stopped, and they had achieved belief. He outlined four ways of doing this:

1. The method of tenacity. The well-recognized symbol of this approach was the ostrich with its head in the sand. A person who said he did not want to know about a problem because it might require him to change his habits was being tenacious. Peirce included censorship in this category, as well as the killing or exiling of dissenters.
2. The method of authority. This was the method of orthodox churches which claimed to have established a creed true for all time and whose religious leaders applied that creed to daily events.
3. The *a priori* method. Here a thinker worked out a system and then applied it deductively. Others accepted it because it saved them the trouble of thinking for themselves. They became comfortable when the tenets of the system became habitual in daily life.
4. The method of science. Peirce was always a man of science as he understood the term: "the method must be such that the ultimate conclusion of every man shall be the same, or would be the same if inquiry were sufficiently persisted in." Restated in familiar language, the fundamental hypothesis of science was: "There are real things, whose characters are entirely independent of our opinions about them; those realities affect our senses according to regular laws, and, though our sensations are as different as our relations to the objects, yet, by taking advantage of the laws of perception, we can ascertain by reasoning how things really are." Any man, "if he have sufficient experience and reason enough about it, will be led to the one true conclusion. The new conception here involved is that of reality."

Pragmatism thus began as a denial of certain types of inquiry. It said that no sensible individual could stop listening, establish immortal truths, or lay down the law by institutional authority. The scientific, realistic approach was to deal with facts with an open mind and publicize the results in such a manner that any other person could confirm the conclusions. Inquiry stopped when the investigator believed something new

and established a habit, a new way of behaving based on that belief. Thus, to someone who asked what an idea *meant*, the proper answer was a description of "what habits it produces, for what a thing means is simply what habits it involves."

Such an approach dismissed most metaphysical discussion. Peirce insisted that no one could have an idea which related "to anything but conceived sensible effects of things. Our idea of anything *is* our idea of its sensible effects; and if we fancy that we have any other we deceive ourselves." He then laid down his famous rule for attaining clarity of apprehension: "consider what effects, which might conceivably have practical bearings, we conceive the object of our conception to have. Then, our conception of these effects is the whole of our conception of the object."[16]

James had long known Peirce both as a friend and source of ideas. In 1861 he had mentioned him in a private letter to his family as "a very 'smart' fellow with a great deal of character, pretty independent and violent though." Four years later, he was telling his sister about his attendance at a Peirce lecture, "which I could not understand a word of, but rather enjoyed the sensation of listening to for an hour." Then came the days of the Metaphysical Club, where Peirce both taught and confused his friend. The tenor of the relationship came through in an 1875 letter, in which William was amused to find that his most unphilosophical brother Henry had been entertaining Peirce in Paris. William assumed Henry would find Peirce an uncomfortable companion, "thorny and spinous, but the way to treat him is after the fabled 'nettle' receipt: grasp firmly, contradict, push hard, make fun of him, and he is as pleasant as anyone." If, however, you allowed yourself to be overawed, "you will never get a feeling of ease with him any more than I did for years . . . I confess I like him very much in spite of his peculiarities, for he is a man of genius." James persevered throughout Peirce's sad failure of a life, always trying to find him jobs and to keep his spirits up. He also learned much of his pragmatism from Peirce, although he gave it his own emphases and irritated his old friend severely with his elaborations, alterations, and misconceptions.

Elements of Peirce's pragmatism lurked beneath the pages of James' writings all through his career, but did not come to the surface in a noticeable way until 1898. In "The Pragmatic Method," James briefly summed up Peirce's 1878 position with approval, and then indicated that he preferred to express it more broadly. "The ultimate test for us of what a truth means is indeed the conduct it dictates or inspires. But it inspires that conduct because it first foretells some particular turn to our experience which shall call for just that conduct from us." His version of Peirce's principle was "that the effective meaning of any philosophical proposition can always be brought down to some particular consequence, in our future practical experience, whether active or passive; the point lying rather in the fact that the experience must be par-

ticular, than in the fact that it must be active." Shortly thereafter, he wrote a definition for Baldwin's *Dictionary* that began: Pragmatism was the "doctrine that the whole 'meaning' of a conception expresses itself in practical consequences, consequences either in the shape of conduct to be recommended, or in that of experiences to be expected, if the conception be true; which consequences would be different if it were untrue, and must be different from the consequences by which the meaning of other conceptions is in turn expressed."[17]

James in short received inspiration from Peirce but went beyond him, in ways he perhaps did not fully realize. Each man had his special concerns, and these differed so markedly that their close personal relationship seemed miraculous, a tribute to James' good temper. For Peirce, the enemy was nominalism in the medieval sense, with its contemporary allies such as materialism and individualism. A realist, he yearned for universal doctrines that could unite men into some community greater than any individual could possibly achieve by himself. For him, pragmatism was a theory of meaning; in a 1909 letter to James he referred to it as "logical analysis, i.e., definition," and continued: "the *definition of definition* is at bottom *just what the maxim of pragmatism expresses.*" For James, by contrast, pragmatism was a theory of truth in addition to being a theory of meaning, and at times he simply equated truth and verification. An individualist with nominalist tendencies, however capable he was of denying it, James shared Peirce's religiosity without his yearnings for universally true ideas and communal spirit. Peirce grumbled in public on occasion about James' distortions of his ideas, but his clearest statement came in a private letter to Christine Ladd-Franklin. "My point is that the meaning of a *concept* . . . lies in the manner in which it could *conceivably* modify purposive action, and *in this alone.*" James, with his aversion to "generals," defined pragmatism "as referring ideas to *experiences,* meaning evidently the sensational side of experience, while I regard *concepts* as affairs of habit or disposition, and of how we should react." As H.S. Thayer has neatly summed up the matter, "Peirce was concerned to explicate the idea of meaning whereas James was concerned to explicate the meanings of ideas."[18]

Peirce scorned a popular vocabulary and never sought a public. James, by contrast, was an inveterate popularizer, and his lectures published as *Pragmatism* in 1907 were the sort of discourse that put Peirce's teeth on edge. At the beginning of his second lecture, James told one of the most famous anecdotes in the history of American philosophy, and this version rather than any technical definition came to represent the purport of the philosophy to the larger public. James returned one day to a camp after a hunting trip to find everyone in the midst of a furious argument about a squirrel. This squirrel was apparently clinging to one side of a tree-trunk, while on the opposite side of the tree a man was standing. This man tried to get sight of the squirrel by moving rapidly around the tree, but no matter how fast he went, the squirrel kept up

with him, and the man never did see the animal. The problem was simple: Did the man go around the squirrel or not? He certainly went around the tree, and the squirrel was certainly on the tree, but did he really go around the squirrel?

By the time James arrived, everyone was on one side of the argument or the other, exhausted with the arguing. They wanted James to be the judge. He refused to join in a "metaphysical" argument. The solution, he said, depended on what a person meant by "go around." If he defined what he meant by this term, he no longer had an argument. His answer perfectly illustrated what he meant by the pragmatic method. "The pragmatic method in such cases is to try to interpret each notion by tracing its respective practical consequences. What difference would it practically make to any one if this notion rather than that notion were true? If no practical difference whatever can be traced, then the alternatives mean practically the same thing, and all dispute is idle."

In the sixth lecture, James took his ideas into the knotty area of truth. Truth for him was what a person achieved from verifying a statement; it was "a collective name for verification processes." Truth no longer meant something ideally true, true for all time. It was an operational concept limited to the present time and present circumstances, dealing with events in flux. Every time the situation changed, truth changed. True ideas *are those that we can assimilate, validate, corroborate and verify. False ideas are those we can not.* That is the practical difference it makes to us to have true ideas; that, therefore, is the meaning of truth, for it is all that truth can be known-as." Truth was thus not a stagnant property. Truth *"happens* to an idea. It *becomes* true, is *made* true by events." The idea that truth was relative was officially in the air, an American contribution to a European debate already in progress.

Pragmatism thus had considerable relevance to a developing modernism, but too many students of the subject stop there. James himself clearly did not, and in the years before his death was working out a "radical empiricism" which deserves a place in any discussion of American modernism. In the preface introducing *The Meaning of Truth* (1909), he defined "radical empiricism" as consisting of a postulate, a statement of fact, and a generalized conclusion. "The postulate is that the only things that shall be debatable among philosophers shall be things definable in terms drawn from experience." "The statement of fact is that the relations between things, conjunctive as well as disjunctive, are just as much matters of direct particular experience, neither more so nor less so, than the things themselves." "The generalized conclusion is that therefore the parts of experience hold together from next to next by relations that are themselves parts of experience. The directly apprehended universe needs, in short, no extraneous trans-empirical connective support, but possesses in its own right a concatenated or continuous structure."

He had come to the point where he could write, as he did in the title of one chapter in his posthumous *Essays in Radical Empiricism* (1912), of "A World of Pure Experience." Empiricism, a word he had clung to throughout most of his philosophical life, could hardly go farther. Mind, in essence, became a function of the stream of experiences. Distinctions between mind and body, between in-the-brain and out-in-the-world, disappeared. The world was made up solely of experiences, the flux of life that had been so important a part of the *Principles of Psychology*. Well before the novelists made the issue one of the major contributions of modernist discourse, James could put into italics: *"the relations that connect experiences must themselves be experienced relations, and any kind of relation experienced must be accounted as 'real' as anything else in the system."* On this principle, "a 'mind' or 'personal consciousness' is the name for a series of experiences run together by certain definite transitions, and an objective reality is a series of similar experiences knit by different transitions."[19]

IV

Just as James' psychology seemed closely intertwined with his philosophy, so his religion seemed inseparable from either. The psychology of religion fascinated him, and his essays on pragmatism returned frequently to the religious consequences of his position. He had a scientific and personal interest in the "fringe of consciousness," and in "A World of Pure Experience" he could insist that "our fields of experience have no more definite boundaries than have our fields of view. Both are fringed forever by a *more* that continuously develops, and that continuously supersedes them as life proceeds." He wanted to know about dreams, the unconscious, obsessions, madness, mediums, and anything relevant to religious experience. He wanted to test these phenomena in a manner known to scientists everywhere, using the best methods available so that any conclusions could be replicated. Most scientists wanted to avoid such controversial materials, but James studied them with tenacity, sure he was on to matters that his less imaginative confreres wrongly ignored. As John McDermott has pointed out, in his purview, "everything real is to be experienced somewhere, and everything experienced must be real somewhere."[20]

James described religion as "the great interest of my life" in a personal letter of 1897, but then added that he was "rather hopelessly non-evangelical," and "took the whole thing too impersonally." This seems accurate enough. No son of his father could be unaware of religious questions, but James never showed much interest in theological doctrines, had no loyalty to any religious institution, often felt "anti-Christian," and confessed that Buddhism appealed to him. But religion as a question, as an area for investigation, obsessed him, and he argued for the right of every human being to believe. No one could get through

the day without believing in some things that he could not prove scientifically, and beliefs about God deserved just as much consideration as beliefs about vivisected frogs. As he explained his position to E.L. Godkin: "I mean by religion for a man *anything* that for *him* is a live hypothesis in that life, altho' it may be a dead one for anyone else." He tried to show, in "The Will to Believe," "that whether the man believes, disbelieves, or doubts his hypothesis, the moment he does either, on principle and methodically, he runs a risk of one sort or the other from his own point of view." He argued publicly that the truest scientific hypothesis was the one that worked the best, and he advocated a kind of religious Darwinism: let the faiths fight it out, and may the fittest survive—"fittest" meaning the faith that "worked" the best. He personally felt "as if a terrible coldness and deadness would come over the world were we forced to believe that no informing spirit or purpose had to do with it," and any faith was justified that helped him deal with such a situation. He himself had "no living sense of commerce with a God" but envied "those who have." He did sense that "there is *something in me* which *makes response* when I hear utterances made from that lead by others. I recognize the deeper voice. Something tells me, *'thither lies truth.'* " As George Santayana grumbled some years later, James "did not really believe; he merely believed in the right of believing that you might be right if you believed."[21]

James' interest in the boundaries of consciousness tapped a significant tradition in American history. Spiritualism in some form had been a matter of public discussion since 1848, and educated people in New England and New York had amused themselves with the possibilities of table rappings, séances, communication with the dead, and such phenomena ever since. Henry James, Sr., had been interested in the subject, and for many years those who pursued the matter regarded themselves as more scientific than those who scoffed. Despite strong clerical opposition, spiritualist investigation insisted on questioning church doctrine, analyzing biblical texts, and speaking to skeptics like Unitarians and Universalists about rational faith—in sharp contrast to those churches that stressed an irrational one. As a rule, those attracted to spiritualism opposed doctrines of the Trinity, of innate depravity, predestination, and vicarious atonement. By pursuing his interests James was continuing an honored tradition of New England skepticism and rationality. Brother Henry devoted *The Bostonians* to an acerbic examination of the subject.

Formal study of psychical phenomena achieved institutional status in England in 1882, with the formation of the Society for Psychical Research, and the distinguished men who involved themselves with the group produced an extensive record of research and publication over the next twenty years. James was the first important American to associate himself with such work, and was certainly the most eminent American involved when the American Society for Psychical Research

met for the first time in 1885. Much of the work yielded little of signif-
icance, but with the famous Leonora Piper, James was sure he had
found someone who could withstand the closest scientific scrutiny. James'
wife and her mother were impressed at what Piper seemed to know
and encouraged James in his enthusiasm. Piper went into trances easily
and seemed able to commune with the dead. During one winter, James
visited her about a dozen times and became convinced of her honesty.
What she conveyed was generally trivial, but none of the members of
the family could imagine any way she could have known what she seemed
to know unless she had occult powers. James thought so highly of her
skills that when his fellow spiritualist researcher, Richard Hodgson, died,
he attempted to commune with him through her. He did not succeed,
yet he refused to dismiss the possibility completely. His scientific con-
clusion about the whole business was a masterpiece of precise care in
phrasing: "I find that when I ascend from the details to the whole
meaning of the phenomenon, and especially when I connect the Piper
case with all the other cases I know of automatic writing and medium-
ship," in addition to the many examples of spirit-possession in human
history, "the notion that such an immense current of experience, com-
plex in so many ways, should spell out absolutely nothing but the word
'humbug' acquires a character of unlikeness."[22]

When it came to the fringe of consciousness, James' mind rode off
in all directions, like the legendary rider of Stephen Leacock. Two of
those directions resulted in a series of lectures which were effective in
spreading his ideas far from academe. In 1896 James delivered the
Lowell Lectures on exceptional mental states, and in 1901–02 the Gif-
ford lectures on the varieties of religious experience. Because James
never prepared them for publication and editors mishandled his notes,
the Lowell Lectures have been almost forgotten until recently. Pub-
lished in a well-edited version in 1983, they permit students of modern-
ism to see how pervasive the new ideas on various aspects of the uncon-
scious had become in his thought and in the sophisticated Boston
community. Since 1893, James had been teaching abnormal psychology
to seminar students, visiting asylums, consulting with experts such as
Adolph Meyer out in Worcester and his old friend James Jackson Put-
nam in Boston. A loose grouping known as the Boston School of Psy-
chotherapy had been pioneering in the treatment of diseases that seemed
to have no organic basis, and James had noted some early European
work in the area in the *Principles of Psychology*. Establishing priority in
this area is difficult. Scholars in England, Germany, and France knew
of James' work on consciousness, and he knew of theirs. The question
remains open as to who influenced whom the most.

In these lectures, James went over dreams, hypnotism, and automa-
tism first; in so far as he borrowed from anyone, he borrowed back
from British researcher F.W.H. Myers a few of his own ideas on the
stream of consciousness. He then went on to the topic of hysteria, where

he outlined a theory of subliminal selves, where innumerable streams of consciousness lay below the surface, and individuals developed a double consciousness to deal with what most people later called the conscious and the unconscious. Such unconscious layers of mental activity appeared under hypnosis, through automatic writing, or in hallucinations, and James closely followed the research of Jean Martin Charcot at the Salpêtrière to insist that hysteria was of psychic origin. Even as Freud, Breuer, and Janet were arguing in Europe about hysteria in the 1890s, so James could declare that "consciousness splits, and two halves share the field." He also noted the new talking cure, which he took from Breuer rather than Freud: "The cure is to draw the psychic traumata out in hypnotism, let them produce all their emotional effects, however violent, and *work themselves off*. They make then (apparently) a new connection with the principal consciousness, whose breach is thus restored and the sufferer gets well." James took most of his specific examples here from Janet.

James then continued through the topics of multiple personality, demoniacal possession, witchcraft, and degeneration, but long before he came to the chapter on genius he had once again become the public preacher. Whether the topic of genius belonged in lectures on exceptional mental states perhaps is a question that says more about life in a democracy than many people wish to admit, but James could not resist once again making his case for non-conformity and the broadest possible field of experience, as well as for the social utility of his approach to American life: "The real lesson of the genius books is that we should welcome the sensibilities, impulses, and obsessions if we have them, so long as by their means the field of our experience grows deeper and we contribute the better to the race's stores; that we should broaden our notion of health instead of narrowing it; that we should regard no single element of weakness as fatal—in short, that we should *not be afraid of life*." Geniuses "are organs by which mankind works out the experience which is its destiny." No one could say that morbid people did not have much to offer others or that mere healthy-mindedness was a universal good. "A certain tolerance, a certain sympathy, a certain respect, and above all a certain lack of fear, seem to be the best attitude we can carry in our dealing with these regions of human nature."[23]

Shortly after delivering these lectures, James received his invitation to deliver the far more prestigious Gifford Lectures in Edinburgh. In two private letters he outlined his intentions, and did so in language that indicated the continuities between his interests in empiricism, exceptional mental states, and religion. "The problem I have set myself is a hard one," he wrote Frances Morse in 1900. First, he wanted "to defend . . . 'experience' against 'philosophy' as being the real backbone of the world's religious life." Second, he wanted "to make the hearer or reader believe, what I myself invincibly do believe, that, although all the special manifestations of religion may have been ab-

surd . . . yet the life of it as a whole is mankind's most important function."

A year later, he could be far more specific to Henry Rankin. "The mother sea and fountain-head of all religions lie in the mystical experiences of the individual, taking the word mystical in a very wide sense." James disliked theologies and ecclesiasticisms as superimposed, and always returned to the word, "experiences." These experiences "make such flexible combinations with the intellectual prepossessions of their subjects, that one may almost say that they have no proper *intellectual* deliverance of their own, but belong to a region deeper, and more vital and practical, than that which the intellect inhabits." As such, intellectual arguments cannot destroy them. "I attach the mystical or religious consciousness to the possession of an extended subliminal self, with a thin partition through which messages make irruption," making us all aware "of a sphere of life larger and more powerful than our usual consciousness, with which the latter is nevertheless continuous." The experiences we have from this sphere "communicate significance and value to everything and make us happy." Religion conceived in this manner "is absolutely indestructible. . . . Something, not our immediate self, does act on our life!"[24]

The Varieties of Religious Experience, the published version of the Gifford Lectures, was an instant and continuing success and remains for many James' most important contribution to public discourse. In a time of skepticism he gave the approval of science to belief of some kind, and many were grateful. Caustic colleagues might refer to the book as *Wild Religions I Have Known,* and orthodox religious thinkers deplore its inattention either to eternal principles or functioning institutions, but James spoke to individuals in need as one who had also suffered, and the message got through.

For him the essence of religion was individualistic. "Religion" he defined as *"the feelings, acts, and experiences of individual men in their solitude, so far as they apprehend themselves to stand in relation to whatever they may consider the divine."* One's feelings should be "solemn, serious and tender"; what mattered was "the manner of our acceptance of the universe." Religion was also empiricist and pragmatic. Not the origin of religion, "but *the way in which it works on the whole*" was to be his "own empiricist criterion," and he invoked such a criterion: "By their fruits ye shall know them, not by their roots." Religion was as religion did, and the experience of individuals was relevant in a way that theological principles were not. "Both instinctively and for logical reasons, I find it hard to believe that principles can exist which make no difference in facts," and he summed up the pragmatic conception of God with his usual clarity: "God is real since he produces real effects."

In the process of working out his religious views, James seemed to be continuing his long-standing, nineteenth-century concerns, as of course he was. But he was also giving every evidence that he intuited

those of the dawning century. A man who had spent much of his professional career worrying about conscious experience in individuals came logically to the conclusion that, "if we look on man's whole mental life as it exists, on the life of men that lies in them apart from their learning and science, and that they inwardly and privately follow, we have to confess that the part of it of which rationalism can give an account is relatively superficial." In fact, in most people, "instinct leads, intelligence does but follow," and "articulate reasons are cogent for us only when our inarticulate feelings of reality have already been impressed in favor of the same conclusion." The functioning of religion, it seemed, was not only irrational, it was relative: "Does it not appear as if one who lived more habitually on one side of the pain-threshold might need a different sort of religion from one who habitually lives on the other?" he asked pointedly. "This question, of the relativity of different types of religion to different types of need, arises naturally at this point. . . ." Just as every one had a different psychology and physiology, so every one should develop an appropriate religion.

Embedded in the book, therefore, were many of the words that modernists could recognize as their own: empiricist, pragmatic, individualistic, anti-institutional, irrational, pluralistic, relativist. Even words like "madness" and "horror" seem appropriate to careful consideration of the volume. James may have given people cause for faith and joy, but he was capable as well of recalling his own traumatic young adulthood and passing on a vision that many of the next generation could adopt as their own: "The normal process of life contains moments as bad as any of those which insane melancholy is filled with, moments in which radical evil gets its innings and takes its solid turn." The lunatic, after all, took his sense data from daily life. "Our civilization is founded on the shambles, and every individual existence goes out in a lonely spasm of helpless agony."[25]

Modernists knew the real thing when they experienced it. As Gertrude Stein, one of his most devoted students, wrote: "Is life worth living? Yes, a thousand times yes when the world still holds such spirits as Prof. James. He is truly a man among men; . . . a scientist of force and originality embodying all that is strongest and worthiest in the scientific spirit; . . . a metaphysician skilled in abstract thought, clear and vigorous and yet too great to worship logic as his God, and narrow himself to a belief merely in the reason of man."[26]

Of necessity, William and Henry James, Jr., shared a common background. But where William passed through severe psychological distress to channel his emotional needs into psychology, philosophy and religion, and to receive institutional support for his work from Harvard, Henry passed in a less painful way into the worlds of professional writer and European expatriate. Both brothers stressed pure experience: Henry channeled his concerns into an art of the theater, making his fictions dramas of consciousness. The more complex his work became, the more critical his readers became, and Henry all but lost the audience he once had among both reviewers and readers. But younger American modernists knew instinctively that he had supplied them with the precedents they needed to put mental realities into art and to make relations between characters and moral values a drama of its own. In remaining independent of institutions and largely self-supporting as a mature writer, he also set an example rather different from Whistler's: the artist of uncompromised integrity, following his instincts into now fictional territory and still being able to pay his bills.

CHAPTER 3

Henry James & the
Drama of Consciousness

In the course of his ceaseless fretting about the well-being of his children, Henry James, Sr., wrote to his friend Emerson in 1849 that he was gravely pondering "whether it wouldn't be better to go abroad for a few years with them, allowing them to absorb French and German and get such a sensuous education as they can't get here." Even to consider that a sensuous education was desirable made James an unusual father; to act as he did was even more unusual. Not only did the James children become "hotel children," uprooted constantly from any place that might be considered home, they never had to adjust to organized schooling, with the discipline and socialization that such an experience brought. They never knew the strict Calvinism that had been so much a part of their father's world, and they experienced sermons and theology as quaint persistances of a culture becoming extinct as they watched it. They never needed to concern themselves much with the worlds of business or politics that had been so central to the life of Grandfather William. They never needed to accustom themselves to America at all.[1]

William ultimately made his peace with America and found a useful career in teaching and writing at Harvard. His younger brother Henry never did. His sensuous education was the one that took most thoroughly. He satirized the remnants of Calvinism, disliked business and ignored politics. In looking at the careers of the two brothers, the phrase "the same only different" should be the one that recurs. They shared the same family, the same intellectual heritage, the same wealth and rootlessness. They remained close after their fashion, writing fascinating letters to each other for life. Each continued to cultivate his sensibility throughout a distinguished professional career. Henry decided that advanced education and a regular job were not for him, for sensibility required steady observation, travel and publication. Homosexual by instinct, he evaded the obligations of family life even as he evaded the loyalties of a typical American. In his very different way, he too was a precursor of a modernist sensibility for Americans.

The influence of the theater was most striking. Much of Henry's later autobiographical writing recalled his frequent exposure to and fascination with the theater: trips, billboards, performances, actors, readings in the home. The New York of *A Small Boy and Others* was a stage for him roughly from his fifth to his twelfth year, and he absorbed it far beyond the capacities of his fellow countrymen. While William tried to draw, Henry tried to compose scenes: "I cherished the 'scene'. . . . I thought, I lisped, at any rate I composed, in scenes; though how much, or how far, the scenes 'came' is another affair. Entrances, exits, the indication of 'business,' the animation of dialogue, the multiplication of designated characters, were things delightful in themselves . . ." At some point after his eighth birthday he was old enough to go to the theater with the family, and he could never get enough, retaining the vivid memories for life. He might not feel especially at home at home, but "I was with precocious passion 'at home' among the theatres . . ." The experience had any number of consequences: not only did he have an exposure to drama forbidden to most Protestant children, he had a formative taste of spectatoriality: life for him was a series of images and scenes, in which he was an observer and not a participant. The chaos of life with his father required some sort of organization if it was not to lead to mental illness. Henry organized it into plays, and when he came to write mature prose he organized that into scenes of consciousness. Life became a consciousness that perceived scenes.

In childhood, William was the active one; in Henry's recollection, William was the child who played with boys who cursed and swore, while Henry had to admit sadly to himself that he, alas, did not. He never did; he much preferred the world of literature, and what he could not absorb from the theater, he obtained from European books and magazines. He read French novels, for example, and obtained fluency in the language at an early age. Balzac was an early favorite, and in time Turgenev—since Russian literature normally came to Americans in its French translations. But the chief influence at least at first was the English: the arrival of the *Cornhill* or some other journal containing the latest serial, and the delight in a Trollope, Thackeray, or George Eliot novel as it came out in delicious installments. The greatest impact probably was that of Dickens, that most theatrical of prose writers, whose works were read in countless living rooms and put on the stage in countless reductions, as soon as they appeared. One of the most poignant scenes in Henry's autobiography was his being sent to bed even though the family was about to read from *David Copperfield*, which had just begun arriving. He pretended to obey, but in fact hid himself behind "the friendly shade of some screen or drooping table-cloth"; glued to the carpet, he held his breath. "I listened long and drank deep while the wondrous picture grew, but the tense cord at last snapped under the strain of the Murdstones and I broke into sobs of

sympathy that disclosed my subterfuge. I was this time effectively banished, but the ply then taken was ineffaceable."[2]

Since much of this theater and many of these stories came from Europe, no child in Henry's family could escape European influence. He recalled years later a friend of French background, Louis De Coppet, who "pressed further home to me that 'sense of Europe' to which I feel that my very earliest consciousness worked. . . . He opened vistas . . ." Once there, the vistas remained, due to family travels. From 1855 to 1858, while Henry was in his early teens, the James family was abroad, and although he returned in 1858 for a brief period at Newport, he was once again in Europe in 1859. During the early 1860s he was again in Newport and briefly at the Harvard Law School; for a time thereafter he was at work on his first literary efforts and living in Boston. In 1869 he was again on the Continent, and although he returned twice to America he finally determined in 1875 that he would live in Europe permanently. He had ample opportunity to see England, France, Germany, Switzerland, and Italy, and he found them all more stimulating than America.

Henry James was in no way hostile to his native land or his heritage. Like most sensitive people in any country, he was ambivalent about his background. His attitudes came through most clearly in his private letters, where he could be very explicit. To him in 1867, for example, young Americans seemed culturally "men of the future" who would soon have a crucial role to play. He thought it "a great blessing" to be an American, and thought it "an excellent preparation for culture. We have exquisite qualities as a race, and it seems to me that we are ahead of the European races in the fact that more than either of them we can deal freely with forms of civilization not our own, can pick and choose and assimilate and in short (aesthetically etc.) claim our property wherever we find it." Americans might yet find that to pick and choose among other cultural traditions would enable them to make important cultural achievements. "We must of course have something of our own—something distinctive and homogeneous—and I take it that we shall find it in our moral consciousness, our unprecedented spiritual lightness and vigour. In this sense at least we shall have a national *cachet*." He expected nothing much during his own lifetime, but eventually he predicted that in time "something original and beautiful" might "disengage itself from our ceaseless fermentation and turmoil."

Yet he had to live his own life as it came to him, and it came tediously in America. While resident in Cambridge, he reported to William that life, at least in the James house, was "about as lively as the inner sepulchre," and the Harvard that William found so scientifically stimulating left him cold. Americans abroad were no more stimulating. When William asked him if the average Englishman "killed" the average American, his reply was scathing: ". . . the Englishmen I have met not only kill, but bury in unfathomable depths, the Americans I have

met. A set of people less framed to provoke national self-complacency
than the latter it would be hard to imagine." He repeated one word
over and over: "vulgar, vulgar, vulgar. Their ignorance—their stingy,
grudging, defiant, attitude towards everything European—their per-
petual reference of all things to some American standard or precedent
which exists only in their own unscrupulous wind-bags—these things
glare at you hideously." Yet even with his cultural wind up, he re-
mained even-handed. "On the other hand, we seem a people of *char-
acter,* we seem to have energy, capacity and intellectual stuff in ample
measure." The vices he mentioned were only "the elements of the mod-
ern man with *culture* quite left out. It's the absolute and incredible lack
of *culture* that strikes you in common travelling Americans." English-
men had manners and a language, while Americans seemed to lack
both, "but particularly the latter." Yet he had seen "some nice Ameri-
cans and I still love my country." All in all, as he wrote Charles Eliot
Norton in 1872: "It's a complex fate, being an American, and one of
the responsibilities it entails is fighting against a superstitious valuation
of Europe."[3]

Europe, by contrast, was a theater of consciousness, and he watched
the performances joyfully. For a while, France seemed to be his pre-
ferred European country, especially Paris. Close friends like De Coppet
and John La Farge kept his young world alive with tales of life in France,
and when he finally did arrive the effect must have been overpowering.
Even in old age, he could recall clearly "the further quays, with their
innumerable old bookshops and printshops," which "must have come
to know us almost as well as we knew them; with plot thickening and
emotion deepening steadily," a young visitor would mount "the long,
black Rue de Seine—*such* a stretch of perspective, *such* an intensity of
tone as it offered in those days; where every low-browed vitrine waylaid
us and we moved in a world of which the dark message, expressed in
we couldn't have said what sinister way too, might have been 'Art, art,
art, don't you see? Learn, little gaping pilgrims, what *that* is!' " James
tried desperately to learn all that Paris had to offer, but the sense of
intimidation lingered for some time: "Style, dimly described, looked
down there, as with conscious encouragement, from the high grey-
headed, clear-faced, straight-standing old houses—very much as if
wishing to say 'Yes, small staring jeune homme, we are dignity and
memory and measure, we are conscience and proportion and taste, not
to mention strong sense too: for all of which good things take us—you
won't find one of them when you find (as you're going soon to begin
to at such a rate) vulgarity!' "

Yet to an aspiring cosmopolitan, culture was people not buildings,
creative activity not scenery. James socialized at the top of Parisian ar-
tistic life, only to discover that even Gustave Flaubert and his circle
seemed provincial. Like so many French, they seemed incapable of
transcending their own culture. The Paris that James most admired

was that of his friend Ivan Turgenev—a Russian, after all, who could adapt to Paris or any other rewarding place—who was fully civilized in his discourse and still capable of great art. In *The American,* James demonstrated that French society could, in its ossified self-complacency, be fully as obnoxious as anything to come out of America. Yet elements of his early love of France never left him, and even when he was talking about English landscape, monuments, and people, he took as his role model a French critic: "deep in the timorous recesses of my being is a vague desire to do for our dear English letters and writers *something* of what Ste. Beuve and the best French critics have done for theirs."[4]

As a permanent residence, Paris soon palled and he tried London. His first impressions had been, again, a bit wide-eyed. "I have been crushed under a sense of the mere magnitude of London," he wrote his sister Alice in 1869. "The place sits on you, broods on you, stamps on you with the feet of its myriad bipeds and quadrupeds." He dined with Leslie Stephen, heard Ruskin lecture on Greek myths, visited William Morris' home and found Jane Burden Morris fascinating. A year later, he had more experience and the infatuation had worn off. "Among my fellow-patients here I find no intellectual companionship. Never from a single English man of them all have I heard the first word of appreciation or enjoyment of the things here that I find delightful," he wrote William. "As for the women I give 'em up; in advance. I am tired of their plainness and stiffness and tastelessness . . ." By 1877, he knew more about who he himself was and whom he could genuinely admire. "To tell the truth I find myself a good deal more of a cosmopolitan (thanks to that combination of the continent and the U.S.A. which has formed my lot) than the average Briton of culture," he wrote Grace Norton; the British at their best did not measure up to Turgenev, and implicitly not to Henry James, either.

His opinions over the years grew more and more acerbic, especially about the rottenness of the British upper class, but he never failed to appreciate the theater of it all. With all its faults, London remained "interesting," and his position clear at least in his own mind: "I am not at all Anglicized, but I am thoroughly Londonized—a very different thing." He was above all a cosmopolitan, not an English American or anything or the sort. "I have not the least hesitation in saying that I aspire to write in such a way that it would be impossible to an outsider to say whether I am, at any given moment, an American writing about England or an Englishman writing about America," he wrote William in 1888; "and so far from being ashamed of such an ambiguity I should be exceedingly proud of it, for it would be highly civilized. . . . The great thing is to be *saturated,* with something—that is, in one way or another, with life . . ."[5]

Of the other countries which James visited, Italy was the only one he considered living in. Indeed, James' enthusiasm for London occasionally seemed dependent on the many Italian paintings he could view

there. Once again, early impressions were most enthusiastic: "I should like in some neat formula to give you the *Italian feeling*—and tell you just how it is that one is conscious here of the aesthetic presence of the past," he wrote William in 1869. A year later he was in Rome: "At last—for the first time—I live! It beats everything: it leaves the Rome of your fancy—your education—nowhere. It makes Venice—Florence—Oxford—London—seem like little cities of pasteboard. I went reeling and moaning thro' the streets, in a fever of enjoyment." He went from one fabled tourist attraction to another, "all the Piazzas and ruins and monuments. The effect is something indescribable. For the first time I know what the picturesque is . . . In fact I've seen Rome, and I shall go to bed a wiser man than I last rose—yesterday morning."

Here too, time took a severe toll. "I feel forever how Europe keeps holding one at arm's length, and condemning one to a meagre scraping of the surface," he wrote Grace Norton in 1874. "I have been nearly a year in Italy and have hardly spoken to an Italian creature save washerwomen and waiters." He admitted that this could be his own fault, but still the lack of any genuinely Italian contacts bothered him. "Sometimes I am overwhelmed with the pitifulness of this absurd want of reciprocity between Italy itself and all my rhapsodies about it." Things were no better elsewhere. "Florence, fond as I have grown of it, is worth far too little to me, socially, for me to think complacently of another winter here," he wrote his mother. "Here have I been living (in these rooms) for five weeks and not a creature, save one Gryzanowski, has crossed my threshold—counting out my little Italian, who comes twice a week, and whom I have to *pay* for his conversation!"[6]

In a sense, then, no country would do, at least as home. James traveled, sampled, and observed. In time he settled in England, but outside of London, content with the company of his imagination even as he filled his evenings with the society of inadequately stimulating people. He came to realize that "consciousness is an illimitable power" that only a precious few shared. Ideas of cosmopolitanism merged with ideas of consciousness, and the ideal writer became the observer with the most absorptive mind. "Try to be one of the people on whom nothing is lost!" he exhorted the readers of "The Art of Fiction," and insofar as such a posture was physically possible, he tried to be such a consciousness. Absorbing the theater of life became his daily task and the way, in old age, he organized his life story. "The personal history, as it were, of an imagination, a lively one of course, in a given and favourable case, had always struck me as a task that a teller of tales might rejoice in, his advance through it conceivably causing at every step some rich precipitation," he wrote. "Fed by every contact and every apprehension, and feeding in turn every motion and every act, wouldn't the light in which it might so cause the whole scene of life to unroll inevitably become as fine a thing as possible to represent . . ." He asked him-

self: "What was *I* thus, within and essentially, what had I ever been and could ever be but a man of imagination at the active pitch?"[7]

II

Henry James was a writer of books, not a man of critical theory, and he worked out his aesthetics by reading his fellow craftsmen. He learned the most from Balzac. In 1875 he published a long appreciation of the French realist that illuminated his own practice. He emphasized Balzac's "intimate knowledge of Paris which was to serve as the basis—the vast mosaic pavement—of the 'Comédie Humaine,' " and the massive factuality of it all. "Behind our contemporary civilization is an immense and complicated machinery—the machinery of government, of police, of the arts, the professions, the trades. Among these things Balzac moved easily and joyously; they form the rough skeleton of his great edifice." He "hated the bourgeoisie with an immitigable hatred," and was "with glee, with gusto, with imagination, a monarchist," for a monarchical society was "unquestionably more picturesque, more available for the novelist than any other." He seemed to have no morality of his own, thought most people selfish, and made money "the most general element" in his works; "other things come and go, but money is always there." Balzac was at his best when he was conveying "his mighty passion for *things*"; and at his worst when he tried to theorize: "from the moment he attempts to deal with an abstraction the presumption is always dead against him." Balzac was, in short, one of those on whom nothing was lost. He certainly had his defects, and James could be contemptuous in dismissing them, but his criticism was a way to keep in mind the true beginnings of the American modernist sensibility. The consciousness of reality, the sense of the local, the detailed impressions: these aspects of genuine experience were the starting places for the young Henry.[8]

The sheer bulk of James' criticism is no indication of his devotion to a given writer; he wrote for a market, which often did not coincide with his preferences. But his remarks, sometimes fleeting, on three other writers, usefully flesh out his aesthetics. In 1865 he reviewed *Our Mutual Friend* in a scathing manner that made no mention of his own immense personal debt to Dickens. He was especially caustic on Miss Jenny Wren, the dwarf seamstress: "Like all Mr. Dickens' pathetic characters, she is a little monster; she is deformed, unhealthy, unnatural; she belongs to the troop of hunchbacks, imbeciles, and precocious children who have carried on the sentimental business in all Mr. Dickens' novels . . ." James thought the atmosphere such caricatures created unacceptable, for "a community of eccentrics is impossible Who represents nature?" Unlike a true realist, Dickens seemed unable "to see beneath the surface of things," and James tagged him "the greatest

of superficial novelists," who "has added nothing to our understanding of human character. He is master of but two alternatives: he reconciles us to what is commonplace, and he reconciles us to what is odd."

On George Eliot, James wrote a great deal, although with equal exasperation. Eliot believed that the novel "was not primarily a picture of life, capable of deriving a high value from its form, but a moralised fable, the last word of a philosophy endeavouring to teach by example." She had but a feeble sense of drama, and no free aesthetic life. Charles Baudelaire went to an opposite extreme. A disciple of Edgar Poe—always a bad sign to James—Baudelaire had at best only "a certain groping sense of the moral complexities of life," and seemed to suffer from a "permanent immaturity of vision." He may have written about evil and won notoriety, but appearances in this case were deceiving: "he strikes us on the whole as passionless." Baudelaire "knew evil not by experience, not as something within himself, but by contemplation and curiosity, as something outside of himself." Evil for him began "outside and not inside," and consisted "primarily of a great deal of lurid landscape and unclean furniture."[9]

The lessons were relatively obvious. A serious novelist should not dwell merely on the surface of life, but ask questions of relevance and importance. He should not dwell on the eccentric or the odd, but rather on the representative. He should find his meanings in the local, and not attempt vast generalizations about morality or character. He should not pretend to be wicked or to have experienced an extreme in life unless he could convey his sense of such experience. He should convey that experience through drama, show rather than tell. James found his novelist in his friend Turgenev, "the first novelist of the day." The genial Russian was a "story-teller who has taken notes," and his works were "a magazine of small facts, of anecdotes, or descriptive traits, taken, as the phrase is, *sur le vif*." In his works, "his object is constantly the same—that of finding an incident, a person, a situation, *morally* interesting." He thus skated the thin line between Balzacian detail and Eliotic moralism, and came to represent for James something of a cultural ideal. Person and aesthetic merged: he and his work provided an "impalpable union of an aristocratic temperament with a democratic intellect." James would "never forget the impression he made upon me" when they first met: "I found him adorable. . . . so simple, so natural, so modest, so destitute of personal pretension and of what is called the consciousness of powers." To a writer like Turgenev, most quarrels about aesthetics were irrelevant relics: "The only duty of a novel was to be well written." American modernism in part came directly out of these concerns.[10]

III

In a sense, James had drama on his mind throughout his conscious life. References to dramatic criteria turn up at odd moments in his early

writings, and youthful exposure kept having adult consequences. As a student in Boulogne, he had had for a friend Benoît Constant Coquelin, and years later his friend popped up, acting at the Comédie Française in *Jean Dacier;* for James the coincidence was significant. Not only were the "well-made" plays of Scribe and Sardou the most important standards by which both he and his audiences judged dramatic art, but in such an atmosphere, the Comédie Française was very special; it "always counted," he wrote in the early 1880s, and "it is on that, as regards this long day-dream," that he had lived. Coquelin's performance threw him "into a great state of excitement," and he did not think he "ever followed an actor's creation more intently." He was sure that, "if I could have sat down to work then I probably would not have stopped soon." But he did not write a play, because he could not, having too many pending commitments to honor. Instead, he walked around Paris in an agitated condition, thinking of "what it said to me that I might do—what I ought to attempt."[11]

At about this time, John Hare asked him to write a play, and although nothing came of this particular suggestion, James was clearly considering the writing of plays, and such a concern inevitably colored his ideas about whatever else he was doing. He worried about the composition of *The Portrait of A Lady,* and whether or not "the complete unfolding of the situation that is established by Isabel's marriage may nonetheless be quite sufficiently dramatic." He tried to make "Daisy Miller" into a play. But he decided that, although he himself thought the dramatic form to be "the most beautiful thing possible," the condition of the London stage was intolerable: "one must be prepared for *disgust,* deep and unspeakable disgust," or else be "overcome by the vulgarity, the brutality, the baseness of the condition of the English-speaking theatre today." Yet he needed money and was willing to take commissions. Edward Compton wanted him to make a play out of *The American* and he agreed to do so, altering the book to allow for the obligatory happy ending. The play had a decent success in London in 1891 and Henry all too buoyantly wrote to William: "I feel at last as if I had found my *real* form, which I am capable of carrying far, and for which the pale little art of fiction, as I have practiced it, has been, for me, but a limited and restricted substitute. The strange thing is that I always, innermostly, knew *this* was my more characteristic form . . ." Thus encouraged, James wrote *Tenants, Disengaged, The Album,* and *The Reprobate,* none of which made it to the stage.[12]

The major catalyst in James' shift to the theater was Henrik Ibsen. Although many differences separated the two artists, James could find in Ibsen a major dramatist who was as opposed to bourgeois provincialism as he was. Finding the Norwegian theater of his youth hopelessly backward, and reaching rather early the conclusion that the works of the reigning French school were "dramatic candy-floss," Ibsen developed a form of drama crucial to modernism. He took the forms of high tragedy that he inherited and made tragedy ordinary in character and

language. He threw out the artificialities of plot that, from Shakespeare to Scribe, had become conventional—the coincidences, mistaken identities, lost letters—and replaced them with what were, on the whole, the sorts of events that might happen in any middle-class community. Above all, he developed into a master of "double density dialogue," talk that often conveyed two or more meanings simultaneously as it went round and round an important subject even as it pretended to be matter-of-fact, conveying its multiple meanings without the help of narration or monologue. Henry James was especially conscious of this third innovation and his later work is a continuing example of his debt to Ibsen's techniques.[13]

Critics like Edmund Gosse in England knew Ibsen's name in the early 1870s; the two corresponded occasionally and Gosse wrote over twenty articles on Ibsen between 1872 and 1878. William Archer translated Ibsen's *The Pillars of Society,* which became, as *Quicksands,* the first Ibsen play to reach the English stage. Gosse and Archer continued their work in the 1880s in considerable rivalry and with significant impact on cultural history. Archer was the man who interested George Bernard Shaw in the subject, an interest that led to the writing of *The Quintessence of Ibsenism* (1891), while Gosse informed James about Ibsen in 1891. As he wrote Gosse, James at first was unimpressed. He found *Rosmersholm* "dreary" and *Lady from the Sea* "tedious," and was skeptical about *Ghosts:* "They don't seem to me dramatic, or dramas at all—but . . . moral tales in dialogue—without the objectivity, the visibility of the drama." But *Hedda Gabler* was another story, and James praised its "angular irony," found its realism to have "a charmless fascination," and approved Ibsen's "perfect practice of a difficult and delicate art, combined with such aesthetic density" and his "admirable talent for producing an intensity of interest by means incorruptibly quiet." He wrote Archer that "the *Wild Duck* is altogether beyond the contemporary neat everlasting and exclusively adulterous Frenchmen," and declared: "I like Ibsen, I think quite as much as you ought to ask one who deals with him on our restricted basis to do. And more than this, I *respect* him . . ."[14]

The immediate artistic impact of Ibsen was to encourage James into writing plays, a serious if understandable error. James had never thought like a member of a popular audience, he did not talk like one, and he had contempt for most London theatergoers. He loved drama and felt its value to a writer of fiction, but such a recognition did not mean that he had any talent for the stage. The most obvious result was the *Guy Domville* fiasco of 1895. James had produced a sensitive work, one which his admirers could appreciate in prose and possibly on the stage as well. But the performance on opening night was poor, the audience restive, and James made the mistake of taking a bow as the author. He was nearly hooted off the stage, in an incident that came close to making him physically ill. It certainly did end a five-year period devoted chiefly

to the stage. As he wrote William Dean Howells: "I have felt, for a long time past, that I have fallen upon evil days—every sign or symbol of one's being in the least wanted, anywhere or by anyone, having so utterly failed." He insisted to his brother that the play had been a private if not a public success, but for someone openly after the financial rewards of popularity, that was small consolation.[15]

This concern for the stage meant that James never could make up his mind what medium he should use. Perhaps the most obvious example of this was the uncertain history of *The Other House,* a justly forgotten novel of 1896. The work apparently began with a notebook entry for 26 December 1893, where he sketched out a plot that in various ways suggested *Rosmersholm.* It dealt with the promise a young father had made to a dying wife never to remarry and thus expose his daughter to the horrors of a stepmother. Originally a play scenario, "The Promise," the work was restricted to the stage and the few characters who struggled over the fate of the father and the little girl—very much a struggle for possession, with two outside observers to give a sense of perspective to the passions on display. In a series of preposterously melodramatic events, the young girl is found drowned, and it seems possible that either of the two women contending for the father's hand, or the father himself, could have done the deed. The plot itself is hardly worth retelling, and is significant here only as an example of the knots James could tie himself in, in his efforts to be a dramatist. Since "The Promise" did not seem very promising as a play, it became *The Other House* and sold more than it deserved as a novel. He then reworked it again into a play, and never succeeded in getting that version on the stage either.[16]

Yet the drama was having a beneficent impact on his work at the same time that it seemed so fruitless. He made his first notebook entry for *The Spoils of Poynton* on 24 December 1893, just two days before the original entry for *The Other House.* He had heard a complicated story at a dinner party, "a small and ugly matter" about a Scottish laird who inherited a large house from his father, including many valuable art objects, but when he married, his new wife insisted that they take exclusive possession and displace the mother. A row ensued, but what interested James the most was the conflict of tastes between the aesthetic mother and the philistine wife: "There would be circumstances, details, intensifications, deepening it and darkening it all. There would be the particular type and taste of the wife the son would have chosen," out of a tasteless house, "the kind of house the very walls and furniture of which constitute a kind of *anguish* for such a woman as I suppose the mother to be." A year and a half later he returned to the subject, as it seemed relevant to a commitment he had made to supply three short stories to Horace Scudder at the *Atlantic.* He reminded himself that "every thing of this kind I do must be a complete and perfect little drama," and that what was wanting from his plan was "a full roundness

for the action—the completeness of the drama-quality." He talked of having "three chapters, like 3 little acts," each taking about fifty pages of manuscript.

What in fact he was working towards was an implicit unity between narrative and dramatic structures, a unity based on the inherent drama of a conflict of tastes rather than on some presumptive translation of the novel to the stage. James' original sense of the stage had been too limited and mechanical; he worried too much about whether a novel would translate into a play or vice versa. He needed rather to mate the virtues of the new form to the major concerns of his art, and to see the process as a major development away from Balzacian realism. He still believed that a writer, a consciousness, should see everything, should be saturated in all of life. But he had come to see, as he wrote later in his preface to *The Spoils of Poynton*, that Balzac, Flaubert, Maupassant, and the rest could never really write effectively about what interested Henry James. He was interested in consciousness and perception, and they were interested in data. He wrote of "clumsy Life again at her stupid work," and of "the fatal futility of Fact." Fleda Vetch "almost demoniacally sees and feels, while the others but feel without seeing." This provided a vivid example of the general truth that for "the spectator of life," the "fixed constituents of almost any reproducible action are the fools who minister, at a particular crisis, to the intensity of the free spirit engaged with them." Drama for James was coming to mean a drama of consciousness, of conflicting perceptions. In *The Spoils of Poynton*, the drama was between the spoils of Poynton Park and the philistine contents of Waterbath, between Fleda and Mona, between taste and tastelessness, intensity and numbness, intelligence and stupidity. Even as he was failing with one theatrical experiment, James was succeeding with another. He was creating the drama of consciousness.

Without quite naming what he had discovered, without perhaps knowing exactly what it was yet, he nevertheless knew that the years of misery and depression had not been wasted. "When I ask myself what there may have been to show for my long tribulation, my wasted years and patience and pangs, of theatrical experiment," the answer seemed clear. "What I have gathered from it all will perhaps have been exactly some such mastery of fundamental statement—of the art and secret of it, of expression, of the sacred mystery of structure." The time had not been wasted, no matter how depressing it had been to live through. "What the resultant is I must now actively show."[17]

For several years, the dramatic experiments continued. He wrote later in his prefaces that his constant refrain to himself had been "dramatise, dramatise," and his prose of the late 1890s was something of a laboratory for the possibilities of dramatic presentation within the formats of the story and the novel. In *The Spoils of Poynton, What Maisie Knew,* and *The Awkward Age,* he had his characters have duets with each other, whirl in and out of complex dances of discourses and relationships as

if in a ballet, and indeed go through a long novel constructed chiefly upon dialogue. He thought in terms of foreshortening, scenic alternation, and the use of retrospective recovery of material that happened off-stage but was crucial to the plot. He brooded over the point of view and other unifying devices, and came to insist that all the characters in a novel actually be important in some functional way to its themes. The stage seemed to dictate the formal presentation of the plot of the novel, and in one illuminating passage in his notebooks he insisted that "the *scenic* method is my absolute, my imperative, my only salvation," the only method he could trust "to stick to the march of an action. How reading Ibsen's splendid *John Gabriel* a day or two ago (in proof) brought that, FINALLY AND FOREVER, home to me!" He now had to apply the lessons to "this interminable little *Maisie*"—the result being one of his most effective works, all things considered the best of his applications of dramatic principles during this period.[18]

IV

If the drama gave James a new form for the novel, life seemed to be giving him new content as well. He had once been a master of light comedy, had all but created the international theme, and explored aspects of American social history and the life of anarchists in London. He had written frequently about men, although they were often artists and rarely seemed to work for a living in any believable way. Still, given his preferred milieu of leisured Americans coming into contact with Europeans of an appropriate social class, his work seemed realistic, dealing with the externals of social life in ways recognizably kin to those of his French, Russian, and British predecessors. But in the 1880s, signs of change appeared. He wrote less about Americans and more about the British. He came to prefer women to men as centers of consciousness, assuming that women were more conscious, more sensitive or artistic, "finer" as he often said. He developed an interest in young girls, sometimes cruelly neglected ones, who often did not understand what they saw or heard, as the foci of entire novels. He wrote explicitly about sexual rivalries, implicit homosexuality, bastardy and adultery. All around him, the certainties of the social fabric were fraying. He knew Cora Crane, the prostitute wife and widow of Stephen Crane, and Morton Fullerton, the philandering lover of Edith Wharton. He helped care for the illegitimate children of Harold Frederic. He himself was in love with a handsome male sculptor. Life and art were both changing, and "realism" as a concept had to evolve along with life if it were not to become fraudulent. James was naturally a reticent man and censorship a real threat in both England and America. Yet he was, after his peculiar manner, brutally honest in his perceptions. He had to develop new ways of including his more complex vision in his prose.

James did not begin as a novelist of consciousness. In looking back

at *Roderick Hudson* while writing the prefaces to the New York edition, he insisted that "the centre of interest throughout "Roderick" is in Rowland Mallet's consciousness, and the drama is the very drama of that consciousness. . . . ," but this was true only in the most external way. Mallet's perceptions were central to any understanding of the novel, but no reader ever felt himself inside Mallet's head or bound up in his consciousness. James was on firmer ground when he turned to *The Portrait of A Lady*. Still dealing with the international theme, still entranced by money and leisure and the marriage market for well-endowed American girls, he was nevertheless concerned with the brutalities of human greed and deception, and the psychology of illegitimacy. The novel was a transitional one in the best sense of that much-abused word, summing up the best in an old form and hinting strongly that something new was under way. "Place the centre of the subject in the young women's own consciousness," he remembered saying to himself, "and you get as interesting and as beautiful a difficulty as you could wish. Stick to *that*—for the centre; put the heaviest weight into *that* scale, which will be so largely the scale of her relation to herself." Then, after a discussion of how to develop the reader's interest in his basic themes, he got to the crux of the matter of both the novel's greatness and its importance for the development of modernism. He wanted to convey in some impressive way, "what an 'exciting' inward life may do for the person leading it even while it remains perfectly normal." He produced his desired effect in chapter forty-two, Isabel Archer's long meditation by the dying fire, as her memory played over the course of her unhappy life. "It is a representation simply of her motionlessly *seeing*, and an attempt withal to make the mere still lucidity of her act as 'interesting' as the surprises of a caravan or the identification of a pirate." It all happens "without her being approached by another person and without her leaving her chair. It is obviously the best thing in the book . . ." It was indeed. Even as William James was only beginning to put into words the scientific version of the stream-of-consciousness, his younger brother had embodied it in a novel. Not Proust, not Joyce, but Henry James deserves chief credit for this extraordinary innovation in literature.[19]

But James did not develop into a "stream-of-consciousness" novelist; in that sense, *The Portrait of A Lady* was a false dawn. He became instead a novelist of consciousness, which was not quite the same thing. The key document examining this development is, oddly enough, the preface to *The Princess Casamassima,* the novel of London anarchism that was as close to naturalism as James ever got. The point here is not the boilerplate of London poverty or the presumptive biological inheritance of Hyacinth Robinson, which have attracted scholarly attention and condemned the book to a rather marginal existence as something exceptional in James' proper development as an artist. For the author and for the student of an approaching modernism, the book was really

about "some individual sensitive nature or fine mind, some small obscure intelligent creature . . . capable of profiting by all the civilization . . . yet condemned to see these things only from outside." Hyacinth was a Fleda Vetch born male and poor and able to know what he was missing without ever having the hope of participating in a truly cultural life. In imagining Hyacinth Robinson, James came to realize that protagonists "are interesting only in proportion as they feel their respective situations; since the consciousness, on their part, of the complication exhibited forms for us their link of connexion with it." He drew his elitist, modernist conclusion from this contemplation of a poor young anarchist: "We care, our curiosity and sympathy care, comparatively little for what happens to the stupid, the coarse and the blind; care for it, and for the effects of it, at the most as helping to precipitate what happens to the more deeply wondering, to the really sentient." The modernist novel would be about what happened to the really sentient, or about what appealed to the really sentient about lives they could not otherwise know. The modernists did not rule out the poor and the stupid entirely as subject matter, but circumscribed such subjects severely and made exceptions grudgingly.[20]

Each of the dramatic works of the later 1890s was in some degree a novel of consciousness: the perceptions of Fleda Vetch about the spoils, the knowledge that Maisie saw but did not know, the dramatic dialogue that Nanda Brookenham had to listen to in order to recognize the wickedness of the sexual sweepstakes surrounding her coming of age. Like a connoisseur with a new treasure, James turned his new subject matter over and over, examining it in new lights for yet newer perceptions. Despite his passion for ambiguities, however, he did tire of this sort of experiment, as some of the grumbling in his notebooks and letters indicated. But before he had done, he wrote one final work in this style which enabled him to pass beyond these experiments to his "major phase." In *The Sacred Fount*, a novel infrequently discussed and often dismissed, he intentionally carried his own method to a logical absurdity, and in the process produced a work that put into artistic form his and his brother's aversions to men of theory. Isabel Archer had a sensibility worth exploring, as indeed did several of the minor characters in *Portrait of A Lady*. But the narrator of *The Sacred Fount* is essentially a fool of theories, a genteel prig who gets so into his absurd ideas that he confuses himself and everyone around him. In the process, the novel becomes a classic of unreliable narration as well as a fictional study of the problem of knowledge. Its style could only have irritated William, but its content was right up his pragmatic alley.

The opening pages convey the satiric tone. The narrator, who deserves to remain nameless, speaks of the "happy ambiguities" of his forthcoming journey, which he will take unexpectedly with Gilbert Long. Long "was stupid in fact" but "he had also, no doubt, his system, which he applied without discernment." Thus James foreshadows the central

intellectual problem of the book, the inapplicability of systems to the
understanding of real problems. He then has conversations like this
one between the narrator and Grace Brissenden: "Didn't you really
know?" "Why in the world *should* I know?" "Oh, it's only that I thought
you always did!" This goes on for a while, until the narrator mutters:
"In point of fact I didn't in the least." The reader seems to have been
thrust all unwillingly into an elementary philosophy class, devoted to
the problem of knowledge, taught by a director of admissions instead
of a professor of philosophy. The narrator and Grace then speculate
about whether Brissenden would "see" his wife at all, as they do. Grace
says that the narrator is in for "an interesting new experience" on his
visit, for he will presumably see in one of the couples he will meet the
beneficent effect of a clever wife on a stupid husband.

To make a hopelessly convoluted story clear, what happens as the
novel and the weekend party continue is that the narrator develops a
kind of vampire theory of personal relations. He becomes convinced
that in a marriage between the young and the old, or the intelligent
and the stupid, the old person will drain the youth out of his partner
and become younger, and the stupid person will drain the brains out
of the more intelligent. The more capable or youthful partner will in
turn change, becoming stupider or older. The narrator, once con-
vinced of his theory, goes around the weekend party snooping on peo-
ple, especially couples, trying to determine who is having relations with
whom, in the process starting all kinds of aimless hares of gossip and
misunderstanding among the other guests. James himself once re-
ferred to the novel as a joke, and it surely was, but one with more
meaning for cultural history than it usually gets credit for. It satirizes
the problem of knowledge; it plays with the relations of people; it mocks
relativity; it makes James' own obsession with ambiguities seem as ridic-
ulous as it occasionally was; it even makes fun of the drama. As the
narrator says of this antidrama in which nothing ever happens: the
events of the weekend would be "a tolerably tight, tense little drama, a
little drama of which our remaining hours at Newmarch were the all
too ample stage." Whatever the narrator needs, he will supply—regard-
less of whether it is actually there or not. Life had less to it than met
the eye.[21]

V

The last three completed novels were landmarks on the path to an
American modernism. On a relatively superficial level, they brought
together James' thoughts on his most enduring themes: the role of money
in social relations, the sensibilities of the innocent young, the corrup-
tion of civilization, the clash between American moralism and Euro-
pean aestheticism. On a more significant level, they fused the artistic

attitudes which Henry had been developing with the philosophical bias of William.[22]

James intended *The Wings of the Dove* to be a novel dramatizing consciousness, with all the key events happening offstage. "Kate's understanding with Densher" was *"in its explicitness* simply the subject of the book, the ideas without which the thing wouldn't have been written," he wrote Mrs. Humphry Ward in 1902. The novel was "essentially a Drama, like everything I do, and the drama, with the logic, the progression, the objectivized presentation of a drama, is all in their so meeting." As the book was composed, its main field was "in Densher's consciousness"; that composition involved "the closing of Kate's, and there is no torment worth speaking of for Densher; there's *no* consciousness—none, I mean, that's at all dramatic—their agreement hasn't been *expressed* and this expression, above all, been *the thing* he has subscribed to." The style was dense, rich and elusive, seeming to enact the moral complexities and hesitations of the characters as they evolved values in a universe of chance. The plot was simplicity itself. Kate Croy and Merton Densher were lovers without money. Milly Theale, "an angel with a thumping bank account" in Kate's words, was dying and eager for the experience of life and especially of a husband. Merton planned to marry Milly, inherit her money, and then marry Kate. James set out to do something specific and he did it.[23]

If that were all, the book would not have the importance for modernism that it has. Like the other two late novels, it embodied not only James' traditional themes, but his brother's as well—their views continuing to be compatible but expressed differently. Henry exposed characters to circumstances illustrative of pragmatism, free will, and indeterminacy even before his brother's formulations reached him in book form. In his original formulations, for example, money for James was a novelistic necessity: it gave his characters the right to travel and to be free of daily requirements of the sort that James did not care to write about. It might corrupt both those who had it and those who wanted it, but it did not possess philosophical importance. Money now meant freedom: freedom not only to move, to live in large homes, to meet people, but freedom also from higher laws, from the organizing principles of the universe. Money seemed to free people from the dull security of moral requirements and expose them to the excitements of corruption, deceit, and pure aestheticism. The predictable became the unpredictable; appearance clashed with reality on a much deeper level than before. Money took beautiful, innocent, rich Milly Theale from the world of William Dean Howells and placed her in that of Oscar Wilde. Like a radical empiricist, she wanted to cultivate her faculties and to inhabit a world of pure experience. Yet she found that her most decent yearnings brought her to the edge of unspeakable deceit. She used her free will and found that her intentions went awry. The world was one of confusion, of flux—of modernity; without the health to face

it, she turned her head to the wall and died. With her died many of the innocent certitudes of Victorian America.

This quest for pure experience, for the perfectly free imagination, became obsessive for James as he himself grew older and increasingly realized that some options in life were no longer possible for him. No matter what his brother might write about the dilemma of determinism or the ability a person might have to shape his own destiny, Henry James knew the limits of the possible. Despite the defeats that he suffered in writing plays or establishing relationships, he knew that, all things considered, his own conscious life had been very rich. He had chosen wisely when he had chosen to live alone, to write, and to reside in Europe. So acute a sensibility, however, sympathized with others less lucky, and one famous meeting resulted in *The Ambassadors,* a book which examined his characteristic themes from a new angle.

As the incident entered his journal, his friend Jonathan Sturges told him of meeting Howells at Whistler's house in Paris about eighteen months earlier. That American novelist of ordinary democratic life in his native land had just arrived in Paris to visit his architect son, only to be called back to America after just ten days due to the illness of his father. Conscious of what he had missed all his life, and what he seemed doomed to miss yet again, Howells laid his hand on Sturges' shoulder and said something like this: "Oh, you are young, you are young—be glad of it: be glad of it and *live.* Live all you can: it's a mistake not to. It doesn't so much matter what you do—but live. This place makes it all come over me. I see it now. I haven't done so—and now I'm old. It's too late. It has gone past me—I've lost it. You have time. You are young. Live!" James admitted to amplifying and improving the words a bit—the journal was his, after all—but the core of meaning was obvious. If you have a consciousness, cultivate it. Take chances. Your will is freer when you are young. Make your own universe. Don't let institutions hold you back. Think of the possibilities, the results!

The idea was so adapted to James' sensibility that the seed began to sprout as soon as planted. He began with "the figure of an elderly man who hasn't 'lived', hasn't at all, in the sense of sensations, passions, impulses, pleasures—and to whom, in the presence of some great human spectacle, some great organization for the Immediate, the Agreeable, for curiosity, and experiment and perception, for Enjoyment, in a word, becomes, *sur la fin,* or toward it, sorrowfully aware." The poor man has lived for duty and conscience and never really enjoyed himself; he has lived "for pure appearances" instead of pure experience. He would be vaguely intellectual, *"fine,* clever, literary almost," perhaps the editor of a magazine as Howells once was; a man who "married very young, and austerely. Happily enough, but charmlessly, and oh, so conscientiously: a wife replete with the New England conscience." The essential idea of the novel would be "the revolution that takes place in the poor man, the impression made on him by the particular experience" Since,

in Tom Appleton's phrase, all good Americans go to Paris when they die, the scene would have to be Paris. James thought his aging central figure would go out "to look after, to bring home, some young man whom his family are anxious about, who won't *come* home," only to decide that the young man was quite right, he should stay where he was. It might be too late for the older man, but not for the younger.[24]

However the details might change, the core idea remained as James wrote the novel. Lambert Strether is a man of perception and taste; above all, he has a pragmatic sense of consequences. Sent out to investigate Chad Newsome's suspicious willingness to remain indefinitely in Paris, Strether finds Chad with an attractive mistress, Mme. de Vionnet, an older woman clearly taking very good care of her young American. Chad looks as if he has become "free," and has certainly overcome that "failure to enjoy" which seemed to be the distinguishing characteristic of his home town of Woollett. Shocked in a way, like any conventional American, Strether has the perception to realize that for Chad, the situation works. Under such tutelage, he has improved his personality considerably, and at least in his particular case, conventional American presuppositions do not work. That is, the results in consciousness, in the quality of his pure experience, justify his behavior. In seeing this, Strether has his own consciousness raised—as Chad notes, Paris is "too visibly good for you"—if rather too late in life to do much more than let his imagination roam. In the process, James came perilously close to asserting openly that American moral principles did not work; that they too often produced mean-spirited and provincial types like the Pococks, unable to comprehend much of anything beautiful, "fine," cosmopolitan, or liberating. If corruption worked, so to speak, then three cheers for corruption.

In its carefully wrought way, *The Golden Bowl* holds all of these themes within its flawed beauty. The Prince, the complete cosmopolitan, must marry Maggie Verver, the impossibly wealthy American heiress, to recoup the ancestral fortunes. One of her best friends is the mateless Charlotte Stant, fully as cosmopolitan and attractive as the Prince, and as it turns out a woman who once had a close relationship to the Prince, a relationship which could not lead to matrimony because of the lack of money on both sides. Maggie, a woman who "wasn't born to know evil," has an intense relationship to her father. Her marriage threatens this—one relationship threatens another—and a marriage between Charlotte and her father seems an ideal way to keep everyone together. One relationship leads to another, which leads to another, and the novel becomes a study in the relativity among four characters. It takes place, of course, on stages, in scenes, and is intensely dramatic in its organization. It also explores Henry's version of the problem of knowledge. He repeatedly plays with the contrast between appearance and reality, between what his characters seem to know and what they can be sure of knowing. In the course of staging his elaborate drama, James once

again keeps his great scenes off the stage, preferring to stress his characters' consciousness of their relationships. So thick are the ambiguities that pronouns diffuse and become indefinite, to the point where even the characters speaking become confused. No one seems really to "know" anything, nothing is certain, everything becomes relative. The characters form various *tableaux vivants,* while beneath the surface glitter reality seems to dissolve.

The good, sensible Assinghams occasionally come on stage to give an anchor of common-sense realism to the events, and Fanny Assingham at one point provokes the Prince into declaring that he does not possess the "moral" sense, meaning "always as you others consider it." In his possessing cosmopolitan charm while lacking moral sense, he represents for James the attractions of Europe at their most elegant. Adam Verver, by contrast, may live in Europe to collect art and be near his daughter, but he is quintessentially American, the best that America could produce; by contrast to the Prince, he has to play "the innocent trick of occasionally making-believe that he had no conscience"; with him, it is all "the *imitation* of depravity." Father-in-law and son-in-law, America and Europe, moral principle versus no moral principle: as the Prince is fond of saying, "We haven't the same values," and this clash of values in intimate relationships gives the novel its dramatic core. Adam marries Charlotte, and then spends most of his time with his daughter. Charlotte and the Prince are thus not only free to pick up their old relationship, they are all but compelled to do so by proximity and boredom. Indeed, as in *The Ambassadors,* such an illicit relationship on these terms not only seems comprehensible, it seems silly even to question its legitimacy. Such is James' mastery of situational ethics, of the pragmatic sense of context, that an unwary reader can find himself matter of factly agreeing that adultery and incest of this kind have their merits. A man incapable of falling for Charlotte has lost interest in life; a woman who could resist the Prince has problems even Henry James could not solve. Once again, the moral chaos of modernity is there in all its inveigling charm.

Charlotte makes all this explicit in chapter five of Book III. "There it all is—extraordinary beyond words," she says to the Prince. "It makes such a relation for us as, I verily believe, was never before in this world thrust upon two well-meaning creatures. Haven't we therefore to take things as we find them?" Charlotte has been frittering away her excess time and her husband's excess money with cab rides, museums, galleries, and bookshops. She tells the Prince that she would have gone to the zoo had it not been too wet; she even looked into Saint Paul's. But the results were deeply unsatisfying; even when she saw her husband, he was playing with his grandchild if not doing something with his daughter. "What do they really suppose becomes of one?" she asks plaintively. Indeed, Maggie and her father seem positively to want the Prince and Charlotte to keep each other company, if not with the con-

notations the relationship would actually have. "How can we understand anything," she asks, "without really seeing that this is what they must like to think I do for you?—just as, quite as comfortably, you do it for me. The thing is for us to learn to take them as they are." They make the best of a highly ambiguous situation.

The most masterly scene in the book comes in chapter two of Book V. With the Assinghams, the two chief couples are a party of six together for an evening of bridge. The cards, of course, provide only the scenic surface of the ambiguous relationships at work: for by now, in some form the various secrets have started to come out. James has each character at a different level of knowledge: everyone knows something about what has been going on, but no one knows it all; everyone knows something different, and no one knows how much the others know. While the others play, Maggie sits looking over the top of her review, unable to concentrate: "she was there, where her companions were, there again and more than ever there; it was as if of a sudden they had been made, in their personal intensity and their rare complexity of relation, freshly importunate to her." The "facts of the situation were upright for her round the green cloth and the silver flambeaux; the fact of her father sitting, all unsounded and unblinking, between them; the fact of Charlotte keeping it up, keeping up everything, across the table, with her husband beside her; the fact of Fanny Assingham, wonderful creature, placed opposite to the three and knowing more about each, probably, when one came to think, than either of them knew of either." In the air above all "was the sharp-edged fact of the relation of the whole group, individually and collectively, to herself . . ."

Only in this context does Henry's response to William's *Pragmatism* become fully comprehensible. William occasionally made sarcastic remarks on Henry's convoluted style, and nothing in their correspondence forbade frank disagreements or demanded uncritical acceptance of each other's work. Henry no more had a philosophical mind than William had a literary one, yet each had traveled a path so closely parallel to the other that comprehension most of the time was immediate. William made intelligent remarks about Henry's prose on occasion, and Henry returned the perception when he received *Pragmatism*. He thanked William for "the spell" that the book "cast upon me; I simply sank down, under it, into such depths of submission and assimilation that *any* reaction, very nearly, even that of acknowledgement, would have had almost the taint of dissent or escape." The delay in conveying his gratitude was actually a measure of the book's impact. "I was lost in the wonder of the extent to which all my life I have (like M. Jourdain) unconsciously pragmatised. You are immensely and universally right . . ."[25]

VI

Henry James spent his mature years as an unpopular writer. His early successes did not lead to an easy acceptance or comfortable retirement. Individual volumes did not do well, and James had trouble placing his work in magazines before bringing it out in book form. The New York edition of his most significant work did not sell well. Yet as is so frequently the case in cultural history, the work seemed influential almost in inverse proportion to its public acceptance. His very willingness to experiment seemed to attract the next generations: his devotion to a literary vocation gave them a role model; his criticisms of America and his willingness to expatriate himself showed them how a person could be an American and yet not permanently suffer aesthetic damage; they approved of his attention to European writers from several cultures. Technically, he proved a mine of innovation. His experiments with limiting the point of view, of using unreliable narrators, and of being ambiguous, appealed to modernists for whom nothing in life seemed certain. The scenic method was also influential. Sure that Ibsen and other modernist playwrights had pioneered something of importance for novelists, they learned from James how to rework drama for the uses of fiction. They found in James' willingness to juxtapose his scenes a premonition of the montage, as it developed later in film and painting. They liked as well his merging of the objective and the subjective, the blurring of the lines between the individual and society, the narrator and his characters, the players and the audience. And in his slow move toward the plotless novel, the novel in which nothing happens—for 600 pages or so—they could find precedent enough for even a post-modernist attitude toward art. The trail is clear from James through the great modernists to Beckett and Gass, and even to the critical attitudes that dominated much literary discourse in the 1960s and 1970s.

Yet, with these precursors, one has to be careful. They were not modernists however much they helped make modernism possible. However much he might write one of the wickedest novels in literary history, in *The Golden Bowl* James remained in some ways Victorian and American. He obviously admired the virtues of Adam and Maggie Verver. The descendants of the Puritans had much to be said in their favor. James might feel the attractions of aestheticism and the compelling situation in ethics, and yet he could never himself have yielded. Maggie, when all is said and done, does win in the end: not only does she know, she prevails; she might lose her father to America, but in fact the family does separate, and distance will solve the problem that ethics cannot. Likewise, in *The Wings of the Dove*, not only does Densher fail to marry Milly, he fails to win Kate as well, and the novel ends suggesting that he has truly fallen in love with Milly's memory. This implicit bias in the plots of both works undercuts any real claim James himself might have to being a genuine modernist. He could under-

stand modernist views, he could portray modernist situations, he could set modernists a good example—but then the very setting of a good example was a Victorian idea. Imagine Baudelaire, Huysmans, or Wilde worring about setting a good example! An American would have to work hard indeed to be a genuine modernist.

Still, James' position remained secure. As T.S. Eliot remarked in 1918: "there will always be a few intelligent people to understand James, and to be understood by a few intelligent people is all the influence a man requires."[26]

BOOK II

Discontent in the Provinces

The consciousness of modernity and the self-consciousness of being a creative artist in contact with it developed in several provincial cities almost simultaneously. European ideas were circulating in the colleges often independent of the faculty, occasional journalists and artists with European connections were beginning to publicize their ideas, and a sense of solidarity against convention was emerging during the last half of the first decade of the new century. In time, everyone tended to move to within commuting distance of New York City, if not to London, Paris, or some other European city. But until the 1930s New York was not a city where creative figures grew up; New York was a mythical environment, a state of mind, where intellectuals and artists were always between twenty-one and thirty-nine.

The provinces of modernism were several, but they concentrated in two major and three minor communities. The most important were Philadelphia, around the University of Pennsylvania; and Chicago, in the world of journalism. Of lesser importance were New Orleans, where jazz was developing in a black and mulatto environment separate from white, middle-class America; Hollywood, where sunshine and cheap labor were providing a hospitable environment for the new technology of the cinema; and in German Baltimore, where Gertrude Stein attended Johns Hopkins and H.L. Mencken was establishing himself as an editorial focus of new writing.

Philadelphia

Philadelphia was no hotbed of cultural innovation. It had been the second city of the British Empire during the Age of Franklin, but had lost that status by 1800. By the middle of the nineteenth century it was stodgy and dull, devoid of innovation in literature, derivative everywhere else. But since Franklin's day, it had been a city of institutions, a city where cultural life was possible. Not everyone was devoted to the making of money. Children could grow up in homes where books, music, and art were taken for granted, however antique the forms might be. Institutions also drew students, and these could mix with the children of the faculty, or from the professional classes, or from a less likely institution such as the local branch of the U.S. Mint.

If any single individual embodied the beginnings of an American modernism as a self-conscious climate of creativity, Ezra Pound did. No one had a more impeccably American background, more intelligently supportive parents, or more opportunities to learn new ways of artistic expression. No one had a greater force of character or more self-assurance in conveying his ideas. No one was more capable of irritating the custodians of religious and academic ideas of culture. No one had closer or more devoted friends of genuine ability in his own generation. As William Carlos Williams said shortly before his death: "Before meeting Ezra Pound is like B.C. and A.D."

Pound had a legendary American heritage before he was born. His paternal grandfather was Congressman Thaddeus C. Pound, one of the lumbermen, railway builders, and miners who had won the West. He had fought Frederick Weyerhauser, the lumber baron beyond all lumber barons, but had lost out in 1881 as, among other things, Weyerhauser consolidated the Northern Pacific Railroad. Thaddeus Pound had fought the eastern banks and issued interest-free scrip that circulated as money when he could not get sufficient credit lines. On occasion he even fought the very forces he himself embodied, trying to help Indians harassed by the expansion of the white community and calling for at least some attention to conservation. He was conscious enough of literature to name his son Homer. Mostly he lived as he liked and for years ignored public opinion to cohabit with a woman not his wife.



Insofar as any man embodied the best of democracy to Ezra Pound, his grandfather did: in Cantos 22 and 97, and in Pound's Jeffersonianism, Thaddeus Pound lived on. Ezra saw his grandfather only once, when he was three; all he could remember was a beard. It was enough.

Thaddeus did not approve of nepotism or the spoils system, but he needed someone to look after silver mines that were in danger of claim-jumpers. A Federal Land Office had just opened in Hailey, Idaho Territory, and he got Homer a job there registering claims and assaying silver. Homer did well in the raw West, managing to do so without being shot. But his bride Isabel had been gently reared and did not take to the place. Ezra was born there in 1885, but eighteen months later his parents returned to the East Coast. Uncle Ezra Weston had a boarding house on 47th Street in New York, between 5th and Madison Avenues; a grandmother lived nearby. The child long remembered the tales and the people he encountered there while his father sought a permanent job. The Westons were rich in pretensions and comfortable in finances. One branch of the family were Wadsworths, making Ezra kin to Henry Wadsworth Longfellow, whose very name irritated him in his maturity. He preferred Capt. Joseph Wadsworth of Connecticut Charter fame, and in Cantos 109 and 111 celebrated this stalwart democrat as a counterweight to Franklin D. Roosevelt, for whom a mature Pound never had much use. Later Wadsworths were successful capitalists and Pound admired them as well—they created wealth without recourse to manipulation or usury. Even after Homer found a permanent job with the branch of the U.S. Mint in Philadelphia, the family traveled back and forth to New York, and these voices of childhood lingered to haunt the Cantos, as in Canto 74. Some talked politics, some recalled the black South, and all of them constituted the Old America, complementing the mythical hero on his father's side of the family. Uncle Ez, of course, had a special impact: a namesake, a role model, a persona the young poet could use in his dialogues with himself, his audience, and his country.

By the early 1890s, the Pounds were settled in the upper-middle-class suburb of Wyncote, ten miles north of Philadelphia on the railroad. The house was large, the boy had plenty of space, and Homer Pound was especially hospitable. Jews, Italians, and foreigners came frequently as guests, despite the raised eyebrows of neighbors eager to keep the area exclusive. The family also took in boarders, usually preachers or temperance advocates—individuals compatible with the social conscience evident in the family. Homer and Isabel were founders and pillars of the Calvary Presbyterian Church, and maintained long and sincerely felt relationships with Christian Endeavor and social settlement groups. In 1897 Ezra formally accepted membership in the Presbyterian Church; he was a special admirer of the Reverend Mr. Carlos Terry Chester, pastor during the middle 1890s, and as late as 1909 dedicated *Exultations* to him. Because public schools were not well-

established in the area, Ezra attended mostly private ones, all nearby. The Cheltenham Military Academy, where he went from age twelve to sixteen, put him in uniform and made him attend drill, probably the last time in his life when anyone made him look like or walk in step with anyone else.

But what Ezra remembered most clearly was the Mint. He often went down with his father, obviously enjoying the easy-going atmosphere that prevailed there. His father seemed to him a master alchemist in a Greek temple, determining the values of substances with uncanny precision. As an old man, Pound recalled for an interviewer the sight of men, naked to the waist, as they shoveled silver coins around in the gas flares—"things like that strike your imagination"—to reappear in Canto 97. Unlike gold, silver was hard to test: "the test for silver is a cloudy solution; the accuracy of the eye in measuring the thickness of the cloud is an aesthetic perception, like the critical sense. I like the idea of the fineness of the metal, and it moves by analogy to the habit of testing verbal manifestations."[1]

Pound's exposure to Europe began at twelve. Uncle Ezra had died in 1894, but his widow, Frances Amelia Weston, always known as Aunt Frank, remained in comfortable circumstances thanks to her boarding house, and in 1898, at her expense, she, Isabel Pound, and Ezra took a grand tour in the long tradition of such jaunts. For three months they visited London, Brussels, Cologne, Lucerne, Florence, Gibraltar, and Paris. It was all a great lark; Isabel faded into the background and Pound recalled himself and Aunt Frank as they discovered a world far removed from conventional American life. Pound lived most of his life abroad, and inevitably, as in Canto 74, the visits tended to merge and blur in his memory. But first visits are always important and he seemed to feel a special kinship for Italy and France. He returned in 1902, this time with his parents; little contemporary evidence survives concerning either trip.

Pound was only fifteen when he entered the University of Pennsylvania in 1901. He was too young and intelligent to fit in well, and had the special burden of living at home. He was alone as far as his peers were concerned, although he did meet two friends who became important to him. The first, William Brooke Smith, was a student at the Philadelphia College of Art. Hilda Doolittle recalled him at the end of her life as "tall, graceful, dark, with a 'butterfly bow' tie, such as is seen in the early Yeats portraits." He was also consumptive, dying in 1908; Pound dedicated *A Lume Spento* to him. Doolittle herself was the other. She and Pound liked to disappear on long walks and read poetry to each other: the great romantics and Victorians, sometimes Blake, Swedenborg, or a book of Yoga. She was Isolde, his Is-hilda; he was her Trist-an, her man of sorrow.

Wagnerian heroes were never noted for schoolwork. Pound's parents, not to mention the faculty, were concerned. The trip to Europe

in 1902 had not focused Pound on anything testable. He returned and moved into a dorm; he found his second friend in William Carlos Williams, "Billy" to his friends. But he needed a small college with close faculty contact, new role models, mentors who knew something about literature. Carlos Chester suggested his own alma mater, Hamilton College, in Clinton, New York, and Pound transferred there. He was lucky: Hamilton accepted his work, spotty though it was, and supplied Pound with the models he needed. If he seemed out of place among the other students, which he did, he found solace elsewhere. He met the young Viola Baxter through a church group, and she helped make life so pleasant for him that they maintained sporadic contact for years afterwards—he even set her up with Williams, who liked her fully as much, although she ended up marrying a man named Jordan. Even more important, Pound became passionately attached to a woman about eight years older than himself. Katherine Ruth Heyman was an accomplished pianist specializing in the music of Scriabin, and a Jew. The affair was platonic, like all Pound's American relationships, but decisively formative. Pound dedicated "Scriptor Ignotus" to "K.R.H.," and when the time came to flee America in 1908 he chose Venice, because of her, and then London, because she was going there.

The faculty were tolerant of Pound's eccentricities. They knew of his dislike for institutional food and his attempts to cook his own. Stories soon abounded of his calling on one faculty member, asking to use the bathroom, and emerging half an hour later having had a hot bath; or of his dropping in on another, most probably Joseph D. Ibbotson, a specialist in Anglo-Saxon and Middle English, at 11:40 P.M. In an encounter inconceivable at Pennsylvania, Pound had been walking home after a trip to Utica, seen the professor's light, and being lonely had rung the bell. They sat by the fire smoking together until 3:00 A.M., discussing Ossian, a recent enthusiasm, and condemning professors who used faulty texts in their classes. Most of all they explored Anglo-Saxon poetry: "Pound had tried his hand at verse in Anglo-Saxon and had experimented with adaptations from the Chronicle, in modern imitations of the Anglo-Saxon verse forms." Pound was also deep into the works of Dante Rossetti and William Morris, those late Victorian revivers of things medieval.[2]

Pound's love for Chaucer and Sir Thomas Malory was only a part of his larger love for all of medieval romance; and that in turn was an integral part of his growing insistence, not yet fully articulated, that he could reject an American culture which did not seem to have a place for him and choose another. The key professor in this shift was Dr. William P. Shepard, a Heidelberg Ph.D. who was in charge of French, Spanish, and Italian medieval literature, and a particular expert in the work of Dante. He and Pound were working in a new area of scholarly research where controversy abounded and capable scholars remained skeptical both about the integrity of the texts that they had and the

meaning of those texts. Central to Pound's training were H.M. Chaytor's *The Troubadours of Dante* (1902), which with its glossary, grammar, and notes helped make the troubadours so available that even popular novels started coming out based on these new sources; and the three-volume, bi-lingually organized set of the *Divine Comedy* in the Temple Classics series, which Pound bought and inscribed in March 1904. He began reading the volumes immediately, made marginal notes, and was soon on the way both to *The Spirit of Romance* (1910) and Imagism.

Pound's role in the history of the scholarship of the period remains controversial. By rigorous academic standards he was technically incompetent, something hardly unusual in an undergraduate with a mediocre record, but he was not incapable. Unlike better trained scholars, he had an imaginative capacity for getting inside the verse, a skill which he began to use almost immediately in translation. One appeared in the *Hamilton Literary Magazine* early in 1905, and Pound was soon getting away from pedantic literal renderings and into re-creations, adaptations, or imitations, works obviously based on medieval sources but translations more of the spirit than the meaning of the texts. Scholars whose careers were based on philological principles and exhaustive research into minor areas of language were predictably incensed, and certainly Pound made occasional howlers. But in the process he became the founder of modern poetry translation, sensitized himself to language in an original way previously unknown to American poetry, and worked toward critical principles crucial in the development of modernism.[3]

Simultaneously, he was distancing himself from American culture. Few obstreperous young poets were so lucky as Pound, having parents to rebel against who loved him dearly, who supported his efforts far beyond what most parents could have tolerated, and who understood letters written without intellectual condescension. At the start of his last semester at Hamilton, Pound was being firm about his ideas both to Isabel and Homer. Isabel had made the mistake of indicating her approval of the Emersonian ideas he had been exposed to at the college, but Ezra chided her that she "needn't begin to crow just because I happen to hear a little Emerson. He and all that bunch of moralists, what have they done?" Everything good in their work they got from the Bible "and the rest is rot. They have diluted Holy Writ. They have twisted it awry. They have it is true weakened it sufficiently for the slack-minded and given vogue to the dilutation." The chief reason to read Emerson and his ilk was that "you can't trust a word they say and the exhilaration produced by this watchfulness for sophistries is the only benefit." But he got positive "joy" from studying his "mediaevalians." You "current eventers think you're *so* modern and so god darn smarter than anybody else," that it "is a comfort to go back to some quiet old cuss of the dark, so-called silent centuries, and find written down the sum and substance of what's worthwhile in your present day

frothiness." He was not about to attack progress, "but it's good to know what is really new. Only if you want to boast your progress stick to chemistry and biology, etc., things that change per decade. But for love of right mercy and justice, don't try to show off modern literature and brain quality." He then dismissed Emerson once more as making men think only to "detect his limitations," and went into a ringing defense of Dante. "But find me a phenomenon of any importance in the lives of men and nations that you cannot measure with the rod of Dante's allegory." Until his mother could "show me men of today who shall excel certain men some time dead, I shall continue to study Dante and the Hebrew prophets."[4]

What Pound did not go into with his parents, understandably enough, were more personal reasons for studying medieval romance. The men who developed the *canso,* the short lyric about love, were a fairly raffish crew: a few princes, perhaps, but also a healthy measure of ex-monks, poor knights, and outright plagiarists. The courtly love of which they sang insisted that the lady involved was the person who held the moral well-being of the gentleman in her hands. At times, matters seemed platonic enough, which must have appealed to an undergraduate then in love with at least three women; but the stress was on an insistent sexuality that implied consummation and the tone occasionally quite bawdy. The physical side of love was something that should be taken for granted, not dwelt upon. In Pound's understanding of courtly love, love of a woman focused an artist on an ideal, it raised his conscious-ness to a higher plane, ultimately a divine plane, and thus made the artist into a priest. As poetry, the lyrics became coded messages, songs that sounded well enough in public but that simultaneously sent private messages to the beloved. He treated Hilda Doolittle, Viola Baxter, and Katherine Heyman in the same way, as beautiful, intelligent, and spir-ited means for raising his perceptions and his art to new levels. Sex, poetry, the divine, and the concealed thus all came together in ways a young man might discuss with a young lady and perhaps with an es-pecially sympathetic professor, but not with his parents. Pillars of the Presbyterian Church would not understand the lecherous lords of the twelfth and thirteenth centuries, unwilling to accept any external force as they traveled about seeking to express the highest ideals in the low-est postures.[5]

Pound might moan privately about "these desolate regions" of New York State, but however lonely he might have felt and been, he had had intellectual stimulation, encouragement, and toleration of a high order. Yet he did not know what to do next. He took his Ph.B. in 1905, tried in a desultory way to find a job at various preparatory schools, and then went on to graduate school for lack of anything better to do. Since his family lived in the Philadelphia area and he was familiar with the university, he went back to Penn despite his earlier unhappiness. For a year this worked surprisingly well, for he could take a substantial

amount of work with Professor Hugo Rennert, a specialist in Romance languages with whom he got on well; he also studied Latin with Walton B. McDaniel. He muttered about going on for his Ph.D. He amused himself with Spanish drama, but tried to keep up elsewhere as well: "I am trying to keep half a dozen languages in order & swallow the litterature of Spain entire"—the languages seeming to be Provençal, French, Latin, Italian, and German. He went to the theater and took fencing lessons. By early 1906 he was maneuvering for a $500 fellowship for the next year, got it in April, and in anticipation spent the money he had, working on Lope de Vega in Madrid for a possible Ph.D. thesis, and then touring Spain, Gibraltar, southern France, Paris, and London.[6]

The next year should have been better: the bright young M.A. of many talents finishing his course work for the Ph.D., winning another fellowship or two, then an instructorship, and writing a dissertation on some aspect of the medieval romance. But even before the term began, he interrupted his vacation tennis to write Viola, in what already sounded a bit like the voice of Uncle Ez: "The horse thieves are among my most treasured forebears. I would rather have a horse thief any day than a president of Hawvud, . . ." Harvard had done nothing to offend him, but supplied a nicely distant surrogate for Penn. While he waited for the term to get under way, he conveyed a "salaam" to her mother, "due to my studies in the philosophy of the Hindoo Yogis," and indicated that money and his career as a man of letters were very much on his mind. "My days are filled with playing tennis, cursing this type writer when it refrains from working properly, borrowing money when possible, repaying it when compelled to, and divers other harmless pursuits of the young." Unfortunately, few outlets were available which liked his stuff and paid for it. He had an especially painful encounter with *Munsey's,* an unlikely choice at best. "The boss of Munsey's had the grace to return a personal note with my last eruptions. Said he was interested said I was really doing good work, but too UNCONVEN-TIONAL in treatment for magazines he was running—. Too d bad I cant get onto conventionality arent it." In his spare time, he found some solace in studying Whistler and Maeterlinck.[7]

While editors rejected his unconventional writing, professors rejected his unconventional mind and behavior. As he began to work with a new group of scholars, Pound quickly came to loathe the university, a feeling which did not abate for the rest of his long life. He continued to work with Rennert, but became disgusted with another man's course in French phonetics, which he never completed. In the spring he worked entirely with other members of the department. He did not complete a single course and apparently flunked Josiah Penniman's course in literary criticism. Passionate about his work, insisting on a comparative perspective in a university divided into national literatures, and in many ways brighter than his teachers, Pound could not hold his nose and get

through the stables like subsequent generations of less talented aspirants. Penniman was one of those non-publishing entrepreneurs who fall upwards in academe, defying both gravity and commonsense. Already the dean of the faculty, he eventually became Provost. Pound was doomed at Penn. "The dean has decided that I am the worst stirrer up of trouble in the Univ.," he wrote Viola. He solaced himself by attending *Caesar and Cleopatra*, since at the time he was telling everyone, including Felix Schelling who taught a course in drama, that Shaw was greater than Shakespeare. He did not finish Schelling's course either.[8]

Pound needed a job. The Penn English Department obviously wanted to get rid of him, and its members were more than willing to write letters recommending him for distant and insignificant campuses—a classic academic ploy. Wabash College in Crawfordsville, Indiana, offered itself as the next victim, and Pound had an interview with its president, a dour Presbyterian Doctor of Divinity, George Lewes Mackintosh. Wabash was expanding into athletics and Romance languages, and in the quaint fashion of the old American college was willing to make a young and inexperienced instructor with only an M.A., the head (and sole member) of its new department.

Pound arrived to find an institution comparable to a parochial school. Tight regulation and censorious townspeople permitted little relaxation on or off campus. He was expected to be in his place at daily chapel unless ill. The rules forbade smoking yet he loved to smoke exotic foreign cigarettes. He was responsible for three classes of over one hundred students, and found that he had to attend YMCA receptions as well. He took solace in the domestic comforts: "the people here wash my dishes and their cow politely offers me cream," and insisted to Viola that he was "very comfortable altho apparently utterly incapable of transmitting that feeling to anyone else." Naturally enough, his mood varied. He could write Billy Williams about his interest in "art and extacy—, extacy which I would define as the sensation of the soul in ascent, art as the expression and sole means of transmuting, of passing on that extacy to others," recommending Whistler's "10 O'Clock" talk and all the Yeats that Williams could find. But he could also write an old friend from Penn, Lewis Burtron Hessler, who was teaching rhetoric at the University of Michigan, that he found Indiana "the last or at least sixth circle of desolation," and feared that "the perfeshun of teaching has nothing more juicy to offer me than the position which in the logical sequence of events I slide into here in a very short lapse of years." His crying need was for "mere degenerate civilization, as represented by cock-tails, chartreuse and kissable girls," and he feared that such needs "may call me from thes[e] ways of middle class prosperity and these paths of peace into some inferior and less respectable walk or amble of life."

The next day Pound's fall from grace began. A vaudeville girl lived across the hall from him who made her living at least in part by imper-

sonating men. Gregarious and lonely, Pound befriended her, but in Crawfordsville nothing remained hidden long: "Two stewdents found me sharing my meagre repast with the lady-gent impersonator in me privut apartments," he wrote Hessler; "the lady being stranded & hungry & it not being convenient to carry a dinner across the hall. . . ." Pound was already a subject of gossip for having nothing less than a chafing dish in his room—only a poet could do it justice—and he seemed to realize that he was on thin ice: "keep it dark and find me a soft immoral place to light in when the she-faculty-wives git hold of that jewcy morsel." Meanwhile he asked Hessler not to mention it to his parents and said he was "at present looking for rooms with a minister or some well established member in facultate. For to this house come all the traveling show folk and I must hie me to a nunnery eer I disrupt the college[.] Already one delegation of about-to-flunks have awaited on the president to complain erbrout me orful langwidge and the number of cigarillos I consume. Have just met the town artist returned from 72 NotreDame DesChamps so I guess I am fer hell an gone."[9]

Pound did change living quarters several times during the fall, finally landing with two pillars of maidenly respectability, the Misses Ida and Belle Hall. The Halls liked to rent to respectable bachelors, but nothing in their previous experience prepared them for Pound. Both were staunch Presbyterians and had influential friends among the college administrators. But Pound continued to live much as he had. He cooked on his chafing dish, wore his floppy hats and capes, and even sported a cane as he walked around campus. He found other young faculty who were friendly and felt much as he did about being marooned in the middle of nowhere; they visited his rooms until late at night, and when they did not he read into the wee hours. He cut chapel, duly noted in the school newspaper, made irreverent remarks in class, and insinuated publicly that athletes should bathe more often. The climax came on a freezing night in February, 1908. He walked downtown to mail a letter, found a chorus girl stranded, took her to his rooms and let her spend the night in his bed—while he remained chastely on the floor. He went off to teach, and the Misses Hall discovered the lady the next morning. Phone calls and confrontations occurred, President Mackintosh made him a cash settlement, and Pound departed immediately.[10]

The affair had its comic side but its results were serious. Already disillusioned by his second year at Penn, Pound had had it with American academia. He could never qualify for a good job without a Ph.D. and with an aura of sin about his name. His private life was also in shambles. His parents and Penn contemporaries stood by him in the scandal, but he hated being financially dependent and needed to be on his own. He wanted to live where poetry was respected and a poet could live by his art. Katherine Heyman was in Venice, and he thought

seriously about the possibility of becoming her manager. He heard that
the London Polytechnic Institute wanted a lecturer in medieval litera-
ture and thought he might qualify. He borrowed some money from his
father, visited Billy Williams, and took a boat for the Mediterranean.
He stopped off at Madrid, Gibraltar, and Tangier, engaged in a little
currency speculation, and made stabs at writing a novel; by late April
he had reached Venice. He thought about writing ghost stories for the
money, paid a printer to bring out *A Lume Spento*, and presented him-
self to friends in June as "managing the 'greatest livin' she pyanist' the
only specimen in captivity," Katherine Heyman, "*the* Welt meisterine of
the ivories." Kitty had money and a career, and together they enjoyed
the opera, theater, and restaurants of Venice. In August, her schedule
took her to London. Pound shipped twenty of the one hundred printed
copies of his new book to his father for possible reviewers, and went to
London with her. He loved it. "London, deah old Lundon, is the place
for poesy," he wrote Williams once he had settled in.[11]

II

Hilda Doolittle was Pound's closest friend in his Philadelphia years, his
Muse, his Dryad, and his fiancée. She long remembered their first
meeting at a Hallowe'en party when she was fifteen and he sixteen. It
was a fancy dress party, and Ezra came in a green robe that she thought
"Indo-China-ish": he had obtained it, he said, while on a trip with a
cousin some years earlier. The robe caused considerable discussion, all
the more because it seemed color-coordinated with his "Gozzoli bronze-
gold hair" and his "odd eyes." He subsequently gave it, much as he
loved it, to the sister of a friend of hers who was ill, "just to cheer her
up." The memory was certainly vintage Pound lore, an early example
from someone who remained devoted to him, after her fashion, for
life. Ezra the peacock, the non-conformist, the subject of talk, the im-
pulsively generous. You couldn't forget him.

As an adult, Doolittle wrote prose that was evocative, diffuse, discon-
tinuous—and often about Pound. She found it hard to get away from
Pound in Philadelphia, Pound in London, Pound in Paris, Pound the
lover who filled a decade of her life with more excitement than a woman
could stand. She remembered him reading William Morris to her "in a
field under a very Preraphaelite apple tree. He shouted very loudly,
more and more loudly at the end of each verse. 'Three red roses across
the moon' and '*Ah, qu'elle est belle, la Merguerite*' became at the last rep-
etition an Iroquois battle cry." She recalled him at parties, liking "choc-
olates with hazel-nut hard centres," unable to "sing or dance or play
the piano" but doing them anyway. She also never forgot his character-
istic way of approaching a painting, or his prose when discussing it.
"Ezra had a way of dashing at a picture and finding its salient beauty.
He was much liked by out of the way painters but made himself terribly

conspicuous, standing in his then Whistler manner in the (then novel) horn-rimmed spectacles before various Philadelphia Academy of Art atrocities and commenting in a loud voice." [12]

You certainly never forgot Pound if you came from a sheltered, religious background, the way Doolittle did. Born in 1886 in Bethlehem, Pennsylvania, she combined two clashing strands of American religious history in her heritage. Her father was Charles Leander Doolittle, a professor of mathematics and astronomy at Lehigh University, a veteran of the Civil War, and a puritan who reminded his daughter of the men in high-peaked hats in the Thanksgiving issues of popular magazines. Her mother was a mystical Moravian, and for eight years the family lived on Church Street—no less—in a closely knit Moravian enclave in Bethlehem. The family was always conscious of its place in the "Invisible Church," the group having been driven underground for centuries by both Protestant and Roman Catholic persecution. Her mother's family, the Wolles, had direct antecedents in the first groups of settlers who had come to Pennsylvania in the 1730s and 1740s, and remained central to contemporary church affairs. Hilda always thought of herself as her father's girl and was his favorite child, but she never forgot her maternal heritage, studied it throughout adulthood, and persistently named her poetic sensibilities "Helen," the name of her mother.

Bethlehem was not totally devoid of poetic talent; one of her fellow students in kindergarten was William Rose Benét. But intellectual liberation could not really begin until her father moved to Philadelphia in 1895 to accept a professorship at the university; he became Flower Professor of Astronomy and the founding director of the Flower Observatory in 1896. He remained for her life "my father, the Astronomer," a daily presence in her conversation, whose work on stellar coordinates, constant aberration, and latitude variation was one of the most important projects in the astronomy of that period. The city and the university thus became available to Hilda when she was nine, and so her teenage years were spent among university people not constricted by the narrow demands of a once-persecuted sect. She met Pound in 1901, and in 1904 entered Bryn Mawr, where Marianne Moore became a good friend. All signs pointed to a normal college and family experience for a well-bred girl from the intellectual middle class.

But in 1905 or so, she and Pound became engaged, or at least tried to; his parents approved heartily, and as Homer Pound was a responsible and successful person, that meant something. But the Doolittles were austere, religious, and academic, and the Flower Professor had no use for flamboyant young men in Oriental robes. Pound by then had a reputation for being odd, unreliable, and sexually adventurous, and Charles Doolittle dismissed him as a nomad unsuited to his favorite daughter. Pound introduced her to the world of modern literature in ways that Bryn Mawr did not, but she fell apart under all the pressures.

Never a stable person, she could not cope with the emotional strain of devotion to two men who disliked each other. Her grades suffered, she dropped out of Bryn Mawr in 1906, and in desperation she turned for comfort to a woman friend, Frances Gregg. For a time, all was perhaps innocent even by the standards of the day, but relationships evolved rather quickly. Doolittle might have been a Moravian and a puritan, but Pound was a Troubadour, eager for love and romance wherever he could find it. Hilda was soon in love with both Ezra and Frances; Ezra was in love with both of them. Hilda's fiancé, as Frances recorded in her diary, was also the man who gave Frances her first kiss.[13]

In the midst of Pound's crisis at Wabash, Doolittle wrote to her other devoted admirer, Billy Williams, summing up clearly her emotional situation. "I am, as you perhaps realize, more in sympathy with the odd & lonely—with those people that feel themselves apart from the whole—that are somehow lost and torn and inclined to become embittered by that very loneliness . . ." A good Moravian did not think first of herself, but of her first love. "In the meantime, perhaps I am not all together without use in devoting my life and love to one who had been, beyond all others torn & lonely—and ready to crucify himself yet more for the sake of helping all—I mean that I have promised to marry Ezra . . ." She hoped that she would remain "to you as the very dear friend that you are to me. If I am not that & more it will be through no desire of mine—for you are to me, Billy, nearer and dearer than many—than most, I may say whom I call 'friend.' "

Six weeks later, however, she was obviously lonely, missing Pound, and finding home close to intolerable. She told Williams she would do almost anything to get abroad. "Die Wander-lust is upon me! I would scrub floors to get abroad—you know the feeling." Meanwhile, good student of Pound that she was, she consoled herself by "soaking" in Browning. She also thought about writing more and more seriously, and by 1910 was writing her first significant verse, modeled on works of Theocritus which Pound had given her. He returned that year for a brief visit, they met, renewed their engagement, and he persuaded her to follow him back to London. She went, and only after she settled in and met Pound's exciting circle of friends did she discover that he was also engaged to Dorothy Shakespear.[14]

III

The third member of the little group of young poets in the Philadelphia area, William Carlos Williams enrolled in the University of Pennsylvania Medical School in 1902 at the age of only nineteen, fresh out of high school. One of his roommates had a grand piano, so large it seemed impossible that it was in his room at all; Williams had brought his violin along, and the two almost immediately began to play together. Williams was lonely, homesick, and eager for companionship,

and in talking to his new friend mentioned his interest in writing. The pianist immediately mentioned "a guy in our class" who had been "questioning everything that the prof says," making "quite a commotion," and getting the whole class "interested." That sounded promising, and Williams indicated that he would be happy to meet the fellow. As eager as he was to find a kindred spirit, Ezra Pound came around that afternoon and found that while Williams did not really claim to be a writer he was indeed keeping a journal and was apparently trilingual, which seemed impressive. Pound was then only seventeen, still beardless, but he "had a beautifully heavy head of blond hair of which he was tremendously proud. Leonine. It was really very beautiful hair, wavy. And he held his head high." They became "fast friends," and Williams recalled later Pound's seeming ability to "talk forever, always with his twitch and his cough which is characteristic of him, out of sheer embarrassment, because he was always forcing his opinion." Through Pound he soon met Hilda Doolittle, and fell half in love with her, to Pound's irritation.[15]

Williams came from a background that seemed designed to make him feel left out of things American. His mother's family had been living in the West Indies for at least three generations. Roman Catholics from Bordeaux on one side, they were liqueur merchants in St. Pierre until Mt. Pelée erupted in 1902, destroying business and family in one catastrophe. On the other side, the family was Sephardic Jewish, Dutch in origin, successful merchants in Mayagüez. Williams' mother thus grew up speaking French, some Spanish, and only the most broken kind of English, in a home that was financially comfortable and given over, at least in her memories, to the arts. Even in old age, she could recall the details of the time when Louis Moreau Gottschalk came to play in their home, or when a young Adelina Patti came to sing, "flying about and call[ing] my father Uncle." She herself played the piano, her elder brother Carlos played the flute; and although her father died when she was only eight, she never forgot his ability to dance. By 1876, she was an orphan dependent on her brother, but he was a successful doctor and able to finance a period of study for her in Paris. There, for several years in her late twenties, she made creditable progress as an academic painter. But the money ran out, Elena Hoheb had to come home, and when a friend of her brother's began to court her seriously she accepted the proposal and soon found herself in, of all places, Rutherford, New Jersey. She complained, often bitterly, about her lost opportunities and her having to live in an alien land. But her son remained fascinated, if also exasperated, with her throughout her long life, and in a letter of 1923 told her: "Perhaps the greatest gift you have given me is your dissatisfaction with life. You have been bitten by disappointment and it has been felt by your children as well as yourself. This has not been a misfortune to me at least. It has kept me continually on the alert for something unearthly, something I want very

much and, now that I am getting a little sense, something I know that I can get and have every day—if I am able." [16]

The man Elena Hoheb married was almost equally exotic in a suburban American context. William George Williams appears cryptically in his son's autobiography as "an Englishman who lived in America all his adult years and never became a citizen" because he found it more convenient to travel in South America with British than with American documents. But in fact an air of mystery always hung over his family history. No one knew who William George's father was, and although the poet's grandmother, whose name by then was Emily Dickinson Wellcome, was readily available for all sorts of questions from the young, she refused ever to talk about such things. All that seemed to survive was the knowledge that when William George was about five his father disappeared and his mother began her travels. In time she landed in a Brooklyn boarding house, hoping to become an actress. Instead, she met a photographer from St. Thomas named George Wellcome, married him, and took her son with her to the West Indies. Widowed in 1874, she returned to the New York area when her son married. As advertising manager for Lanman and Kemp, manufacturers of a popular cologne named Florida Water, William George often went on lengthy journeys throughout Latin America, where he oversaw the establishment of branch offices for the company. Quiet and civilized, he sometimes seemed absent even when he was present, allowing the house to be dominated by his wife and especially his mother. [17]

The Williams family were thus not typical residents of Rutherford. Outwardly devoted to commerce, founders of the local Unitarian Church, comfortable in their economic circumstances, they could have merged silently with the great middle class of their adopted country. In many ways they did, and in none more obvious than William Carlos' lifelong devotion to medicine, a profession not notable for non-conformity. Yet behind the facade, things felt very different. Elena may have joined her husband by converting to the Unitarian Church, but she was in private a practicing medium, given to alarming trances and the reception of messages from the dead. Grandma Wellcome shared this tendency; she became a Christian Scientist. Uncle Godwin went certifiably insane and was eventually institutionalized.

The house itself was often full of visitors, friends, and relatives from Paris and the West Indies, and the poet felt for life a special affinity for Spanish because he heard so much of it at home. The absent father added a special spice to things. He brought back tales of disease and exotic food from his travels, and amused his bored wife by reading to her of the Paris she longed for—as in du Maurier's *Trilby,* which the poet remembered listening to secretly from his bed, his parents thinking him safely asleep. So great was the impact that he even named his pet white mice after its characters: "Trilby, pure white, and Little Billee, a black head and white and black body." But above all, there was

the theater. William George loved Shakespeare and the theater gener-
ally. He was a key figure in the local Gilbert & Sullivan society, and was
so enthusiastic about their work that he put up a stage in the family
cellar and supervised his sons, the poet and brother Edgar, in *The Mi-
kado* and *H.M.S. Pinafore*. William Carlos was smitten for life. Even in
old age, he recalled fondly his time in the Mask and Wig Club in Penn-
sylvania, and his momentarily toying with the idea of giving up medi-
cine entirely in order to write plays, or even to be "a scene shifter."[18]

As a serious-minded medical student, Williams had plenty to do at
Pennsylvania; he was also priggish and moralistic, tormented both by
his sexuality and his disapproval of any overt expression of his im-
pulses. With his rather flamboyant mannerisms, Pound offered him both
friendship and a model for aesthetic rebellion. While Williams filled his
notebooks with bad imitations of Keats, Pound wrote daily sonnets—
destroyed at the end of the year—and assimilated the pioneers of re-
cent British verse: Browning, Swinburne, and even Yeats, who came
through Philadelphia and read his works in 1903. Pound shared his
friend's affection for theater, and Williams never forgot the senior class
performance of *Iphigenia in Aulis,* in Greek, at the Philadelphia Acad-
emy of Music. Pound was one of the women in the chorus, "the focus
of attention," "dressed in a Grecian robe," "a togalike ensemble topped
by a great blond wig at which he tore as he waved his arms about and
heaved his massive breasts in ecstasies of extreme emotion."

Williams also felt at home with Homer and Isabel Pound, informing
his mother in early 1904 that they were "very nice people and have
always been exceptionally kind to me." He informed Elena that Pound
was "a fine fellow," "the essence of optimism," with "a cast-iron faith
that is something to admire." Yet he noted that "not one person in a
thousand likes him" because "he is so darned full of conceits and affec-
tations." Williams assured his mother that his friend was "a brilliant
talker and thinker but delights in making himself just exactly what he
is not: a laughing boor." Even with great patience friends had trouble
knowing him, and if he suspected that someone was probing his pri-
vacy, Pound would "immediately put on some artificial mood and be
really unbearable." This was a shame, for Pound wanted very much to
be liked, "yet there is some quality in him which makes him too proud
to try to please people. I am sure his only fault is an exaggeration of a
trait that in itself is good and in every way admirable." In an assessment
remarkably acute, Williams concluded: "He is afraid of being taken in
if he trusts his really tender heart to mercies of a cruel crowd and so
keeps it hidden and trusts no one."[19]

Hilda Doolittle was more of a problem: Williams admitted that he
found it next to impossible to be just friends with an attractive woman.
But he tried, wavering between love and friendship. He occasionally
visited the Doolittle home, where Mr. Doolittle and his young second
wife tried to maintain an atmosphere suitable to academic astronomy.

"A tall gaunt man who seldom even at table focused upon anything nearer, literally, than the moon," the professor rarely seemed to look at anyone, seldom spoke, and even when he did try to communicate, usually stared over everyone's head until he had finished and seemed scarcely to expect any reply. Such was his devotion to his work that toward dawn, after long January nights, his wife "would go out with a kettle of boiling water to thaw the hairs of his whiskers that during his night-long vigil had become frozen to the eyepiece of the machine."

But Hilda was something else. One night in the spring of 1905, a group of young people got together, five men and five women. The ladies were "a deuced of an intellectual bunch," not good looking or even pretty, he wrote his brother, "but they are all pleasant to look upon because they are so nice." Hilda caught his eye immediately. "She is tall, about as tall as I am, young, about eighteen and, well, not round and willowy, but rather bony, no that doesn't express it, just a little clumsy but all to the mustard." She was "full of fun, bright, but never telling you all she knows, doesn't care if her hair is a little mussed, and wears good solid shoes. She is frank and loves music and flowers and I got along with her pretty well." She was "a fine girl, no simple nonsense about her, no false modesty and all that, she is absolutely free and innocent. We talked of the finest things: of Shakespeare, of flowers, trees, books & pictures and meanwhile climbed fences and walked through woods . . ."

But Doolittle had a streak of strangeness in her that Williams could never quite cope with; he needed a mate who would calm and stabilize him, not exacerbate his erratic tendencies. He discovered how extreme her behavior could be one day on the Jersey shore, where he, Pound and several other friends gathered for a party. At one point, she had put on her bathing costume, and, ignoring a storm and heavy breakers, had become entranced with the natural spectacle before her. Without a thought for the dangerous realities involved, she simply went out to meet the waves: the first knocked her down, and the second drew her into the undertow. One of the men there was a powerful swimmer and he managed to get her out. She was unconscious and nearly drowned, but survived to write poetry and behave oddly for many more years. The party symbolized the end of college relationships: "We never met as a group thereafter."[20]

At this point, the paths of the Philadelphia modernists began to diverge; differences in behavior and attitude that the common life of college had masked, began to appear. Williams kept in touch with Doolittle for a while, but without her physical presence to stimulate his interest, he found he had less and less to say to her; their few later contacts were unimportant. With Pound, Williams maintained an erratic epistolary relationship for many years—a relationship possible largely because the two saw each other so infrequently that they hardly had the opportunity to quarrel. Pound did favors for Williams in the

way he did for many other young poets before World War I, and the two traded ideas occasionally, but Pound's political development in Italy after 1925 made close relations impossible, even though the letters continued.

In the long view, what separated Williams the most from his two closest literary friends was neither geography nor personality, but profession. As he recalled in his autobiography, Williams had to make two key choices in this period of his life. The first "concerned itself with which art I was to practice." Music was out, for he was not good enough; he also wanted "something more articulate." He found painting "fine, but messy, cumbersome." Sculpture did not appeal much: "I once looked at a stone and preferred it the way it was." As for dance, "Nothing doing, legs too crooked." For some reason he did not mention the drama, which elsewhere appeared as a major interest. But writing appealed to him, and perhaps he implicitly included drama under that category. "Words offered themselves and I jumped at them. To write, like Shakespeare!" The second choice was whether to continue with a profession or to try to live by writing. In his heart he knew that he could never adjust to the requirements of the marketplace. Pound fumed about money for the next fifty years; Doolittle had a private income. Williams became a doctor: "But it was money that finally decided me. I would continue medicine, for I was determined to be a poet; only medicine, a job I enjoyed, would make it possible for me to live and write as I wanted to."[21]

Once made, the decision had enormous consequences. Many leading modernists lacked jobs or professional qualifications, preferring to retain their freedom to write, travel, and enjoy themselves. But unless they inherited money, married well, or were extremely lucky in their royalty statements, such an existence implied poverty, frustration, and the neuroses that developed with too much freedom. The human mind could stand only so much free time, and without the demands of some job external to self and typewriter, artists all too frequently devoted their writing time to alcohol, drugs, odd religions, and absurd feuds. By choosing medicine, Williams also chose to remain for life in one place, to restrict his opportunities to travel, and to truncate his writing time. He could meet only those few artists who lived near New York City, and absorb aesthetic ideas only while in a state of exhaustion, resting between office and hospital. In time, it meant that he had to cope directly with America, with Paterson nearby to Rutherford, with the objects and demands of daily life. Nothing was quite so real as a broken bone or a diseased baby. The same temperament that led him to medicine, to this basic daily encounter with life and death at its least "poetic," chose a life that all but dictated an aesthetic of the object.

Williams managed only two trips to Europe before the mid-1920s. The first of these, about a year and one-half in 1897–99, was as a schoolboy, attending the Château de Lancy near Geneva with his brother,

while his father was on one of his extended trips to Latin America. Williams claimed to have met students from a dozen nations including a "particular pal" from India, but little resulted from the experience. Because the language situation was polyglot, the operative language at the school was usually English, and so even though Williams subsequently had several months in Paris he never achieved fluency in French or felt comfortable in French culture. In 1909–10, he studied pediatrics in Leipzig for half a year, and then traveled extensively throughout Western Europe and London. The experience had little scientific value: Williams knew little German when he started out, and he hardly studied long enough to profit from technical medical lectures. Besides, although he admired the Germans for certain bourgeois virtues, he basically disliked them, finding them dull, conventional, and unspontaneous. Instead, he took a course in modern British drama at the university—from an American!—went to Ibsen plays, and Richard Strauss' *Elektra*. He let his hair grow and sprouted a moustache, but went back to his customary appearance when he left on his travels. A week with Pound in Kensington on the way home was the core of his British experience. He heard Yeats read and watched in bemusement some of his old friend's European and bohemian affectations, but the scene did not appeal to him. He wanted to get back to America and go to work, knowing he could learn as much about poetry out of Pound from long distance as he could in his company. Yeats, after all, was not the sort of modernist that a sensible American doctor could ever do much with.[22]

Williams presents the curious case of an artist whose principles were developing ahead of his practice. His own poems from the years before the war deserved no immortality; they ignored reality and were hopelessly derivative in form and content. Yet in his informal way, Williams was already developing his own American modernism. Lack of contact with Pound and London probably slowed him down for the short term, but increased his genuine originality over the long. Already integrating the world and the word in his medical life, he had found a new sense for the meaning of the word "new." To Pound, it seemed to mean something literary, quite apart from life, as in new forms, new cadences, new images. But Williams was an instinctive Jamesian without ever having been familiar with the work of William James. New to him meant "fresh," an experience life supplied the poet directly. The newness of form, cadence, or the image might follow, but experience in all cases generated it; it did not impose itself on experience.

Williams had also developed a concept of pure experience that expressed his own personal need to integrate work and world, object and concept. Never much of a formal aesthetician, he nevertheless by 1913 was arguing gently but firmly with Harriet Monroe about life, poetry, and the modern: "Now life is above all things else at any moment subversive of life as it was the moment before—always new, irregular. Verse

to be alive must have infused into it something of the same order, some tincture of disestablishment, something in the nature of an impalpable revolution, an ethereal reversal, let me say." An editor like herself should not meddle with the verse of poets like himself, for that violates the integrity of both poet and experience, as summed up in the poetry. What might seem obscure to her might actually be fresh, a new way of speaking that went beyond conventional grammatical presumptions. Obscurity itself might well be part of the point: "To directly denote the content of a piece is, to my mind, to put an obstacle of words in the way of the picture. Isn't it better in imaginative work to imply war in heaven, for instance, by saying, 'Peace on Earth,' than it would be to say it flat out, 'War in Heaven'?"

His poetry began to change in a major way. Instead of the older conventions, he began to develop his own, based on colloquial speech and everyday subject matter. "I had to start with rhyme because Keats was my master, but from the first I used rhyme independently. I found I couldn't say what I had to say in rhyme. It got in my way." He experimented with Whitman, but that did not work very well either. "With Whitman, I decided rhyme belonged to another age; it didn't matter; it was not important at all." He finally settled on the concept of the rhythmic unit. "The rhythmic unit decided the form of my poetry. When I came to the end of rhythmic unit (not necessarily a sentence) I ended the line." [23]

CHAPTER 2

Chicago

In contrast to Philadelphia, where modernists discovered their work and each other most often within educational institutions, in Chicago they found only the most marginal institutions helpful. Chicago modernism had only three outlets: the *Friday Literary Review*, *Poetry*, and the *Little Review*. The first paid its contributors in books and its staff scarcely a subsistence wage; the second paid nominal sums for contributions and relied chiefly on subsidies for capital; and the third became something of a legend even in bohemia for its fiscal marginality. In Chicago, an artist needed commissions, an outside job, or a rich mate.

Chicago was primarily a city of prose; even its best poetry qualifies. Chicago was meat, railroads, and grain; it was banks, skyscrapers, and brokerage houses. It also had a wealthy class as yet unaccustomed to wealth; such people were aware of churches as objects of charity and were discovering educational institutions, museums, the Art Institute, and the Symphony. But only rarely and nervously did they show much interest in anything new, or in the artists capable of creating it. Wealth normally required death and inheritance before it fertilized the arts, and even then it preferred a German accent or a French diploma. Where Chicago did excel was in architecture, but the architects involved were progressive or conservative, not modernist.[1]

Conventional treatments of Chicago literary life lump writers together in unfortunate yet illuminating ways. Chicago did have a brief outburst of activity that many participants and their chroniclers have called a "renaissance," and those involved usually knew each other and shared tastes in literature as well as lifestyle. Most of this activity was in no definable way modernist: it was often surprisingly conservative in its sense of form, progressive in its quest for moral reform and democratic expression, and quaintly romantic in its rediscovery of the pangs of adolescent self-discovery. Even those who praised European modernist work found it impossible to write anything comparable. What Chicago did for modernist impulses was give them room to grow and opportunities to appear in print, even though full maturity sometimes had to find outlets elsewhere; and the city supplied opportunities, even before Greenwich Village in New York, for certain themes of modern-

ism to emerge: above all that of free sexual expression and its relation-
ships to psychotherapy and the unconscious.[2]

II

The *Friday Literary Review* was a supplement to the *Chicago Evening Post*
that first appeared on 5 March 1909. Its editor was Francis Hackett, an
emigré from Ireland whose overriding concerns at the time were di-
vided about equally between a hatred for the Roman Catholic Church
and a hatred for the British Empire. In politics, he was a liberal, but
he maintained an interest in things modernist whenever they touched
Irish letters; if Maurice Browne, the Englishman who ran the Little
Theater, put on a Yeats play, Hackett was there. He maintained good
contacts with New York lawyer and collector John Quinn, the most
eminent supporter of James Joyce in America, and the man Ezra Pound
called on frequently to bail out impoverished geniuses. For office assis-
tant, Hackett chose a very young Floyd Dell, elevating him after a year
to "Associate Editor." When Hackett left Chicago, Dell took over, the
first issue under his full authority appearing 28 July 1911. For slightly
over two years, until September 1913, Dell presided over the most ex-
citing place for a writer to be in the Midwest. In effect, his home and
office constituted an informal salon for the cultivation of contemporary
artistic values.[3]

The core of the group came from Davenport, Iowa. It included George
Cram Cook and his third wife, Susan Glaspell, and the various friends,
lovers, and former lovers they and Dell had accumulated during ado-
lescences that threatened to become permanent. Discussing each other
in all-night gatherings, reading and writing about each other's work,
they were by the 1920s publishing both autobiography and fiction that
made these years into bohemian legend. The most garrulous of the lot,
Dell was convinced that his every sexual palpitation was worthy of
analysis, and that whatever he wrote had a modern edge. Neither his
sexual nor his literary achievements were all that central; but they were
symptomatic. What was unusual was his willingness to present his life
in public, to display his experiments to a world that, for a brief time,
almost took him at his word.

The picture of Davenport that emerges from the autobiography,
Homecoming (1933), and Dell's novel, *Moon-Calf* (1920), is that of a city
with a large German and significant Jewish population that produced
an unusual cosmopolitanism. "It had an intelligentsia, who knew books
and ideas. It had even some live authors . . ." Dell was never one for
real squalor or disorder, but he discovered in Davenport a bohemia of
a sort somewhat different from that which Henri Murger had por-
trayed in Paris. "The Bohemian world of Murger did not please me; it
was too pathetic—people were always dying in those garrets, and dying
without an idea in their silly heads." The bohemia he approved "was

the one seen for a moment in every history of Parisian revolutionary uprisings, in which Bohemian students fought and died behind barricades in each crisis of liberty." He thought of himself as a committed socialist and insisted on the compatibility of a freer lifestyle with radical social change. The working people he met at socialist gatherings were "all rather middle-class in their ways of life," and felt no affinities for the "disorderly, pig-sty, lunatic Bohemianism" of literary legend. Dell was an easy convert. He read Gronlund's *Cooperative Commonwealth* and the works of Robert Ingersoll, sampled Marx and Haeckel, declared himself a Monist and an Atheist. Such intellectual restlessness was hardly typical of Davenport, but it was not that unusual, either.[4]

Dell had come from a respectable but downwardly mobile family that never recovered from the Panic of '73. His father, once an independent butcher, was often unemployed, and his siblings had few prospects. But his mother was determined on something better for her dreamy fourth son, and she encouraged his esthetic and intellectual efforts. Local librarians helped guide his reading, and teachers encouraged him to write stories even in high school. Unlike most budding American modernists, Dell liked the works of Poe and imitated them in juvenilia. Indeed, he read whatever he could find, sopping up romance and realism with equal avidity. He even claimed later that the Mark Twain of *The Prince and the Pauper* laid the most important foundation for his conversion to socialism. Dropping out of high school, Dell worked in a candy factory and was soon friendly with several workers; a mailman introduced him to socialism. One crucial figure in his growth was Rabbi William Fineshriber, whose home and synagogue were centers of new ideas. Dell thought so highly of him that, when he married Margery Currey, he asked the Rabbi to perform the ceremony even though neither spouse was Jewish.

One of the more useful chroniclers of midwestern cultural activities, Harry Hansen first heard of Dell as a precocious high school student already peddling verse to *McClure's Magazine* and deeply into socialism. In those days, Dell was "a slight, diffident lad, who walked as if he were treading on eggs and who smiled faintly and deferentially at whatever was said, especially when he did not believe it"; he was perfectly capable of leading a serious discussion on whether the chicken or the egg came first. Dell "was a lean lad with a bit of fuzz on his cheeks; rather negligent of his clothes and somewhat diffident in his manner; unobtrusive in a group, with a sort of smile which might be half interest, half disdain." Yet he was a wonderfully fluent talker, going on and on about philosophers, poets and writers few had heard of. "Nobody really understood the boy save for the few kindred souls he had enshrined in *Moon-Calf*," and "when they called him a socialist they felt they had accounted for any eccentricities he might possess."[5]

For a brief time, Jig Cook was Dell's most important friend. Cook was then living, Dell recalled, in "the gardener's cottage on the family

estate," supporting his writing "by chicken-raising and truck-farming, to the chagrin of his young wife and the scandal of local respectable society." Cook was trying to pioneer new ideas by an obsessive concern with the past. He was concerned with all pasts, Susan Glaspell wrote, his past, the past of his family, the region, and even the Indians who had been there first. "He loved all things that record time," she said, and this "emotion about time molded his life." Most of all he was obsessed with the past of Greece; he studied Greece at Harvard, he read its literature whenever he could, and attended Greek plays. A man of religious cast of mind, he was into ecstasy: in sex, alcohol, literature, and God. He devoured *The Birth of Tragedy* and claimed to be a Nietzschean until Dell converted him to socialism. Always unstable, Cook suffered periods of depression that made writing and human relations both difficult. As Dell noted sadly: "Seer more than artist, he had never been fully articulate either in his novels or in his plays, despite the grandeur of their conceptions; meanwhile his creative energies spilled over in talk so luminous and profound, in friendships so stimulating, that they conveyed to all who knew him an impression of true greatness far exceeding his tangible achievements." Jig's mother marveled at the relationship of the aging, heavy-set Cook, with his Harvard and European education and presumptive genius, to the slight, faun-like, and uneducated Dell: "Jig and Floyd—it's like a St. Bernard following a little terrier around."

Jig's "respectable" marriage ended among the chicken coops and he remarried an anarchist, Mollie Price. A dancer who also wrote for Emma Goldman's *Mother Earth*, Mollie adored her much older husband, even as she befriended Dell and seemed more appropriate for his company than Cook's. Dell thus watched with audible disapproval as Cook's second marriage fell apart and Cook took up with Susan Glaspell, leaving Mollie pregnant with their second child. He went to Chicago to get away from the mess, and on 14 April 1913 married Glaspell. That marriage lasted, although he solaced himself with poet Eunice Tietjens, photographer Marjorie Jones, and others along the way. Cook soon moved to New York for his winters and Provincetown for his summers, and he and Glaspell won fame with the Provincetown Players. In time that palled, and Cook's basic incompetence at practically everything won out. The couple went off to Greece and played the parts of pilgrims to classicism. Their lives there, in their combination of squalor and aimlessness, deserve to be the subjects of musical comedy rather than history. He died ingloriously early in 1924; the bite of his pet dog infected him with glanders, a disease that virtually never affects people.[6]

Glaspell was more substantial. The child of a family of largely New England background, like so many in early Iowa history, she rebelled against its conventional prescriptions to write novels, plays, and stories that attracted attention. Like so many in the circle she eventually joined, she thought of herself as being on the left, yet was apolitical. Self-

effacing, idealistic, sentimental, she depended on men; not for her the feminism of some in her generation. She paid the price by falling in love with a handsome, passionate, and unreliable "genius." As critics have noted, she had good autobiographical reasons for constructing certain of her plays around a character who never appears. As Dell summed her up: "Susan was a slight, gentle, sweet, whimsically humorous girl, a little ethereal in appearance, but evidently a person of great energy, and brimful of talent; but, we agreed, too medieval-romantic in her views of life."[7]

Through Mollie Price, Dell was soon in contact with anarchist journals in New York. Anarchists like socialists were all for free love in a more open world, and Dell soon had an enthusiastic letter from Alexander Berkman—addressed to "Miss Floyd Dell." At the same time, he was voting for Eugene Debs and cooperating with social settlement workers in Chicago. Political lines being so fluid, Dell saw nothing odd in staying with Graham Taylor at The Commons when he moved to Chicago, or in teaching a literature class at Hull-House. But such political connections soon palled; Dell had neither mind nor temperament for politics detached from literature. Anarchists, nihilists, atheists, and socialists all soon bored him and he turned his attention to writing.

The reviews Dell wrote in Chicago displayed not the taste of a nascent modernist, but the whims of a hungry boy before a smorgasbord, hostile to restraining parents and chewing more than he could digest. Like many who identified with modernity, he gloried in the new for its own sake, without seeming to see meaningful patterns of creative activity. He knew he was hostile to convention and gentility, thus conflating literary and sexual issues, but had no real knowledge of modernist form. In certain moods he was a decadent, looking back to Pater, Swinburne, Fitzgerald, or Symons for exquisite moments and gemlike flames; more frequently he was Edwardian, using the hortatory tones of Chesterton, Wells, or Shaw to mark obvious ironies and make moral points. He seemed at his most modern in paying attention to Gertrude Stein, which he did on rare occasions, or in his admiration of Ezra Pound, as when he greeted *Provença* in a way that pleased its temperamental author. Even here, though, the Pound poems under consideration were hardly among his more difficult, and extra-literary issues probably played some role. Lucian Cary, one of Dell's closest friends in Chicago, had been on the Wabash College faculty at the time of Pound's unfortunate experience there; he had told Dell of the events and they formed the basis of a Dell short story.[8]

Dell, indeed, displayed an unmodernist preference for life over art. As his visits to The Commons and Hull-House indicated, he was into reform; he did not worry about corrupt politicians or dangerous drainage systems, but he did want to change attitudes. Those which concerned him the most were sexual, and so he displaced personal concerns onto public issues, meditating on women who were socialists,

anarchists, designers of utopias, or reform journalists. The chief fruit
of these concerns was *Women as World Builders* (1913), which examined
Charlotte Perkins Gilman, Jane Addams, Beatrice Webb, Emma Gold-
man, Ellen Key and others who were demanding more enlightened
attitudes. At the same time, Dell and Margery Currey tried to provide
a living example of the ideal family unit of the future. Supported by
his writing and her school teaching, they lived together but kept sepa-
rate studios; hers became the salon for artists in the 57th Street area.
Currey was the person who kept the parties going administratively and
gastronomically; he verbally remade the world. This pattern, of com-
petent, energetic women supporting socially backward, underfinanced,
verbally fluent men, repeated itself in Greenwich Village and Paris in
short order.

The men were good at writing things down. In a letter of May 1913,
Dell described his own bohemia to an old Davenport friend. It was
11:30 P.M., and he had just returned from seeing Lucian Cary and his
wife, "to my ice-cold studio, where I have built a fire with scraps of
linoleum, a piece of wainscoting, and the contents of an elaborate filing
system of four years creation," he wrote Arthur Davison Ficke. "I am
writing at a desk spattered with Kalsomine, and lighted by four can-
dles." His room contained "one bookcase and nine Fels-Naptha soap-
boxes—full of books—counting the one full of books I am giving away
to get rid of them—a typewriter stand, a fireless cooker, a patent coat
and trousers hanger, and a couch with a mattress and a blanket." Every
night he rolled himself into the blanket and slept until his cold shoul-
ders and the early morning daylight woke him up, at which point he
rewrapped himself and slept until 8:00. He then got up, went to the
faucet which was the only plumbing in the building, took "a sketchy
bath" and went out for breakfast. "In the window seat, along with my
shirts, is a great bundle, containing a magnificent and very expensive
bolt of beautiful cloth, for curtains for the windows." If he could ever
get that and his new suit paid for, "I shall give a party, and you shall
come and see the combination of luxury and asceticism which will be
the charm of my studio. At present its only luxury consists in that same
asceticism." He might face frustrations at the office, but always found
"balm" for them at home. "After next Wednesday I shall sit at this desk
and produce literature. Never was place so provocative of expression."[9]

Such descriptions are more than historical wallpaper. Too much lit-
erary history has text speaking to text in a contextual vacuum, a situa-
tion which the human incapacity ever to recall party conversation clearly
has exacerbated. What the Dell-Currey salon did was to bring people
together who otherwise might never have met, to encourage them to
voice their fears and aspirations, and to make them realize they were
not alone in their battles for artistic expression. This need for mutual
moral support lay behind the glowing if vague memories of one of the
most eminent of the visitors. "We were all following, or we hoped we

were following, the same path. We were devotees of the arts," Sherwood Anderson wrote in his unfinished memoirs. "Oh what talks we had, what walks in city streets at night, what gatherings in rooms, what attempts to find, in the huge undisciplined city, little nooks, quiet places, little restaurants where the food was cheap and unusual, where we could sit, as we imagined it might be in some old world city, hearing some strange language spoken by dark heavily built men with beards or huge mustaches who sat over their food and drink." Everyone was in the same boat. "None of us had any money and we were all working at jobs. We wrote advertisements, we worked on newspapers, clerked in stores or offices, all of us determined that what we were doing, to earn a little money for room rent, for laundry bills, for food, to buy, in the fall, an overcoat, socks, neckties, suits of clothes, etc.—this, we hoped, but a temporary matter." "Oh, for freedom," they kept saying to each other.

Nor did these gatherings stop at the social. All his life, Anderson faced the charge of critics that he had read Freud and was embodying psychoanalytic ideas in his characters. All he had really done was stay alert in a stimulating bohemia. "We were in fact wallowing in boldness. At the time Freud had just been discovered and all the young intellectuals were busy analyzing each other and everyone they met. Floyd Dell was hot at it." Anderson had not read Freud and refused to do so, but felt rather ashamed of himself about the issue. Dell walked about the rooms conversing brilliantly. "I had never before heard such talk. How it flowed from him. What vast fields of literature he covered. He became excited. He shouted. The intense little figure became more and more erect." Both Dell and his friends were into "psyching" each other, not to mention folk passing in the street. "It was a time when it was well for a man to be somewhat guarded in the remarks he made, what he did with his hands." [10]

In such a context, the superficiality of Dell's written work became irrelevant. In addition to Anderson, his group contained Theodore Dreiser, Jig Cook, Susan Glaspell, and such lesser-known figures as poets Edna Kenton, Eunice Tietjens, Witter Bynner, Harriet Monroe and Alfred Kreymborg, and novelist Ben Hecht. Occasional foreign visitors, such as John Cowper Powys, sometimes joined in. It is difficult to avoid the conclusion that many modernist ideas spread because intelligent people were talking to each other.

III

The world of *Poetry* was very different. No one who knew Harriet Monroe could imagine her living in bohemia, availing herself of free love, or psyching party guests. In her own writings and personal taste, she was even less a modernist than Dell. Tiny, temperamental, prickly but warm-hearted, she seemed to the young Eunice Tietjens "somewhat

austere" and hard to know. But, largely through good advice and the accidents of a quirky taste, she provided more modernist poets an outlet than any other editor.

She was from an older generation. Having been born in 1860, she was fiftyish when the renaissance began; the daughter of a prominent lawyer, "finished" in an exclusive convent school, she was an underfinanced member of the upper class in Chicago, making what money she needed by journalism, teaching, and lecturing. The sister-in-law of architect John Wellborn Root, she was the author of architectural criticism which won the admiration of no less than Louis Sullivan, the teacher and role model of Frank Lloyd Wright. Acquainted socially with some of the writers of the *Friday Literary Review*, she agreed with them as well on the realistic goals that modern art should have. Disliking the false sentimentality and detachment of late nineteenth-century verse, she wanted a poetry that expressed modern life. Frustrated in her own attempts to publish, she became increasingly aware of how few publications welcomed verse that was in any way out of the ordinary. *Poetry* was her response. Circularizing possible donors in April 1912, she pointed out that virtually all volumes of poetry required subsidies from their authors, that most magazine editors would accept no verse longer than twenty to thirty lines, that levels of payment were inadequate to sustain life or art, and that critics and buyers paid next to no attention when a book did come out.

Monroe was energetic, persistent, and lucky. She raised the money she needed from members of her own social circle, acquired a sensible assistant in Alice Corbin Henderson, signed up Ezra Pound as her foreign correspondent, and for several years published an extraordinary number of significant poems. The wife of painter William Penhallow Henderson, Alice was "small, crisp, and incisive, full of an enduring energy in spite of a frail physique," and much of the openness to new work at *Poetry* was "due to her," remembered Tietjens, who joined the staff after about a year and remained for decades. As long as Monroe and Henderson worked together and kept Pound pacified, things went well; but Henderson came down with tuberculosis and in 1916 she moved permanently to Santa Fé. Her letters kept coming in and she retained some influence; but Pound exploded, and Monroe proved too uncertain in taste to edit a distinguished journal on her own.[11]

Monroe had originally approached Pound because she liked his earliest work; she cared less for his work after 1915, and felt blankly puzzled when she read the Ur-Cantos. She did not care for the work of Tom Eliot. She responded most enthusiastically to the progressive poets, especially Vachel Lindsay. Even in the 1930s, she referred to Lindsay as "perhaps the most gifted and original poet we ever printed." She was even uncertain about the work of Robert Frost. To Pound's indignation, Henderson had turned down a Frost contribution unaware of its connection to their new London correspondent, and as Pound in-

sisted later with only some exaggeration, "I hammered his stuff into *Poetry*." Relations were soon more amicable and Frost was writing friendly letters from New Hampshire. One, indeed, pointed up the way Frost too was growing skeptical of modernity in verse. "I don't really feel as if I had got anywhere with it even helped as I have been by wifely counsel," he wrote wryly about the Ur-Cantos in March 1917. "There's stir in the poem of the Poundian kind and I can't say that I don't like it. But it leaves me partially baffled." He chalked some of the obscurity up to Browning's influence. "I grant him the Sordello form. I suppose the meaning is meant just to elude you going out as you came in." Such meanings which were hard to pin down were among "the resources of poetry, or so I have always held." He truly loved some obscure works, and claimed on balance to "more than half like the poem: I trust I make that clear. I'd be half inclined to publish and let the public be damned. Them's *my* sentiments." She did, but she needed coaxing.[12]

Such matters were not meaningless squabble. Monroe's sense of propriety was strong, and she did not want to offend members of her social class or possible contributors. She found the language in a few of Pound's contributions vulgar and offensive, and advised him to get out of doors more often and get away from the tiresome adulteries of English literary life. At a few of her corrections Pound was genuinely puzzled; he must surely have anticipated trouble with his work, but not all that he received, and her attempts to keep criticism of Christianity muted especially irritated him. He found it almost impossible to control his typewriter when she complained about the work of Eliot, finding it too depressing. They papered over the rifts for a while, but during the summer of 1916 she cut the "bloody" out of Pound's line, "And dine in a bloody cheap restaurant," and deleted a whole line from Eliot's "Mr. Apollinax": "He laughed like an irresponsible foetus," thus ruining the poem. Pound raged, slowly shifting his attentions to the *Little Review* and other journals, while Eliot silently refused to submit anything further.[13]

The poet who gave Monroe the most trouble was Amy Lowell. With her, the problem was not obscenity nor pessimism, and certainly not propriety, but rather Lowell's insistence that her every word was sacred and never in need of editing. Beginning in September 1912, Lowell bombarded Monroe and Henderson with missive after missive, as if in imitation of an imperialist warship subduing an obdurate fortress. A model of patience and tolerance much of the time, especially when dealing with anyone of Lowell's social class, Monroe protested little but held her ground as best she could. Lowell kept her informed of affairs in Boston and London, and even paid a pleasant visit to Chicago. When the printer accidentally dropped a line from a Lowell poem, thus making possible a vulgar interpretation of one of her works, Lowell went into telegraphic paroxysms which did not endear her to anyone. After that, interest in her work, or in her as the self-proclaimed leader of the

Imagist movement, declined. She belittled Pound as best she could, and expressed her indignation that he and Lindsay seemed to be getting more attention than she. The cannonading continued, but she never forced Monroe to capitulate. After all, as Alice Henderson wrote from Santa Fé: "There is only one way to handle Amy, and that is with a pair of tongs." [14]

The pattern that emerges from such a diverse correspondence is that of an earnest, well-meaning woman doing her best in dealing with a contentious collection of poets. They had to realize that Monroe was no modernist and did not pretend to be. She supported genteel experiment, and only Pound's pressure put truly modernist work into *Poetry*. Like her acquaintances Henry James and James Whistler, she was a precursor of modernism, not a pioneer. Perhaps the best indicator of her essential position was not her views of poetry, but her response to the Armory Show as art critic of the *Chicago Tribune*. When she reported on the cubist and futurist work, she could hardly conceal her amusement. The crowd, she reported, was gaping and laughing. "And no wonder, for if these little groups of theorists have any other significance than to increase the gayety of nations your correspondent confesses herself unaware of it." She called attention to the work of Marcel Duchamp, "whose *Nude Descending a Stairway* looks like a pack of brown cards in a nightmare or a dynamited suit of Japanese armor." As for Picabia's "Dance at the Spring," she thought it suggested "a pile of red blocks in an earthquake." She found the work of "Paul Picasso, the cubist leader," only slightly more intelligible, and had "no use for" Matisse. She preferred the productions of Odilon Redon. [15]

IV

When Pound became fed up with Monroe, he turned to Margaret Anderson and her *Little Review*. In doing so, he attached himself to a truly bohemian journal and an editor whose commitment to modernism, from clothes and living circumstances to art and anarchism, was as strong as that of anyone in Chicago. The *Review* achieved fame later for printing the early chapters of *Ulysses*, fighting bravely both moralistic and governmental censorship. It deserves this small immortality, an important part of the cultural history of New York after 1917; but it also deserves mention for its earlier pioneering of modernist art in Chicago.

Margaret Anderson was a born rebel. She rebelled especially against her neurasthenic mother, who frittered her life and her husband's money away on inconsequentials, all the while disapproving of Margaret's reading as likely to cause trouble. Margaret hated bourgeois values, thought Christianity musty, and wanted self-expression above all things. She threw herself into odd jobs, working as clerk in a bookstore or as staff member of the old *Dial;* and she decided that she preferred a life of extremes to one of sobriety. "I am either profligate—or I can be

miserly. I knew if I didn't rush to extremes my heritage would swamp me." She lived in poverty yet splurged once a week on quality chocolates: "Of course I could have bought more and cheaper candy, but the box was handsome and satisfied my hunger for luxury." As for the larger attitude toward her life in Chicago, she was clear: "My attitude during this epoch was: Life is just one ecstasy after another."

Ecstasy came hard. She often rented drab quarters. For the six warmest months of 1915, she lived "a North Shore gypsy life" with her extended family in tents. "We dined together under the evening sky and slept under the stars." Her entire wardrobe consisted of "one blouse, one hat and one blue tailored suit"; she washed the blouse in the lake every second day, remarking that it was made of a material that did not need ironing. She was so pretty that men had trouble denying her, but even women were impressed. Anderson "was as beautiful as Rupert Brooke and as flaming as Inez Milholland," Eunice Tietjens recalled. In her one suit and hat, "under which her blond hair swept like a shining bird's wing, she stood pouring out such a flood of high-spirited enthusiasm that we were all swept after her into some dream of a magazine where Art with a capital A and Beauty with a still bigger B were to reign supreme, where 'Life Itself' was to blossom into some fantastic shape of incredible warmth and vitality."

Like so many other literary confrontations that occurred during the renaissance, the announcement of the start of the *Little Review* came at a party at Margery Currey's studio. Anderson had been depressed and sleepless, she recalled later, about the lack of significant artistic activity. She wanted ecstasy, but no one was saying anything inspirational. People lacked inspiration and outlets both; the lack of one reenforced the lack of the other. She thought that if she had her own magazine, she could "spend my time filling it up with the best conversation the world has to offer." Sure that this was a "marvellous idea," she decided "to do it." She had no money, but cadged enough on her charm to get started. She had no experience, either. Tietjens recalled that when the first galley proofs came to the office, they looked awful to her and she was shocked; "it never occurred to her that she would have to proofread galleys!" [16]

Anderson made no pretence at being an intellectual and disclaimed the role of writer. But she clearly articulated the basic attitudes that most bohemians of the period shared. "I have always felt a horror, a fear and a complete lack of attraction for any group, of any kind, for any purpose," she wrote in the midst of her discussion of the Dell-Currey salon. She made an exception in this case because she liked the atmosphere Currey created and the conversation Dell stimulated. She also appreciated the food, which she often lacked at home. She translated his socialism into a belief that "democracy and individualism were synonymous terms." But she clearly felt more at home with Emma Goldman. After hearing her lecture, Anderson was full of praise. Here

was someone after her own heart, "a whole-hearted idealist—oh, very ideal—with humanity as her personal problem. She hadn't an idea that any decent person doesn't start life with—and end it with for that matter." In person, "Goldman surprised me by being more human than she had seemed on the platform." She proved to be "gay, communicative, tender" in private, although "always grim when distressed." Under her influence, "I became increasingly anarchistic."[17]

V

Among those gathered in Currey's studio to hear Margaret Anderson announce the birth of her journal were the two greatest contributors to Chicago modernism, Theodore Dreiser and Sherwood Anderson (no relation). Dreiser did not impress Margaret. She had praised *Sister Carrie,* but insisted later that "Dreiser was never any good until some exchange of sex magnetism put him at his ease." She had no intention of joining the lengthy list of his conquests, so a relationship was impossible. Besides, "his talk had no flavor for me. . . . Dreiser had no more wit than a cow." She felt more rapport with Sherwood Anderson. "I liked Sherwood—because he, too, was a talker and of a highly special type. He didn't talk ideas—he told stories."[18]

Such impressions, seemingly erratic and even whimsical, nevertheless indicated an intuitive sense of a writer's modernism. Dreiser's role in cultural history was obscure to his friends and remains unclear decades later. His case is instructive. Better than any other important figure, Dreiser demonstrated the roots American modernism had in Darwinism and its literary subsets, realism and naturalism. Dreiser was an archetypal outsider trying to find a language appropriate for describing America. In his family he saw behavior which conventional language could not describe in print; in his reading he found ideas which explained for him the workings of both human nature and capitalism. When he put his observations before the public, he found an immediate response from those with related missions; but he also encountered the hostility of genteel Anglo-Saxons determined to keep the Goths away from the gates. Innocent of any modernist concern with form or linguistic experimentation, Dreiser nevertheless belonged on the ragged edges of modernism for his persistence in writing about sexuality, morality, religion, and science. He was the writer who most effectively spread the word that Christian ethics played no role in the modern world, that cause had no necessary relation to effect, and that life did not mean anything at all.

Such a bleak outlook derived most commonly from European sources, and as his critics persisted in pointing out, Dreiser came from an ethnic background unprecedented in American letters. His father, Johan Paul Dreiser, had fled the Prussian military draft in 1844. From a solidly burgher, Roman Catholic family, he thrived in America as a worker in

woolen mills in Ohio and Indiana. In the freedom of the New World
he could take his wife from a community he would never have encoun-
tered in Germany. Sarah Mary Schänäb was a Moravian farm girl twelve
years younger than Paul, as he was soon calling himself. Her strongly
Mennonite family opposed the marriage but the couple persisted. Thir-
teen children came in monotonous succession; the last ten survived to
adulthood. Such physical and financial burdens caused hardships in a
family dependent on a worker's income, and the marriage was not happy.
Paul proved to be a fanatical Roman Catholic, mercilessly indoctrinat-
ing his children in an old-world way. His wife, warmer, more forgiving
and less dogmatic, often undercut his discipline, hiding the sins of her
children from him or otherwise shielding them from paternal retribu-
tion. Many of the problems were outside the control of either. A seri-
ous accident which Paul suffered in 1866 may have caused long-term
mental and physical damage; what it did not do, the shifting economy
did: the wool business hit a peak in the area in the late 1860s, and a
downward spiral began that engulfed the family. The firm which had
produced a good income failed, Paul's position shifted from "manager"
to "laborer," and he never recovered.

Herman Theodore Dreiser was a mama's boy. Born in 1871 and thus
very young during the depression of 1873, he could not have been
much aware of the family tragedy occurring around him. In essence,
his father was going through something which Sherwood Anderson later
described better than he: the rise of a machine technology that made
his skills obsolete. In Anderson, the skill was usually harness-making,
not the best one to have with bicycles and automobiles on the horizon.
With Paul Dreiser it was the weaving of wool. Technical innovations
led to the closing of most of the mills in the upper Midwest, and a
marked shift to the East, where larger, more efficient factories could
function closer to their sources of supply. As Paul became less potent
as a wage earner, he became more assertive at home. He wanted his
children to become priests, good workers, and devoted mothers. They
all rebelled. After a youth spent committing pranks and minor burglar-
ies, their eldest son became Paul Dresser, a song writer; in maturity he
lived in open sexual relationships which were the reverse of those his
father approved, eating and drinking his way into an early grave. Brother
Rome wandered around the country, never held a regular job, and
showed up at odd intervals to disturb family tranquility. The sisters
liked men, and the men got them into trouble. The behavior of these
siblings gave Theodore his most important early fictional material.

Late in the 1870s, the family broke up and never lived as a unit
again. Sarah occasionally took in laundry or kept boarders; sometimes
Paul Dresser breezed in, flush with money from his women or the sales
of his songs. The remnants of the family moved regularly, arriving first
in Chicago in 1884. Even though neither mother nor children lived
there continuously, Chicago remained for thirty years the focus of fam-

ily attention. Chicago was the city where Emma had her liaison with a married man; he stole $3700 in cash and jewelry from his employer's safe, and the two then fled to Montreal and then New York City. To supplement this nestegg, they sometimes ran a "bedhouse," the sort of boarding house where whores could take customers for brief encounters. Chicago was where Sylvia became pregnant and had her baby. Chicago was where Theodore hustled odd jobs before settling on journalism. After an abortive year at the University of Indiana, Chicago was where he returned, to become a lowly member of the legendary Whitechapel Club, a group of newspapermen which included Brand Whitlock, Opie Read, Melville Stone, and Arthur Henry. After a brief stint in St. Louis, Dreiser returned to Chicago once again to see the World's Columbian Exposition, meeting his first wife, a demure schoolteacher, who was there on a group tour. He was always traveling, usually between Chicago and New York but with many stops along the way. No matter where he was, Chicago dominated his imagination and memory. He set his three best early novels there.[19]

Dreiser's mature views developed directly out of his early experiences. He identified his father with a rigid and intolerant Catholicism, and condemned all institutional Christianity for the rest of his life. His mother, however, was to him "beyond or behind so-called good and evil. Neither moral nor immoral, she was non-moral, intellectually, emotionally, temperamentally." His brothers might behave in unorthodox ways, his sisters get into trouble, but early in his account of their lives together, Dreiser drew what for him was the obvious lesson: "what a curse to the individual are the moral or social doctrines or taboos of any given day! And what creatures of infinite jest, as well as obstinate and meaningless notions and convictions, we really are!" He naturally read the books he encountered with such attitudes in mind, and the most important were "Huxley and Tyndall and Herbert Spencer, whose introductory volume to his *Synthetic Philosophy (First Principles)* quite literally blew me, intellectually, to bits." Man was just a meaningless, minute speck blown about in an uncaring cosmos. "Man was a mechanism, undevised and uncreated, and a badly and carelessly driven one at that." Such language, in its technical and philosophical inconsistencies, can seem derivative from any number of thinkers, both Darwinian and modernist. With Dreiser, at least, his early experiences gave him a Darwinian language with which to confront modernist issues. His mother was as beyond good and evil as Nietzsche; the sexuality of his sisters was tropistic, a biological or chemical force that they could not control.[20]

Dreiser's favorite early reading was in European realism and naturalism. His problem was that America would not let him write in the same way. "You couldn't write about life as it was; you had to write about it as somebody else thought it was, the ministers and farmers and dullards of the home." No day went by without the newspapers being

"full of the most incisive pictures of the lack of virtue, honesty, kindness, even average human intelligence not on the part of a few but of nearly everybody." Not an individual, family, or organization failed at some point to commit infractions of this code, yet the spokesmen of society persisted in speaking out of both sides of their mouths: "all men were honest—only they weren't; all women were virtuous and without evil intent or design—but they weren't; all mothers were gentle, self-sacrificing slaves, sweet pictures for songs and Sunday schools—only they weren't; all fathers were kind, affectionate, saving, industrious—only they weren't." Fiction that reflected his reality had no audience, and usually no publisher.[21]

With jobs and money scarce, Dreiser wasted most of two decades writing hackwork. He remained ambivalent in many of his attitudes. He retained more religious feeling than his autobiographies suggest; he admired successful businessmen even as he saw the impoverishing effects of their activities on poor people; he idealized women, yet lusted after their bodies; he was immersed within the world, yet needed detachment to write. When working on *Sister Carrie* in the late 1890s, he was in no sense a modernist, cut off from society, worrying about choosing a past, developing new forms, picking the precise word, breaking out of the prisonhouse of language, or carnivalizing. Like Balzac or Tolstoy, he wanted to re-create all of society into a text about life as he lived it. He used his own reactions to Chicago, one sister's love life, and his own recollections of poverty and success to fashion a work which, unknown to its creator, broke new ground. Here was an ethnic, not an Anglo-Saxon; a mechanist, not a Christian; an immoralist, not a sexual conformist; an honest writer, not someone given to smarmy euphemism. Conventional literary and moral attitudes scarcely existed in this world. Carrie drifted, in her rocking chair, toward success. She wasn't moral and neither was her world. Even Emile Zola had believed in biological laws governing the universe. Dreiser played with such ideas; perhaps he thought he believed them; but his work denied them.

At this point, Dreiser's critics and censors become relevant. Although Frank Norris recommended *Sister Carrie* to the publisher, Frank N. Doubleday, and his firm brought it out, neither Doubleday nor most critics liked the book. It was too blunt an assault on conventional Christian values. The firm ignored its own product, and the book languished. Dreiser became discouraged, had a nervous breakdown, and stopped writing creatively for a decade. With the support of H.L. Mencken and Arthur Henry, among others, he recovered slowly, to write *Jennie Gerhardt,* based on the life of another sister, and the two works based on Charles T. Yerkes, the Chicago traction magnate, *The Financier* and *The Titan.* But Dreiser's critics had wounded him. Like some shaggy beast in a jungle, he was capable of decent behavior when not being bothered, but when bothered he got his back up. The core

of the criticism was that he was not fit for the world of letters because of his background and attitudes.

In the best-known of these assaults, "The Barbaric Naturalism of Mr. Dreiser," Stuart P. Sherman laid out majority opinion with admirable clarity in 1915. "I do not find any moral value" in Dreiser's works, "nor any memorable beauty." Both Dreiser and his works were "ethnic," their viewpoints naturalistic, Darwinian and simplistic. All Dreiser's works were "illustrations of a crude and naively simple naturalistic philosophy," which argued "in behalf of a few brutal generalizations." We lived in a jungle, struggling, where legal, moral, and social codes meant little. "The central truth about man is that he is an animal amenable to no law but the law of his own temperament, doing as he desires, subject only to the limitations of his power." Victory "goes to the animal most physically fit and mentally ruthless." As if such hostility were not enough, Dreiser found his own friends trying to tone down his works, and his own publishers squeamish about printing them. He was willing to admit that he might need editing, and in certain cases accepted it in good humor, but emasculation was another thing.[22]

Dreiser had long held at least some opinions that seemed genuinely modernist. In private, unpublished notes, probably dating from 1911–14, he insisted that no truth had been "more thoroughly established than that there exists some strange link between beauty and happiness," and that he believed "in the supremacy of art." In a 1912 interview, he declared: "I think I'm a believer in art for art's sake"—the "I think" being a perfect example of his doubts that he truly belonged—going on to contextualize his remarks by referring to his doubts that differing temperaments made strictly moral conditions possible. He publicly admired the work of Alfred Stieglitz. By 1915, while he was living in New York, a friend had introduced him to the works of Freud, that "Hannibal of the mind," and he was soon familiar with *Three Contributions to the Theory of Sex* and the *Interpretation of Dreams*. Freudian imagery entered his vocabulary, and he gave a sympathetic ear to Abraham A. Brill, Freud's most visible New York supporter, when he met him in 1919; they were soon good friends. The words, in short, are there for at least a *prima facie* case for Dreiser as modernist, but the evidence is inadequate. He was more of a late Darwinian, ingesting new ideas as they came along without changing the paradigm. He did not believe in logic, order or progress, but he never integrated such attitudes into anything new.[23]

Dreiser's 1915 review of Ford Madox Hueffer's *The Good Soldier* indicated as clearly as any one piece could his unwillingness to think in modernist categories. Retelling the plot and citing Hueffer's own words about his methods, Dreiser grumbled, "a good explanation of a bad method." Hueffer had taken a splendid idea but had "not made it splendid in the telling." No doubt his literary relationship to Joseph Conrad had ruined his capacity for telling a story. The plot of any

novel "should go forward in a more or less direct line," or at least it "should retain one's uninterrupted interest. This is not the case in this book. The interlacings, the cross references, the re-re-references to all sorts of things which subsequently are told somewhere in full, irritate one to the point of one's laying down the book." Instead of coming out in a straight-forward manner, Hueffer remained intentionally obscure. "Every scene of any importance has been blinked or passed over with a few words or cross references." "Every conversation which should have appeared . . . has been avoided." Such flaws were "a pity. The book had the making of a fine story."[24]

VI

Sherwood Anderson was another story. Equally provincial, midwestern, brooding and sex-obsessed, he too came from the hinterland to the big city. He too felt the sting of poverty, the fears of downward mobility, the fascination with the machine and with capitalism, and the need for visible success. He too had only minimal education and struggled all his life to write prose that was clear, grammatical, and properly spelled. But where Dreiser framed out a rough philosophy of life and then piled up prose in an attempt to make sense out of it all, Anderson never concluded much of anything. He listened at the parties that Dell and Currey gave and sampled the liberations of bohemia. He brooded about Russian novelists and Mark Twain, and amused himself with those ideas of Freud which seemed to match his own. He wrote incessantly if not coherently, rarely finishing his projects. These works remain uneven, the low points worse even than Dreiser at his most lugubrious. But in his endless searching, his questioning and self-doubting, Anderson accomplished what neither Dreiser nor anyone else did: he made the quest itself into art; he made a narrative of narratives; he made incompletion an art form. Anderson was the first American prose modernist, and *Winesburg, Ohio* the first canonical prose work in the climate of creativity.

The bare facts of Anderson's life are now well-known. He was born in Camden, Ohio, the third of seven children of Irwin M. and Emma Smith Anderson. Irwin was a Civil War veteran who had gone into the harness business. Comfortable enough at first, he soon found that his skills were inadequate. The family had trouble paying the rent and moved frequently. The children took odd jobs; the mother took in laundry. The houses needed patching; food was available, but neither varied nor plentiful. Under such stress, Irwin drank and chased women, while Emma daydreamed. In 1884, the family settled into Clyde, Ohio, the closest thing Sherwood had to a home town, where he remained for slightly over a decade. His mother died in 1895 and the family slowly split up. Sherwood moved to Chicago, as did several siblings and other friends from Clyde. He tried mindless and menial jobs, and ea-

gerly sought out a chance to serve in the Spanish-American War. In 1900, he finished the equivalent of high school and returned to Chicago to work as a copywriter producing advertising for the Frank B. White Company and its successor, the Long-Critchfield Company. Part of his job was to produce brief pieces for *Agricultural Advertising*, and so in this restricted sense he began to publish in 1902. He married an educated, genteel, upper-middle-class girl in 1904, moved to Cleveland to run a mail-order firm called United Factories Company in 1906, and a year later shifted to Elyria to run Anderson Manufacturing Company, whose chief product was Roof-Fix, a successful roofing compound. In November, 1912, he suffered something resembling a nervous breakdown, and early in 1913 returned to Chicago and resumed work for Long-Critchfield. He lived an increasingly bohemian life on the edges of the Dell-Currey salon, devoted more time to writing, divorced his wife, married a bohemian sculptor, and developed close ties with Greenwich Village intellectuals, especially those around *The Seven Arts*.[25]

Harry Hansen captured Anderson as he seemed to be before he became a legendary presence in literary mythology. Anderson was always reading from his works in progress, often by candlelight. He "wore his hair long and shaggy; his tie was often askew, his trousers bagged at the knees, he wore big, heavy shoes and his hands were large and clumsy." Anderson's face "had in it powerful masses, rather than lines, but when he read it was with a voice that conveyed gentleness and a great depth of sympathetic feeling." Anderson came to embody certain things which his younger friends knew only by reputation. He "had come to grips with life. He had lived his life intensely, ecstatically, humbly, sorrowfully, arrogantly. He had tasted adversity and misfortune; he had been on the highroad to a certain kind of middle class success; he had deliberately uprooted himself when surroundings and human contacts became tedious to him." Anderson was "trying to apply his philosophy that life is not a mean thing to be tamed and held to hard and fast canons, but a beautiful, wild thing of ecstasies and dreams, something that must be lived deeply to be understood."[26]

With Dreiser, the facts of family life were important, forming the core of three of his first five novels and several overtly autobiographical works. With Anderson, the facts were an aggravation, at best the source of myth. No "factual" figures exemplified this better than his father. Irwin had been a respectable person in his day, with his Civil War service a high point of his sense of worth. But as he lost his independence and became a housepainter, paperhanger, and drunk, he became for his son the embodiment of much that was wrong with America. He became Windy McPherson and Tom Willard, characters in *Windy McPherson's Son* and *Winesburg, Ohio*, figures of caricature full of self-delusion and the cause of public embarrassment. So much is fairly obvious, given Anderson's clear identification of himself with Sam Mc-

Pherson and George Willard, the sons in the novels. But what such facile source-hunting too often obscures is that Sherwood knew himself to be much like Irwin. Both hated routine and responsibility; neither could deal in a straight-forward way with women or jobs. Both lived in the past and preferred to observe rather than to participate in the present. Above all, both were tellers of tales. Just as Irwin went on and on about the Civil War, Sherwood went on about Clyde, business life, Chicago, and his yearnings for something better. In writing about his father, then, Anderson was in part writing about himself. Since his father was a teller of tales, Anderson became a teller of tales about a teller of tales; indeed, an unreliable narrator recalling the tales which an equally unreliable narrator told about events that may or may not have happened.

Two extensive books document what Anderson was doing. The best contemporaneous record is now the letters he wrote to Marietta D. Finley, an intimate friend whom he met at the Little Theater and who briefly shared his bohemian life in Chicago. In one of the first surviving letters, he confided to her his feelings of "the utter meaninglessness of life." He fell into such moods, and they passed, but then he had to return to the office. No sooner was he there than he found himself in a meeting, which went on for hours "over the question of the advisability of advertising a new kind of hose supporters." He knew he had obligations, but nevertheless admitted to wanting to shoot "the men in the room with the greatest glee." Given such a work environment, he liked to think of himself as "an outlaw," stealing money from a stupid world. As far as he could see, Chicago was "horrible," "materialistic," and "a city of the dead," and most life in America no different. "The average man I see who has passed his fortieth year is a nervous wreck."

Living in such a place, however, had the advantage of opening his mind to memories, especially those of his childhood in Clyde. As he put them into the tales that were becoming *Winesburg, Ohio,* he came to assume that he embodied a great deal more than he seemed to. "Nearly all of the qualities of the Americans of my time are embodied in me. My struggle, my ignorance, my years of futile work to meaningless ends—all these are American traits." For years he had tried to make money, selling himself to a false god. "I tried hard to be cunning, to be shrewd. I must have lied and boasted and cheated prodigiously." Life had become "an insane nightmare. At night I tried to heal myself. Sometimes I got drunk. At other times I walked alone . . ." He crept away into the fields, wept and swore. "My wife thought me insane." He took a certain amount of inspiration from James Whistler and Henry James: "They simply progressed beyond American thought and American understanding. They entered into the world of art that has no boundary lines." He admired them, but their way was not his. He was too crude and provincial, too much a part of the very America he wanted to reject. He scorned the giving of moral lessons; he could not believe in

socialism or any political solution. Instead, he wanted to be a Whistler or James who survived at home. He took to describing his writing room in Chicago as "like a temple into which I go to worship"; and he told his friend that "we have to learn here in America that art is the great, the true religion. It alone satisfies." It sounded a bit like a cigarette commercial, but was nonetheless honestly meant.[27]

Such facts mattered little to Anderson; he wanted to remember them, poeticize, mythicize, and reshape them. In the early twenties, he published the document that gave a permanent form to his own life. Because it is factually hopeless as a source and wanders uncertainly in form, *A Story Teller's Story* (1924) has never received the attention it deserves. No one seems to have realized that its unreliability was part of its point, or that the narrative as it wandered was illustrating the mind as it ranged from the mere facticity of the present to the rich myths of the past. Take the case of Anderson's description of his father, with which the book opens. "My father, a ruined dandy from the South, had been reduced to keeping a small harness-repair shop and, when that failed, he became ostensibly a house-and-barn painter." He lied about his job: "he called himself a 'sign-writer.' " Neither father nor son was very good at such making of signs—"helpless with a brush,"—and so two of Sherwood's brothers did most of the painting. They painted their messages on barns and fences. If the owners agreed, all was well and good; if they did not, the family passed its time in romance, Irwin regaling them with tales from the Civil War to pump up their courage in case a farmer took a shot at them while they painted. When things seemed propitious, they painted quickly and fled, as if from pursuers, even as the aging author reminded readers of the need for such experiences for art, and then settled on the figure that in one guise or another, became crucial to his modernist vision: "we were all of us—mother father and the children—in some way outlaws in our native place . . ." Of course the tales were untrue, romantic tales were supposed to be untrue. Irwin was no Southern dandy, but a comfortable middle-class Ohio boy who had fought for the Seventh Ohio Cavalry, seen a bit of action, and then lived a life too prosaic to stand. Irwin was always "playing some rôle," for he was an artist; Americans did not understand art, and so artists became exiles, pariahs, or outlaws, escaping the mundane for a better world. "Surely there was something magnificent in my father's utter disregard for the facts of life."

There was, indeed, especially since the refrain of the song which Anderson could never get out of his head was: "You grow more like your dad every day." The clues, scattered through the book, indicate plainly that not only did Anderson resemble his father in many ways, he constructed his book along many of the same lines as his father's romantic tales. For Anderson, too, went into advertising, proving to have a certain skill at it; he, too, hated his life and wished to be elsewhere. Deeply bored, he insisted that "to the imaginative man in the modern world

something becomes, from the first, sharply defined. Life splits itself into two sections," the life of fancy and the life of mundane reality. As he listened to the talk of hosiery, Anderson let his mind wander back to his father; he too wanted to tell tales. His autobiography was clearly one of those tales, and made "no pretense of being a record of fact." The book was "merely notes of impressions, a record of vagrant thoughts." He had not and would not "put them into one truth, measuring by the ordinary standards of truth. It is my aim to be true to the essence of things." He knew that the minds of his own day would find fault and declare "I have no feeling for form" and point to "the meandering formlessness of these notes."

The form of the autobiography was thus an implicit criticism of American commercial life, a defence of the imagination and of the artist/outlaw as he lives his hidden life in moments of ecstasy, only allowing it to appear, so to speak, as signs painted illegally on barns and fences. In this context, Anderson's breakdown, one of the most publicized in American cultural history, took on its mythical form. Anderson retold the story many times, embellishing it like any son of his father would; he was, after all, not writing history but encapsulating the crisis artists felt when trapped in American culture. "It came with a rush, the feeling that I must quit buying and selling, the overwhelming feeling of uncleanliness." He was in his whole nature "a tale-teller." His father "had been one and his not knowing had destroyed him. The tale-teller cannot bother with buying and selling." If he did, it would destroy him. The form of the tale presented a problem: straight-forward narratives were American conventions, forms that matched the prosaic contents of life. If narrative reflected capitalism, if proceeding from fact to fact and incident to incident implicated an author in buying and selling, then he had to paint his signs when and where he could, abandoning "The Poison Plot." "What was wanted I thought was form, not plot, an altogether more elusive and difficult thing to come at." Modernism supplied him with a rationale for what he was trying to say, and friends to advertise his achievement. "I was just as willing to be a modern as anything else, was glad to be."[28]

From his friendships within the Dell-Currey salon, through his correspondence with psychoanalyst Trigant Burrow, to his public praise for the more opaque works of Gertrude Stein, Anderson indicated his affinities to modernism in any number of ways. But his major contribution will always remain *Winesburg, Ohio*, a collection of stories that he wrote chiefly over the winter of 1915–16, and began to publish in the *Masses* in February 1916, with installments also appearing in the *Seven Arts* and the *Little Review* over the next two years. A frequent subject for critics, the book has been read as an important statement of the revolt of Americans against their village upbringing, a criticism of the effects of capitalism, and a work of Freudian insights into sexual repression and its displacement onto religious obsessions. Critics have

attacked it as formless, incoherent or filthy, depending on their concerns. In some ways it is all of these things. Most of all it is the first important full-length achievement of American modernism, a book whose defects are often also its merits, and those merits part of the very definition of "modernism."

Building on the themes of both life and earlier work, Anderson dwelt once again on the memories of war as a series of tales which old men tell young men. Neither the fathers nor the sons are reliable narrators; they distort when they understand, and usually they do not understand. "The thing to get at," Anderson writes in the opening paragraphs, "is what the writer, or the young thing within the writer, was thinking about." In contrast to the other Chicago realists and naturalists, Anderson was intentionally into the mind, into the facts of mental processes rather than external reality. He discovered a succession of incoherent monologues, of narratives based on distant memories, on dreams, fears, anxieties, and longings. The tale-tellers speak past each other, rarely communicating much more than when they were not communicating. Often the tales are not intended to communicate, one person to another, but rather to give body to an inner conflict, as narrators conduct public dialogues with themselves. They do not expect a response; they merely wish to have someone there to bounce words off.

Sitting in Chicago remembering his life in Clyde, Anderson pondered the episodes of sexuality that brought the book so much attention. Indeed, insofar as one phrase sums up the process of the book, it is a book about the telling of tales about the memories of sexual thoughts: a book less about events than about yearning, about love aborted rather than consummated, about beautiful dreams dissolving into shoddy realities. The events happen so swiftly, so seemingly indirectly, that they hardly happen at all. A woman runs naked in the rain, a minister becomes a peeping tom, a doctor stuffs his pockets with truths written on scraps of paper. Upon examination, objects and events become emblems of mental states which were sexual in origin. Sometimes the sexual yearning bursts into violence, sometimes into religion; sometimes it even provokes marriage, which conceals rather than solves the problems. Anderson's characters, like Anderson himself, needed to be free of their fathers, their poverty, their villages, and their jobs. Above all, they needed to be free of their language, to find some new way to express themselves. American life had struck them dumb, and through his book Anderson tried to give formal expression to the messages within them.

That is why complaints about form, plot, and balance are irrelevant to the book's stature. Anderson was not producing a rounded view of American institutions, and of course the book lacks functional businessmen, laborers, meals, daily rituals, political activity and the endless boilerplate of data dear to nineteenth-century authors desperately meeting the length requirements of monthly journals. The book also

lacks any genuine sense of the normal; to be normal in Winesburg means to be grotesque in some way, and the only thing a sensible soul can do is escape, normality being possible only from a distance. The book is about thought and memory, lust and fear, and the distance between an event and the perception of an event. The distortions, evasions, and incomprehensions are part of the point. A straight-forward narrative would have implied a kind of normality, a facticity, that would have distorted Anderson's message. Only a true modernist would have sensed that to be honest, a writer had to present his work in a new form that resembled dream states, that embodied the stream-of-consciousness. Straight narratives, like straight roads, were urban improvements; rural minds meandered like rural paths, doubling back on themselves and often passing through impenetrable underbrush.

Chicago was thus only marginally within a modernist camp by 1917. Its most talented artists were firmly committed to sexual liberation in some form, thought of themselves as sympathetic to socialism but were more likely to be anarchists suspicious of political involvement. They sometimes read psychoanalytic literature, and talked about its ideas whether they had or not. But in formal intellectual terms, less went on than met the eye. Chicago poets wrote nineteenth-century verse, only rarely achieving anything identifiably progressive; the modernist verse they printed or read came in the mail from London. Chicago novelists usually began as journalists and retained for life conventional prejudices about the narration of facts. But concealed within most Chicago work was an obsessive concern with the self: the self as trapped but talented, seeking words in a world that had cheapened language. The unifying form in Chicago was the autobiography, the story of the artist as emblematic of a country. George Cook and Susan Glaspell did not find their autobiographical forms until they organized the Provincetown Players, but Dell, Dreiser, and Anderson all filled their books with themselves and their problems. Confronted with a world that seemed meaningless, they imposed a meaning as best they could. Sexuality was central but religion a fraud. Communication was vital but business a plague. Cities freed the soul while small towns repressed it. The fact of the matter was that facts needed recalling, facts needed a narrator. The outlaws, the nuts, the queers, the grotesques, were living examples of the facts of life without communication, meaningful work, and love. Of all those Chicago artists, only Sherwood Anderson managed to convey successfully what this all meant. *Winesburg, Ohio* was the best expression in prose of pre-war American modernism.

CHAPTER 3

New Orleans

In every way, New Orleans was different from the other cities which incubated American modernism. Its heritage was cosmopolitan but predominantly French; it was Roman Catholic in religion; it was sexually liberated; it was proud of the arts and cultivated them. Of the arts available, music predominated: Philadelphia could have poetry, Chicago the novel, and Baltimore criticism; in New Orleans, people danced, sang, and played. Drawing inspiration from all over the South and Southwest, from St. Louis and Kansas City as well as the smallest Mississippi hamlets, New Orleans put it all together. The sounds of New Orleans helped liberate Western music from European conventions: as Los Angeles helped liberate the eye, so New Orleans liberated the ear.

Black New Orleans was also different. Few of the generalizations which categorize the place of blacks in American life held for the city. Before the Civil War, free blacks had been commonplace. They were often foreign-born, skilled in useful crafts, as French and Roman Catholic in cultural orientation as whites. Blacks in slavery in New Orleans had a mild life by comparison with blacks in other cities or on plantations. Housing was never segregated; whites, free blacks, and slaves mingled daily as a normal thing; and many slaves found it possible to learn a trade and obtain at least a minimal education, thus easing their transition to freedom after the war. The artistic life of New Orleans was very nearly unitary, in that most of the influences were open to all who cared to experience them. No one assumed equality or publicly questioned the status of slaves; but in practice, many slaves could get permission to hear concerts or attend the opera, or could sneak in if they were circumspect. Many free mulattos could become proficient enough at musical instruments to hire themselves out as teachers; and many of those teachers had white pupils. Blacks played for white audiences and copied white tunes. Military marches and black drumming, quadrilles and slave songs, all filled the air, which no one could segregate. A city of many voices, rhythms, and languages was open to all.

Black society after 1865 did remarkably well for a generation. Segregation was impossible in practice, for black housing was so dispersed

among the white that circumstances did not permit it. Schooling was at least partially integrated. Between five hundred and one thousand blacks studied in integrated institutions, meaning that close to one-fourth of the black population in the schools were learning to deal with whites on a daily basis—and significant numbers of white children were learning to deal with blacks. Blacks also had public and private segregated schools to attend, although most schools faced severe financial problems. Three new institutions offered college education to blacks: Straight, Leland, and New Orleans universities operated at what were probably high school levels with money from Northern philanthropists, the Freedman's Bureau, and various churches, especially the Baptist. New Orleans University offered competent musical training and actively preserved black music, including spirituals. Vitally needed in many ways, such institutions had a negative side-effect: desperate to achieve equality and acceptance, upwardly mobile blacks copied white standards of propriety in music. They saw popular musical forms as "vulgar" and worked hard at inculcating European standards, of tonality as well as dress. Black children faced disapproval from parents and teachers if they wished to play the music of their own people. Nice boys studied Czerny exercises, not the bamboula; they joined high school bands and did not yearn for careers in the local barrel houses.

Blacks also pioneered in the establishment of numerous organizations that supplied their community with services otherwise unavailable. Funeral services were especially important, as well as visible to outsiders. The funeral march, in full regalia, soon became a New Orleans tradition largely identified with blacks: the slow march to graveside, the brief services, and then the joyful return. With the brother or sister off to a just reward in a better place, those who remained could celebrate with a clear conscience. Often the marches took their material from the Baptist hymnal, fusing the military band traditions of the city with church music, with dance music, and with whatever remained of black African rhythms from the days before the war. When the saints came marching in, they brought the basis for a more original style of musical creation.[1]

II

New Orleans thus had a gumbo culture; the food was famous for its spicy mixtures and the people and the music were not far behind. The mixing of the people produced the Creoles of Color, the half-castes and quarter-castes. Some mulattos successfully passed for white; others tried and failed. "We had French, we had Spanish, we had West Indian, we had American, and we all mixed on an equal basis . . . ," Jelly Roll Morton recalled in the 1930s, conveniently subsuming his black heritage under the word "American." Morton was one of those Creoles who tried all his life to pass but never quite made it.

He became instead the self-crowned king of the New Orleans pianists, a living bridge between the white and black heritages in the city, and between the ragtime piano of his adolescence and the jazz of his maturity. Other Creoles who played comparable roles included Freddie Keppard, Lorenzo Tio, Sr. and Jr., and Sidney Bechet.

These Creoles faced a difficult situation. Accustomed for generations to an easy access to the white community, enjoying near equality in practice so long as they did not demand it in theory, they lost status steadily toward the end of the nineteenth century as segregation forced them into the catch-all status of "black." Familiar with white music, often with some training and sophistication, they tried to maintain their identity, belittling darker musicians and refusing to socialize more than they had to. The mulattos "wouldn't invite us to none of their entertainments; they just wouldn't affiliate with dark people," the dark Johnny St. Cyr recalled. "Wouldn't intermarry. They were actually more prejudiced than many white people back in that time." Morton interpreted history to suit his color. He insisted that Freddie Keppard's 1908 band, which included cornet, trombone, clarinet, drums, and piano, established the first Dixieland jazz sound, a decade before the much touted but all-white Original Dixieland Jazz Band of 1917; and he rated Keppard as a better trumpet player than the much darker Louis Armstrong.

Morton formally identified himself with French and Roman Catholic culture. But although he had spoken French as a child, he quickly changed his name as well as his language "for business reasons when I started traveling." Musically sensitive from an early age, he made his first instrument out of "two chair rounds and a tin pan," so that he could pound out raucous imitations of the music around him. He experimented with the harmonica and the jew's harp, and became familiar with the banjo, drums, piano, trombone, and other instruments common in New Orleans. The city was awash in brass left over from the Civil War and the Spanish-American War; it added percussion and guitars from black tradition; and it used pianos and violins from European parlor music. Morton was attracted to the piano: first inspired by a concert in the French opera house, he was a transfixed auditor at a party when a man sat down and played a rag. Eager to learn, Morton searched for teachers but found few who could even read music properly. He eventually found help at the local Catholic university, St. Joseph's, whose faculty moonlighted on the side. Morton himself had only the most elementary of formal educations, dropping out of primary school to wash dishes, pick berries, or whatever was required to bring in a little money.

Even in the late 1930s, Morton could remember the names of the New Orleans clubs: "the Broadway Swells, the High Arts, the Orleans Aides, the Bulls and Bears, the Tramps, the Iroquois, the Allegroes that was just a few of them, and those clubs would parade at least once

a week." They always had a band, and "the grand marshal would ride in front with his aides behind him, all with expensive sashes and streamers." Whenever possible the parades included beer and sandwiches, not to mention whiskey and gin, and a boy with an appetite, let alone musical talent, knew he could do no better elsewhere: "There was so many jobs for musicians in these parades that musicians didn't ever like to leave New Orleans." Funerals were a subject of gastronomical as well as musical fascination. "At any time we heard somebody was dead we knew we had plenty good food that night." When he belonged to a quartet, they "specialized in spirituals for the purpose of finding somebody that was dead, because the minute we'd walk in, we'd be right in the kitchen where the food was—plenty ham sandwiches and cheese sandwiches slabbered all over with mustard, and plenty whiskey and plenty of beer." The dead man would be out in the parlor all alone, but he did not seem to be much of a priority. "He was dead and there was no reason for him to be with us living people." Eventually they would get together to sing "Nearer my God to thee," "very slow and with beautiful harmony, thinking about that ham," sometimes experimenting with the harmonies. They'd be "sad, too, terribly sad," but the feast would be eaten, the march begun, and the music played. Into the vaults the bodies went, usually above ground because of the soggy soil conditions, and then the band would strike up, the drums and the snares summoning the brass, and off they would go, singing "Didn't he ramble? / He rambled. / Rambled all around, / In and out the town. / Didn't he ramble? / He rambled. / He rambled till the butchers cut him down." "That would be the last of the dead man. He's gone and everybody came back home, singing. In New Orleans they believed truly to stick right close to the Scripture. That means *rejoice at the death and cry at the birth* . . ."

While still in short pants, Morton was an habitué of Storyville, the thirty-eight block district adjoining Canal Street where prostitution had become legal, taking its name from Sidney Story, the alderman who proposed the legitimization. None of the available jobs attracted Morton, but his skill at the piano admitted him to places where his age might otherwise have been a problem. His family disapproved heartily, but the money was good and the working conditions better than the alternatives. He still sounded a bit dazzled by the memories decades later. "Lights of all colors were glittering and glaring. Music was pouring into the streets from every house." Women were everywhere, "standing in the doorways, singing or chanting some kind of blues—some very happy, some very sad, some with the desire to end it all by poison, some planning a big outing, a dance, or some other kind of enjoyment." Drugs and alcohol were ubiquitous, and he had missions "to Chinatown many times with a sealed note and a small amount of money and would bring back several cards of hop." Sex was freely available and Morton enjoyed his share. His very name had sexual con-

notations and so did his other local name, Wining Boy. But then, even the word "jazz" in its earliest incarnations, was slang for the sexual act. Wine, women and piano were all in the gumbo together.

The music that Morton evolved from all this was eclectic. His father had been a trombone player, achieving many of his effects through study of French opera. Morton imitated him, and achieved numerous "tailgate effects," as trombone techniques were called, on his piano. Alphonse Picou showed him Caribbean effects on the clarinet. Many songs were simply French or Spanish material given a ragged beat, perhaps with animal sounds, mutes or other examples of "dirty" notes. This soon added up to the art of ragtime: as with any term in folklore, dates and places remain vague and imprecise; but the new style was soon identified chiefly with New Orleans.[2]

Insofar as such things are traceable, the roots of ragtime went back to the mid 1830s. When Thomas D. Rice imitated the dance of an old black and became famous for his "Jim Crow" routine, he helped begin the craze for black-faced minstrel shows. Not a black himself, the actor had taken black anecdotal material, set it to the music of both an Irish folk song and an English stage song, and found that people loved it for complex reasons. Most of these involved entertainment, not race; most Americans outside the South knew little about blacks in real life; they just wanted to chuckle and perhaps learn something about exotic people far away from their daily concerns. But in the curious way of folklore, the material caught on. The young Stephen Foster saw "Jim Crow" Rice perform and was himself doing black-face shows when he was only nine years old. By the 1840s, some of Foster's songs, like "The Camptown Races," were catching on as well, and by the 1850s Foster was cooperating with E.P. Christy, leader of the Christy Minstrels. Most of the songs that resulted were sentimental and nostalgic, which hardly mattered; but like the minstrel shows that went with them, they dealt with blacks as cliché figures incapable of civilized life. In a typical minstrel show blacks had thick lips, big feet, wool-wire hair and fangs, and seemed happiest in slavery, stealing chickens, eating watermelon, and living in a perpetual childish dependence. The same derogatory pictures adorned the covers of the first published rags in the 1890s.

Popular culture influences high culture in many ways, but rarely has the picture been so murky as with minstrel shows and the music that grew out of them. After the Civil War, blacks needed jobs badly and nothing seemed more natural than that they take to the stage. People had been looking at stage blacks for two generations, and blacks reasonably assumed that they would accept real blacks in place of the black-faced whites of tradition. But white audiences wanted their prejudices confirmed. They wanted blacks to remain in their places, to be funny, exotic, anecdotal, and unthreatening. They had trouble thinking of them as social equals; legally equal but socially separate became the law of the land in 1896, just one year before the first published piano rags.

Had blacks asserted equality in minstrel shows, few whites would have come. In entertainment, popularity comes first.

The ironies were many. In terms of non-musical elements, the easiest way to remember minstrelsy is the career of Billy "Big Mouth" Kersands, and its impact on a jazz personality such as W.C. Handy. Kersands was probably the highest paid performer in the business, as popular with the black community as he was with the white: he was the slow-witted baboon who could somehow get a cup and saucer, or perhaps several billiard balls, into his mouth at once. Handy, the self-styled "Father of the Blues," recalling Kersands and the other performers of his childhood, insisted that his work with them "had made of me a professional musician and a bandmaster." Working with a minstrel show had taken him all over North America, given him steady work and respectability of sorts, and introduced him to black musicians he would never have met otherwise. Minstrelsy "had taught me a way of life that I still consider the only one for me."[3]

The musical impact of minstrelsy, while obscure, is vital to understanding the origins of ragtime and its successor, jazz. The cakewalk was central. It was "originally a plantation dance, just a happy movement" which the slaves performed "to the banjo music because they couldn't stand still," the aged black entertainer Shepard N. Edmonds recalled for Rudi Blesh and Harriet Janis. Usually on Sundays, when even slaves stopped work, they "would dress up in hand-me-down finery to do a high-kicking, prancing walk-around. They did a take-off on the high manners of the white folks in the 'big house,' but their masters, who gathered around to watch the fun, missed the point." The couple that put on the best show received a prize, traditionally a cake, and this became the origin of a phrase still in the language, "to take the cake," usually implying outrageous behavior carried out with finesse and charm. Some later scholars doubt the historical accuracy of this custom, and surviving documentation is scanty, but parading around in outlandish finery became a part of post-war minstrel shows. In the 1890s cakewalk dancing contests became a craze in the United States, and thanks to the John Philip Sousa Band at the Paris Exposition of 1900, in Europe as well. Lest anyone doubt the impact of such things on the intelligentsia, no less a modernist than the leading musical innovator of his generation, Claude Debussy gave the form immortality with "The Golliwog's Cakewalk" (1908), the last of the pieces in his "Children's Corner Suite."[4]

The cakewalk also retains an emblematic importance, for its provenance says something about music as social criticism, and the language of race relations in general. The original slaveholders were whites who dressed well, behaved in a pompous manner, and flaunted their pleasures before their slaves. The slaves, accumulating old clothes and already accustomed to playing for white audiences, could put on public shows that made the whites laugh but that ridiculed them as well. The

black-faced minstrel performers, who were themselves white, picked up the ceremony, usually using a two-step marching tune so that the actors could strut about and flaunt their finery to the audience. The whites presumably considered the performance to be a parody of slave manners; blacks saw a bit more, knowing that the minstrels were actually ridiculing blacks who had been ridiculing whites. When, by the 1890s and later, blacks themselves took on these roles, they had to perpetuate stereotypes established by the whites, acting quite as ridiculously as those whites who had debased the image of their race. Thus, white audiences demanded that blacks behave as whites had behaved when they imitated blacks who were secretly ridiculing white slaveowners. This complex situation boiled down to a story of multiple deceptions, with, as usual, blacks saying one thing to their own community, another to the white one.

"Rag" thus probably owes at least some of its meaning to the concept of kidding: to rag someone is to kid them, to give them a hard time; it owes nothing to the idea that occasionally surfaces, that "rag" refers to the ragged clothing of blacks. But even in practice, the term had all the ambiguities that terms in popular music, and cultural history in general, tend to have. In contemporary usage, "rag" meant almost any popular march for a band, a category given its ultimate form in Irving Berlin's "Alexander's Ragtime Band" (1911); or else it meant any of the popular "coon songs" to emerge from the minstrel shows, such as "All Coons Look Alike to Me" and "Under the Bamboo Tree." Among the favorite hits of about 1902, these works represented black music to the larger public of both races, however little they sound like the modern idea of rag. Yet even these debased creations had their impact on modernism, as T.S. Eliot could testify. A great aficionado of Boston lowlife during his Harvard days, Eliot wrote the latter song into the tambo and bones section of "Fragment of an Agon": "Under the bamboo / Bamboo bamboo / Under the bamboo tree / Two live as one / One live as two / Two live as three / Under the bam / Under the boo / Under the bamboo tree." And no reader of *The Waste Land* is unaware of "that Shakespeherian Rag— / It's so elegant / So intelligent," which is a direct steal from the Ziegfeld Follies of 1912.[5]

This imprecise popular usage soon merged with the mainstream of American popular music and lost whatever originality it had. The most important form of ragtime was a syncopated piano music, in accord with the definition in the 1908 *Grove:* "RAG TIME: A modern term, of American origin, signifying, in the first instance, broken rhythm in melody, especially a sort of continuous syncopation." The earliest piano rag scores usually identified their contents as cakewalks, marches, or two-steps, and thus the word meant, in brief, a syncopated dance. Like the minstrel show, all these forms had their brief periods of popularity; that of the rag proved as enduring as it did in part because it arrived at the same time as the perfection of the piano roll. The stately dance

marches were the perfect creations for the new industry. Just as the middle-class homes of later years featured victrolas, radios, and televisions, so the white middle-class could feature their piano with its player mechanism, capable of keeping teenagers moving for hours in excellent fidelity. Such success, as always, had its price. Too many publishers issued cheap imitations, too many composers, many of them white, ground out sleazy versions of the real thing; and too many young pianists, unable to play complex rags, required simplified versions. The scores that remained after the ball was over were only dubious guides to the richness that once was ragtime.

As far as the artistic history of New Orleans is concerned, the core of ragtime history was in Sedalia, Missouri, and the difficult life of Scott Joplin. Joplin grew up in Texarkana, Texas, the son of a free black woman and her formerly slave husband. Conditions remained impoverished in the black community; the temptations of alcohol and gambling were openly available. But Joplin's family worked hard and yearned for something better. Music was everywhere: his father Jiles played the violin, his mother Florence the banjo, and no one in his family distinguished white and black forms. Before he was freed, Jiles had played waltzes and quadrilles for his white masters, as well as slave songs for his own people. The church retained a strong influence. Once separated from white Christianity, black religion was free to develop its own music: ring shouts, hand-clapping, and notes foreign to Western forms of notation had room to flourish along with the Baptist hymnbook. A sense of African polyrhythm, so much more complex than European beats, could compete with the two-step and simple counterpoint. Scott received what little training he could find from local teachers, and had his greatest aptitude for the piano. His mother took him along while she cleaned houses, and he first experimented on the instruments of white people, sounding out the parlor songs, Sousa marches, and dance tunes. She soon found him an instrument of his own, and he became popular at black social events, mixing black and white material indiscriminately. His biographer has even suggested that his mother's banjo playing may well have prepared him to absorb the banjolike effects which romantic New Orleans pianist Louis Moreau Gottschalk had achieved in his famous piece, "The Banjo." Unlike the piano, the banjo recorded well on the primitive phonograph equipment of the turn of the century, and one element of the sound of ragtime is its banjolike effects.

Joplin wanted an education, training, and a position of social acceptability and in about 1888 he left Texarkana to become an itinerant pianist, selling his wares wherever they found a market. Life was rough and required a pianist to perform in any barrelhouse or brothel that allowed him to collect tips. White ballads and black folksongs coexisted easily in such a world, and an improvising pianist could not help but pick up all the influences in the air. At some point in the late 1880s or

early 1890s, all the influences began to fuse in the custom of ragging the time of marches, dance tunes, cakewalks, two-steps, and even occasional popular classics. Ragging meant placing the emphasis on notes which conventional meter underplayed, a harmless way to vary playing which could go on for hours. Black players were especially familiar with call-and-response singing of a type that had its origin in work songs, in which a leader invented one line after another, with a chorus coming in over and over again. Work songs went on as long as the leader could invent variations and the workers had the energy to respond as they did the job. Being a piano music, ragtime had only one instrument but the pianist had two hands, the left one maintaining a steady beat while the right one went off on one variation after another.

About 1890, Joplin settled in St. Louis, where a saloonkeeper named Tom Turpin was doing some of the earliest raglike experiments on the piano at his Rosebud Bar. Between them, Turpin and Joplin all but established the form of the "classic rag": the catalytic event was apparently the Columbian Exposition in Chicago in 1893. Joplin had no official role in the white city, but the crowds spawned a red-light district in which pianists from all over the Midwest could influence each other with new ideas. Joplin returned to St. Louis eager to write down his music. He scarcely knew how; he scarcely knew what. His first efforts were in the clichéd forms of the day and did not pretend to be rags. Finding little market for his talents in St. Louis, he moved 190 miles to Sedalia, a booming town which was railhead for two major railroads and that, not coincidentally, had one of the more vigorous red-light districts in the Midwest. It also had the George R. Smith College for Negroes, which contained a College of Music, and Joplin was able to pick up rudimentary training in composition. Meanwhile both white and black musicians were copyrighting "rag" music; the most important early rag for Joplin was his friend Turpin's "Harlem Rag," copyrighted in December 1897. Only a year and a half later, in the summer of 1899, Joplin finished a piece called "Maple Leaf Rag," publishing it that September. It took off slowly, but when it caught on its publisher could hardly keep up with the demand. It established Joplin and the ragtime craze; for a decade ragtime took over the living rooms as well as the barrooms of the nation, drowning out marches, cakewalks, and two-steps before jazz, in turn, replaced it.

Born in 1890, Jelly Roll Morton was a generation younger than Joplin, but pianists grew up fast in New Orleans; Morton was learning to play by the time he was ten and was an itinerant pianist throughout the South by fourteen. Always retaining a base of operations in New Orleans, he was often in St. Louis, Memphis, or Kansas City, absorbing the musical innovations and returning to Storyville with them. A great admirer of Joplin, Morton rendered "Maple Leaf Rag" in such a way as to make it a classic of jazz development: unlike most performers, Morton made the transition to jazz without difficulty and his talents as

a composer made him, all things considered, the most influential jazz musician of his generation.[6]

Once again, European modernists recognized an innovative form when they saw one. The big year for this was the end of 1918 and the beginning of 1919, when the young modernist conductor Ernest Ansermet returned from an American tour with some ragtime sheet music. He showed it to Igor Stravinsky, who viewed it as yet another colorful example of musical primitivism, of the sort he had been using since *The Rite of Spring* several years earlier. "As I had never actually heard any of the music performed, I borrowed its rhythmic style not as played, but as written. I *could* imagine jazz sound, however, or so I liked to think. Jazz meant, in any case, a wholly new sound in my music." Stravinsky quickly worked it into two piano solos, "Piano Rag" and "Ragtime," and into the far more famous ragtime dance in *L'Histoire du Soldat*, a work which marked "his final break with the Russian orchestral school."[7]

III

In addition to the marching band and the ragtime piano, the blues were the third great contributor to the New Orleans musical heritage. Few subjects have aroused such scholarly controversy, and even after generations of debate standard works disagree about the precise definition of the blues or whether African influences shaped it. Under such circumstances, historians repair to that most standard of reference works, *The New Grove Dictionary of American Music* (1986), adding details from a small number of related volumes. The blues were "a secular black-American folk music of the 20th century," an essential part of which was a tradition of improvisation. The most familiar form such improvisation took was a twelve-bar harmonic progression, "which all blues performers knew and which they played almost automatically: it consists of four bars on the tonic, . . . two bars on the subdominant, . . . followed by two further bars on the tonic; two bars on the dominant seventh, . . . and two concluding bars on the tonic." In its earliest forms, emerging in the 1890s and achieving maturity in the first decade of the twentieth century, the blues were a rural music of the South and Southwest, especially from Mississippi to Texas, which wandering males sang to guitar accompaniment.

Of all the tributaries to jazz, the blues were the most African in origin and black in development. Unknown in Africa in anything like their American form, they nevertheless clearly depended on African assumptions and conventions and the compromises necessary when such assumptions and conventions clashed with Western ones. In most areas of Africa, performers and audience were one group and the instruments often participated directly in a linguistic transmission: the sounds of certain instruments were the same as those of certain words. Going

with these sounds were body sounds, the clapping of hands, the stomping of feet, and the singing of songs. Rhythm was central: not only did Africans have a more complex sense of rhythm than Europeans, they traditionally placed rhythms next to each other, delighting especially in a two-over-three cross-rhythm that seemed ubiquitous in sub-Saharan Africa. Numerous writers have commented on the widespread use in African and other folkmusics of the pentatonic scale as opposed to the diatonic one of Western music, and the famous blue notes of American jazz may be the result of the efforts of Western-trained players and composers to adapt African scales to the diatonic. But the *New Grove* points out that "some West African scales are diatonic, and that pitch inflection occurs in West African music and may thus form part of the African heritage of the blues." Regardless of this area of controversy, "blue notes are universally associated with black-American music in North America, and are unaccountably absent from other Afro-American musics of the western hemisphere." A blue note is, then, "a microtonal lowering or 'bending' of the third, seventh, or (less commonly) fifth degree of the diatonic scale . . ."[8]

Coming as they did out of the tradition of Southern slave worksongs, the earliest blues fused African conventions with messages of deep discontent. Lyrics spoke of the hot sun and the boll weevil, of seductive women and violent men, of too much drinking and time in jail. Everyone wanted to escape the miseries of the present to dwell in an idealized past or future where race and poverty no longer kept a man down. Only a fraction of this music has survived; with rare exceptions, only the efforts of folklorists from the mid-1920s on rescued versions of what remained. Names such as Blind Lemon Jefferson, Leadbelly (Huddie Ledbetter), and Robert Johnson passed into the history books, insofar as anyone could tell, still singing in the authentic "archaic" or "downhome" manner.

The blues entered urban culture shortly after the turn of the century through the efforts of several women who came out of the minstrel tradition. The most important was Gertrude Pridgett, born in 1886 in Columbus, Georgia. She began singing something like the blues as early as 1902. In 1904 she married William "Pa" Rainey, a dancer and singer, and she became "Ma" Rainey, the "Mother of the Blues" as the title of her biography has it. She was soon a veteran performer with her own band, which included drums, violin, bass, and trumpet; she sang in between comedy and circus routines, the blues appearing along with contortionists, jugglers, and acrobats.

Ma Rainey followed the harvest season throughout the South and customarily spent her winters in New Orleans. There she picked up musical ideas and contributed her own to the cultural gumbo. She composed a "Jelly Roll Blues," knew King Joe Oliver, Sidney Bechet, and Pops Foster, and collaborated in her later years with Louis Armstrong on several recordings that became collector's items. Older than most

jazz musicians, she retained more of the rawness of the downhome blues in her singing than did her disciples, most famously her friend Bessie Smith. Rainey's work was full of moans and blue notes, and as her biographer has pointed out: "Her slurs and glissandos recall the earliest formation of the blues as sung speech, sweeping in between notes, eliminating the classical sense of pitch or absolute distinction between one note and the next by touching on quarter-tones and smaller microtones between notes." As if being female and black were not enough to make a person feel like an outsider in American culture, she was also bisexual, yet another example of how sexual, racial, and artistic nonconformity fused to form a sensibility which seems modernist in an international and largely white context.[9]

As with cakewalks and rags, Europeans picked up the blues. Blues effects often appeared in classical works along with syncopations and other presumptively "jazzy" effects by the early 1920s. Few musicians were more fastidious about their work than Maurice Ravel, yet he felt no qualms about attending jazzband concerts or in exploring the technical consequences of jazz. The *Concerto for Piano and Orchestra* (1929–31) makes obvious use of blue notes, not to mention woodblocks, syncopation, and complex tonguing effects in the woodwinds. The *Concerto for the Left Hand,* composed at the same time, builds one of its main themes on both syncopation and blues effects; as Ravel frequently did elsewhere, it made repeated use of both raised and lowered thirds in ways that have to derive from his close study of black American music. Even more specific is the second movement of the *Sonata for Violin and Piano* (1923–27), labeled "Blues," about which he commented: The blues were among America's "greatest musical assets, truly American despite earlier contributory influences from Africa and Spain." He insisted, however, that his flatted sevenths and his syncopation were used with a specifically French and personal effect, and he was correct. No other European modernist could use violin and piano so well to suggest the effects American blacks achieved with the plucked banjo or the sliding saxophone. Perhaps the most remarkable aspect of his use of the blues and other jazz effects was that by the mid-twenties, no one found it unusual. It was simply another example of modernist originality.[10]

IV

The fruitful mixing of African and American elements so evident in the development of the blues was only one example of a larger fusion of forms and customs that constituted a black American folkmusic. When he came to write his now classic history *The Making of Jazz,* James Lincoln Collier found three main features in this folkmusic. "The first is an approach to time that involved an attempt to reproduce in the European system implications of the cross-rhythms of Africa." In such an approach, singers broke away from the basic beat "to produce lines that

were essentially rhythmically free," and found examples which seemed to be "unrelated to the time scheme at all." Black Americans had not reproduced African systems of cross-rhythms, but "they had taken the principle of the cross-rhythm, and found a new way to express it by standing a melody line apart from the ground beat that ostensibly supported it. This principle became central to jazz." The second characteristic was "the manner in which scales were used." Regardless of the problem of how universal the pentatonic scale was in African music, the problem of meshing African scales with European notational conventions produced new sounds and expectations in performers and audiences alike. Negro music gave white musicologists a sense of "intervallic aberrations" that translated into the many popular misunderstandings about what a blue note actually was. Such confusions helped set this new music off from both African and American mainstream musical development. The third characteristic was the use of what jazz musicians came to call "dirty notes," "those guttural tones, rasps, falsettos, and melismas," which colored the melodic line and gave it "variety and expressiveness." Africans produced not only odd vocal effects, they distorted natural sounds, as when they hung teeth from a drum. In such a complex folkmusic "there was no true harmony."[11]

Such a folkmusic did not inevitably produce jazz. It could exist all over the South, and in those parts of the North where blacks had settled in any groups large enough to continue old-time musical traditions. It could, for example, have ties to white church music and produce spirituals that have a flavor unknown to Wesleyan hymnbooks, but that do not have any necessary connection to jazz. But in Catholic, cosmopolitan New Orleans, blacks were better off, better schooled musically, and better able to find steady work. They had platoons of marching and dance bands, which took picnics and funerals equally for granted. They had a steady stream of ragtime pianists coming in and out of the city; if bands were soon ragging tunes, pianists were also composing two-steps and marches for the pleasure-seekers of the evening, and were not above ragging Richard Wagner or Rossini if the audience approved, as it usually did. And when Ma Rainey and the younger blues singers wintered in the city, both bands and pianists could learn from the singers about blue notes, falsettos, and dirty tones. It was a free city, more or less, and freedom meant not only sexual and alcoholic opportunity, it meant the freedom to play the horn like a wailing mistress, or try for pentatonic effects on pianos, that strictly speaking could not produce such tones unless intentionally mistuned.

By common consent, the story of jazz began in New Orleans with the legendary band of Buddy Bolden. Information about his life and his music comes hard. He was born in 1877 and began to play in public about 1895; unlike most jazzmen he rarely played for funerals or other marching band festivities. He developed a popular style of "wide-open" cornet playing, in which he ragged hymns, street songs, and dance tunes.

Bass player Pops Foster heard the band at Johnson's Park and later played with several of its members. He recalled years later that "Buddy played very good for the style of stuff he was doing," describing it, however, as "nothing but blues and all that stink stuff, and he played it very loud." Bolden achieved local popularity for the first five years of the twentieth century; his band, none of whose members could read music, usually included his cornet, a trombone, clarinet, guitar, bass, and drums. It did not play in the brothels where the ragtime pianists reigned, but rather in dancehalls, and outdoors in the streets and parks. Bolden apparently had little contact with whites, and white jazz musicians of a later date seemed unaware of him. By 1906, his career was in sharp decline: a heavy drinker, he became depressive, suffered from severe headaches, and was soon mentally incompetent; from 1907 until his death in 1931 he remained in a mental institution. Rumors and compositions which recalled his memory, proliferated, unencumbered by recordings, sheet music, or much factual material. His work and his band became the original source from which Dixieland jazz sprang into public awareness about a decade after he stopped playing.[12]

Whether the Buddy Bolden band "invented" jazz, whether Jelly Roll Morton did, as he always claimed, or whether it was a creation that simply emerged from the black and Creole music culture, which seems to be the fairest way to describe it since hard evidence is missing, jazz emerged in New Orleans at some point between 1902 and 1910. The "single catalytic event" was the discovery "that if standard two-beat ragtime is undergirded with a four-beat ground beat, the character of the music changes." Add to this fundamental change the blue notes and pitch inflections that had persisted from African sources, and an understanding, which all jazz musicians seemed to agree upon, that you could separate the melody line from the groundbeat, and everything fundamental to jazz was in place. All it took was constant repetition, refinement in the ever-changing world of the New Orleans musicians, and time to spread.

New Orleans had many musicians who took no part in these innovations. The most respectable of the bands, such as John Robichaux's Orchestra, were Creole groups of some training and taste. They could read music, included violins, played for expensive white parties, and ignored the likes of Buddy Bolden and Jelly Roll Morton. At a less exalted level, both Creoles and blacks played in the marching bands. Parties and funerals continued to occupy the masses of people, and marching bands, while unpolished, provided training for young musicians. They were not playing "hot" Dixieland music, but they were capable of ragging almost anything, jazzing up the standard repertory as they became more accustomed to the new style. As with the more respectable dancebands, the personnel of these groups was fluid; musicians passed from one to another as friendships and openings dictated. Musicians wanted to work and played whatever it took.

Two other types of band were less respectable, all but untrained, and more creative. Small, irregular groups of three or four players, usually using a piano-drum-cornet-guitar grouping, specialized in the rawest sort of downhome blues, which appealed to lower-class customers. The lyrics were often unprintable. Individuals of talent, such as Sidney Bechet, sometimes played with them to learn the blues. Finally, a fourth group produced the jazz band as it became known to a larger public. Playing in such locations as Funky Butt Hall, such groups usually had a cornet, clarinet, trombone, guitar, bass, drums, and a violin; the violin often doubled the lead with the cornet, and violinists were in some demand because they were often the only people in the band who could read music. Some bands used a piano instead of a guitar for indoor occasions, but outdoors the bass and guitar carried the rhythm. Buddy Bolden's band fell into this category, and from this band and those who admired Bolden and his music, jazz evolved into the style of playing which appeared on the first phonograph records.[13]

As with everything factual in early jazz history, the linkages remain unclear, but most jazz historians consider Freddie Keppard to be Bolden's successor as the best cornet player in the dance world. Born in 1889, he reigned for only a half dozen years before leaving in 1911 to spread jazz around the country. While in New Orleans, Keppard had played for the band which trombonist Edward "Kid" Ory ran. This band, which often included Sidney Bechet, had the reputation of being the best in the city. When Keppard left, Joe Oliver replaced him and quickly became the best cornetist in New Orleans. He produced only one student: Louis Armstrong. Surviving phonograph records may present a skewed sample to posterity, since many of the best musicians rarely recorded, but Armstrong overshadowed everyone during the 1920s. His only rivals were Morton on the piano and in composition, and Sidney Bechet on clarinet.

Armstrong had been born most probably in 1898, regardless of the later date he usually used. He was a product of the roughest black society: from the black section of Storyville, the son of a prostitute, he had none of the advantages of the Creole world. He claimed to remember Buddy Bolden playing at Funky Butt Hall, and since he lived in the area and Bolden was still playing when he was six or seven years old, there is no reason to doubt him. A more formative experience was the period which Armstrong spent in the Colored Waifs' Home. Always in trouble, he was sent to the home for his own good, learned a bit of discipline, lived on beans and molasses, and picked up a rudimentary ear for music. Orphanages usually had bands; this one consisted of a bass drum and about fifteen brass, chiefly cornets, trombones, and horns. Playing by ear, Louis learned the usual marches, religious pieces, and sentimental tunes of the day, at first on a tambourine, then a drum, an alto horn, and eventually a bugle. A bugle is essentially a cornet without valves, and he soon began to play the instrument with which he

made his reputation. He was essentially self-taught. This contributed to his originality, but also to his poor embouchure, which had severe consequences for his lips a decade later. Such playing also meant a curious attitude which Armstrong had throughout his life: he never really regarded himself as a jazz trumpeter; he had the image of himself as a danceband musician, a brassband musician, and an entertainer. The technical side of what he was doing did not appeal to him, and jazz as pure art did not concern him. He loved melody and showmanship, and was better at it than anyone else. As several generations of admirers discovered, he remained within the minstrel tradition, something of a lovable ham who did not take his enormous talent all that seriously.[14]

Late in 1917, government action ended the legality of prostitution in Storyville. America was at war, too many soldiers had access to a place notorious for violence, vice, and disease, and national political concerns asserted themselves. A progressive administration asserted its Protestant moral standards and crushed one of the few places in the country where alternative views of sexuality and art could thrive. The prostitutes went back into the larger society and the musicians looked for gigs elsewhere. An exodus of talent from New Orleans began that sent jazz onto the riverboats that plied the Mississippi, out to California, and up to Chicago. In 1919 the Kid Ory Band broke up, and by 1920 few good players remained in the city. With the establishment of that last relic of progressivism, prohibition, organized crime replaced disorganized prostitution as the economic foundation of underworld musical creativity, and for organized crime, Chicago was soon the place to be.

V

Much of the impact of this music on white America and Europe came after 1917, dependent not only on traveling musicians but also on commercial recordings of quality. But whites were involved in the history of jazz from the beginning. Never important in a genuinely creative sense, they were essential in an economic and educational sense. Whites controlled most of the money that hired bands and virtually all of the economic structure of the music printing and recording industries. In the end, they bleached much of the originality out of the blues, but that was perhaps inevitable. Most black figures of economic talent cared little for the music either; they wanted to sell products, and public taste in jazz music, black or white, was not better than public taste in other areas of culture.

White musicians were always around in New Orleans. The leading figure in Buddy Bolden's time was the bass drum player Jack "Papa" Laine, who organized his first band around 1892 or 1893. Whites could pick up ragtime beats as quickly as blacks, and the marching band heritage was more white than black anyway. By 1910, competent white musicians who apparently played jazz included cornet players Nick

LaRocca and Paul Mares, clarinet players Larry Shields and Leon Rop-polo, and at least two musicians so light-skinned that they played black or white as the occasion warranted: trombone player Dave Perkins and clarinet player Achille Baquet. As such ambiguities indicated, segrega-tion was a legal concept more honored in the breach than in the obser-vance in musical life in Storyville. "The white and colored musicians around New Orleans all knew each other and there wasn't any Jim Crow between them," Pops Foster has insisted. The big difference was instrumentation. "None of the white bands had any violin, guitar, man-dolin, or string bass."[15]

When it came time to travel, however, the whites were more conspic-uous. Keppard, Morton, and Bechet all traveled constantly, but they were identifiably black musicians in a segregated world outside New Orleans. They did not have the connections to make much of an im-pact at first. The great northward migrations of blacks during the war years were only just underway, and Northerners were not accustomed to hearing black music or thinking of blacks as musically creative. But in 1915, trombone player Tom Brown went to Chicago and attracted attention for the "jass" music he brought with him. White drummer Johnny Stein led a second group and others both black and white were soon welcome in Chicago. Band personnel changed constantly, but by 1917 a group calling itself the Original Dixieland Jazz Band, led by Nick LaRocca, went to New York City and quickly made a name for itself at Reisenweber's Restaurant, an elegant "lobster palace" of consid-erable social cachet. RCA Victor recorded it in February 1917, and as the Original Dixieland Jazz Band was soon widely known, jazz not only had its proper name at last, but had its first hit tunes. White bands did not originate this music, but they formalized it into the hot, driving Dixieland style. It owed more to John Philip Sousa than Africa, and thus did not strike white ears as oddly as downhome blues did.[16]

More significant for the history of creativity was the impact that jazz had in modernist Europe. There, jazz was an important component in modernist efforts to change the discourse of art in three obvious ways. The first of these was nationalism, the effort by composers from widely disparate countries to go back to folk roots and establish a better sense of nationhood. Sibelius reinvigorated the legends of the Finnish *Kale-vala*, while Bartok and Kodaly went into the hinterland after Hungar-ian and Roumanian folkmusic. Jazz in this sense was an American folk-music, the expression of a racially distinguishable group with a heritage and identity distinct from the rulers of their geographical area. Second, jazz seemed primitive at a time when Parisian artists especially were looking to Africa for new forms. The interest of Picasso remains the best-known example of this. Third, jazz was an essential component in the modernist fight against the overblown romanticism of Richard Wagner, whose interminable operas embodied everything that a good young modernist should abhor. Jazz was a new language that seemed

deceptively simple, modest, hard, spare, and unpretentious. Jazz was a useful weapon in a much larger battle.

The place of jazz in this battle is clearest in the career of Darius Milhaud. Milhaud, too, was interested in folkmusic, enchanted by the "primitive," and bored with Wagner. Rejected for military service for health reasons, he spent two years in Brazil with his friend Paul Claudel, passing his leisure time studying, among other things, the cakewalk-like costumes, dances and music of the Rio Carnival season. "I was fascinated by the rhythms of this popular music," he recalled later. "There was an imperceptible pause in the syncopation, a careless catch in the breath, a slight hiatus that I found very difficult to grasp." He "bought a lot of maxixes and tangos and tried to play them with their syncopated rhythms, which run from one hand to the other." Such interests in popular folkmusic went along with an interest in modernist tonal experiment. In writing "L'Enfant prodigue," for example, he wanted "to eliminate all nonessential links and to provide each instrument with an independent melodic line or tonality. In this case, polytonality is no longer a matter of chords, but of the encounter of lines."

Milhaud visited America briefly after his stint in Brazil, and placed his synthesis of his musical Rio, "Le Boeuf sur le toit," in an American prohibition bar. "I thought that the character of this music might make it suitable for an accompaniment to one of Charlie Chaplin's films." But his interest in jazz did not really flower until a visit to London shortly thereafter, when he heard the Billy Arnold danceband. He found this new music "extremely subtle in its use of timbre: the saxophone breaking in, squeezing out the juice of dreams, or the trumpet, dramatic or languorous by turns, the clarinet, frequently played in its upper register, the lyrical use of the trombone, glancing with its slide over quartertones in crescendos of volume and pitch, thus intensifying the feeling." The composition held together through the subtle punctuations of piano and percussion. "The constant use of syncopation in the melody was of such contrapuntal freedom that it gave the impression of unregulated improvisation, whereas in actual fact it was elaborately rehearsed daily, down to the last detail." Aware of the uses which Stravinsky and Satie had made of ragtime, Milhaud wanted to write a ballet of his own, but delayed until he once again visited New York, met blacks, and sampled Harlem. The music he heard had an effect "so overwhelming that I could not tear myself away," and he returned repeatedly. He went home with a collection of Black Swan records and "resolved to use jazz for a chamber work."

As soon as he returned to Paris, he collaborated with Fernand Léger and Blaise Cendrars on a new ballet for Rolf de Maré. The subject was the creation of the world, based on African folklore, and seemed ideal for Milhaud's designs. "I adopted the same orchestra as used in Harlem, seventeen solo instruments, and I made wholesale use of the jazz style to convey a purely classical feeling." *La Création du Monde* was the

best of those compositions directly dependent on jazz music and the experience of black America. It also proved to be something of a dead end. Having created a piece of permanent merit, that elusive "minor classic" that critics often talk about, Milhaud turned to other things. On his next visit to America, he was sorely disappointed to find the music in Harlem bleached by its white audiences and the forces of commercialization. Yet even as he looked elsewhere for inspiration, he retained his fascination with jazz. Fleeing the Nazis, he settled in California. Despite serious illness that immobilized him for long periods, he taught at Mills College, alternating years there with years in Paris. Visitors to Paris, such as trumpet player Dick Collins and drummer Kenny Clarke, found him still avid. "Milhaud began to take notes as we talked and while Dick and I played together," Clarke recalled a 1949 visit. "He used to ask us to stop just in the middle of something, and he'd note it down." He wanted to discover the secrets of "swing," which had swept America in the 1930s. "He was interested in the cymbal beat, in what I did with my left hand. He seemed to know quite a bit about jazz. We stayed there about three hours. He was in his wheel chair, and he'd roll around the rooms, very enthusiastic." He was just as enthusiastic in California, pleased with the students at Mills and advocating jazz to anyone who seemed interested. "It was Milhaud who encouraged me in my playing jazz. He felt that playing jazz was an expression of American culture," Dave Brubeck recalled. "He felt a musician born in America should be influenced by jazz. At the beginning of every composition class each semester at Mills, the first thing Milhaud would ask was, 'Are there any jazz musicians here?' "[17]

VI

The trip from post–Civil War New Orleans to Paris after World War I was thus a long and tortured one. Having its origins in the Africa of the original slaves, jazz developed as the language of several marginal groups in American culture. Regardless of how integrated New Orleans seemed, and regardless of how much better off blacks were there than elsewhere, they were still marginal: the Creoles belonged nowhere, too dark for integration and too snobbish to feel comfortable with blacks; the darker blacks were on the edge of economic desperation, hardly able to clothe themselves or find instruments worth playing. Jazz and segregation forceably united the Creoles and the blacks, but no one in either group could ever feel socially or musically a part of the American mainstream.

Given the rhythms and sonorities of African origin, and the invigorating effect of the clash between pentatonic and diatonic traditions, these blacks developed jazz chiefly through three earlier forms: from post–Civil War era, marches in which the two-step of the military march blended with the two-step of the cakewalk and many compatible Euro-

pean dance rhythms; from the syncopation of the ragtime piano; and from the downhome blues, in which the wails of wandering blacks in country dives reflected the African rhythms and sonorities that entered the musical language of the West as blue notes. Separate in the 1890s, these three forms blended during the first decade of the twentieth century, perhaps as early as 1902 and surely by 1910, into a Dixieland jazz style recognizably similar to that which swept the country in the 1920s; and they did so chiefly in Storyville, a morally segregated area that implied a kinship between racial, sexual, and musical non-conformity. Only minimally aware of European teachings, often untrained and unable to read music, black musicians seem unlikely modernists. Yet they deserve inclusion in the category on their own merits: they were a conscious outgroup in a society demanding conformity, and they developed a new language to communicate among themselves just as African drummers among their ancestors had. Their creativity was thus appropriate for European modernists to pick up as "primitive" stimuli; as new folk sources for the most serious forms of formal artistic creations; and as a means of mocking and parodying that which had become pompous in European concert halls and opera houses. Jazz was one of several new languages available to Europeans already looking at chants, madrigals, and Renaissance dances in their efforts to develop a new classicism. In terms of originality, jazz was the greatest contribution which American citizens could make to this process.[18]

Los Angeles

The American film industry settled in Los Angeles in a swift series of moves that lasted scarcely a decade. In 1906, the American Biograph and Mutoscope Company established a studio, and a year later, Colonel William Selig moved in a film crew to complete *The Count of Monte Cristo*. Adam Kessel and Charles Baumann arrived in 1909, and D.W. Griffith was right behind them. In 1911, two Englishmen who owned the Centaur Company established a branch office; Selig, Pathé, and Bison were in Edendale and Kalem was in Glendale. By the time America entered World War I in 1917, Los Angeles and especially the ex-urban area known as Hollywood, had become the center of American film production. Since the war effectively restricted the operation of most non-American filmmakers, Los Angeles dominated the industry world-wide.

The reasons for this astonishing development were many. The early days of the industry had centered on the New York Metropolitan area including the New Jersey offices of Thomas A. Edison and the landscape around Fort Lee, a favorite location despite terrain and trees that hardly seemed appropriate for stories supposedly taking place in the West. New York had actors with theater experience, inventors essential to early experiments with film and sound, and businessmen with money to invest. But New York proved inhospitable to the new industry. Its weather was cold and dark much of the year, restricting shooting time. It had highly paid workers who raised labor costs. Worst of all, it had Edison and the patent trust that he used to milk the new industry for as much money as he could. Brilliant in his irascible way, Edison had never been interested in projecting pictures onto screens; but his offices had provided support to William Kennedy Laurie Dickson and that brilliant young man had broken most of the essential ground necessary for the production of a Kinetoscope that could show motion pictures to one viewer at a time.

Meanwhile, Thomas Armat and Francis C. Jenkins were developing a Vitascope capable of projecting pictures onto a screen that many people could view at once. Edison hired Armat in 1895 and the organization soon had a functional Vitascope-Kinetoscope that became the basis

of the modern movie projector. By 1896, projected pictures were available in New York City, Paris, and London. More interested in the phonograph than the photoplay, Edison himself contributed little to developing the camera, but his name and organization were essential to this rapid spread of the new technology and he demanded the profits that seemed likely to be substantial. In 1908 he had formed a patent trust with most of his European and American competitors in an effort to monopolize these profits. Lawyers tied up challengers in expensive court actions; goons occasionally beat up competing actors, damaged equipment, or stole cameras. The Los Angeles area seemed ideal for all these reasons. Land and labor were cheap, New York was far away, a wide variety of scenery was close at hand, the sun shone most of the year, and if things got tense the Mexican border was only about one hundred miles away.[1]

Of these new arrivals, Griffith was unquestionably the most important. A barnstorming actor who had experienced years of economic uncertainty, a nostalgic Southerner who frequently recalled his "old Kentucky home," he stumbled into movie making because the new industry provided him jobs when and where he needed them. No more than any black jazz musician did he have "modernism" on his mind, nor was he consciously seeking out a new language to express the way he, as a displaced Southerner, felt about life in a nation dominated by Yankee views. The logic of the new technology, and the improvisatory ways in which he met its challenges, led him inadvertently to the position of an innovator who set important precedents for modernists whose interests were not directly in film, but rather in literary narrative or in more complex forms of picturing reality than were available in traditional art academies.[2]

Griffith joined the American Mutoscope and Biograph Company in 1908. Its standard film lasted about ten minutes, which was long by industry standards; typically, it consisted of from eight hundred to one thousand feet of film, which was all a single reel could contain. Despite the short life of the industry, the product was already mired in cliché. Slapstick comedies constituted about half the Biograph output, with topical documentaries and melodramas making up the rest. The key to public interest in film was movement, and initial filmgoers had seemed willing to pay for anything that moved: railroad trains were especially popular, especially if they headed directly at the audience, and automobiles were soon equally so.

In these early days, the cinema had no established syntax. No one had given a moment's thought to the development of a new art; companies merely ground out their products and directors followed the precedents they knew best. These all came from the theater: the camera stood in a location comparable to where a patron purchasing orchestra seats would sit, and it viewed a stage. Actors entered and exited as if they were on stage, they made up for the stage, they overacted melo-

dramatically so that patrons far off could get some idea of what was going on, they struck pantomimic poses. They could get away with this for awhile because patrons expected theatrical conventions and knew no alternatives. Novelty alone was enough to keep people paying their nickels.

Before Griffith, only one American director had broken with these conventions in an effective way. Edwin S. Porter made a series of films that taught others something about editing, continuity, the building of narrative suspense, and the use of parallel stories. The French innovator Georges Méliès had pioneered in the use of trick photography and fantasy, and Porter also experimented with dreams, in one example using a well-known comic strip as the source of his fantasy. As early as 1903, Porter's *The Life of an American Fireman* used a close-up for the first time and perhaps deserves credit for being the first photoplay of any merit. Later that year, *The Great Train Robbery* broke clearly with static theatrical conventions in its creation of a genuine narrative that was more than merely a series of shots. It combined both theatrical scenes and location shots, had a sense of pictorial continuity, and utilized forward-cutting, cross-cutting, and the flashback in its suspenseful evocation of parallel action.[3]

When Griffith began, directors had virtually no status. Someone had to be in charge of the filming process, and in the early years the cameraman was usually that person, since most businessmen in the front office assumed that the quality of the picture was more important than the quality of the script or the acting. Directors at first were involved as organizers of actors and no one expected them to have any training or technical knowledge. Indeed, for anyone like Griffith, who regarded acting in legitimate theater as his true vocation, loss of status was a real risk of becoming known as a director of film. Nevertheless, he was willing to try, and *The Adventures of Dolly* (1908) was the result. The camera remained fixed in one place, the actors performed as if on a stage, no one appeared in a close-up, and the film was essentially twelve shots, one after the other. The precedents of Porter notwithstanding, Griffith began like everyone else, lucky to avoid cinematic disaster but in no way waving a standard of innovation. Shot in two days, 18 and 19 June, it was in the laboratory for a few days and ready on 22 June. The front office approved and it was showing in Union Square on 14 July.

Everything in those days was improvised and much that soon became conventional in cinema was the result of experiment on the job. Griffith used nothing like the finished shooting scripts of contemporary directors, simply working out his scenes day by day. He wanted to convey emotions in ways unavailable to directors who persisted in making long, single shots, and so he experimented with close-ups of facial expressions. He discovered that he did not need to shoot a scene from a single vantage point, but could vary his camera position, using several shots to make up one scene. He found out that the overdramatized

acting style of the theater looked bad on film and toned it down. He changed the application of make-up. As for the fade-out, which Griffith used so effectively that it became something of a signature device of his work, his cameraman Billy Bitzer has left a wry memoir about how things were. "It has been asked many times whether Griffith or Bitzer should be credited with the fade-out. It probably should be neither one," Bitzer wrote. "I had been so preoccupied with the mechanics of the camera that I did not pay much attention to what was later lauded as a marvellous achievement." To him, it was all just another day's work. "If Mr. Griffith asked for some effect, whether a fade-out or whatever, I tried one way or another to produce what he wanted. When it worked successfully, we were hailed as inventors." In fact, both men had seen the pioneering experiments of Georges Méliès and had forgotten what they had seen; they reinvented the device because they needed it. Film syntax demanded it and improvisation recovered it: ". . . we did not create the fade-out. I believe it really was Méliès."[4]

Griffith's patience with the weather in the New York–Fort Lee area ran out in the fall of 1909. Early in January 1910, he packed up his cast in the middle of a picture and headed for Los Angeles. Bitzer appreciated the warmth and the light, but was less happy with more technical matters: the "tap water was full of alkali," he grumbled later, and he had "trouble washing paints, and we had to erect a water tower for pressure on what we did use. My test prints came out badly and had to be sent to New York for processing. I sweated, fumed, cursed, and clawed the end of my stogie." Griffith, however, was energized by the new terrain. He quickly rented a loft in which he could store his materials, and found a vacant lot at the corner of Grand Avenue and Washington Street where he could film outdoors. As Mary Pickford remembered it, the lot was fenced in and had "a large wooden platform, hung with cotton shades that were pulled on wires overhead. On a windy day our clothes and curtains on the set would flap loudly in the breeze." All the local studios were out in the open like that, their situation being the origin of the phrase, being "out on the lot." "Dressing rooms being a non-existent luxury, we donned our costumes every morning at the hotel." They rehearsed in a loft in a decrepit building, where the only furniture was "a kitchen table and three chairs." Griffith sat on one, "the others being reserved for the elderly members of the cast. The rest of us sat on the floor."[5]

Nothing modernist motivated Griffith's directing. He wanted to please his financiers, his audience, and his own taste. The financiers feared that any innovation would hurt sales, while his audience dwelt in a world of melodrama and romance that scorned esoteric experiment. As for Griffith's taste, he took no known interest in new literature, painting, or music. He certainly revered Poe, but his chief literary inspiration was clearly Charles Dickens. When people asked him why he was making the experiments that seemed so innovative in a cinematic context,

he retorted that he was only doing what Dickens had done. In this he was clearly correct. Dickens had written great literature about ordinary people; he had mixed the scandalous with the divine; he had indulged in shameless melodrama; he loved the parodic and the hyperbolic; he indulged in caricature; his plots were cross-cut and employed radical juxtapositions of material. Above all, his books were fun and the public doted on them, even if they were great art. Griffith did not need Mikhail Bakhtin to tell him about dialogic imagination and the carnivalesque; Dickens was his Rabelais and his Dostoyevski, and in many ways he pioneered the aesthetic future with his eyes firmly on the past.[6]

The recollections of Karl Brown, Bitzer's assistant, clearly showed aesthetic innovation arriving by accident. According to Brown, Griffith used a fade-in and a fade-out with every shot; he never called "cut" like other directors. "I didn't know why until it finally dawned on me that Griffith himself never knew in advance whether he would need or not need a fade to open or close any scene he ever shot, even in the close-ups. So everything faded in and everything faded out and he was ready for anything." He shot this way, Brown decided, because of his slavish dependence on audience reaction and his willingness to change scenes that did not get an appropriate response. He took his first cuts and went off, "anywhere," to find "the most *un*sophisticated, least theater-wise audiences he could find." He had been an actor in the sticks, and he knew what melodramatic tricks worked out there. "What these horny-handed sons and daughters of toil wanted was a full-course theatrical feast of tragedy and comedy, not delicate tragedy but raw blood, and not witty comedy but blatant slapstick. Everything had to be spelled out in black and white: deep-dyed villains and the purest possible heroes and heroines."

Far better than any scholar, Brown formulated The Plot: "There were rules never to be violated. The hero must never stain his hands with blood. The heroine must be pure to the point of pathological absurdity. Devices had to be invented to bring this impossible state of affairs about." One was the Mysterious Stranger, who appeared briefly at the start to tell the audience: " 'Twas on just such a night as this ten years ago that that foul caitiff who calls himself Reginald van Millionbucks visited upon my beloved sister a fate far worse than death. The search may be long and the quest forever in doubt, but I have sworn to bathe my hands in his heart's blood,' " and so on. He then disappears.

He reappears at the end, when interesting events are in motion. The heroine "is strapped to the railroad tracks, a train bearing down on her at full speed; the hero is strapped to a log moving inch by inch toward a whirling saw blade; the orphan asylum is a mass of flames; and the Old Homestead is in the very process of being foreclosed to turn dear old Denman Thompson out into the cold." Alternatively, an outcast heroine "is dying in the snow outside Grace Church, while the choir inside is singing "Nearer, My God, to Thee" ' and all hell is breaking

loose, when the Mysterious Stranger reappears to fire a blast from a double-barreled shotgun straight into the heart of the cowardly villain, who proceeds to die in writhing agony all over the stage as the lovers are untied, the girl rescued, the Old Homestead saved, and nobody goes over the falls to their death after all." This was what the public wanted and Griffith believed his duty was to give it to them.[7]

When Griffith's imagination transcended popular preference, he found small sympathy in New York. The front office was inclined to let him alone as long as the pictures kept making money, but they made no bones about their belief that the greatest profit was in brief, cheap pictures. Inspired by Italian films that were becoming longer and more spectacular, Griffith wanted to produce his own *Quo Vadis?* in many reels, with a cast of hundreds and sets to match. Without keeping New York informed, Los Angeles went into the production of *Judith of Bethulia*, based on a melodrama by Thomas Bailey Aldrich. This American spectacle required sets without precedent, the scenery of the western San Fernando Valley, and funding beyond anything acceptable. He did it anyway, and New York, unwilling to let any such thing happen again, held the film from release and suspended his right to direct as he pleased. He soon left Biograph to work on his own.

Such a tale would normally be worth hardly a footnote in cultural history, except that in producing a spectacle of the most crowd-pleasing kind, Griffith pioneered what Soviet filmmaker Sergei Eisenstein later pointed to as the first use of the *montage* in film history. In setting his scenes, Griffith had juxtaposed shot after shot of seemingly disconnected material, not only of common citizens inside the gates of Bethulia, but also of the assaulting Assyrians outside. Continuity of a traditional kind had disappeared: what the viewer retained was a new sense of space built in the mind out of shot after shot. The violating of space meant a new type of mental image, a kind of spatial equivalent of what Ezra Pound tried to create in his paratactic verse, written simultaneously in London with no known points of contact with Griffith. Griffith's close-ups not only *"show"* or *"present,"* Eisenstein wrote, they *"signify,"* they *"give meaning,"* they *"designate."* He created *"a new quality of the whole from a juxtaposition of the separate parts."* From his work, *"we advanced the idea of a principally new qualitative fusion, flowing out of the process of juxtaposition."*[8]

II

Once free of Biograph restrictions, Griffith could plan his own films. If he could arrange the financing and stay clear of the lawyers and thugs of the patents monopoly, he could make films that were as long and as expensive as he wished. He was in no doubt about what he wanted to do. An old friend from his barnstorming days, Thomas Dixon, Jr., had written a bestselling novel, *The Leopard's Spots;* as *The Clansman,*

it had toured successfully as a play. Although any modern audience would reject the extreme racism of Dixon's work with disgust, neither Griffith nor many other Southerners saw much to criticize. He knew that the Yankee history of the Civil War was all wrong. He knew that his own father had been in the Ku Klux Klan. He knew that Negroes were decent people, often loyal and true to their masters, but he was incapable of seeing them as equal to whites. He knew that women were pure at heart and that young ethereal blondes were the purest of all. He knew that purity attracted lechery and debauchery and that these primitive impulses dominated blacks and the whites who pandered to them. He knew that the people loved spectacle and would be willing to pay top dollar to sit for two or three hours if a director captured their attention. He knew that the public responded well to violations of space and time, and never more so than in cutting back and forth between chases and rescues, or between close-ups of the people and long-shots of massed men spread out on a landscape.

He bought the rights to Dixon's novel, based his own impulses on the play, and in the end did what he pleased; only a few pages of Dixon's survived the final cut. Using a modest scenario and no shooting script at all, he began work on the fourth of July 1914; he winged it in the same improvisatory way in which he had always worked. What he produced was melodrama: "There was nothing high-flown or arty about *The Clansman* as Griffith shot it," Karl Brown remembered. "Everything was of the earth, earthy. Carpetbaggers were crooked, crookeder, crookedest." Ralph Lewis, who played a character loosely based on Representative Thaddeus Stevens, was a hateful image of blind cruelty. He and his characterizations were "lifted straight out of the old rip-and-tear period of Griffith's acting experience without breaking bulk." A villain was a villain, and you were supposed to hate him and want to see him punished. Walter Long played Gus, the black rapist-murderer, the same way. "Walter made no effort to look like a real Negro. He put on the regular minstrel-man black-face make up, so there could be no mistake about who and what he was." Lillian Gish was the Angel in the House, out of Dickens or Wordsworth, "like a nun, breathless with adoration." Mae Marsh essentially played herself, "a prankish little hoyden cute as a bug's ear, the sort of kid sister everyone would love to have." Elmer Clifton was everyone's idea of the stalwart young soldier, "the beau ideal of the gallant youth of song and story." The Little Colonel was a hero who "would fight, yes, but only in defense of his sacred homeland. He never killed anyone, even in the heat of battle." He might "charge the enemy, ram the flag into their cannon's mouth, and then retire to his ruined mansion, covered with honor and with very little else," but he bore his disaster like a gentleman, "never complaining, never repining." The whole film was based on this sort of melodramatic type-casting, "not because Griffith wanted it so but because his audience, that million-headed but singlehearted monster, had to have its

villains and its heroes clearly labeled so it could know whom to cheer for and whom to hiss."[9]

Griffith and his admirers made all sorts of claims for *The Birth of A Nation,* the title *The Clansman* received just before it went into general release. The popularity and critical acclaim which the movie received, and the controversy which its racial assumptions engendered, later led to minute examinations of film history to see which director had pioneered what invention. In such an analysis, the film became a summation of earlier innovations and not a pioneer of anything. The use of close-ups went back to the earliest documentaries of the 1890s; contrasting vista views began as early as *The Great Train Robbery.* Griffith himself was the probable originator of the flashback, in his early film *The Fatal Hour,* and rather more effectively in his remake of "Enoch Arden," *After Many Years.* The use of flashbacks and parallel editing to create suspense, with their violations of time and space through the workings of montage effects, went back to *The Lonely Villa* and *The Lonedale Operator* in addition to these. The fade-out was more a technique for dealing with erratic scenarios than a technical invention, and no one really knows precisely where it originated, although both Griffith and Bitzer deserve credit for its development. Cinematic lighting was in many ways original in Griffith films, but Bitzer's experiments deserve emphasis; Griffith himself apparently tried for a long time to transfer dramatic lighting to the cinema, with unfortunate results. Other claims were equally dubious, and Griffith was often willing to take credit for accidents, Bitzer's experiments, or inventions from Europe of which he may have been only half-aware or may have genuinely forgotten. Lillian Gish, for example, makes much of Griffith's use of music to convey emotion, something hard for modern viewers to appreciate since available prints convey no sense of what audiences heard in 1915. Joseph Carl Breil manufactured a score for *Birth of a Nation* that used Edvard Grieg's "In the Hall of the Mountain King" for the ride of the Klan, and "The Ride of the Valkyries," a famous work of Richard Wagner, to evoke the Klan call. Griffith was no Wagner; but he knew what he wanted to create and Breil's synthesis was "new" and effective.[10]

The success of *Birth of a Nation* left Griffith in a quandary. No artist wants to follow a major work with anything less than another one, and yet he had nothing appropriate. He aspired to higher greatness yet had no idea of how to get there. What he did have in progress was "The Mother and the Law," a small-scale film that expressed his irritation at the progressive social worker mentality that interfered with the lives of the poor out of misguided benevolence. Its origins are now lost, but the story concerned a Boy and a Dear One who love each other in the slums, face problems of strikes, death, crime and deceit, and have to put up with social workers who take their child away because they seem not to be fit parents. Griffith pulled out every melodramatic stop in detailing the unmasking of a treacherous plot to execute the Boy for a

crime he did not commit, complete with a race to the Governor and a reprieve from the gallows at the last possible second. Thrilling stuff with considerable technical interest, if a viewer has left his skepticism and sense of the likely at home for the evening. Yet after *Birth of a Nation*, "The Mother and the Law" seemed anticlimactic.

At the same time, the Italians were goading him yet again, challenging his preeminence as a director. Giovanni Pastrone's *Cabiria* arrived, a plotless extravaganza in twelve reels that was so visually overwhelming that it changed the sense of scale of what a film could be. Griffith hauled key members of his staff all the way to San Francisco to see it, and it went to his head like strong drink. Such a work spoke to his audience, it captivated them, and he had to equal it. He wanted the authority of the Bible and of the Christian religion, he wanted ancient grandeur, he wanted to clobber intolerant social workers, and he wanted his audiences to leave the theater in awe. He still did not have a shooting script. He seemed to have no clear idea of what he would do. He began to shoot other stories. One concerned the Persian siege of Babylon in the sixth century before Christ; another concerned the Christ story; a third dwelt on the French Roman Catholic persecution of the Huguenots, ending with the Saint Bartholomew's Day Massacre. The actors seemed to have no idea whether they were connected or not. The stories themselves did not even, in any clear or consistent way, deal with intolerance. But money was pouring in and Griffith was busy pouring it out again; for the moment, everyone seemed happy.

The issue is an important one, for it concerns Griffith's status as a modernist. If, in fact, he really did not know what he was doing, was floundering with too much money and too little inspiration, then *Intolerance* was a fluke, an accidental masterpiece that spoke to the next generation but that said things about film syntax unknown to the director himself. Given Griffith's racism, his sentimentality, his love of melodrama and old-fashioned values, he seems often enough to be a textbook conservative, trying to hold off progress and the modern. Given his erratic impulses toward grandeur, religiosity, the family, and the need for a chase, he only stumbled into modernism while actually doing something quite different. "And so, after spending something like $2 million and close to a year and a half out of our lives, Griffith shuffled all four versions of *The Mother and the Law* together like a pack of cards, and called the resulting four-ply story *Intolerance*," Karl Brown has stated. In one sense he is surely correct, although at the same time himself inadvertently permitting a modernist interpretation. For such accidents, such attempts to reach the public mind as well as to mystify and overwhelm it, such brilliant improvisatory chutzpah, was itself modernist. *Intolerance* might be intellectually shallow and emotionally incoherent; it might be drunk on its own sense of filmic spectacle; it might not even be about intolerance at all; and yet it might still be a success as art.

No one knows how creativity works; often it seems to happen in ways unknown to the creators. Griffith could in fact make a case for his "fugal" form, for his four stories that clashed and jarred each other and the unsuspecting viewer. "The stories will begin like four currents looked at from a hilltop," he said in language reminiscent of William James. "At first the four currents will flow apart, slowly and quietly. But as they flow, they grow nearer and nearer together, and faster and faster, until in the end, in the last act, they mingle in one mighty river of expressed emotion." Well, they did and they didn't, and one man's river could be another's swamp. But in the most lucid paragraph that he ever wrote about his work, he did make a strong case for his own status as a modernist artist and the film as a modernist classic. "The purpose of the production is to trace a universal theme through various episodes of the race's history. Ancient, sacred, medieval and modern times are considered," he said, making perfectly good sense. "Events are not yet set forth in their historical sequence or according to the accepted forms of dramatic construction, but as they might flash across a mind seeking to parallel the life of the different ages." *As they might flash across a mind:* these words are the core of the case for Griffith as modernist. As T.S. Eliot later pointed out in his famous discussion of *Ulysses,* such parallels between ancient and modern, such mental constructs of the fragments of civilization, lie at the core of modernism.

The best compromise position on these issues is to assert that Griffith was a precursor of modernism, like Whistler or William James, but never made the transition himself. His film was a modernist masterpiece, almost in spite of itself. "In terms of technique—both the innovations of Griffith and the mechanical means to implement those innovations—the film is a virtual textbook," William K. Everson, the best historian of silent films in America has written. It contains "forerunners of glass shots, an ingenious improvised camera-crane which even foreshadowed the effects of the zoom lense in certain shots, the most sophisticated use yet of toning and tinting, coupled with mood lighting, for dramatic effect; some astonishingly 'modern' performances, especially from Mae Marsh and Miriam Cooper; and, of course, a pattern of editing, or montage, which was to be of profound influence on the Soviet films of the twenties." [11]

Regardless of whether or not Griffith was a true modernist or more properly a precursor of modernism, his relevance to the subject was over with this film. It received some acclaim and achieved what seemed to be popularity for a few months, but then interest in it stopped. It lost a great deal of money; worse, its pacifistic and self-critical subtexts, attractive in a time when President Wilson could win reelection because he had kept America out of war, became all but intolerable when he took America into war. Griffith was suddenly out of favor with his bankers and his audience, and he never had the chance to continue his experiments. On 17 March 1917, he set sail for England and a differ-

ent type of film career. He had many more pictures to make, but they were of a different sort from *Birth of A Nation* and *Intolerance*.

III

The Griffith company spawned many careers but none less probable than that of Mack Sennett, *né* Michael Sinnott. Griffith had no obvious sense of humor and rarely indulged in comedy. Sennett did little else.

"I was a Canadian farm boy with no education. I moved to the United States and worked as a boilermaker," goes a typical straight-faced passage in his ghost-written autobiography. Of Irish Roman Catholic background, he was born in Québec in 1880 and was as inarticulate in French Canadian as he was in English. At seventeen, he moved to Connecticut to work in the American Iron Works, a job his large build (6'1", 210 lbs.) suited him for. He hated heavy labor and preferred acting. Although he had no noticeable talent, he moved to New York in 1902 "to be a singer and actor . . . I was name-smitten and stage-smitten, but mostly money-smitten. I like money and I like to talk about it." He began his career in burlesque as the hind legs of a horse and developed a philosophy appropriate to such a position: "I especially enjoyed the reduction of Authority to absurdity, the notion that Sex could be funny, and the bold insults that were hurled at Pretension."

He soon attached himself to Griffith and learned how to direct. "He was my day school, my adult education program, my university." Griffith liked to take walks, and Sennett made a habit of being available to walk with him. "So far as any knowledge of motion-picture technique goes, I learned all I ever learned by standing around, watching people who knew how, by pumping Griffith, and thinking it over." They disagreed solely on comedy. ". . . I discovered that he was not so fascinated by comedy as I was, and he went into silences when I brought up my favorite people, policemen. I never succeeded in convincing Mr. Griffith that cops were funny." He was soon writing scripts in much the same way others entered films: casually, in need of money and having no better possibilities in sight. "There is no greater inspiration than a hungry vacuum under the belt. I bought a dozen pencils and a stack of paper and set about learning how to write for the screen, in exactly the same way I was trying to learn to be a director. I copied people who knew how." A plagiarism of O. Henry was his first effort; he was soon selling brief dramatic scenes to Biograph.[12]

Photos that survive give little indication of the impact Sennett had on those who worked closely with him. Griffith recalled him as "a short, burly, bearlike figure with long gorilla arms dropping from a pair of incredibly hugh shoulders. And always there was a wide, good-natured grin on his face." Bitzer's memory was even more detailed. "He was just the sort of man we needed around to play cops or a mug. But a dress suit looked like a suit of armor on him, for he was made like a

box. His head seemed to sit on his square shoulders without a neck, there was no visible waistline, and seen from any angle, he was square from his head to his bulldog shoes."

Sennett worked with Griffith between 1908 and 1912, about four and a half years, before striking out on his own. He announced the formation of Keystone on 12 August 1912, and arrived in Los Angeles with his companion and favorite comedienne Mabel Normand on 28 August. He began making pictures immediately, but did not hit his stride for several months. *The Bangville Police*, released 24 April 1913, was the first real success for the Keystone Kops. The first pie landed in the face of Roscoe "Fatty" Arbuckle in a film of July 1913. The first successful two-reeler, length being a sign of maturation, was *In the Clutches of A Gang*, released 27 January 1914. The formulas fell into place with remarkable speed, like everything else at Keystone.

Film historians often pass over Sennett and Keystone too quickly; they should not. No form was more popular or cut so successfully across class lines. Adults and children, rich and poor, intellectual and anti-intellectual joined in the laughter and that laughter was an important inspiration for modernism. Modernism thrived on hostility to institutions, to authority, to hypocrisy. It doted on speed and machinery. It loved the violation of time and space. It was often parodic. Sennett's background in lower class, authoritarian Québec had planted a permanent sense of grievance in him and laughter was his weapon of revenge.

Sennett had many debts which he scrupulously paid. In addition to Griffith, he learned especially from the French, who in turn made his work something of a cult: "it is about time I confessed the truth. It was those Frenchmen who invented slapstick and I imitated them . . . I stole my first ideas from the Pathés." Well, perhaps, but the slapstick per se was a prop from American vaudeville. Essentially, a "slapstick" was a goat bladder that had been stretched on a stick; if you hit someone with it, it made a flatulent sound, and such bathroom humor remained at the core of Keystone comedies. Much depended on embarrassment and shame: making people who seemed to be wealthy or powerful, parent figures in short, look ridiculous and even bestial in their behavior. Slapstick was a bit of harmless revenge by children against parents as well as by the impotent against the powerful. A thrown pie was merely a gooey variation on the well-established theme. To throw a pie at a fat man was to bring down someone large and powerful. Even the casual racism, not unexpected in a Griffith disciple, was basic vaudeville: a black-faced comedian or comparable Jewish stereotype reflected generations of popular art forms that reassured insecure white Americans of their superiority to those of other origins.[13]

As a genre, slapstick comedy was first of all a parody. Sennett's *At Twelve O'Clock* parodied the old Biograph film, *The Fatal Hour; His Bitter Pill* was a burlesque of William S. Hart's westerns. Other subjects

are clear enough from their titles: *A Small Town Idol, The Grand Army of the Republic, Fatty and Mabel Adrift.* Nothing was safe, from the Civil War to young love. In no other context was the popular origin of much of the modernist impulse so nakedly visible. The coincidences, the disguises, the put-downs of noble sentiments and emotions, the sentimentality capable of laughing at itself, as if to say, "we believe even if we know it's kind of ridiculous because we can't take anything straight any more": all these make Mack Sennett something of an American Erik Satie, placing *Relâche* across the face of the nineteenth century as he led a *Parade* into the twentieth.

Sennett gave his viewers a fabricated reality; the more he distorted the known and predictable, the more the audience roared. Indeed he soon made a formula where the unpredictable became all too predictable, and violations of time came on schedule. The essence of the formula was the chase, a linear event that degenerated into incoherence as soon as Sennett touched it. People, animals, and cars all chased each other for absurd reasons, often through houses, gardens, and anything else that might get in the way. Such chases had little rational logic because they were as irrational as anything in modern life. Sennett routinely used trick photography to make a few actors do the work of many: he filmed car and train wrecks, leaps and falls that made viewers gasp and giggle at their sheer impossibility. He used slow motion, fast-motion, and double exposure techniques. The use of liquid soap and skilled racing drivers produced improbable road effects; a camera working in reverse as a locomotive backed up could then run in the usual way to produce a wonderful illusion of imminent collision. Hundreds of people could pile out of a car if the camera stopped and started at appropriate intervals. Such violations of time and space were both funny and modernist.[14]

As was the case with Griffith, the inclusion of Mack Sennett in a study of modernism has problematic elements. In terms of conscious intention or pretensions to an elitist sensibility, the topic would make a good parody in view of Sennett's notorious anti-intellectualism. He himself was without public illusions on the subject: ". . . we *did* create a new kind of art. But while we were doing it we had no more notion of contributing to aesthetics than a doodlebug contributes to the *Atlantic Monthly*." But accidents have their places in art as in life, and any description of modernism must begin with experiments with space and time, with anarchistic impulses and parody. Not only did Sennett inspire the most improbable people with his antics—"My admiration for Mack Sennett is temperamental and chronic," wrote Theodore Dreiser— but he consciously tampered with the medium in creative ways. Not only did he film in slow motion and use reverse cranking, he invented a mode of editing that became something of a silent film comedy trademark. In appropriate chase scenes, he habitually cut out every third or fourth frame in key sequences to add a jerky quality that modern view-

ers probably assume to be a flaw either in old film or in modern, unsuitable projectors. It isn't; it was intentional, to give visual distortion to aberrant behavior, to have a medium appropriate to the message, as it were. E.E. Cummings was soon doing similar things in poetry, and the work of Apollinaire in France, or of Hugo Ball and the Dada group in Switzerland provided appropriate parallels.[15]

Sennett hit his stride in 1914 and 1915, but even as he did so business matters began to affect his operation just as they had Griffith's. Even as *Tillie's Punctured Romance* (1914) gave Charlie Chaplin his first major role and assured Sennett a permanent place in the history of art, financial difficulties were pushing him toward a 1915 reorganization into the Triangle Film Corporation, in association with Harry Aitken, Griffith, and Thomas Ince. A big new studio was soon under construction, but as with so much of modernist art, the process of institutionalization was a sign that truly creative work was about over. The anarchic quality of the early Sennett films gave way to formula, and the director soon had crews making two-reelers all over California. The antics became less earthy and vulgar, characters seemed somewhat more human, and plots became almost intelligible. The Triangle Distribution Corporation, formed late in 1916, led to increased business pressure to return to one-reelers and to make higher profits, and Sennett soon sold out. On 1 July 1917, production was over, although Triangle continued to grind out spiritless imitations until it joined Biograph in the oblivion that awaited film companies that had lost their most gifted creative spirits. Sennett himself continued to make pictures independently, but he was no longer an important innovator.[16]

IV

As the limits of Sennett's lunatic vision became more apparent, his chief discovery became the foremost modernist in American film. Charles Chaplin gets short shrift in many film histories because of his later sexual and political associations and because he contributed little of a technical nature to the history of film. But Chaplin had far more to him than a fortuitous popularity. His work embodied several modernist themes better than anyone else's, his attitudes toward the United States and its political and moral phobias had far more merit than American critics liked to admit, and he brought into American modernism something only a foreigner of his background could: a genuine class consciousness.

Chaplin came out of an impoverished British theatrical family. He had no education worthy of the name; his father died young from the complications of chronic alcoholism. His chief memories were of his mother, an attractive performer ground down by misfortune into insanity. Trying to raise her children alone, she had only a short time on stage before her voice failed her, and she tried to keep the family to-

gether through nursing and sewing. Charlie was soon on the stage, acting with a troupe of clog dancers before his tenth birthday; thanks to his mother's incapacity, he was also periodically a resident in workhouses and orphanages. He was miserable. "Picasso had a blue period. We had a gray one, in which we lived on parochial charity, soup tickets and relief parcels."

As with so many young modernists, the theater was a world of formative experience. It not only provided a possible career, it liberated the mind from conventional restraints in behavior and morals. In Chaplin's case, it did this and more, and once again his mother was the important influence. "If it had not been for my mother I doubt if I could have made a success of pantomime," he recalled in 1918. "She was one of the greatest pantomime artists I have ever seen. She could sit for hours at a window, looking down at the people on the street and illustrating with her hands, eyes and facial expression just what was going on below." She would simultaneously offer a witty commentary. Through watching and listening, "I learned not only how to express my emotions with my hands and face, but also how to observe and study people." Small wonder that he carried this influence with him for many years. He recalled with special vividness, for example, the London Christmas spectacles involving clowns: pantomimes of *Jack and the Beanstalk* or *Cinderella*. "I used to watch the clowns in the pantomimes breathlessly . . . Every move they made registered on my young brain like a photograph. I used to try it all over when I got home." He then made the connection with the world of Mack Sennett: "It was slapstick stuff . . . What has happened is that pantomime, through motion picture developments, has taken the lead in the world's entertainment. My early study of the clowns in the London pantomimes has been of tremendous value to me."[17]

Britain offered few prospects for advancement, and Chaplin felt his chances were better in America. When the opportunity to play there arose he accepted quickly, opening in New York City on 3 October 1910. The show itself was a disaster, but critics singled Chaplin out as the best of a bad lot of performers. For over a year and a half, he played in New York and toured the country, finding the relative classlessness and the energy of the new country a relief after England. But he was an inveterate non-conformist and even at this early stage of his life, his idiosyncrasies impressed all who knew him. "He read books incessantly. One time he was trying to study Greek, but he gave it up after a few days and started to study yoga," Stan Laurel recalled. Yoga advocated a water cure, "so for a few days after that he ate nothing, just drank water for his meals." He loved music and carried his violin everywhere, having "the strings reversed so that he could play left-handed, and he would practice for hours." For a while he carried a cello around. "At these times he would always dress like a musician, a long fawn-colored overcoat with green velvet cuffs and collar and slouch

hat. And he'd let his hair grow long at the back. We never knew what he was going to do next. He was unpredictable."

In October 1912, the company returned to tour the United States and Canada, and Chaplin's break came the next summer. "I have had an offer from a moving picture company," he wrote his brother Sydney in August 1913, from Winnipeg; its name was Keystone, and he was "to take Fred Mace place. He is a big man in the movies. So you bet they think a lot of me." He had been negotiating for some time and was proud of his success. "I don't know whether you have seen any Keystone pictures but they are very funny, they also have some nice girls ect." He was soon in Los Angeles, "eager and anxious."

Although he gave Keystone credit for teaching him a lot, his time there was one of frustration with formulaic comedy. He clashed with both Sennett and Mabel Normand; only his increasing public acceptance saved his career and won him the right to direct his own comedies. He worried about cinematic syntax, especially matters pertaining to the placing of the camera and the angle of the shots. He learned about improvisation. But his big breakthrough was in the development of his persona, the tramp in costume who made him famous. One day Sennett told him to put on a comedy make-up and develop some gags; "anything will do." Chaplin had no notion of what he should do. He wandered about the wardrobe area, trying on baggy pants, big shoes, hat and cane. "I wanted everything a contradiction: the pants baggy the coat tight, the hat small and the shoes large." Unsure about what age he should be, he added a moustache with the thought that Sennett probably wanted him to look older. Once in the clothes, the character came alive. "I began to know him, and by the time I walked onto the stage he was fully born. When I confronted Sennett I assumed the character and strutted about, swinging my cane and parading before him." Sennett responded immediately and began giggling; Chaplin began to explain him. Quoting the version in his autobiography: "You know this fellow is many-sided, a tramp, a gentleman, a poet, a dreamer, a lonely fellow, always hopeful of romance and adventure. He would have you believe he is a scientist, a musician, a duke, a polo player." He was also, however, "not above picking up cigarette butts or robbing a baby of its candy. And, of course, if the occasion warrants it, he will kick a lady in the rear—but only in extreme anger." Once born, the character all but took over silent films, starting with *Mabel's Strange Predicament* and *Kid Auto Races at Venice, California*, released in reverse order, for some reason, on 9 and 7 February 1914.[18]

By the summer of 1914, Chaplin was restless with Keystone and thinking of going out on his own. He received lucrative offers and wrote Sydney that he ought to come to America and join him. Sydney agreed, and by November the two were working at Keystone but looking for better opportunities. These came from the Essanay Film Manufacturing Company of Chicago. Despite fiscal niggardliness, a factory atmo-

sphere and the Chicago weather, Chaplin signed on and was soon improvising his first pictures. But he hated the city and insisted on shifting to Niles, California, the West Coast office of the firm. He worked there briefly but found conditions inadequate, and soon the company was at work in Los Angeles. By spring, 1915, things were falling into place; *Work* appeared on 21 June 1915.

Work is in its way a modernist classic, marrying a kind of lunatic comedy with a serious social message. It built, as did Chaplin's costume and tendency to pantomime, on generations of vaudeville-style comedy. Paperhangers, like carpenters and plumbers, were staples of the stage with instant appeal to anyone who had ever attempted to make or purchase home repairs. Charlie and his boss reduced a middle class home to sticky chaos and then blew it up, with the help of a recalcitrant oven. But the comedy also conveyed a subtext about the tortures of manual labor. Charlie was the victim, maneuvering a cart packed with the most awkward sort of equipment through streets full of tram tracks, traffic, and manholes. The imagery was one of slavery even before the assault on the middle class began, and Charlie even felt a taste of the boss' whip, reducing him to animal status as a human drayhorse. The family capable of paying for such service had a spluttering husband, a wife who flaunted her sexuality and had a pseudo-aristocratic lover, and a maid who seemed incapable of any duty more serious than smiling. The wife was an especially vicious portrait, paranoid about thieves and convinced the workmen would rob her blind. Charlie and the boss effectively parodied her obsessions, and in short order brought her world down around her ears.

Innocent of Marxist theory and economic conditions in most other countries, Americans took this as slapstick rather than class struggle, but Chaplin was no innocent—some phrase like "outrageous subtlety" seems necessary here. He was safe enough in those days before the Russian Revolution, but on other issues he was on thinner ice. As he pointed out later in the early pages of his autobiography: "To gauge the morals of our family by commonplace standards would be as erroneous as putting a thermometer in boiling water." Neither parent had observed the Christian conventions of sexual monogamy, and Chaplin took them seriously later only when they got him into marital trouble, as they did. He led an austere and lonely life by choice, but he liked pretty women and consummated those relationships that came along. Both in *Work* and in *A Woman* which followed it, his libertarian attitudes were evident. In *Work* it was all harmless enough, along the lines of making a lamp and shade into a hula dancer, but in *A Woman*, with its insistence on bisexuality and female impersonation, he came close to stirring the animosity of his more conventional viewers. The film was even banned for awhile in Scandinavia, a remarkable achievement.

In other pictures, Chaplin played with dreams, religious hypocrisy, and overt homosexuality, all common enough with modernists. But he

also portrayed immigration officials who treated arriving poor people
as cattle, vagrants who were victims of society, and prisoners with whom
the audience was expected to identify—all socially conscious material
unusual in American modernism. This juxtaposition of the personal
and the social in part constitutes the important role Chaplin played
here. He was the most popular of the foreigners who tried to make
Americans see something beyond the conventions of progressivism in
politics and realism in art. In summing up his ambivalence about
America, he wrote: "This time I felt at home in the states—a foreigner
among foreigners, allied with the rest." He read Emerson and Inger-
soll, he planned to remain, but he never felt at home.

People had too much fun watching Chaplin to think about the sub-
texts of his work. But he was a careful craftsman and he grew fussier
as he gained control over his operations. He had to work hard to make
a scene look easy, to repeat scenes over and over again to achieve a
successful improvisation. The humor masked a world of violence and
vulgarity, with the infliction of much pain in the tradition of Sennett
films. The Tramp was a man of fantasy and infinite malleability. He
fulfilled his wishes in a fashion Freud might have approved, and adapted
to so many possibilities that he seemed to have no personality of his
own. Solipsistically, he adjusted the world to meet his own demands,
and expressed hostility to institutions, from policemen and jails to cap-
italists and factories. He loved to juxtapose opposites: kissing and
punching the same man, for example. To dwell on the realism of a
Chaplin film would be quite ridiculous, for much of the point was in
the absurdity of the Tramp's predicaments, of the impossibility of what
was appearing on the screen. Walter Kerr has been the best critic of
this side of Chaplin's achievement, calling attention to the instability of
the character's personality and the permutability of the objects around
him. "What interested him, what delighted him, was instability itself,
the fact that things are certainly not what they seem . . ." Just as the
people adapted, so a dagger could become a toothpick or a tableknife,
scallions become billiard balls, and beer bottles binoculars. The simplest
tasks took on complex overtones, as Chaplin dealt out plates like cards,
shot dice like a baseball pitcher, or used a cooking spoon as a ukelele.
This was modernism coming in by the funny bone.

Chaplin was not unaware of what he was doing. "More than sex or
infantile aberrations, I believe most of our ideational compulsions stem
from atavistic causes." He did not need to read in Freud or Jung to
know that "life is conflict and pain. Instinctively, all my clowning was
based on this." He accepted the thesis that Max Eastman propounded
in *The Sense of Humor* (1921), that humor was derived from playful
pain. Men were as masochistic as children having fun while killing each
other off at cowboys and Indians. But Chaplin took things a bit fur-
ther. Humor for him "is the subtle discrepancy we discern in what ap-

pears to be normal behavior. In other words, through humor, we see in what seems rational, the irrational . . ."[19]

V

Thus even before America entered the war in 1917, the film had established its essential syntax and many of its implications and effects were modernist. *"The art of the photoplay has developed so many new features of its own, features which have not even any similarity to the technique of the stage that the question arises: is it not really a new art which long since left behind the mere film reproduction of the theater and which ought to be acknowledged in its own esthetic independence?"* asked Hugo Münsterberg. A leading psychologist whom William James himself had brought to America, Münsterberg recognized that the photoplay should "be classed as an art in itself under entirely new mental life conditions." He drew special attention to the device now known as the flash-back: it provides "an objectivation of our memory function." In both the close-up and the flash-back *"the act which in the ordinary theater would go on in our mind alone is here in the photoplay projected into the pictures themselves. It is as if reality has lost its own continuous connection and become shaped by the demands of our soul."* The focus was thus on the process of the mind, its function and memory. "In our mind past and future become intertwined with the present. The photoplay obeys the laws of the mind rather than those of the outer world." In doing so, it was inherently a modernist medium, and through it Los Angeles was an important city of origin for modernist ideas.[20]

Coincidentally, the industry itself reached a point of maturity. By 1917, "the classical model became dominant in the sense that most American fiction films since that moment employed fundamentally similar narrative, temporal, and spatial systems," three leading film critics have pointed out. "At the same time, the studio mode of production had become organized: detailed division of labor, the continuity script, and a hierarchial managerial system became the principal filmmaking procedures." From roughly this point on, sad to say, film had less and less to offer to other arts. Having achieved technical maturity it sank into formula and became part of the accepted world of middlebrow culture. Even the arrival of sound a decade later made no difference; in fact, it may have detracted from the impact film had.[21]

CHAPTER 5

Baltimore

Unlike the other incubators of American modernism, Baltimore produced no identifiable group that brought gifted people from different families together in pursuit of new artistic achievements. It had no tradition of innovative cultural activity. But Baltimore had two advantages when it came to producing modernist sensibilities. It had a substantial, established bourgeoisie not based on ideals which were exclusively British or Protestant in origin; and it had a private university which drew talented graduate students from all over the country.

Baltimore had never been typical in its ethnic composition or cultural orientation. It was Southern rather than Yankee, yet unashamedly commercial; it was ethnically diverse, yet long settled. In 1890, less than sixteen percent of its citizens had been born abroad: about 69,000 out of a total population of 450,000. The predominant group in the city was German: fully one-fourth of the population was either German-born or the children of German immigrants. Successful in business, the Germans had newspapers in their own language, formed clubs and labor unions, ran their own churches and charities, and felt no conflict between their citizenship and their cultural origins. Secure in their knowledge of German literary and musical achievements, they had few of the puritanical reservations about the arts that impoverished the lives of English-speaking Americans. If few bourgeois pushed careers in the arts on their children, few protested if the children became interested. Houses had magazines with pictures as well as books; pianos, stringed instruments, and music lessons were available.

The city was cosmopolitan beyond the norm. Led by James Cardinal Gibbons, the Roman Catholic Church was fully integrated into civic life and displayed little of the clannishness that marked it elsewhere. Its leading layman, Charles J. Bonaparte, was a wealthy graduate of the Harvard Law School who was friendly to efforts at conservative reform; he soon became Secretary of the Navy and then Attorney General, through the sponsorship of his friend Theodore Roosevelt. Even more unusual in the America of the 1890s, the Jewish community was also vigorously involved with local political and civic affairs. German Jews such as Lewis Putzel and Isaac Loeb Straus both represented the

city in the House of Delegates and were active in reform efforts at the turn of the century. The historian of progressivism in the city has estimated that Roman Catholics provided eight percent of the active group, and Jews a remarkable sixteen percent, highly unusual proportions for what was in essence an attempt to restore Protestant moral values to the politics of a rapidly changing country.[1]

The crucial institution in the shaping of Baltimore culture was the Johns Hopkins University. The first American graduate school of international stature, the Hopkins had opened its doors in 1876 and immediately attracted major scholars. Including such alumni as John Dewey and Woodrow Wilson, it helped spread new ideas in both the liberal arts and the sciences. In medicine, the university was arguably the best in the world: it attracted William Henry Welch in 1885 to organize the medical school, and in 1889 William Osler arrived to become chief physician at the university hospital. Welch had trained in New York and Germany, and Osler in Montreal, England, and Germany. Together they represented the highest standards of medical science, and with Howard A. Kelly and William B. Halstead they made the Hopkins preeminent. Their presence was not only crucial in focusing local reform efforts in matters relating to public health; it also meant that gifted students who otherwise would have found no reason to live in the city came to Baltimore. If such students did come, they could hardly remain unaware of the city's 67,000 resident blacks. The Johns Hopkins Hospital and Medical School were located in one of the black slum areas and thus medical students became intimately acquainted with the largest unassimilated minority group in the country.[2]

In this context the German-American bourgeoisie produced two families that contributed to the history of American modernism—one Jewish, the other Gentile. In doing so it illustrated some of the persistent paradoxes of the modernist experience—the presence of nonconformity within conformity, of deviance within normality, of hostility to capitalism within capitalism, of cosmopolitanism within provincialism.

II

Properly speaking, the family of Daniel and Amelia Stein had no home town. Daniel's eldest brother, Meyer Stein, had emigrated to Baltimore in 1841, and within months he had settled in and brought over his parents and four brothers, Daniel being eight at the time. Family members ran a retail clothing store that specialized in imported textiles, but quarreled so often that they broke up; Daniel and Solomon opened another store in Pittsburgh in 1862. Even this venture foundered, chiefly due to Daniel's bad temper and to personal animosities between their wives. The families lived in twin houses in the suburb of Allegheny, and tension was inescapable. Leo was born in 1872 and Gertrude in

1874, and as soon as she was able to travel safely the brothers dissolved their partnership. Solomon moved to New York City to grow wealthy as a banker, while Daniel pursued business interests in Europe. Although Gertrude Stein had no memories of Allegheny as an adult, she delighted in having been born in a place that proved so difficult for French bureaucrats to spell, in a family from the "very respectable middle class." "She always says that she is very grateful not to have been born of an intellectual family, she has a horror of what she calls intellectual people."

For the next five years, Leo and Gertrude lived in Vienna and Paris in a family that included a Baltimore aunt, Rachel Keyser, as well as their two brothers and sister. But Amelia was homesick and lonely due to her husband's long business trips, and they returned in 1879; they considered staying in New York City and forming a new partnership with Solomon; they lingered in Baltimore with old friends and relatives; but in the end moved to East Oakland, California and the life Gertrude recalled fondly in *The Making of Americans*. This proved to be the family's first lengthy residence in an area almost empty of Jews. Leo recalled occasionally hearing an anti-Semitic remark, but for Gertrude Jewishness seemed irrelevant. The sunshine, good food, and sense of physical freedom remained with her for life. The Steins had servants, tutors, and a governess, and as the youngest child she was pampered. Leo could not get along with his father; he remembered the same period for its conflicts over eating and thought it the origin of his lifelong digestive disorders. The word Gertrude usually used in describing Daniel Stein was "depressing" and insofar as the two youngest children experienced a benign father figure, they did so in the person of their eldest brother, Michael.

Intense and argumentative, Leo was always a step or two ahead of Gertrude, and in her memory those steps led most fruitfully to the theater. Actors in those days, she recalled, liked the West Coast and because of the great distances involved tended to stay for extended periods. Anyone could go, she insisted—always taking her family's privileged financial circumstances as a norm—and she went as often as she wished. She long recalled the escape across the ice in the play of *Uncle Tom's Cabin*, the fight in *Faust*, Buffalo Bill and the Indian attack, and in *Lohengrin* "the swan being changed into a boy." She could remember Booth playing Hamlet and she rested "untroubled" in the sound of Bernhardt's French. She had a taste for melodrama and the theater as spectacle—she compared a child's experience of it to a circus—but did retain one feeling that was important to her later career: "nothing is more interesting to know about the theatre than the relation of sight and sound."

By the late 1880s, however, life in Oakland was clouded. Amelia slowly died of cancer. Mike returned from the Hopkins to manage the Omnibus Cable Company and provide family stability, but without Amelia

both Leo and Gertrude were more exposed to their father's vagaries; their sister Bertha could do little more than keep the household running. In 1891, Daniel also died and Mike became the legal guardian of his youngest siblings. The next year Leo and Gertrude returned to Baltimore, and "home" became the house of Aunt Fanny Bachrach. While Leo soon went on to Harvard, Gertrude settled into a more gregarious lifestyle than the one she was used to. She enjoyed "the cheerful life of all her aunts and uncles," and traveled occasionally to New York City, still the home of Uncle Solomon and Aunt Pauline Stein, to see operas and visit museums. Their son Fred was at Harvard with Leo and became his life-long friend. Gertrude soon grew restless without Leo to lead the way. Despite her informal education and lack of any high school degree, she entered the Harvard Annex (shortly to become Radcliffe College) as a special student. Mike, meanwhile, remained in California. He reorganized the family business and sold out to Collis P. Huntington, staying on as the superintendent of the Market Street Railway Company. He disliked business life, however, and retired in 1903 to lead a life of leisure in Europe.[3]

Both Leo and Gertrude enjoyed Cambridge in the nineties. They shared interests in biological and philosophical topics and the new elective system enabled them to pursue their whims with little faculty harassment. Although Leo continued to provide intellectual and social guidance, Gertrude lived in a boardinghouse where she could meet a variety of people, and was active in the Philosophy Club and the Idler's Club, a dramatic group. She was a well-adjusted person difficult to distinguish from her peers. Leo, one of his friends recalled, tended to be off pursuing his own agenda: "He was reserved, neurotic, probably partly ill, and his chief interest lay in the field of art." He also tended even then to subject "his sister to constant criticism . . ." Gertrude's swelling size and passive friendliness foreshadowed her future as hostess in Paris, but nothing in her writings or behavior indicated any talent with words or ability to write in an original way.

One of the more memorable things Leo did during his undergraduate career was to leave for a year. He spent the summer of 1895 in France and Germany, haunting the Louvre, informing Gertrude of his passionate devotion to the work of Rembrandt and Rubens and his disappointment at much of the architecture he saw in both countries. Teaming up with his cousin Fred and recent Harvard graduate Hutchins Hapgood, Leo then continued around the world, recording stops in Kyoto, Canton, Ceylon, and Egypt—he assured his sister than climbing a pyramid was "hardly worth the effort except that it gives you a realizing sense of its size." The three got a bit on each other's nerves due to Leo's inability to "leave the slightest subject without critical analysis. He and I argued the livelong days," Hapgood recalled in the late 1930s. Leo was "almost always mentally irritated," and the "slightest flaw, real or imaginary, in his companion's statements, caused in him intellectual

indignation of the most intense kind." He seemed to feel that "anything said by anybody except himself needed immediate denial or at least substantial modification." The three then returned to Harvard, where Leo and Gertrude both completed their undergraduate work and Hapgood took an A.M. The Steins and Hapgood subsequently crossed paths many times over the next twenty years.[4]

"The important person in Gertrude Stein's Radcliffe life was William James," she recalled in the early 1930s. She worked in his advanced seminar, despite inadequate preparation—but then James was never one to worry much about academic criteria. He enjoyed working with her and regarded her as a promising student of psychology. In the seminar for 1895–96, one of James' most outstanding students, Leon Solomons, working with Arthur Lachman, who later became a professional chemist, initiated a study of automatic writing that led to Stein's first publications and had a long-range impact on her literary production. When Lachman left Harvard, Stein took his place. In the 1930s, when Stein's growing fame caused controversy about her training and methods, he wrote a brief memoir of the collaboration.

At that time, Gertrude was "a heavy-set, ungainly young woman, very mannish in her appearance." "She always wore black, and her somewhat ample figure was never corseted." She frequently looked "untidy," "awkward with her hands," seemed untalented in art or music, and did no knitting or needlework. Such a sexist description probably said as much about Lachman's views of womanhood as about Stein. More to the point was his description of her as "never a real student," and someone given to declaring as factual, chemical data which were demonstrably untrue. He thought of her as a wonderful conversationalist, "who brought an intelligence that even at this early stage of her career was remarkably keen and an obvious gift for fascinating a great variety of people."

Leon Solomons was "one of the most remarkable men it has been my good fortune to know," Lachman recalled. "He was a man of unusual mental powers and strongly impressed his ability on all who were fortunate enough to know him, even to more or less casual acquaintances. While not a dominating personality, he was widely read, deeply thoughtful, and enormously stimulating." They had been friends from high school and had studied chemistry together at the University of California. Solomons then went to Cambridge where he studied mathematical physics before switching to psychology. His one "soft spot was spiritualism," an interest he had acquired from his family, "who were devout believers in occult phenomena." But as his studies in physical science progressed he became increasingly detached about the subject. "Together we had read studies on this subject by eminent scientists such as Crooks, Lodge, James, Zollner and others." Under William James, such study seemed not only natural but reputable, and led to experiments in related areas. Fearing fraud, Solomons and Lachman con-

cluded that the only experimental approach open to them "in which trickery was definitely ruled out lay in the study of automatic phenomena, or more particularly, what is known as automatic writing." Their method was simple. "One of us would be armed with a pencil or ouija board, and the other would read aloud to him. The pencil was allowed to work its will and at the end of the experiment the 'readee' attempted to recall what had been read to him. At times we even went so far that the subject would be reading one story and manipulating the pencil at the same time, whereas the other operator would read an entirely different story."

On the whole, the results of these experiments were "inconclusive. They proved that this phenomenon was merely one aspect of a rather common ability of the human mind. Any good court reporter is an example of how the finger can perform accurately while the mind is partly distracted elsewhere." He also thought that pianists who could play and talk at the same time provided another example. In the beginning of their work, "the markings on the paper consisted almost exclusively of doodlings. Later, words appeared, frequently misspelled." On infrequent occasions, "sentences would appear, their subject matter quite irrelevant." Solomons became proficient in writing words down, but as far as Lachman was aware, Stein did not go much beyond the doodling stage. "The experiments were discontinued shortly after Gertrude Stein took over and were briefly published by her in the Harvard Psychological Review," but they proved of little importance: "Their chief characteristic was that repetition of isolated and more or less meaningless words upon which Gertrude herself later rose to fame Whether consciously or deliberately, her literary style undoubtedly stems from her experiments in automatic writing."[5]

Leon Solomons left what he referred to as "that barbarous hole known as Cambridge" in 1896 to return to California; his surviving letters indicated the serious nature of his relationship to Stein and of her approach to her work as an undergraduate. In October he outlined his current plans, and then asked: "Are you going to follow out our original plan of making two investigations, one on fatigue, as a simple question in Physiological Psychology, and another on the applications of these principles to the examination question; or are you going to lump the whole business"? While he pursued "the subject of cutaneous sensibility," and "Locomotor Ataxia" as an apprentice psychologist, he also worried about melancholia among Jews, persistent ill health, and his discouraging search for a job. He spelled out the work he intended to pursue, while she in turn assured him that her own character was changing: she who had been broad, shallow, and philosophical in Cambridge would become more precise and scientific as a medical student. He returned briefly to Cambridge, visited his former teachers, and edited her second article: ". . . you ought to be ashamed of yourself for the careless manner in which you have written it up." She hurt her

good material with a shoddy writing style. The article appeared with this help, but Solomons did not long survive, dying at age 27.[6]

The death of Leon Solomons in 1900 produced one of the few surviving notes between William James and Gertrude Stein, James remarking, as everyone did, how promising Solomons had been and mentioning his own persistent ill health. The note was cordial and indicated ties beyond the usual affection between a famous professor and two of his best students. This personal bond aside, James' impact on Stein remained problematic. She admired him without reservation for life; she began seminal work of her own under his direction; she presumably read through the "Jimmy," the abbreviated version of *The Principles of Psychology,* since it was a required text in a philosophy course that Stein took as a freshman. But she was no intellectual and displayed no interest in James' later work.

Leo Stein was the one who followed James' development and who tried to integrate Jamesian insights into both his life and his aesthetics. He read *The Varieties of Religious Experience* when it appeared, finding it a "splendidly broad-minded sane treatment of the theme" and a book which "ought to have a very considerable influence on the study of the subject. It was eminently desirable that fresh air should be allowed to blow in on that theme and thanks are due to James for opening that window." After the lectures in *Pragmatism* appeared, he found James "a wonder" and wrote a friend that "James goes directly to my most innards in Phil. as Shakespeare and Keats do in poetry. But the apprehension is of course much more complete because my own thinking goes so absolutely on all fours with his." "The genuine coherent grip of his mind and his marvellous power of expression delight me more and more in every reading and re-reading of his books and the crass incapacity of brilliant thinkers but unimaginatives had led me to much reflection on the subject of criticism." This reflection did not produce anything new in his mind, "but has simply intensified my conviction that the pragmatic power required for valid critical work is very great, and that most critics fail hopelessly because, leaving the question of their talents aside, they do not start with this implicit proposition."

Leo then turned back to *The Principles of Psychology*—the full-length "James," not the "Jimmy"—and read it "with great joy and wished that there had been 3,000 pages instead of only 1,400." When James died in 1910, he recorded the "painful shock" it gave him in a letter to Gertrude. He brooded continuously about James' legacy and wrote long letters that he delayed sending or did not send at all, as if he were working out the implications of a book on his friends. In one outburst in 1911, he dwelt on "pragmatism which is nothing but a doctrine as to how thinking actually goes on." He threw out most traditional problems, even those like free will and determinism that James and Henri Bergson worried about: "Elan Vital and durée reelle are merely verbal makeshifts like the rest." As the words poured out of him, he occasion-

ally hit on ideas that had implications for modernist art. "In my belief everything that can be known is spacial. Ideas are in space pain is in space emotions are spacial facts." "I believe that consciousness is nothing more nor less than binocular vision which means stereoscopic vision." He expressed contempt for metaphysics and mechanistic conceptions and criticized James' treatment of these issues. He then concluded: "My business for some time to come is self realization."

Like so many intellectuals, Leo dwelt on his problems without making a book out of them, his mind changing so fast that neither his pen nor his attention span could keep up. He lapsed into silence for over a year, developing his ideas on consciousness, and then lost interest in them while involved in a love affair. But he revered James' memory and philosophy for life. As late as 1941, he was still referring to "me and Billy James" as "the only really concrete-minded people I knew," and insisting that "I, as was right and proper, discovered pragmatism independently."[7]

III

By the fall of 1897, Leo and Gertrude were back in Baltimore, Leo pursuing his interests in biology at the Hopkins, Gertrude studying in the Medical School. Neither settled into serious professional study: Leo still haunted art museums and after three years left for Florence and the pursuit of a career in art; Gertrude lasted four years, but after a brave start she confessed her boredom to all who listened and failed to complete her degree. In her case, however, the Baltimore residence proved crucial for both her life and her work. This was the period in which she came to terms with her sexual orientation. Already a Jew in a Gentile world and a woman in a male academic environment, she realized that she was a lesbian in her personal life. She was a writer, not a doctor. Her four years in Baltimore, and the succeeding ones in Europe during which she digested the Baltimore experience, shaped her modernism in form, style, and character portrayal.

At first, brother and sister lived together, with the assistance of a German housekeeper, Lena Lebender. He began to collect the Japanese prints that marked the beginning of so many Americans' interest in non-Western art; both of them cultivated friends, with Leo taking the lead. The most enduring of these friendships turned out to be Gertrude's with the sisters Claribel and Etta Cone, like the Steins the offspring of a German-Jewish immigrant. Their father had been a wholesale grocer and their brothers were getting rich running the Cone Mills, makers and exporters of textiles. An independent eccentric, Claribel had graduated from the Woman's Medical College in 1890 but refused to practice medicine because she disliked contact with patients. Instead, she preferred to research and teach, and maintained a continuing relationship to the Pathology Department at the Hopkins. Etta was qui-

eter and less assertive, spending more time on family obligations and on art. Chiefly under Leo's stimulation, she began to buy pictures: with Gertrude, she was also an avid shopper for less esoteric goods, such as clothing. The curious combination of medical knowledge, the purchase of art, and the accumulation of bourgeois goods persisted as a social bond between the sisters and Gertrude for many years, continuing happily with Alice B. Toklas as the fourth member when she and Gertrude began to live together. In a curious way, the relationship between Stein and Toklas resembled that between Claribel and Etta Cone, the strong and forceful eccentric with the milder and more domestic helpmate.[8]

Baltimore also included a different social set that took shape while Leo and Gertrude lived together but that persisted and changed its contours after his departure in 1900. This was a group of college women, often of Quaker background, who were busily ridding themselves of Victorian conventions in ideas, dress, behavior, and sexuality. One of the leaders of the group was Mabel Haynes; one of the less forceful participants was May Bookstaver. Haynes and Bookstaver developed a close romantic relationship, about which Stein for a long time remained oblivious. Naive, picturing herself as unemotional and mistrustful of passion, not really aware of what was happening to her, Stein developed something of a crush on Bookstaver. As this deepened into a lesbian attachment, Stein discovered that Haynes was her rival for Bookstaver's affections, and went through a period of confusion, depression, and travel that solved nothing.

The affair did supply her with material for writing. In 1903, even before it was over, she made abortive attempts to create art out of her misery. She worked on four related projects over the next decade or so, often literally sitting down with the letters that she and May had exchanged, letters that others had written to her, and at times letters that she solicited to provide her with good material. No writer has ever been more literally autobiographical than Stein in these efforts. In a fit of rage in the early 1930s, Toklas destroyed much of the evidence relating to her predecessor in Stein's affections, but she assured interviewers that the letters did exist and that Stein often wrote by laying them out and weaving them into her prose. Such procedures raise questions about the validity of quoting from "fiction" to analyze living people, and no one should be deceived that the writings have the status of history. They don't; they have some validity as to mood and provide useful hints to scholars. What they do display is a set of obsessions, a style of psychological analysis, and a developing mode of expression that constituted one important American contribution to modernism.[9]

Stein began to keep notebooks for what became *The Making of Americans* in England in 1902. While keeping in touch with May by post, she accompanied her brother to Haslemere, where Bernard Berenson lived with a group of British and American literati that included his brother-in-law, Bertrand Russell; and to a flat in Bloomsbury. The atmosphere

in Haslemere was pleasantly distracting, but London proved lonely and gloomy. As she haunted the British Museum and read widely in the literature of England from the fifteenth through the nineteenth centuries, she wrote down booklists and quotations that appealed to her. She was interested in narrative and in the personality types of the people she knew. When she returned to America and her hothouse emotional life, this reading tended to merge with her life; conversation and personal letters mixed with the residue of her reading at the British Museum. *The Making of Americans* began as an attempt to bring it all together, to write a long traditional novel about her family and herself and their places in American history. While visiting New York City in 1903, she wrote several chapters. They reflected her reading all too obviously—Lyly's *Euphues* does not mix well with either Trollope or the American landscape—and were based on events in the lives of the New York branch of the Stein family and an unfortunate marriage which one daughter made. Stein called the family the Dehnings and conceived the book as a conventional Victorian morality tale of a girl who would not take family advice and married the wrong man.

Had not Stein gone on to write radically different books, no one would pay the surviving early fragment much attention. It has no literary merit, yet retains biographical importance. Buried in the literary affectations were attitudes important for her career and its impact, and as the manuscript noted in passing, "beginnings are important." The fragment was admiring of "the rare privilege" "of being American" and somewhat allusively celebrated the immigrant, bourgeois Jewish experience. "We need only realise our parents, remember our grandparents and know ourselves and our history is complete." In the face of "the breaking Anglo Saxon wave" that such immigrants faced, they could begin with nothing, but, "peddling through the country," progress respectably into the middle class: "I am strong to declare even here in the heart of individualistic America that a material middle class with its straightened bond of family is the one thing always healthy, human, vital and from which has always sprung the best the world can know."

The fragment had curious premonitions of Stein's later style. One paragraph used the word "proud" five times in describing Mrs. Dehning; others used the word "type," as in "that dubious character the adventurer type"; or "nature," as in the lives of young women who have "those intenser natures that by their understanding make each incident into a situation"; or "ideal," as in Henry Hersland being "a man who embodied her ideal"—each indicating an interest in abstract generalization about human behavior that stood halfway between her psychological studies under William James and her mature fictional style, in which individual behavior always illustrated some generalization. The most poignant paragraphs were the two that, in the midst of the Victorian archaism of language and bourgeois clutter of possessions, defended the role of the eccentric daughter that Stein knew she was. There

could be "nothing more attractive than a strain of singularity that yet keeps within the limits of conventional respectability; a singularity that is so to speak well dressed and well set up. This is the nearest approach the middle class young woman can hope to find to the indifference and distinction of the really noble." Americans even in her unusual family were not adjusted to the concept. "It takes time to make queer people time and certainty of place and means. Custom, passion and a feel for mother earth are needed to breed vital singularity in any man and also how poor we are in all these three."[10]

After producing this fragment, Stein deleted three introductory and about thirty-nine additional pages from her notebook and turned to a project even closer to her daily life. In doing so she gave up many of the clichés of the family novel—not only its style but also its attention to groups and the development of narrative over time—and concentrated on herself, the private Stein that remained the focus of most of her writing. Her subject was the lesbian triangle that had developed between herself, May Bookstaver, and Mabel Haynes, she and Mabel being rivals for May's affections. From Baltimore to Tangiers to London to New York and on to Italy, the chronology of the book closely followed her own tortured itinerary during the first years of the century. Gertrude was Adele, May became Helen Thomas, and Mabel became Mabel Neathe. Leo became a sexless cousin, all but invisible, and indeed men played no role in the story. Instead women took on masculine qualities: Adele "did thank God" that she "wasn't born a woman," and she congratulated Helen on being "the very brave man," while the narrative voice attributed "the more unobtrusive good manners of a gentleman" to Mabel. The book repeatedly dwelt on the deceptive nature of appearance and reality, as elements of character as well as sexual identity became problematic. Thus the description of Mabel Neathe: "It is one of the peculiarities of American womanhood that the body of a coquette often encloses the soul of a prude and the angular form of a spinster is possessed by a nature of the tropics."

The book repeated the concerns of the *Making of Americans* fragment. Adele continued to defend middle-class values, such as those concerning respectability, decency, and motherhood, while admitting her own individual non-conformity: "I am rejected by the class whose cause I preach but that has nothing to do with the case," she said. "I simply contend that the middle-class ideal which demands that people be affectionate, respectable, honest and content, that they avoid excitements and cultivate serenity is the ideal that appeals to me, it is in short the ideal of affectionate family life, of honorable business methods." She dwelt repeatedly on the appeal of America: the American flag "looked good," and the girl who had been so depressed and homesick in London rejoiced in the New York streets, "without mystery and without complexity," the buildings seeming "clean and straight and meagre and hard and white and high." In a "turgid and complex world"

such things were important: "I wanted to escape all that, I longed only for obvious, superficial, clean simplicity." Life in such a country had certain literary consequences: the "clear eyed Americanism" of Boston seemed to encourage a "ready intercourse, free comments and airy persiflage all without double meanings which created an atmosphere that never suggested for a moment the need to be on guard." She also mused further on "types" and "ideals" in personal relations, subjects that were growing in importance in her attempts to understand people.

These considerations aside, *Q.E.D.* or *Things as they are* retains historical importance as the first text to imply some of the formal consequences of modernist non-conformity. Just as Adele for a long time seemed unable to realize the true nature of Helen's relation to Mabel, she had trouble putting her own feelings into words. Respectable, bourgeois German-Jewish girls had no way of talking about lesbian passions. Bodies masked spirits, gestures and expressions meant several things at once, lovers found their pulses incorrectly adjusted, and no one knew where she stood. Ethics were inadequate to cover the situation. Adele worried about "One's right to do wrong." She had "not yet learned that things are not separated by such hard and fast lines," and that she should consider that "all things are relative." Words failed: "neither of them undertook to break the convention of silence which they had so completely adopted concerning the conditions of their relation." A writer found herself using a medium that by its very nature was inappropriate: "You hide yourself behind your silences." What after all could a writer write when words were inadequate or did not exist? Several of the crucial elements of modernist discourse lay here: the deception of surface, the relativism of ethics, the silence that is eloquent speech. Stein dated the manuscript 24 October 1903 and put it aside. In several ways it was obviously unpublishable at that time.[11]

Stein's relations with Bookstaver and Haynes were an obvious triangle, written up as such in *Q.E.D.* That catharsis was not enough, however, and in the late fall of 1904 and early winter of 1905 she returned to the theme in a disguised form, mixing the sexes and casting a figure somewhat like herself as a fourth, observing element. Stein had for years known the president of Bryn Mawr College, M. Carey Thomas, her housemate and colleague Mary (sometimes Mamie) Gwinn, and Alfred Hodder, a teacher of philosophy. Regarded as one of the most promising of the younger philosophers at Harvard in the eyes of William James and Josiah Royce, Hodder was a fascinating, erratic friend of Leo and Gertrude Stein and of Hutchins Hapgood. Cynical about academia, he nevertheless turned out an apprentice book which Leo much admired, and accepted a position at Bryn Mawr. There, despite having a wife and children, he became fascinated by Gwinn, and from 1896 to 1904 they conducted a relationship that kept students and faculty buzzing all the way to Baltimore and New York, as alumnae and friends chewed over the latest news. Hodder and Gwinn finally went to

Europe to marry. For Stein, who saw herself as resembling Hodder's long-suffering wife, a rather innocent Western American girl, the scandal was a triangle with obvious parallels to the Stein/Bookstaver/Haynes imbroglio.

In the manuscript finally published as *Fernhurst*, Stein began with a meditation on feminism and its progress in the America of her lifetime. Women had demanded their rights and in many ways achieved them in the West, at coeducational schools and women's colleges. But in her eyes, only some women were equal to men; most were not: "the great mass of the world's women should content themselves with attaining to womanhood." Such was a modernist comment on progressivism, with its assumptions about equality and the efficacy of suffrage, and in one sense the book then became a study of the unintended consequences of progressive reform, with Carey Thomas as Dean Helen Thornton, the woman who thought men and women equal, "with a mental reservation in favor of female superiority," as befitted the last in a long line of intolerant Quaker feminists. Fernhurst College was an extension of this attitude, an institution with the "dreadful task to decide for any young woman, what college shall make for her a character."

Into this gynecocracy, with its chatter about Swinburne, Wilde, Pater, and Henry James and its passionate discussions of "naive realism" in philosophy, came Philip Redfern, based chiefly on Hodder but also on another of Carey Thomas' rivals at Bryn Mawr, Woodrow Wilson. Courtly, Southern and egotistical, Redfern entered into that key word for both the novel and for modernism, a "relation" with Janet Bruce, the character based on Gwinn/Bookstaver. The ambiguity which lesbian relations once caused now included illicit heterosexual ones: "An observer would have found it difficult to tell from the mere appearance of this trio what their relation toward each other was." For Dean Thornton, relations were power: "It was impossible for her to be in relation with anything or anyone without controlling to the minutest detail." For Bruce, relations were experience: ". . . her deepest interest was in the varieties of human experience and her constant desire was to partake of all human relations," but she never succeeded "in really touching any human creature she knew." As for Redfern, he "never came into personal relations with any human being"; he wanted to be boss and his chivalry masked a contempt for others, but especially women. In such complex relationships, no one understood anyone else, nothing appeared the way it was in reality, and words no longer made sense. As Stein wrote about the talk between Redfern and his fiancée: "They spent much time in explaining to each other what neither ever quite understood." The line could be an epitaph for countless works usually labeled "modernist" and "post-modernist."

Fernhurst, like its predecessors, did not have much going for it as literature. Stein was working her ponderous, meditative way toward major insights that other writers put into works far more compelling

than her own. She could never achieve a consistent tone in her narrative voice, and she was forever telling readers what to think instead of showing them events worthy of making them think. The very closeness of her writing to the events in her life made them hard to put onto the page objectively. The woman who became the master of the witty epigram was a conversationalist, not a writer, one who inspired others to do things she could not do herself. *Fernhurst* too went into the drawer, to reappear in the Martha Hersland chapter of *The Making of Americans.*[12]

After she had settled in Europe, her memories of Baltimore continued to haunt her geographical imagination, even as her relations with May Bookstaver haunted her artistic imagination. In the spring of 1905 she began work on what became *Three Lives,* continuing for about a year. As her first publication to attract any notice, and a volume which was written in a relatively clear style, the book has had a significant place in literary history for some time. Much of this has been for the wrong reasons. Literary scholars have fastened on the influence of Flaubert, who supplied a precedent for the three seemingly realistic stories and their occasional echoes of the material in *Trois Contes;* interdisciplinary scholars with a knowledge of art history have taken the fleeting references to Cézanne in Stein's autobiography and insisted upon the mysterious relationships between paint and print. Both approaches have enough validity to encourage closer examination of the work, but yield little to anyone actually determining how Stein's creative faculties were working day to day. She herself told a friend in 1906 that she thought the book "a noble combination of Swift and Matisse," but so far no one has pursued those charming but very red herrings as they swim enticingly through her letters.[13]

Three Lives was most obviously a recollection of Stein's Baltimore. It appeared as Bridgepoint, with its German immigrant and black populations receiving foreground attention. The book was about outsiders, in other words, those people who like Stein did not fit into the American mainstream. It was also insistently medical; she included Dr. Jefferson Campbell as a major figure, a midwife and another doctor as minor ones, and various medical events that attracted their attention as the plots evolved. One of the requirements of the Johns Hopkins Medical School was that its students deliver babies, and they customarily did so in the black slums which bordered on the campus. Stein disliked the task, but she performed it; she also flunked obstetrics, which was the most obvious reason for her not taking her degree. But above all, the book is a continuation of the interest she had long displayed in character types, and of her ruminating about why she and May Bookstaver could never get their pulses synchronized. In his slow, repetitive, and obtuse thought processes, Dr. Jefferson Campbell was the male stand-in for Gertrude Stein and the Adele of *Q.E.D.;* Melanctha Herbert was a mulatto May Bookstaver, as mysterious in her sexual passions as He-

len Thomas in *Q.E.D.;* the third figure, a version perhaps of Mabel Haynes/Neathe, was Jane Harden. These parallels did not go very far and at best retain only antiquarian value. What was important was Stein's obsessive return to her own life, her relations with others, her identification with poor immigrant and black outsiders, and her attempts to fashion a language capable of conveying what she later termed the "prolonged" or "continuous present."

Three Lives had little unity apart from Stein's life in Baltimore. "The Good Anna" was based on the life of Lena Lebender, the devoted servant who took care of Stein and Emma Lootz after Leo left Baltimore; "The Gentle Lena" was apparently based on a story Lebender had told Stein about someone else's marital misfortunes. The style wavered from satire to realism, the subjects from sexual disaster to the antics of dogs, and readers have used non-analytical terms such as "realistic" or "shrewd" or "interesting" in characterizing them. In "Melanctha," which has received the most attention, the style seemed more consistent, in its repetitive way pointing to later experiments of Stein and others in portraying process, relation, and consciousness. All this was true, although it had the atmosphere of the lucky accident about it. Stein had been obsessive in her love for May and she wrote obsessively to get it out of her system. "Melanctha" was therapy as much as literature; it was important as an influence, as so many of Stein's works have been, without being artistically convincing. Six years after she completed it, one of her better friends unburdened himself to her frankly. Henri-Pierre Roché admitted that he found many lovely things in her work, but he compared it to a diamond mine, the diamonds scattered among other substances and requiring much "digging, finding, cleaning, polishing." He became angry with her; she spoiled her work "by those d repetitions, by so many words duplicate. Many repetitions have great 'purpose' and efficiency, but they have a sea of sisters which, I think, have perceivable meaning for nobody but you." He could only begin to read her when he felt strong and wanted "in a way to suffer." He soon became "giddy, then sea-sick, though there are islands to be seen . . . c'est une inundation l'hiver dans la campagne." He went on and on, protesting the prolixity and asking for revisions and cuts.[14]

The central message of the book came out in one of Dr. Campbell's agonized expressions of puzzlement. "I certainly do wonder, Miss Melanctha, I certainly do wonder, if we know right, you and me, what each other is really thinking. I certainly do wonder, Miss Melanctha, if we know at all really what each other means by what we are always saying," he complained. "I don't like to say to you what I don't know for very sure, and I certainly don't know for sure I know just all what you mean by what you are always saying to me." As the narrative voice says over a paragraph later: "He did not know very well just what Melanctha meant by what she was always saying to him." No, he certainly did not, and neither does the reader. Consciousness was the subject

and language was in the foreground instead of plot, character, and setting, but a little of this could go a long way with more readers than Roché.[15]

As for the book as a pioneering piece which explored the life of blacks from a white perspective, Stein had little of this in mind. She had wandered around the ghetto on her medical rounds but knew no blacks well. But writers had to use what they knew, and she knew very little about anything beyond her upper-middle-class female upbringing. "I am afraid that I can never write the great American novel," she wrote a friend. "I don't know how to sell on a margin or do anything with shorts or longs, so I have to content myself with niggers and servant girls and the foreign population generally." Hers was the language of slumming, of the picturesque; it was a historical accident that she had written her best work to date about the love life of a black woman. She had unconsciously identified loosely with those whom society ignored, knowing intuitively that blacks, foreigners, Jews, lesbians, women, and writers had probably better stick together when facing a society of Anglo-Saxon males. When later black writers such as Richard Wright, Eric Walrond, and Nella Larsen Imes praised the book for its insights into black speech and attitudes, Leo was quite right to hoot about the whole thing. The book "was really not about Negroes and had only Negro local color, and as the psychology of whites and Negroes of the same cultural grade is essentially the same, the extra psychology will give Negro psychology, provided he understands that cultural group," he told Walrond and repeated in a 1934 letter. In that sense the book was a racial compliment. It treated blacks as if they were whites; Jefferson Campbell's problems, after all, were Gertrude Stein's.[16]

In the summer of 1906, shortly after completing *Three Lives*, Stein returned to the manuscript of *The Making of Americans*. For the next two years she concentrated her efforts on the huge work, and for three more, until 1911, she worked at it, night after night. Her intentions were fairly clear: she wanted to use the Stein family as the basis for an analysis of the American experience. The two chief families in the work were both hers: the Dehnings were based loosely on the New York branch of the family; through the marriage of Julia Dehning and Alfred Hersland, they were related to the Herslands, loosely based on Stein's more immediate family. Bridgepoint, now a Baltimore with an a mixture of New York City and perhaps a touch of Cambridge, lingered on briefly as an East Coast geographical base of action; Gossols was the Oakland of Stein's childhood, absorbing more attention as the book went on. The points of emphasis that appeared in the early chapters and the Fernhurst episode achieved final form. The book was implicitly admiring of idiosyncrasy within a middle-class environment, celebratory of an America in which the author did not want to live. The author herself appeared fragmentarily in several characters, chiefly as Martha Hersland, but also in minor roles such as that of Hortense

Dehning, the baby of the family who was so much in awe of her elder brother. Leo Stein was a basis for David Hersland, whom Stein demoted to being Martha's kid brother and then killed off in a suffocating blanket of verbosity as the Stein menage in Paris was breaking up. Much of the interest which the book has retained for its few readers has been because of its value for Stein's biography. It remains a useful ur-source for her highly personal view of her family and its life in Baltimore and Oakland.

It has retained value as well as an attempt to work out Stein's final views on the psychological ideas she toyed with at Radcliffe. Despite her status as a favorite student of William James and Hugo Münsterberg, and the seriousness evident for a year or two in medical school, Stein always had a tendency to characterize people in a facile way. Her earliest articles had passages which some referee should have laughed out of the *Psychological Review,* and over the next decade she toyed with the idea that all people were either dependent/independent or independent/dependent in their "bottom natures," and that the way to determine such natures was to observe repetition in their lives. Sometime after the age of thirty, the patterns of repetition settled irrevocably, a person became who she was, and the job of chronicler was to portray the process in a kind of continuous present. Past and present merged, perspectives blended and a reader should be able to comprehend the whole of everyone all-at-once, the personal and the biographical becoming representative and abstract.[17]

Discussing the book twenty-five years after having completed it, Stein particularly stressed four ways in which *The Making of Americans* brought together modernist attitudes. In college she had become "more and more interested" in her "own mental and physical processes and less in that of others," discovering as she went that only through experience and not by talking and listening could she ever learn anything effectively. Medical school only confirmed her prejudice that "myself and my experiences were more actively interesting" to me than "the life inside of others." Second, she faced the problem of "putting down the complete conception" that she had of someone: she had acquired her sense of a person gradually "by listening seeing feeling and experience," but then when she had it she "had it completely at one time." The problem in *The Making of Americans,* then, was "to make a whole present of something that it had taken a great deal of time to find out, but it was a whole there then" and she had to express it as such. Third, she returned several times to the film. She could not recall whether she had even seen a film at the time she was writing, but that was not relevant: "I cannot repeat this too often anyone is of one's period and this our period was undoubtedly the period of the cinema and series production." What she was attempting in the book was "what the cinema was doing, I was making a continuous succession of the statement of what that person was until I had not many things but one thing." Fi-

nally, she thought her goals identifiably American in their modernism: "I am always trying to tell this thing that a space of time is a natural thing for an American to always have inside them as something in which they are continuously moving." Think of the obvious materials of American life, she concluded her lecture on how she wrote the book, "of cowboys, of movies, of detective stories, of anybody who goes anywhere or stays at home and is an American and you will realize that it is something strictly American to conceive a space that is filled with moving, a space of time that is filled always filled with moving and my first real effort to express this thing which is an American thing began in writing The Making of Americans."[18]

Many critics have seen the book as representing a literary counterpart to Picasso's analytic cubism, or an American version of Zola's Rougon-Macquart cycle. Both Picasso and Stein were presenting objects, however distorted, devoid of any symbolic meaning. Martha Hersland was one representation of Stein and Picasso's portrait of her another: neither photographic nor symbolic, but rather an essence or generalization of the specific case. As for the more literary parallels, the obvious ones to make were not so much to Zola as to Galsworthy or Mann. No one could pursue the ramifications of bourgeois marriage customs at greater length than Galsworthy, and no one better captured the sense of bourgeois blood as it thinned into aestheticism than Mann. As an artist, however, Stein was unworthy of mention in the same league with either. Part of this was lack of talent—as befitted a writer trying to escape narration, she was without narrative ability. Part was the inappropriate nature of her originality. Gifted at original insights into language, she had no skill in putting those gifts into any long work which could appeal to an audience which her personality had not already captured.

Much of the problem lay in her theorizing. It was as simple-minded as ever, and becoming obtuse in its context and connotations. The period in which Stein concentrated on the writing of her book was also that of the Otto Weininger vogue. To anyone familiar with either Weininger's life or major book, the interest which both Leo and Gertrude took in his ideas seemed preposterous; yet Leo thought him a genius and both brother and sister urged the book on friends in the United States. Such approval said all too much about some of the underlying compulsions within American modernism. For Weininger was that phenomenon that occasionally appeared in European cultural history, an anti-Semitic Jew. The son of a Jewish goldsmith who was a lover of the music of Wagner and himself an anti-Semite, Weininger was a precocious dandy who seemed brilliant in his potential yet deeply flawed in every achievement. He converted to Protestantism, traveled about Europe, and turned out a shoddy Ph.D. thesis for Friedrich Jodl at the University of Vienna. Published in expanded form as *Geschlecht und Charakter*, the book reflected not only its author's racial self-hatred,

but also his misogyny. Internalizing his father's contempt for his intellectually inferior mother, Weininger seized on an idea suggested to him by a friend who had been a patient of Freud. The gist of it was that every person is a combination of male and female qualities, and that the way these qualities operate in daily life is the key to human behavior. Weininger subsequently sought Freud out and forced the manuscript of his dissertation on him. Freud later claimed to be "the first to give an unfavorable opinion of it," even in the early version that had no overt anti-Semitism and less criticism of women. When *Geschlecht und Charakter* came out, Freud referred to it as "a rotten book" in a letter to Fliess. Whatever the relationship to Freud, certainly a minor one as far as Freud was concerned, Weininger was a tormented man who needed help. He seemed to feel that normal sexual relationships were impossible; he never had much to do with women. He may have been homosexual, and his book was tolerant of sexual deviation, but if so no data survived. He committed suicide in 1903.[19]

Weininger's book was published in English as *Sex and Character* in 1906. By 1908 it was a hot topic in the Stein circle, apparently because it stressed the way a completed individual could transcend time and place, conquering the drives and conflicts that were so tormenting. But the bulk of the book seemed an unlikely path to peace of mind. Amidst a parade of pseudo-scientific terms and statistics, the book asserted that "absolute sexual distinctions between all men on the one side and all women on the other do not exist"; and that "male and female, man and woman, must be considered only as types, and that the existing individuals . . . are mixtures of the types in different proportions." Women faced one put-down after another. They could not appreciate genius; they did not long for immortality; they were without logic; they had neither souls nor egos; they could never be geniuses: "A female genius is a contradiction in terms, for genius is simply intensified, perfectly developed, universally conscious maleness." The basic point was always the relation of this sexual nature to time: "The first general conclusion to be made is that the desire for timelessness, a craving for value, pervades all spheres of human activity. And this desire for real value, which is deeply bound up with the desire for power, is completely absent in the woman." As for Jews, a separate chapter effectively segregated them. They were not a race, people, or creed, but rather "a tendency of the mind." Great geniuses were commonly anti-Semitic, even if Jewish in origin; they could not escape the conclusion that "Judaism is saturated with femininity . . ."[20]

All this was not only a long way from Freud, it was foreign to every implication in the work of William James, so tolerant and pluralistic in his values. But neither Gertrude nor Leo were discriminating in their enthusiasms, and for Gertrude especially the book provided an outlet for her feeling of being "singular." She hated being a woman and was capable of denying that she was one; she was uncomfortable being a

Jew and systematically "forgot" her heritage; she approved of certain aspects of her life as an American, but as an adult she never wanted to live there. In *The Making of Americans,* these notions took odd shapes. Sexuality never really appeared, even though marriages formed the core of the book: Martha Hersland somehow managed to get herself married to Philip Redfern and pass through the first two years of marital life between paragraphs! The immigrant German-Jewish life of Baltimore became de-ethnicized as well as de-Semiticized. The comfortable bourgeois environment, with its rich, right American living, never had any tangible connection to the making of money. Stein did not like being a woman, being Jewish, or being involved with American business, and that was all there was to it.

The verbal consequences of these evasions were immense. Much of her seeming abstraction of language and of character types was really more a generalization from these unspoken tensions. She had no experience in the world, no career, no religion, and no sex, for the language that she knew could not talk easily about such things, the publishers she contacted would not print books that dealt with them, and audiences would not buy them if available. Silence was one response; verbosity and repetition were the other side of the same coin. The price of this non-conformity was great, for it meant as well that Stein never got the kind of critical help that she needed. As a much-cossetted younger sibling she was used only to praise anyway. Domestic praise coupled with public contempt meant that she never got trained. She never received good advice and would have been unlikely to take it if she did. She was spoiled both in the basic sense in which an indulged child is spoiled, and in the larger sense in that her work was spoiled. It grew only surreptitiously, in the dark; it did not have to make sense.

That is why she could write some of the odd passages in her notebooks. Picasso, for example: he "has a maleness that belongs to genius. Moi ausi." The French was peccable, as it often was, and the idea daft. Yet to anyone recently come from reading Weininger, it made a mad kind of sense. Like so much of modernism.[21]

IV

Gertrude Stein and Henry Louis Mencken make an odd couple, establishing the parameters of creative originality in modernist thinking. Stein exploited her inability to communicate with America into the most extreme examples of modernist discourse to achieve influence; Mencken sampled modernism, allied himself to it tactically to achieve common purposes, and withdrew into an influential conservatism. Stein became the Mother of the next generation of modernists; Mencken the Father of the next generation of Tory cynics. The man who seemed to some the essence of modernist anarchy turned out to be, at heart, a good bourgeois and not a modernist at all.

The Menckens' agnostic Protestantism provide a foil to the Steins' assimilationist Judaism. In Germany, the Menckens had long been prominent, first as merchants, then as academics, and then once again as merchants. Mencken's grandfather came to Baltimore in the 1848 migration and settled into the tobacco business, bequeathing the firm to son and grandson. He married a woman from Jamaica whose family had originated in Northern Ireland; she brought the English language as well as Scottish blood into the family, and even after she died her language reigned supreme: the family appreciated German culture, but did so in English, and their loyalties became entirely American. In politics, Mencken's grandfather was pro-South in the Civil War, Democratic in his voting until he became an anti-union, high-tariff Republican. His son August, Mencken's father, shared these values and reenforced the German core of family life by marrying the daughter of a Hessian who had also come to Baltimore in 1848.

Born in 1880, H.L. Mencken thus found himself in a German-American bourgeois family that was successful, yet set apart by ethnicity from being entirely comfortable with mainline American values. Few issues demonstrated this separation better than religion: the Menckens were skeptics who did not concern themselves with religious questions one way or the other; to rebel against such a family meant to become religious, not to lose religion, and Henry felt no such rebellious urges. Instead, as he studied at a German-oriented secondary school and a public technical high school, he found compatible heroes: the Charles Darwin of *The Origin of Species* and the Herbert Spencer of the *Social Statics;* and especially the "bulldog of Darwin," Thomas Henry Huxley. "Huxley, I believe, was the greatest Englishman of the Nineteenth Century—perhaps the greatest Englishman of all time," he proclaimed in the *Evening Sun* in 1925, on the centennial of Huxley's birth. In literature, Mencken loved most the poetry of Kipling, which he imitated, and the work of Mark Twain, especially *The Adventures of Huckleberry Finn.* Such tastes could seem liberated, but in some ways were not. Mencken, culturally, was a child of late Victorianism, for whom the controversies of that period, in England, could remain relevant only because the Anglo-Saxon America which he encountered as an adult was so far behind the rest of Western culture.

Rather than go on to college, Mencken tried the family tobacco business; it bored him. When his father died prematurely he escaped into the world of journalism and never regretted it. He read on his own in a wide and miscellaneous way, coming to conclusions that solidified rather than changed over time. He peered out at the world of Theodore Roosevelt and decided that he had "no more public spirit than a cat." He watched progressives excite themselves about immoral politicians, trusts, impure food, and the white slave traffic, and decided that his "true and natural allegiance was to the Devil's party, and it has been my firm belief ever since that all persons who devote themselves to forcing vir-

tue on their fellow men deserve nothing better than kicks in the pants."
While all America seemed to be readying itself to stand at Armageddon
and battle for the Lord, as ex-President Roosevelt exhorted them to do
in 1912, Mencken decided that religion was "fundamentally opposed
to everything I hold in veneration—courage, clear thinking, honesty,
fairness, and, above all, love of the truth. In brief, it is a fraud." He
was emotionally secure in his skeptical German family, yet scornful of
the Protestant Anglo-Saxon society he had to write for. He read Amer-
ican journalists who interested him, such as Percival Pollard and James
Huneker, but he read them mostly for clues as to what European works
he should investigate.[22]

Mencken achieved a name in journalism early, and thus had to face
the question of staying in Baltimore or moving to New York, where
most of the editorial opportunities were. It says a great deal about his
attitudes to modernity, and the presumptive charms of bohemia and
Greenwich Village, that he was scarcely tempted. He felt the appeal of
"a sense of the snugness, the cosiness, the delightful intimacy" of the
city, that caused his soul to glow. Baltimore, he proclaimed, was "a Per-
fect Lady" among cities, full of "the impalpable, indefinable, irresistible
quality of charm." With the experience of another decade behind him,
he returned to the subject in 1925. "Coming back to Baltimore is like
coming out of a football crowd into quiet communion with a fair one
who is also amiable, and has the gift of consolation for hard-beset and
despairing men." He could now resist the temptations of New York
City even more easily. He thought of himself as "the most arduous
commuter ever heard of," dividing his time between the two, but in-
sisted: "this feeling for the hearth, for the immemorial lares and pen-
ates, is infinitely stronger here than in New York." Human relations in
a place such as Baltimore, "tend to assume a solid permanence. A man's
circle of friends becomes a sort of extension of his family circle." Such
were hardly the sympathies of most modernists, rootless and cosmo-
politan by choice and scornful of bourgeois comforts. He could even
speak of "a tradition of sound and comfortable living," a phrase so
close to the words Gertrude Stein used about her family's ambience
that it seems hard to believe the two writers were unaware of each
other. But they were; life in Baltimore was simply comfortable.[23]

Mencken preferred to keep his cosmopolitan yearnings in his mind
rather than in his geographical location. His first extended subject was
George Bernard Shaw, about whom he wrote "a little handbook" which
appeared in 1905. Shaw himself had published *The Quintessence of Ibsen-
ism* in 1891, and Mencken set out to do something similar. The result
was mostly a book of plot outlines that scarcely qualified as literary
criticism. Yet it showed many of the characteristics of Mencken's more
mature work. Excluding only a brief preface, it managed to mention
Charles Darwin in the first paragraph, and Thomas Henry Huxley and
Herbert Spencer in the second. It listed Nietzsche, Sudermann, Haupt-

mann, and Ibsen as the obvious references a bit closer in time. It tied science, social thought, and theater together with a ringing statement about truth: "For six thousand years it had been necessary, in defending a doctrine, to show only that it was respectable or sacred. Since 1859, it has been needful to prove its truth."

The book remains peculiar to read for anyone familiar with Shaw's plays or other writings. On the one hand, Mencken did not like moralism, preaching, or admonitory interjections which he associated with conventional theater or Christian discourse. He also did not like socialism, anti-vivisectionism, vegetarianism or any of the other reforms which Shaw advocated. On the other hand, he clearly wanted to write about someone whose values agreed with his own, and he seemed perfectly willing to ignore any aspects of Shaw's mind that did not suit his purposes. So he passed over Shaw's various reforms and even his didacticism. "Shaw is not a mere preacher," he proclaimed, against considerable evidence to the contrary. "The function of the dramatist is not that of the village pastor." His function is, rather, "to picture human life as he sees it, as accurately and effectively as he can. Like the artist in color, form, or tone, his business is with impressions." Such logic already breached conventional definitions of realism and impressionism, and Mencken then compounded such terminological confusion by comparing Shaw to Beethoven and Millet, and concluding: the dramatist "concerns himself, in brief, with things as he sees them." Within a few paragraphs, however, a more crucial element appears. In all of Shaw's plays, Mencken intoned, the "chief concern" is the "conflict between the worshippers of old idols and the iconoclasts, or idol smashers." An obvious set of equations was at work here: aesthetic success = a realistic view = iconoclasm, but do it without preaching.[24]

Mencken never really pretended to be a dramatic critic; his job for a time was to review plays, so he reviewed them. If a publisher wanted a book on Shaw and Shaw interested him, he wrote the book. Such adaptability was admirable, especially for a man with no college education or background in theater, but it also indicated a mind unaware of its limitations. Mencken had neither read nor seen most of the products of British drama; no one in Baltimore could have, save the odd English professor with grants enabling him to go to London. He knew no more about English and American literature or philosophy. If he knew anything at all, it was the tradition of nineteenth-century German classical music, which his family and friends played with enthusiasm. But even there, his taste was conventional and even primitive, accepting obvious "masters" and going little beyond them. Mencken was, in short, untrained in those areas where his interests lay, and his writings, even more than the writings of most critics, were expressive not of aesthetic judgment but of personal prejudice. He was reading, watching, or listening to works of art with extracurricular intentions: he wanted to advocate the religious, scientific, and social views of his German fam-

ily as he understood them, to a community of Anglo-Saxons which rejected them. Mencken was carrying on something of an ethnic guerilla war, and the arts provided him with convenient weapons.

The publishers of the Shaw book asked him for a similar study of Friedrich Nietzsche, and so Mencken dutifully worked his German up to a functional level and started plowing ahead. He continued his interests in the theater, co-translating three Ibsen plays, but he seemed fed up with the theater as he experienced it in Baltimore and New York City, and turned to German subject matter, and the writings of its most visible iconoclast, with relief. Nietzsche's work was then but little known, few works in English dealt with him one way or the other, and so Mencken could approach him with relative impunity.

To contemporary readers, Nietzsche is an archetypal modernist. No longer the Anti-Semite proto-Nazi of early polemics inspired by his distressing sister, he has emerged as a major prophet of a world that does not evolve, where every true statement seems to contain within it an equally valid contradiction, and where self-mastery is a central, internal drama profoundly opposed to political activity. Nietzsche was the great questioner of all systems, the disturber of complacencies, the attacker of conventional Christianity, and the elitist with contempt for the masses of mankind and women of all kinds. He preferred aesthetics to ethics, and insisted that happiness and virtue were irrelevant standards of philosophical judgment. He was also ill much of his life, from both real and imaginary diseases, and his frequent nausea at times took on the quality of a comment on life as he saw it.

Mencken shared many of Nietzsche's biases. He thought of himself as a great iconoclast, an elitist, a scoffer at conventional Christianity and bourgeois notions of virtue, and a twitter of women on virtually every subject. He too had no faith in political reform. He too was a hypochondriac who delighted in detailing his miseries and cures for correspondents. But like many critics, Mencken tended to make Nietzsche over into his own image. Being Darwinian to the core, Mencken believed in progress and evolution, however much he might scoff at those who interpreted such doctrines within the economic framework of the Gilded Age. Not for him any notion of eternal return. Nor was Mencken ever the aesthete that Nietzsche seemed to be. He certainly valued artists, German musicians especially, but he deeply mistrusted bohemian life and gave no thought to living as an aesthetic act. At heart, Mencken was a moralist critical of the stuffy behavior of those around him; Nietzsche was an immoralist who wanted to remake ethics from top to bottom. Mencken never doubted certain verities; Nietzsche doubted everything. The difference between them was that between a Modernist who questioned the most basic assumptions of science and skepticism and a Victorian believer in science at its most hard-headed and skeptical. Where Mencken's ideas were derivative and soon forgotten, Nietzsche's stress on illogicality and the absurd, his insistence that the

world need not be intelligible and that nothing was either absolute or divine, have made him a seminal figure for existentialism and post-modernism.

The writing of *The Philosophy of Friedrich Nietzsche* (1908) was excellent training for Mencken, implanting discipline, a foreign language, sustained analysis, and the knowledge that someone far away shared many of his cherished biases; many doctoral programs have failed to do as much. The reviews were kind if uninformed, and the book soon needed reprinting. But Mencken was no more a critic of philosophy than he was of drama; the next job that came his way was that of literary critic. He took it, mastered it as well as most did in that era when gusto passed for analysis, and found himself the author of *A Book of Prefaces,* an important critical work that, almost despite itself, informed the literate public about what was going on.

The Smart Set was a magazine with a checkered past. The self-styled "magazine of cleverness," it had a whiff of the 1890s about it, a decadence that seemed to be looking the world directly in the eye, but carefully winking as it did so. It pretended to cosmopolitanism, but even after Mencken began to contribute a book column to it in 1908 it hardly threatened the idealistic conservatism of most American literary life. *The Smart Set* was, however, always a factor in the consideration of aspiring writers, for it considered works no one else would look at, and it sold well on college campuses where originality had some chance of finding a market. If Mencken wanted to push his views of Nietzsche, or tell the world repeatedly about the neglected virtues of *The Adventures of Huckleberry Finn,* he could do so without being in danger of losing his job. With the arrival of Willard Huntington Wright, who retained editorial authority for precisely one year, 1913, Mencken had the opportunity of staking out new positions with the cooperation of a man with the prejudices of a European modernist. The brother of painter Stanton Macdonald-Wright, Willard was eager to use such models as *Simplicissimus* in Germany and the *English Review* in England to open the American mind to modernist influence.[25]

Mencken was capable of stumbling into modernist tastes on his own, but with Wright's help he was soon an integral part of battles largely taking place in London. He corresponded with Ezra Pound, the self-appointed agent for several modernist writers and painters. Pound's major energies in 1914 were directed at *Poetry* in Chicago, but he was always on the look-out not only for outlets for himself, but also for T.S. Eliot, James Joyce, W.B. Yeats, and others. Soon, for example, Pound's poetry and Joyce's fiction were appearing in the magazine. In his role as critic, Mencken welcomed Pound's *Provença* as a work whose "stanzas often attain to an arresting and amazing vigor," impressing him as being "rough, uncouth, hairy, barbarous, wild." He called attention to certain defects, especially an earnestness of tone and a violence of expression that he thought almost comic, but concluded that the collection was

"one of the most striking that has come from the press in late years." After awhile, however, Mencken cooled. He feared, he told Louis Untermeyer in 1918, that "puritan pressure has converted him into a mere bellower."[26]

Likewise, Mencken admired Joyce's early stories. Joyce was unknown in America outside a very narrow circle, but Mencken gladly bought "The Boarding House" and "A Little Cloud" in April, 1915. In a warmly supportive letter to the writer, he explained that the young publisher, Benjamin W. Huebsch, was planning to bring out all the stories as a book and did not want to compromise his sales chances by having any more printed elsewhere. Due to the difficulties caused by the war, *Dubliners* did not appear until 1917, leaving the *Smart Set* stories as his few lonely works available in America until then. Pound also forwarded excerpts from Joyce's *Portrait of the Artist as a Young Man*, which Mencken found impressive but "too long and diffuse" for the magazine. It wanted 30,000-word novelettes, and while Mencken thought it possible that radical cutting could be done to *Portrait*, he "felt that it would do unpardonable violence" to the story. If Joyce had anything of an appropriate length, Mencken would be more than happy to look at it.[27]

As these activities suggest, Mencken had affinities for the new work, although neither Pound's early verses nor Joyce's stories were more than potentially modernist in terms of theme or form. Mencken had other moments when he seemed more than usually open. He was never especially conscious of painting at any time, yet he liked the ideas of Willard Wright. "One thing has always stuck in my untutored mind: that too much stress is laid upon subject in painting. That is to say, it is a fallacy to assume that every painting must represent something," he wrote in December 1913. He, for example, got pleasure "very often out of a wholly meaningless arrangement of lights and colors." In music, which seemed to be a parallel case, he was likewise "suspicious of program stuff: the pleasure I get out of Richard Strauss has nothing to do with his banal 'plots', but with the sheer exuberance of his orchestral colors." If he had the money, his house "would be filled with beautiful woods, metals and pottery, but there would be darn few pictures."[28]

Mencken's ambivalence toward modernism came out most clearly in his discussions of psychology. He had praise for the pioneering work of Havelock Ellis on sexuality, for Ellis stressed the physical causes of psychological disturbances. Such a mind-set appealed to Mencken's Darwinism. But with psychoanalysis he was more cautious. Not seeing at first that Freud was as Darwinian as he was, Mencken understandably used American referents and identified the new movement with Christian Science, New Thought, table-rapping, and the mental clutter left in New England in the wake of William James. By the end of the decade he was more favorable, if not exactly a convert: "there must be something in it." Freud seemed deluded at first, "but the more his fun-

damental ideas have been put to the test the more plain it has become that they are essentially sound." Mencken mentioned Adler, Jung, Ferenczi, Brill, and Jones, whose texts were making the utility of the ideas obvious. No longer was "transcendental pish-posh" a problem. "The process of thought, under this new dispensation, becomes thoroughly intelligible for the first time. It responds to causation; it is finally stripped of supernaturalism; it is seen to be determined by the same natural laws that govern all other phenomena in space and time." No one who worshipped at the shrine of T.H. Huxley could fail to be impressed. In other moods and in private, however, he remained capable of dismissing Freud as a solemn German fraud whose work was "chiefly piffle."[29]

Mencken's backing and filling about modern art and modern psychiatric theory make him appear indecisive or inconsistent, but he was genuinely ambivalent, and for excellent reasons. As a late-blooming Darwinian, he brought many of the attitudes of that climate into the debates on modernism; his positions could seem modern for the wrong reasons. The most relevant example of this came in his conservative operating definition for literary realism. He began with the assumption that a good novel showed a man's attitudes evolving during a struggle with fate, in a world with no sense of a Higher Purpose. If a novelist shared this bias, avoided preaching, and kept the plot going at a good rate, Mencken approved. Realism was intellectual honesty, and if an author were intellectually honest then his general outlook presumably resembled Mencken's. But he defined a realism that even William Dean Howells, for whom he normally had little regard, could have approved. "Art can never be simply representation. It cannot deal solely with precisely what is. It must, at the least, present the real in the light of some recognizable ideal; it must give to the eternal farce, if not some moral, then at all events some direction," he said in his clearest statement of critical principles. "For without that formulation there can be no clearcut separation of the individual will from the general stew and turmoil of things, and without that separation there can be no coherent drama, and without that drama there can be no evocation of emotion, and without that emotion art is unimaginable."[30]

Written in a review of the work of Arnold Bennett, such a criterion seemed unexceptionable. But Mencken preferred the work of Joseph Conrad in England and Theodore Dreiser in America, and both had views of reality that conventional moral attitudes found threatening. The case for Mencken as a critic sympathetic to modernism stands or falls with these two writers, especially Conrad. Mencken, after all, thought *Lord Jim* the greatest novel in English and did more than anyone else to make Conrad's name familiar; Conrad himself was grateful. But the praise was half misplaced. Mencken found Conrad realistic. He liked Conrad's irony and detachment, and his ability to pity without sentimentalizing. He approved of an outsider who could master a new language and use it, without moralizing, to support aristocratic values and

criticize the facile egalitarianism and moralistic optimism of Anglo-Saxon Protestantism. He felt a kinship for Conrad's overwhelmingly masculine view of women. He was at home in a bleak, deterministic world that offered no final answers to complex questions.

But Mencken had no use for Conrad's formal experiments, which were at the core of his claim to be a canonical modernist. Unwilling to tarnish his hero in public, he could be grumpy in private. "Conrad is one of my superstitions, and so I can't argue about him intelligently," he wrote a friend in 1911. "The trouble with him, I fear, is a deficiency in the sense of form. He often staggers into his stories in a crazy manner." He mentioned a work that had just been published. "The thing is clumsy, inept, maddening. Its long prologue has no sense. You will find the same fault in 'Lord Jim'—and yet that same 'Lord Jim' is colossal." He had to read and reread it before he could figure it out, and it tried his patience. Conrad's formal experiments, his use of form to underline his skepticism about truth, did not appeal to Mencken at all, if he really comprehended them. They got in his way; but they were also core ingredients of Conrad's modernism. As with Nietzsche, in other words, Mencken made Conrad over into a Huxley who spoke to his condition in strange new ways.[31]

The work of Theodore Dreiser was distinctively different from that of Conrad, yet once again Mencken fell back on his customary categories; because these categories fitted Dreiser better than they did Conrad, the resulting criticism was and remains an important part of literary history. Mencken met Dreiser early in 1908, when Dreiser was an editor and Mencken a ghostwriter working on child-care potboilers. Despite obvious differences, the two men shared so many experiences and biases that they became fast friends. They both came from Germanic stock, disliked Christianity, lived in defiance of conventional sexual morality, hated censorship, and remained skeptical of most of the platitudes of the day. Both knew the world of journalism and each needed the other: Mencken needed work, a subject for his writing, and a cause for his love of battle; Dreiser needed an editor who would prune his excessive detail, focus his disjointed plots, clean up the worst of his Germanic sentimentalisms, and then trumpet the resulting achievements to a public dopey with romance. Fortunately for their relationship the first Dreiser book to receive Mencken's attention was *Jennie Gerhardt*, which Mencken genuinely liked and helped Dreiser improve successfully. But Dreiser's work was so uneven, and his disposition about well-meant criticisms so truculent, that the relationship suffered. Mencken disliked much of *The Financier* and all of *The "Genius,"* reserving his praise mostly for *The Titan*. Had the two of them not been as one about the German cause in World War I and the censorship at work in America, they would probably have broken off their friendship. During one brief period their mistresses were sisters, and perhaps that helped smooth things over; but Mencken's exuberant denunciations of Dreiser's many

flaws hurt the novelist severely. What was worse was that Mencken was generally right.

The Dreiser which Mencken presented to the public was one part Dreiser himself, meaning data which the artist supplied upon request, but two parts Mencken. Brushing off the usual literary influences that an academic might point to in explaining Dreiser's aesthetic progress, Mencken pointed specifically at "the chance discovery of Spencer and Huxley at twenty-three. . . . Spencer with his inordinate meticulousness, his relentless pursuit of facts, his overpowering syllogisms, and Huxley with his devastating agnosticism, his insatiable questioning of the old axioms, above all his brilliant style." No one need go farther "to find the genesis of Dreiser's disdain of the current platitudes, his sense of life as a complex biological phenomenon, only dimly comprehended, and his tenacious way of thinking things out, and of holding to what he finds good." For Mencken, the logical person to compare Dreiser to was Conrad. "Both novelists see human existence as a seeking without a finding; both reject the prevailing interpretations of its meaning and mechanism." For Dreiser, as for Conrad, "the struggle of man" was "more than impotent"; it was "gratuitous and purposeless." Man for both was "not only doomed to defeat, but denied any glimpse or understanding of his antagonist." Mencken noted differences between the two, the European being aristocratic in origin and the American being common, for example; and he thought Dreiser's talent "essentially feminine, as Conrad's is masculine; his ideas always seem to be deduced from his feelings." But both for him were prophets of modernity in the novel, the best that each country could produce.[32]

Mencken may have been closer to the mark with Dreiser than he was with Conrad, but the question of Dreiser's "modernism" is another matter. Dreiser was, to be sure, an ethnic, an outsider, and an outspoken immoralist whose sexual adventures, which he recorded in detail, remain exhausting to contemplate. He lived a bohemian life, flouted convention and gloried in combat even when such fighting harmed his literary reputation and bank balance. But all things considered, he was not so much a modernist as a fellow traveler. He did not experiment with language like Pound and Stein; he seemed innocent of any sense of form. The words poured out of him like cement: sometimes he managed to erect impressive structures, but often he just produced rubble. Not for him any notions of the prison-house of language or the spirit of carnivalization. He remained, like Mencken, the disciple of Huxley and Spencer who had fallen among bohemians. And Mencken, no less than many conservatives, deplored Dreiser's libido, his lack of tact, and his inability to see that, in a good novel, enough was as good as a feast.

The man who became famous as "The Sage of Baltimore," in other words, participated in modernist controversies but remained at heart a Victorian. When he had shrewd insights to make about modernist writers, they were usually because of shared views about the nature of man,

society, and the universe, and not because of any sympathy Mencken had for experiment. The proof of such a generalization lies more in music than in literature. When Isaac Goldberg was gathering material for his pioneering biography in the middle 1920s, he asked his subject for an outline of his views. The results were predictably conservative, Germanic, and as Mencken himself suggested, "very orthodox." He lauded Beethoven and Bach, Brahms and Schubert, Mozart and Haydn. He was dismissive of Dvorak and Debussy, and thought Chopin a composer "best heard after seeing a bootlegger." Such persiflage was predictable.

When he came to the moderns, he insisted that he was much interested in them, for he was "fond of experiments in the arts. But I'd rather read their music than hear it. It always fails to come off: it is Augenmusik." He thought that Igor Stravinsky "never had a musical idea in his life," in the sense that Schubert or Mozart had them. "He makes up for his lack of them by tuning his fiddle strings to G-flat, D-sharp, B and B-sharp, and playing above the bridge. That such preposterous rubbish is solemnly heard and applauded is sufficient proof that a sucker is born every minute." He was content to dismiss everyone else and rest secure in the knowledge that there were "only two kinds of music: German music and bad music"; or, he might have added, traditional tonal music and modernist fraud. He ignored Prokofiev, Bartok, and even the good German, Hindemith. He scarcely mentioned an American, and was dismissive of jazz. By 1925, he was clearly in the conservative camp; but by then he had stopped writing about literature at all.[33]

BOOK III

London: Where Ezra Pound
Appropriated the Salons
of Yeats & Hueffer

In a poem in *A Lume Spento,* Ezra Pound addressed the "strange face there in the glass," wondering if it provided "ribald company," was a "saintly host," or perhaps a "sorrow-swept" fool, and asked himself about his own identity. He knew that his soul possessed "myriad" identities, "that strive and play and pass," that "jest, challenge" and "counterlie" the I, and repeatedly he queried the "I": who are you? Until he answered that question, he could not really choose his tradition. Without identity and tradition, he could not find his voice, his tone, and rhythm.

With loving incomprehension, his mother suggested that he write an epic about the American West, the land of his ancestors. But he had rejected that tradition, and thus her suggestion provoked a characteristic outburst. "My Gawd!! What has the west done to deserve it," and asked her to consider what an epic needed for a foundation: "a beautiful tradition," "a unity in the outline of that tradition," "a Hero, mythical or historical," and "a darn long time for the story to loose its gharish detail & get encrusted with a bunch of beautiful lies." He snorted that "Mrs. Columbia has no mysterious past to make her interesting; & her present . . . oh ye gods!!" He railed against American capitalism, insisting that "the american who has any suspicion that he may write poetry will walk very much alone with his eyes on the beauty of the past of the old world, or on the glory of a spiritual kingdom or on some earthly new Jerusalem which might as well be upon Mr. Shakleton's antarctic ice fields as in Omaha for all the West has to do with it."

Yet despite himself, he clearly responded in an almost subliminal way to her suggestion, as numerous elements in the Cantos later testified. "Epic of the West. It is as if I asked someone to write my biography. It is more as if I had asked them to do it 12 years ago. It is truly american, a promoter's scheme, it is stock & mortgages on a projected line

of R.R. Which last sentence is the only one in the language of my native land. Surely we parley Euphues." It would not do, either for subject matter or audience: "I should like to make a bit of poetry, but if I should really do something in that line america would never really find it out. They'd hear a lecture about it & swallow somebody else's opinion & persist in their ignorance of the original."

He consciously turned whatever face he had against America. In "Redondillas, or something of that Sort," a poem deleted from the original *Canzoni* (1911), the memory of the suggestion clearly lingered, and he put it to rest for two decades. "I am that terrible thing," he wrote, "the product of American culture." He "would sing of the American people" and his hope that God would "send them some civilization." He could "demonstrate the breadth" of his vision: talk of the tariff bored him, but he had heard of Theodore Roosevelt. The "Common Man" bored him, "usually stupid or smug." He had "no objection to wealth," of course, but "the trouble is the acquisition." It would, after all, "Be rather a horrible sell to work like a dog and not get it." He could not consider himself "specifically local" or even national. He may only recently have arrived in Europe, but spiritually he was home: he was "more or less Europe itself," identified with Strauss and Debussy, with Klimt and Zwintscher. Grandfather and the West would have to wait.[1]

He preferred to turn his face toward the British literary establishment of his own or a slightly older generation. Within a few months he proved remarkably successful, although the impressions he left were decidedly mixed. He was, after all, a distinct outsider, unsure of himself, without funds, without a track record in poetry or criticism, and at first without friends. Edwardian England was a tight little cultural island and a bumptious American was noticeable. "I am afraid I never took Ezra quite seriously. His hair, his beard, his rimless eyeglasses, his dry cough, his comic transatlantic parade of wide but rather defective scholarship, and his delicious early nineteenth century affectation of 'dressing the part of poet' amused me intensely," Douglas Goldring remembered in the early 1930s. "I always felt that he had read Henri Murger and seen Puccini's 'La Bohème,' and innocently believed it was all true. The joke was that he expected London . . . to be impressed by his fancy assortment of languages and the blue glass buttons on his overcoat." Goldring himself thought Pound "one of the best of men," with "a wholly disinterested love of good writing," and quite "unselfish" in discovering and proclaiming genius wherever he found it.

Goldring was less interested in poetry than in prose and publishing, however, and there Pound's scholarly defects—his unfinished training at Penn, his tendency to be into everything rather than focused on a specialty, his very talent at recreating the work he was translating—showed all too obviously. England had real experts in Chinese and Provençal, men indeed who could do little else. "They may be plain and

ugly, with walrus moustaches and pot-bellies. They may be silent in drawing-rooms and inconspicuous socially. But what they happen to know they know. And as they freely decorate the London social scene they make London a dangerous place for all who are not masters of their subjects," Goldring continued. Pound's attempts to explore such languages and cultures left him open to criticism, "and in time his linguistic howlers became the subject of remark." Despite this, Pound made remarkable progress "and had his measure of fame in London's 'inner circle.' Perhaps his greatest achievement was to reduce the great W.B. Yeats from master to disciple. I shall never forget my surprise, when Ezra took me for the first time to one of Yeats' Mondays, at the way in which he dominated the room, distributed Yeats' cigarettes and Chianti, and laid down the law about poetry."[2]

To be in the Yeats salon was to know his intimate friend, Olivia Shakespear, "the most charming woman in London," Pound thought, and a writer herself. He first met her in January 1909, and in less than a month, he had not only attracted the mother, he had fascinated her lovely daughter, Dorothy. "He has a wonderful, beautiful face, a high forehead . . . , a long, delicate nose, with little, red, nostrils; a strange mouth, never still, & quite elusive; a square chin, slightly cleft in the middle—the whole face pale; the eyes gray-blue; the hair golden-brown, and curling in soft wavy crinkles. Large hands, with long, well-shaped, fingers, and beautiful nails," she wrote in her notebook. "I do not think he knows he is beautiful." He sat cross-legged in front of the fire, talking of Yeats and all the arts, and she wondered, already at their first meeting, if he were a genius, or "only an artist in life." She was convinced that "he has passed most of his life in tracts of barren waste—and suffered that which is untellable." He was quite willing to starve for poetry, having "no care for hunger & thirst, for cold . . ."[3]

Conscious of public and private faces in his social life, Pound was equally concerned with masks in his literary life. He tried to be a manager for Katherine Heyman; he thought about taking a doctorate at Oxford; he toyed unenthusiastically with fiction—none of which worked out. He made more progress in his attempts to become a scholarly lecturer, and at the time he met the Shakespears was already delivering lectures on "The Development of Literature in Southern France" at the Polytechnic on Regent Street, and was hoping to give another series in the fall. And as he wrote Viola Baxter, he was also "gunning for a job as MUSICAL CRITIC, that being the only field of criticism where my knowledge of the subject will not be a fatal & irremovable bar to my success." If he scarcely knew who he was professionally, he was hardly better off in his poetry. Working his way through medieval romances, he wrote of "These tales of old disguisings, are they not / Strange myths of souls that found themselves among / Unwonted folk that spake an hostile tongue," taking on himself the disguises of those who took on disguises. Only a few years later he could look back and muse: "In the

'search for oneself,' in the search for 'sincere self-expression,' one gropes, one finds some seeming verity. One says, 'I am' this, that or the other, and with the words scarcely uttered one ceases to be that thing. I began this search for the real in a book called *Personae,* casting off, as it were, complete masks of the self in each poem."[4]

The mask of poet appealed to him the most. He had brought copies of *A Lume Spento* with him, and in December he brought out *A Quinzaine for this Yule;* but all this made him, as he punned to Burtron Hessler, was "the undiscovered author of two leaflets of unintelligible worse." But as his tendencies in college and university had indicated, he never distinguished too closely between his own verse and his translations, improvements, and imitations of medieval verse. Inhibited by his native cultural environment, he felt free to write as a *jongleur,* taking on the voices of Bertran de Born or Arnaut Daniel and using his voice and pen to relive their lives for an audience.

He might scoff at the specialization of academia and its requirements to lecture and publish, but in fact he felt drawn to that mask as well, the don acquainting young minds with the great literature of the world. His short course of lectures early in 1909 and the longer course that followed in October, led in classic academic fashion to *The Spirit of Romance* (1910). Neither philology nor *explication du texte,* the book was a medievalist work comparable in methodology to that of William Lyon Phelps at Yale, the great enthusiast of undergraduate teaching, or Edmund Wilson, the most sensitive advocate of high literary journalism, informing an audience of what was available and some of the pleasures that awaited there. Its originality of viewpoint and sensitivity of translations put it well ahead of much scholarly work of the day, but Pound was already too far away from academia to reenter. He looked at rare intervals for professorial approval, and in a few years angled a bit shamelessly for a Ph.D. based on this work, but he was well out of it and surely realized that this was the case. Even literary journalism did not appeal to him much, although he was soon writing a lot of it. To him it was prose and prose was inferior. "I should never think of prose as anything but a stop-gap, a means of procuring food" which was "on the same plane with market-gardening," he wrote his mother in September 1909. "If a thing is not sufficiently interesting to be put into poetry and sufficiently important to make the poetical form worthwhile it is hardly worth saying at all."[5]

Despite his uneasy relationship to academia and his awkwardness before the experts of London parlor culture, Pound was at heart a humanist and his goals never in conflict with the liberal ideals of any good university. His attraction to the literature of twelfth-century France and Spain and it successors in Italy fitted well with such ideals. The culture of Provence in its time was the most civilized in Europe. Few citizens took the more dour aspects of Christianity seriously, heretics felt welcome, cultural contacts with the Arabic world were frequent and liber-

ating, and a tradition of verse could evolve which implied lessons some-
one like Pound wanted modern readers to learn. In particular, sexual
attractions were a natural part of daily life, prudery was rare, a man
could enjoy the favors of many women and jealousy was in bad taste.
The verse that expressed these attitudes was an oral verse, songs which
traveling entertainers sang. It was simple and direct, idiomatic, hostile
to inflated rhetoric and circumlocution. It also seemed compressed and
obscure at first glance, with words referring to events or having private
meanings that only initiates could understand. The sentiments might
seem artificial, the lady addressed was usually married and never named,
but both singer and audience could amuse themselves with possible so-
lutions to the *romans à clef* which some songs suggested. For a scholar
who had just left an intolerant and prudish country, such a land peo-
pled by *jongleurs* who supported themselves however precariously by
their verse, must have seemed attractive indeed.

Provençal culture lasted until 1209, when the Albigensian Crusade
slaughtered thousands of the inhabitants and drove the poets into exile
or a verse oppressively Christian in its moral sentiments. In *The Spirit
of Romance* Pound largely ignored the historical and political issues and
followed the genre into the Italy of Sordello and Dante and the Por-
tugal of Camoëns. All, he insisted, attempted "to refine or to ornament
the common speech." Singers of romance thought that "the mood, the
play," was "everything," while "the facts" were "nothing." He placed a
special emphasis on Arnaut Daniel, whose canzoni he regarded as among
the "perfect gifts" of the twelfth century. What Daniel and the trouba-
dours were doing, he wrote, was "melting the common tongue and
fashioning it into new harmonies depending not upon the alternation
of quantities but upon rhyme and accent." Such poetry was difficult to
translate, but none the less fascinating for that. "I think it is safe to say
that he was the first to realize fully that the music of rhymes depends
upon their arrangement, not on their multiplicity." From this percep-
tion, Daniel "elaborated a form of canzone where stanza answers to
stanza not boisterously, but with a subtle persistent echo."

The book echoed persistently with words, phrases, emphases, and
names that showed up later in Pound's verse. He was particularly insis-
tent about the impact of Arnaut Daniel on Dante, and thought that
"those who are trying to trace the sources of Dante's style would do
well to consider how much he owes to Daniel's terse vigor of sugges-
tion," a phrase indicative of interests soon leading to Imagism. His trip
through Dante's hell even produced an aside that silently made it a
stylistic ally of *Ulysses, The Waste Land,* and the *Cantos:* "beneath the reek
of the lurid air, over rivers of blood, guarded by monsters from the
classic mythology, he shows us the world, blind in its ignorance, its vi-
olence, and its filth." Throughout the book, Pound insisted on an aes-
thetics of intensity. "Great art is made to call forth, or create, an ec-
stasy. The finer the quality of this ecstasy, the finer the art: only

secondary art relies on its pleasantness," he wrote. He then elaborated:
"An art is vital only so long as it is interpretive, so long, that is, as it
manifests something which the artist perceives at greater intensity, and
more intimately, than his public." He even made a comparison that
must have made a few European eyes blink. He introduced the work
of James Whistler, and the "kind of painting, when first seen," which
"puzzles one, but on leaving it, and going from the gallery one finds
new beauty in natural things." Dante's work, he thought, was of this
"sort." More conventional scholars did not write in this way, and the
book remains of interest today chiefly to Pound scholars with historical
interests. But the book was not incompetent, and indeed a remarkable
achievement for someone just twenty-four years old.[6]

Assuming the masks of Provençal and Italian troubadours only masked
Pound's larger aesthetic problem as an artist. So did the scholarly prose
packaging of *The Spirit of Romance*. He was chiefly a poet and regardless
of what he *had* to write, poems were what he *wanted* to write. The book
was full of translations, evocative if not always pedantically accurate,
and he continued for years his interest in translation from any number
of languages, alternately enchanting and infuriating scholars who never
dreamed of publishing such works themselves. The impact of these ef-
forts was extraordinary but hardly sufficient for the face Pound saw in
the mirror each morning. He soon had a critical rationale for such
work; what he lacked was a mask or style truly his own.

A generation later, Pound had the concept he needed. He called it
"criticism in new composition," the most intense form of criticism. Out
to reform all culture, politics, and education as well as poetry, Pound
could see his most original poetry as a criticism of all aspects of inher-
ited culture, the poet finding his place within the ferment of all civili-
zations, making new the old, recreating, reformulating, rephrasing the
vast body of neglected linguistic accomplishment from Florence to Pe-
king, from Homer to T.S. Eliot. In his earliest critical writings, he was
less sure of himself and his voice, but in a series of important critical
articles he developed his notion of "the method of Luminous Detail."
Poetry should not be written directly about other poetry, nor should it
be written to illustrate some abstract concept. Poetry should choose some
significant, specific something which could focus the attention of the
reader on a matter of larger import. He chose as his key example a
passage from Jakob Burckhardt in which the historian noted a shift
from the Medieval to the Renaissance embedded in a changed attitude
toward war. New commercial ideas had made old ideas of aggrandize-
ment obsolete. "In the history of the development of civilisation or of
literature, we come upon such interpreting detail. A few dozen facts of
this nature give us intelligence of a period—a kind of intelligence not
to be gathered from a great array of facts of the other sort. These facts
are hard to find," he thought, but "swift and easy of transmission. They
govern knowledge as the switchboard governs an electric circuit."[7]

Such ideas, still nascent in Pound's first year in London, had intermediate impact on Imagism and long-term effect on the *Cantos*. But his early verse, at times indistinguishable from his translations, demonstrated that he was still buried in the minor poetry of the English language of the 1890s, with its echoes of the great Victorians and its world-weary sense of an exhausted Epicureanism. He had studied the verse of his own time under Cornelius Weygandt at the University of Pennsylvania, a man of above-average critical discernment, and in his 1915 essay on Lionel Johnson, Pound recalled being "drunk with 'Celticism', and with Dowson's 'Cynara', and with one or two poems of Symons' 'Wanderers' and 'I am the torch she saith'." This was probably the only occasion on which Pound felt Penn ahead of American taste; as he wrote Floyd Dell, he did not "expect to be liked" in his native land, "for I dont think many people have had 'the ninetys'." But he had, from Arthur Symons to his Crawfordsville chafing dish, and as late as 1911 still maintained that Dowson and "The Rhymers" "did valuable work in knocking bombast & rhetoric & victorian syrup out of our verse. . . . they ring true, as much of Tennyson & parts of Browning do not." And Dowson "never, I think, lets his word intoxication run away with him, as does Swinburne. To me he holds a very interesting position, strategically, in the development of the art." Pound always retained a certain affection for the cultivation of aesthetic moments, for intensity, suggestiveness, and atmosphere, and seemed interested in discovering the spiritual implications in physical circumstances. Yet despite American attention to this verse, and its existence as a living tradition, Pound felt cut off from both his country and from the history of poetry. As T.S. Eliot later phrased it, "The question was still: where do we go from Swinburne? and the answer appeared to be, nowhere." Assuming the mask of Bertran de Born was certainly not a completely satisfying solution.[8]

Pound had his precious side, but both his linguistic and his sexual inclinations were too normal for him to feel comfortable for very long in Swinburne's company. For awhile, the dominant voice in his work seemed to be that of Dante Gabriel Rossetti. Many of his translations sound more like Rossetti translating medieval verse than the verse itself; the voice, once adopted, appeared in the archaic diction and convoluted syntax of other poems as well. But Pound soon developed another, healthier option in William Butler Yeats. Though Pound had been at Hamilton during Yeats' visit to the University of Pennsylvania, he had long been aware of Yeats' 1890s verse and several of Pound's earliest efforts show a heavy influence. One of the reasons Pound decided to remain in London when his abortive venture as Katherine Heyman's manager petered out was that Yeats was there, "the only living man whose work has anything more than a most temporary interest—possible exceptions on the continent," as he wrote his mother. For him, Yeats "has once and for all stripped English poetry of its per-

damnable rhetoric. He has boiled away all that is not poetic—and a good deal that is. He has become a classic in his own lifetime and . . . has made our poetic idiom a thing pliable, a speech without inversions."[9]

As Douglas Goldring's memoir has indicated, Pound met Yeats early on and became an integral part of his salon, to the point of seeming to control his cigarettes and chianti along with the conversation. By October of 1909, they had apparently had one talk that lasted five hours, and two months later Yeats was writing Lady Gregory about "this queer creature Ezra Pound," who has "got closer to the right sort of music for poetry" than Florence Farr, author of *The Music of Speech:* "it is more definitely music with strongly marked time and yet it is effective speech." By the summer of 1910, Pound was noting privately that Yeats had been doing "some new lyrics—he has come out of the shadows & has declared life—of course there is in that a tremendous uplift for me"—and now the two were "in one movement with *aims* very nearly identical." The shadows of the nineties seemed to be gone, and he and Yeats had come to agree without consciously influencing each other.

The relationship continued over several years. In February 1911 they had a holiday together in Paris, and from November 1913 Pound served for three months as Yeats' secretary while Yeats collated Lady Gregory's work on Irish folklore with other myths and fables. Yeats admitted that Pound's criticism had altered his own views of his poetry; he repaid the debt by putting Pound in contact with James Joyce, whose influence later helped Pound formulate the larger framework of the Cantos. The two also praised each other in ways that could only have boosted both egos and reputations. When Yeats came to Chicago to speak at a banquet in his honor on 1 March 1914 he went out of his way to talk of the value Pound's criticism had had on his work, read "The Ballad of the Goodly Fere" and "The Return" aloud, and called the latter "the most beautiful poem that has been written in the free form, one of the few in which I find real organic rhythm." Two months later Pound returned the compliment. In a review of *Responsibilities* in *Poetry,* he defended Yeats staunchly from attacks by other critics, calling him "the best poet in England" and "assuredly an immortal."[10]

Such an extended relationship, both personal and professional, indicated a modernist kinship, but differences in theme and practice remained significant. Both men felt isolated and misunderstood, and remained involved with the poetry of the Irish twilight for too long, but the differences were more than merely those of two deeply idiosyncratic men from different countries. Yeats chose his isolation in a way different from Pound. Pound had really tried to adjust, to take a Ph.D. and instruct raw American youth, and found himself rejected by his society. Yeats had a tradition within which he could function in a way Pound did not—Pound could choose a past in Ireland as well as in Provence, but the point was that he had to choose, where Yeats had

only to accept and rework a heritage already in his bones. The men shared many notions about art, occult religion, and mythology, but here too Yeats was far more a genuine symbolist than Pound.

While digesting the influence of Rossetti and Yeats, he did what he could to earn money and maintain his social connections. His economic position was weak, he remained partially dependent on his family, and they wanted him home. Early on, he could joke to Viola Baxter, that "Yrs. humbly is by way of gittin more or less celebre as a riter if he can stand the climate. The English Review give me 3½ pages of hoorah 3 quid for a explosion," but he also had to note wryly, "Several papers are also cheerin' loudly, but it don't seem to affect the sales." By early 1910, he was preparing a return visit "to the land of the free and the home of the bronze coffin industry" to see his family and friends and reexamine the possibilities of life as a poet. He completed *The Spirit of Romance* in February 1910, took a week to show a visiting William Carlos Williams around London—he took him to visit Yeats and "crammed him with Turner"—and went off to Italy. The Shakespears came for an extended visit, and he and Dorothy were obviously deeply in love by this point. He returned to London in May, waited until his book was safely published in June, and sailed immediately for America. He translated Cavalcanti and wrote verse of his own steadily during the summer and early fall in Philadelphia with his parents. Things had not changed in suburbia: "The rottenist morality that an artist can have is that snivveling 'idealism' which tries to pretend that life is something more prudish than gord made it."[11]

The chief artistic result of the trip was a reconsideration of Walt Whitman and his work. When Floyd Dell wrote to ask him about Whitman that winter, Pound responded that he had never "owned a copy of Whitman" and "to all purposes never read him." He thought that what Dell and "every one else take for Whitman is *America*. The feel of the air the geomorphic rythm force." Yet he insisted here and elsewhere that "Whitman is the only American poet of his day who matters. He was sincere in his rythmic interpretation of his land & time. He was too lazy to learn his trade i.e. the arranging of his rhythmic interpretations into harmony." For Pound, Whitman "was no artist, or a bad one," but he insisted, "he matters. The rest tried to be american hard enough but they never lay naked on the earth. They bathed with their clothes on, & the clothes were 'made abroad.'" For himself, Pound believed "in an absolute rhythm,—an exact correspondence between the cadence-form of the line & some highly specialized or particular emotion. These change with the seasons, work written in the mode of 30 years ago is always bad work because the writers are copying not making emotional translations of their time.—I mean writing out of life."

In another, long unpublished fragment from this period, Pound worked out his ideas still further. Whitman "*is* America. His crudity is

an exceeding great stench, but it *is* America. He is the hollow place in the rock that echoes with his time. He *does* 'chant the crucial stage' and he is the 'voice triumphant.' He is disgusting. He is an exceedingly nauseating pill, but he accomplishes his mission." Whitman seemed to be entirely free from renaissance humanism or any Greek ideals, and was "content to be what he is, and he is his Time and his people. He is a genius because he has a vision of what he is and of his function. He knows that he is a beginning and not a classicaly finished work." Pound thus honored him, "for he prophesied me while I can only recognize him as a forebear of whom I ought to be proud." Stating that "Mentally, I am a Walt Whitman who has learned to wear a colar and a dress shirt (although at times inimical to both)," Pound admitted the American to his exalted pantheon of forefathers, along with Dante and Shakespeare, and thought "we have not yet paid enough attention to the deliberate artistry of the man, not in details but in the large." Whitman was "the first great man to write in the language of his people," and he wanted "to drive Whitman into the old world. I sledge, he drill." [12]

Pound was obviously as ambivalent about Whitman as he was about America, but he brought his emotions together long enough to write "A Pact," (1913), his famous tribute to this countryman:

> I make a pact with you, Walt Whitman—
> I have detested you long enough.
> I come to you as a grown child
> Who has had a pig-headed father;
> I am old enough now to make friends.
> It was you that broke the new wood,
> Now is a time for carving.
> We have one sap and one root—
> Let there be commerce between us.

Fair enough, and the impact was clear on Imagism, the *Lustra* poems, and in some sense the rest of his career. But Pound remained testy and ambivalent. "Whitman is a hard nutt," he wrote his father. "The *Leaves of Grass* is the book. It is impossible to read it without swearing at the author almost continuously." [13]

As 1910 wore on, Pound shifted his base from Philadelphia to New York. While there he worked on what became "Patria Mia," saw a collection of both old and new poems, *Provença*, through a Boston press, and had reunions with Hilda Doolittle, soon to be on her way to join him in Europe, and Billy Williams, newly settled into his medical practice in Rutherford. He looked up John Butler Yeats, father of the poet, and the Irish-American lawyer and collector of artistic and literary materials, John Quinn. Yeats was an old man of considerable charm, and he welcomed Pound to his salon at Petipas', where painters such as John Sloan, Robert Henri and George Bellows, and the critic Van Wyck Brooks were also regulars. On one occasion, Quinn took Yeats, Pound, Sloan and a few others to Coney Island and had what Sloan called a

"splendid time" at Quinn's expense, dining at the Raven Hall, riding elephants, shooting "the shutes," and taking "a wild ride" in "some tubs." The memory of the day lingered on, and Quinn recalled it specifically early in 1915 when he opened his important decade of correspondence with Pound.[14]

These visits, while important, ended badly. Pound had an attack of jaundice late in the year and spent time in a hospital. The opportunities for publishing profitably or in any other acceptable way earning his living by his pen seemed as dim as ever, and his parents, normally so supportive, did not sympathize with his desire to return to Europe. He went anyway in late February 1911, writing them: "I regret your lack of reconciliation. You never seem to consider my necessity to live. If I muck around here thru the summer, I won't at the end of it have done anything that I haven't done before. However, what's the use of arguing. I have my work to do and must choose my own way of getting it done." He passed through England quickly and went to Paris, where he saw Yeats, completed his work on Cavalcanti, and corrected the proofs of *Canzoni*, the last of his apprentice volumes of verse. In June, he wrote Viola Baxter from an Italian hotel that he was recovering, and translating Arnaut Daniel, "who wont interest you much & no longer interests me at all—well not quite but I won't miss him when he is going to the printers." By July he was in Verona, sightseeing with Billy Williams' brother Edgar, something of an expert on the architecture of the area. He then headed toward England, stopping in Giessen where Ford Madox Hueffer was trying, in his ineffectual way, to win a German divorce. That meeting marked the beginning of a new phase in American modernism.[15]

II

Pound's arrival in London in 1908 had preceded by only a few months the founding of *The English Review*, a journal that for many years remained Hueffer's chief claim for distinction in literature. Organized "with the definite design of giving imaginative literature a chance in England," it printed Hardy, James, Galsworthy, Wells, and a Constance Garnett translation of Tolstoy in its first issue. It kept to this standard throughout the period of Hueffer's influence, which ended early in 1910. May Sinclair introduced Pound to Hueffer early in 1909, and the two men formed a friendship that lasted until Hueffer's death in 1939. Its first fruits were the publication of nine of Pound's poems, including such subsequent anthology favorites as "Sestina: Altaforte" and "The Ballad of the Goodly Fere." Friendship with Hueffer also carried with it admission to the second salon which Pound all but appropriated during his London years. Hueffer's marriage was breaking up at the time, and he had taken up a relationship with novelist Violet Hunt. Her home,

South Lodge, became as important a gathering place for writers as Yeats' flat.[16]

Pound cut quite a figure there. "When I first knew him his Philadelphian accent was comprehensible if disconcerting; his beard and flowing locks were auburn and luxurient; he was astonishingly meagre and agile," Hueffer recalled in 1931. "He threw himself alarmingly into frail chairs, devoured enormous quantities of your pastry, fixed his pince-nez firmly on his nose, drew out a manuscript from his pocket, threw his head back, closed his eyes to the point of invisibility and looking down his nose would chuckle like Mephistopheles and read you a translation from Arnaut Daniel," most of which Hueffer could not understand. Pound quickly discovered what many subsequent American visitors have also noted, that his role was to break down social as well as intellectual rigidities in societies which had become all but petrified by custom. Violet Hunt may have been living in sin but she was a lady of great propriety and formality in many other areas of life, and her home needed Pound to air it out. As Douglas Goldring, Hueffer's chief assistant, has recalled, Pound was the chief reason for the transformation of South Lodge "from a rather stuffy and conventional Campden Hill villa, into a stamping ground for les jeunes," and "Ezra's irreverence toward Eminent Literary Figures was a much needed corrective to Ford's excessive veneration for those of them he elected to admire." Pound "sallied forth in his sombrero with all the arrogance of a young, revolutionary poet who had complete confidence in his own genius," and "quickly established himself at South Lodge as a kind of social master of ceremonies." He discovered tennis courts in a communal garden opposite the house, and liberating them from long disuse, made daily matches one of the attractions. "Ford and Violet, both of whom adored every form of entertaining and loved to be surrounded by crowds of friends, were delighted." Every afternoon "a motley collection of people, in the oddest costumes, invaded it at Ezra's instigation, and afterwards repaired to South Lodge . . . to discuss *vers libre,* the prosody of Arnaut Daniel," and the villainy of their enemies.[17]

Pound and Hueffer, despite superficial differences of nationality and religion, shared many basic attitudes. Neither accepted the family religion after a certain age. Neither had any reverence for established literary reputations or the opinions of the academy. Neither cared for the liberal political ideas that dominated the public life of their maturity, preferring an inarticulate variety of Tory anarchism. Both thought the chief function of the state ought to be to support art and artists. Both fell in love easily and regarded conventional marriage as fit only for the conventional. Both revered genuine artists and the craft of writing. Both were gifted if disorganized editors. Both had been used to money as children, missed it terribly as adults, and handled it badly when they got any. Both revered Henry James.

Unlike Pound, who was first a poet, a critic under duress, and never

a novelist, Hueffer was genuinely undecided as to where his true talents lay. He was never a great novelist and only sporadically even a good one; he was far better at pointing out what he or one of his friends was trying to do than in doing it himself. He was at his best in the editor's chair, choosing the most promising submissions; and at South Lodge, dispensing Hunt's food and tossing out ideas for others to chew. Pound apparently knew him first as a poet—the work printed in *From Inland* (1907)—and justly admired Hueffer's ear for the rhythm and music of words. These poems were reputable enough, but Pound seemed to learn the most from the *aperçus* Hueffer would wheeze through his blond moustache. Hueffer had a great gift for the *"mot juste,"* thought "poetry should be at least as well-written as prose," and told *les jeunes* that "good prose is just your conversation." These phrases seemed important to Pound, however inadequate they might seem as a valid basis for a new poetics.

After Hueffer left *The English Review,* he and Hunt were determined to regularize their relationship. The legal Mrs. Hueffer was a good Catholic, fanatic about the sanctity of marriage and the reputation of her two daughters. She refused to cooperate and Britain's divorce laws made it all but impossible for Hueffer to proceed alone. He had, however, any number of German relatives, and a friend suggested that he shift residence to Germany, establish citizenship, and take a divorce there. Why the couple should care about the proprieties at such a late stage, and what ridiculous legal advice led them to believe such a scheme would work, remain among the minor mysteries of literary history. They had a holiday in Germany and then Hunt became ill and returned to England. Hueffer settled in Giessen to establish the legitimacy of his claim to being a solid German citizen. He wrote constantly; even so he was bored, disliked his reduced standard of living, and thought the food terrible. Pound found the whole business irresistible, and addressed Hueffer as "My dear ole Freiherr Von Grumpus ZU und VON Bieberstein."

Pound arrived in Giessen in mid-summer; he was there in early August, later recalling "Aout 7" as the day during which he had proudly showed Hueffer his *Canzoni*. Hueffer's reaction has gone down in history, courtesy of the obituary that the poet wrote in 1939. Hueffer "felt the errors of contemporary style to the point of rolling (physically, and if you look at it as mere superficial snob, ridiculously) on the floor of his temporary quarters in Giessen when my third volume displayed me trapped, fly-papered, gummed and strapped down in a jejune provincial effort to learn . . . the stilted language that then passed for 'good English' in the arthritic circles" That roll "saved me at least two years, perhaps more. It sent me back to my own proper effort, namely, toward using the living tongue (with younger men after me), though none of us had found a more natural language than Ford did." Hindsight lent wisdom; at the time Pound was perhaps hurt, certainly

not convinced. Upon his return to London, he informed his mother that he had had "very little time to myself while with Hueffer. Not that there was much work done, but we disagree diametrically on art, religion, politics and all therein implied." Even a year later, he could still insist in print that "colloquial poetry is to the real art as the barber's wax dummy is to sculpture," and he thought that there were "few fallacies more common than the opinion that poetry should mimic the daily speech." Yet his respect for Hueffer never wavered, either in public or in private. Hueffer was "an artist mature" and "perhaps the most accomplished writer in England. Almost a Great man," he wrote Alice Corbin Henderson, "he has it in him to be the most important prose author in England, before he shuffles off, after James and Hardy have departed."[18]

III

As Pound's importance in the South Lodge salon indicated, he had made his way into a core grouping of British literary figures with startling rapidity. His early call on publisher Elkin Mathews had led rather swiftly, through intermediaries, to Hueffer, the Shakespears, Yeats, and a position of genuine importance in the cultural life of a foreign country, one which foreigners did not penetrate all that easily. The lonely provincial was soon meeting, and often helping, a few of the great figures of modernism, including several whose personalities and works seem antithetical to his own. One example indicates Pound's range here. One of Hueffer's discoveries had been D.H. Lawrence, and Lawrence and his friend Jessie Chambers were soon guests at South Lodge. In November of 1909, Pound met them there. Although Chambers regarded Pound as "an amiable clown"—at their first meeting, he had startled her by springing to his feet, "bowing from the waist with the stiff precision of a mechanical toy"—Lawrence seemed impressed. He described Pound as "a well-known American poet—a good one." Their chief difference seemed to be that "his god is beauty, mine life," but otherwise Lawrence found him "jolly nice." Pound took him "to supper at Pagani's" and afterwards they "went down to his rooms at Kensington. He lives in an attic, like a traditional poet—but the attic is a comfortable well furnished one." Lawrence thought him "rather remarkable—a good bit of a genius & with not the least self-consciousness." Pound was impressed by Lawrence's work, admitting privately that he thought Lawrence "learned the proper treatment of modern subjects before I did," but found the man uncongenial: "Detestable person but needs watching."[19]

Aside from a few poems, Lawrence's subsequent emergence as a major modernist had little direct connection with Pound, but two other London acquaintances had significant effects on his emerging poetics. On 23 February 1909, Elkin Mathews introduced Pound to the Poet's

Club. The club was the creation of T.E. Hulme, a figure largely un-known during his brief lifetime, but one who has had a considerable posthumous fame as the progenitor of Imagist poetry, the originator of critical ideas which T.S. Eliot later developed, and the popularizer of a set of Tory ideas which found favor among many British and American conservatives. Hulme was a belligerent reactionary in reli-gious and aesthetic ideas while at the same time a modernist in poetry. He impressed people first with his large size and ostentatious abrasive-ness, always flavored with an elaborately ironical tone: "I am a heavy philosopher," he would intone grandly as he gobbled down sweets be-fore laying down the law about some current philosophical or literary dispute. When that seemed inadequate he might take out the custom-made brass knuckles he liked to carry, the gift of sculptor Henri Gaudier-Brzeska. A brilliant student at school, he had wasted a poten-tially distinguished academic opportunity at Cambridge through sheer indolence and lack of discipline, being sent down in his second year for assaulting a policeman. Pound referred to him once as "the outward image of a Yorkshire farmer—the pickwickian Englishman who starts a club." Hulme in turn patronized Pound, and was capable of dealing with him contemptuously. In time they grew apart, Hulme feeling that he had no place in Pound's post-Imagist allegiances, and late in life Pound came close to denying that Hulme had had much importance to the history of verse. This was inaccurate; Hulme may not have had significant direct influence on Pound to anything like the extent that Hueffer had, but his presence was central to the larger history of mod-ernism in poetry.

Hulme was never much of a poet himself. He wrote seven works that survive, most between 1908 and 1910, and seemed not to value them overmuch. He was, however, passionately interested in critical theory, for he was studying the work of his friend Henri Bergson at that time, and identified strongly with any aesthetic that was sympathetic to the anti-intellectualism and intuitionism then becoming popular. Like Wil-liam James, he was convinced of the reality of the flux of phenomena and thought that intuition enabled a man to participate in it. Images seemed to him integral to this position: abstractions might be appro-priate for prose, but only images made poetry and allowed participa-tion in the flux. Only poetry permitted direct communication, because only poetry conveyed live images. Prose was indirect, its images dead and clichéd. All writing tended to become "objective correlatives," the "visual" language purged of "counters." He also disliked the regular meter of contemporary verse; it seemed oral and hypnotic and thus unable to convey images properly. As his ideas evolved, he decided that the Poet's Club was outdated and promptly seceded. In March 1909, the "Secession Club" began meeting at the Eiffel Tower, and Pound first showed up at its fourth meeting on 22 April 1909. Other regular members included F.S. Flint, Edward Storer, Joseph Campbell, and

Florence Farr. This was the group that Pound later referred to as "the forgotten school of 1909," where Imagism had truly begun.[20]

At least for some time, Pound seemed not to realize Hulme's ironic contempt for him. In November and December 1911, Hulme gave a series of lectures on Bergson at a private house in Kensington; Pound and Dorothy Shakespear attended them, and he informed his mother that they were "rather good." Only many years later did Pound snarl about how Hulme's "evenings were diluted with crap like Bergson." Recovering Pound's original impressions of these talks is not possible; he surely did not share Hulme's clearly expressed aversion to the scientism and intellectualism of late Victorian thought, for those were not Pound's own particular problems. Nor was Pound religious; indeed, he was fleeing the very dogmatism that Hulme found attractive, and years later Pound did not respond to such ideas even when his loyal supporter T.S. Eliot rephrased them. Bergson was thus no great revelation to Pound, but rather a thinker of passing prominence whom he could take or leave as circumstances dictated. But the imagist theory was another matter; Pound liked that regardless of its pedigree.[21]

The relationship between Pound and Hulme, and the closely related one between Pound and F.S. Flint, remain serious lacunae in cultural history, for despite some good work which has been done, large-scale syntheses still mistake some of the froth of literary agitation for the substance of real achievement. In this case, Hulme, a charismatic personality who influenced writers more talented than himself, has won a spurious posthumous fame as an original thinker, which he was not. He was derivative and inconsistent, no matter how fascinating he was to know. Flint, on the other hand, has all but disappeared from literary history, surviving largely because he wrote a brief history of Imagism that irritated Pound, and exchanged testy letters with him that remain central to any clear understanding of the subject. Some day Flint will have a biographer who will point out how intelligent and significant he was, both in the history of poetry and the history of criticism, especially the criticism of French literature and its role in English-language culture. Among other things, such a biographer could point out that Hulme's French was so bad that he could not competently translate the Bergson texts he was attempting to introduce to England, and that Flint did much of the work, for which he received no credit, little money, and considerable abuse from Hulme.[22]

Given British class prejudices and the persistent scholarly habit of aping them unconsciously, such an imbalance was perhaps inevitable. Flint, poor man, was not of the right class and never had the chance to be sent down from Cambridge. He was almost entirely an autodidact, picking up his knowledge of French language and European culture on his own, with an unassertive humility that masked the fact that he actually did know what he was talking about once he began to write at length. But he lived badly, often in poverty and depression, and in

circumstances that distressed even potential American friends. Hilda Doolittle was hardly a snob by British standards, yet when Pound "resurrected" Flint from an especially bad patch and helped him onto his feet as a respectable journalist, her shudders went across the Atlantic. Ezra "always has some under-dog on hand," she wrote Isabel Pound with a prim sigh. "One Thursday it was a derelict poet named Flint who made the fatal mistake of marrying his landlady's daughter, a hapless little cockney." He "thought a dinner party might set them up, and I was flattered by an invitation to see it through—E. and I agreed after that it *had* required tact. The little lady criticised the omelet (I think she had never dined out before) and informed me that she had a 'boiby whose naime was Ianthe!'—However, after two years silence, the baby's pappa once more breaks into song!" Subsequent relations between Flint and Doolittle, it should be noted, were far more friendly and affectionate than this introduction might suggest. Richard Aldington had a similar opinion. He recommended Flint's work to Harriet Monroe, but described him personally as "genus irritabile—you know the tag—and Flint is really an extremely worthy but extremely sensitive person. He is also extremely unfortunate in his private life and circumstances. He has not the bravura and slap-dash methods of our friend Pound and is therefore a little apt to be overlooked. He has also no critical faculty in regard to his own work."[23]

In actuality, the differences between Flint and Pound were more those of personality and point of view than of major historical substance. The two men had both been to the same meetings over several years, had known the same people and read many of the same books—often French ones that Flint had introduced to Pound. As he so often did, Pound had even exerted himself on several occasions to get Flint jobs translating, tutoring, and lecturing, quite aside from the many meals they shared. Flint clearly also shared with Pound his personal knowledge of such French figures as Remy de Gourmont and Henri-Martin Barzun, and this knowledge was materially useful to Pound both on his subsequent visits to Paris and in his development of a poetics. But Pound, even when selflessly helpful to friends like Flint, was also overbearing both personally and intellectually. Flint might introduce him to French writing, but as soon as he could Pound not only absorbed this new material, he transformed it, rephrased it, and used it in new ways; often those ways irritated the very people instrumental in calling his attention to it in the first place. Genius does not usually recognize limits and has its own internal criteria as to what is important. Talent prefers the quiet absorption of new material and its expression in a clear, comprehensible manner. Pound was a genius who absorbed everything he could and did as he pleased; Flint was a talented journalist of great utility at the time, but of only historical importance. Each man lived through his own Imagism.[24]

Flint insisted that Imagism began as early as 1908 in the mind of

T.E. Hulme, and saw evidence in the Poets' Club and the small pla-
quette of verse published as "For Christmas MDCCCCVIII," which had
included Hulme's "Autumn." He found suggestions of Imagism in the
work of Edward Storer and thought Storer used a "form of expression,
like the Japanese, in which an image is the resonant heart of an ex-
quisite moment," although the poems he quoted in support of his as-
sertion were not convincing. He too, he recalled, had been thinking
along the lines of French and Japanese poetic diction, and because of
this had discussed the matter with Hulme and joined with him in their
secession from the Poet's Club to the Soho restaurant, precisely dating
the start of the meetings at 25 March 1909, a month before Pound
arrived. Discontented with the way English verse was written, they had
proposed "at various times to replace it by pure *vers libre;* by the Japa-
nese *tanka* and *haikai;* we all wrote dozens of the latter as an amuse-
ment; by poems in a sacred Hebrew form . . .; by rhymeless
poems . . . and so on." Hulme was clearly the ringleader, who "in-
sisted too on an absolutely accurate presentation and no verbiage." Hulme
and another member "used to spend hours each day in the search for
the right phrase." When Pound joined the group he was quite ignorant
of any French poetry after Ronsard and played small role indeed in
the group's discussions. But in 1912 he had included five poems of
Hulme's in *Ripostes,* noting as he did: "As for the future, *Les Imagistes,*
the descendants of the forgotten school of 1909 (previously referred to
as the 'School of Images') have that in their keeping." By then Pound
was discovering more recent French work, codifying its lessons, and
about to start yet another of his propaganda campaigns. Flint con-
cluded, honestly but a bit obtusely: "There is no difference, except that
which springs from difference of temperament and talent, between the
imagist poem of to-day and those written by Edward Storer and T.E.
Hulme."[25]

Pound was furious. "After deliberate consideration, I still think your
article on the 'History' in the Imagist number of the Egoist is
BULLSHIT," he wrote Flint. He admitted that he was a difficult per-
son and assumed that Flint was mostly out to "prod at me," but still,
Flint ought to realize that "the whole drive toward simple current speech
etc. comes from F.M.H., and that it was never decently considered by
the group of 1909"; that Pound was not out to get Hulme or deny him
credit; that Storer was never important and "it is ridiculous to pretend
that the Hellenic hardness of H.D.'s poems is in any way traceable to
his custard"; and that Flint had quite misphrased what energized the
movement and underestimated the changes that had taken place be-
tween 1909 and 1913. He had also left out Richard Aldington, who
had been far more important as poet and presence than Storer.

Flint replied to this "bolt from Olympus" the next day. He insisted
that Hueffer had been "one of the generals of division in an army
composed of many divisions," adding correctly that "his operations seem

of paramount importance to you because you were enrolled under him." Flint was happy to acknowledge Hueffer's influence on Pound and admitted that such material should have been in his article; he added that he was not in any way irritated with Hueffer and only regretted that they could not see each other oftener. Flint then went on to deny that he had accused Pound of obscuring Hulme's glories, to reassert Storer's importance quite apart from any possible connection to Hilda Doolittle, and to claim that Pound neglected some real continuities between the 1909 and 1913 versions of Imagism. As for Pound himself and his role, Flint did not mince words. Where you failed, he told Pound firmly, "is in your personal relationships; and, I repeat, we all regret it. You had the energy, you had the talents (obscured these by a certain American mushiness), you might have been generalissimo in a compact onslaught; and you spoiled everything by some native incapacity for walking square with your fellows." As for himself, "You must not presume, because of my diffidence and timidity in conversation, that you were illuminating me in the long hours of stuccato [sic] discourse with which you have favoured me on divers occasions. Your friends have always been too polite to tell you that you were chewing the rag of an old story." Anyone familiar with French literary theory knew the "Don'ts of an Imagist" long before Pound formulated them for an English audience.

Flint then went on to make general points that any historian of Imagism should still accept. He had not traced Imagism to any particular person, because unlike Pound he was trying to describe a larger context than the merely biographical. Imagism "was a general movement, a product and impulse of the time, brought about by the pressure of older and outworn work that has a tendency to accumulate towards the end of the trajectory of its impulse." He freely admitted to Pound that Pound had "organised the movement to the extent of arranging for the publication of the first collection of its poems. But as an exponent of Imagism, you do it damage. Its vogue in America," which he admitted knowing nothing about, was "not due to your propaganda," but rather "to the fact that the inhabitants of the U.S.A. seem ready to accept anything. It has no vogue in England." He was writing in 1915 when Vorticism had long replaced Imagism as Pound's focus, and he insisted that this new perspective warped Pound's point of view.

Pound was a bit calmer when he replied a few days later. "If you had begun by admitting, as you do in your letter of July 3d that the difference between the school of 1909 and Imagisme was a difference of 'form and style' you would have come very near to satisfying me." If he had added "that there is also a difference due to a 'sense of concision', I think we might fairly agree." But Pound noted dryly that he had thought up the term, and when he had done so, "I certainly intended it to mean something which was the poetry of H.D. and was most emphatically NOT the poetry of friend Storer whom I do not

despise. And in that definition the other two original imagists most certainly concurred, and if you have . . . never understood that distinction you were in error to subscribe yourself a fourth or fifth to our agreement." In 1909 there had been little agreement: "I seem to remember Hulme vainly trying to convince people of something. There was little or no formulation." But that was not true in 1912.[26]

IV

As Flint had indicated in passing, Imagism had far more resonance for American poets and critics than it had for British; even as its history diverged permanently from the course of British poetry, Pound dextrously abandoned it to pursue his relationship with Yeats, to develop an interest in the literary remains of Ernest Fenollosa, and to follow both men as their minds worked through promising insights from Oriental literature.

In November 1913, Pound accompanied "Uncle William" to his Stone Cottage retreat in "a wild spot in Sussex" to be a secretary, nurse, companion, student, and teacher to the older man. Pound had not looked forward to the trip. He wrote his mother that the venture "will not be in the least profitable," insisted that he detested the country, and feared that Yeats would only amuse him "part of the time and bore me to death with psychical research the rest. I regard the visit as a duty to Posterity." Yeats suffered from a digestive disorder that reduced him to a milk diet for weeks at a time. Acute eyestrain gave him headaches and prevented him from reading. Pound read to Yeats, taught him to fence, and set him a useful example of perpetual poetic motion, always working even when he seemed relaxed. The experiment was so mutually rewarding that the two continued it in 1914 and 1915.[27]

These winters in Sussex had lingering and perceptible results in the careers of both men. Yeats admitted to Lady Gregory that he found Pound "a learned companion and a pleasant one," "full of the Middle Ages." Pound helped him "to get back to the definite and concrete, away from modern abstractions." To discuss a poem with Pound was like getting Lady Gregory herself "to put a sentence into dialect. All becomes clear and natural." About Pound's poetry, Yeats was less enthusiastic, finding it "very uncertain, often very bad though very interesting, sometimes. He spoils himself by too many experiments and he has more sound principles than taste." Meanwhile, Yeats wrote to Harriet Monroe that he was genuinely ambivalent: "although I do not really like with my whole soul the metrical experiments he has made for you, I think those experiments show a vigorous creative mind. He is certainly a creative personality of some sort, though it is too soon yet to say of what sort. His experiments are perhaps errors, I am not certain; but I would always sooner give the laurel to vigorous errors than to any orthodoxy not inspired."[28]

Pound had a similar ambivalence about Yeats' work, but that did not prevent him from two other discoveries that he made during this period and cultivated with Yeats' help. The occult was a subject by which Pound found himself fascinated almost in spite of himself. He was far more hard-headed than Yeats when it came to anything relating to mysticism and psychic phenomena, but he was so acute in his perceptions, so willing to borrow traditions, adopt masks, and speak in voices not his own that he could appropriate Yeats' interests without strain and without any of the excesses of the typical convert to a new worldview.

This new direction was evident in the correspondence between Ezra and Dorothy by early 1914. She asked him about symbolism and his answer distinguished between two varieties: "the literwary [sic] movement" that Arthur Symons had written about in *The Symbolist Movement in Literature* (1899) and for which the work of Villiers de l'Isle Adam was a preeminent example; and "real symbolism, Cabala, genesis of symbols, rise of picture language, etc." He then suggested that she look at Montfaucon's *Le Comte de Gabalis* (1670), *Le Grimoire du Pape Honorius* (1629), and Joseph Ennemoser's *The History of Magic* (1854), works which taken together covered diabolism, apparitions, dreams, second sight, somnambulism, divination, witchcraft, and vampires, not to mention table-turning and spirit-rapping. Both Ennemoser and life at Stone Cottage turned up years later in Canto 83, but as of January 1914, the important subject was symbolism, and in particular Pound's loathing of the conventional. "There's a dictionary of symbols, but I think it immoral. I mean that I think a superficial acquaintance with the sort of shallow, conventional, or attributed meaning of a lot of symbols *weakens*—damnably, the power of receiving an energized symbol," he wrote Dorothy. "I mean a symbol appearing in a vision has a certain richness and power of energizing joy—whereas if the supposed meaning of a symbol is familiar it has no more force, or interest of power of suggestion than any other word, or than a synonym in some other language." This led directly toward the insistence in *Gaudier-Brzeska*, that "to hold a like belief in a sort of permanent metaphor is, as I understand it, 'symbolism' in its profounder sense. It is not necessarily a belief in a permanent world, but it is a belief in that direction." He then immediately disassociated himself from literwary symbolism, because it "has usually been associated with mushy technique." Even more lasting was his sense that such occult knowledge, such sense of the true nature of symbolism, was secret, esoteric and possible only for an elite. On this issue, most modernists could agree.[29]

Pound also shared with Yeats an enthusiasm for the literature of the Orient: the Chinese written character, Chinese poetry, and the Noh plays of Japan. Only a month or two before joining Yeats at Stone Cottage, Pound had been dining at the home of Sarojini Naidu, where he met Mary Fenollosa, the widow of Ernest Fenollosa, a well-known

American expert in Japanese literature and culture. As Pound recalled in an interview half a century later, she said that her husband "had been in opposition to all the profs and academes, and she had seen some of my stuff and said I was the only person who could finish up" the work which her husband had left in note form. The chemistry must have been remarkable. Mary had seen some of his poems, presumably work now included in *Lustra*, she had liked them and their author, and that was that. She entrusted a substantial amount of material to Pound's care and added to it a few years later. Out of the interests which this material stimulated in Pound's imagination, came his own most perfect poems, more sharply focused critical ideas, and a new fascination for the theater which he shared with Yeats.[30]

The theoretical bases of Fenollosa's teachings were summed up in his essay, "The Chinese Written Character as a Medium for Poetry," which Pound tried to see into print without success for several years. It did not have a permanent form until 1936 when Pound published it in hard covers with a brief introduction and notes, heralding it as "not a bare philological discussion, but a study of the fundamentals of all aesthetics," by a man for whom "the exotic was always a means of fructification." In the essay, Fenollosa insisted that Chinese notation was "something much more than arbitrary symbols," being based "upon a vivid shorthand picture of the operations of nature." To him, "the Chinese figure follows natural suggestion." If you take the three ideograms for "man sees horse": "First stands the man on his two legs. Second, his eye moves through space: a bold figure represented by running legs under an eye, a modified picture of an eye, a modified picture of running legs, but unforgettable once you have seen it. Third stands the horse on his four legs." Upon close examination, "the greater number of these ideographic roots carry in them a *verbal idea of action*," they are not pictures of things especially. "For example, the ideograph meaning 'to speak' is a mouth with two words and a flame coming out of it. The sign meaning 'to grow up with difficulty' is grass with a twisted root." He insisted that "a true noun, an isolated thing, does not exist in nature."

Fenollosa insisted repetitively that Chinese was "poetical" and "close to nature." He warned that "in translating Chinese, verse especially, we must hold as closely as possible to the concrete force of the original, eschewing adjectives, nouns, and intransitive verb forms wherever we can, and seeking instead strong and individual verbs." He thought it quite easy to translate into English, the chief barriers being grammar and grammarians. Pound hardly needed to be warned about either. "Nature herself has no grammar," Fenollosa continued. "Fancy picking up a man and telling him that he is a noun, a dead thing rather than a bundle of functions!" Chinese words were like nature, "alive and plastic, because *thing* and *action* are not formally separated." The Chinese language naturally knew no grammar. Accordingly, Chinese poetry de-

manded that "we abandon our narrow grammatical categories, that we follow the original text with a wealth of concrete verbs."

He was particularly insistent about the use of metaphor to write about the unseen. "Art and poetry deal with the concrete of nature, not with rows of separate 'particulars' for such rows do not exist. Poetry is finer than prose because it gives us more concrete truth in the same compass of words." The chief device of poetry is metaphor, "at once the substance of nature and of language. Poetry only does consciously what the primitive races did unconsciously." Thus he could conclude that "the Chinese written language has not only absorbed the poetic substance of nature and built on it with a second work of metaphor, but has, through its very pictorial visibility, been able to retain its original creative poetry with far more vigor and vividness than any phonetic tongue."[31]

The essay proved an invaluable catalyst for ideas with which Pound was already deeply involved. The Chinese language so considered was an obvious reenforcement for his experiments with the image and his desire to clean up the slosh of English prose and rid poetry of the pentameter. He summed up its teachings in a letter to Iris Barry: "He inveighs against 'is,' wants transitive verbs. 'Become' is as weak as 'is.' Let the grime *do* something to the leaves. 'All nouns come from verbs.' To primitive man, a thing only IS what it *does*. That is Fenollosa, but I think the theory is a very good one for poets to go by."[32]

Many subsequent critics have insisted that Pound and Fenollosa were both wrong about the Chinese written character and Pound took a lot of heat for basing his ideas and his translations on less than perfect insights. As a poet, Pound had the right to take what he pleased and to do with it what he wanted, and his poetry was justification enough for his efforts. But even in the history of poetics, his mistakes proved extraordinarily fruitful. He effectively established what has variously been called the ideogrammic, juxtapositional, or paratactic method: the method in which the poet omits connectives and implies immaterial relationships by placing images next to each other. Stated baldly in this way, the relation of such a poetics to other areas of cultural modernism is obvious. In music, in art, in physics, in philosophy, such juxtapositions became the core of what it meant to be modern. Leave out the copulas and the connectives, provide an alternative to metaphor, and what remains is a relational universe with nothing sufficient unto itself. Cubism, collage, montage, carnivalization, uncertainty, indeterminacy, all have analogies in some way to the ideogrammic method in poetry. His search for the language beyond metaphor with luminous details, carried on at least since his work on Arnaut Daniel, had finally born fruit. In its cultural meaning, the method meant that relations were more important than things, that all processes in nature were interrelated, that everything was in flux and that nothing was ever finished.[33]

Such concerns seem a bit grand when confronting *Cathay*, the su-

preme achievement of Pound's London period. The man of many masks had found another kinsman in Li Po/Rihaku, whose various guises often matched Pound's. Li Po was known to drink to excess, to indulge in swordplay (remember Pound's fencing), and to love travel. Precocious as a student, he refused to become a traditional poet, preferred experimentation, and was not averse to mimicry and parody. By ignoring many of the rules of traditional Confucian verse, he helped to make it new, in part by picking and choosing those aspects of his heritage which he found invigorating. By assuming the mask of Li Po, Pound could also give vent to his complex emotions about the condition of the artist in time of war. The artist was lonely, his friends were gone, often to the front, and although he could cherish memories of past glories, the future seemed grim indeed. Civilization as he knew it had had one brief moment, perhaps five years, and was about to disappear as it had in China, to survive in great poetry but hard to find as a concrete place in which to thrive. Once more choosing a past, once more donning a mask, Pound could write about the war and its impact while seeming to escape from it. Gaudier-Brzeska wrote from the front how much the poems meant to him, "so appropriate to our own case."[34]

Chinese poetry had been in the London air for some time, part of a continuing vogue for Orientalia. Even without the Fenollosa manuscript notes, Pound could hardly help but have known many odd details about the subject. Both Olivia and Dorothy Shakespear had been interested in Chinese poetry before meeting Pound, and Dorothy actually studied Chinese for awhile. Arthur Waley, probably the best-known translator of Chinese prose in the West, dined regularly with members of the Pound circle—although the chronology of the Waley relationship and its possible impact remain obscure. Even the redoubtable Amy Lowell had a serious and long-standing interest in the poetry of Asia, and the subject was hardly a novelty in cultivated Boston circles long before Pound discovered it. Thus, the mere fact of Pound's enthusiasm was not what was important. What was important was the quality of the poetry that Li Po inspired him to write, the theory that he deduced, and the impact that both had on successive generations of poets and students of literature.

The best of the Cathay poems—"Exile's Letter," "Lament of the Frontier Guard," "Song of the Bowmen of Shu," and "The River-Merchant's Wife"—are in some ways the most perfect embodiment in Pound's canon of his Imagist principles. They avoided moralizing, they presented their material straight-forwardly, avoided abstraction, and were precise and concrete in diction and expression. Following Fenollosa's theories, they tried to be ideogrammic with some success, juxtaposing images and sometimes destroying sequential logic. On the other hand, the ghost of the early Yeats and the 1890s world of Arthur Symons was not entirely gone either. Pound still liked to evoke ethereal atmosphere and the play of light and dark shadows; he occasionally lapsed into

symbolism. Intensity, after all, was a key element of almost all modern work, but poets were not yet accustomed to its practice. The subject was fraught with linguistic problems anyway: Layers of reference which were clear to the readers of Li Po needed to become equally clear to readers of Ezra Pound. What Pound was achieving in *Cathay* was a freedom from involved syntax, from archaism and inversion; in this he was relatively successful. He was almost ready to assume the masks of Sextus Propertius, Hugh Selwyn Mauberley, and the narrator of the Cantos.[35]

Pound was precise about what he was doing, although he published his views obscurely and they are not yet readily available. In "Chinese Poetry," (1918), he pointed out the harmony between Chinese and Imagist poetry, especially in their mutual insistence on "vivid presentation"; and he went to some lengths to describe Li Po as a practitioner of "criticism in new composition" whose "chief honor consists in weeding out, and even in revising," the poems he accumulates. He then identified five qualities of Chinese poetry: it is obscure, much like the medieval verse of the *trobar clus* tradition; it is clear and simple; it is mystical, with a Yeatsian plentitude of "fairies and fairy lore," and on the whole "quite Celtic"; it is human, fitting in well with a strand of western poetry from Ovid to Browning; and it is natural, like much Provençal verse associating human emotions with their natural settings.[36]

As T.S. Eliot noted in 1928, Pound became "the inventor of Chinese poetry for our time." While Chinese translation owes much to Arthur Waley and others, only Pound made it of central concern to poets, because only Pound remade the one literary tradition into the other, something rather different from mere translation. The ideogrammic method has yet to run its course, but merely to name William Carlos Williams, Charles Olson, Robert Duncan, Allen Ginsberg, and Gary Snyder gives some indication of its impact. Even this enormous impact is hardly the whole story. What Pound really did was to open up all time and every place to a humanistic vision, to demand uncompromisingly that anyone intelligent who wanted to participate in civilization had to be aware of everything, to keep working at the fruits of human wisdom wherever and whenever found, for anything less was mere provincialism and to rest was to die.[37]

The final area where the interests of Pound, Yeats, and Oriental literature came together was in the Japanese Noh theater. Included among Fenollosa's notes were translations of Noh plays that were "a definite find," as Pound wrote Alice Henderson in January 1914. "A new beauty as worth discovering as was the Chinese art a few decades ago. The books and translations hitherto printed give nothing, or next to nothing of a notion." A few days later, he wrote Harriet Monroe that "this Japanese find is about the best bit of luck we've had since the starting of the magazine." Earlier attempts to translate Japanese into English

had been "dull and ludicrous," while the new material "ranks as re-creation. You'll find W.B.Y. also very keen on it." He was indeed. As subsequent scholars from T.S. Eliot on have noted, Yeats was fasci-nated by the parallels he sensed between Japanese and Irish speech, his characters sometimes coming perilously close to sounding like the cast of a work by John Millington Synge. The two men soon found, in Mi-chio Ito, a Japanese in London able to help them understand the dra-matic meaning of the texts, and Yeats found his urge to write plays, dead for five years, wondrously restored.[38]

Yeats announced his discoveries in two important documents of 1916. One was the introduction he contributed to Pound's edition of Fenol-losa's work, *Certain Noble Plays of Japan*, published by the Cuala Press. He asserted that with the help of these works, he had "invented a form of drama, distinguished, indirect, and symbolic, and having no need of mob or Press to pay its way—an aristocratic form." Europe had become "very old," and its creative figures needed to look elsewhere for fresh inspiration. The Orient was the obvious place to look, and he thought that the time was appropriate "to copy the East and live deliberately." He thought it "natural that I go to Asia for a stage convention, for more formal faces, for a chorus that has no part in the action, and perhaps for those movements of the body copied from the marionette shows of the fourteenth century." Like Pound, he loved masks, and Japanese ones enabled him to transcend the limitations of his players and always produce "a work of art." He quickly set to work, and the result was *At the Hawk's Well*, which he put on privately in 1916 before audiences that included Pound and Eliot. As he summed up the mean-ing of his new work shortly thereafter: "I desire a mysterious art, al-ways reminding and half-reminding those who understand it of dearly loved things, doing its work by suggestion, not by direct statement, a complexity of rhythm, colours, gesture, no space-pervading like the in-tellect but a memory and a prophecy. . . ."[39]

Noh plays went back to fourteenth-century Japan. In a mixture of prose and verse, they used a highly symbolic stage and masked char-acters. Three or four instruments provided music for dancing and singing. No curtain separated the few sets on a bare stage from the audience. Costuming tended to be colorful and luxurious, and fans seemed to be everywhere, symbolizing a sword, a cup, a mallet or what-ever else the plot required. The plays could be either realistic or fantastic, and some were essentially dreams. Five types were common: god-plays, battle-plays, wig-plays (about women), mad-plays, and de-mon-plays. Pound used the last four of these when he chose 15 plays out of the 2000 extant ones. As with the imitations of the Chinese poems of Li Po, Pound had his problems with Noh. Although he had the help of Arthur Waley, many errors invaded his texts and no one really knows if the mistakes were his, Fenollosa's, or Waley's. He also proved capable of rather ruthlessly altering texts to suit his purposes. Increasingly con-

temptuous of conventional religion, he ignored the close relation which Noh had to the Buddhist and Shinto faiths, totally misinterpreting one play in the process.

But the issue of accuracy was less important here. Japanese theater stimulated Pound's imagination as it did Yeats', in the process convincing him that paratactic verse need not limit itself to the length of a haiku; a poet could write intense, concrete, suggestive, allusive verse over longer forms, using masks, voices and musical analogies to communicate to an elite. The lessons once learned, he passed on. He published *'Noh', or Accomplishment* in 1916, appearing as co-author with Fenollosa, yet only a year later was almost dismissive of the whole subject. "China is fundamental, Japan is not," he wrote privately. "Japan is a special interest, like Provence, or 12–13th Century Italy (apart from Dante)." He still liked individual items in Fenollosa's Japanese material, but found no true comparison. "China is solid. One can't go back of the 'Exile's Letter,' or 'Song of the Bowmen,' or the 'North Gate.' " By 1917, he was writing with the firm authority of a man who knew exactly what he was doing.[40]

V

The other major British writer with whom Pound had a long-term personal as well as professional relationship was Wyndham Lewis. In an encounter that later went into Canto 80, Laurence Binyon, assistant keeper of the Print Room at the British Museum, took Pound to the Vienna Café in 1909 and introduced him to Lewis and T. Sturge Moore. Their earliest meetings did not go well; someone had informed Lewis that Pound was Jewish as well as American, two presumably good reasons for his not fitting into the London aesthetic scene. Lewis was a bit surprised to confront "an unmistakable 'Nordic blond,' with fierce blue eyes and a reddishly hirsute jaw." He soon turned his back on "this cowboy songster," sensing "little enthusiasm," and left the gathering sure Pound had "bitterness in his heart." Most Englishmen disliked Pound, as far as Lewis could see, and Pound returned that feeling, approaching strangers "as one might a panther, or any other dangerous quadruped—tense and wary, without speaking or smiling."

This sense of being an outsider was actually one the two shared which was perhaps why Lewis spotted it so vividly and why the two were soon such close friends. His assessment of Pound was especially acute on two grounds—Pound's national heritage and his devotion to literature. He insisted that Pound had always been and would remain "violently American. Tom Sawyer is somewhere in his gait, the 'Leaves of Grass' survive as a manly candour in his broad and bearded face: the 'tough guy' that has made Hemingway famous, and the 'strenuousness' of him of the Big Stick, are modes of the American ethos with which Pound is perfectly in tune." As for literature, Pound "was a man of letters, in

the marrow of his bones and down to the red follicles of his hair. He was a born revolutionary, a Trotsky of the written word and painted shape." Pound "breathed Letters, ate Letters, dreamt Letters. A very rare kind of man," Lewis concluded in 1937.[41]

Indeed, everything in Lewis' background seemed to make him what he eventually styled himself to be: an "enemy" to British establishments of all kinds. His father was an American of Quaker ancestry, a some-time soldier, lawyer, musician, horseman, and sailor who lived on family money and never made much pretence of adjusting to a materialistic society which he despised. His mother was an English woman whose heritage was Scots-Irish and Roman Catholic. In 1882, Percy Wyndham Lewis was born on his father's yacht, then sitting at a dock at Amherst, Nova Scotia—making him a Canadian citizen, an identity he retained for life. In 1888, his parents moved permanently to England, only to separate in 1893 when "the Old Rip," as Lewis called his father, ran off with a red-headed housemaid. While his mother persevered in genteel poverty, Lewis attended Rugby and the Slade School, picking up enough inside knowledge of the British social system to cope with it if he had to. He preferred enmity. He disliked the philistinism, snobbery, and conformity of British public schooling, and seemed to have an inbred dislike of any institutional authority. He learned a lot, but later seemed mostly to have learned what to attack in politics, literature, and art. As if this were not enough to establish his kinship with Pound, he then went off to the Continent for several years—chiefly Paris, but with extensive travel in neighboring countries—studying at the Académie Julian, visiting the Bauhaus, meeting Gertrude Stein, hearing Henri Bergson lecture, and reading Nietzsche. He took as his role model the talented if raffish painter Augustus John, from John's large black hat to his extraordinary capacity for multiple sexual liaisons; in so doing, he gave Pound a living role model himself, improving on the legends of Whistler that Pound had found so appealing.[42]

Pound not only liked Lewis, he genuinely admired his art. Since much of Lewis' work in this period has disappeared, the record is fragmentary, but from "Kermesse" (1912) on, Lewis was clearly a major modernist painter; with the publication of *Tarr* (1918, but begun 1911), he was a major prose modernist as well. The record of his intellectual milieu is at least as confusing as that of his output, for in his post-World War I works Lewis often reversed his earlier allegiances and obscured his genuine debts. He disliked thinking that exposure to the ideas of Bergson or the art collection of Stein had been important in his development. He was merciless in his assaults on F.T. Marinetti and Futurism, although he had adopted their general tone of violence, their stress on the present, their love of speed, and their contempt for conventional values. He came perilously close to turning even on Pound. While admitting that "a kinder heart never lurked beneath a portentous exterior than is to be found in Ezra Pound," he insisted on publicly call-

ing his friend "a genuine naïf," and "a sort of revolutionary simpleton." Pound seemed to be equal parts of Bergson, Marinetti, Hueffer, Edward Fitzgerald, and Buffalo Bill. "It is disturbance that Pound requires; that is the form his parasitism takes. He is never happy if he is not sniffing the dust and glitter of action kicked up by other, more natively 'active' men." It was a dubious way of repaying a man who had helped him repeatedly in many ways, emotionally, artistically, and financially.[43]

Given the noisy cultural atmosphere of prewar London and the sense that both Pound and Lewis had of being outsiders, the obvious need was for publicity. Publicity meant shows and newspaper articles, cafés and parties, new names and definitions. To receive attention and sales, artists needed to manufacture a movement: they needed a name, a journal, and an aesthetic platform. Pound was becoming adept at such matters; his clothes, his manners, and his genuine ability combined to make him seem the soul of brash creativity, and his search for new ideas was already leading him into Imagism and the poetry of the Orient, when his relationship with Lewis bore fruit in the closely related areas of painting and sculpture. "Vorticism" was the name Pound and Lewis used to distinguish their work from the welter of other movements competing for attention in London: from the Post-Impressionism of Roger Fry's Grafton Gallery shows, from Futurism, Cubism, Fauvism, and the other "isms" of Modernism. *BLAST* was the chief journal. The platform appeared in its most coherent form in Pound's memoir of Henri Gaudier-Brzeska, the sculptor whose work seemed to embody a formal essence implicit in Lewis' paintings and Pound's verse.

In 1912, Lewis was an associate of Roger Fry and the Omega Workshops, the leading advocates of modern French painting styles in England. By the middle of 1913, personal, aesthetic, and financial friction between Lewis and Fry was building up and in October Lewis led an exodus from the Omega group that marked the obvious formation of an identifiable new movement. Including Frederick Etchells, Cuthbert Hamilton, Edward Wadsworth, and C.R.W. Nevinson, it became publicly identifiable with a December show in Brighton, "English Post-Impressionists, Cubists and Others." In a note for the catalog, Lewis insisted that the painters formed "a vertiginous, but not exotic, island in the placid and respectable archipelago of English art," a formation "undeniably of volcanic matter and even origin." These painters claimed a general commitment to the underlining of the "geometric bases and structure of life," to the "rigid reflections of steel and stone in the spirit of the artist" as well as to "a desire for stability as though a machine were being built." By March 1914, the same group dominated Kate Lechmere's "Rebel Art Centre" at 38 Great Ormond Street, announcing lectures on poetry and music, and partying at the Cave of the Golden Calf just off Regent Street, where Frida Strindberg, the wealthy

and histrionic former wife of the playwright, provided an Austro-Hungarian respite from Anglo-Saxon propriety. *BLAST* I appeared only weeks before the guns of August began firing; a much-delayed *BLAST* II appeared in July 1915, effectively ending the movement, although Pound tried to keep its spirit alive a while longer.[44]

In *BLAST* I, Pound defined the vortex as "the point of maximum energy," and insisted that the "fundamental tenet of vorticism" was: *"Every concept, every emotion presents itself to the vivid consciousness in some primary form. It belongs to the art of this form. If sound, to music; if formed words, to literature; the image, to poetry; form, to design; colour in position, to painting; form or design in three places, to sculpture; movement, to the dance or to the rhythm of music or verses."* He went on to review some of the men and ideas—Pater, Whistler, Apollinaire, Flaubert, Imagism—which had prepared the ground for Vorticism. He distinguished his position from Symbolism and Futurism. He carefully pointed out some of the ways in which the arts were related, yet also insisted that in certain ways a critic could carry such relationships too far. He then demonstrated that, at least for Vorticism, painting had replaced music in the avant-garde universe. Where Pater had argued that all the arts aspired to the condition of music, Pound found them more properly aspiring to the condition of painting. Imagism and painting in particular had close ties: If the image were "that which presents an intellectual and emotional complex in an instant of time," then "the image is the poet's pigment." Jacob Epstein, allied to Vorticism without being himself a Vorticist, had said that he was interested in "form, not the *form of anything*," and this distinction was central to Pound's position. He stressed that: "Every concept, every emotion, presents itself to the vivid consciousness in some primary form. It belongs to the art of this form." He then summarized: "The image is not an idea. It is a radiant node or cluster; it is what I can, and must perforce, call a VORTEX, from which, and through which, and into which, ideas are constantly rushing." As Wyndham Lewis put it to Douglas Goldring: "You think at once of a whirlpool, at the heart of the whirlpool is a great silent place where all the energy is concentrated, and there at the point of concentration is the Vorticist."[45]

Such definitions had an authoritative sound to them, but they meant little at the time. Pound always tended to sound more revolutionary in theory than in his actual poetry, and neither poets nor painters changed their styles because they suddenly adopted Vorticist principles. Indeed, Lewis tended to scoff at the whole thing, claiming late in life that "Vorticism, in fact, was what I, personally, did and said, at a certain period." As always, Lewis pleased himself in his art, preferring to paint rather than write—although he did write a respectable amount, always stressing the need to do *"what nature does"* rather than trying to imitate it, something he thought "an absurdity." For Pound, the movement was a bit more significant, and not merely for the controversies it provoked.

What Lewis' work helped Pound to do was to get beyond linearity and metaphor in ways almost as important for his poetry as his study of Fenollosa's notes. The core of this influence he made clear in a 1916 letter to John Quinn, where he talked about the movement that he had just summed up in *Gaudier-Brzeska*. He thought he should do a similar book on Lewis, for aside from Picasso, only Lewis had the capacity for greatness. "It is not merely knowledge of technique, or skill, it is intelligence and knowledge of life, of the whole of it, beauty, heaven, hell, sarcasm, every kind of whirlwind of force and emotion. Vortex. That is the right word, if I did find it myself." He then recalled the time three or four years earlier, when he had remarked to Epstein: "The sculpture seems to be so much more interesting. I find it much more interesting than the painting." Epstein replied: "But Lewis' drawing has the qualities of sculpture," or something close to that, and this remark sent Pound "off looking at Lewis." The encounter was important. The sculptural qualities in Lewis' work in paint were one way of conceiving a new form for poetry as well: poetry as a pattern, as a non-linear design, as a form that was not a form *of* anything, that did what Nature *did* but did not imitate Nature. Like Fenollosa, Lewis helped catalyze Pound into the poet of the Cantos.[46]

VI

Pound's circle of acquaintances among Americans in London was just as wide as among Europeans, but in their eyes he was an even more important figure than he was for the Europeans. The English, Irish, and French artists that Pound assisted usually had traditions and contacts of their own. They needed Pound for his critical talents, his flair for publicity, and his contacts with innovative journals and publishers; as the war persisted, they relied on him increasingly for American money as well, chiefly that of John Quinn in New York. But the Americans in London were even worse off. In some cases they arrived chiefly because Pound was already there; in others, he provided an entré into a society usually closed to untried ex-colonials.

Hilda Doolittle was the first of these. Thinking of herself as Pound's fiancée, she toured Europe for about four months in 1911 and then settled in London. She soon learned about Pound's understanding with Dorothy Shakespear, but was nevertheless determined to remain abroad. Miserable at home, she had to face continuing pressure from her family to return, but resisted firmly. Instead, she kept as brave a face as she could, continued to see Pound and to meet his friends, and to write verse. By December, she could write to Isabel Pound that she was "happy," and that both she and Ezra had had a "surprisingly cordial" reception. She listed some of the names of the people she had met, including May Sinclair, Alice Meynell, and Ernest Rhys, and mentioned the parties, concerts, "a dinner once in a while, and kindness every-

where!" Happiness for her, she wrote, "has meant brousing in picture gallerys, hour after hour,—'The National' is my favorite haunt! Exploring old churches and church-yards—odd corners in Lincoln's Inn Fields, remote by ways and bridges by Hammersmith: feeding many ducks who quack gratefully in St. James' park: and seagulls, who look on and soar disdainfully aloft;—more ambitious adventures into Hampstead Heath and Goldner's [sic] Green!"[47]

About three months later, in February 1912, a young Richard Aldington met Pound and showed him several of his early verses "over a beef-steak in Kensington." Pound approved of his rhythms and his attempts at free verse and shared some of his own work. Aldington quickly came to the conclusion that Pound was "the most able corrector of other people's poems I have ever met," and Aldington long remained grateful for the encouragement. Within a brief period, Aldington, Pound, Doolittle, and Brigit Patmore became something of a poetic foursome, meeting almost daily for afternoon tea at the Grosvenor Gallery in Regent Street. "I was so happy" then, Doolittle recalled in 1929, in a letter to Pound. "Do you remember how you came to Golders Green and they practically gave me the sack afterwards because we had all trailed that atrocious sort of monastic walk singing?" She thought of herself as "a sort of disembodied creature, half-born, so happy. In America, those last years, I had been dead." In his memoirs Aldington made fun of American expatriates and their "almost insane relish for afternoon tea," and wondered a bit that most of their radical discussions of poetry could take place "in the rather prissy milieu of some infernal bun-shop full of English spinsters," but at the time he loved the attention of the most stimulating poet in London and two highly attractive and intelligent women. At some such meeting, probably in August, Pound proved to be immensely pleased with Doolittle's first tentative efforts, and after a bit of revision and cutting, put the by-line of "H.D., Imagiste" at the bottom, promised to send her work to Harriet Monroe in Chicago, and proclaimed them all Imagistes. They were a "mouvemong," as Aldington always spelled Pound's French accent, a movement with its origins in T.E. Hulme and the forgotten school of 1909.[48]

At this point, Harriet Monroe established contact with Pound, and Chicago became something of a literary suburb of London. He personally had only his poem on Whistler, and one other, ready to print, but claimed on the flimsiest of evidence that, with Monroe's cooperation, they could "carry into our American poetry the same sort of life and intensity" which the painter had infused into modern art. He looked forward, with characteristic understatement, to "our American Resorgimento," which "will make the Italian Renaissance look like a tempest in a teapot!"

The letters began to pour into Chicago. "You can put me down as 'foreign correspondent' or foreign editor if you like, and pay me whatever or whenever is convenient," Pound wrote on 21 September. "You'll

get whatever I do that is fit to print." He planned to send "some of young Aldington's stuff," and positively looked forward to doing battle with the forces of conservative poetry in Boston and New York: "you might send me some of the clippings and perhaps I can riposte on them from a less expected quarter." By October he was sending "some *modern* stuff by an American, I say modern, for it is in the laconic speech of the Imagistes, even if the subject is classic." Hilda Doolittle had been living with Greek language and culture since childhood, and came by her reticences honestly. "This is the sort of American stuff that I can show here and in Paris without its being ridiculed. Objective—no slither; direct—no excessive use of adjectives, no metaphors that won't permit examination. It's straight talk, straight as the Greek!" The poems were indeed classical, having been written in imitation of the work of Theocritus; Pound had given her a copy of his work in translation.[49]

Doolittle was never capable of asserting herself in the Poundian manner. Tall, shy, and insecure, she seemed attracted to both men and women who appeared self-confident. Pound was special and despite his marital rebuff she remained under his spell, seeing him constantly and following his suggestions even as she informed Monroe privately that she wanted to be printed only as "H.D.," and not as "H.D., Imagiste." Aldington soon took Pound's place in her personal life. He was younger, different from anyone she had known well, and although British, was pro-American enough to be writing Monroe about how he was defending American culture to his countrymen: they were "all stupified by insularity & bored to death" with "inanition. The future is America's!" John Gould Fletcher sketched the couple effectively: "While H.D. was tall, slim, lithe with a pale oval face framed in masses of dark hair, and a nervous shyness of manner that only emphasized her fragility, Aldington was bluff, hearty, and robust, with the square shoulders of an athlete, the bullethead of a guardsman, and a general tendency to beefiness which proclaimed his British quality." Sometimes as a threesome, often in the company of others, Pound, Aldington, and Doolittle visited Paris and Italy; she reported to Isabel Pound that she did not much like Florence but loved Rome. Doolittle's Paris diary, the first eighth of which has been chopped out, indicates a period of great turmoil and something of a major crisis during the spring of 1912, but once Aldington arrived she regained her cheerfulness and offered detailed descriptions of natural, architectural, and artistic Paris. "My mind is aflame with Paris," she declared.[50]

Pound, on the other hand, seemed "very sad" on 10 June 1912, perhaps because he realized that in gaining Dorothy Shakespear he had lost someone equally important to him. A year later, writing from Venice, he told Shakespear that Doolittle and Aldington were "submerged in a hellenism so polubendius and so stupid that I stop in the street about once in every 15 minutes to laugh at them—convulsed & deprived of the powers of motion." He was clearly jealous. "Hellenism?

True, they have attained a dullness almost equal to the expression (facial) of gk. statuary—but I wonder—I think they must be in love." They were indeed. They married in October, and Pound was soon referring to Aldington somewhat contemptuously as "Mr. Hilda." The couple returned to London, and Aldington informed Pound: "Fat Ford is back, and I am to be the mari complaisant and let him have my wife as a secretary. I regret it the less as he is now writing a passing marvellous novel, which will kick em all in the guts, Conrad included."[51]

Doolittle was never a theorist or propagandist. What she did was to write verse in a Greek manner that focused Pound on exactly what he had been trying to say. By concentrating on images, by presenting rather than representing, by leaving out all the needless words of the Victorians and the Symbolists, she produced a paratactic verse that has reminded many readers of the metaphysicals. In so doing, she seems more genuinely original than Pound, fresher in her perceptions, and despite her "Greekness" less likely to lapse into imitation and pastiche. She became the necessary muse of the movement, her work being the occasion of Pound's remarks on the image, on precision, and on the natural object always being the adequate symbol. Imagism originated in the impact of both her person and her work on Pound, and only subsequently deteriorated into a word that seemed to cover any sort of free verse evocative of nature and the poet's perception of it.

Doolittle's achievement proved to be considerable, but most of it came after the period of her relationships with Pound and Aldington. Instead of writing, she had to deal with one emotional tangle after another. Pound was lost to her, although they corresponded occasionally and affectionately for life. Aldington and Pound soon quarreled, although Aldington too retained fond memories of the brief years of Imagism and his poetic coming-of-age. But merely to look at the surface history of Imagism is to miss the undercurrents of personal behavior that always marked the rise and fall of aesthetic schools in this era. Aldington had no intention of limiting his sexual attention to his bride, and was soon deeply involved with Brigit Patmore, and then Flo Fallas and Dorothy (Arabella) Yorke. Doolittle herself soon became emotionally involved with the Russian-American writer and translator John Cournos, a friend of Aldington's as well, and then with D.H. Lawrence. As the war worsened she bore a stillborn child and developed a hysterical ambivalence about all sexual relationships including the one with her husband. He was soon in the military and the marriage was clearly over long before they officially separated. She consoled herself with music critic Cecil Gray and bore him a child in 1919. She and Aldington no longer lived together, and she sought financial and emotional support from Annie Winifred Ellerman, daughter of a man reputed to be the wealthiest in England; as Bryher, she became Doolittle's constant companion and a writer of some note. Amidst such entanglements, the miracle was that anyone got anything done.[52]

By 1941 Aldington was hardly an unbiased source, but he was not unfair to his first wife. He insisted that she had been "more distinguished . . . than Ezra, both as a person and as a mind." He had "never known anybody, not even Lawrence, with so vivid an aesthetic apprehension." Lawrence was, he thought, keenly aware of the living world, "but he was almost blind to the world of art." "To look at beautiful things with H.D." was, by contrast, "a remarkable experience." She had "a genius for appreciation, a severe but wholly positive taste." She lived "on the heights," and never wasted "time on what is inferior or in finding fault with masterpieces." She responded "so swiftly" and understood "so perfectly," that the work of art seemed "transformed. You too respond, understand, and relive it in a degree which would be impossible without her inspiration."[53]

VII

Pound's second great American discovery was Robert Frost. "Have just discovered another Amur'kn," he wrote Monroe's assistant Alice Corbin Henderson in March 1913. "VURRY Amur'k'n, with, I think, the seeds of grace." He was reviewing Frost's work, planning to condense it of course, and would send some poems along shortly. The relationship proved difficult, however, and Frost later remarked that they quarreled after six weeks. In fact, the two equally irascible poets worked together a bit longer than that, helped by the fact that they did not meet all that often. This said, by September Pound was sounding a bit defensive, writing Monroe: "I admit he's as dull as ditch water, as dull as Wordsworth," but "he is trying almost the hardest job of all and he is set to be 'literchure' someday." In October, he admitted to Henderson that "of course Frost isnt quintessence, it is honest homespun, dull and virtuous." The man "is as pig headed as any New Hampshire hecker that ever put punkin seed into a granite field with a shot-gun." Frost would "gain a lot if he could mobilize, but he can't and one has to put up with it. Wordsworth," he repeated, "is equally stolid," but he insisted parenthetically that "THAT is NO excuse, for either of 'em."[54]

Frost had moved his family to England in the late summer of 1912. Unknown as a poet, he attended plays and explored London for several weeks, and then settled into a cottage in Beaconsfield, about twenty miles north of London. In October, he found a small publishing company in Bloomsbury, David Nutt; Nutt's daughter-in-law, a depressed-looking woman with a French accent, liked Frost's work, got him to agree to a contract which he later regretted, and published *A Boy's Will* in April 1913. While the book was in press, Harold Monro opened the Poetry Bookshop in January and Frost soon met Frank Flint there. "I see by your shoes you are an American," Flint remarked to him as they started chatting. They became friends with remarkable swiftness. The subject of Ezra Pound came up quickly; Frost had never heard of him.

The bookshop was planning to have readings every Tuesday and Thursday at 6:00 p.m., and would Frost like to join them? He could hardly contain himself. Amy Lowell later dismissed the Bookshop environment as having an atmosphere of "overwhelming sentimentality," but it did serve to bring together figures as disparate as Pound, Yeats, Sturge Moore, Ernest Rhys, Francis Meynell, and Rupert Brooke.

About two weeks after meeting Flint, Frost participated with such vigor that he feared he was misunderstood. "I was only too childishly happy in being . . . for a moment in a company in which I hadn't to be ashamed of having written verse," he wrote Flint. "Perhaps it will help you understand my state of mind if I tell you that I have lived for the most part in villages where it were better that a millstone were hanged about your neck that you should own yourself a minor poet." He was less enthusiastic about Harold Monro, a figure who could also provoke Pound into paroxysms: Frost thought Monro a "gloomy spirit." "No one can laugh when he is looking. His taste in literature is first for the theological and after that for anything that has the bits of sin."[55]

With his reading of Bergson, Frost was well-prepared to meet T.E. Hulme and the poets who saw Hulme frequently. But although Frost was desperate for such company, his feelings of inferiority were almost crippling, and the "heavy philosopher" was a bit intimidating. This is "a minor note by a minor poet," he began a letter to Flint in July 1913. He had shown Flint several poems and received lengthy criticisms, but asked him not to show the poems to "Hume" until "you hear from me again. . . . I am suffering from uncertainty with regard both to the poems and to myself. Sometimes I despair of myself for several kinds of a fool."

Yeats was equally intimidating, but in different ways. Frost recognized his merit and yearned to know him better, but the two were traveling different if parallel lines. Pretending to an intimacy he never had, Frost retailed stories about Yeats to his friends—often, as with Hulme, carefully misspelling the name as "Yates," perhaps to take sly revenge against distant eminence. Yeats' fascination with "leppercauns" and fairies was clearly a bit disillusioning; Frost could not comfortably wear a Yankee mask in an atmosphere of Irish twilight. Eleanor Frost was characteristically tart on the relationship. "Yeats has said to a friend, who repeated the remark to Robert, that it is the best poetry written in America for a long time," she wrote a friend. "If only he would say so publicly, but he won't he is too taken up with his own greatness." Frost in fact felt most comfortable with the so-called Georgian poets, those being featured in Edward Marsh's *Georgian Poetry, 1911–1912* (1912), and its four successors. Frost was especially close to Wilfrid Gibson, then living over Harold Monro's shop, and through Gibson he met Lascelles Abercrombie and others in the group.[56]

Although Flint remained in some ways Frost's closest confidant, the relationship became increasingly a postal one. By early 1914, Frost was

having grave doubts about the utility of Pound's friendship, was discovering the flaws in the contract he had too willingly signed with Mrs. Nutt, and was becoming discouraged about his family life in London: the children had schooling maladjustments, health was a perpetual consideration, and everyone was a bit homesick. In April they all moved to Gloucestershire, where Frost immediately settled into one of the better-known friendships in literary history. He and Edward Thomas lived within walking distance of each other and at times each seemed able to remain psychologically erect only by leaning on the other. One of the more depressed cases in the history of poetry, Thomas had long fought poverty, lack of recognition, and a seemingly permanent writer's block as far as verse was concerned, by churning out literary journalism. Only perpetual walks in the country and a devoted wife kept him going at all until Frost came along. But Thomas had reviewed *A Boy's Will* in *The New Weekly,* noticing that Frost had "trusted his conviction that a man will not easily write better than he speaks when some matter has touched him deeply," and both the kindness and the perception about the role of sound in poetry immediately struck a note with Frost. For Thomas, Frost's presence and encouragement meant the end of his block, and all the poetry for which he became so well-known poured forth in the three years before his death in World War I in 1917. For Frost, Thomas provided a suitable, Georgian alternative to the Imagism and Vorticism then winning so much publicity in London. "What imbeciles the Imagistes are," Thomas was known to grumble, and his attitudes helped Frost free himself from Pound's obsession with the image and with paratactic patterns, to explore his own preference for sound, ordinary speech, and narrative linearity.[57]

Life was companionable but hardly luxurious and both wives had their troubles caring for thoughtless mates. Eleanor and Robert Frost and four children lived in a laborer's cottage that sat on a rough patch of land planted in potatoes. The two poets would hoe together, talking poetry. Frost never paid any attention to time, and people came and went, eating as they pleased and sleeping when tired. Bread, fruit, and cold rice were the staple foods. Inside, the house was distempered pink, and never seemed to have enough chairs for socializing. Nevertheless, "fragile and weariable," Eleanor would serve the men "an al-fresco tea" as they talked, oblivious of anything not directly relevant to poetry. One of Frost's favorite topics was his friend Pound, who could not possibly have survived in such basic surroundings. Frost told Thomas and anyone who would listen about "the exotic Oriental dressing-gown of purple silk" in which Ezra Pound had welcomed him to London; "my dazzling friend Ezra Pound," as he would put it, in a voice as undazzled as a Yankee could manage.[58]

Georgian poetry as a whole bore little resemblance to Imagism. It perpetuated many of the Romantic obsessions with nature, emphasizing the expression of basic human emotions through descriptions of

country life. It fled the city and much of civilization as artificial, and exhorted readers to a manly activism poles apart from the aestheticism of Pater or the Irish twilight of the early Yeats. But in one area, Georgian and modernist concerns came together, and Frost became the great poet of that area. No less an influence on Pound than Ford Madox Hueffer had been going around for years telling poets to write as they spoke, to avoid the artificial diction and imagery that clogged much Romantic and Victorian verse. Pound himself had great trouble ridding his verse of archaisms, and Frost occasionally yielded to habit in his earliest verse. But by *North of Boston* (1914), he was settling into ideas that he maintained for a long time. "The living part of a poem is the intonation entangled somehow in the syntax, idiom, and meaning of a sentence. It is only there for those who have heard it previously in conversation," he wrote Sidney Cox in January 1914. "I say you cant read a single good sentence with the salt in it unless you have previously heard it spoken. Neither can you with the help of all the characters and diacritical marks pronounce a single word unless you have previous heard it actually pronounced."

Less than a year later, he had his "new definition of the sentence" ready to forward. He wanted literary critics and teachers to realize that "the sentence as a sound in itself apart from the word sounds is no mere figure of speech." He wanted to show "the sentence sound saying all that the sentence conveys with little or no help from the meaning of the words." The sound of a sentence, in fact, could be quite opposed to the sense of the words, and the tension between the two was "irony." A poet had to realize this distinction, "between the grammatical sentence and the vital sentence." People already knew enough about "the seeing eye." "Time we said something about the hearing ear—the ear that calls up vivid sentence forms." With such common concerns, a Georgian like Edward Thomas could write, in the review of *North of Boston* that established Frost's reputation for the larger British public, that Frost's poems were "revolutionary because they lack the exaggeration of rhetoric." Frost's medium "is common speech and common decasyllables, and Mr. Frost is at no pains to exclude blank verse lines . . ."[59]

If Thomas was decisive for British audiences, Pound and his connections with *Poetry* were for American ones. Pound's mask of Whistler, dressed in Oriental dressing gowns, seemed to clash too sharply with Frost's mask of Yankee, uttering monosyllables in a potato patch. But Frost and Pound did share numerous experiences and values, from birth in the American West and an insistent identification with American values, to feelings amounting to paranoia about the place of poets in a democracy and devotion to the vocabulary of common speech. Each was so lonely and eager for colleagues that friendship was possible at first, even if it could not last. By April 1913, Frost was already fearful that Pound, "the stormy petral," had overdone it in his article in *Poetry*,

"denouncing a country that neglects fellows like me." By July, he was speaking of Pound's "bullying me on the strength of what he did for me by his review in Poetry. The fact that he discovered me gives him the right to see that I live up to his good opinion of me." Pound insisted that "I must write something much more like *vers libre* or he will let me perish of neglect. He really threatens." Frost tried to be grateful, but "if any but a great man had written it, I should have called it vulgar. . . . Still I think he has meant to be generous." The tone of his letters to Flint about "that great intellect abloom in hair" was more caustic, as befitted an audience already skeptical. "Pound can be cruel in the arbitrary attitudes he assumes toward one. It pleased him to treat me always as if I might be some kind of a poet but was not quite presentable—at least in London. Some of the things he said and others imagined drove me half frantic." Flint tried to mollify Frost somewhat, insisting that Pound's "bark is much worse than his bite; and that much that seems offensive to us externally is merely external and a kind of outer defense—a mask." But Frost never did calm down on the subject. He disliked Pound's manner, his emphasis on the eye rather than on "the sound of sense," his preference for writing to an elite audience rather than to a broad one, and his attitudes toward America. Frost planned to return home and soon did; he did not want Pound to make him needless enemies. When it came to gratitude, he felt it mostly for Flint: "You and a bare one or two others are England to me . . . ," he wrote from New Hampshire in 1916.[60]

The Frost who returned to America has gone down in cultural history in many guises, from the homespun Yankee to the unpleasant neurotic. Rarely do critics emphasize his modernism or his eminence within its disorganized ranks. By 1916, Frost had published *A Boy's Will*, *North of Boston*, and *Mountain Interval*, the latter two volumes especially including major Frost statements that warrant a high place. At a comparable date, only T.S. Eliot had written anything more important, and much of Eliot's work remained unknown. Pound himself, so much better known and far more important as a presence in cultural history, was only beginning to hit his stride with *Cathay* (1915); the works that merit a high modernist rank were still to come. Frost's ambiguous status stems not only from his later place as the white-haired bard of the Kennedy administration, but from his point of departure in the history of poetry and the aural rather than the visual nature of his innovations. Unlike Pound and Eliot, Frost neither came out of the decadent nineties in England or France, nor was he familiar with languages or scholarship. He came instead out of Wordsworth and Hardy and the long tradition of English poetry about nature. Too neurotic to survive the demands of employment or life in cities, he needed isolation and the comfort of a habitual round of rural tasks.

His work reflects this, and on its surface seems essentially satisfied with old-fashioned ways. People could read it as they did the Geor-

gians, to maintain sanity and order in a world given over to industrialism and war. But Frost really had no faith that God was in his heaven, that all was right with his world, or that human life meant anything at all. His wife was a confirmed and outspoken atheist and Frost himself often seemed close to such a position. If God were not dead to Frost, he certainly had a malicious sense of humor, and the tension between the familiar comforts of nature and the lack of any larger meaning remains one key way of identifying the modernism of his verse. Anyone who takes religious or philosophical comfort from a Frost poem has probably misunderstood it.

Frost's sense of geography was also deceptive. His place seemed to be so completely in New Hampshire, his vocabulary that of a garrulous farmer, that no one associated him with the sophistications of London or Paris. Much of his best work came to maturity in England, where he was associating with Pound, Yeats, Hulme, Thomas, and others among the best-read men of letters of their day. "Places are more to me in thought than in reality," he wrote Sidney Cox, and he clearly needed "New England rural" as a kind of anchor for the experiments he wished to make. William Carlos Williams did much the same with Paterson, yet because Paterson was a city, it seemed somehow more modern. The man who could take natural imagery and use it to make points about a universe that did not mean much of anything, could also use his special place to underline his points about the placelessness of people, the homelessness of those who desperately needed some sense of security. Frost felt comfortable with New England if not in New England, and his sense of place was yet one more ironic way of inveigling readers into a web of meaning that they preferred not to see.

Finally, Frost chose to make his experiments in sound rather than in sight. While other modernists aspired to the condition of painting, Frost aspired to the condition of conversation. Unsophisticated in music, he was capable early in his London years of responding immediately to modernist harmonies even when he could not spell the name of the composer. He went to hear "the Liebichs" play late in 1913 and wrote Flint about it. "I almost overtook something elusive about rhythm that I am after when Liebich played Debuyssy. I have to thank the day for that . . ." Such coincidences are illuminating, for Debussy was both a pioneer modernist in his sense of color and his chord progressions, and seemingly a conservative in writing impressionistically about clouds, festivals, or the sea. *Music*, anyway, is too strong and precise a term for what Frost usually called "the sound of sense." *Conversation* is a better word; common, ordinary, rhythmic, capable of conveying one meaning in the sense of the words and another in the tone. Conversation involved masks as well, the talker always "puttin' on" for his audience, speaking one way to one person, another to the next. Frostian conversation could also include counterpoint, a suitably musical term for the layering of voices as well as meanings, so that a poem seemed to be

saying several things at once, some of them contradictory. And just as music had beats, measures, and rhythms, so Frost's talkers organized their speech, seemingly so laconic and unsophisticated. Thus in certain very odd ways, he had his kinship to Erik Satie and Virgil Thomson, evoking complicated modernist ideas through the simplest of means, sneaking in at the ear while all eyes were focused on the image. Any magician knew how to do it.[61]

VIII

When Robert Frost returned to the United States early in 1915, he was largely unknown and discouraged. He disembarked with his family at the foot of 42nd Street and trudged up toward Grand Central Station. Stopping to buy a newspaper, he glanced at the *New Republic* and noticed that it had a review of *North of Boston* by Amy Lowell, a woman whom Pound had wanted him to meet. The review was largely favorable and seemed a good omen. In a short time he was in Boston and rang her up to thank her for the notice. She immediately asked him to dinner, and Frost was soon at Sevenels, the famous house where the "last of the barons," as she sometimes styled herself, held court for visiting literati. Surrounded by seven spoiled sheepdogs and a library worthy of a university English department, she was alternately charming and fuming her way into literary history. Without half the talent that Frost had, she had the wealth and contacts that he lacked. She introduced Frost to John Gould Fletcher, one of her closest friends among modernist writers, and Ada Dwyer Russell, the retired actress who had become her constant companion. Lowell had her own fund of stories of Ezra Pound and Imagism; she too was more concerned with the musical than with the visual. Like her friend Fletcher, she was fascinated by "polyphonic prose," the Ballets russes and the experiments of Debussy and Satie. She even wrote poems consciously evocative of Bartók and Stravinsky.

Equally canny, equally manipulative, Frost and Lowell were well-matched in their odd ways. Lowell needed allies in her campaign to become the generalissimo of the movement for modern poetry in America. Frost needed publicity, explication, and a good agent. As usual, she did most of the talking, and the friendship proved mutually rewarding. In addition to the review, Frost soon received valuable notice in Lowell's *Tendencies in Modern American Poetry* (1917). In a largely biographical and atmospheric account, she praised him as a bucolic practitioner of "poetic realism." He was a success, she wrote, beyond anyone else in her volume: "But his canvas is exceedingly small, and no matter how wonderfully he paints upon it, he cannot attain to the position held by men with a wider range of vision." Friendly enough to her in public, Frost was furious in private—he was sure she regarded Edwin Arlington Robinson as a better poet, and he did not like it at all.[62]

Amy Lowell had trouble with most of her literary friends. She was no more willing than Pound to hear her judgment questioned. Returning from her pre-war foray to London, and the memorably embarrassing dinner where Pound and his friends had mocked both her size and her sensibility, she had moved swiftly to assert control over Imagism in America through her contacts in the Boston publishing world. Publicly, she took a position that gave no indication of her personal slights. Picturing Pound as a dictator, she proclaimed herself an advocate of democracy. She wanted to edit anthologies of Imagist verse in America, modeled after Edward Marsh's Georgian volumes. Aldington referred to her proposal as "A Boston Tea Party for Ezra," throwing out the dictator and letting the people rule—not realizing that a democratic Lowell was a contradiction in terms. She proposed that they all work together as friends with no one arbitrarily being editor or judge. Each poet would choose his or her best work, and each would have roughly the same space in each annual anthology; alphabetical order would determine who came first. Lowell would deal with publishers and perform the editorial tasks, including disbursement of royalties.

Not wishing to cut themselves off from Pound, Aldington and Doolittle pleaded with him to join in, but he refused. He wanted no part of Lowell's "democratic beergarden"; he was sure she would cheapen Imagisme into Amygism, using her contacts with the Pound group to publicize her own inferior work. Her group should call themselves *vers librists*, since that was what they wrote. They were no Imagistes or imagists. Most of the work in the proposed anthologies struck him as diffuse and unworthy of the name he had developed. The volumes were a small but definite success with the public, but on the whole Pound was right. Imagism with or without its "e" disappeared as a term with any precise meaning, becoming more or less synonymous with free verse about nature that tried to avoid affected rhetoric.[63]

The figure of Amy Lowell bulked larger in the history of Imagism after Pound disowned it, but even then she overrated herself and her influence. Most of the real work of *Some Imagist Poets* went on in England. Aldington and Doolittle, with Flint in the background, formulated the principles of this new phase of the movement and worked out the bulk of the selections. Inevitably, their views reflected Pound's. The chief manifesto was the preface to the 1915 volume, where Aldington laid down six principles. Great poetry used "the language of common speech," always using the "*exact* word, not the nearly exact, nor the merely decorative word." Great poetry had to create "new rhythm—as the expression of new moods—" and not "copy old rhythms, which merely echo old moods." It allowed "absolute freedom in the choice of subject," and especially insisted upon the "artistic value of modern life." It presented "an image," not as a substitute for painting but as an attempt to "render particulars exactly" and avoid "generalities, however magnificent and sonorous." It wanted "poetry that is hard and clear,

never blurred nor indefinite." It insisted that "concentration is of the very essence of poetry."

Lowell herself may have thought she belonged in this company, but on her own she rarely did; D.H. Lawrence was equally out of place. In *Tendencies in Modern American Poetry* she described Imagism as a "renaissance," "a re-birth of the spirit of truth and beauty. It means a rediscovery of beauty in our modern world, and the originality and honesty to affirm that beauty in whatever manner is native to the poet." Its rules boiled down to: "Simplicity and directness of speech; subtlety and beauty of rhythms; individualistic freedom of idea; clearness and vividness of presentation; and concentration." In practice she sometimes flirted with Symbolism and mostly stuck with Impressionism. Not for her the harsh discipline of Pound and Doolittle.[64]

IX

As the world went to war in 1914, then, modernist impulses in American poetry operated in three contested terrains. Harriet Monroe ran *Poetry* in Chicago; with the advice of Alice Corbin Henderson close by, and with letters pouring in from Boston, London, and elsewhere, she was tolerant of the new work but rarely enthusiastic. Her journal remained important only so long as Pound and Eliot cooperated, and after 1917 it all but disappeared from view. Amy Lowell reigned in Boston, publishing her anthologies, assembling her essays, and venting strong opinions. But John Gould Fletcher aside, few paid her much heed. Like so many monarchs in the modern world, she could reign but not rule; she solaced herself over the years not with innovative verse but with her research into the life of John Keats. Power in poetry centered on Ezra Pound. If Pound were in London, representing modernism at Yeats' evenings and at South Lodge, then the center of American modernism in both poetry and criticism was at those salons, with Pound as major domo if not host. He provided a one-person network for Americans new to London. He laid out opinions that defined the important critical issues. To some he seemed unbearable; to others, irresistible. In effect he became ubiquitous, the first American that both British and American writers thought of when they encountered a new issue. He irritated friend and foe alike into creativity.

Pound's ubiquity has never received much historical attention. His biography is now readily available, and scholars have given his poetry microscopic examination. But, fleeting references aside, no one has gone through the personal letters and related materials of the many figures his life and work touched. Everyone knows he performed crucial editing services for T.S. Eliot, but few realize how "definitive" he was for the Amy Lowells, the John Gould Fletchers, the Robert Frosts, and the rest who often seemed not to know what they themselves thought until they confronted Pound and defined the ways in which they disagreed

with him. Pound even had this effect in disciplines that seemed far from poetry. He influenced criticism in all the arts for the next three generations; he was important for photographers and sculptors. His own writings on art and music in time filled two fat volumes, but these should not really be the focus of attention on these matters. The focus should be on Pound himself: the one-person salon who brought people into contact with new ideas and each other, and then sent them out— different, modernist, in ways that they themselves only partially understood.[65]

As in any study of influence, the subject far transcends life in one city over less than a decade. But it starts in London, with four pilgrims who all sought Pound out and used his friendships and his contacts to stimulate their minds, imaginations, careers, and sometimes bank accounts: Conrad Aiken, T.S. Eliot, Alvin Langdon Coburn, and Jacob Epstein.

As early as January 1913, Conrad Aiken had written Harriet Monroe in great irritation at the way Ezra Pound's views had become ruling doctrine for *Poetry*. Pound had recently published a piece on current poetic activity that had ignored the Georgian revival, and Aiken denied the validity of such a view. He thought Pound egotistical and his views "propagandist. And propaganda has no place in a magazine of this sort." Pound "writes good poetry, when he is not too intent upon writing good poetry," but his opinions were another matter. "Must we agree with him, for instance, that Whitman is the poet most worth imitating, and that *vers libre* or some form evolved from it is the poetic form of the future? Must we share all of Mr. Pound's growing pains with him, pang by pang?" These were good questions, questions Pound might well have enjoyed wrestling with, perhaps even endorsing them later. But in 1913 Aiken was in no position to wage successful critical war on Pound. He himself was under the spell of John Masefield and valued the work of Abercrombie, Drinkwater, de la Mare, and even W.H. Davies above that of the Imagists.[66]

Monroe never responded to Aiken's complaint, but he soon went public in journals not under Pound's influence. In *The New Republic* he asked pointedly if there were any end to the pretensions of the Imagists. Aldington was praising Doolittle, Fletcher was praising Lowell, and all of them seemed to be attacking any poets who used rhymes or recognizable rhythms. By 1915, the Imagists had "become nothing but a very loud-voiced little mutual admiration society." He admired occasional pieces by all of them, but insisted that *vers libre* was a fad and not a panacea. He thought Pound was theory-ridden, and that all of the verse was limited in its range and appeal. He noted that words like "charming," "interesting," and "delightful" were about all the critic could say in judging such works, for they seemed to have no intellectual or emotional force. He laughed at the Imagist attack on decorative verse and insisted that Imagists rarely wrote anything else themselves.

He continued the attack in *The Poetry Journal,* where he pointed out that although the Imagist platform was admirably clear, it seemed to have little to do with the verse in the volumes he was reviewing. Imagism was a vague and general term that boiled down to "the quality of *vividness,*" and was hardly anything new on the poetic horizon; Imagists "have only taken what has been a characteristic of all the best Anglo-Saxon poets and made it a principle." They asserted sensation rather than feeling, and as a result everything became "a chaos of delicate detail." As for Pound's famous aversion to anything cosmic, Aiken snorted in response: what about *The Divine Comedy* and *Faust?*—Weren't they cosmic? And why forbid suggestiveness? Lots of good poetry was suggestive, and not hard and clear at all.[67]

Given Aiken's critical competence and personal familiarity with the major figures of Imagism, his unwillingness to confront Pound's poetry in print remains a critical puzzle. He once dismissed *Pavannes and Divisions* as dull beyond measure, and entitled his piece "A Pointless Pointillist: Ezra Pound," but that aside, the record is bare on Pound the poet and sparse indeed on Pound the writer of anything else. The solution seems to be that Aiken regarded Pound as a psychological threat. They knew each other well for only about six weeks in London in 1914. In some moods, Aiken would insist many years later that he "didn't *dislike* him—we weren't soulmates—one must make a distinction"; or alternatively that "I liked him but he was a dogmatic creature—an opinionated S.O.B. . . . arrogant . . . conceited," and compare him to a Spaniard who rode his donkey while making his wife walk. Fair enough. But when an interviewer asked him if Pound had been any help in his work, Aiken replied: "Not a bit. We agreed to disagree about that right off, and I felt right off, too, that he was not for me, that he would become the old man of the sea and be on my shoulders in no time—which is exactly the experience that Williams had with him." In short Pound was formidable, overpowering, and Aiken feared for his aesthetic independence. He took his sly revenge in *Ushant,* calling the by then anti-Semitic Pound Rabbi Ben Ezra, who "if a good teacher, was also something of a tyrant."[68]

All modernists had their memories of a life that never seemed to fit into society, but with Aiken the burden was greatest. He had been born into a Savannah medical family. Dr. William Ford Aiken had come from Scottish Quaker stock, attended Yale and the Harvard Medical School, and pursued eye-ear medicine in Vienna and Berlin. Anna Aiken came from radical Unitarian and Quaker stock; her father had been a minister. The couple settled in Georgia because of an excellent job opportunity. "His pa a doctor, painter, writer, / his ma a beauty, but which the brighter?" their son asked in his "Obituary in Bitcherel." "They brought him up to read *and* write / then turned him loose to his delight." But soon his father sank into paranoia, convinced that his pretty wife was socializing beyond propriety. "Then all went sour: all went

mad: / the kitchen was sullen: the house was bad: / beaten he was: bare-backed: crossed hands / on bedstead knobs: trunk-straps, three bands: / for something nobody yet understands." On 27 February 1901, when he was eleven years old, Aiken woke up to hear his parents quarreling; his father counted to three and two pistol shots rang out. Aiken got out of bed, walked through the room where his three siblings were sleeping, opened the door to his parent's bedroom, and had to step over his father's body to see if his mother, her mouth still wide open for a scream, were still alive. They were both dead. He got dressed, told the cook to give the children their breakfast downstairs, walked to the police station, and informed the authorities of the murder-suicide. The press made a sensation out of it all, but that was trivial compared to the impact on the young boy. It became the traumatic event, the defining incident in his life, in *Ushant*, where, "finding them dead," he "found himself possessed of them forever."[69]

The children split up and Conrad went to live with an uncle in New Bedford, later attending schools in Cambridge and Concord. Perhaps understandably he became obsessed by "the ancestors, the ancestors, the unconquerable ancestors, whose tongues still spoke so clearly, whose hands still reached so unmistakably, and whose wills were so indistinguishable from one's own!" He was convinced that, "bandied about from one relative to another, from aunt to uncle to cousin, and for a decade therefore more at home in school or college than in any corner of any house, he had become for the entire family an embarrassing symbol, a reminder, the something that had been sacrificed . . ." He developed an acute need for a home, "a sustaining, but above all *uninstitutional*, locus of one's own." He could not find it in America. He dutifully went off to Harvard, but psychologically it was not the Harvard other students attended. He recalled chiefly "the places to which he could escape from Harvard" while he was there, ranging from Concord to local vaudeville joints. He certainly preferred New England to the South, but he felt essentially placeless, rootless.

The great event for which Harvard provided the stage was his meeting with Tom Eliot. Aiken won election to the *Harvard Advocate* toward the end of his first year, and met Eliot, a year older, at about that time. The two shared many frivolous and bibulous interests, but in between the punches and the riotous trips into Boston, they spent five years trying to work out a new poetic language: "We were feeling our way towards it, something less *poetic*, more inclusive, more quotidian, admitting even the vernacular, and lower in pitch: a new poetic voice, one in which one could *think*. How to do this and still manage to make it come out as poetry, this was the problem." As is so frequently the case with writers of all kinds, the desire to say something new did not always result in the actual saying of anything new. Aiken always had this problem, being far more acute on the flaws in the verse of others than he was on the flaws in his own. Still, his major surviving work

from his undergraduate days had occasional merit. Published sixty years later, "The Clerk's Journal" concerns a love affair with a waitress and is often derivative and clichéd, but Aiken was quite right to see in it premonitions of *The Waste Land*. It evokes a gray, depressing urban environment, and the tawdry nature of love amongst the balance sheets, invoices, ledgers, and related paraphernalia of the lower middle class. It concludes on an appropriately lugubrious note: "And I go on with tired feet.— / And life is paved with cobblestones."[70]

Aiken liked Harvard, but not enough to devote his life to formal studies. During his senior year he decided to take the Gautier short story "La Morte Amoureuse" and translate it into verse, cutting class until he was done. No one at Harvard even a few years later would have noticed his absence, but in 1911 the dean put him on probation and forbade any more cuts. Aiken was so upset at his treatment that although he was the designated class poet for the coming graduation ceremonies, he resigned. He went to Italy with a classmate, to enjoy "that magical spring and summer, which had had, for him, the effect of finally opening all doors, everywhere." He soon settled into the role of an artist for whom scholarship, fame, or any public status was anathema. "It was his decision that his life must be lived *off-stage*, behind the scenes, out of view," and no subsequent events changed this austerely private self-perception. He returned to Harvard to graduate and marry a Radcliffe woman, then went back to Europe. Several stays in the U.S.A. notwithstanding, by the 1920s he had become one of the most determined of the many American artistic exiles resident abroad. England became the closest thing to home he knew: "He had his 'place,' now, in Ariel's Island: he was conscious of having acquired his own right to it . . . Now, in effect, he lived there."[71]

All the while, poetry was pouring out of him, far too much of it. Large amounts never made it into print, but in 1914 he brought out *Earth Triumphant*, a traditional example of romantic rhyme and rhythmic patterns, pretentious and clumsy. Eliot read it in galleys and "remarked that the hero was perhaps not as innocent and romantic as he was made out to be, and maybe carried rubber goods in his hip pocket. And of the book at large, that it was 'wrinkled with thought.'" Aiken subsequently agreed with him, considering nothing in the book "to be even remotely salvageable" when he put together his *Collected Poems*. One problem, as he recognized in the preface, was that he could not get Masefield out of his head. He denied that he was imitating Masefield and insisted that he was "experimenting with narrative poems of modern daily life" before he had ever heard of him, which was true but did nothing to redeem the works in the volume. He not only identified his lady with Nature at excessive length, he struck a characteristically romantic pose of an anchorite dwelling on the relationships of love and death, of beauty and decay, and continued to do so for several more volumes. He sounded more modern in his juxtapositions of the

sublime and the sweaty, of true love and dancers all but rutting on the floor, but always lapsed into such lines as "O youth, O music, O sweet wizardry / Of young life sung like fire through beating veins!"[72]

Aiken's background supplies several clues to the apparent contradictions in his work. The talented but paranoid father who so haunted his dreams had been a poet as well as a doctor and had left a legacy of unpublished poetry replete with passion and morbidity. When such emphases appeared in Aiken's work, reviewers tended to see the influence of Poe, but although Aiken read and admired Poe, his father was a more likely source. Aiken always retained a blunt, materialistic, Darwinian, medically explicit approach to life, love, and religion. He was also obsessed with sex, and nympholepsy was a constant theme. Passion was hard to talk about, but a poet could dwell on eyes and mouth and the sounds of heavy breathing. Aiken had learned to read in his father's medical books; the surgery and waiting room had been parts of his own home. When a young poet combined such a background with frequent visits to the vaudeville district of Boston, some elements of modernity in verse came of their own accord. As Eliot wrote him after the publication of *Turns and Movies* (1916), "anything which can so disgust, must have power."[73]

Every modernist followed a different course to modernism and Aiken was no exception. If he were unusual in his affection for Masefield, he was even more so in his flat rejection of such common positions as the defence of art for the sake of art, or the striving for perfection of form. Life for him was tragic, foolish, and petty; he was inclined to ignore such preciousness. Although he acknowledged the influence of William James over the Harvard he knew, for him "the real excitement" was George Santayana, author of *The Sense of Beauty* and *Three Philosophical Poets*, who was still working out his system of aesthetic materialism. Very early on Aiken absorbed Havelock Ellis and the available volumes of his *Studies in the Psychology of Sex*, and in old age recalled correctly that "Freud was in everything I did, from 1912 on"—interests far in advance of those of most American intellectuals.

If like many modernists he admired the work of Whistler and had a life-long passion for Japanese art, he was unlike them in being closely familiar with contemporary classical music. Here the influence was direct and genuinely interdisciplinary, with Richard Strauss the dominating figure. The composer of tone poems on nympholepsy (*Don Juan*), nature (*An Alpine Symphony*), and Nietzsche (*Thus Spoke Zarathustra*), Strauss was an influential bridge figure between the romanticism of Liszt and the modernism of Schönberg. In both operas and tone poems, Strauss experimented with extremes of dissonance and tonal structures, coming close to atonality without quite reaching it. Instead of pursuing the inner logic of his own work, Strauss drew back, and in *Der Rosenkavalier* (1911) turned instead to elegant comedy and in time to a variety of symbolist melodrama. The parallels to Aiken's work in

this evolution remain remarkable and largely unexplored in criticism. Aiken too drew back from many of the implications of his own ideas and even in maturity never pushed himself to the attainment of a form or style equivalent to his content. He too produced much that seemed uneven or rhetorical. Regardless of the merit of these parallels, music always remained important to his conception of his own work. "I always hankered to be a composer—I was mad about music, though I never studied seriously, and can't read a note." He too wrote symphonies, thinking of *The Charnel Rose* as his Symphony #1 and *The Jig of Forslin* as his Symphony #2. "They had the tone of the time, and they married the unlikely couple of Freud and music." [74]

Aiken played his major role in the American encounter with European modernism during his brief visit to London in 1914. Eliot had been trying to place his own poems unsuccessfully and seemed insecure about their quality. He brought "The Love Song of J. Alfred Prufrock" to London, "shyly produced" it for Aiken, and seemed to have "no notion of the extraordinary quality of it." Aiken offered to place it for him and showed it to Harold Monro, who declared it "absolutely insane" and "practically threw it back at me," saying that he could not be bothered with such stuff. After *The English Review* also turned it down, Aiken suggested that Eliot call on Pound in Kensington. On 22 September 1914, an "American called Eliot called this P.M. I think he has some sense tho' he has not yet sent any verse," Pound wrote Harriet Monroe. A week later he knew he had the real thing at last. "I was jolly well right about Eliot. He has sent in the best poem I have yet had or seen from an American. PRAY GOD IT BE NOT A SINGLE AND UNIQUE SUCCESS." Eliot "is the only American I know of who has made what I can call adequate preparation for writing. He has actually trained himself *and* modernized himself *on his own.*" "Prufrock" was soon in the mail, although due to Monroe's distaste for Eliot's work it did not appear until June 1915. [75]

This crucial service aside, Aiken remained a marginal figure in American modernism. His mind was curious and his intentions often excellent, but he wrote too much and had trouble cutting the extraneous. Pound and Eliot never indulged themselves in such prolixity. Aiken turned out five symphonies before turning to fiction. Despite flashes of merit in the verse and an occasional short story that seemed nearly perfect, Aiken never achieved first rank status. No less a figure than Freud admired his fiction for its clinical perceptions, and certainly no one in American literature carried the ideas of Pound or the techniques of Joyce farther, but the books remain curiously inert. Even *Ushant*, brilliant as it is as autobiography, has never achieved canonical status. Aiken remains historically important for his friends and intentions, for his critical competence and his unwillingness to compromise his ideals.

X

No one could make such judgments about Tom Eliot even a few years later. If ever a poet or critic became canonical, in the process defining the canon as he wrote, Eliot did. By the 1920s, Eliot dominated London literary activity fully as much as Pound had a decade before, through *The Criterion* extending his sway over an astonishing range of writing and teaching in America and the Empire. Such an Establishment position seemed unimaginable before 1917. Eliot spoke in many voices, much as Pound donned many masks, but as a young man those voices were all estranged, reflecting psychological turmoil which he only partially understood.

In terms of social status, Eliot belonged. The family came from the clerico-mercantile class that had long formed the minds and characters of New England. Eliots were Massachusetts Calvinists in the seventeenth century. They became concrete for the poet in the figure of his grandfather William Greenleaf Eliot—a Unitarian minister of extraordinary financial ability. He had left the Harvard Divinity School in 1834 to bring his faith to St. Louis. Successful, he died shortly before Eliot's birth in 1888, but his influence lingered on. His faith in liberalism, in good works, in applied ethics, provided the "given" in the Eliot family. Passed on by Henry Ware Eliot, a brickmaker, and Charlotte Champe Eliot, a dominating mother with aspirations to being a poet, to their seventh child, such a faith became the focus of much which the mature T.S. Eliot attacked in the modern world.

Women dominated the home. While Charlotte pushed self-improvement and wrote poetry about prophecy and martyrdom, a devoutly Roman Catholic nanny, Annie Dunne, provided more personal and less complicated devotion—and at least one visit to the local Catholic church that remained permanently in Eliot's memory. Four elder sisters filled in when needed. Since young Tom was born with a congenital double hernia and was never robust, an atmosphere of female cossetting was inevitable. His only escape from suffocation was at best partial: summers in New England were a family custom, and the Eliots regularly spent the months from June to October in Hampton Beach, New Hampshire, or Gloucester, Massachusetts. In 1896, Henry Eliot built a summer home in Gloucester. Tom sailed, explored the seashore, and watched birds—pleasures he could pursue on his own. The memories and images remained with him for life.

Eliot had the education traditional for his class at that time: Smith Academy in St. Louis, a prep school for Washington University that emphasized language, literature, and history, which he attended from 1898 to 1905; and Milton Academy, a proper New England prep school, which he attended for one year—a year far from home, where his mother could not follow. In 1906 he entered Harvard, where he remained more or less for eight years, completing the A.B. and A.M. and, except for a

bureaucratic formality, the Ph.D. as well. He was tall, thin, intense, and attractive. As Conrad Aiken has testified, he liked parties and the theater; he dressed well and belonged to several proper clubs as well as the board of the *Advocate*. He sometimes looked liturgical, but behind the clerical pose lurked a bit of the buffoon. He had manners and grace; he did not have a religion.[76]

To his friends, Eliot fitted in. His family secure, united and warmly supportive, his school record impressive, his relatives ubiquitous at Harvard and in Boston, his friends sharing his interests—surely here was no modernist, alienated from his country and its traditions! Yet as always with Eliot—whether as poet, philosopher, or gentleman—appearances were deceiving. "Some day, I want to write an essay about the point of view of an American who wasn't an American, because he was born in the South and went to school in New England as a small boy with a nigger drawl, but who wasn't a southerner in the South because his people were northerners in a border state and looked down on all southerners and Virginians, and who so was never anything anywhere and who therefore felt himself to be more a Frenchman than an American and more an Englishman than a Frenchman and yet felt that the U.S.A. up to a hundred years ago was a family extension," he wrote Herbert Read in 1928. "It is almost too difficult even for H[enry] J[ames] who for that matter wasn't an American at all, in that sense." No wonder he seemed elusive even to his good friends. As Martin D. Armstrong wrote to Aiken in 1914 about their mutual friend: "when you steal up & try to catch hold of him, off he goes like a sand-eel & begins twirling again a few yards further on."[77]

Like Henry James, Eliot had both a family and a heritage to escape and no clear idea at first what past he should choose as his own. Late in life, when Donald Hall interviewed Eliot for the *Paris Review*, the poet recalled that when he began writing at about age fourteen he was "under the inspiration of Fitzgerald's *Omar Khayyam*," writing "a number of very gloomy and atheistical and despairing quatrains in the same style, which fortunately I suppressed completely . . ." By the time he came to early maturity at the end of his Harvard associations, he had switched his attention to more suitably modernist influences: Baudelaire, the seminal figure in the origins of a modernist consciousness; and Jules Laforgue. No poet in England or America much interested him. He was only "slightly aware" of Edwin Arlington Robinson, thought of Thomas Hardy as a novelist, and felt Yeats to be too deep in "Celtic twilight" for his taste. But the French were different.[78]

The catalyst of Eliot's interest in symbolism was "Arthur Symons's book on French poetry," *The Symbolist Movement in Literature* (1899, revised 1908). Symons was never precise in his definitions but the general tenor of the book was clear enough. He called attention to the careful elaboration of form in the work of Gérard de Nerval, Villiers de l'Isle-Adam, Rimbaud, Verlaine, Laforgue, and Mallarmé, and spoke of their

"perfecting form that form may be annihilated." He thought their work "an attempt to spiritualise literature, to evade the old bondage of rhetoric, the old bondage of exteriority." His subjects were engaged in a "revolt against exteriority, against rhetoric, against a materialistic tradition; in this endeavour to disengage the ultimate essence, the soul, of whatever exists and can be realised by the consciousness"; in their work, literature "becomes itself a kind of religion, with all the duties and responsibilities of the sacred ritual."

Symons devoted only a half-dozen pages to Jules Laforgue in his book, and perhaps a third of that was direct quotation. The man had died two days short of his twenty-seventh birthday and his *oeuvre* was understandably slender. But Symons found its effects impressive—its "colloquialism, slang, neologism, technical terms"—and thought the verse "alert, troubled, swaying, deliberately uncertain, hating rhetoric . . . really *vers libre* . . . broken up into a kind of mockery of prose . . . Here, if ever, is modern verse . . ." Laforgue was a poet who disdained the world that fascinated him and so constructed his own, "lunar and actual, speaking slang and astronomy," in which "frivolity becomes an escape from the arrogance of a still more temporary mode of being, the world as it appears to the sober majority." This was "an art of the nerves," full of "the laughter of Pierrot." In this vision, Eliot saw some of the essential qualities he needed to function as a poet. In Laforgue's metaphysical Pierrot, his *"Pierrot lunaire,"* he found the archetype, as it were, of several of his most notable personae, sharing such inspiration with European modernists like Stravinsky and Schönberg. The effect of carnivalization, so common in modernism, perhaps had a few American roots in the trips Eliot and Aiken took into the vaudeville district of downtown Boston, but it got its reenforcement from this obscure *blagueur*.

Most references to Symons and his influence on Eliot stop here, but they should not. Eliot did not call attention to the conclusions of the book, but he could not help but have noticed Symon's affinities to his own painful psychological state. In his final paragraphs Symons asserted that there was "a great, silent conspiracy between us to forget death; all our lives are spent in busily forgetting death." Most people live in a world they cannot tolerate, and so "must find . . . escape from its sterile, annihilating reality in many dreams, in religion, passion, are . . . fleeing from the certainty of one thought: that we have, all of us, only our one day; and from the dread of that other thought: that the day, however used, must after all be wasted." But such a focus on death forces a man to ask the meaning of life; happiness is surely not the answer. "Only very young people want to be happy. What we all want is to be quite sure that there is something which makes it worth while to go on living, in what seems to us our best way, at our finest intensity . . ." Symons believed that mysticism presented "a theory of life which makes us familiar with mystery, and which seems to harmon-

ise those instincts which make for religion, passion, and art, freeing us
at once of a great bondage." Eliot's Pierrot also had more to him than
met the eye; and he himself knew something about bondage. Modern-
ism was still celebrating Mardi Gras, but Ash Wednesday was only a
night away.[79]

As soon as Eliot had digested Symons he ordered the three volumes
of Laforgue's *Oeuvres Complètes* and read them over the summer of 1909.
He discovered a poet intrigued by art, culture, and speculative thought.
Like Eliot, Laforgue used irony as a way of protecting his reserved
nature. He saw the mass of men as inhabitants of a carnival, vulgar and
garish; a man of his sensibilities preferred to regard the external world
as deceptive and to withdraw from it. In a curious bifurcation of enthu-
siasm, Laforgue stressed both the facts of life near at hand and the
reality of internal consciousness: he once referred to himself as "the
poet of factory chimneys" and thought each individual "a keyboard
played on by the Unconscious." As befitted the sardonic poet of carni-
vals, Laforgue filled his verse with unexpected juxtapositions, portman-
teau inventions and puns, all expressed in ironic tones. He loved to use
scientific ideas in unscientific contexts, or alternatively to exalt ephem-
eral material. His life was too short to produce a body of work of any
decisive influence in French literature, but his stress on the ephemeral
influenced Gide, his ideas of the unconscious affected Remy de Gour-
mont, and his sense of irony helped purify French modernism in gen-
eral of outdated forms and ideas. In one of those odd quirks of literary
history, however, he played a greater role in English culture than in
French: his "les choses miniscules" led clearly to Hulme's "small, dry
things" and Imagism, and through Eliot, F.S. Flint, and Pound he be-
came a seminal figure in the history of American modernism.[80]

Under his influence, Eliot began to write poetry in ways new to him,
experimenting with the use of voices that expressed his own despair,
masking his identity with the guises of pierrots far gone in flippancy or
banality. Descendants of the puritans had been self-centered and un-
sympathetic for generations, and Eliot's verse spared no one including
himself in its vision of evil, both personal and social. He looked as he
wrote, the clothes, the cane, the buffoonery, and the somber look
masking the despair beneath the surface. Both Boston vaudeville and
New England understatement added a Yankee tone to the Laforguian
impulse. In the spring of 1910, he apparently had a religious experi-
ence of some sort, without quite knowing what to think or do about it.
He completed his A.M. degree, idled the summer away, fought off family
efforts to keep him nearby, and went off to Paris.

In Paris the spirits of carnivalization and the pierrot made more sense.
He could think high thoughts and haunt the Left Bank simultaneously,
the Absolute and the depraved co-existing in such a way as to exclude
the bourgeois St. Louis middle. He worried in a Henry Jamesian man-
ner about missing those experiences which made a life worthwhile, yet

never quite managed himself to enjoy the experiences he was actually having. He went to the Collège de France to hear Henri Bergson lecture seven times, leaving impressed, almost in spite of himself, with a new sense of how consciousness and time actually functioned. Yet he was still bored and aimless. He worked at his French with Alain-Fournier, who introduced him to the work of Gide, Claudel, and Dostoyevsky. He felt strong sexual desires and equally strong feelings of aversion and repression—his one outlet was the reading of books like Charles-Louis Philippe's *Bubu de Montparnasse,* a study of sexual low-life. He absorbed ideas from the right-wing Action Française, but Harvard and Irving Babbitt had already acquainted him with a dislike of both romanticism and democracy, and this new exposure could hardly have been formative. He visited London in April, but found it quite as drab and banal as St. Louis, Boston, or Paris. He began to write his "vigil poems," most notably "The Love Song of J. Alfred Prufrock," with their isolated speakers talking into the nighttime void, in a mindless and rambling way seeking some ordering principle in a world that seemed not to have one. Conrad Aiken immediately recognized the quality of the verse that resulted, but no one else did; Eliot put it aside until the meeting with Pound in London a few years later and meanwhile turned to the study of philosophy.[81]

Few significant personal documents remain for this crucial period of Eliot's intellectual and emotional development. He was obviously in deep pain on several levels, in quest of answers to questions almost too complicated to phrase clearly. His religious background seemed arid and he embarked on an anthropological voyage in search of something better. William James had long been pointing out that geniuses, savages, and children all seemed to share certain qualities of perception denied to normal people, and while Eliot certainly had his differences with James, and never felt any Freudian interest in childhood, he did find in the study of primitive culture material that stimulated his imagination. He read widely in the works of Emile Durkheim, Lucien Lévy-Bruhl, and James Frazer, identifying as he did the notion of an unconscious with both the mental lives of primitive people and the contemporary philosophical notion of immediate experience. Frazer was an especially strong influence, as all readers of *The Waste Land* recall; before the war, his emphasis on comparative religious study as a methodology, and on fertility rituals as a specific topic, were especially energizing to the lassitudinous poet. In its various editions (1890, 1900, 1907–1915), *The Golden Bough* suggested to Eliot that a study of this specific form of behavior could provide acute insights into contemporary problems. It was an enactment of the unconscious, a concrete embodiment of an aspect of the human personality which was essentially unknowable. Just as the myths associated with primitive behavior helped organize life into a manageable narrative, so a poet could synthesize the fragments of modern behavior into new ways of controlling the

unknowable. Here lay the origins not only of Eliot's fascination with religious ritual, but his later critical admiration for the method of Joyce's *Ulysses* and for Stravinsky's *Rite of Spring*.

James also provided an impetus for Eliot to read widely in the literature of mysticism. While Eliot never studied directly with James, *The Varieties of Religious Experience* was a book that Eliot read with enthusiasm; he supplemented it with W.R. Inge's *Christian Mysticism* (1899) and Evelyn Underhill's *Mysticism* (1911). Finding the American religious past arid and provocative of just the neuroses which he himself shared with James, he looked as far afield as he could to choose another. While James only fleetingly indicated his approval of Buddhism, Eliot went much deeper into the subject. He found Harvard rich in opportunities to do this. He studied Sanskrit with E.R. Lanman, Indian philosophy with James Haughton Woods, and Buddhism with Masaharu Anesaki, quite obviously seeking the sort of obliteration implied in the word, *nirvana*. He wanted to transcend the past, his lack of faith, his sense of sexual and social disgust, his sense of the chaos of impressions. If, as he recalled in *After Strange Gods* (1934), he managed to attain only a sense of "enlightened mystification" from these studies, they did provide him with an alternative past to puritanism and Unitarianism, with a comparative religious framework against which he could measure Christianity, and with images usable in poetry. His Church of England had at least some of its origins in ancient India.

Philosophy seemed a logical career for someone of Eliot's interests. He could not make a living as a poet and worried deeply about religious questions. Anthropology was not yet really a discipline. He returned to a department, however, that was entering permanent decline. James, Josiah Royce, and George Santayana had made Harvard preeminent in the field, but James died in 1910, Santayana left permanently in 1912, and Royce had a stroke in 1912 and was in poor health until his death in 1916. Other appointments did not measure up. President A. Lawrence Lowell refused to appoint the two best candidates for personal and political reasons, and so Bertrand Russell and Arthur Lovejoy passed their careers elsewhere. Ralph Barton Perry and William Ernest Hocking were satisfactory and socially safe, but hardly inspirational, and Eliot made his own way among the ghosts of the recently or nearly departed. He took both an undergraduate and a graduate course with Santayana, but never felt at ease with him. He recalled that *Three Philosophical Poets* and an occasional essay had been important to him, but the man himself was another matter. He disliked Santayana personally, "because I have always felt that his attitude was essentially feminine, and that his philosophy was a dressing up of himself rather than an interest in things."

He apparently found Royce's seminar most useful. Yet the record of that seminar indicates that Eliot concerned himself not with Royce's ideas but with anthropology. His position was radically relativist and

behaviorist. "Mr. Eliot's conclusion was, on the whole, skeptical as to whether any conclusive results could be reached," the seminar secretary recorded. Eliot "said no interpretation helps another. Interpretation adds to and thus falsified the facts, and presents a new problem to disentangle. Interpretation is the other fellow's description." On another occasion he insisted: *"Behavior is the chief fact you have."* Early in 1914 he was arguing that "the chief difference between description and explanation was in the act rather than in the content. Explanation is more primitive, description more sophisticated." If these fragmentary comments indicate anything, they indicate that the chief American philosophical influence on Eliot was actually Charles Peirce rather than James or Royce.[82]

Eliot discovered the work of F.H. Bradley in 1913 and used it as a focus for his concerns with the unconscious, the primitive, the religious, and the behavioral. The result was his doctoral dissertation, published half a century later as *Knowledge and Experience in the Philosophy of F.H. Bradley.* In a passage from *Appearance and Reality* which Eliot subsequently quoted, Bradley argued that immediate experience, the ultimate fact from which we start, means "first, the general condition before distinctions and relations have been developed, and where as yet neither any subject or object exists. And it means, in the second place, anything which is present at any stage of mental life, in so far as that is only present and simply is." As such, the idea of immediate experience hardly seems especially original, echoing as it does Bergson's *durée réelle* and James' "pure experience." Eliot himself asserted that immediate experience as Bradley defined it was never present as such, but something given which philosophers had to postulate and upon which they could found knowledge. The problem for the philosopher was that "no experience could be merely immediate, for if it were, we should certainly know nothing about it." An epistemologist would find some of the problems involved with this disturbing, but Eliot thought that he could defend the terminology involved by showing that the words "express the theory of knowledge which is implicit in all our practical activity."[83]

At the time Eliot formed his philosophical position, Harvard was deep in the prevalent controversies over realism, as embodied in *The New Realism: Cooperative Studies in Philosophy* (1912) and related publications. In Royce, Harvard also possessed the best-known idealist in philosophy at that time. Eliot essentially took the position of a pragmatism opposed both to realism and idealism, managing the not-inconsiderable feat of doing this in his dissertation without irritating either Perry or Royce. He was convinced that he had no sure basis for epistemological analysis; the ultimate was unknowable and most apparently fundamental distinctions relating to it were invalid. Mixing his Bradley with James' essays on radical empiricism, he insisted that in the beginning, "consciousness and its object are one" even if the beginning were "only

an abstraction." He argued instead for a neutral monism, to avoid any notion of consciousness as an entity or of the object as independent. "What James calls the context is that of which Bradley speaks when he says that the finite content is 'determined from outside.' This determination from the outside is unending." After a complex discussion in which he made clear his opposition to the positions of Bertrand Russell and G.E. Moore, he concluded that "immediate experience" was the "only independent reality."

Eliot's dissertation is in places remarkably opaque, and any reader can sympathize with him as an old man declaring that he could no longer "pretend to understand it." But the distinctions involved in the discussions of objects and the consciousness of objects, and of immediate experience, had profound consequences in his attitudes toward his chosen past, myth and truth itself. He developed a coherence theory of truth. Since consciousness and its object were one, no one need bother trying to match up object and perception, or past fact and present consciousness of such fact. The past, like the present and the future, was an "ideal construction," and therefore ideas of the past were true, "not by correspondence with a real past, but by their coherence with each other and ultimately with the present moment; an idea of the past is true, we have found, by virtue of relations among ideas." Not only were words and memories coherent with objects and facts, symbols were also a part of that which they symbolized. The student of French Symbolism insisted that "no symbol" was "ever a mere symbol, but is continuous with that which it symbolizes. Without words, no objects."[84]

Eliot's dissertation was hardly a seminal modernist text and does not warrant extended examination. It was rather a useful apprentice work, exposing him to a major writer who wrestled with problems of compelling interest. Eliot was no disciple of Bradley, but rather a friendly critic pursuing private truths, some of which were endemic to a modernist sensibility. Already familiar with anthropology and psychology and toying with the connections between primitivism and the unconscious, Eliot seemed comfortable with a pragmatic skepticism about metaphysical truths. For him, Truth in any capitalized sense was impossible; truth in a small and personal sense was possible, for "all significant truths are private truths." God apparently existed, but you can't talk about him any more than you can talk about immediate experience. What you can talk about is behavior, and what in Royce's seminar Eliot referred to as "amended behaviorism" was about as far as you could go. In a manner that bridged the gap between the William James of the *Principles of Psychology* and the John B. Watson of *Psychology from the Standpoint of a Behaviorist*, Eliot assumed that mental events were continuous with their physical basis. On minds and their experience, he concluded that "their objectivity is continuous with their subjectivity, the mental continuous with the merely mechanistic." Thus Bradley helped Eliot combine his private concerns with an up-to-date mode of academic discourse. He

gave Eliot a way of describing his feelings of mystical emotion in a philosophically acceptable way, integrating them with a modern psychology. Bradley, in short, provided for him what myth provided primitive man and psychoanalysis the disturbed patient. But once Bradley had performed this function, Eliot had no more use for him. Poetry proved a more efficacious means of dealing with a reality that seemed increasingly threatening.[85]

While he was wrestling with Bradley, Eliot made friends and decisions that permanently shaped his life and work. One crucial contact was with philosopher Bertrand Russell, who spent an unfortunate spring semester at Harvard in 1914. Critical of American life and bored by his colleagues, Russell excepted Eliot from his condemnation, finding him "very well-dressed & polished, with manners of the finest Etonian type." Eliot in turn immortalized one April visit which Russell made to the home of a woman in whom he was interested, in "Mr. Apollinax," with Russell as a "priapus in the shubbery," his laughter tinkling among the teacups, "submarine and profound." Eliot mocked the low level of conversation which bored Russell, and concluded: "Of dowager Mrs. Phlaccus, and Professor and Mrs. Cheetah / I remember a slice of lemon, and a bitten macaroon." For the moment it hardly mattered; Eliot took up a Sheldon Travelling Fellowship as soon as classes were over and went to Europe. He arrived in Marburg in the middle of July, intending to study, but the war broke out and by August he was in London.[86]

He quickly became known. Conrad Aiken was there, introduced his friend to Pound, and Pound swung into action. Letters went out to Harriet Monroe and others, and Eliot was soon friendly with Fletcher, Doolittle, and the Vorticists. He apparently never met T.E. Hulme personally, but made a distinct impression on various Englishmen. Wyndham Lewis long recalled Eliot's "Gioconda smile," his drawl, his relatively large size, and his dimples. They met in Pound's Kensington flat, Pound himself lounging in apparent exhaustion, "in typical posture of aggressive ease," eating preserved fruit. Douglas Goldring, who met Eliot somewhat later, recalled him as "affable, but his manner seemed slightly donnish and inhuman." Eliot made Goldring feel like a young curate in the presence of an ecclesiastical dignitary. "He struck me as having brains without bowels." Lady Ottoline Morrell thought him "dull, dull, dull. He never moves his lips but speaks in an even and monotonous voice, and I felt him monotonous without and within." She thought him "obviously very ignorant of England," someone who "imagines that it is essential to be highly polite and conventional and decorous, and meticulous." Osbert Sitwell left one of the most detailed recollections. Writing about his first meeting with Eliot, apparently in the fall of 1917, Sitwell recalled "a most striking being, having peculiarly luminous, light yellow, more than tawny, eyes: the eyes, they might have been, of one of the great cats, but tiger, puma, leopard, lynx, rather than those of a lion." Sitwell compared his nose to "that of a figure on an Aztec carving

or bas-relief." Though reserved, Eliot "had armored himself behind the fine manners, and the fastidiously courteous manner, that are so peculiarly his own," and despite the uncongenial work that he had fallen into, seemed "always lively, gay, even jaunty." His clothes, usually "check or 'sponge-bag' trousers, and a short black coat—were elegant, and he walked with a cheerful, easy movement."[87]

This was not an easy act for Eliot to pull off, for in fact his early years in England were, on the whole, miserable and unproductive. He studied for awhile at Oxford under a disciple of Bradley, Harold Joachim, and worked on his thesis, but he soon became disenchanted with Oxford and returned to London. He took a series of low-paying and exhausting teaching jobs, at High Wycombe Grammar School for one term and then at Highgate Junior School for four terms. He taught four extension courses between 1916 and 1919, for Oxford, the University of London, and the London County Council, with somewhat more consequence: the courses on modern French literature, Victorian literature, and Elizabethan literature provoked him to do the reading that resulted in his earliest important criticism. The surviving syllabi indicate that by 1917 he had most of his characteristic views on religion, literature, and politics in place, a decade before he announced them publicly. But knowing his own mind hardly put bread on the table, and in March of 1917 he began working at Lloyd's Bank. In May, he became assistant editor of *The Egoist*, replacing Richard Aldington; in June, the Egoist Press issued *Prufrock and Other Observations*. He completed his pioneering *Ezra Pound: His Metric and Poetry* in September. If the poetry had all but dried up, the criticism was about to flow. But he was tired, ill, impoverished, and discouraged for reasons that had little to do with all this, and the Sitwells and the Goldrings who saw him could have had but small notion of how heroic his life really was at this time.[88]

Eliot's arrival in England had been unexpected; he was supposed to be in Germany and his friends easily lost track of him. In October 1914, Bertrand Russell was astonished to bump into him on New Oxford Street. Delighted to meet his pet pupil, Russell invited Eliot to Cambridge to speak on "The Relativity of Moral Judgment" to the Moral Science Club in Russell's quarters. At the same time, Eliot was deeply involved in a crucial and even more personal relationship. In the space of only about two months in the spring of 1915, he met Vivien (or Vivienne) Haigh-Wood at Oxford—possibly in the rooms of Scofield Thayer—carried on an uncharacteristically enthusiastic courtship, and married her late in June. "Eliot has suddenly married a very charming young woman," Pound noted to his father. Russell took a closer look, as he was wont to do whenever a pretty woman came into his vicinity. "I expected her to be terrible," because Eliot had been so mysterious, he wrote to Lady Ottoline Morrell after a dinner with the couple. But he was impressed instead. "She is light, a little vulgar, adventurous, full

of life—an artist I think he said, but I should have thought her an actress. He is exquisite and listless; she says she married him to stimulate him, but she finds she can't do it. Obviously he married in order to be stimulated. I think she will soon be tired of him."[89]

Vivien had been a governess, painter, and ballerina in her somewhat aimless life; although not unintelligent she had no pretence to an advanced education, but she did occasionally exercise a sharp wit. She also had a long history of both physical and mental illness, suffered more than most women from menstrual problems, and feared her recurrent menorrhagia so hysterically that she was given to washing her bedsheets over and over again, even when she stayed in a hotel. Still, no detached observers thought the relationship any odder than most marriages. Brigit Patmore thought her small, slim, and pretty: "Light brown hair and shining grey eyes. The shape of her face was narrowed to a pointed oval chin and her mouth was good—it did not split up her face when she smiled, but was small and sweet enough to kiss"; she seemed to shimmer "with intelligence." Two years after the wedding, Aldous Huxley met the couple for the first time at their flat, writing Morrell that he could perceive quite obviously "that it is almost entirely a sexual nexus between Eliot and her: one sees it in the way he looks at her—she's an incarnate provocation—like a character in Anatole France. What a queer thing it is." The judgments of the men were correct. Vivien was definitely provocative in a sexual way, and while Eliot had presumably wanted to be provoked, to break out of his loneliness and despair, to flee the suffocating female propriety of his mother's house, the attempt had failed.[90]

The various relationships that developed were quite as complicated as anything in the Aldington-Doolittle-Lawrence menage, with an undertone of deception and manipulation worthy of Choderlos de Laclos. Throughout the period, Russell was intimately involved with Morrell and was soon deeply in love with Lady Constance Malleson (a.k.a. Colette O'Neil); his letters to both women convey information a more reticent man would be afraid even to dream about. He had recently pursued Helen Dudley during a trip to Chicago, and his enthusiasm for Katherine Mansfield was not based on a deep love of her writing. Russell, in short, twitched expectantly whenever a pretty woman wandered into view, half the time not seeming to know himself whether he was disinterested, paternal, or off on a chase yet again. His relationship with his prize American student and his provocative bride had elements of all three. Russell had deep affection for Eliot. He helped Eliot financially and socially; he offered the couple use of his flat in Bury Street. He paid for Vivien's dancing lessons and took her on an occasional holiday. Eliot was clearly grateful for these attentions and said so. His marriage was a failure, his finances were distressed, and anyone who would take his increasingly hysterical wife off his hands was doing him a favor.

As Russell analyzed the situation in 1916, the Eliot honeymoon had been a failure. Russell probably did not know about Eliot's double hernia or his acutely puritannical upbringing; from his point of view the result was what mattered. Vivien tired of her husband quickly and he seemed disgusted with her. She was in despair and thinking of suicide; she clearly sensed in Russell a sympathetic male on whom to lay her burdens. He expected her to fall in love with him, but thought that it could not be helped. She had a history of unsuccessful love affairs, was ambitious beyond her powers, and her life seemed a chaos. She needed a religion, or at least an external discipline. "At present she is punishing my poor friend for having tricked her imagination," and he wanted "to give her some other outlet than destroying him. I shan't fall in love with her, nor give her any more show of affection than seems necessary to rehabilitate her."

Russell's use of terminology was worthy of his high philosophical reputation: he could make words mean anything he wanted, and in this case they certainly were supposed to mean one thing to Morrell and another thing in reality, whatever that was in this situation. On one trip with Vivien he consummated the relationship at least once; neither of them enjoyed the experience. He may not have regarded an unpleasant evening of this sort as intimate, and he may honestly have thought he was doing something useful by way of rehabilitation, but such self-sacrifice was for nought. Vivien slipped more deeply into mental instability, took drugs, and was apparently capable of stealing from friends. She picked mercilessly at her husband when unable to do anything else, and bits and pieces of their talk pop up in *The Waste Land* and other poems. Eliot had every reason for trying to fend off biographers, but he also left a fascinating trail for them to follow. No one knows if he was aware of his wife's betrayal, nor can anyone measure its effects on her already fragile mental stability.[91]

The contrast between Vivien Eliot and Dorothy Pound and the homes they constituted for their mates underlines the theme which recurs so often in the study of modernism: the same only different. Here were two close friends, who from the fall of 1914 at least until the publication of *The Waste Land* eight years later criticized each other's work with extraordinary skill—Eliot apparently offering suggestions on the Ur-Cantos almost as important as Pound's on *The Waste Land*. Each knew the work of Yeats, learned or reenforced their ideas from Bergson and Hulme, borrowed from French critics such as de Gourmont and Gautier, and studied the literature of Dante and his contemporaries. Each rebelled against American culture, hated inflated rhetoric, thought art should have a "resembling unlikeness" to the world, and stressed the presentation of objects and ideas rather than any mimetic representation. Each in his own way dwelt on consciousness, immediate experience, and memory. Each made parody and pastiche integral to modernist composition, and not just in poetry. Each married a local woman

and showed every sign of settling in as a permanent resident of England.

Yet the differences in the wives represented differences in a wide variety of other ways. Sexuality was always important for modernists, both in theory and in practice. Eliot's poetry makes sex dirty, an integral part of the squalor of London and human existence in general. Eliot's mystical experiences translated into religious commitments that in turn dominated his poetry for the rest of his life. Although retaining a sense of his Americanism, he really did settle into London life, adopting the clothes and accent of his adopted country along with the religion and literature. Pound became the Whistler of his generation, liberated in sex as well as diction, his beard, earring, and clothing marking off his self-image fully as much as Eliot's formal attire did his—what Virginia Woolf called his four-piece suits. Pound could dominate a room while lounging in it; Eliot often seemed to be hiding in the shadows, sometimes not saying a word for hours. Pound had no use for Eliot's religion; born a skeptic, he remained one for life, reserving his commitments for political and financial views unworthy of his literary insights. In time, he joked about the Reverend Eliot, who gave up the Muses for Moses, and won eminence in literature chiefly by disguising himself as a corpse.

Chemistry should have a word for what happened here: similar elements combining under different circumstances to produce different compounds. The attitudes to words such as "religion," "myth," "ritual," and the rest—all in the region of the anthropological study of religion—were crucial for the entire history of modernism. Each man was constructing his own past, his own myth about how and why the world functioned as it did, but for Eliot the experience of religious mysticism, the need to feel a kinship to primitive man, and the craving for myths that would make all his random findings cohere, were what made life possible. In time, he would be complaining that he much preferred Pound's form to his content, and that much of the Cantos was arid and depressing. Eliot's work and the comparable work of Joyce defined one genus of modernism.

For Pound, such ecstasy and such a craving for unity were simply not there. Pound was a secular humanist, a rationalist, a man who found the meaning of life both in day-to-day pleasures and in the working of his fecund mind. He thus searched the past for the scattered objects that remained from those who felt as he did, almost as if they were random pieces of wood he could bring home and carve into beautiful shapes. Pound was not haunted, as Eliot was; immediate experience was important in itself, but not for any cosmic implications. Pound thus bequeathed a parallel but distinct modernist heritage, one of objects rather than myths, of montage rather than Symbolism, a kind of documentary of dislocation, in which his true kin were Rimbaud, William Carlos Williams, Gertrude Stein, and their followers. Pound's personal

Arthur Dove in Paris. (*Courtesy of William Dove*)

Louise Arensberg. (*The Arensberg Collection, the Philadelphia Museum of Art*)

Walter Conrad Arensberg. (*Arensberg Archives, Francis Bacon Library, the Francis Bacon Foundation*)

Gertrude Kasebier. (*Photograph by Eduard Steichen, the Metropolitan Museum of Art, the Alfred Stieglitz Collection*)

Marcel Duchamp, Raymond Duchamp-Villon, Jaques Villon. (*The Smithsonian Institution*)

Mabel Dodge. (*Yale Collection of American Literature*)

Marsden Hartley. (*Photograph by Alfred Stieglitz, the Metropolitan Museum of Art, gift of Marsden Hartley*)

Eduard Steichen, self-portrait. (*The Metropolitan Museum of Art, gift of Grace M. Mayer, in honor of William S. Liebermann*)

Alfred Stieglitz. (*Photograph by Heinrich Kuehn, the Metropolitan Museum of Art, the Alfred Stieglitz Collection*)

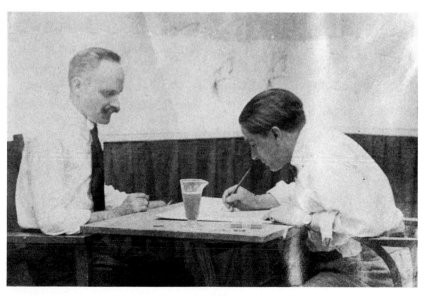

Marius de Zayas and Francis Picabia adding watercolor to reproductions of Picabia's work in *291* during the summer of 1915. (*Bibliotheque Literaire Jacques Doucet*)

T. S. Eliot. (*With permission of the Houghton Library, Harvard University*)

Gertrude and Leo Stein. (*Yale Collection of American Literature*)

Violet Hunt. (*Reproduced from* Violet, *by Barbara Belford, with permission*)

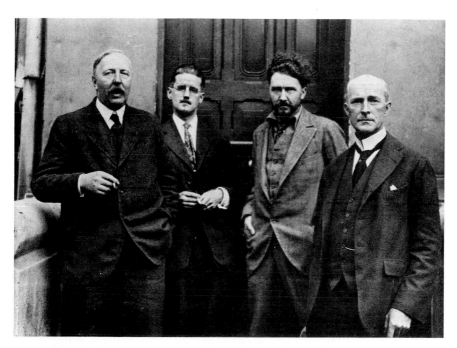

Left to right: Ford Maddox Ford, James Joyce, Ezra Pound, John Quinn. (*The Harry Ransom Humanities Research Center, the University of Texas at Austin*)

Margaret Anderson. (Little Review *Papers, the Golda Meir Library, University of Wisconsin-Milwaukee*)

Harriet Monroe. (*Department of Special Collections, the University of Chicago Library*)

character and the controversies that dogged him during his difficult life have obscured the clear divisions between these modernist extremes. The scathing remarks that Williams vented with distressing regularity about Eliot and the impact of *The Waste Land* help to formulate this division. While Eliot and Yeats were pursuing religion and myth, Pound and Williams were redefining the relationships between words and objects.[92]

Perhaps the final irony of the relationship between Eliot and Pound is that critical convention has reversed the important relationship each had with his own verse. Because Pound made such explicit references to identifiable experiences, ideas, and literary figures in his work, critics have often assumed that his work was personal, and often that it seemed obscure because it was so personal, so hermetic in its references and allusions, that no outside reader could truly penetrate it. In fact, Pound was writing about civilization, about how a man became civilized and cosmopolitan, using himself as illustration. By contrast, Eliot became the critical prophet of the new textual criticism, of an impersonal poetry, of tradition dominating the individual talent. For decades, his biography was so obscure that no one could see its relevance to understanding his verse. But as recent work has demonstrated, the voices of the early poems all speak in some sense for Eliot, the references are to his family, his past, his trips to Boston with Aiken, his religious feelings, his despair, his feelings of sexual inadequacy, guilt and disgust, and his depressing jobs as teacher and banker. Eliot in fact was the personal poet, the poet who always took the time "To prepare a face to meet the faces that you meet," as if to expose a deceptive part of himself so as to hide a more important part. Yet he left tracks, like a criminal careless at the scene of his crime, all but asking the police and the reader to find him out. Contemporary readers forget too easily that Vivien Eliot read and commented on *The Waste Land* and often knew the specific events and conversations her husband was referring to.

Eliot always retained both his sense of detachment from current events and his loyalty to Pound. Even in 1946, when Pound's reputation was at its nadir, he recalled publicly the enormous debt he and other artists owed to Pound, the selfless cultivator of geniuses, the impresario of modernist culture. "Pound did not create the poets: but he created a situation in which, for the first time, there was a 'modern movement in poetry' in which English and American poets collaborated, knew each other's works and influenced each other." Had it not been "for the work that Pound did in the years of which I have been talking, the isolation of American poetry, and the isolation of individual American poets, might have continued for a long time." In addition, Eliot insisted that Pound's criticism was "almost the only contemporary writing on the Art of Poetry that a young poet can study with profit." In the face of those who loathed Pound's Fascism, his anti-Semitism, and his silly obsession with Social Credit, Eliot insisted: "It is on his total work for

literature that he must be judged: on his poetry, *and* his criticism, *and* his influence on men and on events at a turning point in literature."[93]

XI

On the surface, few figures would seem to have less in common than the fastidious Eliot and the most eminent sculptor on the British scene. Yet, as with so much in modernism, surfaces were deceiving. Certainly Jacob Epstein's left something to be desired. He was, Pound informed his mother in 1913, "a great sculptor," but: "I wish he would wash, but I believe Michel Angelo *never* did, so I suppose it is part of the tradition." He was also irascible, and his surviving letters leave the impression of a man living in a state of constant irritation; yet as Pound noted in reference to a mutual friend, "I have never known anyone worth a damn who wasn't irascible." Like Eliot, Epstein was a displaced person, growing up in the wrong place and family for his talents. He too emigrated as soon as he could, becoming a British citizen in 1907 and only rarely thinking of or returning to America thereafter. He too felt a deep attraction to the primitive, and explored its possibilities for modernist creativity even more than Eliot. He too found conservative attitudes more comfortable after the War. He too found acceptance of the highest kind in his adopted land, becoming Sir Jacob in 1954.[94]

Born in 1880, into a family of Polish Jews who had recently arrived in New York City's Lower East Side ghetto, Epstein grew up far from the prim comfort of Eliot's St. Louis. He loved the streets and became so attached to the ghetto area that even when his family left it, he returned over and over again to draw strength from its sensuous stimulation. He hung around cafés a lot, sketching, and in the process made the acquaintance of journalist Hutchins Hapgood. On one occasion Hapgood returned with Epstein to Epstein's Hester Street garret to see sketches "of old Jewish applewomen below his window, of poverty-stricken old Jewish rabbis and philosophers in the cafés, of anemic feverish writers on the Yiddish newspapers, sweatshop workers, girls and young men; and a drawing of Emma Goldman, as a very young woman, lying in bed." The sketches had an "intense vitality" that impressed Hapgood, and when he completed his small masterpiece, *The Spirit of the Ghetto,* he asked Epstein to supply illustrations. The results pleased everyone, perhaps too much so; the publishers paid Epstein $400 before he completed the job, and he took off for Paris immediately, leaving a friend to finish the last few drawings.[95]

After three years in Paris, he decided to settle permanently in London in 1905. Essentially a rootless cosmopolitan who never identified much with either his family or their religion, Epstein chose a past of Greek, Roman, and Egyptian sculpture located in London; he especially loved the Elgin Marbles at the British Museum. He was not, at least at first, an *enfant terrible* trying to shock the bourgeoisie after the

manner of some modernists. He might live in a slum or in a tiny attic over the Poetry Bookshop, as he did for awhile, and consort with raffish friends like Augustus John, but that did not lead to modernism in any definable sense. If Hapgood's memory was correct, Epstein at first sculpted as he drew, taking his subjects from his friends and their children. His first big commission was to carve eighteen figures for the headquarters of the British Medical Association in the Strand. For fourteen months during 1907–8 he worked on the over–life-sized figures, offending the prudish, initiating the sort of violent controversy that pursued him for life, and undoubtedly contributing to his reputation for irascibility. Shortly after completing this project, he embarked on his tomb for Oscar Wilde (1912) in Paris, choosing an Egyptian style and the motif of a fallen angel. Its sexual frankness disturbed even the French, however, and Pound was soon snorting in *The New Age* about the public wish to adorn "Epstein's work with black butterflies, *à cause de pudeur.*" By then his own mask was in place, and it had a public scowl and temper tantrum handy for all journalistic confrontation. As he wrote John Quinn, the New York lawyer and collector who was then actively buying Epstein's work, he felt mostly "bitterness" at the course of events. Quinn, no matter how supportive he might feel for the artist, thought Epstein had it coming. He observed privately to Pound: "Confidentially, Epstein seems to have taken the line all along of a man with a grievance or lack of appreciation. It was as certain as fate that he would have trouble with the Wilde monument. He should have taken his medicine and not complained about the attacks." [96]

Such a man felt right at home in Pound's London set and the alternative British worlds that sometimes intersected with its members. Through Augustus John, he met Lady Ottoline Morrell; she heard of his poverty, went to his studio in Cheyne Walk and commissioned a garden statue. Through her, Epstein met her friends, who included W.B. Yeats and Lady Gregory, and he did a bust of the latter. He was soon a close friend of T.E. Hulme—a useful alliance, for the combative Hulme was more than willing to write articles defending his new friend and was reputedly at work on a full-length book on Epstein when he died in the war. Hulme led him to Pound and Epstein was soon a Vorticist in everything but name, contributing two sketches to *BLAST* I. He participated in the decoration of Frida Strindberg's Cave of the Golden Calf, and so won Pound's approval for his work that the poet rated him higher than his close French friend, Henri Gaudier-Brzeska, writing Dorothy privately: "Epsteins stuff throws him into the shadow, but then Epstein is 20 years older." In Paris, working on the Wilde Memorial in 1912, Epstein greatly expanded both his range and his friendships. He recalled Picasso and Brancusi when he came to write his autobiography, but wrote in most detail about Modigliani: "I saw him for a period of six months daily." "His studio at that time was a miserable hole within a courtyard, and here he lived and worked." The

place then contained "nine or ten of those long heads which were suggested by African masks, and one figure. They were carved in stone, and at night he would place candles on the top of each one," making the effect of "a primitive temple."[97]

Picasso, Brancusi, and Modigliani were all important in the discovery of primitive art; 1906–7 was a crucial year in this context, and by the early teens primitivism was common. Nevertheless, Epstein deserves a significant place in the revival of such forms. The exact date upon which he began to collect primitive sculpture remains unknown, but may well antedate Picasso's interests in this area. He certainly was acting independently of Picasso or anyone else, remarking later that he started collecting the objects in part because they were "the only sculpture that I could afford." Some critics thought he intentionally cultivated the ugly, but he dismissed them contemptuously. Religious motives were at the inspirational base of African and South Pacific art, they conveyed "a feeling of awe and fear," and he greatly valued their implicit naturalism. The modern artist of the pre-war period, he insisted in interviews published in 1932, "was experimenting in a similar manner. The very first periods of cubism are an attempt at a compromise between naturalism and design." Earlier artists had resisted the pressures of conventional taste by discovering the art of Japan, and Negro art [by which he usually meant African art] was useful in the same way to those who came a generation or two later. Negro art's "true influence should be to suggest new ways of interpreting nature. A primitive art is always a sounder influence than one that is highly sophisticated." He stressed: "the chief features of negro art are, its simplification and directness, the union of naturalism and design, and its striking architectural qualities." He particularly mentioned Gauguin in Tahiti and Modigliani in Paris as two great artists who had used primitive work creatively.

When confronted with the assertion that Negro art had had a powerful influence on his work, Epstein insisted that such a statement was "both true and untrue." It was not true in the way most people thought. They saw that he had modeled African types and assumed an influence. This was nonsense and he was not a primitive. "I am interested in the negro type of beauty, but the results are purely traditional and European in technique"; had he used Russian or Indian models, he would not in any way be implying the influence of Russia or India. "I am influenced by African sculpture in the same manner that all primitive work must influence the artist," he said. "African work has certain important lessons to teach that go to the root of all sculpture. I have tried to absorb those lessons without working in the African idiom." The concept of influence had been corrupted. "The word 'influence,' as I understand it, means more than a mere surface study, it means a full comprehension of both mind and technique, that go to the composition of a work, and a translation of that, according to the personality of the artist."[98]

Despite the fact that he was the ablest sculptor of public monuments in Europe, Epstein received no acceptance from proper circles in England. The Royal Society of British Sculptors denied him membership. Commissions were few. Epstein gravitated naturally to those who understood. They in turn shared his senses of grievance, exclusion, and poverty. The war only made things worse and gave some concrete grounds to general feelings of persecution. He wrote John Quinn that the country had gone "war-mad" and that he thought his proper business was to "get on with my work and to get things in hand finished." For him, "life has always been war" anyway, and the outbreak on the Continent simply focussed attention. He was already "among the best-hated ones here," and he seemed prepared to tolerate criticism of himself for being a British citizen and not volunteering, or in time being drafted. He did not oppose the war or even conscription, he told his friends, he just thought service a waste of his time and talent, which it certainly was. He quarreled with the equally touchy Wyndham Lewis and was soon seeing less of Pound as well. Pound professed ignorance of the matter. "What the later quarrel with Jacob is, I do not know, save that Jacob is a fool when he hasn't got a chisel in his hand and a rock before him," Pound wrote Quinn in 1916; "and Lewis *can* at moments be extremely irritating." Pound was no one to talk; none of them was. Irascibility was a quality all artists needed in such an environment and perhaps the one thing wartime shortages did not deprive them of.[99]

Thanks to Pound's "Rock Drill" Cantos, the work for which critics most remember Epstein is the *Rock Drill* (1913–16), in both the early revision of the plaster ready-made drill and the final revision of the cut-down torso in metal. The work is primitive, threatening, atavistic, and modern all at the same time, and seems wonderfully Vorticist when viewed next to the paintings of Wyndham Lewis or David Bomberg. The surviving picture of "Cursed Be the Day Wherein I Was Born," (1913–15), based on a Bakota figure, titled with the words of Job, yet fiercely geometrical in its planes and seemingly as rigid as Epstein himself, reenforces the impression that the sculptor was growing away from nature and was indulging both in sensationalism and an anti-humanism that could and did lead to the right-wing politics that Pound and Lewis represented in the 1930s. Given the anthropocentric art that both preceded and succeeded Epstein's Vorticist phase, and the frequent invocation of both Egyptian and Judeo-Christian religious themes, the proper focus should be on Epstein as a cosmopolitan humanist trying to produce in three dimensions what Eliot and Pound were trying to do in their writing: to embody in art the best that humanity has produced in religion and culture broadly conceived. Above all he honored tradition and knew the place of individual talent within it. "No one has a greater respect for tradition, or for the great works of the past, than I have," he told his interviewer. "I realise that no great work has ever been

produced by flouting tradition. *The whole integrity of art lies in its traditions. Tradition does not mean a surrender of originality.*" And he warned his critics: *"never be a slave to labels."* [100]

XII

The final important figure among the Americans in London was Alvin Langdon Coburn, a photographer who did portraits of both Epstein and Pound and who liked nothing better than taking pictures of artists of all kinds. A respected craftsman since his teens, Coburn made a London reputation long before Pound. He did not appear in Pound's letters until the fall of 1914, when Pound listed him as a part of his faculty for an abortive College of Arts in London. A month later, Pound and Coburn were companions at the exhibition of Modern Spanish Art at the Grafton Galleries, which in a memorable letter to Harriet Monroe, Pound denounced as "MUCK," most of it being "an archaism of one sort or another . . . Picasso is not mentioned. Even Picabia is a large light in comparison with their twaddle." By March 1915, Coburn was photographing one of Pound's sculptures, and a portrait adorned the original edition of *Lustra*.

Most important for the history of modernist creativity, Coburn invented the Vortoscope late in 1916. "This instrument is composed of three mirrors fastened together in the form of a triangle, and resembling to a certain extent the Kaleidoscope," Coburn recalled many years later. "The mirrors acted as a prism splitting the image formed by the lens into segments." Vortographs could be abstract or they could distort recognizable objects: one of the most famous of the latter being Coburn's Vortograph of Pound. Pound himself was less than reverent to third parties about this contribution of photography to Vorticism. "The Vortescope isn't a cinema," he wrote John Quinn early in 1917. "It is an attachment to enable a photographer to do sham Picassos," "perhaps as interesting as Wadsworth's woodcuts, perhaps not quite as interesting." The devices were useful, however, for public relations purposes, and would "serve to upset the muckers who are already crowing about the death of vorticism." [101]

Coburn was a fourth cousin of F. Holland Day, probably the most distinguished photographer in America at that time, better-known even than his closest competitor, Alfred Stieglitz. An aesthete rare indeed by American standards, Day had a passion for the writings of Keats and Edward Carpenter, the plays of Maeterlinck, and the exquisite public image of Oscar Wilde. "In his house on elegant Beacon Hill, Day used to exhibit his photographs in an incense-laden atmosphere to the *élite* of Boston society. To this shrine I went one day, climbing steep and romantic stairs to gaze in awe and wonder at his masterpieces." Day got on well with his cousin—he had a taste for young men anyway—and provided Coburn an opportunity to visit England. Day was deeply in-

volved in an exhibition at the Royal Photographic Society, scheduled to open on 10 October 1900. They arrived over a year early to prepare for the well-publicized event, in which 375 photographs were to be on display. While Coburn taught Day how to develop his own film, something he had somehow never learned to do, Day introduced Coburn to the worlds of both London and European photography, including Eduard Steichen and Frederick H. Evans. Through Steichen, Coburn discovered Paris; through Evans, he met most of the important figures of British photography. By the time he was twenty-one, Coburn was a member of the Photo-Secession in New York and the Linked Ring in London, the two most advanced groups in the world in his field. For the next twenty years or so he was consistently one of that world's half-dozen most visible photographers.

In 1902, Coburn opened a studio on Fifth Avenue in New York City, not far from that of Steichen at 291 Fifth Ave. He worked for a year with Gertrude Käsebier, a leading member of the Secession group, and spent the summer of 1903 working with Arthur W. Dow, the Professor of Art at Columbia whose influence reappeared repeatedly in the careers of young modernists. Coburn studied painting, pottery-making, and woodblock printing as well as photography with Dow, learning "not least an appreciation of what the Orient has to offer us in terms of simplicity and directness of composition." The Orient directly influenced pictures he shot at that time, and he recalled in old age that all his work had "been influenced to a large extent and beneficially by this oriental background." He remained "deeply grateful to Arthur Dow for this early introduction to its mysteries."[102]

Coburn was young, ambitious, and egotistical and never doubted his abilities. He wanted to meet and photograph great figures and he wanted to make a living at it. He received encouragement from Perriton Maxwell, editor of the *Metropolitan Magazine* in New York, for a series of portraits of Europeans and Americans resident abroad. By July 1904, he was writing Alfred Stieglitz with enthusiasm: "London is great!" and retailing the details of his camera work. He was soon in Edinburgh, "a most 'dollopy' city," and over the next few years mentioned trips to Spanish Morocco, Paris, Dublin, and Germany. He also pursued more advanced studies when he could, improving his technique of photoengraving, for example. But most of all, he was happily headhunting, and an astonishing number of heads seemed to smile tolerantly at the brash American and to have worked with him closely. He never managed to capture Whistler, but he did get almost everyone else.[103]

Coburn's great coup was to approach George Bernard Shaw and make a friend of one of the more unpredictable of British literary lions. By November of 1906, Coburn glowed with self-importance: "Shaw said you wanted a silver print of his portrait of [sic] me but as I have the negative I suggested to him that I should make a 'gravure plate of it for you for C.W. [*Camera Work*]," he wrote Stieglitz. "He said quite

proudly no half tones for me! So as soon as I get the plate steel faced
and a few proofs of it for myself I will send it over." Shaw also paid
attention to Coburn's work apart from himself, and wrote a preface to
the catalog of the exhibition Coburn was arranging—"which you can
reprint if you like." Meanwhile, "I am working like a fiend on my
show. . . . The press is on its hind legs already and I am besieged
with people to interview me." February 1906 was Coburn's month of
triumph, at least in his own mind. A week after the show opened, he
trumpeted his success across the Atlantic: "Nothing like it has ever hap-
pened in England! It takes an American to really do the thing prop-
erly!!" He was breaking attendance records, "there was simply a mob
at my opening evening," not to mention "palms and a band!" English
newspapers were "clamoring for prints and I have so many sitters that
I may have to get a studio to do them in." He was sure that his triumph
was also a triumph for the art of photography: ". . . we will either
beat it into peoples heads that the camera is capable of the greatest art
or die in the attempt." By the end of the month, attendance was still
high and he had "sold a lot of prints and got more portrait work than
I can attend to." He reported modestly: "I have stirred up these dear
quiet Britishers more than I had dared hope!" He was soon famous as
well for his shot of Shaw, nude, in the pose of "Le Penseur." [104]

Coburn had grounds for self-satisfaction. Stieglitz had been featur-
ing his work in *Camera Work* since its third issue in 1903, with major
exhibitions in 1904, 1906, and 1908. The "Photographische Rund-
schau" carried "17 reproductions of my glorious prints" in 1906, he
glowed to Stieglitz, and he seemed perpetually active in setting up or
participating in salons in both England and America. He had a "one-
man show" of twenty-four prints at the Leeds Art Gallery, and was
regularly a part of American and British displays of the best recent
work, along with Stieglitz, Day, Käsebier, J. Craig Annan, Robert De-
machy of Paris, and others less well-known. The British tacitly ranked
him with Stieglitz and Steichen as one of the three best artists of Amer-
ican origin. Even the august Henry James liked his work, and commis-
sioned him to do the pictures for his magisterial New York collected
edition, a project that has secured recognition for his name among lit-
erary scholars ever since. When James presented him with printed vol-
umes, Coburn burbled to Stieglitz: "He is a delightful man and one of
the best friends I have made over here." [105]

Coburn's ebullience masked his rather problematic image within the
world of British photography. George Davison received *Camera Work*
and regularly corresponded with Stieglitz; anyone reading his letters
had to get the impression that Steichen was the ablest American then
showing in England, with Gertrude Käsebier and Clarence White close
behind. He often had praise for Coburn's work, especially at first, but
by 1907 doubts were surfacing: "Coburn has the faculty of seeing things

in a big way and has succeeded in getting this quality into some of his camera work: still, as you say, he is not a Steichen." He found Coburn irritating to deal with personally, and by 1909 seemed to be bending over backwards to be fair. "Coburn is a nice boy and I admire much of his work," Davison wrote Stieglitz. "He is devoted to his photography and publicity for it, and I do not know that he is any the less likeable for the amiable and, may I add, amusing, weaknesses or gentleness which nature has slid in amongst his energies and abilities." Frederick Evans was exasperated with Coburn, not so much his work as his behavior. He was convinced that much of the animosity which divided British and American photographers by 1909 was due directly to "the worthlessness of young Coburn in the amazing tales & misrepresentations he has for so long palmed off on you about us poor Britishers! It is quite comic if only one didn't also feel angry seeing what London has done for that silly lad!" As for Stieglitz himself in New York, the schisms that tore apart the photographic fabric he had once so carefully woven were naked to the eye and Coburn was one of those outside the pale by 1913. "I am not surprised that you should be getting tired of Coburn," Stieglitz wrote Child Bayley. "When one knows him as thoroughly as you do, and as I do, his little game is so transparent so that, at times the continued littleness becomes actively irritating." He thought his protégé "undoubtedly a clever photographer and he has undoubtedly improved—occasionally. But there is no depth in his work. There is no real love, and therefore it can never have a lasting value. His work is like himself, subtly tricky."[106]

By the end of 1917, Coburn had all but dropped out of American modernism and had made a geographical relocation to Harlech in rural Wales which proved relatively permanent; he took British citizenship in 1932. His once promising career had trifurcated and he soon represented symptomatic rather than original modernist interests. He was painting a lot, "directly from nature in a very intense colour. I paint very directly, as rapidly as possible, and never go back to it again," he told the painter Max Weber. He had been meeting the leading British composers, mentioning Granville Bantock, Joseph Holbrooke, and Cyril Scott who were often in Harlech, and he especially liked to "hear absolutely new works played from manuscript"—although in these cases, the music involved was a long way from Stravinsky and Schönberg. Finally, "photography still interests me, but more and more I am drifting towards paint. I think it is the immediate result that I like, and the color!" In time he went back to photography with more seriousness and did some impressive work, but by then he was completely isolated from any recognizable climate of creativity. Even so, he pursued interests in no way unusual for an aging modernist; subsequent letters found him reading Claude Bragdon, Swami Vivekananda, and the Kabalah, and pursuing astrology and ideas about the fourth dimension.[107]

XII

Despite this large circle of British and American creative figures in several of the arts, and despite his own record of achievement, Pound took the war years badly. As befitted a modernist poet, he took world events personally, anger and contempt bursting forth in his correspondence at the deaths of his companions, the lack of interest in new artistic work in London, the decline in opportunities to publish and earn even small sums of money. As Richard Aldington summed up the situation in London to Amy Lowell seven weeks after the war began: "There is nothing doing here." Pound just returned "from the country & looks terribly ill. He lies on a couch and says he has 'cerebral gout.' " Aldington thought him perhaps "a little cracked. He doesn't seem able to talk of anything except himself & his 'work.' "[108]

Pound did not, on the whole, spend much time on the war as a philosophical or political problem. He was convinced that both sides were to blame, equally contemptible and worthy of defeat. "This war is possibly a conflict between two forces almost equally detestable. Atavism and the loathesome spirit of mediocrity cloaked in graft," he wrote Harriet Monroe in November. "One wonders if the war is only a stop gap. Only a symptom of the real disease." He did not have much use for living statesmen under the best of conditions, but in time his irritations focused on the figure of Woodrow Wilson. Wilson's public posturing, his Christian rhetoric, drove Pound to new heights of sarcasm. After one Wilson speech in the fall of 1916, he let loose at Alice Corbin Henderson: "We are still indulging in Armageddon. That consummate cad and liar W. Wilson is 'uncertain' what the conflict is about, but even without his archangelical sanctimonious permission the war continues." He then continued without a pause at a somewhat less general level of discourse: "AND such delicacies as fine-wove or whatever it is paper for sketches, etc., artist materials generally, which come mostly from france etc. etc. holland etc. are not easy to find."[109]

Despite his cerebral gout, Pound continued to act, as Archibald MacLeish later put it, "like a busy bee in the cultural flower garden; he's always cross-fertilizing, dragging things in." He continued to study Chinese poetry and Japanese theater, and did what he could to introduce English speakers to the criticism of Remy de Gourmont and the poetry of Jules Laforgue. He wrote more frequently on artistic and musical subjects. He took care of the personal problems of friends away in the armed services, such as Wyndham Lewis. He kept in regular contact with editors in America, such as H. L. Mencken, both to keep his own markets open and to help others even more isolated than himself. He cultivated John Quinn, and Quinn's money kept Lewis and James Joyce afloat during those difficult times. Yet he was obsessed with his own artistic loneliness and acted in such ways as to make it worse. He severed his connections with the *Egoist;* and as *BLAST* came

and went in two issues, its existence made his work hard to sell in more sedate quarters. Even the most intimate friendships seemed to go sour. "I am very much displeased with Richard, more displeased with Flint, and within the last week I have found it necessary to eliminate Cournos also from my list of acquaintance," he wrote Henderson in August 1915. He found it difficult to work with Hilda Doolittle because of her marriage to Aldington, and nothing else seemed to be going on. "As to actual writing, I think nothing new is done here. The war, and war verse takes all their energy. . . . I think english verse is temporarily dead, deader than mutton . . ."[110]

His parents only made matters worse with their efforts to pressure him into returning to America. "Of course I shall not come to America," he spluttered to his father during the 1915 presidential campaign. ". . . I have no desire whatsoever to gaze on the Schuykill River. And America offers me no means of livelihood, AND it's an intellectual and artistic desert. AND no one has yet shot Woodrow Wilson. And Hughes is not an interesting alternative." He was sure he would get even fewer publishing opportunities than in London, he wrote his mother a month later. Besides, he loathed "the American state of mind." "A Japanese invasion is the only thing that will civilize the West. I suppose it is too much to hope for."[111]

He even managed to quarrel at a distance. Harriet Monroe could always irritate him; while she had been providing him with an invaluable publishing outlet in *Poetry*, her own conservative tastes in poetry and Victorian assumptions in morals and decorum infuriated her European correspondent. He could limit himself to polite if firm protests for awhile, but her dislike of Eliot's work and her growing skepticism about his own were the last straws in a long-standing dispute. In May of 1916, he finally exploded. "Of course the plain damn unvarnished fact is that Harriet is a fool. A noble, sincere, long struggling impeccable fool," he wrote Henderson. "That is infinitely better than being Amy-just-selling-the-goods, but it is damd inconvenient, AND we are all, (I in particular) in a position where it is impossible, base, treacherous to admit that Harriet is a fool. The better the stuff I send in, by me or by anybody, the more God dam worry, fuss, bother to get it printed."[112]

By January 1917, he was writing Margaret Anderson that he wanted an "official organ" where "I and T. S. Eliot can appear once a month (or once an 'issue') and where Joyce can appear when he likes and where Wyndham Lewis can appear if he comes back from the war." As for *Poetry*, he summed up his discontents with brevity: "I have only three quarrels with them: Their idiotic fuss over christianizing all poems they print, their concessions to local pundibundery, and that infamous remark of Whitman's about poets needing an audience." Without any definite word to Monroe, he shifted his attention to the *Little Review*. Monroe and Henderson were furious once they discovered what they

thought was inexcusable perfidy. At the beginning of 1917, Monroe had received Pound's three Ur-Cantos, started to read them, "and then took sick—no doubt that was the cause," she wrote Henderson in March. "Since then I haven't had brains enough to tackle it. . . . think of his expecting us to print 24 pages of that sort of thing in one number. I don't know what to do about it." She clearly preferred both the work and the personality of Robert Frost. By April she had read the Cantos through; admitting their quality, she still had strong reservations: "I can't pretend to be much pleased at the course his muse is taking. A hint from Browning at his most recondite, and erudition in seventeen languages. Of course it would be suicidal to print the three cantos—or even two—in one number." But she finally did print them separately, only to discover that her correspondent had left her.[113]

Henderson was "utterly disgusted" at Pound's shift, declaring that "Ezra has no sense of values." A week later she was a bit calmer, and counseled a letter to him that would chide him on his lack of good manners and insist that he end all connection with *Poetry* to avoid a conflict of interest. "I am honestly too sorry for E. P. to continue mad. He ruins his own case continually and perpetually." Monroe followed her advice, writing Pound early in July at her sorrow at his switch and most especially at the loss of Yeats' work to her competitor. She then went on to call some of his recent prose "slop," terming it "loose, shapeless, full of repetitions," told him he was antagonizing people and concluded: "You are your own worse enemy, alas!" She had a point, but he was no longer listening.[114]

These forays into political and literary foreign relations provided the stage for a more important performance: Pound's continual trying on of masks and experiments with voices as he worked out his plans for his life's major work. "I am working on a poem which will resemble the Divina Commedia in length but in no other manner," he was writing Alice Henderson by the summer of 1915. "It is a huge, I was going to say, gamble, but shan't, it will prevent my making any money for the next forty years, perhaps." A month later, he was describing to Milton Bronner his work on a "chryselephantine poem of immeasurable length which will occupy me for the next four decades unless it becomes a bore." Clearly he had some idea of what he was getting into, even if he had no firm outline or model. The preponderance of the evidence indicates that even though Pound had absorbed Imagism and Vorticism, had read through French critics and philosophers, learned about primitivism from Jacob Epstein and photographic images from Alvin Coburn, and written major poems, he still could not face the mirror each morning with a firm idea of what he would see. Between 1915 and 1917 he produced the three Ur-Cantos as a kind of summary of what he already knew; then, using them as a base, began a process of revision that ultimately excluded the bulk of this work and reshaped the rest into the mature voice of the final Cantos.[115]

The evidence of Pound's uncertain sense of identity litters his bibliography for these few years. Most readers of Pound in this period know that he used "B. H. Dias" as his pseudonym for his art criticism, and "William Atheling" for his music criticism in *The New Age* between 1917 and 1921. But he also signed himself E.P., a persona not precisely the same as Ezra Pound in either poetry or criticism, as Ferrex, Henery Hawkins, Bastien von Helmholtz, Hermann Karl Georg Jesus Maria, Alf Arpur, Walter Villerant, John Hall, and Thayer Exton. On occasion, one of his identities would mention the writings of another, or even criticize them, thus drawing attention to them. Some of this was simply good fun, some of it disguising his work so as not to overpower his small public, and some of it perhaps an effort to avoid disapproval of his words simply because the controversial Ezra Pound had written them. But surely it indicated internal confusion, the pseudonyms being signs of a man arguing with himself, allowing himself the luxury of working out his literary identity crisis in public, for pay. Nor did Pound stop with pseudonyms. He experimented with the writing of imaginary conversations, following the precedents of de Gourmont, Landor, and Fontanelle, and indulged in jeux d'esprits still readily available in *Pavannes and Divisions* (1918). One of these, "Jodindranath's Occupation," he described to Henderson as a story "with a nice thick nauseous Indian atmosphere" most of it "cribbed from the Kamasutra. It may be litteratoor. Am uncertain." He was certainly uncertain; literature it wasn't.[116]

In a sense, all of Pound's past enthusiasms went into the Ur-Cantos. He recalled one of his best friends from his Philadelphia years, the painter William Brooke Smith, the man to whom he had dedicated *A Lume Spento*. He recalled a version of himself as a virginal poet in Venice. He retained elements of the Imagist aesthetic, the ideogrammic method, and the Noh theater. He openly appealed to Robert Browning, *Sordello*, and the Victorian memory of the troubadours to give him a form. Yet the best form he could come up with was Browning's "whole bag of tricks," making the wistful point that the "modern world / Needs such a rag-bag to stuff all its thought in"—only to mix his metaphors a bit by bringing in sardines in the next line. He certainly had Dante in mind almost obsessively, combining the themes of spiritual education with portraits of characters in hell. Elements of mysticism remained from his talks with Yeats at Stone Cottage, and primitivism from his contacts with Epstein and Eliot. At some point he clearly absorbed lessons from Frazer's *The Golden Bough*, Jane Harrison's *Themis* (1912), and James A. K. Thomson's *Studies in the Odyssey* (1914). That he knew the *Odyssey* itself goes without saying.

In his writings on Vorticism, Pound had toyed with the idea of writing a long Imagist poem, agreeing with Keats that any poet who wished to be truly great had to write at length. But such an aspiration did not at the same time supply an appropriate form for such a work. Pound

never showed any great sense of form under the best of circumstances, and as the Cantos in their entirety showed only too clearly, the problem eluded solution in his case. He dignified his work as an epic, consistently defining it as a poem including history, which begs the question and leaves the rag-bag as the central image in a reader's mind. This was not necessarily a bad thing; rag-bags have their uses and can even incorporate sardines in emergencies, but for a poet beginning a life's work, the sense of insecurity must have been great.

Insofar as Pound could explain what he was doing at the time he was doing it, he took his inspiration from Wyndham Lewis, and especially the Lewis of *Timon of Athens*. Both Lewis and his painting were extraordinarily energetic, and Pound seemed captivated both by his friend and by the pattern which such energy seemed capable of creating. He asserted that emotional force created its own image, while denying that this was an explanatory metaphor. "Intense emotion causes pattern to arise in the mind—if the mind is strong enough," he asserted early in 1915. Then he reconsidered his language in a crucial way: "Perhaps I should say, not pattern, but pattern-units, or units of design. . . . I am using this term 'pattern-unit', because I want to get away from the confusion between 'pattern' and 'applied decoration'." He then elaborated: "By pattern-unit or vorticist picture I mean the single jet. The difference between the pattern-unit and the picture is one of complexity." A pattern-unit is simple and repeatable, but when it becomes so complex that additional repetition becomes unnecessary, "then it is a picture, an 'arrangement of forms'." Nor is that all: "Not only does emotion create the 'pattern-unit' and the 'arrangement of forms', it creates also the Image." Such an image could be subjective or objective, but in either case it was more than an idea. It was "a vortex or cluster of fused ideas and is endowed with energy." Such language was neither clear nor in permanent form. But it marked an important break between nineteenth- and twentieth-century poetics. In effect, it meant that he tried in the Ur-Cantos to produce the poetic equivalent of *Timon*, sensed his failure to do so, but then succeeded in the early, mature Cantos.[117]

Many of the problems in the Ur-Cantos are also present in *Sordello*, most obviously in the obscurities associated with a paratactic mode of presenting events. But the two works are hardly contemporaneous, even to someone as capable of choosing his past as Pound. The crucial interventions were two of his greatest literary enthusiasms, Henry James and James Joyce. James the realist and cosmopolitan, James the master who could present states of mind as facts, was the subject of an outpouring of journalism during this period, although the true impact of James' syntax did not affect the Cantos until Canto IV. Pound himself once quipped to an old teacher that "Hugh Selwyn Mauberley" was "an attempt to condense the James novel," but in time the Cantos seemed a better choice for such analysis. With Joyce, the influence of *Dubliners*

and *Portrait of the Artist* complemented that of James: for Pound in 1917 Joyce was above all the author of prose that was "hard, clear-cut, with no waste of words, no bundling up of useless phrases, no filling in with pages of slosh." In essence, Pound was trying to write poetry that was an equivalent to the psychological realism in *Portrait,* a Joycean pattern-unit.[118]

The Ur-Cantos appeared in *Poetry* for June, July, and August 1917, but they underwent revision immediately. Eliot offered criticisms: one long passage and many personal pronouns disappeared, and the material as a whole became more elliptical. No manuscript offers conclusive evidence of what Eliot did, but according to a Pound letter Eliot was the only person who offered criticism which Pound could use. Even more crucial was the arrival, late in 1917 or early in 1918, of the first chapters of *Ulysses.* The impact of this work was great but lies beyond 1917, not being fully evident until the work of the middle 1920s and even later. Not only did Browning and *Sordello* all but disappear, so did the central narrator of Canto I and the dramatic structure of much of the Ur-Cantos. Pound reworked Canto IV, rethought his whole idea, published other, unrelated works, and did not return full time to his epic for several years.[119]

He left a distinctly mixed image of himself to posterity. He rubbed some people the wrong way and a few were public about their dislikes. Frank Flint was one of the most outspoken. In February 1917, he took strong exception to an article in *The Egoist* that he suspected of being self-generated praise on the part of his one-time friend. "The truth is, we are all tired of Mr. Pound," he informed the editor. "His work has deteriorated from book to book; his manners have become more and more offensive; and we wish he would go back to America." British literary folk "are tired of his antics," which have made him "the sinister Charlie Chaplin" of his generation. They are tired of his literary gamesmanship, his "Wild-Westisms," and his "continual attempts to puff and swell himself and his friends into a generation of bulls." They are "tired of Mr. Pound's various and many martyrdoms." They are "tired of him altogether, body and soul, lock, stock and barrel; and those of us who were once associated with him and are so no longer, for very good reasons, detest him with the heartiest of loathings."[120]

In sharp contrast, Pound was already a guru to the next generation, a role he played with zest into old age. Iris Barry provoked several of his most quoted letters on poetry, and in 1931 published a charming brief memoir of life among the Pound set. They met in 1916 in Wimbledon, after an exchange of letters. "At that time his name stood in England, along with that of the sculptor Epstein, for all that was dangerously different, horridly new." But she and other young people were feeling the threat of the war and clung all the more fiercely to those concerns which they would have pursued in peacetime. All were imitating his poetry, but his accent was inimitable. "Pound talks like no

one else. His is almost a wholly original accent, the base of American mingled with a dozen assorted 'English society' and Cockney accents inserted in mockery, French, Spanish, and Greek exclamations, strange cries and catcalls, the whole very oddly inflected, with dramatic pauses and *diminuendos*." In other words, he tried out his voices, masks, and identities every day, in public, in a manner sounding very much like his verse, and had a fine time doing it. He seemed busy and gay, and soon signed his name to letters "with a seal in the Chinese manner that Edmond Dulac made for him." He would cook a good meal in his faun dressing robe and then play on the harpsichord that Arnold Dolmetsch had made for him. Outdoors, he "was always striding about the streets with his head thrown back, seeing everything, meeting everybody, as full of the latest gossip as he was of excitement about the pictorial quality of the Chinese radicals or a line of Rimbaud's or Leopardi's," never forgetting "how much he disliked dons, the Elizabethan influence, the technique of Byron, or how suspicious he was about the Greeks."

The group met weekly for dinner well into 1918, first in Soho and then at a restaurant on Regent St. Pound always looked a bit wild and sounded a bit peculiar, yet was always formal and polite. Dorothy was usually with him, "carrying herself delicately with the air, always, of a young Victorian lady out skating, and a profile as clear and lovely as that of a porcelain Kuan-yin." May Sinclair would come in "raspberry pink," Hueffer would boom out his anecdotes, Violet Hunt would chatter away, and Hilda Doolittle, "taller and more silent even than Mrs. Pound," would always seem "somehow, haunted." Barry recalled Eliot with the clarity of a woman who found him attractive: "Tall, lean and hollow cheeked, dressed in the formal manner appropriate to his daytime occupation in Lloyd's Bank," he was "generally silent but with a smile that was as shy as it was friendly, and rather passionately but mutely adored by the three or four young females who had been allowed in because of some crumb of promise in painting or verse." Mary Butts, Arthur Waley, and Harriet Weaver were there as well, with Wyndham Lewis, Yeats, and Symons showing up on occasion. They all gossiped endlessly of everything from Proust to le Douanier Rousseau, from Chinese poetry to jazz. Above all, with Pound as leader, they kept ideals of civilization alive in a time when they seemed endangered. A chosen few also participated in Yeats' Monday evening meetings, where presumably the talk was more professional and the ladies less distracting.[121]

Charming as they are, salons come and go. What remained was one variety of modernist poetry and ideas that had impact in other arts as well. Whether original with himself or with friends—it hardly mattered—Pound came to seem the chief representative of this new poetic that stressed the reality of the visible world as expressed in concrete language. He represented timelessness, both in the sense of finding the entire past always contemporaneous, and in presenting the present in-

stantaneously to another intelligence. He challenged notions of symmetry with a sense of asymmetry, breaking up as he did so not only the hated iambic pentameter, but also any sense of long forms being necessary at all. Now the luminous detail was the focus, perhaps incarnating truth or reality but mostly being an item of historical detritus that the poet found and presented in a manner free of rhetoric for assessment or contemplation. Rhetoric and abstraction of any kind were suddenly in bad taste. New rhythms, fully as disturbing as any in music, jostled the reader's expectations. Readers, themselves, became an elite, needing languages and training before proper communication could occur. Despite Pound's uncertain taste in art and dislike of film, he learned as well about the collage, the new perspectives, the dream sequence, the close-up, and all the other devices that were soon available for experimentation. Ideograms remained a possibility, even if Pound himself no longer thought much about them. Musical parallels seemed everywhere, even if, especially if, the writer knew little formally about music. Anything could, and did, happen, and more than anyone else, Pound made such experimentation possible.[122]

BOOK IV:

Paris: Where the Stein Families Provided Salons for Visiting Americans

Eduard Steichen was born in Luxembourg in 1879 into a peasant family that had long dreamed about the land of freedom and equality across the Atlantic. In 1881 they all migrated to Hancock, Michigan, only to find opportunities more limited than they could have imagined. Steichen's father lost his health in the local copper mines, and his mother supported the family through millinery work. As a teenager, he developed an interest in photography with the help of a friendly dealer who took the time to explain his wares to the boy. Those were the days when Eastman Kodak advertised to the masses, "You press the button, we do the rest," but Steichen took to the grave the memory of his first roll: of the fifty exposures, forty-nine proved worthless. Despite this discouragement, he never could satisfy his interest in the new art. He became an apprentice in a Milwaukee lithographic firm and was soon using his hobby to suggest improvements to his employers. Neither the pigs nor the wheat in their designs looked real to a farmboy, so he tried to master photographic techniques as a means of producing clearer, more convincing lithographs. Having no one to teach him, he taught himself, by trial and error discovering the essential procedures. "My crowning achievement was to make some portraits of pigs that were much admired by the pork packers," he remembered many years later. "So my first real effort in photography was to make photographs that were useful," and over the course of his career he consistently found "that usefulness has always been attractive in the art of photography."

Thus retold, Steichen's early years have a prototypical sound about them: the migration, poverty, self-reliance, and improvisation are the stuff of countless romances. But modernists felt such experiences acutely at the time. The America they found seemed to have no place for their imaginations, no school for their talents, no jobs for their skills. "Op-

portunities for learning about photography were nonexistent in Milwaukee in those days," and he could not find appropriate books in the public library. A few magazines were available, but their photographs "had an air of banality" about them. He turned instead to painting, most often watercolors of moonlit subjects, and by the closing years of the nineteenth century he was active in a small group of amateurs, the Milwaukee Art Students' League, which hired an old German painter for instruction, and models to sketch. The general attitude of the teacher and many of his friends, however, was that painting was an art superior to photography, as if a great photograph were one that warranted a fine painting. Steichen believed otherwise, and soon was wandering off into the woods, in the twilight or mist, to achieve the somewhat blurred, romantic effects that he wanted. He experimented with light, with exposure time, and with fortuitous accidents. Rain sometimes dropped on his camera, diffusing the light; once he accidently kicked his tripod. "Since diffusion by either action could be reproduced at will, my technical vocabulary took a lurch forward." He became "an 'impressionist' without knowing it."

Steichen tried hard to make a place for himself. He read, took pictures, and participated in shows. In *Harper's Weekly,* he read an article by Charles H. Caffin on "The Philadelphia Photographic Salon" that described the first time an American museum had sponsored a photographic exhibition. One of the names on the jury was Alfred Stieglitz; one of the best pictures was that of Clarence H. White. Greatly excited, Steichen determined to take part in the next salon; when he did so, Clarence White sent a letter praising the originality of his submissions. Much encouraged, Steichen submitted ten works to the jury of the Chicago Salon, scheduled for 1900. White, also on that jury, wanted to hang all ten, but his colleagues cut the number to three. Such discouragements took their toll, as did the loneliness of even a well-paid lithographer. Steichen read an article on a new gum-bichromate process that Robert Demachy was experimenting with in France, and the more he thought about his situation, the more he realized that he had no chance in America. He had trouble finding teachers, shows, friends, paper, chemicals, and knowledge of new techniques. Over the objections of his father, but with the warm support of his mother, he determined to give up his job and try his luck. In the spring of 1900, he stopped off in New York to meet Stieglitz, embarked for Le Havre with a friend, and then cycled to Paris, photographing the country along the Seine as he went.[1]

The Steichen who arrived in Paris had his head full of those painters and sculptors whose work had been available to him in Milwaukee; they conveyed a symbolist, romantic view of art. With him as with so many other potential modernists, that meant that Claude Monet was supreme among French painters, Whistler the great role model among American artists in France, and Maurice Maeterlinck the playwright most able

to convey the relationships between the mind, nature, and any extra-dimensional world that might exist. Where Steichen was unusual was in his admiration for the work of the sculptor, Auguste Rodin. In 1898 the Milwaukee newspapers had covered the controversy involving a commission for Rodin to make a statue of the writer Honoré de Balzac for the city of Paris. When a plaster cast of the proposed work went on display, everyone in French art circles chose up sides to praise or condemn it, with a ferocity inconceivable in the American Midwest. No one in America cared enough about new art to commission, create, or condemn it, but in France these things mattered. The Society of Men of Letters, the commissioners of the work, decided not to accept it, but when a picture of it appeared in the Milwaukee press, Steichen regarded it as "the most wonderful thing I had ever seen. It was not just a statue of a man; it was the very embodiment of a tribute to genius. It looked like a mountain come to life."

Naturally enough, then, his first goal upon reaching Paris was to see more; as soon as he and his friend were settled in a flat, they headed for the Rodin exhibition then on display near the gates to the Paris World's Fair of 1900. They arrived toward the end of the day, took in the Balzac, and noticed a man who looked like the artist should look, off in a group talking. With a "massive head, almost like a bull's," he seemed a perfect candidate for a photograph. He was, but not immediately. Steichen went to the Louvre and the Luxembourg to study old masters and new impressionists, remaining true to his devotion to Monet while pursuing his most basic interest: the "magic and color of sunlight."

For a photographer, however, London seemed a more active theater of innovation, and that fall Steichen crossed the Channel to see the exhibitions of the Royal Photographic Society and the Linked Ring. The Brotherhood of the Linked Ring, as it was officially called, was a group of photographers who were originally British but who welcomed foreign participants in their activities, and preferred to ignore potentially divisive differences between amateur and professional artists that could be damaging to the new profession. The group tried hard to enforce standards, and membership in its ranks was an honor in the eyes of most people concerned with photography in Western Europe. Since 1893, the Linked Ring had been presenting annual salons of new work, and Steichen was eager to have his efforts on display. He was soon meeting the leading British figures in the field, such as George Davison and A. Horsley Hinton, as well as the visiting Americans, F. Holland Day and Gertrude Käsebier.

While not unfriendly, the British were a bit put off by Steichen's American brashness. The editor of the *Amateur Photographer*, Horsley Hinton, had been in correspondence with Alfred Stieglitz since 1896, and regularly informed Stieglitz of doings among the Linked Ring. "I have just met Mr. Eduard Steichen, much of his work which is being

shown just now is attracting a good deal of attention, he is a close friend of Holland Day's," he wrote Stieglitz in October 1900. Since relations between Stieglitz and Day were difficult at best and their rivalry as leading American photographers growing increasingly public, the reference may well have been intentionally irritating. Hinton reported that, like Day, Steichen "is exceedingly interesting, but . . . well, time will perhaps best solve all doubts." It did not, as subsequent letters indicated. Steichen even refused membership in the Linked Ring a year later, something shocking to British sensibilities, and Hinton concluded that Americans were a contentious lot. Nevertheless, he and his colleagues persevered, reconsidered Steichen for membership, and on 7 June 1903 he finally accepted the honor. Hinton made it clear that Steichen's work, not his person, was what the British admired, and by 1904 he was steaming about another seeming affront: ". . . news has just reached me that Steichen has pinned up in the New York Camera Club Room a portion of, or extract from, *a private letter written to him by me.* I do not know how much or how it will appear, but a more outrageous piece of caddishness, to say nothing of dishonesty, I have not met for a long time." Like Alvin Coburn, who Hinton also saw frequently, Steichen was going to have his troubles with the British.[2]

Steichen was young and perhaps unaware of the contentiousness. He did get on well with Holland Day at first, both of them aesthetes into symbolism and archaism as refugees from the crudities of capitalistic civilization. Day was encouraging about Steichen's photographs, choosing twenty-one of his prints for his show, the "New School of American Photography," an enterprise that included virtually everyone except Alfred Stieglitz, who condemned the whole business. In their leisure hours, Day and Steichen also went about the country, taking pictures of each other; and Steichen spent a significant amount of time painting. As the winter wore on, he worried about the connections between painting and photography, and the eternal question of what constituted art. "I am sure the biggest hindrance to fotography has *been* fotography," he informed Stieglitz sententiously; "we have quibbled *fotographs* when it should be *art*." He soon found Day puzzling, but took new delight in Gertrude Käsebier, the leading American woman active in experimental photography.[3]

Steichen returned to Paris and enrolled in the Académie Julian. For a few weeks he tried drawing and painting, but found the atmosphere psychologically depressing and artistically oppressive. "The kind of work that was admired there was cold, lifeless, slick, smoothly finished academic drawing." He was not interested, picked up his materials, and left; "my professional art training came to an end." He returned with relief to photography, and one commission turned out fortuitously to be for a Norwegian landscape painter who happened to know Rodin. Casual talk led to a visit, the visit led to dinner, and one of Steichen's most important friendships began. During the next year, on virtually

every Saturday, Steichen cycled out to Rodin's house, studied his work, enjoyed his company, and took perhaps the best-known photographs of these early years, most memorably "Rodin-Le Penseur" (1902), a composite experiment that pleased its subject enormously. During the week, Steichen became an established presence on the Paris scene for visiting Americans. In the summer of 1901, he was especially hospitable to Käsebier. "We've had a double superlative time in Paris," she reported to Stieglitz. "We have been with Steichen every day and how I have enjoyed him. He is a corker!"[4]

After about a year in Paris, Steichen returned to America. He concentrated his energies in New York City, becoming close to Stieglitz and meeting members of his circle. He joined the New York Camera Club, helped with the publication of *Camera Notes*, and took pictures of the Stieglitz family. He puzzled, as many have since, over Stieglitz' apparent preferences in paintings, which ran to the work of Franz von Stuck and Arnold Böcklin. He realized how deeply Stieglitz disliked Holland Day, and stopped mentioning that rival for the leadership of America's experimental photographers. He also experienced the "most concentrated and exciting experience in portraiture" that he ever had. "In one day I had the job of photographing two great and completely contrasting personalities, J. Pierpont Morgan and Eleonora Duse, within less than an hour's time." One shot of Morgan in particular caught the eye of his librarian, Belle da Costa Greene. She became a great admirer of Steichen's work, and a living connection between the modern art interests of the Stieglitz group and the more traditional tastes of her employer. In time she became a lover of Bernard Berenson, one of several people whose lives linked New York modernism with Florentine critical and historical interests in old masters. The picture, a gift to Stieglitz, ended up in the Metropolitan Museum. Everyone commented on Steichen's use of light and the compelling power of Morgan's nose. What it really did was to bring together modernist photography, an interest in art as a civilizing force, and the institution of the Met, entwined as it was with Morgan's wealth and dictatorial tastes.

Steichen lived at 291 Fifth Avenue while in New York, and the location became central to the Stieglitz circle. The photographers decided they needed a public identity, and using a name derived from artistic dissidents in Vienna and Munich were soon calling themselves the "Photo-Secession." They announced their existence in the July 1903 *Camera Work*. Over the next two years, conditions in Steichen's flat permitted a slight expansion into #293, and a remodeling of #291, and on 25 November 1905, refreshed by one of their regular dinner gatherings at Mouquin's, the group declared their new quarters open with a show of their own work. The number "291" became the universal shorthand for the gallery.

In his private life, Steichen married Clara E. Smith in 1903 and suffered from a severe bout of typhoid in 1904, both events contributing

to much unhappiness in his subsequent European career. At first, all seemed well with marriage, health, and career: as the Morgan picture indicated, Steichen was a success in his own country and could have remained indefinitely, but his artistic conscience gnawed at him. "I was dissatisfied with most of the work I was doing, for it had become rather routine." He was getting orders for his prints, but most of them were for his conventional work, not the innovative pictures he himself valued most. "I made up my mind to get away from the lucrative but stultifying professional portrait business, and early in 1906 I packed up my family and moved back to France."[5]

For the next eight years, Steichen seemed the epitome of the successful American modernist, as in many ways he was. His autobiography passes over his problems with his health and his marriage, and deals only in cursory fashion with his complex relationship with Stieglitz. Letters from French and British photographers tell a rather different tale. Robert Demachy, for example, was the leading French contact for the Stieglitz group. "I have seen Steichen and his very charming wife often and I find him considerably matured both in nature and in talent," he wrote Stieglitz after Steichen's return to Paris. "His paintings are *excellent* and I am sure he will be greatly appreciated over here and he will have a great success at the Spring Salon without doubt." Demachy's letters often became long laments about his own personal problems, chiefly the illness of his mother and a marital separation that unnerved him. He was thus abnormally sensitive to moods, and he assessed Steichen clearly: "he is overworking himself and is so fagged and tired out that he is obliged to rusticate for a fortnight and stop work altogether. He was really looking ill and over strung," and words such as "overstrung" and "overworked" occur repeatedly in his letters.

At the same time, Demachy was high in his praise for Steichen. "His work is excellent. I am sure he will make a name for himself amongst the painters if he can stay over here—his conceptions are absolutely original—with some bit of exaggeration which is a necessary quality at his age and will tone down later—he draws well and has a powerful sense of colour." Demachy admired Steichen's latest photographs, and had special praise for his portraits of Rodin. At the same time, Demachy found the French scene as depressing as his new friend found the American one. Steichen "acts on me as a stimulant of which I have a great need in the atmosphere of indifference which is peculiar to Paris where there are about three photographers who care about each other's work. Here we have no dissensions or back bitings just because nobody takes any interest in anything—in the circle of art—but painting." People seemed appreciative of exhibitions in a general way, but they made no distinction between amateur and professional work. "I work to please myself and in hopes to please men like you—Steichen and perhaps two others—and some painters who encourage me and

honestly criticize my prints but as to doing over here what you have done in America I don't see my way at all."[6]

Steichen was soon in London, to which he returned at regular intervals. He enjoyed both personal and business success. He got along well with George Davison and Frederick Evans, although they too noted his look of being physically run down; but he never could get along with Horsley Hinton. He took pictures of George Bernard Shaw that were among his first works in the new technology of color, which the Lumière Company in France had just developed. But by 1907 his marital problems were starting to cause comment. He and Clara were incompatible, and their early squabbles were portents of the divorce that did not come until after the war.[7]

During his second lengthy period in Paris, Steichen became an integral part of the young modernist network. He met the Stein families, not only Leo and Gertrude, but also their brother Michael and his wife, Sarah. Through them, he met Henri Matisse and Pablo Picasso, and provided the first of several living links between Paris and New York, leading both to incalculable cultural influences and to specific exhibitions. Already friendly with the Philadelphia modernist painter Arthur Carles, Steichen soon added John Marin, Max Weber, and Alfred Maurer to his circle of friends. Despite a home in Voulangis, an inconvenient distance from the stimulation of Paris, the Steichens too had their salon, and visitors made frequent weekend trips out to see them. Stieglitz and his family were among them, and during the summer of 1910, Steichen took the opportunity to show Stieglitz around the Paris scene. He met the Steins, checked out the Vollard and Durand-Ruel galleries, and went to see the Cézannes at the Bernheim Jeune Gallery. "Stieglitz and I laughed like country yokels as we thought of what a red flag this would be in New York," and after the show closed Steichen made preliminary arrangements for a 1911 Cézanne show in New York City.

Such friendships were important for American modernism, but they put strains on artists. All American modernists found their culture constricting to their artistic development, in the process developing languages that conveyed their discontent. But no two seemed to speak the same language. Mutual enemies could be a great bond and exile could throw unlikely people together, but friction and incomprehension were inevitable. Both Stieglitz and Steichen were prima donnas, and neither was eager to compromise. Both had unhappy private lives, and such strains exacerbated professional disagreements. Having welcomed several of Steichen's friends, such as Clarence White and Gertrude Käsebier, into his modernistic circle in their early days, Stieglitz was soon reading them out again. Max Weber was as temperamentally disputatious as anyone, and by 1911 he was off on his own. With Steichen the issues were complex: they included not only personal rivalry, a sense that Stieglitz was becoming hopelessly egotistical in identifying all mod-

ernism with himself and 291, and a few matters of taste, but also the coming war. A German by cultural background, Stieglitz varied between apathy and a mildly pro-German stance. For Steichen, "France had become another mother country to me, and I sided with her in all the arguments with Stieglitz." Stieglitz rarely let himself go in private correspondence, but one letter had a laconic undertone that barely masked his disapproval. "Steichen and his family are over here. The Germans were within a few miles of Voulangis," he wrote Samuel Halpert in late October. "In having to protect the family, Steichen thought it best to come over here. If he had been alone he would have remained in France and probably gone to the front. He is terribly French at heart."

As for Steichen, when he arrived in New York City, he found 291 in the doldrums, everything full of dust and empty of visitors. He helped clean the place up and put on a show that included a few Braques and Picassos, which complemented the African sculptures that Marius de Zayas had collected. That helped, but the enterprise seemed disspirited. When Marcel Duchamp and Francis Picabia arrived, Steichen took little interest. He could find nothing in the war to warrant the implicit anarchism and nihilism of Dada, and he tended instead to cultivate friendships in other arts, such as those with Alfred Kreymborg in poetry and Edgard Varèse in music. He and Stieglitz, once so close, went their separate ways.[8]

II

When Leo Stein left Baltimore in 1900, he intended to settle in Europe and write a book on the Italian painter Andrea Mantegna (1431–1506). Feeling "at loose ends" in America, he was prepared to dabble in art history, but found that he had an aesthetic rather than a historical interest in art. He settled in Florence and made a sustained study of Italian art. His desire to write on Mantegna faded, and he realized that he had quirks of character which stood in the way of such scholarly activity. "Unfortunately, like a child I want very much at the present moment whatever I want at all, even more so with things intellectual than things material," he wrote Gertrude just before Christmas. He considered Leonardo and Dürer, but "Mantegna is the only man who commands my interest in such a way that I want to do my durndest." Even as he wrote, however, the field of his greater skill was opening before his eyes and developing unrecognized. He was barely settled in Florence when he "took lunch" several times with Bernard Berenson and his wife Mary, and sent on to his sister descriptions of the art critic, then on the verge of his reputation as an expert on Italian art. Berenson was "very sensible," despite "that tremendous excess of the I" that a visitor had to get past. The clash of two egos was probably one between equals, and one that continued for many years. Thus, within a

week of arriving in town, Leo had begun to form a network of friends who could stimulate him on artistic subjects. Such ideas on art as he did develop went into conversation, not into books.[9]

The next summer, Gertrude joined him for a trip to Spain, where Leo found the work of Velázquez disappointing, that of Goya "more satisfactory." Because of changes going on at the Prado, he did not see the work of El Greco that became important to him later, and since both Steins reacted badly to the Spanish climate, they retired to Bordeaux to rest. She returned to America and he to Florence, but they traveled to England together in the summer of 1902. They stopped at Haslemere with Berenson, and soon met his distinguished in-laws, Alys and Bertrand Russell. Alys was "a reformer and is now nursing her nerves," and Bertrand "a young mathematician of genius," he wrote Mabel Weeks in mid-September. Gertrude, in these days, was quiet and anything but intellectual; her response to Berenson's talk was to put him on a diet of eggs and milk, which improved his health and disposition, while Leo threw himself into more cerebral matters. "We have Am. vs. Eng. disputes all the time. The general theme is why in the name of all that's reasonable do you think of going back to America?" he wrote Weeks. "It's quite impossible to persuade them that my Americanism is not a pose, and that I really think seriously of returning there—sooner or later." He thought there was "something tonic . . . about America, that I miss here and would not like to miss permanently. If America only were not so far away and if the climate in the possible parts were not so chilly." He looked forward to the day when he and Gertrude would return, perhaps to New England, "and live happily ever after."

That winter in Bloomsbury was Gertrude's low point, and she returned ahead of schedule to America and the relationships that she poured into her writing. Almost as depressed, Leo left England just before Christmas and headed for Paris. With his life lacking direction, he was open to whim and suggestion. One evening, as he was dining with cellist Pablo Casals, he became aware even as he was speaking that he had found scholarship unrewarding and felt himself to be "growing into an artist." He went back to his hotel, lit a fire, took off his clothes, and "began to draw from the nude." He spent a week drawing from statues in the Louvre and was soon taking lessons at the Académie Julian. He decided to remain in Paris, and settled at 27 rue de Fleurus. His efforts at painting and drawing came to nought, but his decision to remain became central to the network he was developing, and his choice of address was soon famous throughout the world of contemporary art.

Having a small but assured income, Stein was eager to buy good new work, but had no idea of how to do so. He wandered through the galleries for perhaps a year before Berenson arrived on a visit and suggested that Stein look up the work of Paul Cézanne at the gallery

of Ambroise Vollard. Stein knew of the place—it looked more like a junk shop than a proper gallery—but had never bothered to check it out. He went in and was soon in a fruitful relationship with Vollard himself. As he wrote later, he thought that his work on Mantegna and the Tuscan quattrocentisti "were an excellent preparation. I was quite ready for Cézanne." When Berenson learned of the impact his suggestion had had on his friend, he put Stein in touch with his Florentine neighbor, the American Charles Loeser, who was a "hardened collector" of everything from ivory-headed canes to Cézannes, and one of Vollard's best customers. Stein went through a "Cézanne debauch," and returned to Paris feeling that he "was a Columbus setting sail for a world beyond the world."[10]

He was soon self-consciously explicating "L'Art Moderne." The Big Four that she had to know about, he wrote Mabel Weeks, were Manet, Renoir, Degas, and Cézanne. "Manet is the painter par excellence," with no peer "in sheer power of handling." Because he did not have a great intellect his work was "largely haphazard," but, although "he rarely realized a thing completely yet everything he did was superb. There is a limpid purity in his color and feeling for effect, a realization of form and vitality in rendering, all of which are most admirable . . ." Renoir is "the colorist of the group," again a man "of limited intellectuality," but one who "had the gift of color as no one perhaps since Rubens"; this color "carried every bit of his work splendidly just as texture and mass carry Manet . . ." Degas "is the most distinctly intellectual," "incomparably the greatest master of composition of our time, the greatest master probably of movement of line, with a colossal feeling for form and superb color."

Cézanne was always the painter Stein returned to. Cézanne had a great mind, along with "perfect concentration, and great control. Cézanne's essential problem is mass and he has succeeded in rendering mass with a vital intensity that is unparalleled in the whole history of painting." Regardless of his subject, "there is always this remorseless intensity, the endless unending gripping of the form, the unceasing effort to force it to reveal its absolute self-existing quality of mass." No picture ever seemed to be complete, and every one seemed to be a battlefield in which victory was an "unattainable ideal." He brought the same intensity to his composition, and his color, "though as harsh as his forms, is almost as vibrant. In brief, he is the most robust, the most intense, and in a fine sense the most ideal of the four."

The catalytic event in the development of Leo Stein into an art collector was not one of his interminable ruminations on art, but his brother Michael's discovery that they had more money available for use than he had expected. Leo continued to buy Cézannes, but added two Gauguins and two Renoirs from Vollard's stock; the pleased dealer threw in a work of Maurice Denis, a gesture which understandably pleased Leo. By now Gertrude was a partner, if a generally silent one, in these

transactions. She noted, in her own letters to Mabel Weeks, some of the financial sacrifices these enthusiasms entailed. "We is doin business too we are selling Jap prints to buy a Cezanne at least we are that is Leo is trying. He don't like it a bit and makes an awful fuss about asking enough money but I guess we'll get the Cezanne." She concluded: "Its a bully picture alright." [11]

By the fall of 1905, the Steins were in high gear as art collectors. The event which precipitated the sale of the Japanese prints was the Salon d'Automne at the Grand Palais. Cries of "Wild Beasts" were in the air as the fauvist style of Henri Matisse made its debut; the picture that focused public attention was his "Femme au Chapeau," a picture of the artist's wife wearing an impressive hat. It was, Leo recalled years later, "a thing brilliant and powerful, but the nastiest smear of paint I had ever seen. It was what I was unknowingly waiting for," although it took him several days to get used to the idea. He bought it, and the negotiations led to a meeting with the painter and the purchase of many more of his works over the next three years. Then, ever fickle, Leo determined that Matisse's works "were rhythmically insufficient," and left to Michael and Sarah the task of keeping the French painter going. They did so, to the life-long gratitude of an artist who was in need of both money and praise.

One of Leo's friends at this time was Henri-Pierre Roché, "a tall man with an enquiring eye under an inquisitive forehead," who "wanted to know something more about everything. He was a born liaison officer, who knew everybody and wanted everybody to know everybody else." Through Roché, Stein met such experimental writers as Alfred Jarry, Paul Fort, and Jean Moréas. When, through one of his dealer contacts, Stein discovered drawings, and then a painting by Pablo Picasso, Roché turned out to know him as well. The two were soon at Picasso's atelier on the Rue Ravignon. "One could not see Picasso without getting an indelible impression," Stein recalled. "His short, solid but somehow graceful figure, his firm head with the hair falling forward, careless but not slovenly, emphasized his extraordinary seeing eyes." The place itself was a mess. "There was a heap of cinders beside the round cast-iron stove, which was held together with a twisted wire (it later burst); some crippled furniture; a dirty palette; dirty brushes; and more or less sloppy pictures." After Stein bought a few of those pictures, Picasso dropped by from time to time with his paint box to clean them up.

Picasso "was then in the last months of the Harlequin Period, painting acrobats and mountebanks," but as Stein saw it, the painter soon exhausted his inner resources. The influence of Cézanne was spreading rapidly, and Picasso felt a need for something new. "It was no longer a time for illustration, and Picasso for the first time tried for something that was not illustration at all." The result was his pink period, "Picasso at his weakest." He lacked direction, and could not even complete the portrait of Gertrude that he began. "Picasso's interior resources were

too small for his then needs, and he had to have support from the outside. He found it in Negro art, which was a kind of substitute for an illustrative subject." He finally completed Gertrude's portrait, which Leo found "incoherent," and kept going for awhile, "but the reality was less than the appearance. I was not seriously interested in this stuff, but I was in his talent." Picasso was soon working and reworking one of his most famous pictures, "Les Demoiselles d'Avignon" (1907), the work critics usually single out as the start of cubism.

For Stein, this work was a "horrible mess." The implication of his analysis was that the air of Paris was full of the ideas of Henri Bergson in philosophy, of a new mathematics, and talk of the fourth dimension in art. "Picasso began to have opinions on what was and what was not real, though as he understood nothing of these matters the opinions were childishly silly." He liked to stand in front of a picture by Cézanne or Renoir, saying contemptuously: "Is that a nose? No, this is a nose," drawing a pyramidal diagram. "Is this a glass?" he would ask, drawing one in perspective. "No, this is a glass," producing a diagram showing two circle connected with crossed lines. Stein would, as he always did, launch into one of his lengthy discussions of philosophy or aesthetics to set his friend straight, but Picasso never listened for long and suited himself. He had "a powerful imagination if you will, but intellect never." Stein tired of his work, buying his last Picasso in 1910; but by then Gertrude was buying on her own, and a year or two later brought a cubist work to #27. "I looked at it often, and it always remained the confusion that it was at the beginning," Leo wrote. "I have of course seen a lot of them, and find these mixed-up ones as futile to contemplation as I find the ideas underlying them to be silly. The so-called analysis is a mere make-believe of analysis, and the synthesis a half-correlated correlation between an intention in respect of the object and decorative exigencies." He began to withdraw from the socializing and proselytizing that had become associated with his apartment, and concluded firmly: "In 'modern art' I was never interested. I don't even know what it is, and I dislike the term."

For a sense of the larger context of Leo's activity, the memoirs of Maurice Sterne provide useful material. A conservative modernist painter, Sterne has testified in some detail about the dull nature of most American artists in Paris at this time, insisting that "the only radical American artists in Paris were Alfred Maurer, Jacob Epstein, Max Weber, Samuel Halpert" and himself. They were, like the Steins, largely a group of Jewish emigrés; indeed, except for Maurer, they were doubly so, being "Russian Jews who had migrated to America in our early teens." Sterne left out a few names and had a few facts incorrect, but his general picture of the innovative art scene as only a small group within a vast horde of conventional foreign students was true enough even for other countries: from Picasso to Kandinsky, Spanish, German, Scandinavian, Russian, and Italian painters all came to Paris at some

point during these years, often to find French artists fully as alienated from bourgeois values as any of the visitors. What they found was usually uninspiring no matter what the nationality of the painter. In such a scene, a cranky, independent, moderately wealthy collector like Leo Stein could have a serious impact. He could and did, despite crippling neuroses and a chronic inability to stick to any enthusiasm for long.[12]

"During these years," Leo Stein "was definitely the head of his own household," Sterne recalled. "He and Gertrude still lived together, and it was Leo who was then the undisputed ruler of the Stein clan. Gertrude had no taste or judgment in the visual arts; at best she was a reflection of her brother Leo." She never initiated the purchase of paintings, and became involved only because of the joint nature of their available income. "It was only when a considerable amount of money was at stake that she even bothered to see a painting before it was acquired." Sterne felt Gertrude's perceptions in literature were of more value than in painting, but on a personal level this hardly mattered because Leo was so domineering that she scarcely had an opportunity to get an opinion in edgewise. Leo was, wrote Sterne, "in a sense, a split personality: cold, annihilating, analytic toward others and blind as a bat about himself. Eventually he realized that he was unhappy and began his interminable self-analysis." Memoir after memoir says much the same thing. Leo was the domineering boss, and incapable of self-perception even after thirty-five years of psychoanalysis. Only such a man could visit the genteel Bernard Berenson and spend a meal regaling his hosts on the state of his stomach, his fasting, and the need to masticate every mouthful thoroughly to avoid dyspepsia.[13]

Leo's personality might have been difficult and his tastes questionable, but he usefully brought together many aspects of the modernist personality. A Jewish exile from a Protestant country, eager for new experiences in life and art, he seemed willing to try anything. The chewing, for example, was the outward sign of his devotion to Fletcherism, a well-known American reform that temporarily roused the enthusiasm even of Henry James. "Fletcherism, which I took up two and a half years ago," he wrote Mabel Weeks in the summer of 1910, "at once put an end to all the acute bowel troubles that I used constantly to have and also it cured me once and for all of the colds which used to be chronic. It also cured me in the main of the broken sleep which had come to be chronic and also of the tired feeling." Such a person was obviously ripe for Freud, like a good Bostonian trying to keep his mind as open as his bowels. "I have lately come to be more and more impressed by the supreme importance of nutrition and sexuality in the determination of human personality and career; naturally they don't make genius, but they determine largely what genius shall produce," he instructed Weeks. "I have just gotten Freud's books, which from the little that I have so far read, are by far the richest and deepest that I know of on the subject of sex, and as far as nutrition—well, I'm toler-

ably full on that myself." He was soon embarked on a serious relationship with a woman off the streets of Paris, which led to a remarkably happy marriage, and when he arrived in New York City during the early days of World War I, he tried formal psychoanalysis with the two leading practitioners in the city, A.A. Brill and Smith Ely Jelliffe. As a modernist, Stein was into almost everything.[14]

As Leo soured on modernism in art, Alice Toklas took over as Gertrude's chief housemate; a split between brother and sister was all but inevitable, although things did not come to a head until 1913. Early in that year he told Mabel Weeks of their "disaggregation," remarking as he did so that Toklas' presence was "a godsend" that made the separation relatively painless. He had come to realize that "there is practically nothing under the heavens that we don't either disagree about, or at least regard with different sympathies. He thought that Gertrude "hungers and thirsts for *gloire*" through her writings, while "I can't abide her stuff and think it abominable." Her friendship with Picasso was all too appropriate. "Both he and Gertrude are using their intellects, which they ain't got, to do what would need the finest critical tact, which they ain't got neither, and they are in my belief turning out the most God-almighty rubbish that is to be found." He was sick of art and sick of the world. They squabbled about their paintings, especially about the Cézannes they both still admired; but in essence she kept the works of Picasso and he took those of Renoir, and with Alice running back forth as a diplomatic messenger, they managed to divide the rest. Leo went off to Settignano, happy in his love and his neuroses, to lead what he later called a life of "practical solipsism."[15]

III

Every modernist who went to Paris for any length of time was fleeing something. America offered its original children a solidly conservative training, if they could get to Philadelphia or New York City, and conventional jobs illustrating for newspapers or journals, or teaching in respectable schools. But America was a cultural backwater in art, and a society devoted to the accumulation of wealth. Parents, teachers, and public officials spoke as one: play it safe, do as your predecessors did, conform, be sensible, relax about the need for self-expression, settle down, raise a family, don't stir people up.

Max Weber was never the sort to play anything safe, and his biography supplies a prototypical example of the modernist experience in painting, an outsider even among the outsiders. One of the Russian Jewish immigrants that Maurice Sterne had mentioned, Weber stood out: he was the best painter, he came back to America in time to spread early word of what was going on, and he left behind the most evidence of his activities. He was also the most Jewish. He went to the Talmudic

school when a boy, learned Hebrew, sang in the synagogue, and spoke Yiddish in his strictly kosher home.

Weber had been born in Bialystok in 1881; he came to Brooklyn in 1891, where his father, a tailor, had been settling in for four years. He brought with him childhood memories of Russian folk art, many of them with a manifestly Christian content. He could recall religious processions, ikons, and the Byzantine coloring in Orthodox churches and ceremonies, in addition to the carvings and paintings common in the synagogues. His grandfather had been a dyer and colorist for the local fabric industry, and the boy had seen toys and clothing far more highly decorated than was common in more subdued Western homes. "I remember seeing whole avenues of colored streams in which these textiles were soaked and colored, and I took such joy—oh, carmines, blues—and the little bottles at home, and the pigments, all that goes into life, you know," he told an interviewer late in life.

Weber studied for two years at the Pratt Institute in New York City, held temporary teaching jobs in Virginia and Minnesota, and sailed for Paris on 16 September 1905, where he remained until December 1908. After working briefly at the Académie Julian, he injured his right hand, gave up drawing, and began a self-imposed course of study that included the European art of the Louvre, the Oriental art of the Guimet, and the African art of the Trocadéro. He became especially interested in sculpture and in primitive work generally, from Egypt, Assyria, and Greece. He also traveled extensively in Spain, where he devoted major study to the work of El Greco, and in Italy, where he concentrated on Giotto, Titian, and Giorgione.[16]

As with most Americans, however, the instruction took second place to people. At the Académie Julian, Weber met Lucien Mainssieux, a cousin of Jules Flandrin, a former classmate of Henri Matisse when the two were working with Gustave Moreau. One thing led to another, and Flandrin was soon teaching Weber what was worth seeing and doing in Paris. He introduced Weber to Robert Delaunay, and Delaunay introduced Weber to his mother's salons, and at one of these Weber met Matisse. Another of his friends at the Julian was a German student, Hans Purrmann. He in turn was a close friend of Maurice Sterne and of Leo Stein; and that was all Weber needed to discover the Saturday evening ritual at 27 rue de Fleurus. He became friendly with Leo, but did not care much for Gertrude, and never became a habitué. Weber did meet Apollinaire and Picasso, but his greatest personal friendship proved to be with Henri Rousseau, often referred to erroneously as "le douanier" because of a minor customs position he had once held. The Weber-Rousseau connection was fully as important in the history of American contact with European modernism as the far more publicized one between Gertrude Stein and Pablo Picasso; and the Weber-Matisse connection was part of the American experience of the Matisse

school, the most important institutional transmitter of ideas in painting in Paris during its brief existence.[17]

Flandrin was a great advocate of the work of Cézanne, and Weber first learned of Cézanne's work from him rather than from the Steins. Flandrin stressed that an artist should not be imitating nature or adopting conventions that he derived from it, but trying to solve spatial problems through the use of color. Having loved color since boyhood days in Russia, Weber became enthusiastic about fauvist experiments, especially those of Matisse. Cézanne's spatial innovations then supplied him with a conceptual basis for experimentation. "As soon as I saw them," he told Holger Cahill of his first sight of ten Cézanne works at the Salon d'Automne in 1906, "they gripped me at once and forever. I began to paint with the palette knife, and to handle the brush as a tool, not as one would hold a pen, to get solidity." Like many young painters in Paris, Weber was using Cézanne to go from impressionism to a style more firm and satisfying, "with color constructions, mixed tones, outlines, diffused contours, and distortions where need be," and in the process regaining many of those Renaissance qualities that had fascinated him in Italy.[18]

Rousseau exercised influence of a different kind. For many in Paris and in subsequent art history, Rousseau has been an eccentric naïf, a primitive folk artist who was more a mascot of modernism than a genuinely talented painter. But artists of the first rank knew better. Picasso picked up his first Rousseau for five francs at a second-hand furniture store, unaware of the existence of Rousseau as a person. Among Europeans, Robert Delaunay, Jules Flandrin, and Wassily Kandinsky all owned Rousseaus, and in addition to Weber, Samuel Halpert and Robert J. Coady among Americans did as well. But such approval should not mask the genuinely eccentric nature of Rousseau, who seemed to come out of nowhere in art history to produce striking pictures that said more things to viewers than the artist had ever intended. Self-taught, Rousseau had a respect for academic conservatism of the Bouguereau variety far beyond anything his younger friends felt, and while modernist theorists were getting farther and farther from true contact with nature, Rousseau kept repeating over and over, "One must study nature always"; "N'oubliez pas la Nature, Weber." But Rousseau's nature was not like anyone else's. As much as any other post-impressionist, he could be spatially perverse even while retaining a rigid structure, and he had a reductive sense of volume that complemented the experiments of the Japanese and Cézanne. As Roger Shattuck has pointed out, however, such technical considerations should not obscure the important basic point, that modernists could read so much into the work of Rousseau because of "its freedom from theory and its utter submission to the total vision of a child." He then pointed once again to the way painters and writers seemed to be anticipating the cinema before they experienced it in reality. Rousseau's seemingly incongruous scenes

suggest "the possibility of an unrolling in time as in space. It is cine-matographic time (a succession of 'stills'), not chronological time."[19]

Rousseau arrived in Weber's life at a crucial moment. Weber disliked the social whirl and the political gossip of Paris, where as he recalled later you could scarcely get a peaceful drink in a café without some frantic soul rushing in to declare that he had just discovered an impor-tant new shade of violet. Weber liked to live simply, and his meager budget allowed for little else. Into this atmosphere, Rousseau brought tranquility and a more salutary set of values. "What made me love his work I think it was the wearisome intellectual hairsplitting of art then in vogue in Paris," he recalled for his Columbia Oral History interview. "For me to go to him, to walk into his studio, was like walking into a vineyard—fresh, no debates—here was art without words . . ." Weber never did care for words. His admiration increased when he saw the degrading poverty Rousseau lived in, as he eked out his finances with lessons in music and painting. Weber began calling every few days at Rousseau's tiny studio, exchanging food for "a place to recuperate, to set the young, perplexed mind at peace."[20]

Even with Rousseau's companionship, though, Weber wanted formal instruction, and he was not happy with any of the existing institutions in Paris. Hans Purrmann was the means of solving his problems. Purrmann knew Sarah Stein, and the two of them had been taking informal instruction from Henri Matisse. Sarah and her husband were among Matisse's closest friends, and remained devoted to his art long after their more famous relatives went on to other favorites. Matisse already had a studio at an old convent building on the rue de Sèvres; with a little financial help from Michael they took over the place and opened a school in which Matisse could instruct a chosen few. Begin-ning early in January 1908, the class did not entirely satisfy Weber, who was impatient with Matisse's methods and occasionally disobeyed him, but it gave him more help than any of its predecessors. Of the ten people in the original class, at least four were Americans: Leo and Sarah Stein, Weber, and Patrick Henry Bruce. Arthur B. Frost, Jr., joined later on that year; Maurice Sterne and Walter Pach visited on several occasions.

In the contexts of the history of modern art and the biography of Matisse, the school does not have much of a role. Matisse felt uncom-fortable, disliked being a pedagogue to those of small talent, and soon abandoned teaching. But in an American context, the school mattered a good deal more. It not only exposed two major American painters, Weber and Bruce, to the work of a French modernist master in inti-mate circumstances; it symbolized the split in the Stein family and in American modernism between the concrete, anti-symbolic modernism represented by Gertrude Stein and Ezra Pound, and the richly evoca-tive, symbolic modernism of Sarah Stein and so many Americans active in photography, such as Steichen and Holland Day.

Sarah Samuels Stein had come with her husband and son to Paris late in 1903; they lived in conventional bourgeois comfort as they accumulated paintings and other objects with as much enthusiasm as Leo and Gertrude. At a time when Matisse was in considerable economic distress, Sarah made him her hero, and many of her evenings at home with guests became opportunities for her to defend the work of this man who, she was convinced, was a great master. In 1906, she and her husband brought Matisse's work to America, and later took occasional commissions to secure other examples of his works for American collectors. They bought his works when few outside the Stein family were doing so, and accumulated even more when Leo and Gertrude broke up. They were among the Americans who loaned Matisse's work to the 1913 Armory Show: two examples that provided the larger public in America with its first close look at a notorious modernist.[21]

Sarah Stein left little evidence of her religious views and was probably as secularized a Jew as her sister-in-law. But at least in art, and in that realm of the humanities designated by the word "values," Sarah was religious. If she did not attend the synagogue, she did attend to the ways in which works of art could penetrate into the invisible world. Unlike Leo, who was always worrying about his aesthetic theories, and Gertrude, for whom personality and gossip represented artistic insight, Sarah was into the infinite, the fourth dimension, and the ways in which a work of art could inform viewers about worlds they could scarcely imagine on their own. In this she was closest kin in spirit to a figure such as Wassily Kandinsky and a side of modernism foreign to the talk at #27. Matisse, for her, evoked other worlds; Max Weber, too, was attracted to those worlds, and used his school experiences for his own purposes.

In Sarah Stein's notes for the class, the most detailed record of what went on that has survived, Matisse sounded humanistic rather than radical. He stressed the value of working from the antique, and condemned any modern neglect of spiritual insight. Very much oriented toward models, he quoted Ingres approvingly: ". . . a sculpture must invite us to handle it as an object; just so the sculptor must feel, in making it, the particular demands for volume and mass. The smaller the bit of sculpture, the more the essentials of form must exist." Nowhere did Matisse raise issues of non-representational art or abstraction. "When painting, first look long and well at your model or subject, and decide on your general color scheme," he cautioned his students. "This must prevail. In painting a landscape you choose it for certain beauties—spots of color, suggestions of composition. Close your eyes and visualize the picture, then go to work, always keeping these characteristics the important features of the picture."

Such instructions were clearly carrying on a direct line from Whistler to Cézanne and the general American perception of impressionism. "Order above all, in color. Put three or four touches of color that you

have understood, upon the canvas . . . Construct by relations of color, close and distant—equivalents of the relations that you see upon the model." Reiterating that he himself "always sought to copy the model," Matisse then concluded firmly: "In still life, painting consists in translating the relations of the objects of the subject by an understanding of the different qualities of colors and their interrelations."[22]

Over forty years later, Weber recalled his experiences in the school for a Matisse symposium. Weber had great praise for Matisse's interest and skill. "He encouraged experimentation, but cautioned us of the subtle inroads and dangers of capricious violent exaggeration and dubious emphasis. He insisted upon good logical construction of the figure, and did not dis[ap]prove of the study of anatomy nor the use of the plumb line," Weber said. "In calling our attention to the salient points in the human body, its movement, volume, sculpturesque content and equilibrium, he would refer to the African Negro sculpture, the great archaic Greek of the fourth and fifth centuries B.C., and unfailingly to Cézanne's architectonic, masonic plasticity, his unique vision, and unexelled meticulous execution . . ." Matisse also placed great stress "upon the problems of color values and harmonies, color construction and gradation," and went on at some length about scientific theories of color. Weber then compared the evenings at the two Stein salons that usually followed Matisse's Saturday instruction. He called #27 "an annex to the Matisse class," with Leo as "moderator and pontif"; at Sarah's, the evenings were less frequent, "more exclusive, but festive and hospitable nevertheless," and the collection of Matisse works on the wall a special attraction.[23]

Weber only remained in the class for about six months, leaving in July to travel through Belgium and Holland, and then back to New York in December. The class was, then, his last organized learning experience in Europe, and the place where, if anywhere, he formulated his early modernist ideas on art, ideas that seemed incongruous when placed against some of his later work. He published a rare statement of belief in *Camera Work* the next year. "In plastic art, I believe, there is a fourth dimension which may be described as the consciousness of a great and overwhelming sense of space-magnitude in all directions at one time, and is brought into existence through the three known measurements." It was not a physical entity, a mathematical hypothesis, nor an optical illusion. "It is real, and can be perceived and felt. It exists outside and in the presence of objects, and is the space that envelops a tree, a tower, a mountain, or any solid; or the intervals between objects or volumes of matter if receptively held." He compared it to the color and depth discoverable in musical sounds, arousing the imagination and stirring emotion. Without specifically using religious terminology, he created a religious effect: "It is the immensity of all things. It is the ideal measurement, and is therefore as great as the ideal, perceptive or imaginative faculties of the creator, architect, sculptor, or painter."

The archaic art of Assyria, Egypt, and Greece, he recalled, using several of the same references he used forty years later in his speech on the Matisse class, evoked this "so-called fourth dimension, the dimension of infinity." Works by El Greco and Cézanne had this same quality, for what was true of sculpture was true of painting. "A form at its extremity still continues reaching out into space if it is imbued with intensity or energy. The ideal dimension is dependent for its existence upon the three material dimensions, and is created entirely through plastic means, colored and constructed matter in space and light." Thus, "Life and its visions can only be realized and made possible through matter." Weber, in other words, found that matter which was just matter, the object that was just an object, only the beginning of perception and wisdom. "The ideal is thus embodied in, and revealed through the real. Matter is the beginning of existence . . ." In language that linked religion and art, and that unintentionally could link psychoanalysis to modernism as well, Weber concluded: "The stronger or more forceful the form the more intense is the dream or vision. Only real dreams are built upon. Even thought is matter. It is all the matter of things, real things or earth or matter. Dreams realized through plastic means are the pyramids and temples, the Acropolis and the Palatine structures; cathedrals and decorations; tunnels, bridges, and towers; these are all of matter in space—both in one and inseparable."[24]

IV

The most impressive art to emerge from this group of exiles and rebels was the collection of coloristic experiments known as Synchromism. Long the victim of inept public relations and scholarly neglect, the Synchromists have recently emerged as a small but important group which made genuine contributions to world art. Like Leo Stein, who remained a friendly critic, they preferred the work of Matisse to that of Picasso, built on principles which they found in the work of Cézanne, and paid close attention to sculptural values. Yet for personal reasons, they feuded with the other coloristic experimenters, the Orphists who followed Robert and Sonia Delaunay and worked out their color theories using ideas developed not only from sculpture, but also from music.[25]

Two Synchromists retain importance in art history. Morgan Russell, born in 1886, trained to be an architect to follow in his father's footsteps. In 1906 he made his first trip to France and Italy and was overwhelmed by the work of Michelangelo. He gave up architecture to study sculpture at the Art Students League in New York City, where he had as fellow students several figures who became important in the history of American modernism: Gertrude Vanderbilt Whitney, a wealthy woman whose money made a difference in the lives of several of the struggling young; Arthur Lee, a minor figure in the history of sculpture; and Andrew Dasburg, who moved on to become Mabel Dodge's

lover and one of the significant modernists whose work connected the worlds of Paris, New York, and the Taos Desert. Whitney encouraged Russell to shift his interests from sculpture to painting; Dasburg became a close friend, sharing living quarters with him for awhile in the bohemian colony in rural Woodstock, New York.

Russell went back to Paris, in the spring of 1908, met the Steins, and through them both Matisse and Picasso. He studied at the Académie Matisse with Leo and Sarah Stein, and also became a devoted admirer of the work of Rodin, who maintained a studio at that time in the same building as the school. He returned briefly to New York in the fall, won the promise of sustained monetary support from Whitney, and returned permanently to Paris in the spring of 1909. He haunted the Louvre, studying Assyrian and Egyptian sculpture as well as Italian, and took these interests to Matisse, for whom he sculpted for over a year. Most of this work has disappeared, but it lingered on most obviously as an influence in the first of Russell's synchromies, the "Synchromie en vert," shown at the Salon des Indépendents in 1913; it is now lost.

On his own, Russell studied the work of Monet, writing to Dasburg enthusiastically of the thirty works he had seen at the Durand-Ruel Gallery. Dasburg soon joined him in Paris, and together they explored the work of Cézanne with Leo Stein. Even when Stein was in Italy, he kept in touch by mail, lecturing in his usual manner. Russell and Dasburg kept in touch as well; the fragmentary evidence of their relationship soon indicating an evolving sense of how Cézanne could teach lessons on "rhythm in color," and the necessity to "feel form if you will paint light." Russell also apparently absorbed a few lessons from the work of Picasso, chiefly from paintings on display at #27. But aside from Leo's disapproval of Picasso's recent efforts, Russell disliked the dark palette that Picasso was then cultivating. He turned instead to the teachings of a rather dour Canadian, Ernest Percyval Tudor-Hart, who was developing a theory of how harmonies in sound paralleled those in color, and how both were psychological in nature. Numerous painters and composers were playing with such ideas at the time, with poets providing parallels in their use of words.[26]

Tudor-Hart's class brought the Synchromist group together. It included, at least on its fringes, Stanton Macdonald-Wright, Lee Simonson, George Carlock, John Edward Thompson, and Thomas Hart Benton. They proved, over succeeding decades, a motley crew. Simonson and Benton both left detailed memoirs of their lives, but both passed over this period in few words, mostly critical. Simonson went on to a distinguished career as a theater designer, and Benton to public notoriety as a pugnacious painter of the American scene; neither valued his experiments with color. Carlock and Thompson scarcely exist as artists outside Benton's memoir, leaving only Stanton Macdonald-Wright as a Synchromist of any stature along with Russell.

Wright, born 1890, was "the most gifted all-round fellow I ever knew," Benton recalled. "He was facile, tall, good-looking. He drooped, attitudinized constantly, and had the assured manners of a young lady-killer," which was appropriate, since he "was the most devoted skirt chaser among us and our most continuous philosopher on the perplexities of sex." He seemed to have acquired the ability to paint without training, and "also had a quick mind, capable of rapid and logical summations of all sorts. He was as brilliant and open as I was confused and devious," associating "with the intellectuals of the Quarter" and relaying "their opinions to me." Benton found Wright's ideas appealing for a time. "Synchromism was a conception of art where, in practice, all form was supposed to be derived from the simple play of color." It brought together "a complex of the various theories of the time relating to color function, and was certainly the most logical of all." Anyone who agreed with the group, "that the procedures of art were sufficient unto and for themselves and that the progress of art toward 'purification' led away from representation toward the more abstract forms of music," had to agree that "synchromism was a persuasive conception."[27]

Russell's diaries provide the best clues to the genesis of Synchromist theory. "Light is projection and depth—not a balancing of forms around a center as sculpture," he wrote in July 1912. "And yet so in sculpture projecting and receding forms. Perhaps a translation of a great work of sculpture, as color and shade, placed in a hollow would give the basis of the problem." Thinking of himself as what he later called a "sculpteur manqué," he continued in August: "There is a need for form that has not existed since the Renaissance . . . Make lines colors . . . never paint 'the thing' or the subject. Paint the emotion not illustration . . . a few curly lines and do depth, rythm light . . . a few little spectrums, dark violets and lights . . ." In September, he was advocating the need "to forget the object entirely, yes to forget it— to put it out of our mind entirely and think only of planes, lines colors, rythms etc. emotional visual quality . . ." By October, he was waxing almost imperialistic, having discovered his own "ism" that could assimilate and go beyond the other movements of modernism. "The point of departure to be forms, spaces or volumes—the light that renders same—this is all—color—depth will result—that is you interpret or exalt the experience of light by color and this exaltation with lines, rythms will give the volumes," he noted. "This is cubisme, Futurisme, Synchromisme and any ism possible for many years, perhaps centuries."

In modernism, such centuries usually lasted a year or two. The Synchromists went public in Munich at the Neue Kunstsalon, during June 1913, and at the Bernheim-Jeune exhibition in Paris in October. As had been the case with many in the Kandinsky circle in Munich, these first ventures into genuine modernity always began with recognizable objects, and true abstraction emerged only later. With Wright, it never

did emerge, but by the time of the Paris exhibition, Russell was creating works genuinely abstract, which remain among the most impressive American contributions to modernism: surely Russell's "Synchromie en bleu violacé" (1913) and "Synchromy in Orange: To Form," (1913–14) belong in this category, with Macdonald-Wright's "Abstraction on Spectrum" (1914) and "Conception Synchromy" (1914) close behind. "One often hears painters say that they work on the form first, in the hope of arriving at the color afterwards," Russell announced in the Paris catalog. "It seems to me that the opposite procedure should be adopted." His "Synchromie en bleu violacé" was a painting in which he had worked "solely with color, its rhythm, its contrasts, and certain directions motivated by the color masses. There is no subject to be found there in the ordinary sense of the word; its subject is 'dark blue,' evolving in accordance with the particular form of my canvas."[28]

With such a promising beginning, Synchromism should have gone much farther than it did, but it bogged down in personal rivalries and tendentious publicity. In Paris, the Delaunay group claimed priority for all experiments in color as form. Sonia Delaunay appropriated the term and insisted into a voluble old age that she and Robert had invented it. In New York City, the Carroll Galleries on 44th Street put on a show in March 1914, that proved something of a fiasco: Stanton's brother, Willard Huntington Wright, had been carrying on a polemic in the press not only against academics in art, but also against such competing movements as Futurism and Orphism, and his overinflated claims for Synchromism begged for hostile reviews for the works themselves. The catalog was inadequate and contained no reproductions. Things degenerated and no one had a chance to discriminate among either the pictures or the ideas. The individuals involved did little better: Russell, except for a brief trip in 1916, remained in France and turned mostly to other types of painting. Wright helped his brother codify modernist beliefs in several books published under his name, but then moved to California and interested himself in films and Oriental art. Benton abandoned modernism entirely. Andrew Dasburg, more of a friend than an collaborator, joined the Mabel Dodge circle and followed its tortuous course from New York bohemia to the very different air of Taos. Other artists showed signs of Synchromist influence, but so many competing influences were available that close analysis remains difficult.

V

Changes came in odd ways to the American modernist community in these years. The rise and fall of the Matisse school was one of them, as it channeled painters toward experiments with sculpture and color. Two others turned out to be crucial: one was the arrival of Alice B. Toklas in Paris, and her gradual displacement of Leo Stein at #27; the other was the evolution of cubism in the work of Picasso, the two relevant

works being "Portrait of Gertrude Stein" (1906) and "Les Demoiselles d'Avignon" (1907), and Picasso's long-range impact on Americans after 1912.

Like Gertrude Stein, Toklas was a child of the comfortable Jewish immigrant world. Polish on her father's side, German on her mother's, she was a child of the West Coast. Her mother's family had been '49ers, drawn to San Francisco by the rumors of wealth in California mines. They looked at the raw chaos and found stability in the mercantile world; by the late 1860s, the pressures of family life required a new house at 922 O'Farrell Street, where a woman could raise her children in peace and play the piano whenever the West seemed too intrusive. Emma, the daughter of the family, married Ferdinand Toklas, a bookkeeper-turned-merchant who based his operations in Seattle. He was often away from San Francisco and a bit formal and distant even when he was present. Alice was thus born at #922 in 1877, into a world of women—a mother, a grandmother, aunts—and in a sense she never knew any other. Males were a bit awesome, often away, and useful for the achievement of wealth and social status. Women served them and placated them, but rarely knew them well.

The cultural icon of family life was the piano. According to tradition, grandmother Hanchen Levinsky had been a pupil of Friedrich Wieck, the father of Clara Wieck Schumann. One of Hanchen's sisters had attempted a concert career, to the consternation of her proper family. Hanchen herself was less assertive, preferring to play for her family and to teach her granddaughter the joys of chamber music within the family circle. Alice rebelled at first, but soon the lessons took hold and she required a teacher from outside. They found a Frenchwoman, whose lessons were good enough to qualify the girl for admission to the music conservatory of the University of Washington, where she matriculated in 1893. Such an escape from family togetherness proved short-lived: her mother fell ill with cancer the next spring and Alice dropped out of school forever. While she cared for her mother and ran the household, she continued her lessons with good teachers and developed a passion for the music of Bach; but when her mother finally died in 1897, her grandfather consolidated the two family establishments at #922, and Alice found herself all but solely in charge. As her friend from next door, Harriet Lane Levy recalled many years later, "Alice remained the only woman there." Despite her youth, "she existed to them only as a housekeeper, provider of food and of general comfort." She sat, unnoticed and silent, at the dinners. She had a reputation for being odd, and fled the chatter and cigar smoke as soon as she decently could, to bury herself in the world of her favorite author, Henry James.[29]

Intelligent women rebelled against such regimes in quiet ways. They developed passions for weekend splurges, exotic clothes, cigarettes, or bohemian friends, as Alice did—the friends including the faintly decadent Gelett Burgess, who later strolled among the modernists and wrote

about them occasionally. Or, as Toklas also did, they developed con-
trary political and social views: she announced herself to be a "good
Democrat" in a family of Republicans, and pro-Chinese in a culture
viscerally the opposite. She became for awhile intensely political and
followed David Starr Jordan into pacifism. What she did not announce
was that she felt exploited, was bored to stupefaction, and responded
sexually only to women.

Harriet Levy provided a way out. Herself from a Democratic family,
pro-Southern in the Civil War and pacifist in tendency, she went to the
theaters and on holidays with Alice, and told her about wider worlds
than a recluse at #922 could intuit from dinner table conversation.
Levy had been to the university at Berkeley—one of her examiners had
been Josiah Royce—and was a good friend of Sarah Samuels, before
she became Mrs. Michael Stein. Both Toklas and Levy yearned for the
stimulation and freedom of Europe, and when Michael and Sarah re-
turned after the San Francisco earthquake in 1906, the possibility arose
of having Harriet and Alice travel to Paris with her. Alice found Sarah
opinionated and domineering and was reluctant to be dependent on
her. Her alternatives were never plentiful nor attractive, however, and
the next summer she made her break. She arrived in France with Har-
riet on 8 September 1907 and went to Paris the next day.

Alice first saw Gertrude at the home of Sarah and Michael. "She was
a golden brown presence, burned by the Tuscan sun and with a golden
glint in her warm brown hair," Alice recalled in her memoirs. "She was
dressed in a warm brown corduroy suit. She wore a large round coral
brooch and when she talked, very little, or laughed, a good deal, I
thought her voice came from this brooch." The voice was unlike any
Alice had ever heard, "deep, full, velvety like a great contralto's, like
two voices. She was large and heavy with delicate small hands and a
beautifully modeled and unique head." Some friends compared that
head to a Roman emperor's, others to the type of a primitive Greek.
Everyone noticed something out of the ordinary. Gertrude, she discov-
ered later, had been reading Alice's letters to a mutual friend and knew
something about her. Gertrude was also lonely, in a psychological way.
Her house might be full of paintings and pilgrims, but Leo was giving
her an increasingly hard time about her writing, and she felt belea-
guered. The vibrations between the two women were good. Alice was
desperate, silent, appreciative, supportive. They were soon devoted
companions, and on a trip to Italy reached an understanding that they
would live together in a quasi-marriage. Bourgeois society being what
it was, they had to proceed cautiously. They first maneuvered to free
Alice from Harriet Levy, who returned to San Francisco in the summer
of 1910 with Sarah and Michael. This enabled Alice to move in at #27,
where she occupied a small spare room. Already souring on Picasso
and on his own sister, Leo offered no objections, and in time her pres-
ence made his departure easier.[30]

Aside from serving Gertrude much as she had served her grandfather and her male relatives, Alice played a small role in the history of American modernism. She did this through her music. When Walter Pach, one of the early painters to visit Paris and a man who played a role in the American reception of modernist painting, wanted a companion for concert-going and an amanuensis for the writing of his articles, Alice was available. When, on those rare occasions, Gertrude wanted to attend a concert, Alice was available. Both were in the audience for the second performance of Igor Stravinsky's "Le Sacre du Printemps," a continuing scandal in pre-war Paris. Since Stein was largely deaf to both sound and rhythm, Toklas provided what links the salon at #27 had to one of the most vibrant and creative modernist activities then occurring in Paris: the Ballets russes. In time, these involved not only Picasso, who married Olga Khoklova, one of Diaghilev's dancers, but also Lee Simonson. Simonson went with Toklas and Levy to Nijinsky's famous performance of "L'Après-Midi d'un Faune," the blatant sexuality of which so shocked its audience. He took his memories of these events with him when he returned to his distinguished American career: "Whatever sense I got of the range of modern *décor* and new methods of stage production I acquired not from the American but from the European theater—from the Ballet Russe . . ." Only the work of Max Reinhardt in Munich rivaled it. Such were the cultural possibilities of the networking at Toklas' new establishment.[31]

At roughly the same time that Toklas was edging Leo Stein out of the picture at #27, Picasso was joining or replacing Matisse as a role model for young American painters. More than Matisse ever did, Picasso shared some of the qualities of personality and background that reappeared among the American modernist community. He was an outsider, from a culturally provincial area. Fascinated by the edges of civilization, he often painted the poor, at times seeming to specialize in theatrical or circus subjects. He was a bohemian, living during these years in squalor, and his early work tended to be realistic and representational. He hated greed and materialism, especially that of the middle class and the capitalist. But his strong social emotions did not lead to socialism in thought nor to efforts at social reform. They led instead to an instinctive anarchism that identified with the poor but saw them as subjects for art rather than reform. He was, not surprisingly, acquainted with Nietzschean ideas as a teenager. Unable to develop artistically in Barcelona, he seriously considered London and Munich. He admired the work of Edward Burne-Jones and the Pre-Raphaelites. He was familiar, at least at second hand through older Spanish painters, with Whistlerian tonalities and Japanese perspectives. But Paris was closer, and seemed linguistically and culturally more approachable. As early as 1901, Ambroise Vollard gave him a small exhibition that won favorable notice, although it led nowhere financially. Not until 1904 did Picasso make his final decision, settling into his legendary haunt at

the "Bateau Lavoir," so-called by Max Jacob because of its resemblance to the Seine laundry barges.

After the classic manner of bohemian romances, he soon spotted a woman from the lower class. Fernande Olivier's parents made artificial flowers, but such was not any life for her. She loved artists, and knew Friesz, Dufy, and Bonnat before encountering her Spaniard. She became his companion for six years and the author of a useful memoir published in 1933. Full of squalorly details that biographers have mined for decades, it recorded how surprised Picasso was when Leo and Gertrude Stein called. "What an odd couple they were!" she recalled. Leo "looked like a professor, bald and wearing gold-rimmed spectacles. He had a long beard with reddish streaks in it and clever eyes. His large, still body fell into curious attitudes, his gestures were concise and neat. He was a typical American German Jew." Gertrude "was fat, short and massive, with a broad, beautiful head, noble, over-accentuated, regular features, and intelligent eyes, which reflected her clear-sightedness and wit. Her mind was lucid and organized, and her voice and her appearance were masculine." Picasso had met them at Clovis Sagot's gallery and was interested in painting Gertrude's portrait. Dressed in brown corduroy and sandals, they were interested in art and seemed rich. "Too intelligent to bother about whether people found them ridiculous, too sure of themselves to care what people thought of them," the Steins "understood modern painting—its value as art and the influence it might have." They seemed to know the current art scene, and promptly bought eight hundred francs worth of art. "It was beyond our wildest dreams." They even invited Picasso to dinner, and while visiting their flat he met Matisse for the first time.[32]

The Steins entered Picasso's life at a time of critical transition. The painter had about exhausted his naturalistic and coloristic insights and had no clear idea of what to try next. Always eager to examine past art, he searched out the basic principles of form by studying Greek lecythi in the Louvre, working his way through Etruscan art as well. During the winter of 1905–6, the museum put on its crucial show of Iberian sculpture from Osuna. Picasso was fascinated; nothing could speak to him more clearly than primitive forms from his own country. At this moment, he began Stein's portrait. By her count, she sat for him eighty times, but he never could get things right. He quit and went off to Gósol to immerse himself in a Spanish landscape that he could now view with new eyes, under the stimulation of the Louvre exhibition. When he returned, now a master of a new technique of reducing human features to the form of a mask, he completed the "Portrait of Gertrude Stein" (1906) without difficulty and without seeing her again. Some viewers were dismayed, but she was content: "he gave me the picture and I was and I still am satisfied with my portrait, for me, it is I, and it is the only reproduction of me which is always I, for me."[33]

Widely reproduced, the picture has become one of the most famous

artifacts of the American encounter with European modernism. It deserves this status, since it is both historically important and intrinsically distinguished, but saying this hardly exhausts the subject. Until recently, critics have noted the extraordinary number of sessions the preliminary work took without asking what transpired, or why Matisse complained to friends that Stein was sharing her ideas only with Picasso and not with him. Now, basing her work on both linguistic and iconographical evidence, Marianne Tauber has shown that in all probability, Stein used the hours to acquaint Picasso with the ideas of William James on perception. Firm proof is lacking, as it is with most of the intellectual and artistic influences on Picasso—he said little publicly, hated to explain his work, and wrote trivial letters—but Tauber has shown convincingly that "striking similarities exist between diagrams from James' chapter on Space Perception and forms used by Picasso in his early Cubist paintings," and that certain of these ambiguous forms "are unique to James and cannot be found in French texts." In James' theory of vision, a crucial aspect "is his insistence that space is a primitive sensation, like the infant's world, which is a confusion of equivocal shapes yet devoid of classifiable objects; they can stand for several things and invite visual punning." James' notion of "the canonical image of objects as seen from 'above'" entered the world not only of Picasso, but of Braque and Gris as well. "Even James' terminology comes through in the few interviews with Picasso that we have."[34]

Thus, although none of the standard histories of art during this period mention them, William James and Gertrude Stein were, in all probability, present at the creation of modern painting in ways that transcended the socializing at #27. Simultaneously with the trip to Gósol and the completion of Stein's portrait, Picasso worked on "Les Demoiselles d'Avignon" (1906–7), the work most critics point to as the turning point in art, "the first truly twentieth-century painting" in the words of Edward Fry. Just as fauvism summed up the art of the nineteenth century, so this picture embodied "new approaches both to the treatment of space and to the expression of human emotions and states of mind." The picture began as a brothel scene, a subject far from unusual in the work of painters such as Toulouse-Lautrec and Roualt, and one which reflected Picasso's concern for the naturalistic depiction of figures on the margins of society. But as he went through his sketches, many of which have survived, Picasso's conception seemed eclectic to the point of thematic confusion. In painting the human figure he abandoned classical norms and realistic anatomical proportions, reducing it to geometrical lozenges and triangles; and in depicting space he ignored centuries of insistence on an internally unified perspective and created a work whose unity depended on the observer. In doing so, he not only worked beyond many of the planar experiments of Cézanne, he did so in an erotic, parodic manner, mocking the works of other painters, most obviously "The Joy of Living" (1905–6) by his rival, Ma-

tisse. By using Egyptian, Catalonian, and Negroid features in the same work, Picasso even managed that elusive modernist goal, the simultaneous perception of both geographical spaces and rapid shifts of time— a new style of changing styles, so to speak. Eroticism, primitivism, anatomical distortion, referentiality, violation of perspective, parody: in one picture, many of the essential elements of modernist art taunt the viewer, welcoming him (a visitor to a brothel presumably being male) to the century of total war on many fronts, from the military to the moral.[35]

Critics will probably never agree about two issues that are vital to the place of this picture in cultural history: the impact of African primitivism and the role of the work in initiating cubism. Iconographical examination seems to indicate that Picasso absorbed African influences at some point while painting the picture; that is why the figures on the right side differ so radically from those on the left. Yet he, and several historians of cubism, deny this, and assert that working out his themes only prepared him to see African art for the first time. Few doubt the centrality of the work to modernism, but numerous scholars now assert that the picture is not truly cubist; that Georges Braque deserves more credit than he usually receives; and that only Picasso's later fame has led to the insistence that he was the first as well as the most accomplished cubist. From an American standpoint, these issues do not matter. The point is that Picasso was absorbing and expressing these modernistic concerns immediately after he completed Stein's portrait, that William James was in all likelihood more central to his work than Picasso himself or later scholars have realized, and that Americans within the Stein circle were peculiarly ready to absorb Picasso's lessons because they were already programmed to think in these new perceptual terms. Gertrude might not care for the work; Leo might join Matisse in sharply rejecting it; the Russian collector Sergei Shchukine might make his famous remark: "What a loss to French art!"; and the painting might remain rolled up in Picasso's studio for years, unseen by any but the most select visitor, but it haunted the imagination of artists, critics, and collectors. American artists knew it was there, they came and asked, for they wanted desperately to be a part of the adventure of modernism. If they absorbed it, they tended to follow Gertrude and Picasso into cubism and the mainstream of modernism. If they rejected it, they allied themselves to Leo and Matisse, and drifted off into the camps of the Orphists and Synchromists, who despised Picasso and preferred instead to experiment with color.[36]

VI

The artist who brought these themes and events together in the most productive way was Marsden Hartley. In many ways, he was the archetypal American modernist: in his loneliness, in his homosexuality, in his eclecticism, in his religious yearnings, in his poverty and depen-

dency. He was also the most significant bridge figure between salons in three countries: the protégé of Alfred Stieglitz, the intimate of Gertrude Stein, he was also one of the few Americans whose work impressed German modernists in Munich and Berlin. In his visits there he also provided the closest contacts which Americans obtained to Russian modernism in art, literature, and religion, in the person of Wassily Kandinsky.

Hartley was born in 1877, into a lower class home in Lewiston, Maine. His father was a British immigrant spinner in the local cotton mills who always lived on the edge of destitution. His mother gave birth to nine children, of whom five survived. She died when Hartley was eight, and the family split up, he being the only child to remain with his father. Many years later, in a rather disorganized memoir, he pointed to her death as the moment when he "became in psychology an orphan, in consciousness a lone left thing to make its way out for all time after that by itself." Even when his father remarried and set up a new home in Cleveland, Hartley stayed in Maine. He dropped out of school in his mid-teens to work at a shoe factory, eventually joining his father and step-mother in Cleveland. He studied art in an informal way with local teachers, but only in 1898, well past his twenty-first birthday, did he finally receive a scholarship to the Cleveland School of Art. He did so well that a trustee offered to subsidize him for the next five years in New York City, so in 1899 he shifted to the New York School of Art, to work with William Merritt Chase. The next year he moved to the National Academy of Design, where one of his fellow students was Maurice Sterne.

All his life, Hartley was something of a mystic, a religious personality who never found a satisfying institutional religion, but who read religious authors and painted with religious motivation. For such a person, the work of Emerson was an obvious place to look for solace—sexless, solitary, irrational, intuitional—that helped make life bearable for a poor painter who had trouble throughout his life dealing with individuals. Hartley discovered Emerson's essays in Cleveland and read them for years, internalizing Emerson's assumption that natural objects embodied spiritual realities. Especially in the cool Maine summers, he explored nature with the zeal of a botanist, seeking God and beauty as he went. He even considered joining the Episcopal priesthood. But he was never a man for dogma or institutions and he took more comfort in a socialist utopian art colony that ran a school in Portland and a summer commune in North Bridgton. He approved its goals, but never really joined. He also spent a summer at Green Acre in Eliot, Maine, a Bahai colony devoted to those Asian religious ideas which were most compatible with what remained of Boston Transcendentalism.[37]

Between 1908 and 1912, Hartley developed a style which his biographer has called neo-impressionist. Alternating between Maine and Boston, he fell under the influence of Charles and Maurice Prender-

gast, the leading practitioners of this type of work in America. Apparently still unaware of the fauvist experiments in color, or Van Gogh's expressionist brushwork, he worked out a style which momentarily enabled him to put Emerson onto canvas in works that made permanent his impressions of Maine in summer and fall. The Prendergasts admired them and wrote friends in New York about his talent. Hartley was soon in contact with Robert Henri, William Glackens, Arthur Davies, and others who were among the best New York could then offer. Hartley heard about Alfred Stieglitz, managed to meet him and display his recent works, and at that point entered the mainstream of American modernism. Always poor and lonely, Hartley was almost pathetic in his need for mentoring; haughty, elitist, and estranged from much of New York culture, Stieglitz yearned for disciples. He promptly changed his plans and gave Hartley his first important show, which opened at #291 on 8 May 1909.

Hartley matured with remarkable speed. He was at first in thrall to Albert Pinkam Ryder, whose gloomy romantic landscapes spoke to Hartley's mystical tendencies, and whose haunted life was already legendary in artistic circles. But Hartley moved quickly beyond Ryder into the works of the three major influences on most early American modernists. From his friend Max Weber, then still a part of the Stieglitz circle, he learned about the Matisse school and quickly broke into fauvist colors and thickly impastoed brushstrokes. When in March 1910, Stieglitz put on his Picasso show, Hartley all but instantaneously produced his "Landscape #32," a work close to Analytic Cubism, although atypical for these years and only a prelude to Hartley's later work in Europe. Only then did he encounter the work of Cézanne. Using reproductions at first, he became absorbed in problems of perspective, form, and color. He had "but one ambition—to put down with a sense of authority and artistic conviction an object—some days for form only—then for color—and so it is good to get at this problem of expressing the impersonal—things without mood—things existing for themselves only as shapes & forms with color—the rendering in line & form of a thought—rather than a phase," he wrote Stieglitz in mid summer 1911. "Cezanne seems to have shown how personal we can become through striving to express the impersonal . . . The greatness of serenity and calmness in art appeals to me strongly as I feel it in Cezanne."[38]

Hartley was fond of taking his artistic temperature, so to speak, studying his infections and fevers and reporting the results to Stieglitz. "I feel as if I were standing continually at a sort of Maeterlinckian threshold waiting my life out for the door to open. . . ," he wrote a month later. He sensed a "progression—enlargement—unfolding of self—inklings of realization." Still in Maine, meeting only one neighbor on an average day, he could easily visualize #291 as his real home, and told Stieglitz as much. "I keep before me on the wall—Cezanne's utterance on form & color: 'when color reaches richness form attains ful-

ness' and it is like a saying out of a book of ancient wisdom—so much significance has it—and in the black and white reproductions of Meyer-Graefe on Cezanne one sees how much this means—and that Cezanne's 'the training of the retina is the whole of a life time' is also a piece of real understanding." He yearned to see Cézanne's works in full color and had his eye on the Havemeyer collection. By September, his artistic isolation weighed on him as heavily as his personal loneliness, he wanted to see the work of Van Gogh as well, and reported that he was producing both still-life and landscape works. Wanting very much to get to Paris, he dwelt for a moment on the few Picassos he had seen. Picasso, he said, had taught him a lot about interesting himself in a problem and its rendering, and setting the mood of nature aside entirely for "the pure beauty of the problem itself." But although Picasso taught him much, "I do not find him as edifying . . . as Cezanne." When Stieglitz sent him more Cézanne reproductions, he was effusive in gratitude and compared himself to a devout person clutching his testament.[39]

Thanks to Stieglitz and several other benefactors, Hartley funded himself for a trip to Paris. He arrived on 11 April 1912, and promptly sent Stieglitz a postcard, saying that he had viewed eight Van Goghs, plus "four Cezannes at Vollard's (funny place)." He plunged into cultural rubbernecking, and on the twenty-fourth reported that he was "doing nothing but looking" and had "seen about all the big things." He thought the independent Salon "perfectly terrible." He spent several days looking at churches, mentioning Lee Simonson as a particularly helpful companion, and was beginning to yearn for a studio and an easel. "I find much to interest me—and a deal to disgust me in the art life here, a great deal of talk & gossip and no work—I shall keep by myself a lot I can see." Soon, he was out in Voulangis with the Steichens, who supplied him with the surrogate family that he seemed always to yearn for. Simonson promised him the use of his studio when he went south on holiday, so Hartley was, for a while at least, almost happy.[40]

By the middle of June, Hartley could report that he had been to two shows at Durand Ruel's and had gone through Vollard's stock but found only the Renoirs and the Cézannes worthy of note. He found the general level of work deplorable. "Matisse becomes one of the gods after this terrible stuff," although some Monets were impressive. "Perhaps France is in the descendant—for one man cannot save a country—and Picasso and Matisse could not save the art of Paris. One has a sense somehow of the mere timeliness of the cubistes and the futuristes. I see them often & have met several . . ." He had been to Delaunay's studio and seen his latest works, "but so far it is like a demonstration for chemistry or the technical relations of color & sound. They all talk so glibly but what do they produce . . ."? Hartley had contempt for talk, or so he said; he certainly did an extraordinary amount of it for a new

arrival in a strange city that spoke a language he could not understand. Still, all was not just art and earnestness; he reported that he had just been to a huge ball, "2000 people in Arabian Nights costume—myself as gorgeous as any in effect." He was sure such an affair could never have happened anywhere else. Meanwhile, he yearned for money and news of #291.[41]

By early July, he was spending more time with Eduard Steichen and Arthur Carles. He was working every day, but felt that little was happening in his life or in Paris. Despite this, he was never short of news for Stieglitz. Vollard had just printed a collection of Van Gogh's letters, and he offered to get that volume, or Gauguin's *Noa-Noa,* should Stieglitz want them. He had apparently visited the Stein home as well, for he mentioned going with Steichen to an American home he did not name to see "a fairly remarkable exhibition of modern pictures" that included Cézannes, Renoirs, Manets, Degas, Sisleys, and Toulouse-Lautrecs. He went on and on about the Cézannes and the Renoirs, and his regular trips to Vollard's to see if anything new had turned up. He filled his cards with names, some misspelled, none with proper accent marks, some simply illegible, but all paled beside one in particular: ". . . how truly fine is Matisse—He is veritably a meteor of high luster in the milkiest of ways."

Hartley had trouble making up his mind about Paris. He was delighted to be there and it tended to overwhelm a poor provincial from Maine. Always, the Louvre loomed in his writing: "like a spiritual Gibraltar stands always the Louvre. I have been in no fit position to give forth anything like my real feelings but now I have fully sensed what it is that one gets in coming to Paris—and it is certainly rare. There is an 'aliveness' stirring in the air—a reverence of the people toward beauty which is truly comforting." About the French he was less certain, finding them "refined to the highest degree" but not "altogether sturdy." "Now and then I have a longing for a great breeze such as one gets from that which is truly American. One certainly does not get it from the motley that float about Paris which one must admit is American." Slowly Hartley realized that the people he had an affinity for were mostly Germans: "And I am so enjoying the small german coterie which I am with always—at the little restaurant where we dine . . ."

Two Germans became especially close friends. Arnold Rönnebeck and Karl von Freyburg were cousins, the first a sculptor who was one of the few Germans whom Gertrude Stein could tolerate, and the second an army officer who for Hartley seemed to bring together in his personality all the best sides of the German character, from sensitivity to rationality. The homosexual Hartley found both attractive, and Charles Demuth was an appropriate fourth member of a convivial group that met most often at the Restaurant Thomas on the Boulevard Raspail. Hartley confided to Stieglitz that he was soon surprising both his friends and himself with "my occasional outburst of quite real german. I didn't

know that I knew as much"—and his quickly formulating plan to travel to Berlin and Munich. "The officer is so handsome and looks a deal like the fellow in that portrait of Signac's who was to marry someone's equally wonderful daughter . . ." Knowing he had a sympathetic ear with the German-American Stieglitz, Hartley freely confessed that "since I have been here and seen the hideous french men—I turn to the germans as to the gods. If there was ever a more ridiculous lot of males as a class it is these french men." His was the first cultural analysis among the modernists to divide national characters on an openly homosexual criterion. French men were "little china dolls horribly dressed," and offered no competition.[42]

Apart from Hartley's interest in him, Karl von Freyburg has all but disappeared from history, but Arnold Rönnebeck cut a more substantial figure. Born in Nassau, Germany, in 1885, he was the son of an architect who was also a professor of his subject. Educated largely in Berlin, he had studied architecture for two years at the Royal Art School, moving on to study sculpture in Munich for two years, 1906–08. In 1908 he began six years based in Paris, studying sculpture under Aristide Maillol for the first three years, and under Emile-Antoine Bourdelle for the second three. A man of some wealth and culture, he not only traveled frequently throughout Europe, he also attended the opera, the Ballets russes, and the theater. His journals, which survive for 1910–12, indicate that he was skeptical of Rodin—"un grand homme . . . mais il reste—le maître du *morceau*. Il n'est pas capable de faire un monument"—but interested in Cézanne and in reading up on his ideas: "La nature est toujours le seul maître," he assured himself. Like most intellectuals in Paris in those years, he professed an interest in philosophy: in Asian ideas as in the *Bhagavadgîta,* in the Greek ideas of Plato, and in the local talent of Henri Bergson.

Rönnebeck was not a happy man despite his advantages. His family life was a mess and Bourdelle never thought much of his sculpture— and in the privacy of his journal, Rönnebeck feared Bourdelle was right, although tactless in the way he conveyed his judgment. Rönnebeck was also highly ambivalent about his fatherland yet resentful of the "Deutschenhass" he met everywhere. He became attracted to emigré Poles while working on a memorial for Michiewicz, and to Americans who were as lonely and out of place as he. He was no homosexual, but rather a cosmopolitan passing through an unhappy phase of his personal life and eager to share ideas, especially on sculpture, with other friendly souls.[43]

Hartley obviously moved in several Paris circles which overlapped but still retained distinctive styles. He had mixed feelings about the Steichen menage out in Voulangis, for example, visiting happily in the country but finding a streak of epicureanism in their visits to the city. Once, he was eating at the Restaurant Thomas with his Germans when he spotted a group of "queenly ones draw up at a curb" that he quickly

assumed were Versailles aristocrats, only to discover that they were waving at him. Suffering his chronic "indigestion and melancholy" he assumed immediately that the group was off to some regal dinner— just the sort of heterosexual upper class socializing that he could not bear—even when he knew that the people were his friends, were relaxed Americans, and had recently had him out to their home. "Do you ever have states of being when you feel like an empty lute on which one may wrap one's fingers?" he asked Stieglitz. "Well I get them at times and I think I had one that night."

By mid-summer 1912 Hartley had made the first connections between his American-modernism-in-Paris interests, and his German-Russian-modernism-in-Germany ones. He discovered the journal *Rhythm*—he spelled it "Rythm" for like most modernists he seemed unable to manage one of the key words in any modernist vocabulary. In it, he found articles on the influence of Gauguin "in which Kandinsky is talked of among others. He is evidently one of Gauguin's pupils & is I believe a modern light in Berlin or Munich—Very likely they talk much of modernism—and God knows they talk much about everything here." He meanwhile congratulated himself on not knowing French very well, since he could thus avoid much of the sort of chit-chat he disliked. "One sees very little here & hears less of Picasso & Matisse. They keep distinctly to themselves," but he hoped to visit Picasso soon, despite this. "I have been to his place twice but at that period he was out of Paris." In a perception that modern scholarship has rejected, he saw the work of Braque at Kahnweiler's gallery and dismissed him as an imitator of Picasso—a charge with its amusing side, since Hartley was himself eclectic and not above imitating Picasso. He also insisted that "Picassos new things are not as interesting I think but one accords him his own right to variations." His description that followed was clearly that of Picasso's synthetic cubist work with its "names of people & words like jolie or bien and numbers like 75," and he especially recalled "one in vivid blue against this geometrical arabesque in browns ochres & blacks."[44]

In Hartley's experience, the influence of people and works of art had no national boundaries, with Kandinsky, Picasso, Gauguin, Van Gogh, and Cézanne mixed into letter after letter. Two weeks later, Rönnebeck was showing him Van Gogh letters and von Freyburg introduced him to pencil drawings by Cézanne and told Hartley of his plans to get out a book on Cézanne's works. Hartley described the small portraits in detail, preferring them to the two landscapes he also studied. Cézanne, he said, "has such a wonderful 'baritone' sense of color—I like to call it—such fullness and irridescence." He also reported seeing a good work from Picasso's blue period, "very gothic in feeling," and was sure that it had inspired some of Max Weber's work. He then passed on, without a pause for breath or paragraphing, to yet another friend from yet another country and discipline. "I have been dining every day with Elie

Nadelman the sculptor." The Polish emigré had been bowing to him "every day almost since I came" but Hartley had dismissed the gesture since it seemed so common in Paris. "He has invited me to his studio for tomorrow afternoon so of course I shall go. He is very nice looking somewhat like a Rossetti type—long wavy hair, smooth face clean-cut with a very engaging presence."

Momentarily at least, Hartley was content with all this attention and these friends. "As it is I am very happy in Paris—I feel like I am being born over again—The heart & soul of me feel so free here." The contrast to his feelings of psychological constriction in America were marked. "I am convinced that it is wrong for one to live anywhere one cannot breathe freely," and Paris has "a substance in the air which creates life in one at every move." He wanted to stay forever. "America is not the only place—and other people manage to do it—why not I? One is so close to the culture of the ages here, so close to the realities which engage the artist and the poet." He sensed "a new crescendo in what I do—a vital something which if allowed to proceed naturally will I am sure come to something." Despite his eternal poverty and loneliness, he found it possible "to live" and not have to "spend a lifetime in *trying to live*. There comes a time later on when one can only wish to have lived and to watch others living, and so one must embrace one's youth eagerly while one has it—and my real youth is now with me." Even in this letter, however, he vacillated, looking forward to Berlin with Rönnebeck, who had just created a sculpture of Hartley that delighted its subject, and fearing to give up the Paris that had made even German culture available to him. "O! I know I shall live here always. I know that where the heart is happy there is home." Meanwhile, belying the loneliness he was always talking about, he was seeing a lot of Jo Davidson and Eduard Steichen and their wives, and was looking forward to seeing Arthur Carles on his next visit to Voulangis.[45]

The August doldrums hit him severely, and he was not the first American to notice that most Parisians were somewhere else. Without his friends he hardly seemed to have an identity, and the subtext of many of his sentences seemed sexual as well as artistic and social. "I have no philosophy to pass around—I believe nothing and know some things and know that there is but one philosophy for an artist and that is hedonism—that one must seek pleasure everywhere or perish . . ." Gertrude Stein was in Spain, and he yearned not only for her "very delightful" presence, but also for the friends and works of art available at her home. He longed to return to look at her Picassos once again: "He remains for me the big thing I felt in America"—and he wanted to visit both Picasso and Matisse at their homes. At the same time, he was looking forward to getting a copy of "Kandinsky's Die Blaue Reiter" to send to Stieglitz.[46]

The famous Parisian museum for the study of primitive culture was then known as the Trocadéro, and Hartley began to come to terms

with its contents in September. ". . . I am taking a very sudden turn in a big direction owing to a recent visit to the Trocadero," he wrote Stieglitz. "One can no longer remain the same in the presence of these mighty children who get so close to the universal idea . . ." He thought the results of his visit were already appearing in his work and that it was "showing a strength unknown in past efforts. These revolts must come and until they come one can only proceed according to one's artist's conscience. They must be revolts of the soul itself if they are to mean anything other than intellectual imitation . . ." He found parallels in the interests of Picasso and a new friend, sculptor Jacob Epstein. Epstein had come over from London to do his Oscar Wilde memorial, but was having "some municipal difficulty"—a mild expression for French unwillingness to deal with Epstein's conception. But Picasso remained the chief inspiration, an artist whose "wondrous power" seemed inborn and not the result of influence at all. Like Hartley, Picasso had trouble talking about his art, and Hartley valued such inarticulateness as a sign of genius. "I admire every line Picasso makes just for this one quality—it has the beauty of the inward seeking and is not attempting to be merely novel or bizarre." At the same time, he was into yet another influence himself: Kandinsky's *Concerning the Spiritual in Art* "is proving itself very interesting" and he would send a copy as soon as he could get it from Sagot's.[47]

Gertrude Stein returned from Spain with Alice Toklas and by the 27th of September Hartley was writing his postcards again. "Was at Gertrude Stein's last Saturday to see the pictures by daylight." She was delighted at the attention Stieglitz was showing her in *Camera Work,* and Hartley was equally delighted to serve as a networker between the salons of Stein and Stieglitz. She also offered to help him get to Picasso if he could not manage a meeting through other friends. "Also to Matisse's—but Picasso remains the real and serious thing to me." After such a brave start, however, the Paris art scene seemed to fall apart. Hartley found the fall salon "very ordinary" with most of the good artists not showing at all. For the moment, he seemed happily settled in the wake of Picasso and did not hesitate to admit it. "Naturally when some see my work they will say Picasso—well I say it too—but I say it first with meaning." It may turn out in a few months to have been a mistake, but if so, "well & good. I shall have been faithful to myself and my ideal. I know mainly this—that the importance of my having come here is incalculable—It has done more for clarity of ideas and sensations than I could have done at home in years."[48]

Hartley came to know an impressive number of European artists and works destined to have permanent places in art history. He did not always respond favorably, retaining the right to discriminate. Rousseau, for example, "leaves an indelible impression upon me. If there ever was true poetry in painting it is in this man." So far, so much like Picasso and the received impression of the Stein circle. But about the

newer men he remained something short of a convert. Francis Picabia, Juan Gris, and Marcel Duchamp, he told Stieglitz in November, "as yet do not show me they are artists. They are all thinkers but art goes only a certain way with the intellect and then it demands the vision." He met Robert Delaunay at the Rousseau show, and the French painter asked Hartley and Rönnebeck to visit him some evening. Hartley thought him "a charming person & his work is interesting," but when he finally saw some of it, Hartley did not find it "impelling—but he is most earnest and sincere."

Americans meant more to Hartley personally. When Walt Kuhn and Arthur Davies called on him, in preparation for the forthcoming Armory Show in New York, he found the attention cheering and recommended them to Stieglitz—probably unaware that his friend was keeping his distance from such stunts. Gertrude Stein did the most to keep him on an even keel. "I go to Stein's frequently and find Miss Stein a truly charming person—a real personality and it is so good to be in that room with such good things. She is very kind to me and seems to understand my silences—for in such a place I don't seem to have any words."[49]

By the third week in November he was in London, which was "huge and most depressing. I don't like it." He was more specific a month later. "London I do not care for but that is because it is too English and I am not keen on English things," he wrote his niece, Norma Berger. "It has character and dignity—but there is too much of a mixture of commercialism and woman suffrage to make it attractive to an artist—it is all so ugly to me." He did cut an impressively bohemian figure, however. "I wear a lovely long black overcoat which a friend gave to me a paddock or frock overcoat—a black fine velour hat and a black velvet tie somewhat of an 1830 collar and a black cane—fancy me with a cane." With his blue eyes and large nose, he seemed proud of the descriptions of his friends: "a Swiss poet friend calls me the Albatross and another calls me the eagle."[50]

The British art scene did not impress him at all. He liked visiting the British Museum, but as for anything contemporary, forget it. "The Grafton Show is most disappointing," yet seemed like an oasis in "the most parched of deserts. The English seem only to be mulling over and over the same sentimentalities in the mildest variations. The so called Post-Impressionists or the Roger-Fry group were anything but refreshing, not to speak of the Camden-town group which is a collection of decent men—painting oh so discreetly and decently." His friends, Augustus John and Jacob Epstein, were "in direct revolution against the Roger Fry group." He had, however, left his own work there and was convinced that it was making an impression. "They are all still-lifes— the which I have entirely departed from in favor of intuitive abstraction—I am rapidly gaining ground in this variety of expression and find it to be closest to my own temperament and ideals." He insisted

that he was cutting loose from influences and striking out on his own. "It is not like anything here—It is not like Picasso—it is not like Kandinsky, not like any 'cubism.' "

His current work was "what I call for want of a better name subliminal or cosmic cubism—it will surprise you." He produced the works before going to London, "as a result of spiritual illuminations and I am convinced that it is my true and real utterance." His new style combined "a varied sense of form with my own sense of color which I believe has never needed stimulation. I am convinced of the Bergson argument in philosophy, that the intuition is the only vehicle for art expression and it is on this basis that I am proceeding." His "first impulses" in this direction, however, came not from Bergson but from Kandinsky, in the book Hartley called "The Spiritual in Art." Then, in an intriguing aside that says much about influence in the arts, he admitted that he could not "tell what his theories are completely but the mere title opened up the sensation for me—& from this I proceeded." He sharply distinguished Kandinsky's ideas from his works, in which he did "not find the same convincing beauty as his theories hold. He seems to be a fine theorist first and a good painter after." Hartley remained eager, despite these remarks, to visit Munich and Berlin and meet Kandinsky in person and talk with the Blaue Reiter group. Meanwhile, he was reading the work of Jacob Boehme to help him formulate his mysticism.[51]

Early in January, Hartley finally made his trip to Berlin, which pleased him far more than London had. "I like its ultra-modernity and I like the calmness of the people. It is so refreshing after the unceasing gesture of the french." He spoke of the people in language which seemed capable of interpretation in both artistic and homosexual contexts. A visitor "sees such fine types all about—a fine extravagance of physical splendour—I think nature is especially interested in her german produce—The general type is so well formed and equipped with energy." Instead of "the sickliness of the french" he found "a fine creative tendency in the race": "It would seem as if there would soon be no french if appearance count for anything." He found a "very encouraging trend toward modernity in art" in Germany, but his few specific remarks indicated that he had seen only a show of the work of Gabriele Münter, "which argued nothing of moment." He was, however, pleased by the museums he visited: "a wonderful lot of primitive art—much more than at either the Trocadero or the British Museum"; he made an exception here for the national museum, "full of awful Feuerbachs and Böcklins which shock one with their mediocrity."[52]

Hartley then went on to Munich, for the most exciting artistic experience of his life. "I cannot estimate to you the worth of this german trip—It has given me my place in the art movement in Europe—I find in this my really creative period," he wrote Stieglitz on 1 February 1913, a week after his return to Paris. "I have something personal to say &

that no one is saying just this thing—It all comes out of a new growth in my life—a culmination of inward desires of long standing." He had gone first to see Frank Eugene, who asked him if there were anyone he especially wanted to meet, and Hartley mentioned Kandinsky. Eugene suggested that his friend, the New York City–born artist Adolph Erslöh, who had grown up in Karlsruhe and come to Munich in 1904, would be a good person to start with. An eclectic painter with the reputation of being a conservative among the modernist set, Erslöh was a man of wealth and taste whose "elegant apartments on the Ohmstrasse in Schwabing" were a bit intimidating to the impoverished Hartley. As soon as the visitor indicated who he was, Erslöh won his gratitude for life with the statement, "you are famous in Munich." Hartley demurred in embarrassment, but was told: "Oh no you are Marsden Hartley—and we were made familiar with you by a woman from Stuttgart who had been in New York and seen your exhibition & she told Franz Marc all about you." Erslöh thought Kandinsky was still in Russia.

He turned out to be wrong, to Hartley's relief. With Rönnebeck, the painter went to what he called alternatively the "Goetz" and the "Golz" Gallery, but which was presumably the Goltz Gallery, and Hans Goltz assured them that the Russian had in fact returned, gave them his address, and said "we would find him very nice & kind and interesting." They dropped Kandinsky a note and the next day visited him and his companion Gabriele Münter. Apparently ignorant of Hartley's work—despite his "fame"—Kandinsky needed Rönnebeck "to describe to him the nature of my new work & he evinced a great interest & asked to exchange photos of work with me—& wished to see the work." Hartley then promptly "met some literary people in the Stefan George circle who had heard of the nature of my work and they expressed great interest in seeing it & asked if I would not be exhibiting in Munich soon—so here at once I found a direct connection for my ideas . . ." He prepared to ship Goltz three or four of his new works as soon as Eugene could work out the details. "This you will observe is a perfect creative condition and it is with these men that I will find my place in the European scheme and it is to Germany that I will go after Paris because I found conditions so agreeable all around—good friends— great activity of life—every thing so clean & healthy after the awful filth of Paris—& such nourishing food the which I haven't had since I came to Paris." He went on and on, contrasting France and Germany to the great detriment of the former, but then returned to the more relevant topic. "You would like Kandinsky very much I know. I have never been in the presence of an artist like him—so free of convention with a hatred of all the traditions that cling to art—bohemianism—uncleanness—lack of mental order—this chaos which makes Paris so charming to those who love looseness."

Hartley was willing to admit that Paris had done much for him, but he flatly denied that he was a bohemian and disliked coterie art groups. Paris had freed him to be himself, and had supplied him with German friends, but "the sources that have helped me to my newest means of expression are without geography—It is a universal essence." He pointed instead to the inspiration of "James pragmatism—slight touches of Bergson—and directly through the fragments of mysticism that I have found out of Boehme, Eckhardt, Tauler—Suso—& Rysbroeck & the Bhagavat Gita." These have "brought me to my present means of expression which in its essence is absolutely as near to myself as I have ever gone." For reasons he could not enumerate, he "felt this great necessity in painting of leaving objective things—and after a summer of still-life I found myself going into the subjective studying Picasso closely finding a great revelation in the Cezanne watercolors—a peculiar psychic revelation to my notion." Cézanne in particular seemed to him to provide a role model here, setting the example of creating "a purely spiritual rendering of forms in space." From this he "proceeded and out of the heat of the reading which for years I have wanted to get," he went to work on a series of paintings, fifteen of them measuring 30″ × 40″ "which those who have seen them say is the first expression of mysticism in modern art." Insofar as he could discover, no other painter had accomplished anything like it: "Kandinsky is theosophic," while Franz Marc "is extremely psychic in his rendering of the soul life of animals," but neither was doing what Hartley thought he was doing. "It is this which constitutes the most modern tendency which without knowing it until I have been to Munich—I find myself directly associated." On a less exalted plane, he was fascinated to see what amounts of money agents for these painters could earn for their clients.

His German visit led Hartley to see modernity in all of European culture, and to assess his own place in it. He thought Kandinsky, of all those he had met, had "about him practically all the modern culture of Europe," and went immediately into the obvious topic that occurred to him next, in an epistolary stream-of-consciousness, "Schoenberg in the new music and it is certainly new from the little I have heard—deeper than anything in the way of new experience in music"—and in all likelihood a subject utterly unknown to Stieglitz and most Americans in 1913. These connections among modernists gave him a sense of innovative solidarity which comforted his harassed soul. They were not only "immensely valuable at this time," but available in Munich, "the hotbed of ultra-modern art." Compared to activities in Vienna and Paris, this was probably not true, but Munich was active and its activities were open to Hartley through his friendships with Rönnebeck and other Germans. He particularly mentioned the work of Franz Marc in this context, and lamented to Stieglitz that Walt Kuhn had been unaware of such work or else unable to get it for the Armory Show. "I am sorry

for the sake of the idea as the new german tendency is a force to be reckoned with—to my taste far more earnest and effective than the french intellectual movements."

Writing this extraordinary letter in Paris, he reassessed the major figures around him in the light of his new German contacts. "Picasso is still the only force of moment here in these sensations. I find Matisse very good—certainly a fine artist—one whose product wears well & has character—but I like Picasso because he remains true to the intuitive processes which are the most creative naturally." When Hartley looked at Matisse's works, he now tended to assimilate them to his growing mystical tendencies and his perception of Kandinsky's as well. "I know now that what I see in his (Matisse's) work is a pure rendering of thought forms as they present themselves to him & with them he creates a consistent harmony." Leo Stein could snort at such work that "it's not art—but metaphysics," just as he said of his sister's writing that "it is not literature," but the world of art was free and wandered "into all spheres and domains," all the while remaining "true to itself everywhere." Hartley was convinced that if Van Gogh had lived to continue painting, "he would have become one of the first psychic painters of the time—as in spite of his assertion that he was a naturalist he was still more the visionary & it is precisely this visionary quality that give his canvases their beauty & not their paneling or their ideas." In the same way, he was convinced that "Cezanne would have gone into higher ethers and attempted to render the cosmos." With both Van Gogh and Cézanne, the cosmos was always standing behind the flowers and fruits and people on the canvas, and this larger sense overrode any surface defect. "It is the vision in them all which is the art," and he shared this vision with them. Such a sense of the cosmos united with Hartley's sense of his own inner weather. As he quoted Odilon Redon by memory: "I have made an art after myself."

He turned these insights against the same Paris that had brought him to such understanding. He felt surrounded by those who were "utterly devoid of earnestness" and who had "no art at all—This is one of the things against Paris—there is too much art here." He felt that he had come too late properly to absorb its traditions and had remained ever since "the observer on the outside of all movements & it has been a happy & safe position for me—It has left me free of ambition & free of prejudice in the large sense." He had learned "that what I came for is not to find art but to find myself & this I have done & I want to go somewhere away from the art whirl and produce myself—and in germany I find the creative condition and it is there that I must go." He could never be French or German and would always remain American, but seemed convinced that only in Germany could his true American vision flourish. "I shall always remain the American—the essence which is in me is American mysticism just as Davies declared it when he saw those first landscapes." He was returning to what he had before "with

a tremendous increase of power through experience." Hartley did not expect to remain in Europe forever, and was sure "that what I have to say can be affected by no one—and it has no relationships to cults or individual systems."[53]

Psychologically, Paris was over for Hartley. He continued to see Gertrude Stein and appreciate the steady praise which she directed toward him and his work. His admiration grew for the work of John Marin, a painter often present but rarely mentioned in most accounts of Parisian modernism. Marin for him stood "alone in the field of water color— Not Whistler—not Turner excels him." Hartley read further in mysticism, especially Eckhardt, and regularly compared what modernists were doing in painting with what Schönberg was doing in music. He felt increasingly secure in his identity and proportionately critical of Paris. He caustically wrote off most Americans in the city as happier playing billiards than painting, and became convinced that Paris had "no place for a mystic." After visiting the Delaunays, he decided that Robert talked too much about his own gifts, and that Jo Davidson had the same problem with less talent. By early April he was packing, and by the middle of the month was sending Stieglitz postcards from Bavaria. He visited Franz Marc, who added a brief postscript to one of them, and reported to Stein that Marc was "so fine and gentle" and a "splendid character. I have no sense of heimweh here on german soil. Marc assures me that all exhibition conditions are open to me." By early May he was in Munich preparing for a show at "Neue Kunst Salon of Hans Goltz," which he had finally learned to spell correctly. "The artists are very friendly and want me to live in Munich & they like my pictures & say they are very new."[54]

VII

So unused to warm welcomes in his life, so sure that he had no home in a philistine world, Hartley gave his allegiance almost immediately to the friends he met in Germany. He was unaware that Americans had long been a part of the German artistic scene and that many significant figures spoke English, had American relatives, had spent time in America or had companions for whom this was true. Sorting out the so-called "Americanness" of any artistic figure is a useless critical endeavor; the important point here is that Hartley's position was not unprecedented and he could feel at home in part because so many had gone before him. On the chiefly European side of the story, Gabriele Münter had lived for two years in America, and both she and Franz Marc were fluent in English. One of the leading figures in German modernist circles was the playwright who had been named Benjamin Franklin Wedekind by a father who had briefly emigrated to America for political reasons. The painter Konrad Cramer had already become something of a German Marsden Hartley, having gone to America with

his wife, American artist Florence Ballin, in 1911, his head full of the ideas of Der Blaue Reiter expressionism. Even as Hartley was soaking up the precedents of Kandinsky and his friends, Cramer was living in Woodstock, New York, his closest friend being the painter Andrew Dasburg, an intimate of Mabel Dodge's salon.

On the American side, the sense of pilgrimage was more pronounced, for the excellent reason that Munich had more to offer American artists than New York had for Germans. Adolph Erbslöh had come over from America and was all but totally assimilated as a German artist. Albert Bloch and Oscar Bluemner were relatively well-integrated, genuinely cosmopolitan artists. From the artistic point of view, the most important of these artists who divided their cultural heritages between Germany and America was Lyonel Feininger, a man whom Hartley came to know fairly well over the next two years, chiefly in Berlin. John Covert went to the other extreme. A young Pittsburgh artist who had studied under a man familiar with both Munich and Paris, Covert had arrived in Munich most probably in early 1909, enrolled in the Akademie der bildenen Künste—to study, as it turned out, under Carl Marr, an American who had become a naturalized German—moved on to Paris in 1912 for two years, and only returned home at the outbreak of the war. Covert, however, seemed to have had no contact with anyone significant: "I didn't get to know a modern artist, or see a modern show, or even meet the Steins," he told Rudi Blesh plaintively in old age. "I must have lived in armor."[55]

For Germans and Americans alike, the central figure in Munich was the Russian cosmopolitan Wassily Kandinsky. Until recently, Kandinsky's later work at the Bauhaus, and the lack of reliable primary sources for scholarship, obscured his central role in the history of European modernism and the American encounter with it. Hartley's awed encounter with the man was thus appropriate: in many ways, Kandinsky was the peer of Picasso and Matisse as an artist and as an influence, and his writing during this period became seminal for many Americans trying to put their ideas into words.

Kandinsky first came into contact with Americans in Paris, where he spent thirteen months between May 1906 and June 1907, based in Sèvres just outside the city. With his head full of religious ideas and symbols, his implicit faith in the artist as a religious prophet, and his assumption, common to many thinkers from Emerson to Baudelaire, that physical objects corresponded with spiritual truths, Kandinsky found much in French Symbolism to interest him. This was a period of near turmoil in Paris art, and thanks to Hans Purrmann, Kandinsky was soon in the middle of it. Purrmann was already an active follower of Matisse, and soon became an organizer of the Matisse school with Sarah Stein. The evidence is fragmentary and circumstantial about whether Kandinsky met the Steins or had any personal relationship with Matisse, but he could not have avoided hearing about fauvist activities and the new

color theories that were making rapid progress among the young modernists. Color could apparently exist independent of form and narrative, and objects were no longer essential to a successful painting. Nonobjectivity was still far off, but abstraction was at the tip of his brush.[56]

Unlike most modernist painters, Kandinsky left a contemporary record of his artistic progress; as with Max Weber he seemed to have begun obsessed with color. "The first colors that made a strong impression on me were bright, juicy green, white, carmine red, black and yellow ochre," is the opening sentence of his reminiscences. "These memories go back to the third year of my life. I saw these colors on various objects which are no longer as clear in my mind as the colors themselves." He soon related these memories with an epiphany years later in Munich. One evening at dusk, he was returning to his studio, his mind on the study he had been making, when he suddenly saw "an indescribably beautiful picture drenched with an inner glowing." He hesitated, and then rushed toward it, "of which I saw nothing but forms and colors, and whose content was incomprehensible." He quickly discovered that he was looking at a picture he had already painted, standing on its side against the wall. "The next day I attempted to get the same effect by daylight. I was only half-successful: even on its side I always recognized the objects, and the fine finish of dusk was missing. Now I knew for certain that the object harmed my paintings."

Such intuitions, not teachers or institutions, have usually been the crucial turning points in cultural history. "Art is like religion in many respects. Its development does not consist of new discoveries which strike out the old truths and label them errors." Rather, "its development consists of sudden illuminations, like lightning, of explosions, which burst like a fireworks in the heavens . . ." The date and the picture scarcely mattered, for in the mind of the artist the relevant question was: "What should replace the object?" He might study Rembrandt or immerse his ears in the music of Wagner; he might travel Europe and absorb fauvism, but that question took over his mind and seemed to resist solution. "I have only one consolation: I could never bring myself to use a form which developed out of the application of logic—not purely from *feeling* within me. I could not think up forms, and it repels me when I see such forms. All the forms which I ever used came 'from themselves.' "

Kandinsky had a rough decade finding his proper means of expression. He seemed to have no country or home and his personal life was unstable. He felt that "art in general" and his "powers in particular were far too weak in the face of nature." Objects overwhelmed him, and years passed before he concluded, "through feeling and thinking, that the aims (and thus the means) of nature and art are essentially, organically and by universal law different from each other." By 1913, the time in which he was writing—and meeting Hartley—he was happy to record that this solution guided his work and cleared away the most distressing aesthetic questions that had plagued him. "This solution lib-

erated me and opened up new worlds. Everything 'dead' trembled,"
from flowers to cigarette butts—"everything shows me its face, its in-
nermost being." He swiftly shifted the ground of his analysis, moving
with intuition rather than logic: "Thus every still and every moving
point (= line) became equally alive and revealed its soul to me. It was
sufficient for me to 'grasp' with my whole being, with all my sense, the
possibility and the existence of that art which is today called 'abstract'
in contrast to 'objective.' "[57]

In 1909, Kandinsky had entered a new phase of both creative
expression and artistic influence. He became a leader in the Neue
Künstlervereinigung München in its efforts to spread the newest artis-
tic ideas. He was close to being an important public figure, and when
he appealed for the public to appreciate Cézanne, Gauguin, Matisse,
and Van Gogh, it made some difference at least with advanced groups.
Inside the artistic community, nothing was ever serene, however, as
artists sharing little but a sense of rebellion squabbled among them-
selves, groups formed and split, and agreement on any single modern-
ist platform was unlikely. By the time of the first Blaue Reiter show, 18
December 1911 to 1 January 1912, the only point of unity seemed to
be that artists should express their inner being, regardless of formal
consequences. "In this small exhibition we are not trying to propagate
one precise and specific form," the first page of the catalog stated, "but
we do hope to illustrate, by the variety of the forms represented, how
the artist's *inner wish* may be variously embodied." An advance an-
nouncement of the Blaue Reiter Almanac, however, let viewers in on
what was to come: "A great revolution, the displacement of the center
of gravity in art, literature, and music. Diversity of forms; the construc-
tive, compositional character of these forms; an intensive turn to inner
nature." The words, Kandinsky's biographer has written, were the art-
ist's: "These are, in general terms, symptoms of a new spiritual Renais-
sance. To show the features and manifestations of this change, to em-
phasize its inner connection with the past, to reveal the expression of
inner aspirations in every form suggestive of inwardness—this is the
goal that the *Blaue Reiter* is striving to attain." In this first exhibition, as
in the second, which opened at Hans Goltz's gallery on 12 February
1912, Albert Bloch was the only American represented, with six works
in the first and eight in the second.[58]

Under normal circumstances, innovative work by a Russian who lived
in Germany and spoke little English should not have won much of an
audience with European dealers or American painters. But Kandinsky
did very well, friends and dealers marketing his work with a success
that Hartley soon envied. Kandinsky helped his cause immeasurably
with the publication, late in 1911, of *Uber das Geistige in der Kunst,* the
accumulated jottings of his teachings and ideas. The brief volume
was available among Germans artists in Paris almost immediately, and
Rönnebeck made sure his friend Hartley knew its contents. It quickly

appeared in French and English, and excerpts in English were printed in Stieglitz' *Camera Work* within months. Ezra Pound discussed it for British readers, in the context of his campaign for Vorticism. Whether by word-of-mouth or by direct contact with Kandinsky's text, Hartley, Bloch, Feininger, and the rest not only had the work of an innovative painter to look at, they had words to remember—words that coincidentally touched many chords which were already reverberating in Hartley's mind from earlier times.

The focus of the book was on the relationships between spiritual states and paint. Kandinsky's Russian Orthodoxy and its expression in colors were as one in his attack on materialism, a word that included both greed for the acquisition of objects and an obsession with objects as the subject for art. "The nightmare of materialism which has turned the life of the universe into an evil, useless game, is not yet past," but the devout artist could have some hope and follow his inner promptings to a different art that would be emblematic of a more spiritual life. Religion and primitivism were both useful in the battle against the enemies that Kandinsky singled out: "blind atheists," those whose politics were "republican," or whose economics were those of the "socialists," or whose science showed them to be "positivists," or whose paintings proved them to be "naturalists." In this connection Indian philosophy had something to offer, and Kandinsky mentioned Madame Blavatsky and Theosophy. Scholars still dispute the extent of Kandinsky's interest in the Occult—Gabriele Münter, with whom he was living at the time, was probably far more interested than he—but it does appear in the text, and such an interest was obviously compatible with Hartley's earlier religious yearnings and the whole "soft side" of the William James tradition in American thought.

Three aspects of Kandinsky's teachings stood out for someone of American background. Geometry was an expression of the spiritual: "The life of the spirit may be fairly represented in diagram as a large acute-angled triangle, divided horizontally into unequal parts with the narrowest segment uppermost. The lower the segment the greater it is in breadth, depth, and area." This triangle "is moving slowly, almost invisibly forwards and upwards. Where the apex was today the second segment is tomorrow; what today can be understood only by the apex and to the rest of the triangle is an incomprehensible gibberish, forms tomorrow the true thought and feeling of the second segment."

In the next paragraph, Kandinsky turned immediately to music for the example of Beethoven, who stood alone at the apex, "solitary and insulted," an eternal example for rejected innovators in art. Music was never far from Kandinsky's thoughts, as he regularly used it as the most obvious means of spiritual expression. The "various arts of today learn from each other and often resemble each other," he noted, pointing immediately to Claude Debussy, a musician "deeply concerned with spiritual harmony," to Alexandre Scriabin, and to Arnold Schönberg.

Kandinsky had a long relationship with Schönberg of seminal impor-
tance for the history of European modernism but in 1911 the Russian
could have known little of the Austrian's work. He quoted instead from
the *Harmonielehre,* concluding that "Schönberg realizes that the greatest
freedom of all, the freedom of an unfettered art, can never be abso-
lute," but that his music does lead listeners "into a realm where musical
experience is a matter not of the ear but of the soul alone—and from
this point begins the music of the future." The painters, at least, had
moved beyond Wagner.

Finally, color. Kandinsky had been a Russian bathed in color as a
child, he had moved in the fauvist circles around Matisse during his
year in Paris, and color theory was never far from the minds of the
most significant painters of the day. He devoted much of his book to
the technicalities of the subject and he did so because he related colors
to "*their psychic effect.* They produce a corresponding spiritual vibration,
and it is only as a step towards this spiritual vibration that the elemen-
tary physical impression is of importance."

These three concerns led naturally to the concept of abstraction, which
Kandinsky welcomed. He was not using the word in its usual modern
sense of meaning non-objective, but rather in the sense that a painter
could abstract qualities from nature, from an organic subject, without
literary or narrative intent. "So the abstract idea is creeping into art,
although, only yesterday, it was scorned and obscured by purely mate-
rial ideals. Its gradual advance is natural enough, for in proportion as
the organic form falls into the background, the abstract ideal achieves
greater prominence." Or, as he summarized this line of argument: "In
short, the working of the inner need and the development of art is an
ever-advancing expression of the eternal and objective in the terms of
the periodic and subjective."[59]

VIII

May 1913 represented something of a turning point for Hartley in more
ways than one. He was preparing not only to move from Munich to
Berlin, but also to move on, as best he could, from the overpowering
presence of Kandinsky. Kandinsky himself had little to do with this;
Hartley was something of a hero-worshipper who first made major
painters into gods, and then became increasingly critical and even jeal-
ous when he feared not only that his own work would not be good
enough for such fast company, but also that critics would find him de-
rivative. His fears were just; Hartley *was* derivative, whether from Ry-
der, Cézanne, Matisse, Picasso, or Kandinsky, and did not for some
years find a style truly his own. He was also poor, insecure, and jealous.
When no less a friend and supporter than Alfred Stieglitz paid $500
for a Kandinsky out of the Armory Show, "Improvisation #27," Hart-
ley resented it. But he was already trying to cut his ties to Munich and

prove to himself, if to nobody else, how original he was.

Thus, when Hartley wrote Stieglitz about the visit of himself, Kandinsky, Münter, Marc, and Bloch to the Galerie Goltz early in May 1913, he was clearly drawing lines. The Russian "volunteered a discourse on the law of form—that of the individual as applied to the universal—mainly a discourse on technical" matters, all of which "left me unmoved." The discussion was friendly and an "interesting conference—the one a complete logician trying so earnestly to dispense with logic and I a simple one and without logic having an implicit faith in what is higher than all intellectual solutions—knowing that intuition if it be organized has more power to create truly than all the intellect ever can." He pictured himself and the Russian as being much like Emerson and Whitman "discussing *Leaves of Grass* on the Boston Common. Whitman listening with reverence to all of Emerson's ideas and leaving him with the firm decision to change nothing in his book." Becoming as ostentatiously modest as he was poor, Hartley then retreated slightly from the picture of himself as Whitman redivivus: "I have no knowledge—only an organized instinct—Kandinsky has a most logical and ordered mind which appeals so earnestly to the instinct which has been soon mastered—In other words in my heart of hearts I think he is not creative." To Hartley, Kandinsky was "an interpreter of ideas—He knows why everything and that simply must not—cannot be in real creation— This is itself illogical." Hartley had been saying all along that art was inarticulate—as inarticulate as he was personally—and that the greatest artists could never say precisely what they were doing. Because he could write down what he was doing, Kandinsky's works were not truly "products of creation—that element of life which insists on self-expression before the mind has power."[60]

Hartley next enlisted Gertrude Stein in his self-promotional efforts with Stieglitz and the fight for recognition and sales in New York City. "In his painting he has done what in Kandinsky is only a direction. Hartley has really done it. He has used color to xpress a picture and he has done it so completely that while there is nothing mystic or strange about his production it is genuinely transcendent," she wrote Stieglitz. "Each canvas is a thing in itself and contained within itself, and the accomplishment of it is quite extraordinarily complete." She then pointed to another quality that appealed to her, "the lack of fatigue or monotony that one gets in looking at his things." His work "freshened" the viewer. "There is not motion but there is an absence of the stillness that even in the big men often leads to non-xistence." She assured Stieglitz that Hartley was on the right track, "the only one working in color that is considering the color as more dominant than the line who is really attempting to create an entity in a picture which is not a copy of light. He deals with his color as actually as Picasso deals with his forms." She then distinguished Hartley's work from that of Delaunay and the Orphists who were, she thought, "producing a disguised but poverty

stricken realism; the realism of form having been taken away from them they have solaced themselves with the realism of light." Hartley had not done this, but rather had dealt "with color as a medium for creation and he is doing it really . . ."[61]

By the second week in May, Hartley was staying in the Rönnebeck house in Berlin. He now enjoyed the luxury of writing off Munich in the same fashion as he had Paris. Munich was "fatiguing" and "so frightfully local," he wrote Gertrude Stein. Single men had an especially hard time. "How different Berlin. Already I feel like I shall one day live again after a seige of catalepsy spiritually speaking." He felt "like I am come up out of a tomb to the light again . . . Berlin is packed with that live-wire feeling—& yet not so verrükt as New York." He reported that he had several exhibition opportunities, which cheered him audibly.[62]

A few days later, Hartley viewed the pageantry surrounding the marriage of Prinzessin Victoria Luise. Where other observers might be disturbed by the militarism and patriotism that were taking over the Prussian worldview, Hartley saw only the materials for art. "It makes a very gorgeous street picture and I have always loved these public spectacles. The military life adds so much in the way of a sense of perpetual gaiety here in Berlin," giving a visitor like him "the feeling that some great festival is being celebrated always," he wrote Stieglitz. Despite the attentions of Rönnebeck and von Freyburg, however, Berlin did not lift his spirits enough to compensate for the problems Hartley always seemed to have. Within a month, he complained of being tired and of having nothing he could do, having run into vexing problems in his relationships with galleries in Munich and shippers in Paris. His poverty was an ache that throbbed through letter after letter. Despite the more tolerant attitudes toward homosexuals in the city, his private life did little to ameliorate his discontent. "I am not happy interiorly and this as far as I can see cannot be changed. Like every other human being I have longings which through tricks of circumstances have been left unsatisfied." He even accused the Germans of being *angstlos* and excessively devoted to domestic and military concerns.[63]

He spent several weeks looking for a "Wohnung" so he would not be so dependent on his friends. Although his moods continued to oscillate between exhilaration and depression, he was happy to be "rid of the art monster of Paris," he wrote somewhat obtusely to its archpriestess, Gertrude Stein. He had been looking at the works of Cézanne, Van Gogh, Gauguin, Picasso, Rousseau, and Severini and immersing himself in the city as a work of art. "It is a place of much yellow essentially—and of much good smiling also." Both he and Rönnebeck missed the life at #27, but that was all they missed in Paris. The French capital simply did not have the colors, the brightness, and the smiles of Berlin.[64]

By August he was relatively cheerful again, a perfect conduit of gos-

sip for his sponsor in New York. He still complained about poverty and loneliness, even while giving the impression of constant socializing, and admitted that he was happier in Europe than he had been in America. He had found a Herr Koehler in Munich who had been hospitable and helpful in arranging exhibitions. His friend Rönnebeck was hobnobbing with royalty and planning to sculpt Mabel Dodge in Florence in September. Hartley himself was looking forward to meeting Arnold Schönberg, "he being very intimate with Kandinsky." Hartley had seen Charles Demuth, who had liked his work and would be contacting Stieglitz about it soon. Demuth had recently seen Gertrude Stein in Paris, and mention of such contact brought back Hartley's sense of gratitude and devotion to her. Stein "is really a splendid person & so gifted with an unfailing sense of values, qualities & depths & knows just where to place them"; he was proud to be "the only American she has given this attention . . ." He was less enthusiastic about the man he called François Kupka, "another theorist of the Kandinsky type," who had visited him with pianist Walter Rummel.

Several days later, Hartley picked up his abandoned letter and went on. He had been to the "Movies" several times, finding them wonderful if ponderous; Kandinsky and Münter were "very fond" of them as well. On matters of art, he was becoming more critical of the work of Matisse and quite caustic about that of Kees Van Dongen. Gertrude Stein, he reported, had found Francis Picabia and his wife "charming," writing Hartley that Picabia seemed to her a "drawing-room version of Picasso—he is intelligent but has no genius . . . harmony but no depth." He then returned to his obsessive theme, the disjunction between artistic and theoretical ability. Kandinsky and Kupka painted by theory, while Hartley painted from experience: "everything I do is attached at once & directly to personal experience—It is dictated by life itself."[65]

Apparently through the mail and with the help of friends on the scene, he shifted his Munich gallery from Hans Goltz to Max Dietzel, but the change meant nothing to his finances in Berlin. He begged both Stein and Stieglitz for funds, borrowing meanwhile from Rönnebeck's father and stalling off his landlord. In the midst of financial degradation he found artistic reward. Herwarth Walden included him in the 1913 *Herbstsalon;* Hartley had five pictures "splendidly hung," he wrote in satisfaction, but had no place in the catalog because he had no photographs he could submit. He was becoming "very fond" of the work of Paul Klee. But still no money came. The epistolary moans continued into mid-October, when Stein sent him 200 francs and a Stieglitz check finally arrived. The weather in New York was a lot chillier than in Berlin. "Your European trip was made possible through American cash, cash which was forthcoming because a few people felt you were entitled to a chance," Stieglitz wrote testily. Hartley had no right to ask for more money until he shipped his work to New York. "I am not opening the little gallery until I know definitely whether you are com-

ing or not. Everything is held in abeyance for you. You are to have the first chance. A certain responsibility toward the others rests on your shoulders." Stieglitz had been exerting such pressure for some time and Hartley did not appreciate it. "My feelings at this hour are a melange of great delight and dread," he told Stein. He thought Stieglitz' whole orientation toward money unacceptable, and that Stieglitz almost went out of his way not to sell the pictures he seemed to be supporting.[66]

In the meantime, Rönnebeck had been visiting Paris and returned with his usual fund of gossip. Hartley conveyed it to Stieglitz with gusto, underlining his commitment to Germany—and his actual incompetence with its language—with such pseudo-Germanic spellings as "Gertrud" and "Piccasso." Rönnebeck had been talking to Stein, and she told him that Hartley had "gone miles beyond them all—Piccasso included because I have succeeded in leaving out the physical element and giving for the first time the pure spiritual." He was delighted to hear that she had hung one of his drawings next to Cézanne watercolors at #27, "with a Manet and a Renoir above it & she told R. that it gave her unqualified pleasure daily & hourly." *"Piccasso has seen the drawing there*— said to Gertrud that he could not understand it . . ." Stein told Rönnebeck that Hartley "had gone beyond Piccasso himself and into a sphere infinitely removed from him & them all—that she sees in me a new & great factor in modern art—etc etc." He went on, in the humorlessly portentous vein he adopted about such praise, that his work was "the result of new inward experiences the result of having come into touch with the great mystics of the universe," and having come to such a supportive city as Berlin. "Read Bucke's Cosmic Consciousness & you will see what it is—I identify my experiences in his book & in Wm. James ['] Varieties of Religious Experience'—This was my first real contact with Miss Stein—was when I asked to borrow her copy of this book . . ."[67]

Once he had enough money, Hartley gave in to the pressure, and sailed for New York on 15 November 1913. He got his show early the next year, the catalog including brief notices by Stein and Mabel Dodge, as well as Hartley's own forward. But he was morose. "I have been here two weeks. It is an eternity. I want to go home. I am homeless here," he wrote Stein. "New York is an inferno—miles of hard hard faces, and hard ambition—smiles are altogether too costly for them here— and gentleness is absurd from the American standpoint. How ridiculous it is to be American in these ways, how miserably inhuman." He had problems with customs officials. He had seen Mabel Dodge, Hutchins Hapgood, and Alfred Stieglitz. "I am glad I can be at Mabel Dodge's some which is a relief from the machine existence." Three weeks later, he had not changed. "I get through many wearisome things because Mabel Dodge is here—she is truly great," but she could not make up for a whole civilization. "N.Y. is such a cemetery for one like

me . . . ," he complained. "The madness of things is such a useless madness—the American rush all over things skimming surfaces & strangling depths—& O my god how everybody talks! Culture is positively a crime—There is need of a fine ignorance." But the wicked city did its duty, his show sold four pictures, and "one year is secure."[68]

He followed his show to Buffalo with Mabel Dodge and Andrew Dasburg to keep him company, which he needed because Buffalo was otherwise desolate in February. "It has been so good to have Mabel Dodge & Andrew here they are so fine & we are such a good three together— M.D. is really the most remarkable woman I ever knew taking it all in all. She is so intelligent & so sympathetic and like yourself a real creator of creators," he wrote Stieglitz. But he refused to be comforted. "There is something so oppressive about these cities of homes to one like myself who has not and never will have one—God forbid that I should ever find myself attached to any one spot or thing." He knew himself too well: "I am a kind of rover in quest of celestial beauty & wherever I find it there my heart is and there my home."[69]

Hartley headed back to Europe as soon as he could. He passed through London, stopped off to see Gertrude Stein, visit Picasso, and check out the Salon des Indépendants, which he found dull. He arrived in Berlin in early May. By June, although delighted to be back in his "Wohnung," he was still worrying about money and his need for freedom, a word which conveyed artistic, sexual, and travel needs in addition to financial ones. He adopted a lordly tone about a former hero. "Kandinsky's book is out in English and it reads well—though I think it is really more for an untutored public than for the more or less sophisticated in matters relating to the subject," he wrote Stieglitz. "I think some things a little over done on the side of the spiritual . . ." His New York networking was paying off, however. "Did I tell you that The Egoist of London . . . has asked me to write an article in the form of an elaboration of what I said in my catalogue as it was seen by Ezra Pound who told me he thought it very good—If you knew Pound you would know that this is really sheer flattery."[70]

Eternally apolitical, Hartley watched Germany strut to war as if in a pageant put on for his special benefit. Fascinated by the atmosphere of stillness, regularly broken by marching men, and the Germanic order that so appealed to him, he told Stieglitz that his best friends were in uniform by 2 August, including the entire Rönnebeck family down to the daughter who had become a nurse. Individual Germans remained friendly and courteous to him and to Americans generally, but had a scorn for American newspapers which misinformed their readers about the true nature of the conflict. He fretted about his funds, and worried about lost mail, sending one letter out with Robert Edmond Jones. But Berlin cultural life went on much as usual and he did not want to go home.[71]

Hartley's painting style was as unpredictable as the war news. He did

work which seemed clearly derivative of Robert Delaunay, at the same
time turning out a series on the American Indian derivative both from
visits to the Trocadéro in Paris and the Ethnographical Museum in
Berlin, and from the interests of such German friends as August Macke.
Occasional works seemed idyllic, complete with unicorns and country
houses, while others reflected the Bavarian folk art influences of the
Blaue Reiter circle. Hartley seemed almost like a trapped animal, dart-
ing from one style to another while avoiding the military catastrophe
that was soon impinging even on his nearly solipsistic world. Rönne-
beck was wounded, and then on 7 October, Karl von Freyburg was
killed in action. A series of military paintings took over Hartley's con-
scious life, producing major works. The most famous of all was "Por-
trait of a German Officer," late 1914.[72]

More than any other, this picture brought together the analyzable
strands of American modernism. It had elements of synthetic cubism,
it seemed abstracted from nature if hardly non-objective, and it used
color in provocative ways. Its loose forms and coarse brushwork also,
for once, did not remind viewers instantly of some better known Eu-
ropean. But the quintessentially "American" touch, as much out of
Emerson as Kandinsky's work was out of Russian Orthodoxy, was the
heavy burden of symbolism the picture bore. Hartley had been flirting
with religious ideas all his life, and the symbolist imagination in many
countries often identified closely with such religious interests. Hartley
was also fascinated by numbers and often passed his musings on to
correspondents. "I have somewhat the same feeling toward the number
27 that I have toward the number 291—They both have a magic of
their own," he wrote Stein. The Stieglitz gallery "is in every way an
oasis in a great place—and once one gets in there—into this room the
size of a kitchentte one gets in touch with currents that give one a great
deal." Stein's home made him feel "as if I were really in somewhere—
whereas most places one goes one remains forever at the gate." In Ber-
lin, he likewise found mystical significance in the number eight, be-
cause of the eight-pointed stars that were so common. Such interests
were clearly visible in his Berlin paintings of 1913.[73]

As if anticipating part of the critical reception of his work, Hartley
denied such symbolic content when the paintings went on display in
1916 at 291. After mentioning the difficulties of travel and work dur-
ing the war, he insisted that the "forms are only those which I have
observed casually from day to day. There is no hidden symbolism what-
soever in them; there is no slight intention of that anywhere." Acutely
aware of anti-German prejudice in the America of that year, as well as
the homosexual subtext of his work so evident when the details of his
life become clear, he claimed to present to the public only "Things
under observation, just pictures of any day, any hour. I have expressed
only what I have seen. They are merely consultations of the eye—in no

sense problem[s]; my notion of the purely pictural." Artists say the silliest things, as one New York critic was fond of remarking, and that surely ranks with the silliest.[74]

In this context, "Portrait of a German Officer" stands out, not only because of its success as a picture, but also because late in his life, Arnold Rönnebeck read a misguided analysis of the picture which Duncan Phillips published, and wrote a letter making clear what had happened. The work had been painted in the winter of 1914–15 in his Berlin studio, and "I am partly symbolized in it." The other subject was von Freyburg, "a first cousin of mine," who, Rönnebeck declared incorrectly, was "killed in action on the 24th of October 1914," calling attention to the number 24 in the lower right hand corner—it actually referred to von Freyburg's age at the time of his death. "He was shot from his horse," and thus Hartley has a small spur under the 24. "He was an active officer in the *4th* regiment of the Kaiser's Guards," and thus the large 4 in the center of the picture, on a blue background implying a shoulder strap. "Next to the 4 there is an *E*. It must be red on yellow ground. It stands for the initial of Queen Elizabeth of Greece. I wore the E on my shoulder, serving at that time as lieutenant in the reserve of Königin Elisabeth Garde Grenadier Regiment Number 3." "In the lower left corner we distinguish the initials K.v.F.," standing of course for Karl von Freyburg. "The triangle holding the encircled Iron Cross symbolizes the friendships and the understanding between 3 men. . . ," i.e., the trio of friends. Hartley had admired the Iron Cross which Rönnebeck received for his wounds, and von Freyburg had loved to play chess, so a cross and chessboards appeared. The Rönnebeck family colors were black and argent, and so these appear, upper middle. The three often met in Munich at the Pinakothek museums, "hence the Wittelsbach blue-and-white banner on the left." Minor errors aside, the letter rang true, both to the circumstances and to the work itself.[75]

Hartley spent most of 1915 in Berlin, painting the war more than actually dealing with it. He seemed better off financially, thanks to his New York trip—even his stationery took on a look of substance, complete with an engraved "M.H." Except for an unpleasant case of blood poisoning in the middle finger of his right hand in mid-summer, things went relatively well for him. He found yet another gallery in Munich, the Münchener Graphik-Verlag, "a galerie which is precisely what 291 would do in N.Y. if it could and I am sure in just this way," he told Stieglitz, with a lengthy description. He planned an October exhibit, war or no war, and in November declared it a success d'estime. But his situation was untenable, as painting supplies became fewer, the strain of war told on public opinion, and Americans became increasingly suspect. Hartley reluctantly gave in, and sailed for New York on 11 December 1915. He insisted that he would be returning soon, but must have had inklings of how hopeless the thought was.[76]

IX

As Gertrude Stein settled quietly into her unconventional ménage with Alice Toklas, and the two of them eased Leo out of the house and Paris as well, her writing changed. The young woman obsessed with herself, her sexual identity, and her family's place in American culture, transcended these concerns in the stimulating atmosphere that her salon encouraged. As she became articulate about fauvism and cubism, and comfortable about socializing with the painters who were the stars of such movements, she could hardly help but make connections between her art and the art around her. The success of such art will always remain a subject of controversy, but the sincerity of it and the radical nature of the questions it asked have become apparent over the years.

The dating of her experiments remains problematical. She cared little about narrative or chronology in either her life or her work, leaving heaps of fragments in notebook and letter form for harmless drudges in universities to sort at their leisure. Despite sustained effort on the part of herself and several friends, she rarely found publishers; the bibliography of publication bears no relation to the time the works were written, and her subsequent remarks have never been noted for reliability. This said, her efforts did have a certain order, even if she carried out several experiments simultaneously, and even if a few works seemed to change style at important points. She had begun her career trying to write relatively conventional narrative, as in *Three Lives*. From about 1906 on, she became increasingly aware of the experiments of Cézanne, Matisse, and Picasso, living surrounded by their works and by Parisian talk about what they were trying to accomplish.

The confusions of plot and focus, and the changes in style that are so marked in *The Making of Americans* are a record of her absorptions. Whether or not she actually wrote while sitting before a work of Cézanne, or in imitation of what Picasso was doing, as the legends have it, she spent her days in an ambience of modernist creativity and could not but have sensed the issues involved. Many of the facile comparisons critics have made about modernist work ignore the problems involved in painting music or composing a painting in prose. Layers of prose could not possibly have the same impact as layers of paint; the composition of a short story in sonata form or an atonal play would be a parlor game, not an important contribution to literature. Thoughts of such possibilities might take an artist part of the way toward original work, but each art has its own structural integrity and a little suggestiveness in analytical discourse is all that such questions warrant.

This said, Stein worked out prose experiments that do share characteristics with work of her time in other areas. The painters of her circle were well aware, in a coffee-and-conversation sense, of experiments not only in the music of Stravinsky, the theater of Jarry, and the poetry of Apollinaire, but also of the mathematics of Maurice Princet and the

physics of Henri Poincaré. Ideas about the fourth dimension, relativity, in ethics if not in physics, non-Euclidean geometry, and the unconscious were everywhere in Paris, all the more fecund for being hard to understand. Writers as well as painters knew that both Cézanne and Picasso had ideas about perspective, space, and time that could have literary application. Stein questioned everything and tried one experiment after another. She had no sense of discrimination about whether what she did was good or bad, innovative or trite; she refused on principle to revise and ignored criticism. Too much of this material was printed after her death, in mistaken acts of homage. Stein badly needed editing, encouragement, and severe criticism. She never got any of these, and floundered in search of a style until she settled into the dialogic monologue of *The Autobiography of Alice B. Toklas* (1932), which received all the attention, and the *Lectures in America* (1935), which should have but did not.

As Stein settled into companionship with Toklas, she settled as well into her adult personality. She was female in a male society, an American in a French society, a Jew in a Christian society, a writer in a society of painters, a homosexual in a heterosexual society. She lived among Germans and Spaniards as well as Americans who shared her sense of being "foreign." She was thus an archetypal modernist, forever on the fringes of bourgeois society, but never feeling at home anywhere. The danger in such a situation was to settle for eccentricity and a largely fiscal relationship to literature, supporting artists or quarterlies and throwing trendy parties. Many in her approximate situation did just that. But Stein did not want to settle; she wanted *gloire* and she was willing to work for it. No one made her write all night; she presumably did so because she had something to say and a significant number of younger artists as well as later critics have agreed with her.

When Stein abandoned narrative, she turned to two experimental forms, the portrait and the play. "Portrait" was a word that transcended the disciplinary lines between writing, painting, and photography. "Play" seemed to be a noun referring to a work for the theater, but in practice was a verb, and as such could apply to any discipline that an artist wanted to play in. By their nature portraits were static, personal, visual, and interpretive. They froze a friend, a scene, or a moment of time; they could do so while violating space. Just as a photographer could superimpose views of the same sitter on the same negative, so a painter could view his subject, as Picasso sometimes did, from several vantage points. Musicians, from the Edwardian Edward Elgar to the young modernist Bela Bartok had already used it, for it freed a composer from the demands of traditional forms without the unfortunate connotations that "tone poem" or "rhapsody" had for a generation needing to distance itself from an exhausted romanticism. Plays were fun. A writer need not think of the stage, for since Shakespeare all the world was a stage. A modernist usually tried to be wry, witty, parodic,

and critical. The French were better at this than Americans, as the young Marcel Duchamp was demonstrating, but Americans sometimes held their own, especially Jews who could call on long traditions of Yiddish humor.

Stein's lesbianism, and the domestic happiness of her new arrangement, remain central to understanding these linguistic experiments. Edmund Wilson long ago suggested that Stein's opacity was in large part due to the inability of English discourse to talk frankly about homosexuality, and although he himself subsequently retreated a bit from this insight, it remains probably valid. An occasional work, such as "Miss Furr and Miss Skeene," recalls the world of Q.E.D. and implies its lesbianism in relatively clear language, the bland surface masking the intensity of the emotional relationships. But the first "book" to emerge in Stein's evolving style was A Long Gay Book, taking a word already common in the homosexual community and one used repeatedly in "Miss Furr and Miss Skeene" and placing it in the title, where it could mislead the philistine and titillate the initiate at the same time. Such doubleness was simple truth anyway: with Toklas, Stein could be gay in both senses.[78]

Consider two passages from "Tender Buttons":

In between a place and candy is a narrow foot-path that shows more mounting than anything, so much really that a calling meaning a bolster measured a whole thing with that. A virgin a whole virgin is judged made and so between curves and outlines and real seasons and more out glasses and a perfectly unprecedented arrangement between old ladies and mild colds there is no satin wood shining.

Aider, why aider why whow, whow stop touch, aider whow, aider stop the muncher, muncher munchers.

A jack in kill her, a jack in, makes a meadowed king, makes a to let.[79]

Neither makes much sense as literal prose, yet both seem to convey private emotions of great intensity. The first, as any Freudian could have told her, outlined sexual activity in terms of climbing paths and mounting, bolstering spirits and bedding in the process. A virgin could be holy, whole and wholly unsatisfied, remaining unviolated yet content in a society where men were unnecessary. The outlines of the body were natural in a room with glasses on the wall and satin wood shining, and lovers could amuse themselves with jokes about the unprecedented relationship they were enjoying, a modernist version of a Boston marriage. The second passage played with the French language in the call for Ada or help, Ada being a pet name for Alice. Giggles intermingle with mock cries of pain, teeth complicating the encounter. A jack could be in a jill even if jack were a girl, and ejaculation or orgasm could make a jill feel like a king. The puns never let up, the last words suggesting toilet, allowing, and "à louer," French for "to let" or "for rent," but also meaning allowing the activity to go on, the premises being vacant until the encounter began. Further analysis is needless: sex, lan-

guage, non-conformity, and the rest are all there. These passages yield more easily than most; many no longer yield at all.

At the time, Stein may or may not have known what she was doing: James Joyce knew exactly what he was doing; Pablo Picasso probably did not, he just did it. Stein was clearly on Picasso's wave length, and neither knew nor understood Joyce. Nothing in her letters or other contemporary materials indicate an articulated awareness of the many problems she seemed to be working out in the long nights after about 1910. But unlike most writers and painters of originality, she later wrote criticism of a sort, and much the best of it was about herself and her work. If at times she was playful, evasive, or master of the circular argument, she could also be shrewd and perceptive. She may well have learned her critical ideas from subsequent experience and read them back into the chaos of her experimental efforts, but her insights nevertheless remained illuminating, in much the same way as Stravinsky's conversations with Robert Craft and his recorded performances in old age of his own difficult scores.

Stein was well-read in Victorian narrative even if she was determined to move beyond it, and she was not generalizing out of the air when she declared that what "made the glory of English literature is description simple concentrated description not of what happened nor what is thought or what is dreamed but what exists . . ." Good English common sense dictated that writing should be direct: "it makes no difference what it is but it must be direct, the relation between the thing done and the doer must be direct. In this way there is completion . . ." Stein had begun her creative life as a student of William James and the concrete factualities of science and pragmatic philosophy. She was, as it were, a radical empiricist of prose. "When I was working with William James I completely learned one thing, that science is continuously busy with the complete description of something, with ultimately the complete description of anything with ultimately the complete description of everything." She had taken this approach and applied it to art. She was first impressed with Millet's "Man with a Hoe," remembering that as a child she had very much wanted a photograph of this work, and when she got one she and Leo received considerable pleasure from it. When they showed it to their more phlegmatic elder brother Michael he said solemnly, it is a hell of a hoe, and "he was right." Some time after, she recalled "being very bothered by Courbet," but his realism raised important issues for her. He used realistic color and evoked the nature that a person could see. "Courbet really did use the colors that nature looked like to anybody, that a water-fall in the woods looked like to anybody." But "what had that to do with anything, in fact did it not destroy a little of the reality of the oil painting"?

At this point Stein was at one of those cruxes where her peculiar insights could be so telling. She placed herself in the Louvre, that museum being hardly a hotbed of modernism. "The Louvre at first was

only gold frames to me gold frames which were rather glorious, and looking out of the window of the Louvre with the gold frames being all of gold behind within was very glorious." She loved looking out of the windows of museums. "It is more complete, looking out of windows in museums, than looking out of windows anywhere else." Soon, she began "to sleep and dream in front of oil paintings," and presumably nature itself became an oil painting. In the process, it dawned on her "that an oil painting is an oil painting." Stein carried repetition and redundancy to new depths in literature, but here her redundancy was creative. Victorian and Edwardian criticism always assumed that the work of art "was" a horse, landscape, or whatever, and even Whistler never tried to deal with the sheer paintyness of a square canvas with a fancy board around it. She began to conclude that "the relation between the oil painting and the thing painted was really nobody's business." A viewer might understandably examine the relation between picture-in-museum and picture-in-nature, for "one always does like a resemblance," but she decided that "that is just a pleasant human weakness." She insisted that "the first hope of a painter who really feels hopeful about painting is the hope that the painting will move, that it will live outside its frame."[80]

At first, Stein seemed unable to get far beyond her narrative impulses in *The Making of Americans*. She could not resist the impulse to cram everything into her writing. "I began to wonder if it was possible to describe the way every possible kind of human being acted and felt in relation with any other kind of human being and I thought if this could be done it would make A Long Gay Book." She assumed that it was "naturally gayer describing what any one feels acts and does in relation to any other one than to describe what they just are what they are inside them." In grave danger of informational overload, she retreated to an aesthetics of intensity. She decided that acting hardly mattered; what mattered was intense feeling. "And so what does it really matter what anybody does." Newspapers were full of such trivia, "but the thing that is important is the intensity of anybody's existence." Portraits were a way out. By avoiding narrative and excessive factuality, she could "find out what it was inside anyone." She could violate space or time or perspective to get at the essence of a person: "I had to find it out by the intensity of movement that there was inside in any one of them." In doing this, she felt a kinship to the two authors she regarded as her closest competitors. "A thing you all know is that in the three novels written in this generation that are the important things written in this generation, there is, in none of them a story. There is none in Proust in The Making of Americans or in Ulysses." Anyone capable of seeing this could presumably pass at once to reading her portraits.

This omnivorous lack of discrimination kept her open to cultural stimulation that better trained, more discriminating readers avoided. She had no ear for music and no first-hand knowledge of jazz, for

example, yet could argue that the fundamental thing "about plays is that the scene as depicted on the stage is more often than not . . . in syncopated time in relation to the emotion of anybody in the audience." Far from being just a trendy remark in the early thirties, when jazz was well-established even in Paris, her intuition said something important about the dialogic nature of the dramatic experience: "Your sensation as one in the audience in relation to the play played before you your sensation I say your emotion concerning that play is always either behind or ahead of the play at which you are looking . . ." Every person was a different audience who experienced a different play because preparation and expectation were different. The meaning of the play was thus completely relative and never twice the same. Jazz bands implicitly realized such a relational dependency between players and watchers, and "made of this thing an end in itself." Such insights are implicitly deconstructionist, and help explain her growing appeal half a century after the composition of the works under discussion.[81]

While working at her portraits and her plays, she soon found herself studying language itself. "I began to wonder at at about this time just what one saw when one looked at anything really looked at anything." Her old enthusiasms waned, but she "became more and more excited about how words which were the words that made whatever I looked at look like itself were not the words that had in them any quality of descriptions," and this "excited me very much at that time." She explored basic grammar, insisting that nothing "has ever been more exciting than diagraming sentences" and the "verbs and adverbs are more interesting than nouns and adjectives." At the same time, she questioned the simplest assumptions of mathematics. "After all the natural way to count is not that one and one make two but to go on counting by one and one as chinamen do as anybody does . . . That is the natural way to go on counting." Her experiments which attempted to expunge nouns did not get very far—imagine a radical empiricist doing without nouns anyway!—and so she compromised: a writer wrote prose best without nouns, but poetry required them. "And what is the vocabulary of which poetry absolutely is. It is a vocabulary entirely based on the noun as prose is essentially and determinately and vigorously not based on the noun." At which point she reached the ineffable as far as English readers were concerned. "A rose is a rose is a rose is a rose," she wrote, making the words into an emblematic ring of which she was so proud that it went onto her stationery: "what did I do I caressed completely caressed and addressed a noun."[82]

After her opaque fashion, Stein was thus a modernist working a highly experimental progress through the possibilities available in her lifetime. She produced prose narrative, critical comment on painting, portraits, and plays; in doing so she seemed to sense, and perhaps feel the influence of, film, jazz, collage, and mathematics. Virtually all modern-

ists had in common a wish to take things apart and start over, to make things new in a radical way. She questioned everything down to the most basic assumptions of perspective and grammar, and in the process mixed her disciplines creatively if confusingly. She elaborated characteristics the way a strip of film did, one and one and one, counting "as anybody does." She found Picasso doing similar things in art. She wished to feel intensely but found the conventions of bourgeois language a prison. Perhaps cubist prose could help, perhaps playing with plays, or syncopating the relationship between performer and perceiver. The point here is not that all of these experiments were valid, but that they were all radical challenges to the status quo. Spoken to friends or to lecture audiences, they could seem shrewd, confusing, or meaningless, sometimes all three at one. But artists looking for new ways to express themselves could take what they needed from her presence and writings. Often what they created were more effective works of art than her own; but such works might not have been possible without her preliminary demolitions.

All this remained in the future. In July 1914, Stein and Toklas left Paris for London to facilitate the publication of an English edition of *Three Lives* and explore the possibility of publishing a volume of portraits. They attended the Ballets russes and the Richard Strauss opera *Elektra;* they took tea with Alvin Langdon Coburn and made a determined effort to meet Henry James. That failed, but they did meet Alfred North Whitehead and his wife, and when the outbreak of war disrupted travel and banking, Evelyn Whitehead insisted that the two women remain until things settled a bit. They did, forming a friendship that reverberated in the *Autobiography* and gave Stein a genuine genius against whom she could measure herself. In October, they returned to a Paris quiet but disrupted. The war was only a short distance away; the painting community had gone into uniform or exile; the art market was dead. In the summer of 1915 they went to Spain to spend a year living chiefly in Majorca, far from the unpleasantness. They returned to Paris in June of 1916, involved themselves in war-related work, and survived to find themselves legends in their own time. They fostered a new generation of writers—a lost generation, as the saying soon was, but hardly as lost as the generation of painters in the decade before 1914.

BOOK V

The Salons of New York

CHAPTER 1

Alfred Stieglitz

Modernism was an outgrowth of urban culture, and no city in America was as productive as New York. All but culturally barren in many decades of American history, it had shown some life in the days of James Fenimore Cooper and Washington Irving, and an occasional novelist or diarist produced work that still commands critical attention. But New York remained forever derivative, no matter how educated and tolerant a few of its leading citizens might become, until the early years of the twentieth century. But that time, the forces of commerce, institutionalized culture, and proximity to Europe became irresistible. New York was *the* place by about 1912 or 1913, and never gave up the lead thereafter. Only the attractions of London and Paris rivaled it for Americans.[1]

Such success can obscure the resistance which new cultural ideas met. The Metropolitan Museum of Art was notoriously hostile to recent work of whatever kind, and Columbia University was as cautious as most universities would have been to ideas less than a century old. Few collectors were interested in recent paintings and even fewer in photographs; conductors remained firmly in the German tradition, resistant to anything later than Brahms or Wagner. Dewey's pragmatism slowly won converts at Columbia after he arrived in 1904, but even so conservative a thinker as Henri Bergson made news with his lectures in 1913 on subjects that were not so very different from what William James had been saying for years. Franz Boas was exploring the foundations for cultural relativism, but received minimal institutional support and had to wait decades for official encouragement. Old publishing houses kept their authors in line, unwilling to defend them against the outrage of parents eager to protect daughters from impure thoughts. Not until the early teens did such pioneers as Mitchell Kennerley, Alfred Knopf, and Benjamin W. Huebsch begin to exercise a small role, and adventuresome publishing had to await the 1920s.

For young rebels against such a status quo, appropriate role models, institutional support, and appropriate languages with which to communicate were hard to find. They could attend art classes and meet each other, as many painters did, but opportunities in music and drama

were pathetic in their inadequacy. An occasional fugitive publishing outlet
sold decadent efforts imitative of the works of Oscar Wilde or Aubrey
Beardsley. Restaurants were more useful, consoling the needy with al-
cohol, friends, and anecdotal material. Newspapers brought scattered
stories about activities in Europe, mostly trivialized. Even such words
as "infrastructure" and "network" were lacking, so that the talented
young hardly knew how to express the deprivations they felt, let alone
take steps to make life more supportive.

The character types most common in the arts made matters worse.
Anti-business, anti-politics, anti-relevance of almost any kind, artists were
often anti-competence as well. They knew that few people, even in their
own families, understood their needs, and that adequate funding was
not there for schooling, showing, or buying. They pitied themselves,
glorying in their inability to flourish under capitalism. They needed
parents to nurture them, grandparents to will them money, teachers to
instill a sense both of the past and the possibilities for the future, and
dealers or publishers to invest in them so that the money came in to
buy food, paint, paper, and self-respect; what they had instead were
friends and mates whose weaknesses complemented their own. Some-
times a figure from the "real world" took pity on them—lawyer John
Quinn became the most famous—buying, cajoling, or baby-sitting the
talented into creation. But Quinns were rare. What New York devel-
oped instead was a new, urban cultural institution: the salon.[2]

No one planned the introduction of salons into New York City. They
happened at the whim of three individuals and those who had influ-
ence on them. Classes, talents, disciplines, and even nationalities could
cross-fertilize there, and the results were often both memorable and
well-publicized. The inarticulate could find defenders, the impecunious
could find money, and the unknown could find publicists; some of these
relationships, far from being merely tactical and exploitative, lasted for
life, with consequences which have yet to find proper interpreters. Alfred
Stieglitz, Mabel Dodge, and Walter Arensberg were, despite great dif-
ferences, important figures in the climate of modernism. Each known
to the others, their groups overlapping in odd but productive ways,
they provided a new infrastructure for the contemporary arts in Amer-
ica. Much of what they fostered was gossip, and some publicity hunt-
ing; but what remained had far more impact than anything going on
at the more sober, established institutions.

II

In many climates of creativity, the lives of certain figures inevitably be-
come paradigmatic. Ancestry, upbringing, education, travel, crises,
breakthroughs, attacks, and achievements become the folklore of the
day, entrance the young and enter the memoir literature to define what
creativity meant at a crucial period in cultural history. For almost any

artist in New York City, by the early 1920s, Alfred Stieglitz had already become such a figure. By the time of the publication of the collaborative volume, *America and Alfred Stieglitz* (1934), he seemed almost embalmed: his life and character, like those of Sherwood Anderson as he left business for art, or Gertrude Stein as she sat writing under a Cézanne portrait, took on iconic lustre: here, his idolators were chanting, here was the man who knew what it was all about; his life was the *Kunstlerroman* that told the universal tale. No one could possibly have deserved such treatment, certainly no one as egotistical as Stieglitz; but his disciples were, in essence, correct. His life was indeed paradigmatic, if not always in the way that they thought.

He was, first of all, an outsider in several obvious ways. In a nation of fervent Protestants, he was apathetically Jewish; neither he nor his immediate family seemed to care much about religion. In a nation of Anglo-Saxon predominance, he was German by culture and preference, the son of a man who had emigrated in 1849 and a woman who had come about three years later. His father had quickly succeeded in the dry goods business, but never surrendered the German language in private life. Such entrepreneurs learned English words and American manners quickly; they might even enlist in the Union Army, as Edward Stieglitz did in 1861; but they read German newspapers, attended fraternal social groups speaking German, and showed their best clothes off at German operas. In a nation where universal public education was still a controversial topic and the experience of visual art and music unusual, Alfred Stieglitz had relatively demanding schooling and lived surrounded by opportunities to see pictures and hear performances. When even these proved inadequate, he did not go west to grow up with the country, he headed east to Germany and so loved the life there that he hated to return.

In many smaller ways, Stieglitz was, if not precisely paradigmatic, at least not unusual in his attitudes. Although positively surrounded by a warm and supportive family—he had thirty-two first cousins on the day he was born, and soon had five siblings—he seemed self-absorbed, openly ignoring the values of most of those around him. In a family of strong egos, he stood out as all but impermeable to influence, grumbling even in old age to his grandniece and biographer: "Everything is relative except relatives, and they are absolute." Rather than deal directly with family pressure, he often retreated into hypochondria. His father, his wife, and his critics all deprived him of health at frequent intervals; success, acclaim, and devoted disciples restored him immediately. Money became an obsession, for family fights centered on it. Stieglitz' mother could never stick to a budget, and his father, so freehanded in some ways, often went into violent rages at her incapacities. Alfred never recovered; as an adult, he could hardly discuss the subject. He deplored anything that smacked of a business attitude to money, could not endure haggling, and scorned any unsuspecting customer who gave

the impression that a painting could be translated into an investment. Artists and connoisseurs should *have* money, he felt, not *earn* it—a policy which, often enough, kept them from selling even when buyers were there.

Some of his rebellions were superficial. Like Whistler before and Pound after him, he developed a complex persona to keep people at a distance. He could be histrionic, and loved to dress in bohemian outfits. His hair often a bit out of control, his tie that of a painter rather than a businessman, his caps and hat out of a costume ball, he seemed often only minutes away from having his picture taken to illustrate some work of Murger or du Maurier. Aware that the first principle of business as of politics was: "Thou shalt not commit a witticism," he was always cracking jokes behind a solemn facade, flirting with pretty girls and kidding male friends.

Personal traits have intellectual consequences. When his father took the family back to Germany so that, among other things, his oldest child could prepare himself for a career in mechanical engineering, Alfred openly rebelled against the prescribed regimen. He not only took up photography and the chemistry that went with it, he struck out in other, more normal ways. He became adept at cards, chess, and billiards, and learned to perform respectably on the piano. He sowed wild oats with some abandon, believing for life that his roistering had resulted in at least one illegitimate child. He surreptitiously supplied pubescent female relatives with the works of Zola—especially *Nana*—Rabelais and Havelock Ellis, and believed his own family background supported Freudian ideas about sexuality, the unconscious, and dreams. So great was his enthusiasm for Freud's work that he was seriously considering devoting an issue of *Camera Work* to the role of the unconscious in art when that journal folded in 1917. One of the contributors was to be Abraham A. Brill, Freud's leading popularizer in New York City. It should go almost without saying that, for such a man, politics was largely an irrelevance and social reform not exactly pressing. Stieglitz paid attention to the poor, and to urban conditions generally, because they were picturesque, fresh subjects for the personal expression of the artist. He noticed the lower classes the way Gertrude Stein did in *Three Lives*, not the way Jacob Riis did in *How The Other Half Lives*.

After a childhood spent chiefly in Hoboken, New Jersey, and New York City, Stieglitz was in German-speaking countries continuously from the summer of 1881 to 1888, occasional holidays, often in Italy, aside. Between 1888 and 1890, he was under increasing pressure from his family to marry within his social set and to settle down as a respectable businessman. In 1890, his sister Flora died in childbirth and the pressure became irresistible. He returned, joined the Helichrome Company, and in 1891 bought the organization with two old friends and renamed it The Photochrome Engraving Company. In 1893, without visible passion, he married the sister of one of his partners, a woman

with no sympathy for art, photography, or indeed any enthusiasm outside those customary in the mercantile aristocracy of New York. Both business and marriage depressed him, and he devoted every hour he could to his photography. He became notorious in some circles for his interest in photographing the city in rain, snow, and cold, and won increasing recognition both at home and abroad for the prints he entered in competitions. Already a member of the German Society of Friends of Photography and a prize-winning contributor to German and British photographic journals, he became a contributing editor of the *American Amateur Photographer* in 1892 and co-editor in 1894; and in the latter year he also won election to the prestigious Linked Ring in England. In 1896, he won major awards at an important exhibition in Cardiff, Wales. He was, in short, a major player on the international photographic scene at a time when other budding modernists remained in obscurity.[3]

Stieglitz did not, at first, think of himself as a theorist of photography, art, nature, or anything else. He was an amateur tinkering at a new hobby, one that was too complicated, and whose primitive early equipment too cumbersome, to have broad appeal. In rebellion against the complacent, manipulative philistia of both his family and his country, he could through photography channel his energies into a field where no one could pester him. Indeed, he needed the hobby so much that it threatened to take over his life: Photography, he told an interviewer as an old man, fascinated him "first as a toy, then as a passion, then as an obsession. The camera was waiting for me by predestination, and I took to it as a musician takes to the piano or a painter to canvas."

Once he had the basic skills down, he worried more about the theory of what he was doing. His early work, insofar as it has survived, was in no way different from the amateur snapshots that any person with time, skill, and equipment could have taken. Nineteenth-century anecdotal and genre painting still reigned outside the avant-garde, and everyone used the language of painting to deal with this new and rather dubious mechanical competitor. In so far as a photographer had artistic taste, he envisaged a scene the way a painter would, composing a pleasing arrangement of light and dark, of horizontals, diagonals, and verticals. A good photograph thus looked like a good painting—and was, by implication, aesthetically derivative and inferior. Both Hermann Wilhelm Vogel, Stieglitz' old teacher in Berlin, and Henry Peach Robinson, the leading British theorist, agreed. After studying Stieglitz' early work and comparing it to little known work of Robinson, Richard Pearce-Moses has found the works "similar in subject and treatment," and in no obvious ways precursors of modern photography. Rather, Stieglitz' works "follow the precepts of Robinson's and Vogel's aesthetic: fidelity to an unobjectionable truth, simplicity, and sentimentality."[4]

At roughly the same time as Stieglitz was under increasing pressure to return to the U.S. and give up such hobbies, a book appeared in

England that stimulated him into rethinking what he was doing. In *Naturalistic Photography for Students of the Art* (1889), Peter Henry Emerson attacked Robinson and the whole Ruskinian tradition of the interpretation of fine art. He made a case for straight photography that became a crucial signpost along Stieglitz' path to a modernist aesthetic. To Peter Emerson, photography should be a science faithful to nature and the proper functioning of the eye: "The principal object in the picture must be fairly sharp, *just as sharp as the eye sees it and no sharper*, but everything else, and all other planes in the picture must be subdued . . . slightly out of focus, not to the extent of producing *destruction of structure*, or fuzziness, but sufficient to keep them back and in place." Such a goal required a skill few possessed, and was more suited to soft British light than to the harsh edges and light of America; it also seemed an almost open invitation to misunderstanding, inviting the inept but "creative" amateur to fuzzy his pictures or to modify them afterwards.

Emerson was an active figure in London, as he helped to form the Camera Club of London in opposition to the Royal Society. He wanted all judges to be artists, and preferred those with experience as impressionist painters because he thought them to be the artists most directly familiar with nature. He wanted exhibitors to show only one picture per frame, with uniform framing; he wanted no retouching; and he wanted the judges to be the hanging committee, each exhibitor being limited to the same number of pictures, i.e., three. Such preferences, seemingly petty or simply quirky, give some idea of what had been going on at Royal Society shows. Pursuing his own ideas as a judge of *The Amateur Photographer*'s "Holiday Work" competition, Emerson came across a dozen of Stieglitz' pictures, recognized their quality, and awarded a First Prize to "A Good Joke." He then contacted his new discovery to see if Stieglitz would translate his book into German. The rapport between the two men seemed very good, at least by mail. Stieglitz never published the translation, but Emerson indicated the tone of their exchanges late in 1889: "Shake—I am an American too."[5]

Such a message, even if open to misinterpretation, could not but have appealed to Stieglitz. He too was something of a displaced American, trained in science, who wanted to create an elite art which was out of the reach of the masses. He used Emerson's ideas as a guide for insulating his activities from the business world of his partners and the social world of his wife. Despite his later reputation as a sharp-edged photographer, he took one picture after another in which steam, mist, twilight, rain, snow, or smoke produced the fuzzy effect that gave such works their generic nickname, the "fuzzies." For awhile, such an emphasis could be a means for establishing photography as a fine art— works of this type were not just pictures, they were a high art that only men of science and sensibility could produce or appreciate. The threat, indeed, was not imaginary. In 1888, George Eastman put the Kodak

on the market, and the slogan, "You push the button, and we do the rest" became a summary statement of the dangers to the new art. Any idiot could operate a Kodak, and soon many were. Serious artists had to organize, as if to repel Tatars.

Stieglitz was all but inert after his return to New York. The change of country, business routine, and marital status obviously contributed to this, as did P.H. Emerson's recantation of many of the ideas in his own book. Deciding that photography was not an art and never could be, Emerson withdrew from view, although his letters to Stieglitz continued. But what Stieglitz needed, once he had settled down, was a new subject as well as an aesthetic. The picturesque scenes he had admired in Europe were nowhere to be found. Not until he could see the city itself as a new subject could he mark his trail into the new century. Such works as "The Terminal" and "Winter on Fifth Avenue" (both 1893) mark the transition. They are examples of a New York Picturesque, both fuzzy and true to nature, unposed yet essentially narrative. As his works from his 1894 trip to Europe indicated, he was still far from a truly consistent modernist view. One of them, "The Net Mender" (1894), was so similar to a painting by Max Liebermann that he faced accusations of plagiarism.[6]

In view of the seeming inconsistency in Stieglitz' practice, the conventional iconographic view of his development will no longer do. The real consistency in his work in the 1890s was contempt for the taste of the masses, the Kodak aesthetic that went with it, and the values of the family members and business partners he did not share. For a man who wanted to be both out of the house and out of the office, the streets were an obvious alternative. As he wandered them, he encountered scenes which piqued his curiosity, reminded him of carefree bachelor days, and took him, however briefly, out of his depressing environment. His trip to Europe did the same. Even if his wife lurked in their hotel room and tried to steer him to shops and restaurants, he could still find moments of respite, camera in hand.

Trapped once again in New York, Stieglitz needed a place indoors in which to hide, nurturing his ideas. He gravitated to the few groups of photographers then active, and in particular to any journal or club that he could push in new directions. In 1893, this meant *The American Amateur Photographer,* where as an editor he could midwife articles in the Emersonian vein, and use his position to establish contact with the Linked Ring in England and comparable organizations on the Continent. But even here, he felt as if he were surrounded by amateurs, and his caustic evaluations of works submitted, summed up in the phrase, "technically perfect, pictorially rotten," became legendary. He quit early in 1896.

A more promising situation arose in May, when he played an important role in merging two weak organizations, the Society of Amateur Photographers and the New York Camera Club. In his opinion, the

surviving organization, the Camera Club of New York, needed a re-spectable outlet, and he proposed a quarterly that could play a role on the national scene. He won a modest subsidy and became chairman of the publication committee for *Camera Notes;* the first number dated July 1897.[7]

As Stieglitz explored the work of the most creative photographers of the day, he faced a situation that seemed anything but modernist. Many works, like his own, were anecdotal, narrative, or genre studies. The acknowledged leader among Americans was the decadent symbolist F. Holland Day, a skilled manipulator of light who photographed his sub-jects as if they had just emerged from a poem of Keats or a story of Wilde. Whistler was obviously an influence on Day and his admirers, and where Whistler went, Japanese influences soon followed. Day's ex-otic clothing, his religious obsessions, and his homoeroticism, while not incompatible with modernism, were too precious to survive for long. Stieglitz courted him, cajoled him, and seemingly did what he could to include him in the events in New York, but Day and he were rivals who were not on the same wavelength, and by the early years of the twen-tieth century were bitter enemies. Since Day was a distant cousin of Alvin Langdon Coburn, and after 1899 close friends with Clarence White and Gertrude Käsebier, such animosities boded ill for the future of modernist efforts in the field, and foreshadowed Stieglitz' later bitter breaks with many of his former friends and disciples.[8]

Most photographers of the time, however, had little in common with Day. While he wandered his perfumed way, they earnestly held heter-ogeneous "Joint Exhibitions" in New York City, Philadelphia, and Bos-ton (1887–94), until the criticism of Stieglitz and others discouraged them. What Stieglitz urged instead was an annual photographic salon with standards. Following the example of the Linked Ring, he sug-gested that the honor of being chosen for show was honor enough, and that prizes were unnecessary. In 1898, he got his chance. The new president of the Philadelphia Photographic Salon wrote him in Febru-ary, informing him that the group would follow his suggestions. A jury of recognized experts, both painters and photographers, would review submissions. In the end, only the photographers were available to serve, and so Stieglitz and two other practitioners winnowed 259 from 1500 foreign and domestic submissions.[9]

This Philadelphia Salon and its two successors were vital in the de-velopment of the network of relationships that provided the core of institutional support for modernism. These salons drew international attention and deserved it. With the more casual photographers ex-cluded, serious artists could expand into the available space, win more attention from both experts and public, and actually meet one another. Stieglitz and Day already had name recognition, but the 1898 show brought the work of Clarence White and Gertrude Käsebier to promi-nence; in 1899, both were on the jury and the great discovery was the

work of Eduard Steichen. By 1900, the jury included Stieglitz, Käsebier, White, Eva Watson, and Frank Eugene—a line-up of artists who would all play important roles over the next two decades. By the turn of the century, in other words, the modernist network was in place before a modernist aesthetic existed and before the fabled gallery at 291 Fifth Avenue had even opened.[10]

Success bred opposition, and in 1901 more traditional attitudes controlled choices of jury and pictures. Stieglitz and his allies boycotted the event and thought about setting up facilities of their own in New York. Eva Watson-Schütze, newly married and hyphenating her name, for example, wrote him in April about the problems in Philadelphia, and about new stirrings in Chicago and in Clarence White's home town of Newark, Ohio. She thought the newly self-conscious artists of photography deserved a closely knit society that would formulate new ideas, supervise salons, and uphold standards both nationally and internationally.[11]

While Stieglitz looked around New York for funding and gallery space, he received important support from an unexpected quarter. Charles H. Caffin, a critic of the First Philadelphia Salon who had reviewed it scathingly in *Harper's Weekly*, made his peace with Stieglitz, changed his mind, and published the first relatively detached assessment of the new movement. An Oxford-educated Englishman, Caffin had come to the U.S. in 1892, at age thirty-eight, and quickly established himself as a sensible critic favoring new and democratic forces in the fine arts. In *Photography As A Fine Art* (1901), he used the work of British photographer J. Craig Annan as a touchstone for examining American work. His well-illustrated volume singled out Stieglitz as the best pictorial photographer and stressed that his work neatly balanced concerns for both science and art without recourse to fakery. A photographer, to Caffin, should always use photographic means to photographic ends, and always demonstrate "Spontaneousness." "In his hands the 'straight photograph,' in the broadest sense of the term, is triumphantly vindicated." Other chapters examined the family portraits of Gertrude Käsebier, the ways an artist like Frank Eugene could stretch the concept of photographic means effectively, the landscapes of Eduard Steichen, and the solid contributions of Clarence White and William B. Dyer. Photography for Caffin was indeed a fine art, and his expressionist approach the best way to evaluate the new achievements: "we have reached the conclusion that the chief beauty in a work of art, be it painting, photograph or silver salt-cellar, is the evidence of the artist's expression of himself."[12]

Following soon after Caffin's volume, the exhibition of "American Pictorial Photography" arranged by "The Photo-Secession" at The National Arts Club in New York, from 5 to 22 March 1902, marked the early maturity of American photography. Artists in Vienna, Munich, and Berlin had pioneered the use of the term "Secession" to separate

defenders of the status quo in painting from those who wished to experiment in radical ways. When Eduard Steichen returned to New York after his initial stay in Paris, he and Stieglitz worked together to put on a show that would gain publicity for their group. Given their general sense of alienation from the customary expressive modes of American life, the adoption of such a term for use in photography seemed natural. The exhibition proved successful: it included, in addition to their own efforts, those of Day, Eugene, Käsebier, and White, and received gratifying newspaper publicity. This show then formed the basis of allied shows that soon opened in Toronto, Cleveland, Minneapolis, Denver, and Rochester, with the work of Alvin Coburn soon an addition. For each of these engagements, Stieglitz was careful to segregate Photo-Secession submissions from others on display. What had begun as several disparate rebellions against philistia, against the majority values of American life, and against the conventions of European and American painting, had become a movement.[13]

III

Anyone seeking a coherent aesthetic position separating the members of the Photo-Secession from others active in organized photography will find both the statements of the artists and the evidence of the pictures bewildering. However skillful, the decadent experiments of F. Holland Day belonged spiritually to the 1890s, his work being more "literary" than photographic in content. Frank Eugene was a long-established painter, trained at the Bayerische Akademie der Schönen Künste in Munich; never a straight or an urban photographer, he shamelessly manipulated his negatives to achieve effects reminiscent of several British and German nineteenth-century schools, as if a photograph could be as artificially posed and as "painterly" as any product of a brush. After 1908 he was a resident of Munich and then Leipzig; although he retained contacts with Stieglitz and other American Secessionists, he dropped from sight as an active participant in "modernistic" events after about 1910.[14]

In many ways, Gertrude Käsebier represented something of an opposite extreme. Born in Iowa, she grew up in Leadville, Colorado, where her father was a silver miner. When he died she went east to live with a grandmother. Quite un-European herself—her name came from her German immigrant husband, a shellac importer—she was a New Jersey farm wife and Brooklyn matron with three children to raise before she received artistic training. Between 1888 and 1893, she studied casually at the Pratt Institute, concentrating on painting and doing little with the camera. Naturally skilled rather than trained, she had an affinity for Japanese landscapes and the work of French symbolists. Only after an 1893 trip to Europe did she shift toward photography. She worked locally with Samuel H. Lifshey, and returned regularly to Paris over

the next few years, but her work always reflected the life of her home and the domestic nature of her experience. Her best-known work remains, typically, "Blessed Art Thou Among Women" (1899), depicting a mother in an informal white, floor-length housedress about to launch her endearingly stiff, formally dressed little girl through a doorway and out, presumably, into a more public world. Almost as famous was her "Portrait of Miss N.," the voluptuous Evelyn Nesbit who figured so prominently in the life and violent death of architect Stanford White. When she experimented with subjects outside the home, they tended to remain portraits, as in her famous shots of American Indians attached to the Buffalo Bill troupe.

As a rule, she did little retouching, preferring to take many negatives and choose the best among them. But she was not immune to post-symbolist fuzziness, the effects coming from focus distortion and from experiments in gum bi-chromate printing rather than explicit doctoring of negatives. Being older than her colleagues and the only woman in the group—members habitually referred to her as "Granny"—she was also less contentious and less given to histrionic posturing. She got on perfectly well with both Day and Stieglitz for years, and mothered Steichen and Coburn on her European visits. When she did break with Stieglitz, as she did gradually from about 1907 to her official resignation in 1912, the reason was less an artistic disagreement than a vocational and financial one. Käsebier wanted to earn a decent living while practicing her art, and had no indulgent relatives to subsidize her. Given an inheritance from his father and substantial subsidies from a wealthy wife, Stieglitz could take a high tone against commerce, but Käsebier found it merely sensible to do what her customers were willing to pay for. He remained unbending, grumbling to German photographer Heinrich Kuhn in 1909: Käsebier "rarely makes good prints now—she has become the business woman through and through." [15]

Next to Stieglitz himself, the most impressive member of the circle to work chiefly in the U.S. was Clarence White. A man whose background was as solidly middle-American as Käsebier's, White was the son of an Ohio pub owner. In 1887, when Clarence was sixteen, the family moved to Newark, Ohio, where his father established a base for a job as a traveling salesman for a wholesale grocery. Showing no outward sign of rebellion, Clarence graduated from high school, joined his father's firm as bookkeeper, remained a devout Presbyterian, and married in 1893. Along with countless other Americans from dreary backgrounds, he visited the World's Fair in Chicago on his honeymoon. He loved it; it was the most urban experience he had ever had.

Hampered by his poverty, job, and rural isolation, White began working on his own during the year of the Fair. He could afford, at most, to expose only two plates a week. He refused to use artificial light, and his job took up most of his time, so he had to rise before dawn to work in early daylight, or race home to get in an hour or two

before sundown. He had no one knowledgeable to talk to. Yet by 1896 he had started winning medals and by 1898 had formed a Camera Club of Newark which, despite all the odds, was as current in its shows as any club anywhere: by 1890 they had seen work by Stieglitz, Käsebier, and Day, and by 1900 Steichen, Demachy, and Eugene. Appearing out of the blue at the First Philadelphia Salon of 1898, he served on the jury in the succeeding two years. He so impressed Stieglitz that Stieglitz arranged a one-man show for White at the Camera Club of New York in 1899; Day did the same at the Boston Camera Club. Eduard Steichen felt so comfortable with the Whites that he and his bride visited them in Newark during their 1903 honeymoon.

The close relationships which these shows imply remain something of a mystery. Although White did admire Oriental art and the work of Degas, he seemed unaware of the European origins of most Photo-Secessionist ideas. He had to produce book and magazine illustrations for money, and was thus inevitably commercial in his interests. In his many travels around the U.S., he became friendly with Clarence Darrow, Eugene Debs, and others on the left, and despite the joshing of Steichen and the scorn of Stieglitz he remained a sentimental, unsophisticated socialist throughout his life—although it never showed in his pictures. He was also inarticulate; where Stieglitz talked interminably and the others at least communicated, White remained silent, both in print and in company. "I don't think he one day made up his mind he was going to work that way; he was just the kind of fellow who would be in it before he knew it," Dorothea Lange wrote decades later. "This was a man who lived a kind of an unconscious, instinctive, photographic life. He didn't ever seem to know exactly that he knew where he was going, but he was always in it." Yet the fact remains that White and Stieglitz got on well for several years, as did the others.

After the 1902 show, these disparate Secessionists had no headquarters. The inner circle dined at Mouquin's or in Chinatown regularly, and gathered frequently at Käsebier's Fifth Avenue studio. In 1905, Steichen suggested his old apartment at 291 Fifth Avenue would be an ideal spot, and so in November of that year members finally had a place they could call their own. After dinner at Mouquin's they formally opened the Photo-Secession and for several years the momentum kept people civil. In 1907, for example, White and Stieglitz collaborated on the making of about sixty negatives, printing about twenty. That same year, White became the country's first teacher of art photography when he accepted an invitation to take a position at Columbia University. Three years later, he opened what he called the Seguinland School on an island in Maine, and in 1914 the Clarence H. White School of Photography in New York. On the surface, the Photo-Secession seemed not only thriving but unified, achieving institutional status.

The surface of this picture was misleading. As long as relationships meant contacts, shows, meals, and stimulation, people got along fine.

The early feud between Stieglitz and Day meant little, for Day lived in Boston, disliked New York, and apparently thought most members of the Photo-Secession his social inferiors. But as *Camera Notes* gave way to *Camera Work,* as unknown artists became established names, and as both artists and critics began praising, blaming, and formulating critical positions in public, friction developed. Stieglitz was charming so long as he was in charge and remained the object of collegial reverence. Major artists put up with him only for so long. Eugene was soon safe in Germany, but Käsebier proved too commercial, and soon White became essentially a paid teacher. Friction grew between 1907 and 1910, and reached the smoky stage with the last important Photo-Secession show at the Albright Galleries in Buffalo.

What really happened at Buffalo remains obscure. Stieglitz devoted a lot of time and energy to it. Even before the show, he had become testy and critical about the Linked Ring and the development of photography in England. As the show loomed closer, he became more fatigued and irritable—his letters to British photographer Frederick H. Evans about packing, shipping, and customs problems indicate that White was only one of many exasperations the show caused him. It did not help that, in the middle of planning the event, one director at the Albright died and an acting substitute had to be brought up to speed. That said, Stieglitz' careless treatment of White's submissions and his unwillingness to rectify a painful situation remain both as evidence of his decreasing interest in photography and his intolerance of criticism from a colleague who had once been a close friend and collaborator.

The specific facts are clear in White's recapitulating letter of May 1912. Important prints, the work of both White and others, had been sent to Buffalo, and no one disputed that they had arrived. When White did not receive them all back, he had complained directly to Stieglitz, who had been in charge and had deeply resented anyone who questioned the fact. Stieglitz then replied with criticisms of White which White deeply resented. "You repudiate responsibility for the care of the prints by saying that they were not loaned to you but to the Photo Secession. You also say that in loaning them to the Secession I loaned them as much to myself as to it," since he was one of its inner circle. "As you are polite enough to characterize my statement as 'false', I take the liberty to call this excuse of yours a piece of petty quibbling unworthy of the Secession, which has always insisted that sincerity is its prime virtue." Because Stieglitz had, undeniably, taken charge of the Albright show, "you certainly took it upon yourself to be responsible for the return of the prints" to all those artists who had contributed. "The management of the Exhibition was in your hands alone, for you made this a first condition before undertaking its direction." Neither other members of Photo-Secession nor trustees of the Albright played a role. Prints came in from all over the U.S. and Europe and presumably Stieglitz had returned most of them. "I cannot see why I should be treated,

in this respect, in any way different from that in which others were treated. Had our friendly relations of the past continued I would, undoubtedly, have saved you the labor of looking up my prints and the prints I obtained from the other artists and taken them away with me." But personal relations between them had "become so strained that it is not pleasant for me to visit the gallery of the Photo Secession."

Stieglitz had apparently snorted that he was not a paid servant and that White could not expect that he be treated as one. White responded that everyone among the membership was a servant who gave his time freely. What Stieglitz could not seem to see was that he wanted to have it both ways: he wanted to be unchallenged boss, and he wanted to speak for the collective membership. The argument, White correctly pointed out with rare specificity, would not wash. "But it was not the Photo Secession but you, who managed the Albright Exhibition. It was you who paid the expenses and settled accounts with the directors of the Art Gallery, and it was you who employed the help and superintended the labor." White could not ask the members to return his prints "because the Photo Secession never meets as a body, never acts as a body, but only meets and acts through you and by you. I prefer to insist on this interpretation of the situation since you have, in your letter to me, shirked your professional responsibility by shifting it onto the shoulders of the Photo Secession." Other members, he was sure, would agree with him and repudiate Stieglitz' approach, "for that is not the spirit which animated them in founding the organization." If Stieglitz were right, then the group would just be one more organization devoted to the politics of art and the advancement of self-seekers. White remained sure that this was not the case. "To the fine spirit which brought us together at one time I still subscribe myself, and will always continue to subscribe myself, a devoted adherent." Meanwhile, he insisted that they divide up, or agree to destroy, all the prints that they had made together only five years earlier.[16]

The Buffalo show and the break with White marked the effective end of the Photo-Secession as a functioning entity. Such an anticlimax could have been due to fatigue, accidents out of anyone's control, creative sterility—several plausible explanations seem available. But beneath the surface of the quarrel with White lay a critical problem, a personality problem, and a genre problem. The critical problem, briefly stated, was the tension between straight, unmanipulated photography and "artistic," manipulated work—clear vs. fuzzy—and Stieglitz' later need to falsify his role in the history of art. The personal problem was the direct result of this, for of all the Photo-Secession circle, White was the one whose work was closest to Stieglitz', and therefore a colleague who could shift swiftly from ally to rival if moods changed. The genre problem was that, by 1910, Stieglitz was well along the road to a concentration on European modernist art, and the work of friends and protégés affected by it. Photography in all three problems could easily

come to represent past error, a sense of fruitless years spent pursuing irrelevant goals.

IV

The Photo-Secession had never theoretically limited itself to photography. An opening announcement in the fall of 1905 talked not only of showing American and foreign photographs, but also of "art productions, other than photographic, as the Council of the Photo-Secession can from time to time secure." For barely a year, Stieglitz showed American, British, French, German, and Austrian photographs; but then, to the surprise of many, he began to branch out. In January 1907, he showed seventy-two drawings and watercolors by the British-American artist Pamela Coleman Smith, and in 1908 included her work in a show of etchings and bookplates by several hands. An echo of 1890s Art Nouveau that was not historically modernist, Smith's pictures were inoffensive and relatively popular, but with the work of other artists, Stieglitz involved his gallery in modernist controversy. From 2 to 21 January 1908, he showed fifty-eight drawings by Auguste Rodin; and from 6 to 25 April, he showed drawings, lithographs, watercolors, etchings, and an oil by Henri Matisse. By the spring of 1909, he was showing the achievements of modernist Americans: oil sketches by Alfie Maurer, watercolors by John Marin, and paintings by Marsden Hartley. The work of others, usually those trained in Europe, quickly followed. By the spring of 1911, a large number of Picasso pictures were on display for a full month. In a brief time, New Yorkers could sample caricatures, children's art, sculptures by Matisse and Brancusi, African sculptures, and archaic Mexican pottery.[17]

As his quirky selection of Pamela Coleman Smith showed, Stieglitz had small personal knowledge of contemporary painting and no innate taste. His family had been devoted to the arts in an amateurish way, but his father had dictated standards that included the work of Franz von Lenbach, Arnold Böcklin, and Franz von Stuck, and Stieglitz assimilated the conventions these works implied painlessly. If a picture conveyed a *frisson* of eroticism, that seemed modernistic enough. Stieglitz did not question customary ideas of form, space, or time. At this early stage, his hostility to convention was vocational, social, and personal rather than aesthetic. He lacked as well the element of personal experience—he was a photographer of great skill, but he was not a painter, let alone a sculptor, at all.

He had a lot to learn and he learned it quickly; by travel, by mail, and by studying the exhibitions which he and others sponsored. During the summers of 1904, 1907, 1909, and 1911, he traveled extensively through French- and German-speaking Europe, seeing as much as he could and picking the brains of those who had preceded him. At least at first, his most important guide was Eduard Steichen. In 1907, for

example, Steichen was Stieglitz' escort at the Bernheim-Jeune Gallery, where Stieglitz apparently got his first important exposure to the work of Cézanne—paintings which he later admitted he found hard to absorb. In 1909, Steichen was there once again, to fill in his friend while the women shopped. Steichen by then was an intimate at both the Stein homes, and he brought Stieglitz to see the Matisses at Michael and Sarah Steins' and the Cézannes, Renoirs, and Picassos at Leo and Gertrude's. Stieglitz long remembered Leo going on and on about Whistler and Rodin and any number of his other subjects, often giving forth opinions which contradicted received ideas in New York. Within days, Stieglitz was seeing the newest works of Maurer and Marin, both of them active in Steichen's New Society of American Artists in Paris. With such a start, Stieglitz could then branch out toward artists not in the Steichen circle, such as Max Weber, and to museums crucial for a modernist sensibility: the Trocadéro for African Art and the Guimet for Oriental. Of all the American painters of the time and place, Weber had the most advanced taste, not just admiring the innovations of Cézanne, Matisse, and Picasso, but actually talking coherently about them. Under Weber's influence, Stieglitz even purchased a Picasso "Nude," a work Steichen never cared for.

After 1907, Stieglitz found a second guide who helped his taste develop further. Marius de Zayas was yet another fringe figure in American culture, appearing out of some exotic nowhere with new tastes, ideas, and languages to play his role. The actual somewhere in his life was Veracruz, where his father wrote history and poetry and published two newspapers. When the repressions of the Diaz revolution in Mexico drove the family abroad, de Zayas settled in New York City, bringing with him an appropriate combination of interests: to an academic knowledge of European art, he added an amateur's enthusiasm for the Aztec art of his native country. He soon earned a reputation in the city for his caricatures in the *New York World,* and when Stieglitz discovered them he offered de Zayas a show: twenty-five were on display in January 1909, and de Zayas was also the focus of shows in 1910 and 1913. He became personally close to Stieglitz, assuming the role Steichen had played in Paris.[18]

De Zayas played his major role in the development of Stieglitz' taste in the fall of 1910, when he went to Paris, plugged into the expatriate network, and sent an illuminating series of letters back to 291. He arrived on 13 October 1910, rented a house and promptly started visiting museums. He went first to the Salon d'Automne, which "made me realize once more the important work you are doing in the Secession for thanks to it, I was prepared to see with open eyes," he told Stieglitz flatteringly. Much of the work struck him as unoriginal. "I found that the largest group is composed by those who after being influenced by Matisse have taken refuge in Greco." This marked a step beyond the initial enthusiasm which many once felt for Japanese art. He did not

care for it. "Their motto must be: repetition with no variation. They all have the same color, the same composition, the same drawing à la Greco more or less spoiled or à la Matisse more or less exaggerated."

One picture particularly seized his attention and he took time to analyze it. "Its title is 'Nu,' and it is executed by Mr. Metzinger," and de Zayas was lucky enough to find a convenient reproduction in a magazine. "The theory of this gentleman is that he sees everything geometrically, and to tell the truth, he is absolutely consequent with his theory. To him a head represents a certain geometrical figure, the chest another, and so forth. The fourth dimension was not enough for him so, he applies the whole geometry. Afterwards I was told that this personalist is also an imitator, that the real article is a spaniard, whose name I don't recall, but Haviland knows it, because he is a friend of his brother." Paul Haviland was a Frenchman intimate with Stieglitz and the 291 circle, Frank Burty Haviland was his Paris-based brother, and de Zayas had just discovered Pablo Picasso, then well-known in the Stein circles but not at 291.

Not all the news was on so exalted a level. De Zayas was pleased at the quality of some of the works that he saw, specifically mentioning those by Maurer and Steichen, but much of his letter dealt with the hostile relations that had developed between Steichen and Weber. For reasons that remain obscure, Weber had been blackening Steichen's name in New York, and de Zayas personally regarded Steichen as the "most important and active member after you" of 291; he found the descent into gossip painful, but thought it "unfair not to put him on gard about the damage Webber wants to do him as an artist and otherwise." On a more positive note, de Zayas saw Marin at the "famous café au Dome"; "He intends to go to New York pretty soon. Steichen says he has done some wonderful work in the Alps." [19]

De Zayas never learned to spell many words or names accurately and his grammar was often Spanish or simply whimsical, but his messages came through clearly despite his linguistic improvisations. By the end of 1910 his mood had soured. "Paris has affected me in a different way from what I had expected. I have a general feeling of disgust. I have discovered to many frauds and roberies in art, to many ill intentions, and to much humbug . . ." Americans associated with 291 were among the few redeeming features of the city. "I saw Steichen lately . . . He is too big to many a brain to understand." His work in oil was improving, but did not show any noteworthy modernist influences. De Zayas had not been able to see Marin for some time, but "Steichen told me that his bussy paintin, that he is working now in oil, and that he is getting to be in the real mood for work."

The Paris damp soon got to him, and for the next few months illness in various forms was a favorite topic. When he recovered, de Zayas was clearly eager to confront modernist painting. He wrote two articles on French art, and made a persistent search for material on Cézanne which

yielded only a brief German-language monograph; he forwarded it along with his articles to Stieglitz. He intended to interview Picasso and write up the results for *Camera Work*. He had become convinced that modern art needed explication, and that if it got such analysis, then the public would be more accepting. Since Spanish came most easily to him, he turned out a piece in that language on Picasso almost immediately. By April 1911, he was suggesting an exhibition of Spanish art for 291, with Picasso at its center. Such a show would demonstrate that what he called "ecleticism" had had a significant impact on "the descendants of Velasquez and Goya." Picasso, he continued, "is very much interested in the idea of the Secession and curious to know the results of his exhibition." The letter arrived in the midst of the major 291 Picasso show, 28 March to 25 April 1911.[20]

By late April, de Zayas could forward examples of Parisian criticism of the Independent Artists Exhibition; he believed, however, that New York newspapers offered their readers more and better art criticism than Parisian ones did. Personally, he was off on a new tack: "I remarked more than ever the influence of the african negro art among this revolutionists. Some of the sculpture have merely copy it, without taking the trouble to translate it into french." He was convinced that the Secession should have a show "of the negro art." All was not the smooth assimilation of new influences, though, for de Zayas reported that Picasso was personally irritated that some of the drawings he had loaned either to Steichen or Stieglitz had not been returned. The charge was by now a familiar one in the 291 milieu; in this case de Zayas blamed Frank Haviland for the problem; but of course the effusive Mexican would never have blamed Stieglitz for anything. At this point, de Zayas' trip ended; he was still in bad health, and his mission was largely accomplished. He returned to New York and, even a year later, faced a stay in Mount Sinai hospital: I "feel quite proud of my disease, for it has been declared by all doctors as 'most unusual'. I feel I am a secessionist even pathologically."[21]

With this much assimilation under his belt, de Zayas had become very nearly the equal of his friend Steichen in the perception of Parisian modernism, and, given Steichen's rejection of the more radical departures from convention, perhaps his superior. Regardless of such considerations, during the summer of 1911 Stieglitz made his last trip to Europe, and both men served as his guides. No one was more aware than he of the progress he had made since his earlier trips. Three weeks spent in the Louvre and among the moderns, he informed Sadakichi Hartmann after his return, "made me realize what the seven years at '291' had really done for me. All my work, all my many and nasty experiences had all helped add to prepare me for the tremendous experience." He remained convinced that Americans had no real art of their own, but Europeans could boast several masters; he singled out Cézanne, Renoir, Van Gogh, Matisse, and Picasso.[22]

At this point, around the turn of 1912, Alfred Stieglitz lost the leadership of the avant-garde in America. Neither he nor any of his artists would have admitted it at the time, but he was no sooner prepared to lead than the leadership slipped from his grasp. In rapid succession, the Armory Show seized public attention and made modernist painters, once the property of a tiny elite, into media heroes; Mabel Dodge's salon hit its stride, bringing not only other painters into view for consideration, but also playwrights, journalists, and those oddities in the modernist camp, campaigners for public causes such as birth control and free schools; and Walter Arensberg established himself, replacing Dodge, as host of choice for partying cultural radicals. Faced with publicity he resented and competitors he did not always understand, Stieglitz retreated. He picked quarrels with even his closest followers, often over marginal issues. With Steichen, the most obvious issue was the war, their conflicting attitudes toward France and Germany masking the fact that they were going separate ways regardless of public events. With de Zayas and several others of the inner circle, the issue was commercial: in his dislike for the public, and the tone of both business and politics in America, Stieglitz preferred to cut himself and his artists off from both publicity and markets. Several of his artists, to his dismay, desperately wanted both appreciation and an income. Even as 291 had to share the leadership of the avant-garde, it came apart from internal friction. Stieglitz remained, during the 1920s, an important figure, but more as a revered ancestor than as a seminal force. Like his friend Sherwood Anderson, he had nothing more to say and many years in which to repeat himself. Acolytes muttered incantations and wrote down his sayings, but Stieglitz became an institution and institutions by nature are not creative.

V

Like most publicity triumphs, the Armory Show had less to it than met the eye. It became an instant cliché. Although many of its works of art were relatively conventional and even conservative, it drew in masses of people and many incompetent journalists who focused on a small number of paintings, working themselves into paroxysms of adjectival eruption and doggerelic effusion. This aspect of the show was important in only one sense: it informed everyone that modernism, whatever it was, was happening. It was a given, it was international, and it was not about to vanish.

As any examination of the surviving documents demonstrates, much of the impact of the show was unintentional. At its core, the Armory Show was the result of the activities of three men who found themselves fortuitously in the right places at the right time to energize and fertilize each other. Stieglitz could lament, publicly and repeatedly, "but I started it all!" but that was true only in a metaphysical sense. Walt

Kuhn started it. Arthur Davies masterminded much of it, and Walter Pach introduced both of them to the artists who mattered. In combination, these three men and their show mentored Stieglitz more than the other way around. What was most important about the show was the sudden injection of attractive foreigners into the New York scene. Steichen and de Zayas were able men of charm and skill, but they were not in the same league, creatively speaking, as Francis Picabia and Marcel Duchamp, and the other French artists who soon joined them.

Walt Kuhn was a first generation American: his father was a German immigrant who owned the International Hotel in New York; his mother was the daughter of a Spanish diplomat. Walt grew up fascinated by vaudeville, the circus, theater, and sports. Never much interested in schooling, he nevertheless went to Munich to study art. He worked under Heinrich von Zügel, a relic of Barbizon *Tierkunst,* who filled his canvases with horses, cattle, sheep, dogs, and varieties of flora. Kuhn did work in a similar vein, then returned to America to teach and draw cartoons for several journals. He married Vera Spier, the daughter of another German immigrant, and was soon active in the circle of progressive painters around Robert Henri, becoming a close friend of William Glackens.[23]

Plans for the Armory Show appeared in Kuhn's correspondence late in 1911. Often separated from his wife, he wrote her frequently and in detail. Requesting her not to discuss his plans with anyone, he mentioned a "new Society" that he had in mind. It would seem to include Robert Henri and his followers, but would actually both coopt and downplay them. Inspired by public support from such open-minded critics as James Huneker, buoyed by friendship with the wealthy lawyer and art lover John Quinn, Kuhn felt ready to take on everyone to open the public mind to new art. His idea was to form "a big broad liberal organization embracing every kind of art, even that which I do *not* like, one that will interest the public. The soft boys must be there too. The thing must be started so that it can grow and be as big or bigger than the academy within 2 or 3 years." He hoped to make Glackens the president, and keep the title of secretary for himself. "Don't worry, I'll be the real boss, but it will be under cover." He planned to be the only person to deal with the press, and to achieve a reputation for absolute "liberality and broadmindedness."[24]

Kuhn discussed matters with Huneker and Quinn, and with his close friend Frederick James Gregg, none of them modernist but all of them sympathetic to much that modernism produced. This pattern of sponsorship by sympathetic non-participants continued in one of the two most crucial friendships of the Armory Show, that between Kuhn and Arthur Davies, the enigmatic artist who soon took the office of president of the new organization. In 1910, when Kuhn and Davies first met, neither Kuhn nor anyone else knew much about Davies' life, the outlines of which only came out many years later. Born in 1862, Davies

was almost a generation older than Kuhn, and he had developed a reclusive life for good reason. Escaping a rigidly Methodist family, he had studied at the Chicago Academy of Design briefly before going off to Mexico as a draughtsman for an engineering project surveying railway lines. A sketcher and magazine illustrator who struck most observers as intense and moody, he seemed to settle down a bit when he married a physician and bought a home near Nyack, New York. Only the name of his home, "Golden Bough," gave a slight indication of the eccentricities to follow. He had taken it from James Frazer's classic anthropological study, soon to inspire T.S. Eliot and other modernists who looked to ancient myths for inspiration.

Davies developed local connections with William Macbeth, one of the more enterprising gallery owners. He commuted regularly to New York City, traveled widely in both the U.S.A. and Europe, and in a vague way associated himself with Robert Henri and "the 8." But neither realism as a style, nor progressive reform as a need, ever appealed to him. He felt drawn to classical art, especially the nude. He disliked academic art, genre painting, and landscapes, and such prejudices were common throughout the more rebellious art circles. But Davies was, like Stieglitz, another admirer of Böcklin and the more mystical symbolist painters of the late nineteenth century; he was also superstitious, believed in astrology and spiritualism, and thought of himself as a psychic. Far from being an ally of the Henri group, he was a rival for the leadership of the more conservative rebels. Never much attracted to cubism, his true radicalism lay in his lifestyle, which he carefully hid. In 1902, he had begun an intimate relationship with Edna Potter, an intelligent, sensual model and dancer, and for years maintained separate families, spending weekdays in the city and weekends in the country.[25]

The relationship between Kuhn and Davies went into its most productive phase in the summer and early fall of 1912. Kuhn was painting in Nova Scotia when Davies mailed him the catalog of the *Sonderbund* exhibition then about to open in Cologne, with the wistful comment: "I wish we could have as good a show as the Cologne Sonderbund." Kuhn responded immediately, cabled Davies to get him steamship reservations, and headed off to catch the show before it closed. Davies saw him off. "It's up to me to get a bunch of fine things and if it can be done within the money on tap, I am going to do it," he wrote Vera from onboard; "that Cologne show is important." He arrived in Hamburg on 29 September and was in Cologne the next day. "Sonderbund great show Van Gogh & Gauguin great!" he effused in a postcard. "Cezanne didn't hit me so hard. I met Munch, the Norwegian this morning fine fellow."

As far as personal exposure to Europeans was concerned, the encounter with Edvard Munch was the high point of the visit. "Munch is about 50, a tall nervous sort of fellow with a handsome head," he told

his wife. "He paints big wild figure things, very crude but extremely powerful. He and I soon made friends" and had dinner together. "He is on top of the wave in Europe," and promised two pictures for the show. Kuhn was pleased as well with other discoveries. "Van G and Gauguin are perfectly clear to me. Cézanne only in part . . . his landscapes are still greek to me, but wait, I'll understand before I get home." He wanted to throw his hat in the air he was so happy. "I feel that this trip will act as a purgative and clarify things which would otherwise require years." He soon headed off for The Hague, Berlin, Munich, and Paris.[26]

In The Hague, Kuhn was pleased at his reception and received numerous promises regarding works of Van Gogh, Schelfhout, and Redon for the show; he had an especially high opinion of Redon. In Berlin, while he poured his major energies into prying works of Van Gogh and Cézanne out of dealer Paul Cassirer, he also took the time to look at a dozen paintings of his former mentor then on show: ". . . this trip is going to do a lot toward clearing my mind," he wrote home. "Today Zügle looks to me like a man with a lot of knowledge and hardly anything else. It was another shock. It showed that I hadn't spent the last 10 years in vain anyway." Otherwise, he was not impressed by the art scene in Germany. No one seemed *"gemütlich,"* and his postcard verdict was: "No good art being done in Germany, am anxious to get through and go to Paris." He delayed, however, long enough to visit Munich, which he judged harshly. "Munich is absolutely dead as an art city," he wrote Vera. Everything had gone sentimental, trashy cabarets had sprung up everywhere, and New York seemed preferable. He gave only the lightest of signs that he was aware of the group around Kandinsky: "I am getting more information regarding all those freak cubists etc" he scrawled on a card.[27]

As Kuhn traveled, notes from Arthur Davies came in, keeping him up to date. Early in October, Davies informed him that he was consulting Roger Fry, widely regarded as the leading English critic of contemporary work, and that Kuhn should make every effort to get good work in London. Davies was less successful in finding native work that met his standards. The "better painters" of America were "not of the slightest interest to any serious artist," and he also conveyed his skepticism about "the successful Norwegian," a reference to Munch. He was relying strongly on the advice of Walter Pach, who was turning out to be the man-behind-the-scenes for the show.[28]

By late October, Kuhn was in Paris, exuberant and "seething with ideas, what a Godsend that I had this opportunity," he wrote Vera. He met Walter Pach immediately and liked him; he disliked Jo Davidson, whom he found very "Jewy." By early November, Davies had arrived, and Pach escorted them to Gertrude and Leo Steins' salon, and to the studios of the brothers Duchamp/Villon, where Davies in particular found the work of Marcel Duchamp appealing. They visited Brancusi and

bought a marble torso which later appeared in the show. They admired the work of Odilon Redon, making decisions that gave that artist his disproportionately large space in New York. They met Patrick Henry Bruce and Morgan Russell, and their works joined those of other active artists on the Paris scene, from Matisse and Picasso to Gleizes and Picabia. Galleries run by Ambroise Vollard and the Bernheim-Jeune were cooperative to a point, and Durand-Ruel supplied several important impressionist works. Vollard's chief rival, the gallery of Emile Druet, supplied over a hundred works. Frenchmen clearly saw possibilities in the American market, and were quick to take advantage of the free publicity.

Although he repeatedly said that Europe was fading and America blooming, culturally speaking, Kuhn seemed fascinated by both the gossip and the art of the most creative city in the world at that time. "Picasso is the great man here. I have seen some really fine things by him but they were not cubistic." Cubism attracted him increasingly, and he noted that it had helped him to understand Cézanne. The futurists, who had just arrived noisily on the scene, he dismissed as "mostly fakers." He was soon coming to conclusions more important than first impressions. "We have not been able to judge at home, what this thing over here really means—the few imitators we knew, could not do justice to it," he told his wife. "You have no idea of the enormity of it. I will try to sum it up for you in a few words."

Since their most recent trip to Nova Scotia, he had had the germ of an idea that Paris seemed to be nurturing: "The extraction *out of nature* of the most simple and expressive force. *Specifically* varied according to temperament, in other words no more *picture* painting, which you know has been my watch word, long before we heard of this." In 1912, this meant "absolutely no concession to any public, other than the will of the artist." Such an attitude was the essence "of this new movement which is as great an event in art history as the renaissance, and it's glorious to be in on it."[29]

By the second week in November, both he and Davies were exhausted; Kuhn declared Paris too stimulating and yearned for the quieter pace at home. He thought that a visit once every three years was all that he could profit from. On 12 November he and Davies went to London for a week, and then returned to New York. By the middle of December, Kuhn had recovered completely, reveling in the increasing attention from the press and the contributions that were arriving. "This show, will be the greatest modern show ever given anywhere on earth, as far as regards high standard of merit," he told Vera with customary reticence. He then added, in an understatement of epic proportions: "Pach deserves a lot of credit . . ."

The relationship between Kuhn, Davies, and Pach remains the unknowable element of the Armory Show. Pach's papers and books say little about what happened, but his role seems to have been crucial.

Pach was himself a modernist painter; he knew all the modernist paint-
ers in Paris, both European and American. He was a critic of taste who
rivaled Charles Caffin in this period and Paul Rosenfeld in the next.
Neither Davies nor Kuhn, by contrast, had any understanding of mod-
ernist work after Cézanne. Kuhn's letters are those of an innocent abroad,
engorging himself with the opinions of others, with an acute sense of
which way the wind was blowing. Little in either his art or that of Da-
vies shows anything like a true understanding of most of the movements
of modernism: a touch of cubism perhaps, but no sense of synchro-
mism, futurism, Orphism, and the rest. In terms of genuine compre-
hension, both Kuhn and Davies were well behind Stieglitz; the show
they did so much to initiate was something of a historical accident.

Insofar as the Armory Show was a publicity event, then, Kuhn and
Davies deserve all credit for it; but insofar as it was a triumph of mod-
ernist taste and a showcase for modernist achievement, Pach deserves
it. Except for an early letter of 12 December 1912 from Kuhn to Pach
which has long been in print, he never got it. Kuhn cooperated with
him for a few weeks and then soured; as for Davies, his feelings came
through clearly in one of Kuhn's letters from the summer after the
show had closed. Davies "has grown tired of too much *Pach*. D. says
Pach is merely a man with an acquired encyclopedia and *no personal
judgement*," Kuhn told his wife. "I was right when I thought that it would
only be a matter of time and he would get wise to Mr. W.P." Occasional
mentions in subsequent letters show Kuhn going out of his way to den-
igrate the art and the commercial activities of the man who had done
the most to make the Armory Show what it was.[30]

These personal rivalries, however, should not obscure the broad con-
tours of what was shaping up to be a battle between four competing
tendencies in the New York art world. Kuhn loved both athletics and
circuses, and his combative attitudes perhaps contributed to an atmo-
sphere that any journalist could have described as a hockey play-off, a
world series, or the greatest show on earth. One group of conservatives
clearly opposed all change. A second, the progressive painters who fol-
lowed Robert Henri and John Sloan, remained representational in form
but politically and socially aware. Kuhn, Davies, and their allies were
obviously a third group of those who were sympathetic to modernism
but not themselves comfortable creating modernist work. Painters of
the Stieglitz camp, with allies such as Pach and Weber who might at
any given time be quarreling with Stieglitz but who still belonged spir-
itually to the principles of non-objective or 4th-dimensional art, consti-
tuted the avant-garde. Tactical maneuvers had momentarily permitted
an alliance between individuals in groups two and three, giving way
quickly to one between groups three and four. But innate dispositions
had to assert themselves over time, and Pach belonged far more in the
modernist than in the merely sympathetic group. A complicating factor
was the matter of anti-Semitism. As Kuhn and Quinn drew closer, the

lawyer's outspoken prejudices reenforced the painter's quieter ones. Since Stieglitz, Weber, and Walkowitz, for example, were Jewish, any long-term relationship to Quinn or Kuhn was unlikely. To be specific, Kuhn dismissed the work of Morton Schamberg as being that of "a Jew," and seemed to widen his use of racial denigration to include Italians as well: he greatly disliked the work of Joseph Stella, for example. Davies aside, the artist whose work Kuhn most admired seemed to be Maurice Prendergast; he found it "absolutely satisfying."[31]

VI

As a publicity event, the Armory Show unquestionably did two things: it raised the visibility of modernist experiments in painting and sculpture, and it lowered the tone in which they were discussed. Although the 291 group already was aware of most of what went on display, the show clearly educated Kuhn and Davies and numerous other artists. Most of the Henri/Sloan group seemed overwhelmed, and if the show did anything to them, it prevented them from developing along their natural lines without giving them a new vision with which they could feel comfortable. Conservatives were alienated and ignored the new work insofar as they could. As for the public and the press, they sniffed, told stories, muttered jingles, and confirmed each other's prejudices. The mass of public opinion about art has never been intelligent in America, and the Armory Show changed an apathy about modernism into active opposition.

Such concerns properly belong more in the history of journalism than the history of culture. For the artists and critics who mattered, the impact was two-fold. In the short run, artists and critics could see the work of foreigners of whom they had previously heard but never actually seen. The works of Cézanne, Gauguin, and Van Gogh were there from among the older pioneers; the works of Picasso, Matisse, the Duchamp/Villon clan, Delaunay, Braque, Derain, and Léger were representative of less familiar artists. Prepared as he was by the steady stream of letters and cards from Marsden Hartley, Stieglitz, for example, could buy his first Kandinsky, "Improvisation #27." But he was appalled, he wrote the painter afterwards, at the stupidity of the people who could not see its importance. "I have known your work for some time and have also known your books for some years."[32]

In the long run, something much more important happened. In the course of putting on the show, the sponsors had attracted a few of the artists themselves. Painters who had been in neglected coteries suddenly found themselves in an America they had known only as legend and myth; they found friends who valued them and their work; they found themselves interviewed in newspapers. For the Stieglitz circle, the most important of these was Francis Picabia, and an examination of his brief periods of residence in New York illuminates not only the

American encounter with European modernism, but also the European encounter with the modernism which American life seemed to embody: the city, the machines, the clichés of popular culture, that were soon having a direct impact on Dada in Zürich and Paris, and an important long range impact on creativity in Central Europe. Jazz was not the only American contribution to Europe in the 1920s.

Fully as much as any American, Picabia was an outsider wherever he was, converting his sense of cosmopolitan displacement into new languages. He came from a relatively wealthy Spanish family that had made its money in Cuba and invested it in Spain. Growing up in Paris, feeling most comfortable with impressionists, he was personally close to Pissarro's sons and a great admirer of the work of Sisley. Sexually liberated, he experimented as he pleased and then settled down, for a few faithless years, with Gabrielle Buffet, whose memoirs of the period remain essential for any understanding of what was going on.

Picabia's painting had gone through a series of enthusiasms, none of them original, before he arrived in New York. He went through a fauvist phase, and from 1909 to 1913 sampled cubism and Orphism as well. In 1910 he met both Marcel Duchamp and Marius de Zayas, became close to both, and experimented with "pure painting," presumably an attempt to produce in two dimensions the effect of music, or at least the contents of consciousness. He was also, like Max Weber, interested in experiments with the fourth dimension. At times, personal dissipation and congeniality were at least as influential as theory on him; he was a great buddy of Guillaume Apollinaire during the period when that poet was pretending to an inside knowledge of cubism, but the record remains more one of a mutual fascination with alcohol, drugs, and fast cars than it does with aesthetics.

For the Armory Show, the Orphist group was crucial. Along with Picabia and the brothers Duchamp, it included not only Delaunay and Kupka, both of them having influence on Americans working in Paris, but also Albert Gleizes and Jean Metzinger, whose book, *Du Cubisme* (1912), was one of the most influential sources of American knowledge of cubism. Gleizes, in addition, lived briefly in America during the war, on the fringes of the Arensberg salon. According to Jacques Villon, Walter Pach was the man who introduced Gleizes to the Orphists, and this connection seems to have been crucial in leading de Zayas and Walt Kuhn to their heavy emphasis on the work of the group that was so apparent at the Armory Show. Duchamp became the most publicized artist of the show, and his brothers, Picabia and Gleizes received invaluable exposure there. Thus, the image of what was truly modern came to American attention directly from Orphist activity and the famous exhibition, *La Section d'Or,* in which they showed their work most prominently in 1912.

Picabia and his wife arrived in New York 20 January 1913 and immediately charmed both reporters and artists. The press interviewed

him frequently, printing his views at length, and everyone seemed to ponder his pronouncements with great seriousness. Essentially, he defended an abstract art which he termed "Amorphism," clearly the product of his talks with his wife, Duchamp, and the Orphist group. He stressed, first, art as a parallel to Wagnerian music: ". . . I am seeking a certain balance, through tones of colour or shades, in order to express the sensations I receive from things in the manner of a leitmotif in a musical symphony. Creative art is not interested in the imitation of objects," he informed the readers of *World Magazine*. He insisted that in his own work, he had gone beyond cubism. He did not care for cubes or the reproduction of models. "My idea is different, for I do not reproduce an original; nobody will find in my painting the slightest trace of a model." He thought art should "succeed in converting thought and inner feeling into something external, projecting on to the canvas subjective emotional, temperamental or mental states," he told readers of the *New York Globe*. Photography had helped greatly here, for as many Americans in the 291 circle had come to realize, photography took care of objective reality so well that painting could turn to other tasks. "Pure art will not be that which reproduces an object but that which makes real an immaterial fact, an emotive fact." He felt free to experiment with one form after another because no subjective art could ever be bound solely to one "definite form of expression," for that soon degenerated into a convention. Cubism had been liberating but had quickly become a convention, limiting artistic freedom: "That is why I have abandoned Cubism" for a totally spontaneous means of expression based on line and colour," he told readers of the *New York Tribune*. He then assured them, in a sentence that made him a friend for life: "The man best informed about the revolution in the art of painting . . . is a New Yorker: Alfred Stieglitz."[33]

Stieglitz was enchanted. He may have felt left out of the Armory Show, he may have been offended by the circus atmosphere, but he doted on the approval of talented foreigners, and both Picabia and his wife received the 291 version of a royal welcome. Picabia had only four works in the Armory Show, but as soon as it closed, Stieglitz put sixteen of his watercolors on display at 291, from 17 March to 5 April 1913; *Camera Work* devoted a special issue to Picabia's work, which appeared in June. The artist and his wife remained in New York until 10 April, and when they left Stieglitz summed up his feelings to Arthur Carles. "All at '291' will miss him. He and his wife were about the cleanest propositions I ever met in my whole career. They were one-hundred percent purity," and this, "added to their wonderful intelligence made both of them a constant source of pleasure." He had come to 291 "daily," and Stieglitz was sure he would "miss the little place quite as much as we miss him. It is all very wonderful." Picabia even left Stieglitz five of his New York works, to use as he saw fit. Meanwhile, Picabia had gotten on so well with Mabel Dodge that the two of them planned to open a

gallery in Paris that would carry on the 291 spirit. As Stieglitz wrote Arthur Carles, "The experiment will certainly be worth while. Of course the outcome will be something entirely different, but it ought to be interesting, if the fellows who are to run it have sufficient character and patience to stick it out." What was essential was that they all share a sense of the 291 ideal. "Picabia has this I am sure. But whether the others who are to associate themselves with him have the necessary purity, I don't know. And purity in the real sense, as I understand it, is the first essential." Stieglitz closed with a mention of de Zayas which indicated the accord between three such different people: "The De Zayas's are up now. It is possibly the most remarkable thing we have as yet had. Even Picabia was astounded at De Zayas's ability."[34]

Recapturing the Picabias' response to this first visit remains difficult. Too much of the story has become subsumed into the story of their relationship with Marcel Duchamp and his role in the Arensberg circle, and the American contribution to the history of Dada. Readers of Buffet-Picabia's French memoirs have tended to ignore the freshness of the couple's perception of America, while readers of the brief English version have not had all the relevant details available. In the complete version, she stressed the central role which Walter Pach played in overcoming their original fears about coming; America seemed so far away and they had wavered back and forth, deciding to come only at the last minute and for only two weeks during the Armory Show. Neither spoke English adequately; Gabrielle understood only a little of what she heard, while Francis could only say "railroad" and "Broadway" clearly. Both found American accents troublesome, and for awhile even had trouble realizing that when people said "Piquébia" they were trying to pronounce their name. Interviews were apparently full of pleasant incomprehension, with Picabia occasionally interjecting his two words in a decent American accent while his wife did her best to comment on their first impressions, on the status of American women, and even in passing on questions of art. The interviews which appeared in the newspapers over the next few months thus have to be taken with several grains of salt; some may have been fabrications, others the result of linguistic confusion.

Still, accuracy was possible for those who wished it. Paul Haviland and Walter Pach were readily available to clarify French expressions, and Marius de Zayas omnipresent. At 291, Buffet-Picabia also recalled meeting John Marin and Marsden Hartley, although dating these meetings precisely no longer seems possible. She also met Arthur J. Eddy, an important early collector and, in *Cubists and Post-Impressionism* (1914), a writer about early modernist art. Eddy was a man who, she remained convinced, did not understand modern work and was really only investing in the art futures market. She recalled Mabel Dodge, characteristically *"en grande crise conjugale et en quête d'aventures sensationelles."* New York was not, however, just people with reputations. It

was also black music and dance—she does not use the word "jazz"; iron bridges; and films, especially comedies, westerns and *The Birth of A Nation,* which they watched for four hours without being bored. The Picabias clearly returned to Paris as fascinated by New York as New York had been fascinated by them.[35]

Thus, when de Zayas returned to Paris in May 1914, he found a situation far different from what he had encountered a mere four years earlier. The preparations for the Armory Show, and the networking that resulted, had made a coherent group out of the French and the American avant-garde; it included individuals who had never been to New York, and knowledge of the work of those who did not live in or often visit either Paris or New York. Cultural orphans from English-, French-, and Spanish-language backgrounds, with admixtures of Russian, German, and Italian, had found their own Esperanto, so to speak, that assumed mutual comprehension through painting and its relationships to poetry and music. When he arrived in Paris this time, de Zayas automatically went to visit Picasso and Picabia, and in his first letter to Stieglitz said that he was waiting to hear from Gertrude Stein so that he could caricature her for *Camera Work.* Over the new few days, he and Picabia crossed the city, visiting painters and galleries: "in all our excursions we make propaganda for '291' and 'Camera Work.' " The publication seemed to be well-known, probably more by talk than through actual subscriptions; de Zayas suggested that copies be sent to Apollinaire and the group involved with "Les Soirées de Paris."

Picasso was friendly, but de Zayas ran into problems with dealers in getting pictures for display in New York. He talked to Daniel-Henry Kahnweiler, one of the best-known of the Paris dealers working with modernist art, but Kahnweiler claimed that his hands were tied because of a contract he had with the Brenner Gallery in New York to be sole agent for Picasso's works. In the ultimate put-down from someone using a Stieglitzian vocabulary, de Zayas then dismissed Kahnweiler as commercial, as if that were not his function. He consoled Stieglitz with the news that the Picabias personally owned about eighteen Picassos, eight of them in his most recent style, and were willing to lend them and even sell them. "Picasso's latest pictures are to me the best and deepest expression of the man, with a remarkable purity that his other work lacks." He wanted to go ahead and plan to use Picabia's collection, and perhaps combine the show with the work of Marie Laurencin, perhaps as a gesture to her companion, Apollinaire. He also began pushing for a show of Negro art at 291, a subject that continued to fascinate him and one that he was soon working into a brief book.

Stieglitz had long had good relations with Gertrude Stein, and had praised and printed her writing, a sure way to her good graces. De Zayas brought him up to date. "I saw Gertrude Stein last Saturday. I was very much pleased with her. For the first time in my life I have had the pleasure of laughter with a woman, and I don't know of any

one who has a deeper sense of the comic than she has." They spent
two hours together, with Alice Toklas hovering in the background, "a
California girl" who was "physically, the reverse of Gertrude Stein."
Picabia and de Zayas, over the next few days, visited Matisse, "in his
Paris studio," finding "his latest work" "very moderate both in color
and form. He show us some interesting litographs." They also spent
four hours at Vollard's house looking at his Cézannes which they found
impressive, and "about fifty rotten Renoirs."[36]

The most important of these contacts, artistically, was with Picasso.
In early June, de Zayas spent "quite a long time" with the Spanish painter.
"We had a very interesting and intimate talk on art and on his latest
manner of expression. He open himself quite frankly," and de Zayas
clearly made an effort to put down notes that would be of use to Stieg-
litz. "The sum and total of his talk was that he confesses that he has
absolutely enter into the field of photography. I showed him your pho-
tographs. . . . He came to the conclusion that you are the only one
who have understood photography and understood and admired the
'steerage' to the point that I felt incline to give it to him. But my will
power prevented me from doing it."

At this point de Zayas took a quick trip to England, both to meet
photographers and to interview possible subjects for his caricatures. He
had a long visit with George Bernard Shaw, and a shorter one with
Roger Fry; he was unimpressed with the show of Independent work
then on display. He had a pleasant meeting with Alvin Coburn. He
then traveled out into the countryside for a talk with Child Bayley, with
whom he was most impressed, and examined over one hundred pho-
tos. Bayley in turn wrote Stieglitz: "A few days ago De Zayas turned
up. He seems a very delightful fellow, and we had quite long confabs,
on most things under the sun. He came down here, so I was able to
show him rural England. . . . Needless to say we talked much of 291
& of 'Camera Work.' "[37]

Back in Paris, de Zayas continued to work with the Picabias and Pi-
casso. He arranged with Gabrielle, the only Picabia with whom he could
talk business intelligently, to send their Picassos to New York, but he
then asked Stieglitz if he were willing to include the work of Georges
Braque as well. Braque was, he said, a "satelite" of Picasso, but he as-
sured Stieglitz that Picasso owed much to Braque as well. He then rec-
ommended a Picabia show as well. "Picasso represents in his work the
expression of pure sensibility, the action of matter on the senses and
also the senses on matter while Picabia's work is the expression of pure
thought. Picasso could never work without dealing with objectivity while
Picabia forgets matter to express only, may be the memory of some-
thing that has happened. One expresses the object the other the ac-
tion." De Zayas thought it interesting to contrast these "two cases of
plastic expression. And I believe that exhibiting them at 291 this point
could be brought out clearly."

In other sections of this letter, he reported that he had lowered his opinion of the work of Marie Laurencin, whose name he never did spell correctly, and at this point she begins to drop from any American view of important work going on in Paris. He was far more interested in Negro art, going back to the Trocadéro again and again to photograph examples of it for use in writing what became *African Negro Art: Its Influence on Modern Art* (1916). He was impressed by a Rousseau collection. Apollinaire, he reported, "is doing in poetry what Picasso is doing in painting. He uses actual forms made up with letters. All these show a tendency towards the fusion of the so called arts. I am sure that this mode of expression will interest you." Meanwhile, he took seriously his self-appointed role as networker between French and American modernist communities. "I am working hard in making these people understand the convenience of a commerce of ideas with America. And I want to absorve the spirit of what they are doing to bring it to '291'. We need a closer contact with Paris, there is no question about it." He spent part of his last few days touring the galleries with Agnes Ernst Meyer, a wealthy admirer of Stieglitz' and the subject of one of Eduard Steichen's most reproduced portraits. She bought a Picasso, a recent, characteristic one.[38]

By early August, as the guns were blasting out over Central Europe, de Zayas was landing in New York with the works of Picasso, Braque, and Picabia that he had been discussing. By November, 291 was showing eighteen sculptures from Nigeria, the Ivory Coast, and the Congo in a show of "African Savage Art"; on 9 December, the Picabias' collection of the charcoal drawings and oils of Braque and Picasso were on display; and on 12 January 1915, three of Picabia's own oils were up for two weeks. They represented the high point of the Paris-New York modernist connection as seen from 291. By the middle of the next August, de Zayas and Picabia, working with money from Agnes Meyer, were planning a new, more commercial gallery, the mere thought of which predictably put Stieglitz' teeth on edge. Undeterred, de Zayas told Stieglitz that his new gallery would help make New York City "a center of modern art, commercially and intellectually." He planned to feature the art of Mexico and Africa as well as sell books. He predicted that "The Modern Gallery" would be "the business side of 291." "Picabia will take care of Europe and Mrs. Meyer and myself of America."[39]

Clearly an era was ending, and not solely because of the war. In slightly over two years, the Armory Show had fused numerous activities on two continents. Beneath all the publicity, artists had met, liked each other, and found common ground. The war essentially closed Paris as a culturally creative place, as it had London; New York survived, in part at least, as a distant suburb of Paris. Even within the New York environment, things were changing: on their next visit, the Picabias were increasingly members of a different salon. But with Walter and Louise Arensberg, they were no longer central. Their friend and col-

laborator, Marcel Duchamp, stole the limelight and in the process shifted the direction of all modern art.

VII

No one, then, had intended the Armory Show to be a European spectacle. The whims of journalists and a public eager to feel shocked at the new created a result that was unexpected, but once the works were in circulation nothing could stop the pressures of public opinion. For the immediate future, Picabia and Duchamp could count on an audience for anything they wanted to do or show in America, but their success masked the failure of American artists to receive much attention. Of those painters who had worked so hard in Paris to absorb modern currents, Patrick Henry Bruce, Arthur Carles, Jacob Epstein, Samuel Halpert, Marsden Hartley, John Marin, Alfie Maurer, Walter Pach, Morton Schamberg, and Abraham Walkowitz were all in the show, and so were several others; yet they did not become household names, and sales were few aside from such hardy buyers as John Quinn, Arthur Eddy, and Stieglitz himself. Some painters were not represented at all. Max Weber, for example, quarreled with the committee members running the show and withdrew; and Arthur Dove was apparently not even asked.

Dove's progress in the years up to the Armory Show demonstrated a number of important aspects of American modernism that often get lost in overviews that focus on European developments, or on the Armory Show as the most important American exhibition. Although he had a brief period in Paris, he was chiefly American in his ideas and emphases. He was a rural rather than an urban personality. He was vaguely Protestant, rather than Jewish or foreign, yet found in anti-institutional religion the same kind of solace that others found in mystical studies or in the use of art as a substitute for religion. He was deeply into science, both biological and physical. He was a symbolist of a sort, as were so many poets, novelists, and dramatists in European modernism, but one who drew inspiration more from American than European sources.

Nothing in Dove's early life seemed to point toward modernism. He was the son of a successful contractor in small town New York State. He took painting lessons in childhood, but neither he nor his parents regarded such activity as preparation for a career. He took a pre-law program at Cornell, with substantial work in architecture and mechanical engineering. But after taking an A.B. in 1903, he went to New York City to work as a professional illustrator for popular magazines. He naturally gravitated toward the ranks of "the 8," most of them journalists and illustrators at some point in their lives, and all of them representational by instinct. He showed talent at caricature and cartooning. Dissatisfied at the professional options open to him, he headed for

Paris in 1907 to see if he could make any headway in his painting, which until that time had resembled a diluted impressionism. He found Alfie Maurer, and the two established a close friendship that lasted until Maurer's death. Yet even in France, Dove's rural, provincial personality kept him on the outside of every circle, and he spent most of his time in the south, near Cagnes. Despite his friendships with several artists in Steichen's New Society of American Artists, he was never a member himself, and never indicated that he wanted to be one. Despite his closeness to Maurer, he never once visited the salon of Gertrude and Leo Stein, where Maurer was an habitué. In itself this might not seem odd, yet in later life Dove so admired Gertrude Stein that he said that she was one of the two people he would most like to have met in his life whom he never did; the other was Albert Einstein.

Dove experimented with fauvism and closely followed the *Cahiers d'Art*, but made so little impression on the erstwhile modernists around him that he scarcely appears in the memoir literature. He apparently saw no abstract art in Europe, yet after his return home in 1909, after about thirteen months abroad, he produced a series he called "Abstractions" which, while immature and derivative, indicated that he was more aware of modernist currents than most of the better-known Americans. Much later, in 1929, he flatly stated in a museum catalog that "there is no such thing as abstraction," and that a better term was "extraction," but such a change in terminology should not compromise Dove's rightful claim to priority. By the time of his first one-man show at 291, early in 1912, Dove had completed the series now called "The Ten Commandments." These were, according to the author of the catalog raisonné of his work, "the first public display of nonillusionistic art by an American."

On the surface, then, Dove should have developed along the lines of his Paris friends. He had been abroad, he had been involved, he returned to meet Stieglitz and show at 291, and his work qualified. Yet his attitudes, while seeming parallel to those of other modernists, were really rather different. He looked far more seriously into the American past than most of them were doing at this time. He noticed European achievements, such as those by Picasso and Kandinsky, as they came along, yet somehow they always seemed complementary and even marginal to his own growth. He was an American original, traveling his own path within sight of the others, but only rarely intersecting more crowded routes.[40]

While other American modernists, especially in photography, were clearly working in a symbolist, post-romantic tradition, Dove remained the purest example of the breed. He rarely spoke publicly about his intentions, and even his letters to Stieglitz concentrated on the trivia of daily life. But in a 1913 letter to Arthur Eddy, he made his clearest statement of what he was about. He believed in "the choice of a simple motif," he told the Chicago collector of modernist paintings. "This same

law held in nature, a few forms and a few colors sufficed for the creation of an object." For him, "the first step was to choose from nature a motif in color and with that motif to paint from nature, the forms still being objective." The next step was "to apply this same principle to form, the actual dependence upon the object (representation) disappearing, and the means becoming purely subjective." Essentially, then, the form of a work of art did not depend on subject matter. An artist did not so much imitate nature, as work the way nature worked. He painted a process, not a specific object, "not form but formation."[41]

Such statements indicated that Dove was implicitly developing a symbolist biology. To adapt a famous phrase of French poet Jean Moréas, he was learning "to clothe the idea in a sensible form." In 1910, after his return from Paris and his initiation into the 291 circle, Dove bought a farm in Westport, Connecticut, within commuting distances of New York but still spiritually separate. For some years he was an egg farmer, gaining experiences that parallel Sherwood Anderson's more famous trials, the basis of his best short story, "The Egg." To any normal farmer, the egg was a prosaic enough object, bearing with it smells, problems, food, money, and such connotations. A realist could make much of an egg, but an artist with Dove's orientation could make more. Eggs were by definition ovoid as well as natural and biological; they could suggest a variety of geometries if their properties were extended into the space/time continuum.

Carried a perceptual step further, they could also suggest cones, and as any student of Cézanne knew, cones were basic to any modern conceptualization of form. Just as he could come to ideas like Kandinsky's from chiefly American sources, so Dove could come to ideas like Cézanne's from sources as domestic as eggs. "I have come to the conclusion that there is one form and one color. That simplifies to the point of elimination, theory, which might be called conscience," he wrote Stieglitz in 1930. "The form is the cone. From it we get the conic sections, the spiral, the circle and the straight line. Whirl the circle and get the sphere. The cylinder is just a circle moving in one direction. The cube of course comes from the straight line section of the cone." Such a synthesis might well not be clear to someone not a sympathetic artist, but mystics have ways of communicating that escape mere quotation, and painters feel uneasy with words anyway. Stieglitz responded sympathetically.[42]

Dove's early career peaked with his 1912 show. He continued to work on a group of sixteen paintings, entitled "Nature Symbolized," which he exhibited in "The Forum Exhibition of Modern American Painters" (1916), but they marked the public end of his early creativity. The Armory Show had intimidated many Americans, and perhaps he too felt that he needed to rethink his premises. But in a basic way, he did not need to do so. Never having enthusiastically committed himself to the ideas and methods of Europeans, he did not have to feel inferior and

derivative. He was, as Stieglitz came to recognize, a true pioneer of the return to American subject matter which became so important in the history of the 291 group and of a large number of creative Americans during the 1920s. His earliest work was most properly an anticipation of the critical ideas of Paul Rosenfeld, the stories of Sherwood Anderson, and the poetry of William Carlos Williams. It thus takes on added importance because he was the first person to give voice to an important form of modernist expression.

VIII

In a sense, then, the Armory Show was largely irrelevant to the inner history of art at 291. It allowed artists some time in the sun, but that aside all it really did was to bring new faces to America and to speed up processes that were already in progress. Certain tendencies pointed toward the modernist future—three futures in fact—and the Armory Show gave all of them a push, but velocity is not originality.

Dove's ideas and career clearly pointed along the first path, of American sources for art; just as the Armory Show did not include him, it did not include the work of the artist who became central both in this tradition and in the life of the 291 group: Georgia O'Keeffe. Stieglitz himself had moved uncertainly toward the second path; rewriting his own history, he had concluded that straight photography was the only justifiable approach to American objects; true art lay in the ingenuity an artist could express in finding evocative forms within the restrictions of the scenes life presented to him. In this context, the young Paul Strand appeared to carry on the new tradition. Finally, along the one path where the Armory Show did play an important role, it brought not only Picabia to New York, but also Marcel Duchamp and several other French artists. They were able to build on tendencies that were evident in *Camera Work* and in several of Stieglitz' most valued advisors. In Marius de Zayas, and to a lesser extent in Benjamin de Casseres, Stieglitz had friends who seemed to intuit the themes both of futurism and of Dada. In the increasingly frantic period of creative experimentation before America entered the war, Picabia, Duchamp, and the others took America far along the path to these two goals. Thanks to them, Dada appeared in New York City even before its formal inauguration in Zürich. It was a mild outbreak, it was spread by foreigners, and it left few scars, but nevertheless, Dada appeared, and with it at least a touch of futurism as well. The story is more involved with the Arensberg salon than with the Stieglitz one, but Picabia moved easily from the one to the other, and his friend Duchamp was a man of whom Stieglitz always spoke highly.

As a mature woman, Georgia O'Keeffe was notoriously prickly, private and uncommunicative to all but a few, but she always liked both Arthur Dove and his work. Of all the 291 group as it stood about the

time of the Armory Show, Dove was the most self-consciously American. He was attracted to American subjects, especially nature in America. O'Keeffe did him one better: she did not go to Europe at all during this period—not, indeed, until 1953. By the time she got to New York the war was on; had it not been, it is hard to imagine that results would have been much different. She felt no need for Europe. The people she needed, and the subjects she painted, were all available. She was already so bohemian in outlook that Paris could have done little for her. She took her private language from the biological shapes of the Southwest, adding an imagery of feminism all the more striking for the fact that she so regularly denied the sexuality of what she was producing.[43]

For someone who stayed home, O'Keeffe was something of a dispossessed wanderer in her ancestry and life. Three of her four grandparents were immigrants: two from Ireland, one from Hungary; only the fourth was native, of Dutch extraction via New York. Religious influences were no more uniform, with Roman Catholic, Episcopalian, and Lutheran strains mixed together somewhat awkwardly. All that seemed stable at first was small town Wisconsin, where Georgia remained until she was fifteen. After that she hardly seemed to remain in any place for very long. She prided herself on her Midwestern heritage, but did so while in Virginia, South Carolina, the Southwest, or New York City. Modernists, even farm girls, had trouble feeling comfortable anywhere.

She attended most schools briefly; they included a convent boarding school in Wisconsin, where she took up the habit of wearing black; and the Art Students League in New York. Her jobs were equally irregular and mismatched. For awhile she abandoned painting for advertising, in the process creating the Little Dutch Girl who adorned cans of Old Dutch Cleanser in countless American homes. For four summers, she taught drawing at the University of Virginia at Charlottesville. Full time jobs in art were hard to come by, especially for young ladies, but she managed to find one position teaching drawing in Amarillo, Texas; another at a women's college in Columbia, South Carolina; and a third at West Texas State Normal College, Canyon. She also studied at Columbia Teachers College in New York. There she met Anita Pollitzer, the friend whose correspondence with O'Keeffe has proven so useful to scholars; and the one whose political attachments to such feminist causes as the National Women's Party colored O'Keeffe's attitudes for life. The women read the *Masses* as well as *Camera Work* and *291*, the works of Olive Schreiner and Charlotte Perkins Gilman along with those of Kandinsky, Clive Bell, and Willard Huntington Wright.

Everywhere she went, O'Keeffe found that her sex and her talent made her out of place. She did not dress in a conventional manner, she did not cultivate her neighbors. She walked alone or with men at all hours, and paid no attention to religious prohibitions. Virtually alone among modernist artists, she was able to look back at her experiences

and the problem she had, and indicate how the language of her paint-
ing was connected to her sense of displacement within these restrictive
American social norms. "I grew up pretty much as everybody else grew
up and one day seven years ago found myself saying to myself—I can't
live where I want to—I can't even say what I want to—School and things
that painters have taught me even keep me from painting as I want
to," she wrote in a contribution to a catalog in the 1920s. "I decided I
was a very stupid fool not at least to paint as I wanted to and say what
I wanted to when I painted, as that seemed to be the only thing I could
do that didn't concern anybody but myself—that was nobody's business
but my own."[44]

When O'Keeffe was just twenty years old, on 2 January 1908, she
met Alfred Stieglitz for the first time; he was forty-four, and she was
in awe of him. That year as well, she visited Lake George, the same
resort area that she and Stieglitz would live in later for over a decade.
At first, of course, everything was formal, distant, and buried in artistic
concerns. Stieglitz was unhappily married and still finding his taste as
a modernist; she was doing still lifes that were imitative of the work of
William Merritt Chase. Like Stieglitz, she soon concluded that great art
was more an expression of the emotions of the artist than a vision of
an object in nature, and on subsequent visits she dropped in to see the
new art. She knew the work of Picasso and Braque as well as that of
Kandinsky among Europeans; and that of Marin and Dove of the
Americans. She preferred them, with Hartley a distant third in her
hierarchy of promising compatriots to watch. Most of her appreciation
was in reserve for the man in charge. "Anita—do you know—I believe
I would rather have Stieglitz like something—anything I had done—
than anyone else I know of—I have always thought that—if I ever made
any thing that satisfies me ever so little—I am going to show it to him
to find out if it's any good."[45]

While O'Keeffe was immured in South Carolina—"Columbia is a
nightmare to me—everything out here is deliciously stupid"—and trying
to keep in touch by reading *Camera Work*—she admired a Picasso draw-
ing and the writings of Gertrude Stein—Pollitzer took matters into her
own hands. On New Year's Day, 1916, she spread out a roll full of
charcoal drawings which her friend had sent her, finding much in them
to admire. Uncertain what to do, she went out to see *Peter Pan*, and
then continued to 291. She showed them to Stieglitz, even though
O'Keeffe had explicitly asked her not to show them to anyone else. He
liked them, and Pollitzer conveyed the news south. O'Keeffe seemed
pleased; she was so shy that it seems unlikely that she would have had
the courage to do something of the sort herself. More on her mind was
the bleakness of her prospects. While her drawings were winning praise,
she had to earn a living, and the prospect of going to Texas "just makes
me feel sick inside."[46]

Pollitzer's initiative effectively began a steady correspondence be-

tween Stieglitz and O'Keeffe, one that comforted her greatly. He also began sending back copies of *Camera Work,* five of them arriving in June: "The pictures excited me so that I felt like a human being for a couple of hours," she wrote Pollitzer. Settled in Canyon in September, she lamented the lack of stimulating books and pictures, even though she said she loved the land and the colors. The correspondence took on a three-dimensional quality, with O'Keeffe passing on Stieglitz' remarks to Pollitzer. "Anita—he is great . . . such wonderful letters— Sometimes he gets so much of himself into them that I can hardly stand it." She indicated an awareness of the wildest new voice in music, Leo Ornstein, in her efforts to make herself clear. "It's like hearing to much of Ornstein's Wild Man's Fancy—you would loose your mind if you heard it twice." She supplemented her diet with *The Seven Arts,* and books by Willard Huntington Wright, Clive Bell, Marius de Zayas, and Arthur Eddy—"All I could find." She also devoured several Ibsen plays and an unidentified volume of Nietzsche. "He is a wonder too."[47]

O'Keeffe's professional arrival came on 3 April 1917, when 291 offered a one-woman show of her watercolors, oils and drawings. She had three days in the sun before the country declared war on the Central Powers. Although the show continued until 14 May, it proved to be the last the gallery could offer. Whatever the more public reasons for the end of exhibitions and the publication of *Camera Work,* which also stopped, Stieglitz could no longer afford to continue as he had. Much of his money came from a brewery which members of his wife's family ran in Brooklyn; with prohibition of alcoholic beverages impending, art was one of the first casualties. "My family and I," he wrote a friend in publishing, "have been badly hit. So badly, that I am compelled to give up 291 and Camera Work." O'Keeffe took it all in stride. She was soon in the city to visit Stieglitz, see some Synchromist works by Stanton Macdonald-Wright, and several others by Abraham Walkowitz and John Marin. The Synchromist works "are wonderful—Theory plus feeling—They are really great," but she was less impressed by Wright himself: "looks glum, diseased—physically and mentally. I'd like to give him an airing in the country—green grass—blue sky and water— clean flowers—and clean simple folks." It was almost a description of what she would do to American modernism after the European unpleasantness was over.[48]

In the same letter in which she described the new paintings she had seen, O'Keeffe also had a photographer to tell Pollitzer about. "Did you ever meet Paul Strand. Dorothy and I both fell for him," she wrote. "He showed me lots and lots of prints—photographs—and I almost lost my mind over them——photographs that are as queer in shapes as Picasso drawings." After looking she went with Strand and Stieglitz to the best place in the area for someone with a lost mind—Coney Island.

Paul Strand represented the second path toward a modernist aesthetic. As painting went after consciousness, expressiveness, extraction

from nature, and the fourth dimension, photography went after the undistorted object, the real. Stieglitz had long been heading erratically in the direction of straight photography, scorning the pictorial effects of his apprentice days, but for several years he had given every sign of running out of gas. Photographs had all but disappeared from 291, and he had quarreled with Day, Käsebier, Coburn, White, and finally even his best guide from his Paris trips, Steichen. Steichen had been the leader of the forces of the "spoiled print," and the man who knew everyone in Paris who had much to do with modernist art. But Steichen was passionately pro-French in the war; almost as bad in the pro-German or pacifist ranks of 291 loyalists, he was against much of what he saw in cubism and much of what was developing into Dada. He found little to praise in the work of Dove, O'Keeffe, or Picabia. As Steichen cut off his contacts with 291, Stieglitz himself seemed to have little to say on the subject, focusing instead on those American painters whom he felt the Armory Show had neglected. With the arrival of Paul Strand, however, he had a photographer from a younger generation who matched his tastes.

Strand was yet another product of immigrant America. The family were Bohemian immigrants who had come to America and changed their name from Stransky to Strand shortly before Paul's birth in 1890. They were bourgeois, not artistic; his father sold cheap French and German cookware to his neighbors. The first memorable event in the boy's life came on his twelfth birthday, when his father's gift was a Brownie camera. The second came when, after years of scrimping on necessities, Paul enrolled in the Ethical Culture High School, where Lewis Hine was a biology teacher. Even then, Hine was more interested in photography than in biology: he taught students how to use a camera after school hours, and on at least one occasion took a group, Strand included, to 291 to see an exhibition. Charles Caffin was the teacher of art appreciation, habitually praising the achievements of Whistler and the Japanese.

When Strand informed his family that he wanted to become a photographer, they raised no objections. Money was scarce but he could support himself as he wished. In 1909, Strand joined his father's business to keep food on the table, but kept up his photography in his spare moments. In 1911, he scraped the money together for a summer in Europe, but saw little modernist work. Instead, he admired Pre-Raphaelite and Barbizon work of a decidedly passé style. Insofar as he took pictures, they were fuzzy spoiled prints of the sort common in artistically self-conscious circles.

After his return, Strand worked briefly in an insurance office but was soon determined to make his way as a professional photographer. He was in contact with White and Käsebier, but he took most of the advice he could use from Stieglitz. He visited 291 repeatedly, for as he told an interviewer in old age, it was "the best criticism I ever had from

anybody because it was the kind of criticism that you could say, 'yes, that's so,' and you could do something about it." He was soon looking at paintings as well, first Cézanne watercolors, and then the oils and drawings of Matisse and Picasso. The Armory Show made a strong impression on him, especially the Cézanne oils and the sculpture of Brancusi. In essence, the photographs that he began to turn out brought these new perceptions together. They are pictures of objects viewed without camera distortions or perceptible manipulations, yet they have sculptural values and abstract patterns which made them modernist.

He was self-consciously experimenting with modernist ideas. Strand set out to "find out what this abstract idea was all about and to discover the principles behind it. I did those photographs as part of that inquiry, the inquiry of a person into the meaning of this new development in painting," he recalled for William I. Homer. "I did not have any idea of imitating painting or competing with it but was trying to find out what its value might be to someone who wanted to photograph the real world." At the time, he was sure he understood "the underlying principles behind Picasso and the others in their organization of the picture space, of the unity of what that organization contained, and the problem of making a two-dimensional area have a three-dimensional character, so that the viewer's eye remained in that space and went into the picture and didn't go off to the side." Like the painters, he wanted "everything in the picture related to everything else."[49]

But having mastered modernist devices, angles, and attitudes, Strand went off in an unexpected direction. He abandoned abstraction for straight photography, conscious of shadows and massing of course, yet increasingly looking directly at the very people whom O'Keeffe was leaving out of her work. He was not opposed to rural subjects, but his focus was on the city. He had become "interested in using photography to see if he could capture the physical movement of people and automobiles or whatever it might be, in an abstract way, always retaining the abstract principle . . ." In a short time, he seemed to be treading the fine line that separated the work of a Stieglitz from that of a Jacob Riis; the city as subject matter, as an aesthetic challenge, versus the city as social problem, as a political challenge. For the time being, he looked with Stieglitz' eyes: "I photographed these people because I felt that they were all people whom life had battered into some sort of extraordinary interest and, in a way nobility"; his famous "Blind Woman" (1916) being a perfect example. In time, however, Strand went the other way; by the 1930s, he was on the far left, politically aware in a way that excited the scorn of his aging sponsor.

For the moment Strand was the new darling of 291, the male photographer to balance O'Keeffe as the female painter. He had a show in March and April of 1916, and dominated the last two issues of *Camera Work*. Stieglitz bragged about him in letters abroad. Strand "is without doubt the only important photographer developed in this country since

Coburn. In my opinion his work is of greater importance than Coburn's," he wrote R. Child Bayley in April 1916. "His prints are more subtle. They have a great lasting quality. He has actually added some original vision to photography. There is no guming no trickery. Straight all the way through; in vision, in work and in feeling. And original. The fellow is very modest."[50]

In a short time, Stieglitz all but reconstituted a complex family with these new artists. Ignoring his own wife to the extent possible, he came to dwell on O'Keeffe even at a distance, and to rely psychologically on Strand even when Strand was off traveling or on military duty. When the young and attractive Rebecca Salisbury came on the scene and became Strand's first wife, matters of art and sexuality became intertwined. For the short run, the Stieglitz crew were in tune with each other and out of tune with wartime America. "Somehow this year I find it hard to adjust myself to the place, altho it is no less beautiful—no less restful," Strand wrote from Canaan, Connecticut in the summer of 1917. "As I wrote Hartley, it seems impossible to thoroughly detach myself from things—as long as I live in this damn country I seem to be attached to the navel of it." Public events and obligations kept intruding on the domain of art. "It seems impossible to get away from the war—it touches everybody now and everywhere one finds the same resentment and lack of enthusiasm. . . . Something—Somehow—seems missing—the salt is out of things—as yet."[51]

In essence, then, the Strand and O'Keeffe paths were running parallel in the same direction toward modernist art; it would develop in a way that related it to the objects of America; and it would be a non-metaphoric, straight art, with non-essentials and fussiness eliminated. So far, at least, the path was cleared for William Carlos Williams in poetry, Charles Sheeler in painting, and Ernest Hemingway in the short story, all of them representative of a major force in the modernism that developed in the aftermath of the war. But to focus on them to the exclusion of a third path would be to make far too orderly a picture. For 291 also harbored anarchic tendencies that had little to do with O'Keeffe and Strand, and a great deal to do with the return of Francis Picabia and his enigmatic friend, Marcel Duchamp.

The arrival of the two Frenchmen in 1915 marked the beginning of New York Dada, a few months in advance of the Zürich variety, and the swift trend among 291 artists, and even more those whose closest association was with Walter Arensberg's salon, to the creation first of a machine aesthetic, and then one which was anti-art. The works which they created made a mad kind of sense as developments of sharp-focused photography. If non-objective art freed photography to be clear, precise, and representational, then photography could be an anti-art as well as an art. Nothing was a clearer presentation of an object than an object itself.

Occasional scholars have probably overdone the American precon-

ditions for Dada. Certainly Marius de Zayas' meditations on photography, which had been appearing in *Camera Work* over many issues, led in this direction; and the rather decadent meditations of Benjamin de Casseres perhaps also deserve mention, if only to preserve the faint connections between 1890s decadence and 1910s nihilism. Certainly many of those concerned shared a familiarity with the misty suggestions of Bergson; and Nietzsche was a pervasive influence on both sides of the Atlantic, if usually in excerpted or digested form. *Camera Work* did circulate among important Europeans by 1914, and apparently the connections which Marsden Hartley established between Paris, Munich, and New York formed some sort of link between Stieglitz, Kandinsky, Wedekind, and Hugo Ball; and between Hartley and Jean Arp. Evidence for such connections remains sketchy, suggestive but hypothetical. More concrete is the evidence that Stieglitz and Apollinaire were exchanging copies of *Camera Work* and *Les Soirées de Paris.* It stands to reason that at least some of the influences flowed from New York to Paris; both Picabia and Duchamp found the New York atmosphere stimulating and at times life-sustaining, and once the war commandeered Parisian energies, New York probably was more fertile than anyone could have imagined a few years earlier. New York was ready for ideas of machine art, parodic art, caricaturist art, and anti-art, and ready in a logical, linear developmental way. Europe needed war tensions, massive slaughter, espionage fantasies, and the hothouse cabaret culture of neutral Zürich to hatch Dada; New York only needed the salons of Stieglitz and Arensberg and the visits of Picabia and Duchamp.[52]

Insofar as it existed at all, however, New York Dada began with the meeting of Picabia and Duchamp in Paris in 1910, and of de Zayas with both of them shortly thereafter. The circle of close acquaintance soon included Walter Pach on the American side, numerous early cubists, and several French artists soon to be in New York: Albert Gleizes, Henri-Martin Barzun, Juliette Roché, and Jean Crotti. Tracking the comings and going of these writers and painters and their friends is pointless; they obviously lived for art, talked an extraordinary amount, and cross-fertilized each other; and they did so in Paris before coming to New York. Once the war drove everyone to New York, it became in essence a suburb of Paris. Its architecture, its pace, its parties, and the rest partly stimulated but mostly confirmed tendencies that were already in motion.

Picabia was thinking about the parallels between people and machines by 1912. By the time of his return to New York in 1915, he was almost a philosopher on the subject. "The machine has become something more than a mere appendix to life. It has come to form an authentic part of human existence," he told the *New York Times;* "perhaps its soul." In his search "for forms to interpret ideas through which certain human characteristics may reveal themselves," he had "finally discovered the form" that seemed to him "the most convincing and the

most symbolic." He had simply "taken over the mechanics of the modern world" and introduced them to his studio. This was the spirit with which he produced those Dadaesque journals, *291* and *391*, represented Stieglitz as a camera and the American girl as a sparkplug, and in general carried de Zayas' caricaturist spirit several steps farther than New York had then seen.[53]

The best memoir of Picabia's New York period is that which Gabrielle Buffet-Picabia published in English; she sometimes collapsed time and made minor errors, but her sense of the meaning of what her husband was doing was accurate. Speaking of Duchamp and Apollinaire as well, she recalled that the three modernists "pursued the disintegration of the concept of art, substituting a personal dynamism, individual forces of suggestion and projection, for the codified values of formal Beauty." In his abstract paintings, Picabia was capable of creating beauty, but his work with machines carried its own logic, and that logic paralleled that in other obvious modernist efforts: the "readymades" of Duchamp, the "calligrammes" of Apollinaire. These works shared "certain postulates" with the works of her husband when he invaded "the plastic field of the 'machine,' this newcomer issued from the mind of man, this veritable 'daughter born without a mother,' as Picabia called his book of poems which appeared in 1918."

Writing in the late 1940s, Buffet-Picabia found it all but incomprehensible how the official world of art had neglected the machine—subjected it, indeed, to "frenzied ostracism." Symbolized by the Eiffel Tower, the machine seemed to be a terrible threat to religion, morals, patriotism, and anything permanent. The modernist artists, influenced perhaps by the futurists but also by the lives they were leading, preferred to embrace the contemporary, to capture dynamism, and to see the human element in the machine. "First enthroned for their own sake, the machines soon generated propositions which evaded all tradition, above all a mobile, extra-human plasticity which was absolutely new . . ." In absorbing this influence, her husband almost always worked "in a humoristic or symbolic spirit" which gave an appeal to his work that more severe challenges to the status quo did not have. Far from being trivial, such works "mark the first symptoms of the crisis of the object . . . which raged in Dada and which, with certain psychological deviations, assumed its full scope in surrealism."

Obsessed with such challenges, Picabia painted furiously for about a year, getting farther and farther from any visual elements and at times approaching the dryness of the blueprint. His works grew hermetic, obviously referring to something but never obviously to anything. He then stopped work and painted next to nothing between 1916 and 1918, throwing himself into publishing fugitive journals and into travel. Something was clearly over, whatever it was; he left New York City in 1917 and never returned. With his departure, the third path toward modernism became hard to follow. After the war, both the machine

and the Dada spirit lived on, often in subterranean ways, but they did so elsewhere than at 291 and its successors: most obviously in the poetry and plays of E. E. Cummings, but pervasively in the creative work of almost anyone aware of what was animating Paris during the early 1920s.[54]

Mabel Dodge

Unlike Alfred Stieglitz, Mabel Dodge was no artist, nor was she European in her cultural roots. Yet in terms of the origins of her attitudes and her impact on New York cultural life, at least a few of the qualities of her early life were similar to those which motivated Stieglitz to become a collector of people who were pioneering modernist cultural attitudes. Born Mabel Ganson, she had grown up in an environment that seemed dominated by three themes: the philistinism of Buffalo and its expression in her family; the problem of being a woman in a society where women had little they could do outside the home; and the sheer boredom of having plenty of money and material possessions and nothing compelling to do.

The family money came from banking, accumulated by her grandfather. Since the money was already there, her father had nothing he had to do and led a life of bored futility. Neither parent had intelligent interests, meals were silent, and parties enlivened only by periodic rages which her father directed at her mother, who returned his rage with icy contempt. As she recreated the scenes of her childhood during the 1920s, Dodge seemed to be adding autobiographical support to the vision which Sherwood Anderson had had about the horrors of life in small American towns. Almost every house, she remembered, "held a family with some strange deviation in it, and they all tried to dissemble their individual peculiarities. Each house held its own secret, helpless shame." No one had any inner life, no one shared intimacies. The Ganson house was "a lifeless place" enlivened only by a large number of animal pictures. "For there it was: we all liked animals. We didn't like each other and we didn't, any of us, love any one outside, so we loved animals instead." She yearned for alternatives, without knowing what they could be.[1]

With a nervous, ineffectual father and a masculine, domineering mother, Dodge had no clear sexual role models, and the rigid conventions of a provincial city prevented her from discovering alternatives. She attended a school in New York for a year, and went to Europe briefly; she even had a year of "finishing" at a fashionable institution in Washington. But she received no stimulation from these activities

and occupied herself with the manipulation of men. Bisexual in many of her impulses without knowing the term, she flirted with girls, boys, and men with pre-Freudian innocence. Intuitively sensing that only through connection with a male could a woman of her time, place, and caste have any independence, she married Karl Evans quickly, as if to get over a disagreeable rite of initiation. No more mature than she was, he fathered a child and then got himself shot in a hunting accident. He died just before her twenty-fifth birthday, leaving her with a baby for whom she had little feeling of intimacy.

Rich, bereaved, and bored women solaced themselves with trips to Europe in those days, and so in the summer of 1904 she went off with her son and two nurses. The sexual charm which she seemed to radiate for much of her early life did its work, and on the voyage she fascinated a wealthy young architectural student who had already studied in Paris, Edwin Dodge. Emotionally numb and physically lassitudinous, she seemed to fit some outmoded Victorian ideal that he had about feminine behavior; he pursued her devotedly until she agreed to marry him, which she did in October. Instead of cheering her up, this devotion depressed her and Edwin must soon have realized that he was in for it. Tolerant and understanding, he both humored her and shared some of her feelings about life in America. Having a comfortable income, the two decided to create in Florence the sort of life that would not be possible at home. Their vision required, she wrote later, "an *ampleur* of airy space," *"grandeur,"* "and no neighbors." Their villa also had to have "the poetic and tender charms of unexpected corners and adaptations to small, shy moods, twilight moods. It would allow one to be both majestic and careless, spontaneous and picturesque, and yet always framed and supported by a secure and beautiful authenticity of background." They found what they were looking for in a structure most recently occupied by a Russian baron; his family "had named it Curonia, which is Italian for Kurland, the province from which they came." The name stuck, and Dodge became the mistress of the Villa Curonia. Included in the decor was a pair of monkeys; she named them after Madame Bovary and her husband.[2]

Many Americans tried to buy the past that their country did not have, and the architectural structures that resulted littered many a landscape from Boston into the darkest West and South. Mabel Dodge was more intelligent than most, and her husband more gifted than many. She explicitly recalled having the latest Henry James novel about the house, and in places her memories evoke a Pateresque picture of Renaissance tapestries and gem-like flames. But a person can only buy so much art and boss around so many workmen before depression and ennui settle in, and the Dodges soon knew first hand what many minor Irish, English, and French artists of the turn of the century were experiencing. When the collecting of art failed to give meaning to their lives, and the muse failed to move them to create anything, they turned to people.

For a few brief years, Villa Curonia became a museum that displayed living works of art, setting precedents for later activity in New York.

The whole thing began casually; Lady Paget was wandering through the rooms, and suggested that Dodge give a reception. She demurred, not knowing most of the local people. Lady Paget replied, a bit contemptuously, that that did not matter; "You just ask them whether you know 'em or not. . . . Open your house to them and see them flock in!" They did, to find the "almost Renaissance . . . Medicean feast," as they strolled "in a poetic twilight against the garlanded background of a spacious fête; music and soft light and roses in the midst of the damask and velvet hangings. Tintorretish." Soon illustrious personages joined the local guests: Paul and Muriel Draper, Gordon Craig, Eleanor Duse, Lord and Lady Acton, André Gide, Pen Browning, and many others now lost to history showed up, along with Gertrude Stein and Alice Toklas, Stein exulting in the hot sun that wilted the less robust.[3]

Dodge was nothing if not self-dramatizing; she pictured herself at the time as "a Nietzschean . . . beyond good and evil, indomitable, unbreakable," but mostly she was a maladjusted, wealthy woman who was both willful and manipulative, and who had more opportunities than most women had for experimenting with life to see what she was good at. By 1912, she had concluded that Italy was a theater too small for her. She was still bored, and her son needed an American school. She closed the volume of her autobiography dealing with her European experiences with a grand contrast between the cultural scenes which predominated on the two continents. "I had learned to live in a place where it was of more importance to have authentic works of art, particularly Italian ones, than to have one's favorite college win the autumn football game, or to have the right president elected." "The values of life were centered in the perpetuity of the grand epochs, and a scrap of genuine primitive painting on a worm-eaten board, found in a dingy, cavernous cellar in Siena or Perugia, meant more to me and my Florentine friends than the tallest skyscraper on earth." She was "horrified at the thought of living in New York," a place which seemed "just too dreary and unattractive for words." She felt only disgust toward an America "where, I felt, there was no place for a person like me, who knew so much now about colors and odors and all the shades of things." She was in tears as she left, telling her son to remember that it was "*ugly* in America. We have left everything worth while behind us. America is all machinery and money-making and factories—it is ugly, ugly, ugly! Never forget that!" Poor John Evans disagreed. He wanted to go back. But hers was an emotion that Alfred Stieglitz, Ezra Pound, and numerous other Americans shared, one that fueled much of their art.[4]

The Mabel Dodge who arrived back in New York had little interest in many of the aspects of modernism. She knew next to nothing about music, apart from gossip picked up from occasional visitors; she had apparently never seen a film. She had visited 27 rue de Fleurus and

knew a bit more about modern painting, but never tried the art herself and had no critical impulses. She praised Gertrude Stein's writings, but did so more as an admirer of the author than as someone who wished to write in a modernist style. Her knowledge of the theater was no greater than that of any educated New York matron. But in one respect, Dodge qualified as more than merely a hostess who fed the alienated young. She was totally absorbed in herself, her moods, perceptions, intuitions, and palpitations. She cared hardly at all for the outside world, working up energy for socially useful activities only when friends and lovers excited her with the sheer spectacle of violence, strikes, and demonstrations.

She settled at 23 Fifth Avenue, upstairs, in quarters that ignored both the city and modernity. "I had had every single bit of the woodwork painted white, and had all the walls papered with thick, white paper." On the three high windows that looked out on Fifth Avenue and Ninth Street, she "hung straight, white, handwoven linen curtains made at Pen Browning's school in Asolo . . ." In her bedroom, she "finally found a use for the yards and yards of white Chinese embroidered shawls and silk I had bought on my honeymoon with Edwin in Biarritz." She had brought over a bed from Paris that came complete with a canopy, "and from this four white silk curtains hung, drawn back at each corner and with their heavy fringes hanging flaccid." Behind the bed was "a great, glimmering white shawl, thickly embroidered with odd birds and reeds, hanging "faintly visible upon the white wall." "The room was dazzling with all this white on white, 'plusieurs nuances de blanc' that Marie Bashkirtsev used to love." Whistler himself could hardly have asked for more. "It seemed to me I couldn't get enough white into that apartment. I suppose it was a repudiation of grimy New York. I even sent to the Villa for the big, white bearskin rug and laid it in front of the white marble fireplace in the front room."

She not only hated being back in America, she hated the related fact that her husband and his step-son got along so well. John liked his American school, and Edwin liked to pretend that he was a practicing architect. She especially resented the way the two of them shed Italian influences and adapted readily to such American activities as baseball. "I hated to see them so cheerful. I hated to see them set off for that American Saturday afternoon, full of interest in that American sport." She "felt betrayed" as she "watched from the window, saw them hail a bus and climb to the top of it and go sailing away from me." She became bored, inevitably. "There was no life in anything about me," and "I began to fall quite definitely ill." She could send her son off to school, but a husband was a bit more planted, domestically speaking. Still, since he made her ill, Edwin had to go. "It took time and increasing depths of melancholy and several nervous crises before our real separation came to pass." Edwin moved in and out, something of a stranger in his

own expensive home; "he would come rapidly into the apartment, ruddy and smiling and endlessly patient and hopeful," and an emotion within her "would rise up from the bottom to repel him, a sort of nausea at the sight of his persistently debonair, hard-shelled, American aplomb." He seemed so happy and well-adjusted to America, and so totally unwilling to look beneath the surface of its shallow life. "Edwin had always seemed curiously unaware of the possibilities lurking in the soul," and she soon persuaded herself that he stood between her and "real life." "Edwin blocked my growth, and my need for new ideas," and she was sure "that the life of ideas could never flourish in his company."

She came only gradually to see what she needed to cure her of such maladjustment to American society. She had been entertaining amusing people in Florence for half a dozen years; she had visited the Steins' and seen how Leo could dominate a room with his discourses on art, and how Gertrude could be an observing presence without having to do or say very much. Dodge too could run a salon, throwing open the doors to her white refuge and seeing what happened when people who were actually doing something in the world came to eat and talk and be talked about. "I wanted to know everybody," and soon, she was sure, "everybody wanted to know me. I wanted, in particular, to know the Heads of things, Heads of Movements, Heads of Newspapers, Heads of all kinds of groups of people. I became a Species of Head Hunter, in fact." No longer did she collect "dogs or glass . . . it was people. Important People." She sent out announcements on 24 May 1913, such as the one which informed Alfred Stieglitz that her apartment would, at stated intervals, be "a meeting place which will be in the nature of a club where both men and women can meet to eat and drink and talk together." The first gathering was on 27 May 1913.[5]

Dodge wasn't kidding; she really wanted to know the heads of everything, and her boredom bred a tolerance that few modernists, or anyone else for that matter, could equal. Coming to New York cultural life all but innocent of contemporary ideas, she was open to anything, and as a result her salon retains importance in cultural history because it became the one place in American life that truly tested the limits of modernism. Insofar as the hungry hordes belonged to categories, they grouped themselves roughly into six that often overlapped: those active in social agitation, usually but not always in extra-political ways; those whose focus was mind cure in its various forms, from Christian Science to psychoanalysis; women and their male allies who were sexual reformers, involved in such issues as the legitimacy of lesbian relationships and the availability of birth control; those who were chiefly educational reformers, trying to change the world through the minds of the next generation; artists, sometimes but not always involved with cubism or a related modernist variety of painting; and most importantly, those who were involved in the theater. In terms of its long

range impact on culture, the Dodge salon had its greatest effect on dramatic life, through its summer colony in Provincetown, and the nurturing of Eugene O'Neill.

A woman of Dodge's background and character could hardly have pulled off a successful salon on her own. She was exceptionally lucky in some of the friends she made, and adept at keeping the friendship of the wildly disparate people that she did meet. The most essential point of contact for her was Hutchins Hapgood, a man whose name appears in most of the more thorough biographies of American modernists, not to mention radicals, writers, aesthetes, progressives, and any number of other significant cultural categories. Dodge first met Hapgood through their mutual friend, sculptor Jo Davidson, in 1912, and they retained contact through many years; both left memoirs which are among the most useful in the annals of American autobiography. If such a book could be written and documented, a detailed life and times of Hutchins Hapgood would come close to being a cultural history of the United States for the first two decades of the twentieth century.

Hapgood had grown up in small town Illinois; his businessman father never accepted the religious views of most Americans and raised his children in an atmosphere of skepticism, while his mother compensated for the lack of cultural life in the area with a passionate love of the theater, especially Shakespeare. Such unusual stimulation affected the children differently; in Hutchins' case he had an interest in things religious which ran contrary to family assumptions, and sexual urges which never achieved satisfactory outlet. He early pictured himself as a lonely outcast who was in some way defective, both physically and socially. He was neither, but such factual statements mean little to those involved, and when he went on to Harvard he took to the place for being what it was: a home for those who were different, and who were intelligent and wealthy enough to explore their differences for four years or so. One of the more amusing manifestations of such feelings is the brief description he gives of "the Laodician Club," which his friend Robert Morss Lovett formed; it elected philosopher George Santayana Pope, and included Hapgood, his brother Norman, and several other erstwhile decadents. They worked at being examples of "Harvard indifference." "We were to be neither hot nor cold. On the first meeting, we lay about languidly on a sofa and rugs and drank weak tea. A few reflections of pale philosophy were suggested, but all positive expression was taboo." Subsequent efforts petered out with a sigh. Cambridge was a long way from Alton, Illinois.

Anyone who felt out of it at Harvard soon found his way to William James if he had his wits about him, and Hapgood was no exception. Hapgood's parents soon joined him and, as a family, they met James "on many occasions." Hapgood remained impressed for life with James' "extraordinary imagination" and his willingness to devote valuable time to needy students. "In my opinion the most valuable thing in William

James's psychology was his conception of the stream of thought." For those who knew James as his students did, what remained with them was the integration of his insights with his character. In his unconventional mind, "fixtures were not a part of his philosophy; he flowed."

The Harvard connection provided chances for networking that lasted a lifetime. Through his brother, Hapgood heard about Bernard Berenson, and when he went to Europe he looked that young art critic up and initiated an intimate friendship that lasted over many years, and many lengthy stays in Florence. Hapgood also explored the Louvre for its art, and Berlin for its night life. As rapidly as he could, he compensated for the sexual starvation of his home town; such relationships with available women marked the beginning of his "intense interest in the individuals who do not occupy a favored position," in a fairly obvious sense combining his own feelings of being a lonely outsider with sympathy for those who were socially outsiders: not only lower class women, but sexual deviates, alcoholics, Jews, criminals, and any number of anarchists and artists. Passing easily from slumming to tourism, he then went around the world with Leo and Fred Stein.

Hapgood considered an academic career briefly, but wanted a closer connection to real life, "real" here defined as what a Harvard aesthete could see if he took a close look at New York nightlife and wrote up what he found. Hapgood joined the *Commercial Advertiser*, to work closely with its city editor, Lincoln Steffens. "Steffens in those days was not interested in sociological or political things; the reforming or revolutionary instinct had not taken possession of him." A veteran police reporter, he was then into writing as art, which meant any picturesque, transparently written view of the city and the many varieties of people who inhabited it. The most picturesque people Hapgood could find were the newly arrived Jewish immigrants who seemed so distressing to more conservative Americans. Hapgood befriended Abraham Cahan, the best of the novelists to come out of this community, began the series of articles that resulted in *The Spirit of the Ghetto* (1902), and haunted the Yiddish and German theaters. He could thus see the works not only of such modernist Germans as Sudermann and Hauptmann, and of Ibsen whether performed in German or English; he could also relish the plays of Jacob Gordin and Yiddish acting such as that of Jacob Adler and Bertha Kalisch. Jewish artists had been seminal in the origins of European modernism both in the Russian-Baltic and in the German areas, and more than any other Anglophone, Hapgood had exposure here to far more of such work than was customary even in New York.

These contrasts between rich and poor, between Americans and Europeans, became dialectic norms for Hapgood. Anyone who could sit in an Italian villa, visiting the Berensons and the Steins, while he was reading the proofs of a book called *The Spirit of Labor* (1907) and beginning to write *An Anarchist Woman* (1909), was a man who loved contrasts and was insatiable in making and continuing personal acquain-

tances. He met painter Maurice Sterne in Florence, and chatted with Matisse and Picasso in Paris. At virtually the same time, "I rapidly acquired a large acquaintance: anarchists, nihilists, and all varieties of revolters." These included Emma Goldman, Alexander Berkman, George D. Herron, and Esther Fox, later the wife of Communist leader William Z. Foster; not to mention the hero of the Industrial Workers of the World, then an unknown William D. Haywood, and Elizabeth Gurley Flynn, the leading woman orator for the organization.

As a dilettante, aesthete, and connoisseur of extremes in art and politics, Hapgood naturally irritated many of those he met; he seemed unserious, inconsistent, illogical, or just trivial. He could be all of these and more, preferring to see his life more as a Jamesian quest than as an achievement. The word he usually used to define his position was "anarchist," and it remains useful in discussing Hapgood both because it sets him off from those who preferred such words as "socialist," "communist," or "progressive," and because it establishes the limits of modernist discourse in the political realm. Given its history in the works of Max Stirner, Petr Kropotkin, and Mikhail Bakunin, anarchism and its many individualist offshoots had a history of radical opposition to capitalism and exploitation that commanded respect even from the most hardened collectivists. It also seemed actively political, which it was so long as the politics was one of opposition to those in power rather than the administration of government once power were attained.

But in practice, in America, anarchism was a social stance, a posture of openness to human experience; an anarchist relished variety and usually saw government of any kind as hostile to nonconformity. Thus in his last formulation of his position, Hapgood could see his anarchism as "identical with the philosophy of Thomas Jefferson—that the government is best which governs the least." In the moral realm, it "was that of Tolstoy's non-resistance to evil." Socially, it means "a willingness to receive hospitality whatever dawning forces there may be in the submerged." It denied "the philosophy of that anarchism which is politically revolutionary. It is deeply sympathetic with the psychology of the underdog, but it doesn't desire that the underdog should be an upperdog." Writing at the height of the New Deal, he added that changing circumstances might well have compelled Jefferson and his other heroes to have a different vision of a government into the redistribution of wealth and status, but that as of the turn of the century such a view of government did not seem plausible.

He took such views everywhere in New York. While earning his livelihood working on the *New York Evening Post* and then on the *Globe,* the successor to the *Commercial Advertiser,* he sampled the range of cultural opportunity. He was "an interested party" in the establishment of the Ferrer School, the experimental institution named after Spanish anarchist Francisco Ferrer; its first director was Bayard Boyesen, son of a friend of Ibsen who had become a Columbia professor, and among

those people a visitor might meet strolling down the hallways were Emma Goldman, Alexander Berkman, Robert Henri, and, for two months in 1917, even Leon Trotsky, then in exile studying painting under Henri. Hapgood was devoted to Marie Jenney Howe, one of the founders of the feminist group, Heterodoxy, which has won posthumous fame from feminists of the 1970s who recovered its history and example for their own uses, especially the legitimacy of lesbian attachments. Hapgood defended such feminism, while downplaying more publicized but less meaningful activities such as the campaign for women's suffrage. He was "a constant visitor" to 291, writing up its activities in his column with such warmth that Stieglitz sometimes reprinted his assessments in *Camera Work*. He reported the Armory Show for the *Globe* and collaborated on a play for the Provincetown Players. He even had enough interest in experimental mental states to read up on psychical research, going beyond William James to the writings of such British enthusiasts as Frederic Myers and Oliver Lodge. When it came to a person with contacts among a large number of distinguished Heads, Mabel Dodge did well indeed to find Hapgood and make him an impresario as well as confident.[6]

II

Four of the six categories of activity that Dodge Salon habitués engaged in remain rich in anecdote without playing much role in artistic creativity. Hapgood's anarchist connections produced such occasional visitors as Bill Haywood, Elizabeth Gurley Flynn, and Carlo Tresca; and Dodge's lover for much of this period, John Reed, always had a whiff of political relevance swirling around his boyish head. Another of Dodge's close friends, Walter Lippmann, went through a brief period of enthusiasm for psychoanalysis; in the course of it, he introduced one of the leading local analysts, Abraham A. Brill, to the guests, and for a while, everyone seemed to be analyzing his or her dreams, neuroses, complexes, and slips-of-the-tongue. Unlikely as it may seem, given her reputation for emotional dependence on men, Dodge was also at least marginally involved in serious feminist issues: both birth control, in the person of Margaret Sanger, and improved working conditions for women, in the person of Emma Goldman, were welcome subjects of discussion in her home; and Dodge personally belonged to Heterodoxy. Finally, she and her friends were all interested in education. Those who had young children, like Sanger, had pressing family reasons; others, like Goldman, regarded the school as a vital social laboratory for trying out their radical ideas. The Ferrer School was thus in a sense a close cousin of the Dodge Salon.[7]

Mabel Dodge herself never gave much attention to theory of any kind: not to anarchism, psychoanalysis, feminism, or education. She worked with people, with Heads, and engaged in their enthusiasms vi-

cariously. She demonstrated the same sort of approach when it came to writing, painting, and theater; in doing so, she sometimes found herself involved intimately with important modernist activities.

The Steins most influenced her introduction to art and writing. Leo fascinated her from their earliest contacts in Paris and Florence. He "was always standing up before the canvases, his eyeglasses shining and with an obstinate look on his face that so strongly resembled an old ram." Always talking, all but oblivious to his audience, Leo comes through her memoirs as a ram who was all mouth. He "would linger for hours, talking very close into any ear he could secure, because, being deaf himself, he thought everyone else was." She recalled one hot summer night in Florence when she was stretched out on a chaise, "with Leo draping himself over the back of it, breathing close, and uttering his puzzling intellectual profundities down one's neck, scarcely noticing whether one listened or not or answered him." "All he wanted in life was an Ear," one of her friends used to say; with one he would "spin intricate, webby thought systems—and always used the longest words in the world. While Gertrude's language grew plainer, his seemed to get more difficult and ponderous." All the substance she could recall two decades later boiled down to "tension." "By 'tension' he meant looking beyond, to what we call the *au de la* for further vision . . ."

But Leo was good for putting her in contact with Head painters. Picasso, she recalled, "was a small, compact man, and the most remarkable things about him were his eyes. They were far apart and of a burning black. He had a most lambent, penetrating, burning look in them." Matisse "was another element altogether. A watery element. Large, pale blue and coral tones—blond—*roux*, fresh and clear." When she looked at his works at 27 rue de Fleurus, they "were all painted with light. He must have seen the waves of light of which we are all compact. The tension Leo demanded was there too." Matisse, she was sure, "*saw through matter.*" When an artist asked her what the modernists were trying to do, all she could say was, "They are going to teach the world to *see*," over and over. With sculpture, the situation was the same. In Leo's study, on the writing table, "there was a small sculpture of Maillol's. Leo made me see it too, and I made up a definition of it that I still think is pretty good: 'True sculpture displaces more space than it encloses.' " This sort of chatter is not criticism; it is gossip.[8]

One reason why Dodge got on with Gertrude Stein as well as she did, was that Stein also personalized things. "Gertrude didn't care whether a thing was *bon gout* or not, or whether it was quattrocento or not, unless it affected *her* pleasantly, and if it did please her she loved it for that reason." She kept Dodge informed of events in Paris art circles on this level. When Stein dined with Marcel Duchamp, she informed Dodge that "he looks like a young Englishman and talks very urgently about the fourth dimension." At times he was more detailed. "Also the futurists are in town. You know Marinetti and his crowd,"

she wrote in March 1912. "He brought a bunch of painters who paint houses and people and streets and wagons and scaffoldings and bottles and fruits all moving and where they are not moving there are cubes to fill in." She was all deadpan enumeration and repetition of nouns, but as description the letter was classic Steinese. "They have a catalogue that has a fiery introduction demolishing the old salons and they are exhibiting at Bernheims and everybody goes. Marinetti has given several conferences and at the last he attacked the art of the Greeks and Nadelman who was present called him a bad name and Marinetti hit Nadelman and they were separated." When she went to London to look for possible publishers, she met Roger Fry and reported him "awfully good about my work." And after the Armory Show, she reported on the new darling of the 291 circle: "I like him," she reported of Francis Picabia. "He has no genius but he has a genuinely constructive intelligence and solid harmony." Even better, he filled Stein in about Dodge and her recent activities. Stein too was into gossip; but mixed with it was often shrewd commentary, and it did not all come from her brother.[9]

For someone who operated on this level, the Armory Show was a Godsend, the sort of media event that invited participation and enthusiasm without demanding much in the way of comprehension. While Arthur Davies was seeking out painters and making the financial arrangements for the show, James Gregg was in charge of publicity, and eager for Dodge's cooperation. She was soon a vice-president of the association putting on the show, and at Gregg's suggestion, she agreed to write an article on Stein. "It was an escapade, an adventure. I, grown familiar in Florence and Paris with Cezanne—whose apples and things were met with in a reassuring friendly way on Loeser's walls—and Picasso and Matisse, familiars at Leo Stein's apartment, perceived that here in this other world they were accounted dynamite." What could she say of Gertrude, who had introduced her to all this? She inhaled the "smell of Scotch tweed and very recondite Turkish tobacco," that Gregg left behind, and despite misgivings produced a short sketch that did much for Stein's American reputation. Stein, she told readers of *Arts and Decoration* for March 1913, "is doing with words what Picasso is doing with paint. She is impelling language to induce new states of consciousness, and in doing so language becomes with her a creative art rather than a mirror of history." Although she termed Stein's writing "impressionistic," which it surely was anything but, she was more accurate in noting that Stein "uses familiar words to create perceptions, conditions, and states of being, never before quite consciously experienced." Stein did this "by using words that appeal to her as having the meaning that they *seem* to have. She has taken the English language" and used it a bit roughly, perhaps, "but by her method she is finding the hidden and inner nature of nature." Dodge thought Stein's prose "working proof of the Bergson theory of intuition." Like William James,

like Bergson, Stein was expanding notions of consciousness, and as Dodge wrote Arthur Davies: "Anything that will extend the unawakened consciousness here (or elsewhere) will have my support. . . . what is needed is more, more and always more consciousness, both in art and in life."

The experience of writing such a piece clearly rattled her a bit; she was not sure she could do the job coherently, and fearful Stein would not like the results. Late in January she filled her friend in, with marvelously modernist sense of time and spelling: "There is an exhibition coming off the 15 March to 15 Feb—which is the most important public event that has ever come off since the signing of the Declaration of Independance—& it is of the same nature." Arthur Davies was "the President of a group of men here who felt the american people ought to be given a chance to see what the modern artists have been doing in Europe America & England of late years," and "they have got a collection of paintings from Ingres to the italian futurists taking in all the french, spanish, english, german,—in fact *all* one has heard of. This will be a *scream!*" Two thousand exhibits would fill the 69th Regiment Armory. "The academy are frantic. Most of them are left out of it. They have only invited modern artists here who show *any* sign of life.." The organizers "have badges (buttons) distributed all over New York with an uprooted pine tree on it & 'the new spirit' underneath." These men, her new friends, "decide which are alive & which are dead—not a dead one is going to show. Some how or other I got right into all this. I am working like a dog for it. *I am all for it.* I think it splendid. . . . There will be a riot & a revolution & things will never be quite the same afterwards." And, by the way, she had done this article on Stein and hoped she'd done a decent job.

What Gregg and Davies did not do for Dodge, Hapgood did. One day he brought her to 291 to see the gallery and meet its proprietor, whom she liked so much that she was still seeing him "very often" a year after the Armory Show. Here again, indefinable impressions overpowered much by way of genuine analysis. Stieglitz "was always struck by the wonder of things, and after a visit to him, one's faith in the Splendid Plan was revived. I owe him an enormous debt I can never repay. He was another who helped me to See—both in art and in life." She was already showing that alarming tendency to see Stieglitz in terms of sublime if indefinable emotions and portentously capitalized letters. Stieglitz in turn introduced her to Dove, Marin, and Walkowitz and "that gnarled New England spinsterman," Marsden Hartley, who would haunt her over the next few years. 291 was also where she met the lover who solaced her while John Reed was away. Andrew Dasburg was "lame, but slender as an archangel and with a Blake-like rush of fair hair flying upward from off his round head."

Dasburg was French born, but had come to America as a boy. He attended the Art Students League and soon won a scholarship in landscape painting to the summer program which the League ran in Wood-

stock, a little town eighty miles upstate which was soon well-known as an artists' colony. Woodstock appealed to him so much that he based his life there for much of the period between 1906 and 1928. In 1907, Dasburg, Morgan Russell, and Walter D. Teague shared a house just outside town, and when Russell went to Paris he sent back numerous letters about the exciting events in the world of art. These fired Dasburg up for a return to his native land; for about fifteen months, he painted, talked, attended the Matisse class, met Leo and Gertrude Stein, and discovered the work of Cézanne. Leo loaned Dasburg one of his small Cézanne paintings, a still life of five apples, and Dasburg copied it repeatedly. He was later fond of saying that his professional life divided at that point, before and after Cézanne. When he added the work of Picasso, he could scarcely contain himself. "I came back from Europe inflamed like a newly converted evangelist."

Dasburg was soon in the thick of things in modernist circles. In Woodstock, he became close friends with Konrad Cramer, newly arrived from Germany with his head and brush committed to expressionism and the work of the *Blaue Reiter,* and by the fall of 1913 both of them were producing pure abstractions, entitled *Improvisation,* or simply *Untitled.* In the city, Dasburg had three paintings and a sculpture in the Armory Show, and when the star of that show, Marcel Duchamp, came to America in 1915, Dasburg became one of his chess partners.

Dasburg attended his first Evening most probably on 11 December 1913, only to find Dodge away, and Steffens and Hapgood in charge. Never having met the lady, Dasburg could hardly have missed her in any emotional way, but he seemed upset that the woman he had heard so much about had not been home. He expressed his emotions by retitling one of his Improvisations, "The Absence of Mabel Dodge," hanging it in her living room to greet her return. She responded: "It was all a flare of thin flames with forked lightnings in them and across the bottom of this holocaust, three narrow black, black, black bars," and began seeing him daily. He celebrated by doing a "Portrait of Mabel Dodge" to balance the "Absence." For about three years, his abstract work flowered impressively; then in 1916, he returned to more figurative and "natural" subjects. In 1918, at Dodge's invitation, he explored the area around Taos, New Mexico, and continued to live there off and on for the rest of his long life.[10]

The other painter with whom Dodge had a serious relationship was Maurice Sterne. When they first met, in May 1915, Dodge immediately noticed that he had "long locks in the manner of Liszt," a "nose, of a Biblical dignity," and a "handsome look of suffering." Her descriptions were a peculiar mixture of the precise male physiognomy and the romantic exotic. Sterne was "the Russian painter who was having an exhibition at Birnbaum's Gallery. He had spent a year on the island of Bali—practically the first white man other than traders ever to go there." "He was a mixture of old and complex racial turmoil, a darkness shot

through with lightning; something dangerous in him threw out the warning to beware of him." She "thought him very romantic. He represented the unknown, the undisclosed soul of Russia." In his turn, Sterne had been through a great deal since his days in Paris. He was exhausted both by his Asian visit and the long trip back, painfully separated from a woman he loved, suffering from syphilis he caught in the arms of Balinese companions, and in need of diversion. Dodge not only had money and a circle of friends he could join, she relaxed him. "It was a period when my own self-confidence had shrunk to zero. I was tired and diffident, and I found relief in Mabel's super-confidence."

Sterne was never a radical modernist; his friends were modernist and he was aware of their work and the influences surrounding it, but he was in essence a representational painter fascinated by the exotic—depending on critical perspective, either a throwback to the precursors of modernism in the 1890s, or a harbinger of the traditional impulses that dominated American work in the 1920s. He talked to Dodge incessantly, malely, but modernist theory hardly made a mark on their relationship. "He was a good talker and though he was not an intellectual man, he had a lot of fanciful ideas and intuitions about everything. He was quite clogged with art theories, with theories about 'significant form' and all that." So much for Roger Fry and the serious impulses behind an artist's professional life. She left that side of Sterne to Leo Stein: the two men "had long, lone conversations about Art, and about psychoanalysis"; she remembered his smell more clearly. Sterne pervaded her rooms "with his cigar, his dark, flowing Orientalism, and his little dissertations upon Art." Each on the rebound, each at loose ends, opposites attracting, Sterne and Dodge played "with the idea of marriage in much the same way that one pokes at a snake with a stick. The idea was dangerous and revolting; yet we couldn't leave it alone." So they didn't, marrying secretly on 18 August 1917.[11]

III

Even before she began to have Evenings, Dodge had discovered Provincetown. Before the war, it "was just a double line of small, white clapboarded cottages along a silent village street, between the bay and the open sea." Several couples among her friends liked to summer there: Hutchins Hapgood and Neith Boyce, Jig Cook and Susan Glaspell, Joe O'Brien and Mary Vorse among them. Summers in New York were hot and boring, and she preferred to be where the sea breezes cleared the air. She became so enamored of the place that she wanted to buy an abandoned life-saving station which lay across the dunes from the town, picturesque but so dangerously located that the government had found more secure quarters some distance away. She lacked the money to purchase it, but a friend bought it for her, to redecorate as she wished

while he retained title. "It was a lovely weathered building half covered with sand with an old boat-house near it." It had no neighbors and stood, "lovely and aloof on the high sand bank above the beach where the fierce waves pounded it all day—a wild enough spot to suit anyone."

Dodge's idea of a seaside cottage was not precisely like anyone else's: "I had its walls painted white all through the inside, shiny white, and the hardwood floors cleaned and waxed." The dishes were "Italian ware from Capone's in Boston, and were rudely decorated with fishes." She scattered low couches about, and hung "huge majolica platters, displaying fabulous fish," on several of the walls. "The beds were narrow, white ones, with perfect mattresses, and white spreads, and everywhere the white and blue paint glistened and shone." She had thought of it as a hideaway for herself and John Reed, but by the time she had it shipshape, she had Sterne in tow, and after all her efforts she only used it for one summer: 1915, the first of two of the most crucial years for the development of the American drama.[12]

Dodge's interest in drama was largely confined to the histrionics of her personal relationships, but once again, in Hutchins Hapgood, she had a guide to a world in which Heads were making things happen. Mary Vorse had discovered the place and passed the word, and by 1911 the Hapgood family had begun to summer there, forming a close group with Cook and Glaspell, and with another Chicago dramatic couple, Wilbur and Margaret Steele. No one, at first, gave a thought to putting on plays. Cook could not resist naming his casks of wine Sappho, Aeschylus, Sophocles, and Euripedes, and theater was rarely far from anyone's thoughts, but Provincetown was too underpopulated for anything organized to seem feasible. But by 1915, things were picking up. Max Eastman and Ida Rauh came, and she was an actress. Bobby Jones was eager to design stage sets in unprecedented ways. Three painters, Marsden Hartley, Charles Demuth, and Brör Nordfeldt, hovered on the fringes; a sculptor, William Zorach, and his wife Marguerite, a tapestry designer, were also available.

The group in Provincetown was thus a combination of people with modernist tastes from both New York and Chicago, most of them fearsomely verbal. They were also, at least in Hapgood's analysis, a special segment of modernist opinion. They "were really more free in all ways than many elements of Greenwich Village—free from violence and prejudice, either radical or conservative." To this sense of freedom they added "a more conscious desire to lead their own lives and to express themselves unconventionally. They felt the thought and emotion of the day was anaemic and rudderless and they felt their own souls were too." They were forever taking stock of their lives, trying to get back to an almost childlike openness, "without reference to their previous theories or the theories of others, revolutionists, so-called, or Tories." None of them, so far as he could recall, began their Provincetown stays

with a primary commitment to the theater as a profession, and most of them did not even attend the theater regularly. What they were interested in was the authenticity of their own lives: "What are we really like, what do we really want, how are we really living, what are the relations actually existing between us?" For the highly intelligent and bored, for those who had tried everything more than once, putting on plays was an outlet they hit upon almost at random.

War and labor unrest hung ominously in the distance, but even in a time of turmoil, they remained reflexively narcissistic. They "were inspired with a desire to be truthful to their simply human lives, to ignore, if possible, the big tumult and machine and get hold of some simple convictions which would stand the test of their own experience." Provincetowners "felt the need of rejecting everything, even the Systems of Rejecting, and living as intimately and truthfully as they could; and, if possible, they wanted to express the simple truth of their lives and experience by writing, staging, and acting their own plays." Hapgood thought that "they unconsciously took the form of the play, rather than some other form, because of the lifelessness of the theatre: here was something obviously needing the breath of life." [13]

If Hutchins Hapgood remains the best guide to the internal dynamics of Provincetown culture, a man who was not even in the town is the best source for the ways in which New York, Chicago, and modernist Europe could interact within the world of drama. Lawrence Langner was a Welshman who rebelled against all the clergy in his family tree. As a young man he worked up an expertise in patent law, and in 1910, he came to New York City as the American representative of a British firm. He loved America and got on well with Americans. A good mixer, he was soon friendly with Walter Lippmann, Waldo Frank, and the group around John Butler Yeats at Petipas'; these in turn introduced him to young enthusiasts in the drama, including Bobby Jones, Kenneth Macgowan, and the Boni brothers, Albert and Charles. Becoming a citizen as fast as he could, Langner joined an American firm, Delco, which needed someone competent to attend to its patent needs in Europe, especially Germany. Early in 1913, when Langner went to Germany to negotiate patent contracts for Delco, he spent his spare time exploring the innovations of Max Reinhardt in Berlin, and made quick trips to Vienna and Budapest. By that summer he was back in Greenwich Village and active in the Liberal Club, an institution which had the flavor of a Dodge salon writ large. The Club had developed from a genteel nucleus of progressives meeting to discuss social issues, into a more innovative group which discussed anything new. Among the speakers at this time, for example, were scientist Jacques Loeb, British feminist Christabel Pankhurst, and Big Bill Haywood. Among the members were Hutchins Hapgood, Neith Boyce, Jig Cook, Susan Glaspell, Marsden Hartley, Bobby Jones, John Reed, and Lincoln Steffens. Langner was closest to Cook and Glaspell, and an eager participant in

the discussions, skits, and unpretentious performances of one-act plays that the Club sometimes sponsored. When several members wished to have a more formal, public dramatic identity, they formed the Washington Square Players. Their first public performances were four one-act plays, presented on 19 February 1915.

Connections between New York and Chicago bohemias were fairly strong by the fall of 1913. Langner himself was in Chicago in 1913 opening a regional office for Delco, and he met Floyd Dell, Margery Currey, Sherwood Anderson, and Margaret Anderson; he even published a play in the *Little Review*. He familiarized himself with the Chicago Little Theatre, which under fellow expatriate Maurice Brown was trying to improve local taste, although these productions only rarely touched on modernism. On the whole, Langner was not impressed by American efforts to write or produce good drama. Soon, even these few Chicago efforts disintegrated, as Langner, Dell, and Sherwood Anderson were soon in New York, eager to write, produce, or support new work.

The earliest efforts of the Liberal Club's Washington Square Players were not distinguished, but they helped activate creative juices, and the results were soon apparent in Provincetown during the summer of 1915. Drama became the vehicle for the expression of the sexual, social, and intellectual tensions that animated the vacationers. No one spoke at the time, for example, of "sexual politics," yet everyone seemed to conflate the political and the personal, with the emphasis on the personal. The first plays to become public were Neith Boyce's *Constancy*, a spoof on the erotic antics of Dodge and Reed; and *Suppressed Desires*, by Glaspell and Cook, which wryly satirized psychoanalysis. Both Boyce and Gaspell, being women who lived in the shade of flamboyant men, have been underrated in subsequent histories. But both were shrewd and talented; both were experienced writers. The plays, especially the latter, hold up well, and were certainly a cut above the usual level for amateur theatrics. The performances occurred at some point in mid-July 1915, in the Hapgood living room, with the most informal of sets. A second program, consisting of Cook's *"Change Your Style"* and Wilbur Steele's *Contemporaries,* was put on down the street in an old wharf house, on 9 September. Steele's work, based on the activities of radical I.W.W. organizer Frank Tannenbaum, was as close as the players came to overt political statement.[14]

The events of the summer of 1915 were too casual and unplanned to do much more than suggest possibilities to the actors and would-be playwrights involved, but when they returned to New York they could not stop thinking about what they had done. The Washington Square Players were by then in full swing, and between 1915 and 1917 they put on sixty-two one-act plays by European and American dramatists whose work seemed too esoteric for popular consumption. In addition to works generated by the Provincetown group, the Players produced

plays by Langner, Zoë Akins, and Theodore Dreiser, and a rich collec-
tion of European works: by Chekhov, Ibsen, Shaw, Andreyev, and
Maeterlinck. Such European fare was only one way in which the two
groups differed. The New Yorkers frankly wished to compete with
Broadway and to broaden public taste. They were eager to put on im-
portant but neglected work that already existed. Provincetowners wanted
to encourage new writing by Americans, and cared little about chang-
ing mass taste. They were more willing to take chances. Both groups
tended to be informal, even casual in their acting and directing stan-
dards, and both concentrated on one-act plays because neither authors
nor actors had the experience to put on anything more complicated.

The summer of 1916 may well have been the most important few
weeks in the history of the American theater, and certainly remains
exceptional even in the much broader perspective of American mod-
ernism. Fresh from a series of European adventures, John Reed re-
turned to contribute several plays on social themes, cheer people up
with his wit and enthusiasm, and carry on his much publicized affair
with Louise Bryant. Wilbur Steele continued to unite personal and po-
litical with an amusing work, *"Not Smart,"* about pregnancy, language,
and social relationships and the various misunderstandings that even
earnest modern intellectuals seemed to have, despite their own best
efforts. Glaspell put on *Trifles,* one of her best efforts and one that
became a minor classic of amateur theatricals. Boyce continued to sub-
mit work, and Bryant, determined to be a writer on her own and not
simply glow in Reed's reflected glory, also participated. The quality of
the writing varied widely and only Glaspell retains much of a place in
the history books. But what the summer did, most of all, was discover
and present the sea plays of Eugene O'Neill, and launch him toward
the Washington Square Players and his first New York successes, *Be-
yond the Horizon* (1918) and *The Emperor Jones* (1920).[15]

Here, once again, Hutchins Hapgood provided the means by which
important people became acquainted. A few years earlier, in his explo-
rations of the New York underworld, Hapgood had written up the life
of his favorite anarchist bum, Terence O'Carolan, always known as Terry
Carlin, and his lover Marie, in *An Anarchist Woman* (1909). The two
men had met in Chicago at an anarchist ball, and royalties from Hap-
good's book helped sustain Carlin in his entirely alcoholic diet and his
shift in domicile from Chicago to New York. There he moved easily
within a large circle of social outcasts, who included Emma Goldman,
her former lover Hippolyte Havel, Hapgood and the fringes of the
Dodge salon. Hapgood always romanticized the lowest classes, and Car-
lin was one of the figures from this world who most appealed to him.
He was "a complete bum, so complete that it was magnificent." No one
ever knew him to hold a job or do anything useful, but he was a won-
derful talker and the soul of charm. "Terry was physically what any
artist would call beautiful, and more than that his soul had the eternal

flame of form." Equally comfortable with intellectuals and thugs, Carlin was not beyond a bit of petty larceny, once altering a check of Hapgood's to cover party expenses. But Hapgood never held this against him, and marveled at some length about the number of young and beautiful women who seemed eager to love Carlin even into his seventies. All this would be of small moment to the history of modernism were it not that Terry Carlin, one evening in 1915 at Jimmy the Priest's saloon, met Eugene O'Neill, who as far as anyone could tell from appearances was just another drunken Irishman.[16]

Of all the alienated outcasts who made up the ranks of American modernism, no one was so extreme a case as O'Neill; he was also the most important figure for whom Roman Catholicism provided cultural roots and a frame of reference against which a person could rebel. The son of a hard-drinking, sexually rapacious Irish immigrant actor and his genteel, lace-curtain Irish-American wife, O'Neill seemed to have been born into a world fraught with religious, sexual, and social friction, one where he had no fixed place. He was a trouper almost from birth, as he followed his famous father from one performance of *The Count of Monte Cristo* to the next; he hated trains and hotels for life. Feeling betrayed and declassed by the life she had inadvertently chosen, his mother took refuge in morphine, and for a long time Eugene had difficulty in comprehending why this person, on whom he was so dependent, behaved in such a disoriented way. Although the family tried to establish roots in New London, Connecticut, they never managed to achieve acceptance; acting was not a respectable profession, and Roman Catholicism not a religion with which many Americans were comfortable; and Ella O'Neill was in no shape to make a home with social graces or take a recognized place in society. Eugene thus entered what he later termed his "rigid Christian exile," two Catholic boarding schools. He withdrew to so great an extent that even as an adult he had trouble dealing with children. He could not talk to them in real life, and he had trouble creating them on stage.

O'Neill learned little at the schools he attended, taking his education outside of class. He found Benjamin Tucker's Unique Book Shop, at 502 Sixth Avenue in New York, and there absorbed the ideas that served him for life. Tucker liked to call himself "an atheist, a materialist, an evolutionist, a prohibitionist, a free trader, a champion of the legal eight-hour day, a woman suffragist, an enemy of marriage, and a believer in sexual freedom," and styled himself in the American context as an "unterrified" Jeffersonian democrat. O'Neill had no use for political reform or prohibition, but he was a libertarian on all sexual matters and tolerant to the point of anarchy on such "victimless crimes" as prostitution. Through Tucker's shop as well, O'Neill discovered George Bernard Shaw's *The Quintessence of Ibsenism,* that notorious misreading of Ibsen's plays as Fabian socialist tracts; and *Mother Earth,* Emma Goldman's journal, to which he became devoted. He found Max Stirner's

The Ego and His Own appealing, and when he discovered the works of Nietzsche, his development was about over. He read *Also Sprach Zarathustra* repeatedly over the years, and told a friend in 1927 that it "has influenced me more than any book I've ever read"; and the next year, when asked if he had a literary idol, replied: "The answer to that is in one word—Nietzsche." [17]

The anarchist path to modernism was an obvious one; both anarchists and modernists cultivated the self and mistrusted institutions, and both had trouble dealing with the larger society in personal as well as philosophical ways. O'Neill's biography is replete with examples of his alienation: he was alienated from his wordly father, from his addicted mother, and from his authoritarian schools. He had trouble dealing with women on any intimate basis, and was one of the most hopeless parents in history. He fought with directors, actors, and critics; indeed, he fought with the drama itself, and his alienation fed directly into the originality of his art, just as it had for Pound, Stein, and the rest. One way to create new forms and languages was to find old forms and words inadequate.

Reductionism is always a danger in such analysis, but the risks are worth the result. The point is not that great art gets reduced to the level of a neurosis or that biography explains art, but that life and thought, reading and action, often come together and reenforce each other, and new modes of living can produce new ways of creating. On no subject is this more apparent than in O'Neill's easily documentable obsession with the sea. Home was New London, where ships came and went. He read obsessively the romances of Jack London and Joseph Conrad, and then talked to any available sailor with tales to tell. *The Nigger of the Narcissus* was the chief inspiration for his decision to sail. Inarticulate in personal relationships, he felt at home among sailors, bums, Negroes, prostitutes, and other outcasts. At sea, the medium could be the message. The limitlessness of the horizon suggested something akin to God, and the sea itself, with its storms and calms, its waves and undertows which seemed to pull a boat in two or more directions at once, teemed with symbolist possibilities. Dreams could take over a man's unconscious, and time appear to have no linear progression. Voyagers were always questing, and a creative mind could find almost any message he wished in the long periods when he had nothing to do. For O'Neill as for Conrad, life at sea had its impact on form, and the form both developed in their respective arts was modernist in direct proportion to the degree that it was nautical.

No fewer than seven of the plays written before the end of 1917 took place on ships, and they loomed large in his later work, from *Anna Christie* and *The Hairy Ape* to *Strange Interlude* and *Mourning Becomes Electra*. Ships were self-contained units that easily became stages. They were a means of bringing disparate people together. They experienced fog, natural disaster, personal combat, and excessive consumption of alco-

hol. Whores sometimes came aboard. Dialects could clash easily. Men could reflect large national attitudes, especially during wartime. Passengers could have class confrontations with laborers. The sea was as replete with formal opportunities for the dramatist as it was for the philosopher.

His education in modernist work, seen on stage as opposed to read in a book, probably began in 1907, when he repeatedly saw Alla Nazimova star in *Hedda Gabler*. Already familiar with Shaw's Fabianized Ibsen, he could begin to make his own. Here was a playwright whose paternal ancestors were sea captains, who hated his father and abandoned Christianity. Sexually promiscuous himself, he also held heretical views on marriage, love, morality, and religion, and these inevitably appeared, if only by implication, in his plays. He too found the theater of his day hackneyed and uninspiring—"dramatic candy-floss" was Ibsen's term for the "well-made" plays of Scribe. As Michael Meyer has summed up the situation, Ibsen had only three options if he wished to write for the conventional European stage: tragedy, comedy, and melodrama. Tragedy was "a kind of grand opera without music, interesting only in so far as it afforded opportunities for sonorous declamations, spectacular outbursts, and striking visual effects." Comedy "was merely an excuse for individual inventiveness." Melodrama was a subject O'Neill knew only too well. Nobody, Ibsen discovered, expected a play to say anything sensible about real life; people wanted fantasy and escape, the very artificiality of the stage distracting them from personal concerns. Verse was the language of choice; a comedy could be in prose, but not a tragedy. No one wanted to see normal people on stage; actors had to be larger than life. To counter such attitudes, Ibsen early advocated two contrary positions: "that tragedy should present recognizable human beings rather than superhuman creatures, and that symbolism should be integral rather than overt."

O'Neill did not have the benefit of modern criticism, but his intuitions clearly recognized a kinship with Ibsen and the similarities in their views remain striking. Like O'Neill, Ibsen was no reformer, or what in O'Neill's day would have been a progressive. Ibsen was a radical Tory, pessimistic about the nature of individuals and cynical about the behavior of the masses, yet radical in his individualism. Both men mistrusted facile enthusiasm, political posturing and loud patriotism. Both knew first hand about the incompatibilities of marriage and the absurdity of conventional religious views of sexual relationships. The great theme which bound them, and which recalled Nietzsche among other O'Neill heroes, was the need to be true to oneself, to be strong but solitary in the face of the conventional. Implied in their attitudes was a deep sense of loss, for both seemed haunted by the absence of the religious certainty which had been a part of childhood and which, for a modern adult, seemed irrevocably gone. In this context, *A Doll's House* was not a work in favor of women's liberation but of self-fulfillment; *Ghosts* was

not a melodramatic shocker but an indictment of the stolid acceptance of convention and an expression of the need to fight against the ethical debility of people who cannot shake off the past. Ibsen was a man who broke down social barriers, throwing out artificial plots and elevated language in favor of ordinary events and comprehensible dialect. For him, too, the political was the personal.[18]

With O'Neill as with modernist theater as a whole, Ibsen proved less important than August Strindberg. He did not have a chance to see Strindberg's works in those early years, but rather read his work along with that of Synge, Yeats, Hauptmann, and other European pioneers. Strindberg took qualities that were often implicit in Ibsen and distorted them to suit his own tortured personality. Strindberg too thought of himself as a man who stood alone, an implicit anarchist scorning the taste of the masses. He too knew the fires of sexual drives and the inadequacies of conventional Christian attitudes to deal with them. He too knew first hand the frustrations of an incompatible marriage. He too was a searcher after religious certainty in a world that seemed devoid of God. But any extensive comparison of Ibsen and Strindberg makes the former seem calm and normal. Strindberg seemed extreme in everything. He flirted with madness, not only as an idea but as an actual paranoid. He dwelt on the love and hatred that seemed to go together in sexual relations, and tortured three wives and various lovers with his violent outbursts.

Such oscillations would tear most people apart, and Strindberg did tear, but he also poured his obsessions into several forms: he wrote fiction, autobiography, and most of all plays. O'Neill gobbled down whatever he could find, the preface to *Miss Julie* being most to the point. Attacking the hackneyed conventions that still dominated most stages, Strindberg took his stance as a modern. "Since they are modern characters, living in an age of transition more urgently hysterical at any rate than the age which preceded it, I have drawn my people as split and vacillating, a mixture of the old and the new . . ." They "are agglomerations of past and present cultures, scraps from books and newspapers, fragments of humanity, torn shreds of once-fine clothing that has become rags, in just the way that a human soul is patched together." He intentionally avoided "the symmetrical, mathematically constructed dialogue of the type favoured in France," and allowed "their minds to work irregularly, as people's do in real life." What interested most people in the contemporary world "is the psychological process." In pursuing the psychology of such characters, Strindberg not only touched on religion, but also on anarchism, suicide, insanity, misogyny, and even the sea—thinking of its horizon as a symbol of inner desolation. As he wrote to his wife in 1893: "life makes me seasick, even if the sea does not."

O'Neill repeatedly expressed his debt to Strindberg, most famously in "Strindberg and Our Theatre," his program note for *The Spook So-*

nata, the opening work of the Experimental Theatre that he, Bobby Jones, and Kenneth Macgowan founded in 1924. If Ibsen were the "father of modernity" for his times, Strindberg "was the precursor of all modernity in our present theatre," and all things considered a greater figure. "Strindberg will remain among the most modern of moderns, the greatest interpreter in the theatre of the characteristic spiritual conflicts which constitute the drama—the blood—of our lives today." He was the playwright of "super-naturalism," in a class all by himself, "since no one before or after him has had the genius to qualify." O'Neill was often vague or inconsistent in his use of technical terminology; by "super-naturalism" he was building on older concepts of realism and naturalism to take into account the subjects of insanity, irreligion, and sexuality that caused both Strindberg and himself legal as well as popular trouble.

Only by such a term, which by implication stretched notions of what was "real" to include extreme mental states and radical changes in how the playwright presented them on stage, could artists "express in the theatre what we comprehend intuitively of that self-defeating, self-obsession which is the discount we moderns have to pay for the loan of life." The older ways of portraying human nature were almost by definition superficial, and the work of older realists inadequate. "But to us their old audacity is blague; we have taken too many snapshots of each other in every graceless position; we have endured too much from the banality of surfaces. We are ashamed of having peeked through so many keyholes, squinting always at heavy, uninspired bodies—the fat facts—with not a nude spirit among them; we have been sick with appearances and are convalescing;" a modern playwright had to work in an "as yet unrealized region where our souls, maddened by loneliness and the ignoble inarticulateness of flesh, are slowly evolving their new language of kinship." Strindberg went through his modernist crisis first, and "expressed it by intensifying the method of his time and by foreshadowing both in content and form the methods to come." By then the most common term for such playwrighting was "Expressionism," and O'Neill was its most important representative in America.[19]

In the collected edition of O'Neill plays, the surviving early work takes up 544 pages through 1917, and not everything survived. Read seriatim, these plays make a heterogeneous impression. In subject matter, they include fragments of his first voyage to Central America, his life as a Princeton undergraduate, his bohemian days in New York, his interest in anarchism and the I.W.W., his tortured feelings about men and women and the family, the impact of war, and of course the sea. Many of them are poor, apprentice stuff. Although he professed to dislike the conventions of tragedy, comedy, and melodrama which he knew so well from following his father around, he was also their prisoner. Some of the plays are so novelistic in atmosphere and stage decoration as to be unactable; others have preposterous turns of plot, whores

with hearts of gold, children pathetically tugging at heartstrings, love affairs between masters and servants, and the sound of a suicidal gunshot arriving on cue as the curtain descends. Yet the seeds of something, presumably modernism, are often there under the fertilizer. Alcohol, drugs, violence, disease, madness, sexual license, and the rest all became standard modernist topics. Fog could be a cliché but also something of a philosophical statement: modern man did float aimlessly, unable to see what was happening, and natural forces did work in horrible ways on the human mind. Dreams often were real to the people involved as well as to artists. Besides, apprentice work is almost always dreadful, and only the most successful of artists have the misfortune of having their early false starts disinterred decades after they seemed safely buried.

Appearing off and on among plays on these other themes, those about the sea do not jump forth as the best. *Thirst,* one of the earliest and most famous, is as melodramatic as any, pushing its emphases on interracial sex and gratuitous violence, including presumptive cannibalism, to ludicrous extremes. *Fog* is a labored attempt to make art out of the craze for extra-sensory perception and communication with the dead. But taken together, the sea plays brought out the best in O'Neill. He knew the sea from direct experience and other playwrights did not. It was a scene free of most of those conventions which O'Neill needed to get out of his system.

Neither critics nor audiences have agreed about the relative merits of O'Neill's plays about the sea. In this rare instance, the author's own opinion stands. *The Moon of the Caribbees* "was my first real break with theatrical traditions," he told an interviewer in 1926; and he told Harvard Professor George Pierce Baker that it remained "my pet play of all my one-acters" in 1919. Unlike most of his work up to 1917, it contained almost no action, few clichés, little melodrama. It had no real plot. The *Glencairn,* a British tramp steamer, is at anchor in the West Indies; the crew, mostly lower class but with a few officers near at hand, entertain a group of "West Indian Negresses" who ostensibly are selling fruit, tobacco, and the like, but are actually there to party. Sex, alcohol, and atmosphere do their work, a fight breaks out and things get a bit out of hand; officers send the women away. To conventional audiences it might seem pointless—which it was, intentionally. For what O'Neill was after here was far from the sort of tripe his father wasted his life presenting. *Moon* is about the mental life of the lower class as it participates, through alcohol, music, and sex, in the same dreams and memories that analysts from William James to James Joyce were discovering. Over the men as they sing, dance, drink, and fornicate, linear time disappears with the plot, and O'Neill lets high and low culture mingle in a way any modernist would recognize as crucial to the new aesthetic values.

Consider less than two pages of dialogue, here abridged:

Smitty: Damn that song of theirs. . . . If I listened to it long—sober—I'd never go to sleep. . . . It's the beastly memories the damn thing brings up—for some reason.

The Donkeyman: Queer things, mem'ries. I ain't ever been bothered much by 'em.

Smitty: But suppose you couldn't put them out of your mind? Suppose they haunted you when you were awake and when you were asleep—what then?

The Donkeyman: I'd get drunk, same's you're doin'.

Smitty: Good advice. We're poor little lambs who have lost our way, eh, Donk? Damned from here to eternity, what? God have mercy on such as we! True, isn't it, Donk?

Smitty is, of course, quoting from the Yale "Whiffenpoof Song," presumably from a popularized version of the sort Rudy Valley made infamous. With it and this play, O'Neill joined the ranks of Pound, Eliot, and all those Europeans who were making high culture out of low culture, fusing memory and desire in a continuous present that made class as well as time irrelevant for perceptive statements about the condition of modern man.[20]

Having no luck with either publishers or directors, O'Neill sought refuge in alcohol and conversations with bums. Taking up with Terry Carlin, he heard about Dodge and her circle; Carlin had enjoyed a peyote trip at one of Dodge's farthest out parties, and was an intimate friend of Hapgood. When word of the 1915 summer theatrics at Provincetown came out, O'Neill and Carlin determined to position themselves for discovery. They squatted in the hulk of a wrecked boat in nearby Truro. Early in the summer of 1916, desperate for new work to fill out the programs of the Players, Glaspell bumped into her old friend. Terry, she asked him, "haven't you got a play to read to us?" "No," he replied, "I don't write, I just think, and sometimes I talk. But Mr. O'Neill has got a whole trunk full of plays." Such meetings have their own dramatic appeal for those in theater. Trunks sounded a bit heavy, but the Players were getting desperate. She asked Carlin to have O'Neill come down that evening with the pick of the pile. He brought *Bound East for Cardiff,* and as Glaspell wrote later: "Then we knew what we were for."

The play opened in the Lewis Wharf on 28 July 1916 with Jig Cook playing Yank. Had any novelist written up the event, a good editor would have criticized the effort for too much of a good thing. "The sea has been good to Eugene O'Neill. It was there for his opening," Glaspell recalled. "There was a fog, just as the script demanded, fog bell in the harbor. The tide was in, and it washed under us and around, spraying through the holes in the floor, giving us the rhythm and the flavor of the sea while the big dying sailor talked to his friend Drisc of the

life he had always wanted deep in the land, where you'd never see a ship or smell the sea." She concluded: "It is not merely figurative language to say the old wharf shook with applause." Early in September, the group put on *Thirst*.[21]

Given this momentum, the veterans of the 1916 summer could return to the Village and energize New York theatrical life. Remaining the Provincetown Players, they found a stage at 139 MacDougal Street, close to the restaurants, bars, bookshops, and apartments that many of them already knew. O'Neill remained their star: *Bound East for Cardiff* was the lead-off play of the 1916–17 season, opening on 3 November; *Before Breakfast, Fog,* and *The Sniper* followed. H.L. Mencken then accepted *The Long Voyage Home, Ile,* and *The Moon of the Caribees* for publication in *The Smart Set,* and by August 1918, all were in print, reaching audiences far from the Village.

Walter and
Louise Arensberg

Of the three major New York salons, that of Walter and Louise Arensberg was the least known to the public and remains the least documented. It was also the most important in terms of its long-range impact on cultural history. In poetry, painting, and music it was crucial in numerous ways; and in that nebulous genre which should exist to include machine art and readymades, it was always preeminent. There, far more than in the Stieglitz salon which it often overlapped, vital issues of two-dimensional and four-dimensional art came up for discussion; and there, far beyond the dreams of anyone in 291, Europe and America not only met and intermingled, but cross-fertilized: sexually, obscenely, mechanically, comically, interdisciplinarily, linguistically, and even artistically.

The Arensbergs were a cultured, ethnically German family in Pittsburgh devoted both to the making of money and the enjoyment of the fine arts. The money came from a crucible factory; the arts included music, sculpture, and engravings. At Harvard, either in class or in his many extracurricular activities, Walter Arensberg encountered George Santayana in aesthetics, Charles Herbert Moore in architectural history, and Charles Eliot Norton in the history of art. Never a scholar, Arensberg preferred to live mostly for poetry. He edited the *Harvard Monthly* and was president of Delta Upsilon, a literary society. He also devoted spare time to acting and playing chess. Graduating with minimum honors in 1900, he spent much of the ensuing period in Europe. He traveled, studied desultorily in Berlin, and spent his most productive time in Italy. Moore had taught him to revere Medieval Italian buildings, and Norton had sparked a passion for Dante. Norton had published a prose translation of the *Divine Comedy* before Arensberg had arrived in Cambridge, and Arensberg imitated him by doing one of his own. Returning to America, he dabbled briefly in journalism and was in and out of Harvard as both student of English and teaching assistant. Academia did not interest him much, and when Norton died in 1908, Arensberg purchased his estate, Shady Hill, and settled in for a life of

creativity and connoisseurship, presumably with a focus on poetry.

As a poet, Arensberg had a slender but definite talent, enough to get him mentioned in the larger histories of poetry, usually in a catchall group including Alfred Kreymborg, Donald Evans, Orrick Johns, and Lola Ridge. Like many from comfortable backgrounds, he felt no need to work productively for money and could suit himself. His poetic facility, combined with his knowledge of romance languages, enabled him not only to translate Dante, but also to explore French symbolist work in some detail. In time he translated Laforgue, Verlaine, and Mallarmé, and the work of such figures colored his own English verse, which appeared as *Poems* (1914) and *Idols* (1916); he scattered a number of more radical works in little magazines.[1]

Many of his friends had trouble figuring Arensberg out, and historians have done little to improve the situation. He had a boyish face and hair that often cried out for a barber. He sometimes looked as if he had slept in his clothes. This dishevelment confirmed the impression he gave of being an absent-minded scholar, always in a realm slightly removed from crass reality. Descriptions of him, even though affectionate in tone, barely mask the psychological instability that seemed to lurk just below the surface of his life. He was in many ways obsessive in his behavior, pathologically suspicious and even paranoid in some of his intellectual interests. He chainsmoked. He worked ceaselessly, pursuing subjects far beyond their intrinsic worth. He often became so distracted that he tuned out family and friends for days at a time. Charming and learned one minute, he could be merciless and hypercritical the next. Art aside, his true obsession was with cryptograms, codes, and other signs of a personality uncomfortable with life as it seemed. The symbolism in Dante, and the authorship of Shakespeare's plays, were his greatest enthusiasms, and at the end of his New York residency he brought out his work for public view in *The Cryptography of Dante* (1921) and *The Cryptography of Shakespeare* (1922). To a sensibility that found stimulation in French symbolist verse, to a mind that tended to see order when others saw chaos, both modern art and modern literature were tonic. Anything opaque gave his restless mind something soothing to do.[2]

One of Arensberg's closer friendships not only clarifies some of his puzzling character traits, but also serves to indicate the interconnected nature of certain modernist concerns in the salon that bears his name. Elmer Ernest Southard was several years ahead of Arensberg at Harvard, but had stayed on after his 1897 graduation to take a medical degree and join the faculty of the Medical School, rising to a chair in neuropathology by 1909. By all accounts as brilliant a man in philosophy as in medicine, Southard had been a valued member of the "Royce Club," an informal seminar in which students and faculty wrestled with philosophical problems. Most of all, he was a disciple of William James, to the point where he could later inform a collector of class notes that

James' course on abnormal psychology, and a long walk and talk they had once taken, were the chief factors in his "real mental set" as a mature physician. In private life, Southard too was a chess fanatic, sometimes carrying on half a dozen games simultaneously, blindfolded.

Documentation of specific meetings is lacking, but Arensberg is on record that he "was enormously indebted to Ernest for the opportunity of discussing with him some of my ideas about 'The Divine Comedy,' " and they could hardly have avoided talk on artistic and philosophical issues as well. Southard, for example, once addressed the Society of Independent Artists, tongue-in-cheek, on the topic, "Are Cubists Insane?" No text survives, but Arensberg recalled later: "It wasn't at all his idea to imply that Cubists were insane. He selected this title, I suppose, as a sort of teaser. What he proposed to show was a parallel between certain types of modern painting and certain psychopathic types as corresponding, in extremis, to certain normal types. Thus he classified Marcel Duchamp as belonging to the schizophrenic group." Arensberg, in turn, was just as involved in Southard's long-term plans. In one of his last letters Southard wrote his future biographer: "What interests me most is a proposition to edit the works and Mss. of Charles Peirce. Walter Arensberg has given a sum for the purpose. . . . I feel that my own intellectual life is going to be made over by the work. I think I shall know whether pragmatism is so by the time I am through . . ." Poetry, philosophy, medicine, insanity—and even chess—were all in the air, and demonstrably interrelated, when foreign art made its publicity coup early in 1913.[3]

The precise chronology that would establish Arensberg's progress through the weeks of the Armory Show, as it traveled from New York to Chicago to Boston, remains obscure. The essential facts seem to be that Arensberg lacked purpose and taste in modernist art before the show opened in New York; that he encountered the exhibition there, but was so shocked by what he saw that he went around in an aesthetic daze for several weeks, procrastinating to the point of paralysis; that through his attendance he met Walter Pach, who gave him a firm but friendly crash course in the new values; and that by the time the show closed in Boston in May 1913, Arensberg was a convert. Because of his early dawdling, he missed out on bidding for the most influential of the new works; by the time the show closed, all the American works had disappeared due to lack of exhibition space. Despite these problems, Arensberg was able to purchase works by Cézanne and Gauguin, and most importantly, Jacques Villon's "Sketch for 'Puteaux: Smoke and Trees in Bloom,' #2," in its English translation, #235 in the Boston catalog, priced at all of $81. Once Pach had nerved up his new friend to make that purchase, the events were in progress that established the Arensberg salon in New York, and that made Arensberg the logical man to greet Villon's brother, Marcel Duchamp, when he arrived in New York in 1915.[4]

The missing element in this sketch of Walter Arensberg, as he moved from Boston to New York in 1914, is his wife and the musical modernism she brought to the salon. Louise Stevens was the daughter of a Ludlow, Massachusetts, textile manufacturer. As so often happened in the history of American capitalism, innovative and energetic capitalist fathers piled up fortunes that enabled shy, sensitive daughters to enter the arts and escape from the very pressures that made such lives financially possible. A model of witty common sense, she channeled her enthusiasms into the study of the piano, over the whole gamut of musical history from earliest baroque to the most demanding of modernists. She was the Arensberg who knew the work of Schönberg and Satie, and who could engage even so radical a young composer as Edgard Varèse in knowledgeable conversation. Her real problem was that she disliked crowds, loved privacy, and harbored misgivings about being hostess of a boisterous salon. She attended often enough, and sometimes played for the guests, but as Louis Bouché recalled years later: Lou "was retiring and didn't seem to like being hostess. Her evenings were usually spent at the opera."[5]

II

One of the few outlets for decadent poetry open to Arensberg and his friends was the little magazine, *Rogue,* which Allen Norton and Louise Norton edited in Greenwich Village. In the brief period between the decline of the Dodge salon and the rise of the Arensberg, Norton parties played a crucial role in bringing artists together. Wallace Stevens, for example, appeared both in *Rogue* and at the parties, and at one of them an admiring young poet spotted him and felt the urge to express his admiration. Stevens seemed so large and burly that the newcomer, Alfred Kreymborg, felt slightly overawed, but in fact Stevens was the truly shy one. He waved a deprecating hand, muttered something like "Jesus," when he found himself cornered, and fended off the approach. Norton had to take Kreymborg aside and explain to him that no one, ever, cornered Wallace Stevens to ask him about his own work. Taking the hint more to heart than he needed to, Kreymborg vowed never to speak to the object of his affections again, and looked over the crowd. He admired the beauty of Louise Norton, spotted Carl Van Vechten and Fania Marinoff, who preened at most of the social occasions that have made it into cultural history from those days, noted the compelling presence of British modernist poet Mina Loy, and finally settled himself near Arensberg. The topic of discussion turned out to be chess, the two hit it off, and Kreymborg was soon an eager consumer of party food as the Arensberg salon got into high gear over the next year.

"Arensberg was passionately fond of Pound and the Imagists," he recalled a decade later, and Arensberg was aware that Kreymborg's

own journal, *The Glebe,* had recently published an issue devoted to Imagist work. Arensberg was critical of both his journal and Kreymborg's, and of Harriet Monroe's *Poetry* as well. None of them seemed adequate in the mission he then felt to bring new poetry to American audiences. Arensberg was already thinking specifically of a magazine of sixteen pages and a circulation of 500 copies per issue. "We'll have Wallace Stevens and Mina Loy to begin with," he said. Kreymborg was sure that, between the four of them, a valuable publication would evolve as a matter of course. Since Arensberg was willing to guarantee a small subsidy, but did not want to play a public role, Kreymborg agreed to manage the editorial details. He tried to write a manifesto, but kept cutting it, until only a single sentence remained: "The old expressions are with us always, and there are always others." He showed it to Arensberg, they mulled it over, and settled on the last word as being the best summation of their modernist goals. In a brief period, *Others* became central to the new poetry. Not as Victorian as *Poetry* or as eccentric as the *Little Review,* it became preeminent among those journals which, as the saying soon was, "died to make verse free."

Also the son of a German immigrant, Kreymborg had grown up poor and had little education. Chess was one of his passions, too, and he quickly developed from thinking of it as a boy's game to an adult's vocation; for a decade, one of his chief sources of income was the accumulation of fees he received from playing at the Rice and Manhattan Chess Clubs in New York. Another passion was music. He became adept at the pianola and the orchestrelle, both of which played rolls of the more popular kinds of classical music, in addition to the inevitable rags and show music reductions. At Aeolian Hall, just down from the Waldorf-Astoria, Kreymborg demonstrated these rolls for customers, in the process giving himself a haphazard grounding in contemporary composition. He "felt like Busoni, the Kneisel Quartet, the Boston Symphony Orchestra, . . . as his insides sang or fiddled or burst into jubilation," he remembered. When the customers left him alone, "he would study until his sight gave out, his feet could pedal no more, his clothes were drenched with perspiration." He imagined himself to be a Hans von Bülow, instructing the masses from the podium in matters of taste. He "fairly wallowed" in the work of Richard Strauss, and for awhile his "first god" was Richard Wagner. His customers did not share his enthusiasms, and he came to "despise" them in their ignorance.

Two friends, Alanson Hartpence and Ethel Thomas, rescued him for poetry. They showed him their own verses and those of their friends and favorites, and talked about fiction and criticism with him. Always regretting that he never had an Ivy League education, Kreymborg did what he could by reading local journalists, his favorite being Hutchins Hapgood. He met John Cournos, who often lived in London and was the first person to mention Ezra Pound to him. But Kreymborg for a long time did not know anything significant about modern poetry, En-

glish or American, and "had to be his own Baedecker." He read what-
ever he could find: "Molière, Ibsen, Nietzsche, Hardy, Dostoievsky,
Turgenev, Browning, Synge, Sterne, Fielding, Balzac, Flaubert, Ana-
tole France." Paying no attention to academic reading lists because he
was unaware of them, he had no prejudices against American work,
coming to love "Poe, Hawthorne, Emerson, Thoreau," and especially
Whitman. "Walt appealed to him as the first original, the one true dem-
ocrat and cosmopolitan on American soil. He alone loomed high."

In painting he also felt his way, this time with rather better guidance.
A long-time friend of Marsden Hartley, Kreymborg was soon meeting
Stieglitz and the 291 crowd, joining in an occasional group dinner at
the Prince George Hotel. Writing of himself in the third person, he
came early to a simple conclusion about modernism: "He gradually
learned that the lines of painting and sculpture complemented the lines
of music and poetry; that, without drawing needless parallels, one could
readily trace a relationship proving that many artists of the age, no
matter what their medium, were seeking similar fundamentals and
evolving individual forms."

The most significant institution for Kreymborg became the Daniel
Gallery, for his friend Hartpence, always known as Lance, was the as-
sistant there to Charles Daniel. An enigmatic bartender who had been
haunting 291 and putting together a small collection, Daniel suddenly
opened his gallery in December 1913, and for the next fifteen years he
was a significant factor in the transmission of modernist art to custom-
ers who would otherwise never have met Stieglitz' mysteriously exclu-
sive sales requirements. Visiting Hartpence there one day, Kreymborg
met two young artists who seemed redolent of distant Europe and all
things new. Man Ray and Samuel Halpert seemed as much Russian as
American to him; more immediately important, they had just rented a
shack across the Hudson River in Grantwood, New Jersey. Although
living was cheap it was also a bit lonely and dull, and if Kreymborg
would like to drop in for a few days, they'd be pleased to have him. He
jumped at the chance, loved the place, and lingered on into the sum-
mer, sharing rent and cooking duties. He even arranged to buy, in
small installments, his first painting, one of Halpert's first works since
his return from Paris, "a row of brooding jugs on a shelf." Kreymborg
soon realized that Halpert had peaked as a painter and would never
grow beyond his first promising homages to the work of Cézanne. But
with Man Ray, life was less predictable. "Man was only twenty-two at
the time, but the large-eyed, curly-haired dreamer had an enviable re-
cord as a daring performer in versatile experiments."

Man Ray was then earning money as a printer, and he and Kreym-
borg soon decided to pool their interests by printing a small poetry
journal. Throwing names around, they found themselves wanting to
return to the soil in some way, and they hit upon the obsolete word
glebe as a good choice—glebe lands being those which supplied clergy

with income. The assumption seemed to be that they would encourage a poetry that went back to the soil for inspiration and had a religious connotation, art being implicitly a modernist religion. They were soon contacting old friends, and John Cournos offered to put them in touch with Pound. Long an admirer of Pound's contributions to *Poetry*, Kreymborg agreed with enthusiasm. He soon had a package of materials for *The Globe*, with scrawled instructions not to be "another American ass" and to print it without meddling—Pound clearly fearful that he might have a male Harriet Monroe on his hands. Kreymborg leafed through the material, which included work by James Joyce, Ford Madox Hueffer, H.D., F.S. Flint, and Pound himself. He printed it with the title Pound demanded: *Des Imagistes, An Anthology*. It made quite an impression, although the expenses and mechanics of publishing soon depressed Kreymborg, and he was losing interest in the venture even as *Others* came into its own.

When, at the end of the 1920s, Kreymborg published his comprehensive history of American poetry, *Our Singing Strength*, he ably summarized both the attractions of Imagism as seen from New York, and its inadequacies over the longer term. Imagism crystallized several tendencies in the modernist camp, he wrote, but it "only gave us forms with which we were unfamiliar, stimulated us to try them." Most of his friends "welcomed Imagism enthusiastically, but were puzzled by its foreign airs and graces. It was not enough." It referred to books they hadn't read and events they did not know first hand. "We accepted the forms, but could not accept the whole spirit. What was all this about the Greeks, the Provençal, the Chinese?" They found the poetry "beautiful, alluring, intoxicating, but it did not stay with us. It was too remote from our lives," which had been lived and would continue to be lived in America. It intimidated Americans who had not been to Harvard or the University of Pennsylvania, and reminded them of their poverty and lack of opportunity. "We craved a more direct cultural expression, however crude, hard and blundering." Free verse was soon clearly divided into two camps: "Americans abroad looked to literature for their models; those at home looked to life." When they did, they found that the author of a single, untypical poem in *Des Imagistes*, was the poet they had been looking for: "my one remaining pal in America," "old Bull" Williams, was the way Pound referred to his college buddy. Williams became Kreymborg's "special ally" in judging the new American verse.[6]

William Carlos Williams had come some distance from his Philadelphia days with Pound and Hilda Doolittle. Realizing that he could not make a living in the arts, he had devoted himself to medicine. He had survived a difficult internship in obstetrics and pediatrics at the Nursery and Child's Hospital in New York City, in an area which even then was a high crime location, obtained a license to practice in New Jersey, and opened an office in his father's home in Rutherford. To fill in the

long days with few patients, and make enough money to marry, he even served as physician to the local high school. In view of his later work, with its meticulous attention to the minute details of real life, his surviving early verses remain something of a shock: they are not only bad, they are fraudulent Keats, leavened at times with imitations of Whitman. Williams then seemed to live in two worlds simultaneously, scarcely even trying to write about anything that was actually happening to him. But he did keep in touch with Pound in London, and much admired the poetry his friend sent him; he devoured Ibsen's plays in print, and attended any rare performance that opened in the area. He went to the Metropolitan Museum, and haunted any small galleries that seemed likely to have new art on view. Nothing he said or wrote left much impression in terms of modernism or showed more than a casual understanding of what was in the air all around him.

Yet something was going on, and not just accidental friendships with Pound, Doolittle, Kreymborg, and the rest of the Arensberg circle. As befitted a follower of Whitman, Williams was deeply interested in the colloquial, and in the objects of daily life. He was also intuitively aware of the relationships between such speech and such objects with rhythm, and the need for poetry to incorporate such a thing as "speech rhythm" and get beyond the sterile controversies that were already all too common about free verse and the place of the image. Measurement in terms of meter, of longs and shorts repeated at tedious length, had to give way in his opinion to more natural forms, such as the waves and ripples suggested by the movement of the ocean. As many suggested, music offered poets possible parallels here, but neither Williams nor Pound had all that good an ear for strictly musical qualities; what Williams did have was an eye that was better than Pound's, and a feeling for implicit drama that provided him with a path for arriving at the paratactic effects which the London Imagists were experimenting with. Williams seemed to see rhythm. He instinctively conflated time and space. He had trouble putting such mixed metaphysical collages into prose, and even more trouble making effective poems out of them. But when he began to, in the early 1920s, his importance for the younger generation of modernists in time surpassed that of even Pound himself.

In 1915, this was all in the future. At that time, Williams was depressed and lonely, making little money and desperate for artistic companionship. The little colony that Halpert, Ray, and Kreymborg had established in Grantwood was perfect for a physician in nearby Rutherford; on Sunday afternoons Williams could forget germs and babies for awhile and drive over to see his new friends. Although he disliked rural life, Walter Arensberg himself was sometimes there, and that champion walker Wallace Stevens. Mina Loy from England and Marcel Duchamp from France provided international flair, and sometimes even the very young found their way, such as Malcolm Cowley. Grantwood became for modern poets what Provincetown became for playwrights,

that semi-mythical ur-source for inspiration, high-jinks, sexual libera-
tion, and alcohol-fueled feelings of mateship.[7]

By the time he published *Al Que Quiere!* in 1917, Williams was notice-
ably stepping over the line that separated his acutely romantic early
years and his pioneering, modernist maturity. The poems themselves
do not give consistent evidence along these lines, but the implications
of the memoir literature are that no matter how deceptive his progress
seemed to be, he was abandoning the romantic obsession with subject-
object disjunctions, and entering that strange new world where subject
and object seemed to be one, where the intensely experienced local
place was actually all places, and where the present was one continuous
time indistinguishable from all other times. Cause and effect do not
seem to exist in his work, because to operate sensibly they would have
to occur in sequence, linearly, and such dependable sequences no longer
existed. Williams had not yet made his shorthand summary of such
matters, "No ideas but in things," but his ideas were becoming visibly
"thingy," and the famous red wheelbarrow, upon which "so much
depends," would be sitting beside the white chickens in *Spring and All*
of 1923. Always anti-intellectual, often xenophobic, sometimes anti-
Semitic, and as prone as Pound to such odd political nostrums as Social
Credit, Williams seemingly intuited the modernist feel for the relativity
of the universe in both a physical and a moral sense. Absolutes of space
and time seemed meaningless to him, God never turned up, and the
poet, or man, became one with the concrete perceptions of the local.

The poetry evoked this view of the world. When he looked back on
his early work, Williams kept mentioning the "rhythmic unit." "The
rhythmic unit decided the form of my poetry. When I came to the end
of a rhythmic unit (not necessarily a sentence) I ended the line." He
did not measure such a unit in the customary way, with capital letters
at the beginning of lines or periods at the ends of sentences. He was
experimenting. "The rhythmic unit usually came to me in a lyrical out-
burst." He wanted his poems to look a certain way on the page, and
"didn't go in for long lines because of my nervous nature. I couldn't.
The rhythmic pace was the pace of speech, an excited pace because I
was excited when I wrote." His lines "were short, *not* studies. Very fre-
quently the first draft was the final draft by the time I reached the third
book, *Al Que Quiere!*" To put it another way, time and space were the
product of mood and whim, and the rhythmic unit was the way a poet
expressed such impulses. The variable foot, as it came to be called, was
the technical result, as important for poetry as non-Euclidean geometry
and the fourth dimension for painting.[8]

Williams was not an inveterate reader of physics books, and appar-
ently found confirmation for his ideas, rather than inspiration, from
popular discussions of space, time, and relativity. Instead, he absorbed
much of what he needed from sampling the works of Gertrude Stein
and watching the rapid evolution of Marcel Duchamp. By the time Wil-

liams began his visits to Grantwood, *Three Lives* was a standard topic of modernist conversation, Stein's contributions to *Camera Work* were the subject of much comment both for the idea of a new painting and its embodiment in a new prose, and the general drift of her ideas on language was in the air. Not much of her most complex experimentation was easily available, so artists could let their imaginations loose and have her mean what they thought she might mean. Williams wanted to express ideas in things and so did she, always remembering the noun: Stein's potatoes, her multiple roses, here becoming equivalents to Williams' wheelbarrow. Both made war on syntax, breaking up sentences in ways readers found difficult to follow. Both disliked indirection. Both warred on symbolism. Both went from one particular to another, only allowing a generalization as being simply the totality of the particulars. Both in practice seemed to merge nouns and verbs, and to find the poem an expressional equivalent of natural processes. As Williams' shorthand summary of his debt to Stein, in *Pictures from Brueghel* (1962) has it: "A rose *is* a rose / and the poem equals it / if it be well made."

Marcel Duchamp, in this context, was the bearer of important if depressing tidings. Although Williams later claimed in his somewhat bilious autobiography that his attempt to talk to the visiting Frenchman at an Arensberg party proved embarrassing and unproductive, the two men were actually pursuing common paths—which Williams clearly sensed, or he would not have so admired Duchamp in the first place. For Duchamp was, at the time Williams met him, already beyond cubism and indeed painting itself. He was into readymades, found objects which the artist chose for whatever reason, and then either modified to suit his taste or presented unsullied to the public for its enlightenment. Art in this context became found: you stumbled over it, saw it in a store window, or even flushed it; art was like the objects in Williams' poems to come, simply there, being nouny and self-sufficient, its very ugliness and commonplaceness a comment on the productions of the dead artists of the past. Duchamp was way ahead of Williams—to use an archaic, hopelessly linear standard both would have rejected—and so in a sense Williams was right to feel "like a yokel, narrow-eyed, feeling my own inadequacies, but burning with the lust to write." And write he did, about the polluted Passaic River, about the waste and decay of Paterson and its environs, about the poor and the sick, and all the other "non-poetical" subjects which he chose, his own readymades. In the long run, any man who could make Paterson into art did not need to feel inferior to the selector of "Fountain."[9]

III

In many odd ways, the work of the most important of the artists living in Grantwood resembled that of Williams. By 1917, Man Ray too was experimenting with forms that would shatter conventional assumptions

of work in his chosen field. During the year before America entered the war, he gradually abandoned oil painting for collages, assemblages, and experiments with the camera. Tired of efforts to re-create an illusive, three-dimensional reality on canvas, he deliberately chose to photograph his works, at first for documentation but then increasingly because he preferred a two-dimensional look. He worked extensively with the airbrush, which created similar effects. He found objects, manipulated them, and reduced them to photographs as well. In many senses, his productions in the 1920s illustrated Williams' poems, even though by then the men had no contact and lived an ocean apart.

Emmanuel Radnitsky was born in Philadelphia in 1890, the son of Russian Jews fleeing persecution and compulsory military service. When he was seven, his family moved to New York City and life in the needle trades. Traditional but not especially religious, poor but aware of cultural opportunities, his parents decided on an architectural career for their son. He acquiesced briefly, but soon found the art which he discovered at 291, the Macbeth Gallery, and other such small institutions more to his taste. As he slowly found a vocational identity, his family found a cultural one. Eager to shed their foreign name and feelings of persecution, the whole family changed its name in 1911, "Ray" being as close as they could come to something totally deethnicized. Since "Manny" had been a nickname throughout his childhood, the artist became "Man Ray" and did everything possible to obscure his origins. He read widely if informally, and found a native role model for himself in Henry Thoreau, that most indigenous of American rebels. He developed an interest in jazz.

The obvious place for an upwardly mobile Jewish artist who thought of himself as a Thoreauvian anarchist was the Ferrer Center. In his trips to 291, he heard other visitors discussing the Modern School and its popular art classes. Late in 1912, Ray began to take instruction, working with Robert Henri and absorbing his version of Walt Whitman along with the fine points of portraiture. Other anarchists of more European orientation were always nearby, and in addition to Emma Goldman, Ray became friendly with Adolf Wolff, a Belgian-born sculptor who was teaching elementary school classes. Wolff not only reenforced the Whitman influence, he proved remarkably helpful in other areas as well. He had a studio that he did not often use, and was willing to lend his impoverished friend the key. Nearby was the McGraw Book Company, and Ray soon had a job designing maps and atlases that financed his artistic activities for the next six years. And Wolff had an ex-wife with a taste for French modernist verse named Adon Lacroix. She and Ray were soon inseparable, and by the time they married in May 1914, she had already instructed him in subject-object relations, deranged mental processes, proto-surrealist violence, and an erotic imagery that sometimes evoked the machine. The work of Apollinaire provided a final link between poetry and painting. In a way unique for

someone who had not made his obligatory trip to Paris, Ray discovered modernism in the most intimate of circumstances.

Even though he always seemed more influenced by poetry and ideas than by paintings, the Armory Show was traumatic. Ray stopped painting for several months, and then launched into "a series of larger canvases, compositions of slightly Cubistic figures, yet very colorful, in contrast to the almost monochromatic Cubistic paintings I had seen at the international show in the Armory." Then, after dwelling on the new impulses as well as sharing numerous walks in the country with his friends, he gradually came to the conclusion that nature bored him. Ray felt none of the inspiration he once knew. Trips, insofar as they provided inspiration, provided only memories, and on one occasion he told Alanson Hartpence that he preferred to "make some imaginary landscapes," and after that, "not only would I cease to look for inspiration in nature; I would turn more and more to man-made sources." By early 1915, "I changed my style completely, reducing human figures to flat-patterned disarticulated forms." "All idea of composition as I had been concerned with it previously . . . was abandoned, and replaced with an idea of cohesion, unity and a dynamic quality as in a growing plant." That growing plant was probably the last analogy to nature to have much meaning either for Ray or those whose development resembled his.[10]

At this point, life began to speed up for Ray. That summer, Marcel Duchamp arrived, and given the networking of the Arensberg salon, was soon a regular visitor in Grantwood as well. Although Duchamp seemed to speak only one word of English, and Ray little more French, the two hit it off immediately. The event, which perhaps should go down in history as the First Encounter of Post Modernism, became encapsulated in the tennis match that resulted. Adon Lacroix served as translator, but essentially she was superfluous. The two played in front of the house, without a net, solemnly hitting the ball back and forth. As Ray called out the score, Duchamp always replied with imperturbable good humor, "yes." The tall, graceful, elegant Frenchman, the short, intense and compact American: as they played their imaginary game and shared silence rather than a comprehensible language, they became a collage, a found scene for the camera that did not snap its shutter for the history of the art in which both were losing interest. Naturally, Ray soon took up chess and became Duchamp's lifelong partner and friend.

In his capacity as the only person who knew anything about art at Charles Daniel's gallery, Hartpence arranged Ray's first important show for October 1915. The canvases themselves were nothing extraordinary, notable chiefly because with them, Ray began his policy of photographing his work so that he could keep track of it. Critics were severe and sales poor. Just as things seemed to be going badly for him, however, Arthur J. Eddy reappeared. The Chicago lawyer who had

been a prominent buyer at the Armory Show so admired Ray's work that he offered $2000 for six canvases. As a connoisseur and author of long standing and adequate purse, Eddy briefly transformed the Ray market and sent Daniel into something close to ecstacy. Ray took his money, rented a studio, and returned to the city to join Duchamp and his friends as an integral member of the Arensberg salon.

In less than two years, Ray transformed his style from one based on romantic French poetry and rural American anarchism, to one based on such unrelated concepts as mechanism, spectator involvement, optical illusion, and intentional violation of expectations about planes and perspectives. At his second show with Charles Daniel, Ray displayed what may well have been the first legitimate American contribution to Dada: "Self-Portrait"—two "electric" bells with a real button to push on a black background. Ray recalled to Arturo Schwarz, years later, that it "made people furious. They pushed the electric button and nothing happened. They thought, if you push the button the bell should ring. It didn't. That made them livid and they said I was a bad workman." Another assemblage at the show was "Portrait Hanging," hung intentionally by a corner in order to tempt a viewer to try to straighten it. The viewer could not, because a hidden nail kept the work crooked, "so that when you tried to straighten it you couldn't shift it or do anything. It just swung back like a pendulum. I wanted the audience, the visitors, to participate in a creative act," Ray recalled. "That's how I would have put it at the time."[11]

His major work of this period, however, remains the famous "The Rope Dancer Accompanies Herself with her Shadow," at 4' x 6' the kind of monumental work that he said the Armory Show freed him to create. The appreciator of vaudeville as well as jazz, he encouraged comparisons here with Tom Eliot and Conrad Aiken on their pilgrimages to the hotspots of Boston to find the carnivalesque inspiration they needed to bridge art and life. The modernist artist was, after all, something of a carny rope dancer, out on a line over empty space, always showing off, always balancing to within an inch of his death, his two-dimensional shadows dancing in the lights. "I began by making sketches of various positions of the acrobatic forms, each on a different sheet of spectrum-colored paper, with the idea of suggesting movement not only in the drawing but by a transition from one color to another," he recalled in *Self Portrait.* "I cut these out and arranged the forms into sequences before I began the final painting." He then became dissatisfied; everything looked too decorative and reminded him of a theater curtain. Then he noticed "the pieces of colored paper that had fallen to the floor. They made an abstract pattern that might have been the shadows of the dancer or an architectural subject," depending on how your imagination worked. He "played with these, then saw the painting as it should be carried out. Scrapping the original forms of the dancer, I set to work on the canvas, laying in large areas of pure color in the

form of the spaces that had been left outside the original drawings of the dancer."

In reworking his composition, Ray made no attempt to establish anything harmonious in color, even though later critics would sometimes sense a Synchromist inspiration here. "It was red against blue, purple against yellow, green versus orange, with an effect of maximum contrast." He laid the color on precisely but lavishly, exhausting his available supplies. The work seemed incomprehensible to visitors who saw it, but gave him immense satisfaction. He realized that their incomprehension and his satisfaction might be related, and even part of the point of whatever it was he was doing. "I began to expect it and even derived a certain assurance that I was on the right track. What to others was mystification, to me was simply mystery." Only then did he meet Willard Huntington Wright, who was arranging the show of Synchromist works that featured his brother Stanton Macdonald-Wright and Morgan Russell. Ray sent in a large work, and no less a figure than Alfred Stieglitz told Ray he approved of it.

But even as he seemed triumphant, Ray was tiring of work in oil. He moved to a new studio in the heart of the garment district, and began to work on a "series of pseudo-scientific abstractions, but before transferring them to canvas," he "traced the forms on the spectrum-colored papers, observing a certain logic in the overlapping of primary colors into secondary ones, then cut them out carefully and pasted them down on white cardboard." He liked the results so well that he saw no immediate need to transfer them to the canvas. He called them "Revolving Doors," and gave them such titles as "The Meeting, Legend, Decanter, Shadows, Orchestra, Concrete Mixer, Dragon-fly, Mime, Jeune Fille, and Long Distance," and mounted them on a stand that was hinged, "so that they could be turned and seen one at a time." He put off actually painting in oil and turned instead to newspaper clippings, or cut-outs of paper in the shape of ovals or rectangles. He covered the results with glass. "While these works did not have the finished and imposing quality of oil paintings, I considered them equally important."[12] William Carlos Williams would surely have understood: Ray was doing in paper what he was doing with the land around Paterson and the water of the Passaic.

Concurrently, and with no known influence coming from European experimental artists, Ray's preferred technique of "painting" was changing. "At that time I'd already done away with brushes and was painting almost exclusively with knives, but I was still not satisfied; I wanted to find something new, something where I would no longer need an easel, paint, and all the other paraphernalia of the traditional painter," he recalled for Arturo Schwarz. "When I discovered airbrush it was a revelation—it was wonderful to be able to paint a picture without touching the canvas; this was a pure cerebral activity." Now the painter worked in the third dimension, but did not try to make a three-

dimensional painting. "Another thing I liked about it was the spontaneous character of the composition." You did not have to wait and you could not correct an error: "it was like shooting with a gun, you either hit the mark or you don't. When I think of it, it was almost like automatic painting." He freely admitted that he "was more interested in the idea" that he wanted "to communicate than in the aesthetics of the picture, and here was a key way to express" his ideas "more rapidly than by a painting." He was, rather obviously, "already trying to get away from painting in the traditional manner."[13]

Use of the airbrush enabled Ray to achieve the type of abstract, or photographic, or two-dimensional effect he wanted. He thus reversed the very nature of romantic symbolism. Just as Williams had eliminated symbolism and metaphor, to unite subject and object, Ray eliminated the personal and the natural to achieve an abstract, devitalized art. He was charmed to discover stenciling, of a kind familiar to any sign-painter. He rented a tank of compressed air and brought it home, to the irritation of his wife. He used it to eliminate, so to speak, himself, the artist: "But I became just as invisible as if I had stayed at the office; most of my spare time was spent in the attic. I worked in *gouache* on tinted and white cardboards—the results were astonishing—they had a photographic quality, although the subjects were anything but figurative." Put another way, he would start with something he had seen, such as a nude woman, a group of dancers, an interior scene, "but the result was always a more abstract pattern. It was thrilling to paint a picture, hardly touching the surface—a purely cerebral act, as it were."[14]

Thus in an astonishingly self-reflexive way, the very imagery Ray used to describe what he had done, made the point that such imagery was no longer a legitimate goal of art. Imagery, as such, was no longer possible. Metaphysics was out. The meaning was that a work had no meaning. Action was itself inorganic. If William Carlos Williams was slowly coming to related conclusions in poetry, Ray was, silently at the time, forging far ahead, if in fact this were a step "forward" in art. It was certainly a move in the direction modernism was going, for with these works Ray became the only American worthy to stand by Marcel Duchamp—where, after all, he often did stand—as Duchamp abandoned painting, attacked retinal art, and found in hardware stores what others professed to find only in galleries: modernist art. As for machines that seemed self-contained and unwilling to communicate, he had something to say, mutely, on that score as well. A faint "yes" echoes down the lawns of art history, even yet.

IV

One of the more intelligent women to discover the Arensberg salon was an attractive debutante named Beatrice Wood. Bookish and rebellious against the boring future that her socially conscious parents had been

planning for her, she yearned for bohemia, with all its artistic and anti-materialistic connotations. Having lost her virtue, or so she claimed, "reading Madame Bovary by a spirit lamp," she acted, studied French, and was *au courant* enough to have attended the first performance of *Le Sacre du Printemps* in Paris. Her mother monotonously threatened suicide because of Beatrice's erratic behavior, but Beatrice continued to throw herself into one enthusiasm after another. Schooling at Shipley and Finch got her admitted to Columbia College, but the staid curriculum of those days did not prevent her from making Whistler's *Gentle Art of Making Enemies* into her Bible, or finding in Elizabeth Reynolds a roommate who was fluent in Russian, a friend of Isadora Duncan and Anna Pavlova, and thus the provider of an entré into the world of theater and dance. Wood learned folkdancing from Pavlova's choreographer, took acting lessons from Yvette Guilbert, and claimed to have danced at least once before Nijinsky himself. While Reynolds went on to marry Norman Hapgood and enter the world of liberal politics and journalism, Wood joined the Theatre Guild, where she shared a dressing room with Edna Millay. As her public career progressed nicely, she became friendly with Ananda Coomaraswamy, who introduced her to a lifelong interest in South Asian art and religion; and with Henri-Pierre Roché, who introduced her to mature love and the Arensberg circle.

In one of his less alert moments, Edgard Varèse, the chief musical figure in the salon, had collided with a vehicle on the New York streets and broken his leg. Still unable to speak English, he lay fuming in a hospital room, desperate for someone to whom he could speak French and explain his music. Wood began to fill his needs, more out of sympathy than erotic involvement, and on her third visit, she met Marcel Duchamp. Since her French was excellent and her cultural values receptive to the new, she could play the muse for both men as they adjusted to the strange new country. Duchamp made a special impression on her. At age twenty-seven, he "had the charm of an angel who spoke slang. He was frail, with a delicately chiseled face and penetrating eyes that saw all. When he smiled the heavens opened." But, she continued, "when his face was still it was as blank as a death mask. This curious emptiness puzzled many and gave the impression that he had been hurt in childhood." He began almost immediately to *tutoyer* her, and she was enthralled. Soon, she, Roché, and Duchamp were a threesome, in a congenial and unpressured way, and when Wood's relationship with the much older Roché wound down, she and Duchamp continued to be intimate until their lives naturally went in different directions.

Wood's autobiography contains the most extensive surviving description of the atmosphere of the salon as it appeared to an impressionable and unprepared newcomer. "Walking into this incredible home I caught my breath, suppressed a giggle, and sat down in a state of shock. One by one I confronted each disconcerting image as it shrieked out at me."

The one that seemed "most awful," she recalled, "was a Matisse, an outlandish woman with white streaks—little daggers—surrounding her entire body"—presumably "Mlle Yvonne Landsberg," which Matisse had painted in 1914. "Near the balcony was a Picasso filled with broken planes supposedly depicting a woman, and a Rousseau with a horrible dwarf in an unnatural landscape"—probably Picasso's "Female Nude" of 1910–11, and Rousseau's "Landscape with Cattle" of c.1906. Duchamp's "Nude Descending a Staircase," version #3 of 1916, "a wild bedlam of exploding shingles, as it had been called, had the place of honor. With great pride they pointed it out to me." At a loss for words, she mumbled that it seemed to move, and hoped she could get by with that. "Nearby on a pedestal was a Brancusi brass that shot up in the air out of nowhere and made me uncomfortable. Scattered throughout the room were works by Picabia, Gleizes, Braque, and Sheeler, African carvings and pieces from a mixture of periods. It made my head spin in disbelief."

Such an atmosphere was capable of disconcerting even mature visitors. On many evenings, one or more pairs of guests would be off in a corner, obliviously playing chess, the word "puzzling" covering the intensity of their play, the art on the walls and tables, and the insecure wonderings of many a guest. Wood recovered to find the hosts warm, affectionate, and welcoming. Lou Arensberg "was not a beautiful woman; her nose was short and upturned, with lines on either side that ran down to her chin like streams trying to find a river," Wood recalled. "Her brown and curly hair was not flattering to her face. But she was direct and sincere and it gave her great charm." Walter, whom Wood thought of more as a poet than anything else, "was also charming but he was not quite so sincere. His cordiality lit up for callers. Like royalty, he was always the gracious host. Men liked his intellect, while women responded to his warmth like moths to light." As people chattered on into the night, alcohol flowed, sweets arrived around midnight, and at some point in the early hours of the morning, the guests drifted away. Such was the unreality of the environment, that even after the nation entered the war, no one spoke of it.[15]

The most important work of art was not on the walls, however; Marcel Duchamp was on display, the centerpiece of the Arensberg salon, from the day he arrived in New York. Once again, the ubiquitous Walter Pach was the link between Americans and European modernism. In 1910, Pach had met Marcel's two older brothers, Jacques Villon and Raymond Duchamp-Villon, on one of his many forays into the Paris art scene. Two years later, on his search for works for the Armory Show, Pach along with Walt Kuhn and Arthur Davies had returned to Puteaux and found themselves especially impressed by the work of the young Marcel: "Sad Young Man on a Train," "Portrait of Chess Players," "King and Queen Surrounded by Swift Nudes," and "Nude Descending a Staircase." All told, they chose eighteen works by the broth-

ers and the quirks of newspaper publicity and public opinion did the rest. Marcel's "Nude" attracted the most attention, making his name either famous or infamous, depending on a person's point of view. When the Germans invaded France and the Paris art scene disintegrated, Duchamp came to think of the city as "a deserted mansion. Her lights are out. One's friends are all away at the front. Or else they have been already killed." At that point Pach returned, told the Frenchman of his fame in America, and suggested that he come for a visit. Already discharged from the army, Duchamp needed government permission, but he determined to seek it. Never much of a patriot, preferring to greet both politicians and soldiers "with folded arms," he came "not because I couldn't paint at home, but because I hadn't anyone to talk to . . ."[16]

On 15 June 1915, Pach was there to meet the boat, along with numerous reporters. After fending off the questions as best they could, Pach and Duchamp went immediately to 33 West 67th Street, the Arensberg address, where Duchamp remained relatively undisturbed for three months, the Arensbergs being on holiday. Duchamp then moved briefly to 34 Beekman Place, where friends of the Arensbergs were themselves on holiday, and then to the Lincoln Arcade Building at 1947 Broadway, a structure where such well-known painters as Robert Henri and George Bellows kept studios. Taking Pach's word for the eminence and personality of the Frenchman, Walter Arensberg apparently needed little convincing. He paid Duchamp's rent after the holidays were over, and the two apparently had an arrangement that whenever Duchamp's "Large Glass," as his work-in-progress came to be called, was actually completed, it would go to Arensberg.

This arrangement suited Duchamp perfectly. Aristocrats had subsidized artists in Europe for years, and he felt such treatment no more than his due. His father continued to send small sums, he lived frugally except when attending Arensberg's sumptuous parties, and he supplemented his income by teaching French to wealthy friends—who in turn taught him English and even took him to dinner after the lessons. More successfully than most bohemians, Duchamp could bear a sense of entitlement to the grave, and did so. The way in which he did this, in effect providing a breathing example of the progress of modernism into post-modernism, gave his career an emblematic quality invaluable to historians. He knew it; "I am a *respirateur*," he told a *Time* reporter in 1965, calmly putting the heavily panting art groupies in their places by refusing to be an Artist.

Duchamp was the product of realism in his very bones. The son of a rural *notaire* in Normandy, he lived in Flaubert country, in a petit bourgeois atmosphere that both nurtured and constricted its young. While his father became the personification of bureaucracy and order in probably the most bureaucratized country in the West, Marcel took his inspiration elsewhere. His mother, whom he disliked, nevertheless was a Sunday painter of urban watercolors, usually of Strasbourg or Rouen.

Her father, Emile Nicolle, was more to the point. A shipping agent by profession, he was an engraver by inclination, "a passionate etcher" according to his grandson, and one of the leading artists of the region.

Marcel was the fourth child of a large family, and two of his older brothers could provide him with role models of a sort, and precedents to follow when he decided to strike out on his own. Gaston had set the pace here, moving off to Montmartre and distancing himself from Normandy provincialism by assuming the name, Jacques Villon, presumably in admiration of medieval poet François Villon. Raymond soon quit medical school to join him, changing his name to Duchamp-Villon. In 1904, Marcel graduated from high school and followed them. More in love with the idea of bohemia than with the actual burdens of painting, he attended the Académie Julian, but found it little more stimulating than a Normandy village. He later claimed to have spent his time mostly playing billiards, and there is no reason to doubt him. "I had no aim. I just wanted to be left alone to do what I liked."

Montmartre was full of artists, from Russians to Americans, and with two gifted brothers to show the way, a good *respirateur* could plunge into the art world and see where it took him. "From 1902 to 1910, I didn't just float along! I had had eight years of swimming lessons," he quipped years later to Pierre Cabanne. Historians have clearly marked out the pool. Unlike the Americans, who usually found Cézanne the first teacher they needed, the Duchamp brothers thought him something of "a flash in the pan." For them, "the conversation centered above all on Manet. The great man that he was." Duchamp stressed that at that time, at least, he was not living among the better known painters and could not speak for everyone; in old age, he thought of himself as a maker of objects, a craftsman more than an artist, and described those closest to him as "cartoonists." After Manet, the great influence chronologically was Matisse, whom he recalled discovering about 1906 or 1907; Duchamp followed him into a Fauvist phase that remains clearly evident in his surviving early work.

Unaware of much going on around him, Duchamp nevertheless did his own thing and was perhaps more at the heart of innovative activity than he let on later. He haunted the galleries, for example, such as the Druet in the rue Royale, but the crucial spot was Kahnweiler's. He claimed that neither he nor his friends knew of "Les Demoiselles d'Avignon," which is not surprising for it was not on general display, but Kahnweiler's was the chief outlet for one school of cubism, that which Picasso and Braque represented, and shortly Juan Gris. "I went sometimes to Kahnweiler's gallery in the rue Vignon, and it was there that Cubism got me." The shock was great, but Duchamp absorbed it in 1911–12, and by the end of 1912, he was already thinking of yet newer experiments. "I had a mania for change, like Picabia."[17]

To dwell solely on schools of painters, however, would be grossly to distort the mental universe in which Duchamp really lived, which did

more to shape his works than any number of paintings. His world was, first of all, an intensely verbal one, radically different from the worlds of Cézanne or Picasso, who sometimes leave the impression of being non-verbal on all matters of aesthetics. In 1906, along with their close friend František Kupka, Marcel's two older brothers moved out of the city to Puteaux, where they lived almost on each other's doorstep, sharing a garden that was soon the scene of chess games and heated discussions. Marcel would often join the group on Sundays, leaving as a record his impressionistic "Red House Among Apple Trees" (1908). In 1908, he decided to move himself, settling in Neuilly, an easy walk over the Seine to Puteaux, immortalizing his presence in the much more important work, "The Chess Game," which pictured both his brothers playing and their wives lounging about. When Duchamp recalled the scenes later, the overwhelming memory was not so much of painting—"I did very little painting between 1909 and 1910"—but of talk, with Kupka, Jean Cocteau, Henri-Martin Barzun, and especially Apollinaire. ". . . You couldn't get a word in edgewise. It was a series of fireworks, jokes, lies, all unstoppable because it was in such a style that you were incapable of speaking their language; so, you kept quiet," he recalled to Pierre Cabanne. "One was torn between a sort of anguish and an insane laughter."

Keeping the straight face of a Normandy *notaire*, Duchamp developed a fascination with linguistic subversion. He loved puns, acronyms, and other verbal games. But, unlike his friend Arensberg, who avoided philosophical positions while decoding Shakespeare and Dante, Duchamp saw such linguistic pyrotechnics as a sophisticated way of expressing nihilism. "One has the impression that every time you commit yourself to a position, you attenuate it by irony or sarcasm," Cabanne said to him. "I always do so. Because I don't believe in positions," was the reply. He believed in "Nothing," and thought the word "belief" to be "another error." In such a world, everything was deceptive and words were no exception. "Words are absolutely a pest as far as getting anywhere. You cannot express anything through words, because language is an imperfect form of communication," he told Arturo Schwarz.[18]

Yet even though his world was verbal, Duchamp never seemed much affected by literature. Once, when fed up with painting and in need of funds, he worked for awhile as a librarian, but he spent little time sampling the available materials. Scholars were always asking him what he was reading, and he usually replied that he read very little. He had admired the poetry of Rimbaud and Mallarmé as a young man, but apparently read little fiction. He seems to have absorbed a bit of Bergson's philosophy through his brothers, who were both enthusiastic about it, and heard about current journalistic concerns through the conversation of Apollinaire and the other literary visitors to Puteaux. The closest he came to admitting a literary influence was that of Jules Laforgue, whom he credited with the original inspiration for the work

that became "Encore à cet astre." He had originally set out to illustrate Laforgue's poem with the same name, one of a group of illustrations for various Laforgue works, but only completed three. As the title implied, the figure in the work was climbing the stairs, but Duchamp was soon envisaging a more impressive work going in the opposite direction, inspired, he would say, by dramatic performances where figures grandly descended stairs. The summary makes perfect sense, but illustrates as well that, as far as literary modernism was concerned, Duchamp had his mind on other things. Indeed, if anyone influenced Duchamp through words, the words were most probably those of Alfred Jarry, whose "Pataphysics" made much more of an impact than anything by any other thinker.

For such an anti-intellectual, chess provided an outlet for intelligence that did not need words and could not be hypocritical. Duchamp played chess, his brothers played chess as he painted them, Arensberg and Kreymborg played chess—bohemians on two continents seemed to need the game to order their universe as well as pass the time. Duchamp liked it because it had "no social purpose. That above all is important," he insisted to Cabanne. When asked if chess were the ideal work of art, he thought this possible. "Also, the milieu of chess players is far more sympathetic than that of artists." He thought such people "completely cloudy, completely blind, wearing blinkers. Madmen of a certain quality, the way an artist is supposed to be, and isn't, in general. That's probably what interested me the most." But such a description actually trivializes a game which obsessed him for forty years, most likely because it brought together in one process, essential themes in Duchamp's evolution as a creative figure. "A game of chess is a visual and plastic thing, and if it isn't geometric in the static sense of the word, it is mechanical, since it moves; it's a drawing, it's a mechanical reality," he explained to Cabanne. "The pieces aren't pretty in themselves, any more than is the form of the game, but what is pretty . . . is the movement. . . . It's the imagining of the movement or of the gesture that makes the beauty, in this case. It's completely in one's gray matter."

In comparing a chess game to a Calder mobile, which he did in passing, he only underlined two of the themes which motivated his work: the game was mechanical and it moved. Here already was a sign of his separation even from the most advanced cubism: Picasso, Braque, and Gris did not paint movement, nor were they into machinery. And when Duchamp made forays toward cubism, in such a work as "The King and Queen surrounded by Swift Nudes," (May 1912), he went still further. The king and queen were chess figures rather than royalty—not that anyone could easily tell—but to surround them with nudes, not to mention swift ones, went beyond the pale. Cubists did not paint nudes, either. They did still lifes; the viewer was the one who moved, if anyone did.[19]

For most onlookers, especially those focused on Paris, the mere mention of "movement" meant futurism; surely Duchamp knew of Marinetti and the rest, with their trumpeting of machinery and speed and the gathering forces of modernization. No, Duchamp said firmly and repeatedly, they were not very well known at the time and at any rate he had paid them scant heed. And if even a friend like Apollinaire suggested such an influence, Duchamp would wearily dismiss his old friend: a wonderful fellow, no doubt about it, but a man who "wrote whatever came into his head," knew little about the subject, and cared even less for accuracy, an assessment modern scholars usually endorse.

Far more important to him was the early photographic work of Eadweard Muybridge and Étienne Jules Marey. "Chrono-photography was at the time in vogue. Studies of horses in movement and of fencers in different positions as in Muybridge's albums were well known to me." His goal, like theirs, "was a static representation of movement—a static composition of indications of various positions taken by a form in movement—with no attempt to give cinema effects through painting." He thus felt that he was far more similar to the cubists than to the futurists. "The reduction of a head in movement to a bare line seemed to me defensible. A form passing through space would traverse a line; and as the form moved the line it traversed would be replaced by another line—and another and another," he told James Johnson Sweeney. "Therefore I felt justified in reducing a figure in movement to a line rather than to a skeleton. Reduce, reduce, reduce was my thought . . ."[20]

Behind these seemingly artistic considerations lay an area of mathematical and scientific speculation that has only recently found its historian. For many years, the fame of Einstein's relativity theory obscured the fact that Einstein had been unknown among artists before 1917. They had been living in a different scientific universe, one which preempted popular attention between the vogues of Darwinian biology and Einsteinian physics. The formal aspects of the scientific ideas of Henri Poincaré, and the geometrical speculations of Georg F.B. Riemann provided a figleaf of respectability for platoons of popularizers who delighted in provoking the public with "fantastic" speculations. Edwin Abbott's *Flatland*, H.G. Wells' *The Time Machine*, and Charles L. Dodgson's various Alice stories, written under the name Lewis Carroll, informed children and adults at all levels of literacy that the world was not what it seemed, that space was curved, that parallel lines did not necessarily stretch forever without coming together, and that time was a possible fourth dimension. Such ideas fed the development of "hyperspace philosophy," Theosophy, and science fiction as a literary genre, and filled the pages of such middlebrow journals as the *Popular Science Monthly* and *Science*. No one intellectually active seemed immune: Charles Howard Hinton, the author of *The Fourth Dimension* (1904), had a respectable Oxford degree and corresponded with William James on sub-

jects of mutual interest; both were discouraged at the lack of interest which other scientists had toward their views.[21]

These influences came to the Puteaux painters through several channels. Kupka, the closest friend of the two older Duchamp brothers, was a convinced Theosophist and believer in spiritualism. Both Jean Metzinger and Albert Gleizes, the leading theoreticians of cubism, read the writings of Henri Poincaré carefully. Duchamp himself read the work of Gaston de Pawlowski, author of *Voyage au pays de la quatrième dimension* (1912), in which Pawlowski defined the fourth dimension as "the necessary symbol of the unknown without which the known could not exist." Scholars have established that Duchamp was consciously using Pawlowski's ideas when he was working out the design for the "Large Glass." These influences even lay behind the antic science that Alfred Jarry developed as pataphysics, and both the ideas themselves and the implicit cynicism behind them led directly to the "playful physics" that Duchamp promulgated with solemnity. When pressed, Duchamp pointed to the figure of Maurice Princet, a well-trained mathematician and actuary who had been a young member of the circle around Picasso in about 1907. Full of the new geometries, Princet became important enough to deserve a fullsome paragraph in Metzinger's memoirs, *Le Cubisme était né* (1972), and Duchamp regularly recalled him in his various conversations. "We weren't mathematicians at all, but we really did believe in Princet," he once told Cabanne. Princet may now seem obscure, "but he played at being a man who knew the fourth dimension by heart. So people listened. Metzinger, who was intelligent, used him a lot. The fourth dimension became a thing you talked about, without knowing what it meant."[22]

For a brief period, Duchamp focused his quasi-scientific interests on the subject of movement, most famously in his nudes going up or downstairs. After a few months of intense productivity, motion bored him and he turned to the fourth dimension as it seemed to apply to canvas and its substitutes. He assumed, as a working principle, that just as a three-dimensional figure cast a two-dimensional shadow, so a four-dimensional figure would cast a three-dimensional shadow: the obvious parallel here being the way architectural drawings could put three dimensions into two in designing a building. Apparently in Duchamp's mind, yet another parallel may have been decisive: an avid chess player, he visualized the fourth dimension as being what a blindfolded chess player saw when he "visualized" the board of his game. He mulled over several possible ways of solving the artistic problems involved, and hit on a solution: use a mirror. He came to think of the fourth-dimensional continuum as essentially the mirror of a three-dimensional one. Once he had hit on this, one further advantage then occurred to him: colors on glass did not deteriorate with time. He knew of Kupka's experiments with glass, and had just visited Munich where the *Blaue Reiter* painters had been using glass in a different way for years. The

speculations of philosophy and mathematics were suddenly having aes-
thetic consequences.[23]

At this point, Duchamp was ready to make one of the most impor-
tant shifts in the history of modern art. Even before Americans had
their publicity festival about his male nude going downstairs, he had
essentially given up oil painting to work on perspective. The "Large
Glass," he told Cabanne, "constitutes a rehabilitation of perspective, which
had then been completely ignored and disparaged. For me, perspective
became absolutely scientific." He now shrank from continuing to paint
in what he called a "retinal" or "olfactory" manner: what modern art
historians would call "painterly," with an intuitable smell of turpentine
everywhere. He did not want to remain occupied with "visual lan-
guage. . . . Everything was becoming conceptual, that is, it depended
on things other than the retina." To explain himself, he needed a
pataphysical science: the science itself, to get away from nineteenth-
century superficiality, but also the "pata," the knowledge that it was all
blague, and that science was inherently no more reliable than art or
religion. "I was interested in introducing the precise and exact aspect
of science, which hadn't often been done, or at least hadn't been talked
about very much. It wasn't for love of science that I did this; on the
contrary, it was rather in order to discredit it, mildly, lightly, unimpor-
tantly. But irony was present." He became a painter who wanted to get
away from painting. "I wanted to get away from the physical aspect of
painting. I was much more interested in recreating ideas in painting,"
he told Sweeney. "I wanted to put painting once again at the service of
the mind." Painting had once been literary or religious and had com-
municated something. It had become superficial and without important
concepts. Painters had become stupid; they should once again deal with
important philosophical issues.[24]

At this point, Duchamp presents an even more delicate historical
problem than he usually does. One aspect of his influence heads off in
one direction, which is properly not a concern for the history of mod-
ernism; a second freezes him in time for two generations in an unre-
presentative position; and a third leads directly to a major concern of
modernism. The first of these aspects is the one for which Duchamp
has since become one of the most studied of modern artists: the con-
struction of the "Large Glass," carried out mostly in America from ideas
developed in Europe: an attempt to evoke the fourth dimension, it is
intentionally a work hostile to art, to cubism, to paint, and to much that
modernism had stood for, even in Duchamp's own work. "Art was fin-
ished for me. Only the 'Large Glass' interested me," he said bluntly to
Cabanne. Art at the service of the mind meant no art at all, but rather
the creation of think-pieces by a craftsman who spent more time play-
ing chess, and much more time breathing, than he did painting. It meant
the assembling of piles of scribbled notes, now formally published, that
explained what he was doing. It meant that creations had to have titles,

and words that explained them, and critics who elucidated what the words "really" meant. It meant the active inclusion of the spectator in art, in a quadrilateral (or four-dimensional) relation of object, explanations, critical commentary and spectatorial puzzlement. It meant an art where the objects subverted themselves, actively combating meaning, scorning beauty, relying on chance and sometimes insulting the viewer. This amounts to an accumulative definition of post-modernism, not modernism, and Duchamp is the first, and very premature harbinger of a climate of creativity that did not put forth most of its highly artificial blooms until after World War II.[25]

The second aspect of Duchamp's influence was, by contrast, the one which he achieved with the "Nude Descending the Staircase" at the Armory Show. Aside from being obviously cubist in form, it brought together two standard concerns of modernist aesthetics: autobiography and arrested motion. Ever since his earliest work, Duchamp had been painting his father, his brothers, or his sisters, especially Suzanne, in his art. He had painted his local area and his devotion to chess. In a more subterranean way that has excited numerous critics of Freudian disposition, he seemed to express incestuous passion for his sister as well as deeply repressed lust and guilt. He openly proclaimed—at least long after the fact—the elements of eroticism in his work, claiming that he wished "to bring out in the daylight things that are constantly hidden—and that aren't necessarily erotic—because of the Catholic religion, because of social rules. . . . It's the basis of everything, and no one talks about it." He was also the "Sad Young Man in a Train," telling Cabanne that of course the work was "autobiographical. . . . My pipe was there to identify me." The implication was certainly there for the taking, that his masturbatory fantasies were the subject of the "Chocolate Grinder," one of the original ideas for the "Bachelor Machine," for bachelors grind their chocolate themselves and can only partake of bridal delights voyeuristically. And just as masturbation provides sex without contact, so the nude that descends the staircase is an example of arrested motion, of static movement, as modernist an idea as anything in sexuality. In his painting, he "wanted to create a static image of movement: movement is an abstraction, a deduction articulated within the painting, without our knowing if a real person is or isn't descending an equally real staircase," he told Cabanne. "Fundamentally, movement is in the eye of the spectator, who incorporates it into the painting."[26]

But with his mania for change, Duchamp could never rest with success, and certainly not with notoriety. From the "Nude" he turned immediately to the "Coffee Grinder," the first significant precursor of the mechanical drawings he was to make, and the objects he was about to choose. His brother Raymond had a kitchen in the Puteaux house which he wanted to decorate with pictures by his friends. He asked several of them to make pictures of uniform size to make a frieze. Marcel did a

coffee grinder, "which I made to explode; the coffee is tumbling down beside it; the gear wheels are above, and the knob is seen simultaneously at several points in its circuit, with an arrow to indicate movement." And then, in one of the wry understatements he loved, he added: "Without knowing it, I had opened a window onto something else." The work is also known as "Coffee Mill," and is dated November–December 1911.

The sad young man then rode his train, the nudes walked down their staircases, and the chesspiece king and queen did their thing; Duchamp also made preliminary sketches for what became the "Large Glass." Then came the two "Chocolate Grinders," the first early in 1913, the second a year later. They ground two ways: they appear in the "Large Glass," but they are also commonplace objects that are mass-produced, mechanical, and not necessarily retinal. They indicated the third path of Duchamp's influence, one which would carry modernism to one extreme, and provide Duchamp with a third type of posthumous fame—naturally enough, long before he became posthumous. For a chocolate grinder, like a coffee mill, could be a found object, a mass-produced product of capitalism, defined by its use. Like other objects, it could receive a title and be given, passively, an aesthetic role if an artist so chose. Whatever it might seem to be in a Freudian analysis, it was also what it was, an industrial object of no symbolic importance. It soon began to accumulate kin: the "Bicycle Wheel" (1913), which spun upside down on a simple stool; the "Bottle Dryer" (1914), which just sat there; "In Advance of the Broken Arm" (1915), otherwise a common snow shovel; "Comb" (1916), and so on.[27]

These objects were soon part of the atmosphere of the Arensberg salon. In October 1916, Duchamp left his temporary quarters, hauling his few belongings and chosen objects back to the Arensberg building, where Walter had set aside studio space for his friend. Walter Pach and John Quinn found him a job as a librarian at the Institut Française, while he also was serving as secretary to a captain attached to the French military mission, and continuing to give French lessons. The "Large Glass" was well under way, and a subject of constant discussion by those in the salon. Duchamp was ready to make his final antistatement about art to Americans.

Duchamp had not, originally, used the English word "readymade," whether hyphenated, capitalized or not, when first choosing his objects. Indeed, he apparently began choosing before thinking that he was doing anything significant, and in a real sense he never seemed to take the subject with much seriousness. But as he pondered machine culture, the products of capitalism, and the boundaries between art and reality, he came up with the French phrase, "le tout fait, en série," and applied it to his bicycle wheel, his bottle rack, and so on. Knowing no English, he nevertheless picked up an English word, "readymade," as if it were in fact a readymade in itself. It apparently came from a term already

common in advertising and on clothing, "ready-made garments," as opposed to "custom-made" or "bespoken" goods like dresses or suits. It was a fashion term to deal with a new fashion in art.

By January 1916, he was referring to the works he had chosen in Paris, especially "bottle rack," as "a sculpture already made" in a letter to his sister Suzanne which was otherwise in French. At first, an artist simply chose an object and put it on display, whimsically, irrationally. But Duchamp soon realized that a title could change the meaning of a work; so could a change of context; so could the attitudes of the viewer. He became more and more happy with what he had stumbled on. He liked the way his choices began as useful but became beautiful; he liked their ironical way of commenting on art and life; he liked the implied mockery of Art, capitalized; he liked the anarchy and the relativity implied; he liked to amuse himself, going around saying things like, there is no answer because there is no question, and when questions persisted, saying, it doesn't make any difference. Here was a pataesthetics for a country that still had trouble swallowing cubism, and one where the word "dimension" referred only to the size of something.

With the amused cooperation of Arensberg, Pach, Joseph Stella, and Beatrice Wood, Duchamp concocted a ruse of such surpassing importance in cultural history that it passed unnoticed at the time, for no one knew enough to comprehend it. The Society of Independent Artists scheduled a show for April 1917, rather obviously intended to be an American version of the French Société des Artistes Indépendants shows. Involving such other members of the salon as Jean Crotti and Francis Picabia, the show was intended to reach far beyond the salon alone. When the society incorporated for legal reasons in December 1916, William Glackens, the well-known realist, Ashcan painter, was the president, and the group included George Bellows, Rockwell Kent, Maurice Prendergast, and John Marin, all of them from outside, as well as Man Ray, Arensberg's cousin John Covert, and Morton Schamberg, all three intimates of the salon. Ostentatiously scorning the usual bureaucratic and aesthetic standards of art world custom, the organizers announced that their purpose was to provide a place "where artists of all schools can exhibit together—certain that whatever they send will be hung." They planned to follow the French Indépendants in their policy: "no jury, no prizes." In addition to showing new work, the Independents would provide public lectures and a tea room where the public could socialize with the artists.

Duchamp was a major organizer of the exhibition, and worked as well on the *Blind Man* that he wished to publish as a forum for those involved. Arensberg served as a managing director and usually hosted the meetings. Pach was treasurer, Covert the secretary. As the person in charge of hanging the works, Duchamp wanted to place everything alphabetically, and all was apparently serene into early April, with the date of the special opening being 9 April, and public admission sched-

uled for the 10th. No one anticipated another Armory Show, but there was still considerable publicity.

Working chiefly with Arensberg and Stella, Duchamp chose a urinal as his next readymade: its smooth, mass-produced beauty, its vast availability and recognizability, its utility all had their appeal. The fact that it told gallery-goers, or at least male gallery-goers, what they could do with their art and their attitudes, was only an added advantage. Here was realism with a vengeance, totally divorced from romanticism, loaded with irony, and fully capable of garnering a little free publicity in the process. Arensberg and Stella bought the object, a common variety manufactured by J.L. Mott Iron Works of Trenton, New Jersey. With a passing bow to popular culture and the spirit of carnivalization, they renamed the Chosen One "R. Mutt," after the character of Mutt in the Mutt and Jeff cartoon strip; the R. stood for Richard, understood as the French slang term for "money-bags," a clear reference to the fruits of capitalism.

Not in the catalog, the object suddenly arrived, the presumptive offering of a fee-paying new member, one Richard Mutt of Philadelphia; it first appears in Beatrice Wood's diary on 7 April. It clearly qualified, since the rules allowed any artist to submit any work that he liked, but George Bellows had a fit. Progressive painters were not long on either wit or irony, which made them earnest reformers but poor bohemian companions; he and Arensberg got into a public shouting match on the subject. The board of directors met hastily, and in a state of confusion narrowly voted not to display the object since it was neither art nor decent. Katherine Dreier later repented her vote, and could perhaps have swung the balance, had she known the circumstances. But although she adored Duchamp, she had had no idea that he was behind it all, and so the "Fountain," to give it its proper name, languished out of sight and eventually disappeared.

Unsuccessful in a public sense, the "Fountain" soon made up for lost opportunity within the salon. No less than Alfred Stieglitz placed it carefully in front of a Marsden Hartley painting, "The Warriors" (1913), and took the photograph through which it entered history. Although other readymades continued to appear, "Fountain" became the readymade of choice for anyone who wanted to discuss the subject, intelligently or otherwise. Deep thinkers, grinning or not, dubbed it a madonna or a Buddha, and Louise Norton even wrote it up as the "Buddha of the Bathroom." Chosen by Duchamp, purchased by Arensberg and Stella, posed by Stieglitz, it was too perfect to forget. Everyone knew it was important, but no one could quite say why, at least until the art critics discovered it as the fountainhead of most of the post-modernist art that did not already come under the influence of the "Large Glass." At the time, the best summary came from Beatrice Wood, including various statements Duchamp had made, published anonymously in the *Blind Man:* "Whether Mr. Mutt with his own hands made the fountain

or not has no importance. He CHOSE it. He took an ordinary article of life, placed it so that its useful significance disappeared under the new title and point of view, creating a new thought for that object."

What she did not point out, and perhaps did not realize, was that in sending forth the readymade as a photograph, the show had also in some measure unified the modernist legacy to post-modernism. Here was a machine made into art, an object tied to a painting, an item in three dimensions made into two, a process in time made static and timeless, a blending of the personal with the public, and an ironical dismissal, as it happened, of modernity in painting. Implicitly but not "really" olfactory, it was certainly not retinal. It also seemed unlikely to have much social relevance. Especially not for a country which had just declared war on the Central Powers.[28]

<h1 style="text-align:center">V</h1>

Early in August 1915, Walter Arensberg introduced Duchamp to his old college friend and fellow poet, Wallace Stevens. The three men dined at the Brevoort and then adjourned to Arensberg's flat, where Duchamp was staying. Stevens "looked at some of Duchamp's things," he wrote his wife, but "made very little out of them. But naturally, without sophistication in that direction, and with only a very rudimentary feeling about art, I expect little of myself." They got on well. "When the three of us spoke French, it sounded like sparrows around a pool of water."[29]

Insofar as any meeting could, that one tested the limits of "modernism" as an organizing category; so long as those sparrows could speak French around the pool, the mission remained a common one. But the differences between Duchamp and Stevens remain striking, even if they never provoked the hostility that Duchamp unintentionally touched off in William Carlos Williams. In certain poems, Stevens could seem an entirely retinal poet, responding only to the surfaces of life. A gourmet in gastronomy as in sensation, an Epicurean from his cigars to his Russian tea, Stevens hardly seemed a proper companion for the austere Duchamp, then into breathing, chess, and the aesthetic implications of plumbing. Here was a Harvard man with a law degree who worked for insurance companies and obviously liked his work, surely the embodiment of a cartoonist's concept of the American capitalist. Why, the man didn't even play chess!

Appearances were deceiving with both men, as they surely realized instinctively, even without Arensberg to smooth the way. Both had begun doing conventional work, seemingly derivative, and had passed through phases that were conventional enough within a modernist framework. Stevens had been a Harvard decadent during the early years of his friendship with Arensberg. A friend rather than a student of George Santayana, he had sampled most of the literature of Victorian

doubt, fears concerning the death of God, and the exploration of the senses as a possible substitute for religion. Stevens read Matthew Arnold and the pre-Raphaelites, even as his verses sometimes echoed those of Shelley and Keats. His ideas often seemed a gloss on those of Walter Pater, expressed in a ballade form that seemed alternately to evoke François Villon and Austin Dobson. Like Pound and even a few English poets, however, Stevens felt uncomfortable in an Anglo-Saxon context and groped for enlightenment across the English Channel. The pierrots of the continental theater entranced him, as they did Stravinsky and Schönberg, and he dabbled in Orientalism like any epigone of Whistler's. Like many late romantics, he felt affinities for symbolism and synaesthesia, for the use of pastiche and the cultivation of dandyism. Two generations of critics have outlined the many affinities Stevens felt for the work of Baudelaire, Mallarmé, and Laforgue, and there is no point in reviewing the details.[30]

The simplest way to formulate the common ground between these wildly disparate figures is to say that they were all obsessed with the relationship between subject and object, between the imagination and reality, between surface and depth. Sometimes the concern took an aesthetic turn, sometimes a philosophical one, and sometimes a religious one; one of the major problems in discussing the issue at all is that the categories often blurred, attitudes changed, and terminology often wandered as if lost between what later critics have been trained to think of as discrete disciplines. The fact is that Stevens himself was neither clear nor consistent, that he regarded some insights as so poetic that they could not be spoken of sensibly in philosophical terms, and never felt that his best work was or ever could be entirely comprehensible. A reader should apprehend the stance of the poet, not try to paraphrase his insights as if he were an incompetent schoolmaster. Stevens was thus perfectly capable of disbelieving in the existence of God, and simultaneously advocating that his wife attend church and believe Christian doctrine. He would scoff at the concept of art for art's sake even as he seemed to live according to its assumptions, and to be using his poetry as a means of supplying order to a world where all was in flux. Like Duchamp, Stevens did not so much supply answers to modern man, as to pose problems. He asked how poets could survive in bourgeois civilization; how institutions, from churches to insurance companies, could help rather than stultify the talented; how painting and music could inspire poetry; how art could function as religion; and how the surface of things could tell observers anything about the depths and meanings of things.

Stevens came from an *echt-Americanisch* background: he was both Dutch and German, as many were in Pennsylvania, and grew up in an environment interchangeably Presbyterian and Lutheran. His parents were committed to the puritan work ethic, and for all his Epicureanism in later life, Stevens remained the hard-working, proudly successful bour-

geois both at home and at work. After leaving Harvard in 1900, he headed for a presumptive career in New York journalism, but the life bored him. So did law school, but he stuck it out and after several disheartening years found his niche in the insurance industry. He remained in New York from 1900 to 1916, frequent trips aside, moving to Hartford only because his job demanded it. Stevens liked both his work and his position, even resisting compulsory retirement in old age. But he was also a poet and knew his worlds could scarcely intermingle. As he wrote in the 1930s:"Perhaps it's the lunch that we had / Or the lunch that we should have had. / But I am, in any case, / A most inappropriate man / In a most unpropitious place."[31]

Stevens was thus, psychologically at least, as much an outsider as Pound or Stein. Realizing the limitations of both his own psyche and American life, he became a solitary traveler, in all senses of the term. He managed to remain alone most of the time even when he was courting his fiancée, and hardly changed after he married her. He walked restlessly all over New York City and nearby New Jersey. He traveled frequently for his company, settling claims and opening branch offices. He did not go to Europe, yet spent much of his imaginative life in Paris, reading the poetry and looking at the paintings. In human relations, he was something of an emotional cripple. Had he not had his Harvard connections, he might well have had trouble finding his voice, not to mention his place in cultural history. Because of the Arensberg salon, Stevens didn't need to go abroad; like Henry Thoreau, who traveled very much in Concord, Stevens traveled very much in New York and then in Hartford: over China and Japan, over Paris and Key West, and over the achievements of world literature.

Such a man, even more than most modernists, tended to a radical narcissism. Discovering the pragmatism of Peirce and James at Harvard, he went farther than either of them in using the self to define the world and to insist on the relativity of ethical insights to the immediate needs of the individual. Neither Peirce nor James killed God off; they doubted or hypothesized substitutes. Stevens followed Nietzsche in his more Dionysian moods; he might regret the absence of the Deceased and admire the architecture He inspired, but he seemed to entertain no qualms about the propriety of funeral services. That left a world without any binding ethical principles, and as conservatives had always feared, such a posture led inevitably to hedonism, to a focus on personal pleasure, and to a sense in which whatever felt intense was moral. Whenever Stevens looked out the window at Nature, he saw as through a mirror, darkly, reading himself instead of the presence of the Deity. Like James, he willed to believe; unlike James, who thought he could commune with his distant or even dead friends, Stevens knew he was always talking to himself. Faith was merely the faith one had in oneself to make poetry out of one's feelings of dislocation.

Stevens was thus open to stimulants. He liked alcohol, to the point

where he seemed mute and hostile without it. He liked jazz and rag-time and sometimes imitated it in verse. He read Murger and thought his own ample form in some way kin to the impoverished inhabitants of a very different bohemia. He read Ibsen and Bergson, without ever mastering either dramatic form or the theory of comedy. He sampled modernist painting and music, but seemed more comfortable with the ideas, the written expressions of what painters and musicians thought they were doing, than with the canvas or the piece itself. He com-mented occasionally on Matisse's principles or Cézanne's letters; he ad-mitted later to a liking for Klee and Kandinsky; he was obviously fa-miliar with works of Stravinsky and Busoni; but he was a man of words. He received inspiration from allied arts, but he was not truly a cubist poet, or a fauvist, or even a neo-classicist, although anyone who used such terms carefully could find them useful in studying his poetry.

New York modernism as seen in the Arensberg salon, thus also had four dimensions. Stevens, Duchamp, Varèse, and Williams provided the parameters, sharing similar problems, or differing within a shared col-lection of values. Where Williams wanted no ideas but in things, Ste-vens wanted no things but in ideas. Where Duchamp despised the ret-inal and demanded the intellectual, Stevens at first gloried in the retinal and then used it as a deceptive surface that hid the depths of his own implicit nihilism. In essence, each artist went out alone into the unwel-coming universe, encountered objects or sounds, and transformed them into art: Imagism raised to the level of epistemology, but an Imagism quite different in implication from that which Pound and Lowell had attempted. As Stevens pointed out in the 1930s: "Not all objects are equal. The vice of Imagism was that it did not recognize this." For him, the goal was what he termed the creation of a supreme fiction, the poet's projection of his consciousness onto a chaotic mass of images. "The author's work suggests the possibility of a supreme fiction, rec-ognized as a fiction, in which men could propose to themselves a fulfil-ment," he wrote of himself in old age. "In the creation of any such fiction, poetry would have a vital significance."[32]

Give or take a few months, 1915 was the great year for Wallace Ste-vens. In such works as "Peter Quince at the Clavier," "Disillusionment of Ten O'Clock," and "Sunday Morning," he came abruptly to his first maturity, achieving for a few years a level he did not recover until the 1930s. The outlandish images, the sensuous sounds, the pessimism of every paraphrasable philosophical point, seemed so unamerican and so inappropriate for a bourgeois culture that few people knew how to read them. Even Harriet Monroe, presumably friendly to both Stevens and to new work, required severe trimming and reworking in "Sunday Morning," before she would print it. No group of works proved so conclusively that the American artistic élite were already modernists before the country entered the war.

"Sunday Morning" is the work to focus on, possibly the greatest achievement of the first generation, certainly one of the few to rank at the top of anyone's list of canonical achievements. In its focus on death it underscores the offerings of life; beauty could not be beauty unless it perished. The coffee and oranges of its opening meditation remind any Stevens reader of his Epicureanism, while the cockatoo carries the usual implications of the exotic that were so vital in his imaginative life. Within seconds, the reader is on an anthropological dig of sorts, with ancient sacrifices mingling with current dreams, and catastrophes lurking outside prosaic walls. Soundless rituals mingle with dead water, Palestine suggests the biblical implications of dead religions, and no one should be able to finish the first stanza without realizing that many of the most important themes of modernism are here in a new way.

Expressed with only slight hyperbole, what has happened is in essence a meeting of William James and Carl Jung; Stevens invokes neither directly, and probably was not thinking specifically of any thinker. He had such things in his bones. But the Jamesian stream-of-consciousness, the mingling of past and present, the persistence of habit, the need to believe in a world that seemed to discourage belief, has taken on the Protestant psychoanalytic flavor of Zürich. Stevens left a key to his frame of mind in a 1909 letter. "What is the mysterious effect of music, the vague effect we feel when we hear music, without ever defining it?" he asked his fiancée. Music "stirs the Memory," he answered. "I do not mean our personal Memory—the memory of our twenty years and more—but our inherited Memory, the Memory we have derived from those who lived before us in our own race, and in other races, illimitable, in which we resume the whole past life of the world, all the emotions, passions, experiences of the millions and millions of men and women now dead, whose lives have insensibly passed into our own, and compose them." This, he concluded, "is a Memory deep in the mind, without images, so vague that only the vagueness of Music, touching it subtly, vaguely awakens, until . . ." and he went into a couplet not unrelated to the later work.[33]

The point here is not to establish direct influence, which is possible but unlikely. The point is that modernist minds were working along parallel lines that sometimes met, in a fourth dimension of their own. Pound had not yet published even the Ur-Cantos, although he was working on them; Eliot was not yet into *The Waste Land,* although he was living it. Williams had not yet become obsessed with ideas being only in things, although all four poets knew what Imagism was all about. But the anthropological/psychoanalytical push that had been in the air of anyone around William James in America or James Frazer in England had become common currency. Ancient rituals were replacing ancient truths, poems were displacing Bibles, and no one could possibly be cheerful about the implications these tendencies had for modern

man. Sunday morning was a depressing time for the inhabitant of a post-Christian universe.

The musing woman is not without her resources. Stevens, unlike the French poets he is so often compared to, loved the sun, and nature, and pungent fruit and bright green wings provided temporary but refreshing relief from approaching death. If she seeks divinity, she has to seek it within herself, for all Stevens' people are narcissistic as well as solipsistic; even passion for him was something solitary—not masturbatory as with Duchamp, not guilt-ridden as with Eliot, or promiscuous as with Pound—but solitary in the sense of sexuality sublimated into aesthetic passion. Stevens was probably the only heterosexual male in all modernism to get more pleasure out of a green cockatoo than out of a beautiful woman. No gusty emotions on wet nights for him, for he has all of human experience to relive.

All the gods are dead by stanza three, and even mythy minds can do little more than evoke their memory. The divine and the human have merged, and so the poet must contemplate the nature of paradise. If death is the mother of beauty, then paradise would not be paradise at all, for it would be unchanging and thus boring. The earth has to contain all of paradise that anyone can know. Birds excite observers with their growth and fluttering, but ultimately merge with time and space to leave only memory, and to suggest that the seasons too will change, and that even spring has implications of the winter that will be the end of it all.

By the fifth stanza, dreams, desires, and death have come together, in images of willows, maidens, and fruit. By the sixth, the sheer transcience of it all has become oppressive: too much of a good thing, in New England parlance. Anyone who gets what he wants soon wishes he hadn't, and neither Stevens nor his woman is any different. The sky, being distant, may be perfect, but the perfect fruit up close has become too heavy, both for the branches and the taste buds of those who would enjoy. Jamesian water imagery flows into memory, as though plums and pears were American versions of Proust's madeleine. Such visions cause an inarticulate pang; Frenchmen can write volumes about such things, but Americans have trouble putting out more than a few stanzas.

The seventh stanza provides a bit of anthropology to balance the psychology, and a bit of male vigor to balance feminine reverie. Flesh and spirit, earth and sky intermingle, and the delicate string music of the woman becomes the savage chant of the men. The summer heat seems to evoke the Holy Land, and by the eighth stanza Jesus is lying in a grave. People live in a chaos of the sun because the gods are all dead; they dwell alone on islands, surrounded by wide waters. Deer and quail provide autumnal company, and berries supply a solitary's nourishment. But anyone who takes much solace from such musings should watch, in the evenings, as "casual flocks of pigeons make / Am-

biguous undulations as they sink, / Downward to darkness, on extended wings."

Wallace Stevens did not need a war to know that grim times were ahead, and that art would never recover the certainties of nineteenth-century form, content, or diction.

A Note on
Archival Sources

This volume is based on a large variety of archival materials, not all of them cited in the notes. Many will not appear until cited in sequel volumes.

The most important collections were those of Ezra Pound, Gertrude Stein, and Mabel Dodge Luhan at the Beinecke Library, Yale University. Closely related were the collections of Marsden Hartley, Hutchins Hapgood, William Carlos Williams, and Arnold Rönnebeck. Of the marginal collections I looked through at Yale, only the papers of Arthur Davison Ficke yielded a few items of relevance before 1917. Researchers should know that these collections sometimes have copies of important materials held elsewhere, e.g., the Williams material at the Lockwood Library, State University of New York, Buffalo. The Pound letters are slowly appearing in print; the so-called Paige carbons of his family letters are especially useful and easy to use. The Sterling Library nearby houses the Walter Lippmann Papers, which proved only marginally useful. I also sampled materials in the Library of the School of Music, and the oral and written archives of Vivian Perlis; these will only be cited in the sequel to this volume.

At the Harry Ransom Humanities Research Center, at the University of Texas, Austin, the most important collections were those of Ezra Pound, Frank S. Flint, and Alice Corbin Henderson. Of some use were the John Gould Fletcher, William Carlos Williams, Ottoline Morrell, Charles Norman, Henri-Pierre Roché, and Jacob Epstein materials. The Gernsheim Collection of photographic materials contains some information on Alvin Coburn. The Fletcher collection includes highly illuminating materials duplicating those at the University of Arkansas, Fayetteville, which would be useful to students of Amy Lowell and American imagism.

The Archives of American Art lends its important collections in microfilm form to cooperating libraries. I sampled a great many of these, but the process is almost archeological, yielding only an item or two

per reel. The most useful were the papers of Walt Kuhn, but see also those of Walter Arensberg, Jerome Blum, Louis Bouché, Arthur Carles, Manierre Dawson, Charles Demuth, Henry McBride, Walter Pach, Charles Sheeler, Abraham Walkowitz, Max Weber, and Beatrice Wood. The staff is helpful in supplying bibliographical information about its collections.

In Chicago, the Newberry Library has extensive collections of the papers of Floyd Dell and Sherwood Anderson. The Regenstein Library of the University of Chicago has the *Poetry Magazine* and the Harriet Monroe materials, which include numerous Pound and Lowell letters, among others.

The New York Public Library has the enormous John Quinn collection. Some of its treasures are available in B.L. Reid's *The Man from New York*, and various published letter collections, but it remains a major source.

I consulted the Conrad Aiken Papers at the Huntington Library, and the Amy Lowell Papers at Harvard only through copies available elsewhere or in print.

The Museum of Modern Art in New York has published its D.W. Griffith materials on microfilm; copies are at the University of Texas Perry-Castaneda Library and other depositaries.

The Columbia University Oral History of Max Weber is exceptionally detailed and useful.

The Walter Arensberg materials at the Francis Bacon Library in Claremont, California, are now on microfilm and available from the Archives of American Art.

I have indicated in my notes some of the difficulties I encountered in using these materials. Many of the letters are in poor condition, are examinable only on microfilm which is blurry and hard to read, or are examinable only in typed copies or in a few instances uncorrected carbons of typed copies. I do not regard it as being the function of a historian to fuss at these materials or to edit them after the fashion of the Modern Language Association editions. I have therefore silently corrected obvious typographical errors in copies, but have preserved all errors which seem to be idiosyncratic or intentional, without littering my pages with "sic" marks. Ezra Pound often wrote in a dialect which some found absurd even among his friends, and typed letters which have entranced and confused countless students. If he wants to invent the word "literwary" or misspell "rhythm" in several variants, that is his business. Charlie Chaplin used "ect." for "etc." like many undergraduates, and did not concern himself with rules of apostrophe. Gertrude Stein habitually used "x" for "ex" forms, as in *xact* and such words. Marsden Hartley never mastered French accents or German umlauts, and never could cope with the name of the painter he regularly called Piccasso. Only when my outside readers, or excessively enthusiastic copy

editors have repeatedly queried a transcription have I relented to use a "sic" in the text, usually indicating even extreme examples with a "sic" only in the notes. I am sure this practice will seem inconsistent, which it is, but my purpose is to tell a story, not to flaunt my knowledge of textual principles.

Notes

A Guide to Abbreviations

Names, Books, Magazines

ACH: Alice Corbin Henderson
ADF: Arthur Davison Ficke
ALC: Alvin Langdon Coburn
AP: Anita Pollitzer
AR: Arnold Rönnebeck
AS: Alfred Stieglitz
BR: Bertrand Russell
CA: Conrad Aiken
CEP: *Collected Early Poems of Ezra Pound*
CN: *Camera Notes*
EP: Ezra Pound
ES: Eduard Steichen
FD: Floyd Dell
FSF: Frank S. Flint
GO'K: Georgia O'Keeffe
GS: Gertrude Stein

HD: Hilda Doolittle
HP: Homer Pound
IP: Isabel Pound
LS: Leo Stein
MD: Mabel Dodge (Luhan)
MH: Marsden Hartley
MZ: Marius de Zayas
OM: Ottoline Morrell
RA: Richard Aldington
RF: Robert Frost
TSE: Thomas Stearns Eliot
VB: Viola Baxter (Jordan)
VK: Vera Kuhn
WCW: William Carlos Williams
WK: Walt Kuhn
WS: Wallace Stevens

Archives

AAA: Archives of American Art, Smithsonian Institution, Washington, D.C.
ACH-UT: Alice Corbin Henderson Papers, Harry Ransom Humanities Research Center, University of Texas, Austin
AR-YU: Arnold Rönnebeck Papers, Beinecke Library, Yale University
AS-YU: Alfred Stieglitz Papers, Beinecke Library, Yale University
CN-UT: Charles Norman Papers, Harry Ransom Humanities Research Center, University of Texas, Austin
EP-UT: Ezra Pound Papers, Harry Ransom Humanities Research Center, University of Texas, Austin
EP-YU: Ezra Pound Papers, Beinecke Library, Yale University

FD-NL: Floyd Dell Papers, Newberry Library, Chicago
FSF: Frank S. Flint Papers, Harry Ransom Humanities Research Center, University of Texas, Austin
GS-YU: Gertrude Stein Papers, Beinecke Library, Yale University
HD-YU: Hilda Doolittle Papers, Beinecke Library, Yale University
JQ-NYPL: John Quinn Papers, New York Public Library
MDL-YU: Mabel Dodge Luhan Papers, Beinecke Library, Yale University
MH-YU: Marsden Hartley Papers, Beinecke Library, Yale University
MW-AAA: Max Weber Papers, Archives of American Art, Smithsonian Institution, Washington, D.C.
OM-UT: Ottoline Morrell Papers, Harry Ransom Humanities Research Center, University of Texas, Austin
Paige carbons: carbon copies made by D.D. Paige while editing Ezra Pound family letters, Ezra Pound Papers, Beinecke Library, Yale University
PM-C: *Poetry Magazine* Papers, Regenstein Library, University of Chicago
WCW-UT: William Carlos Williams Papers, Harry Ransom Humanities Research Center, University of Texas, Austin
WCW-YU: William Carlos Williams Papers, Beinecke Library, Yale University
WK-AAA: Walt Kuhn Papers, Archives of American Art, Smithsonian Institution, Washington, D.C.

BOOK I Chapter 1

1. The best source for James Whistler's early life is Gordon Fleming, *The Young Whistler 1834–1866* (London, 1978); on George Whistler, Albert Parry, *Whistler's Father* (Indianapolis, 1939) is excellent on Russian but skimpy on American material.

2. Elizabeth Mumford, *Whistler's Mother* (Boston, 1939) is the standard source, and often a spirited defense of Anna Whistler's character. Fleming, Parry, and other biographers are generally harsher. A few of Anna's letters, from 1853 until just before her death, have been published as "The Lady of the Portrait: Letters of Whistler's Mother," ed. Katherine E. Abbot, *Atlantic Monthly* CXXXVI #3 (September 1925), 319–28.

3. James A. Whistler to William Heinemann, 1899, and an undated letter to Otto Goldschmidt, both in the Library of Congress; and an unpublished interview with I.B. Davenport, New York Public Library; all three quoted from Fleming, *Whistler*, 29.

4. Anna kept a detailed diary now in the New York Public Library, which is the major primary source for all biographers. E.R. and J. Pennell, *The Life of James McNeill Whistler* (5th ed., one volume, Philadelphia, 1911), prints numerous excerpts, but their own interpolations are all too reflective of Whistler's self-image making and their inadequate knowledge of Russia. They tend to make Anna too attractive and Whistler too precocious, and on these matters Parry and Fleming are more reliable.

5. Parry, *Whistler's Father*, 219–21.

6. Fleming, *Whistler*, 60–69.

7. Mumford, *Whistler's Mother*, 114–28; Fleming, *Whistler*, 37.

8. Pennells, *Whistler*, 18–19; Mumford, *Whistler's Mother*, 147–61.

9. Fleming, *Whistler*, ch. 5; "The Lady of the Portrait," *passim;* John Sandberg, "Whistler's Early Work in America, 1834–1855," *The Art Quarterly* XXIX #1 (1966), 46–60.

10. Fleming, *Whistler*, ch. 6; Stanley Weintraub, *Whistler* (New York, 1974), ch. 3. On life in Washington, see especially Arthur Jerome Eddy, *Recollections and Impressions of James A. McNeill Whistler* (Philadelphia, 1903); and Sandberg, "Whistler's Early Work."

11. Thomas Armstrong, C.B., *A Memoir 1832–1911*, ed. L.M. Lamont (London, 1912), 174–77 and *passim;* Leonée Ormond, *George du Maurier* (Pittsburgh, 1969), ch. 2.

12. Elizabeth Robins Pennell, *Whistler the Friend* (Philadelphia, 1930), 43–45, 91.

13. I have consistently found Denys Sutton, *Nocturne: The Art of James McNeill Whistler* (London, 1963), the most reliable guide on technical matters; here see 21–22.

14. The articles appeared in the *Athenaeum* on 17 and 24 February and 3 and 10 March 1848.

15. Elisabeth Luther Cary, *The Works of James McNeill Whistler* (New York, 1913), 12.

16. *Education de la mémoire pittoresque*, (Paris, 1862), as quoted in Sutton, *Nocturne*, 23. An English version appeared as *The Training of Memory in Art* (London, 1911).

17. Charles Baudelaire wrote a memorable review which scorned the original salon and attacked the general level of Parisian taste. See *Art in Paris* (London, 1965), 146.

18. Daphne du Maurier, *The Young George du Maurier: A Selection of his Letters, 1860–1867* (London, 1951), 4, 6, 16.

19. Jeremy Maas, *Victorian Painters* (New York, 1969), 105.

20. *Ibid.*, ch. 9, quote 125. Membership included the two Rossettis, William Holman Hunt, John Everett Millais, Thomas Woolner (sculptor and poet), James Collinson, and Frederic George Stephens (art editor). Ford Madox Brown soon joined them but was not an official member.

21. See especially Eugene Matthew Becker, "Whistler and the Aesthetic Movement," Ph.D., Princeton, 1959, DA#59 05153, and Robin Ironside, *Pre Raphaelite Painters* (London, 1948), who reprints the statement by F.M.Brown on his "The Pretty Baa-Lambs," 23.

22. Fleming, *Whistler*, ch. 12, "The Lady of the Portrait," and Sutton, *Nocturne*, 48. The work is often listed as "The Lange Leizen of the Six Marks." For background see James A. Michener, *The Floating World* (New York, 1954), and *Japanese Prints from the Early Masters to the Modern* (Rutland, VT, 1959); and Hugh Honour, *Chinoiserie: The Vision of Cathay* (London, 1961).

23. Becker, "Whistler," prints much of the French text, 248–49, from Léonice Bénédite, "Artistes Contemporains-Whistler," *Gazette des Beaux-Arts* XXXIV (1905), 232; and an English translation, 79–80.

24. Sutton, *Nocturne*, 55–7; Whistler to Fantin-Latour, 30 September 1868, Library of Congress, quoted 64.

25. Donald Holden, *Whistler Landscapes and Seascapes* (New York, 1969), 16; Armstrong, *Memoir*, 193; James A. McNeill Whistler, *The Gentle Art of Making Enemies* (New York, 1967, c.1892), 128.

26. In addition to the Pennells' biography, see especially Mortimer Menpes, *Whistler as I Knew Him* (New York, 1904).

27. Pennells, *Life of Whistler*, 113–15; John A Mahey, "The Letters of James McNeill Whistler to George A. Lucas," *Art Bulletin* XLIX #3 (1967), 247–57. Holden, *Whistler*, has one of the best brief discussions of the nocturnes, 16–18.

28. Pennells, *Life of Whistler*, 169–70. The most thorough discussion of Ruskin's ideas in this area is George P. Landow, *The Aesthetic and Critical Theories of John Ruskin* (Princeton, 1971), although it is far too sympathetic and defensive.

29. Pennells, *Life of Whistler*, 240–41.

30. Whistler, *Gentle Art*, 131–59.

31. Arthur Eddy, *Recollections*, 214–15.

32. Algernon Charles Swinburne, *William Blake: A Critical Essay* (New York, 1967, c. 1868), 91; Becker, "Whistler," 149; Barbara Charlesworth, *Dark Passages: The Decadent Consciousness in Victorian Literature* (Madison, WI, 1965), ch.2.

33. Thomas Wright, *The Life of Walter Pater* (London, 1907), 1: 202; Walter Pater, *The Renaissance: Studies in Art and Poetry* (London, 1910), 236; Charlesworth, *Dark Passages*, ch.3; and *passim*: Michael Levey, *The Case of Walter Pater* (London, 1978); Gordon McKenzie, *The Literary Character of Walter Pater* (Berkeley, 1967); and Gerald Monsman, *Walter Pater* (Boston, 1977).

34. See especially Rupert Hart-Davis, ed., *The Letters of Oscar Wilde (London, 1962)*, and *The Works of Oscar Wilde* (New York, 1909), II: 47; Charlesworth, *Dark Passages*, ch. 4; and Richard Ellmann, *Oscar Wilde* (New York, 1987).

35. Théophile Gautier, *Mademoiselle de Maupin* (New York, n.d., Modern Library ed.), xxv; Malcolm Easton, *Artists and Writers in Paris: The Bohemian Idea, 1803–1867* (London, 1964), with the Gautier quote on 69–70, from *Histoire du romantisme* (Paris, 1911, c.1874), 64.

36. The Pennells and Weintraub accept the Murger influence, while Fleming and Sandberg doubt it. Depending on the edition, Murger's name sometimes is spelled Mürger and his first name as Henry. The book title also appears as *Vie de Bohème* even in English.

37. See esp. Becker, "Whistler," 133 ff.

38. Carl Paul Barbier, ed., *Correspondance Mallarmé-Whistler* (Paris, 1964), 5–15, 297–300; George Painter, *Marcel Proust* (New York, 1959), I, 256, 280–81; II, 29–30; Weintraub, *Whistler*, 348–51; Anthony Blunt and Phoebe Pool, *Picasso: The Formative Years* (New York, 1962), 9. Debussy was apparently *not* reviving the old piano "nocturne," which Chopin and John Field made popular.

39. Leon Edel, ed., *Henry James Letters II 1875–1883* (Cambridge, 1975), 167; *III 1883–1895* (Cambridge, 1980), 356; *IV 1895–1916* (Cambridge, 1984), 43; Henry James, *The Painter's Eye*, ed. John L. Sweeney (London, 1956), 143, 165, 172–74, 209, 258–59; Weintraub, *Whistler*, 430.

40. Hugh Kenner, *The Pound Era* (Berkeley, 1971), 174; D.D.Paige, ed., *The Selected Letters of Ezra Pound 1907–1941* (New York, 1950), 10; Ezra Pound, *Selected Prose 1909–1965*, ed. William Cookson (New York, 1973), 115–17.

BOOK I Chapter 2

1. The best biographical source for young William James, with much detail about his father and grandfather, is Howard M. Feinstein, *Becoming William*

James (Ithaca, NY, 1984). The most valuable collection of primary material is F.O. Matthiessen, *The James Family* (New York, 1947); my quotations are chiefly from Henry, Sr.'s, autobiography as reprinted there, 21, 24, 32–34, 49. One quote is from Henry James, Jr.'s, *Autobiography* (London, 1956), 109. Austin Warren, *The Elder Henry James* (New York, 1934), is a dated but useful literary biography.

2. Henry James, *Autobiography*, 133–34, 109, 278, 19, 33, 48, 268, 277.

3. Feinstein, *Becoming William James*, 104; Henry James, ed., *The Letters of William James* (2 vols., Boston, 1920), I: 19–20, 86, 212–13, 218n; Leon Edel, ed., *The Diary of Alice James* (New York, 1964), 4.

4. Henry James, *Autobiography*, 118; Ralph Barton Perry, *The Thought and Character of William James* (2 vols., Boston, 1935), I: 183; Feinstein, *Becoming William James*, 92–108; Henry James, *Lectures and Miscellanies* (New York, 1852), 102.

5. Perry, *Thought and Character*, I: 206, 216; *Letters of William James*, I: 31–32, 43–45.

6. *Letters of William James*, I: 99, 123; Matthiessen, *James Family*, 209.

7. *Letters of William James*, I: 167, 169; Perry, *Thought and Character*, I: 351. The best secondary account is Feinstein, *Becoming William James*, 241–50, which corrects many previous mistakes of emphasis and chronology.

8. Matthiessen, *James Family*, 3; *Letters of William James*, I: 118–22.

9. Perry, *Thought and Character*, I: 274; Gay Wilson Allen, *William James* (New York, 1967), 251; *Letters of William James*, I: 263–64, 301, 325; William James, *The Principles of Psychology* (New York, 1890), I: 192. For general background, especially on Wundt, see John Michael O'Donnell, "The Origins of Behaviorism: American Psychology, 1870–1920," Ph.D., University of Pennsylvania, 1979, #7928159, chapter 2, esp. 66. Since I completed my research this has appeared in print as *The Origins of Behaviorism: American Psychology, 1870–1920* (New York, 1985).

10. Frank M. Albrecht, Jr., "The New Psychology in America, 1880–1895," Ph.D., Johns Hopkins, 1960, was an early history; O'Donnell, "The Origins of Behaviorism," corrects it at several points and adds much new material. For British background, see Reba N. Soffer, *Ethics and Society in England: The Revolution in the Social Sciences, 1870–1914* (Berkeley, 1978), esp. 112–13. For continental Europe a useful overview is Jan Romein, *Watershed of Two Eras: Europe in 1900* (Middletown, CT, 1978). For the fine arts and their relation to new scientific and mathematical thought, see Linda Henderson, *The Fourth Dimension and Non-Eucliean Geometry in Modern Art* (Princeton, 1983). On progressivism, see Robert M. Crunden, *Ministers of Reform* (New York, 1982).

11. For the best overview of James as an adult, see Jacques Barzun, *A Stroll with William James* (New York, 1983). The quotations are from *Letters of William James*, II: 37 and I: 261.

12. Perry, *Thought and Character*, II: 53.

13. James, *Principles*, I: 105, 115, 120, 121; II: 440–50, 455; I: 224–45, 233, 239; *Psychology Briefer Course* (New York, 1892), 263; *Principles*, I: 22–23. For Peirce and Santayana, see the introduction by Gerald E. Myers to the 1981 edition of the *Principles*, xxxvii–viii. The final quotation is from James' essay, "Does 'Consciousness' Exist?" *Essays in Radical Empiricism* (Cambridge, 1976), 14–15. Perry, *Thought and Character*, II: 388, 589, has useful material on James' last thoughts in this area.

14. James, *Principles*, II, 284.

15. Charles Hartshorne and Paul Weiss, eds., *Collected Papers of Charles Sanders Peirce* (Cambridge, 1931–35). These six volumes are cited by volume and paragraph number, e.g., in this case 5.12, for volume 5, paragraph 12, probably written about 1906.

16. These essays have been reprinted many times. I used Milton R. Konvitz and Gail Kennedy, eds., *The American Pragmatists* (Cleveland, 1960), 82–118.

17. *Letters*, I: 35, 80; Perry, *Thought and Character*, I: 363; William James, *Essays in Philosophy* (Cambridge, 1978), 124, 94.

18. See especially H.S. Thayer's introduction to William James, *Pragmatism* (Cambridge, 1975), chiefly xxii–xxv. For lucid summaries of Peirce in the larger context, see Paul Conkin, *Puritans and Pragmatists* (New York, 1968), ch. 6; John E. Smith, *The Spirit of American Philosophy* (New York, 1966), ch. 1; and R. Jackson Wilson, *In Quest of Community* (New York, 1968), ch. 2.

19. William James, *The Meaning of Truth* (Cambridge, 1975); and *Essays in Radical Empiricism* (Cambridge, 1976), 21–44.

20. James, *Essays in Radical Empiricism*, 35, xxvii.

21. James, *Letters*, II: 58, 64–65, 211; Perry, *Thought and Character*, I: 163; *Essays in Philosophy*, 125; George Santayana, *Character and Opinion in the United States* (New York, 1967, c.1921), 77. On Buddhism see the Postcript to *The Varieties of Religious Experience*.

22. R. Laurence Moore, *In Search of White Crows: Spiritualism, Parapsychology, and American Culture* (New York, 1977), esp. 36, 50, 146–47; Gardner Murphy and Robert O. Ballou, eds., *William James on Psychical Research* (New York, 1960), 95–210, esp. 147.

23. Eugene Taylor, *William James on Exceptional Mental States* (New York, 1983), esp. 62, 65, 164–65.

24. James, *Letters*, II: 127, 149–50.

25. William James, *The Varieties of Religious Experience* (New York, n.d.), 37, 43, 46, 28, 466, 128, 153.

26. Rosalind S. Miller, *Gertrude Stein: Form and Intelligibility* (New York, 1949), 146.

BOOK I Chapter 3

1. Austin Warren, *The Elder Henry James* (New York, 1934), 134.

2. Henry James, *Autobiography* (London, 1956), 59, 69 et seq., *passim*.

3. *Autobiography*, 22; Leon Edel, ed., *Henry James Letters*, I (Cambridge, 1974), 76–77, 152–53, 274; Ralph Barton Perry, *The Thought and Character of William James* (Boston, 1935), I: 251.

4. *Autobiography*, 191; *Letters*, I: 76–77.

5. *Letters*, I: 90 ff., 208; Leon Edel, ed., *Henry James Letters*, II (Cambridge, 1975), 135, 197; *Letters*, III: (Cambridge, 1980), 167, 244.

6. *Letters*, I: 142–43, 428, 450; F.O. Matthiessen, *The James Family* (New York, 1980, c. 1947), 289.

7. *Letters*, II: 424; Henry James, *Literary Criticism*, "The Library of America" (New York, 1984), "Essays on Literature," 53, in subsequent notes, this volume will be cited as James, *Literary Criticism*, II; *Autobiography*, 454–55.

8. James, *Literary Criticism*, "The Library of America" (New York, 1984), "French Writers," 31–68. In subsequent notes, this volume will be cited as James, *Literary Criticism*, III.

9. James, *Literary Criticism*, II: 853–58, 1002–03; III: 152–58.

10. James, *Literary Criticism*, III: 968–1034.

11. F.O. Matthiessen and Kenneth B. Murdock, eds., *The Notebooks of Henry James* (Chicago, 1981, c. 1947), 38–39.

12. *Notebooks*, 15, 44, 99–100; *Letters*, III: 329.

13. See especially Michael Meyer, *Ibsen* (London, 1974, c. 1967), 93, 861–62, and *passim*.

14. *Letters*, III: 340–45.

15. *Notebooks*, 122; *Letters*, III: 507–10; Leon Edel, *Henry James: The Treacherous Years: 1895–1901* (New York, 1978, c. 1969), 72–80.

16. *Notebooks*, 138–43; Henry James, *The Other House* (New York, n.d. [1947], c. 1896), with introduction by Leon Edel.

17. *Notebooks*, 136–37, 198–99, 208; James, *Literary Criticism*, III, "Prefaces to the New York Edition," 1140, 1147.

18. James, *Literary Criticism*, III: 1241–44, 1254, 1262, 1267, 1269; *Notebooks*, 263; Edel, *Henry James*, IV: 111–15.

19. James, *Literary Criticism*, III: 1050, 1079, 1084.

20. *Ibid.*, 1087–89.

21. Henry James, *The Sacred Fount* (New York, 1910, c. 1901). The 1979 paperback reprint has an introduction by Leon Edel. The most sensible critique is Jean Frantz Blackall, *Jamesian Ambiguity and The Sacred Fount* (Ithaca, 1965).

22. On some of these connections, see especially Richard A. Hocks, *Henry James and Pragmatistic Thought* (Chapel Hill, 1974).

23. *Letters*, IV: 242.

24. *Notebooks*, 225–29.

25. *Letters*, IV: 466.

26. Sergio Perosa, *Henry James and the Experimental Novel* (Charlottesville, VA, 1978), 199–205; T.S. Eliot, "Henry James," in Edmund Wilson, ed., *The Shock of Recognition* (New York, 1955), 854.

BOOK II Chapter 1

1. The definitive modern source for Pound's early life is James J. Wilhelm, *The American Roots of Ezra Pound* (New York, 1985), to which I am much indebted. See also William Carlos Williams, *I Wanted to Write a Poem* (New York, 1978, c. 1958), 5; Donald Hall, "E.P.: An Interview," *Paris Review*, XXVIII (1962), 22–51, often reprinted; and Mary de Rachelwitz, "His Mother—Her Son," unpublished paper given to me by its author.

2. Archibald MacLeish, in a WYBC radio script, "A Tribute to Ezra Pound," December 1955, copy in Ezra Pound Papers, Harry Ransom Humanities Research Center, University of Texas, Austin (hereafter cited as EP-UT), read the letter which an unnamed faculty member, probably Ibbotson, had sent to Alexander Woollcott, which Woollcott had given him. Pound mentions the incident, about "Bib," Ibbotson's nickname, in Ezra Pound (EP) to parents (HP, IP), 5 March 1905, D.D. Paige carbons, Ezra Pound Papers, Beinecke Library, Yale University (hereafter cited as Paige carbons), EP-YU. On Viola Baxter, see EP to IP, June 1905, EP-YU; and EP to William Carlos Williams (WCW), 8 February 1906, William Carlos Williams Papers, Lockwood Library, University of Buffalo. Some accounts have Katherine Heyman eleven years older than Pound. See Humphrey Carpenter, *A Serious Character*, (Boston, 1988), 49.

3. In addition to Wilhelm, *American Roots,* 138, see Hugh Kenner, *The Pound Era* (Berkeley, 1971), esp. 77, and Stuart Y. McDougal, *Ezra Pound and the Troubadour Tradition* (Princeton, 1972), 4ff. Pound's annotated texts in this area are at EP-UT.

4. EP to IP, February 1905, Paige carbons, EP-YU.

5. Peter Makin, *Provence and Pound* (Berkeley, 1978), esp. 160, 250–51.

6. EP to IP, June 1905, Paige carbons; EP to Viola Baxter (VB), 22 December 1905, 13 January, 5 April, and 17 April 1906, plus several n.d., all Viola Baxter Jordan file, EP-YU. For a sampling of this collection see Donald Gallup, ed., "Letters to Viola Baxter Jordan," *Paideuma* I, #1 (1972), 107–11.

7. EP to VB, 20 August, 12 September, 1 October 1906; two n.d.; and EP to WCW, usually "Billy," 10 January 1907, all including the WCW in Jordan file, EP-YU. Here and elsewhere I have tried to reproduce Pound's text precisely, without using "sic" at every oddity; obvious typographical errors will be corrected. Every student of Pound knows the problems of his unconventional mannerisms and one does the best one can; in this case the letters are in xeroxed form and at times of marginal legibility for technological reasons.

8. EP to VB, n.d., EP-YU; Wilhem, *American Roots,* ch. 10.

9. EP to VB, September (?) 1907, and EP to WCW, 24 October 1907, EP-YU; EP to L.B. Hessler, n.d. but marked "Bertram" Hessler and dated 20 November 1906 in unknown hand, EP-UT.

10. Wilhelm, *American Roots,* ch. 11.

11. EP to VB, May (?) 1908, EP-YU; EP to Hessler, 14 June 1908, EP-UT; D.D. Paige, ed., *The Selected Letters of Ezra Pound 1907–1941* (New York, 1971, c.1950), 7.

12. *The Cantos of Ezra Pound* (New York, 1933), copy EP-UT. This work contains remarks on Pound by fifteen European and American writers; Doolittle's are dated 25 November 1932.

13. Barbara Guest, *Herself Defined* (New York, 1984) and Janice S. Robinson, *H.D.* (Boston, 1982) have basic biographical data. See also "Norman Holmes Pearson on H.D.: An Interview," *Contemporary Literature,* X #4 (Autumn 1969), 435–46; "Charles Leander Doolittle," *Dictionary of American Biography;* and H.D.'s many recreations of her experiences of this period, as in *End to Torment* (New York, 1979) and *HERmione* (New York, 1981).

14. Hilda Doolittle (HD) to WCW, 12 February, 26 March, and 15 May 1908, William Carlos Williams Mss., Beinecke Library, Yale University (hereafter WCW-YU). These references will make no distinctions between originals and copies, and will follow Beinecke practice in using postmarks for dates if no precise notation is on the manuscript itself.

15. William Carlos Williams, "A Tribute to Ezra Pound," WYBC radio script, EP-UT; *I Wanted to Write A Poem,* 6.

16. Paul Mariani, *William Carlos Williams: A New World Naked* (New York, 1981), 14–17; Williams, *Yes, Mrs. Williams* (New York, 1982, c.1959), 5, 45; WCW to Elena Hoheb Williams, 12 September 1923, WCW-YU.

17. Mariani, *Williams,* 1–10; *The Autobiography of William Carlos Williams* (New York, 1951), 14.

18. *Autobiography,* 280, 51; *Yes, Mrs. Williams,* 5–8.

19. *Autobiography,* 52–57; John C. Thirlwall, ed., *The Selected Letters of William Carlos Williams* (New York, 1984, c.1957), 6.

20. *Autobiography,* 67–70; WCW, "A Letter from William Carlos Williams to

Norman Holmes Pearson Concerning Hilda Doolittle and her Mother and Father," *William Carlos Williams Newsletter*, II #2, p. 2.

21. *Autobiography*, 48–51.

22. *Ibid.*, 31, 109–16; *Letters*, 20–21.

23. *Letters*, 23–24; *I Wanted to Write A Poem*, 14–15.

Philadelphia also spawned several modernist painters, but none of these left much written evidence of their early years. Charles Demuth, John Marin, Arthur Carles, Charles Sheeler, Morton Schamberg, and Walter Pach will all reappear on the margins of the modernist scene in New York, in this volume, and in a planned sequel. But the Archives of American Art collections for Demuth, Carles, Sheeler, and Pach are all disappointing. For more accessible material, see Eunice M. Hales, "Charles Demuth: His Study of the Figures," Ph.D., New York University, 3 vols., 1974, DA #74-18162; Emily Farnham, *Charles Demuth* (Norman, OK, 1971); MacKinley Helm, *John Marin* (Boston, 1948); Barbara Ann Boese Wolanin, "Arthur B. Carles, 1882–1952: Philadelphia Modernist," Ph.D., University of Wisconsin, 1981, DA #81-12575; Constance Rourke, *Charles Sheeler* (New York, 1969, c.1938); Ben Wolf, *Morton Livingston Schamberg* (Philadelphia, 1963); Patrick Leonard Stewart, Jr., "Charles Sheeler, William Carlos Williams and the Development of the Precisionist Aesthetic, 1917–1931," Ph.D., University of Delaware, 1981, DA#8123821; and Wilford W. Scott, "The Artistic Vanguard in Philadelphia, 1905–1920," Ph.D., Delaware, 1983, DA#8420983.

BOOK II Chapter 2

1. See Helen L. Horowitz, *Culture and the City: Cultural Philanthropy in Chicago from the 1880s to 1917* (Lexington, KY, 1976); Stephen J. Diner, *A City and its Universities* (Chapel Hill, NC, 1980); and Robert M. Crunden, *Ministers of Reform* (New York, 1982), ch. 5.

Any broad picture of Chicago modernist activity should include two painters, Manierre Dawson and Jerome Blum. As with Philadelphia, only bits and pieces of their lives come through in their unpublished papers: the Manierre Dawson Papers, Archives of American Art (AAA), roll 64, frames 869–991; and the Jerome Blum Papers, also AAA, rolls D237, D238, and 2010. The best secondary treatment is Kenneth R. Hey, "Five Artists and the Chicago Modernist Movement, 1909–1928," Ph.D., Emory, 1973, DA#74–10,285.

2. See Bernard Duffey, *The Chicago Renaissance in American Letters* (Westport, CT, 1972, c.1954); Dale Kramer, *Chicago Renaissance* (New York, 1966); Carl S. Smith, *Chicago and the American Literary Imagination 1880–1920* (Chicago, 1984); and Crunden, *Ministers of Reform*, ch. 4.

3. Floyd Dell, *Homecoming* (New York, 1933), 195; Francis Hackett, *American Rainbow* (New York, 1971), 6, 114–17. The best secondary source for Dell and his circle is George T. Tanselle, "Faun at the Barricades: The Life and Work of Floyd Dell," Ph.D., Northwestern, 1959, DA#59-04844. For a briefer account, see Robert E. Humphrey, *Children of Fantasy: The First Rebels of Greenwich Village* (New York, 1978), ch. 6.

4. Dell, *Homecoming*, esp. 80–81, 147 ff, 170; *Moon-Calf* (New York, 1920), 254–55.

5. Harry Hansen, *Midwest Portraits* (New York, 1923), 208–16.

6. Floyd Dell, "George Cram Cook," *Dictionary of American Biography* (New

York, 1930), IV, 372–73; see also *Homecoming*, 150–57 and *passim*. The essential study of Cook is Susan Glaspell, *The Road to the Temple* (New York, 1927), see esp. vii–viii. Humphrey, *Children of Fantasy*, ch.3; and Susan C. Kemper, "The Novels, Plays and Poetry of George Cram Cook, Founder of the Provincetown Players," Ph.D., Bowling Green, 1982, DA#8227489, are recent studies.

7. Marcia Ann Noe, "A Critical Biography of Susan Glaspell," Ph.D., Iowa, 1976, DA#77–13,119; Dell, *Homecoming*, 170.

8. Floyd Dell (hereafter FD) to George Bernard Shaw (draft), 1908?; FD to "My dear Doctor," 16 May 1908; FD to Arthur D. Ficke (hereafter ADF), 15 April 1913; see also George C. Cook to FD, 16 April 1911, all Floyd Dell Papers, Newberry Library, Chicago (hereafter cited as FD-NL). The sequel to *Moon-Calf, The Briary Bush* (New York, 1921), recreates the Chicago atmosphere. See also "Jessica Screams," *Smart Set*, XXXIX (April, 1913), 113–20, rpt. in Burton Rascoe and Groff Conklin, eds., *The* Smart Set *Anthology* (New York, 1934), 691–702.

9. FD to ADF, 26 May 1913, FD-NL; Hansen, *Midwest Portraits*, 96–8.

10. Ray Lewis White, ed., *Sherwood Anderson's Memoirs* (Chapel Hill, NC, 1969), 317, 339. On Dell's mania for psychoanalysis, see also Gladys Brown Ficke, "Arthur Davison Ficke," an unpublished biography in four volumes, Arthur Davison Ficke Papers, Beinecke Library, Yale University, p.380.

11. Eunice Tietjens, *The World at my Shoulder* (New York, 1938), 24–5. Most factual material will be from Harriet Monroe, *A Poet's Life* (New York, 1938) and Ellen Williams, *Harriet Monroe and the Poetry Renaissance* (Urbana, IL, 1977).

12. Monroe, *Poet's Life*, 279; Pound, *Letters*, 62–63; Robert Frost to Harriet Monroe, 24 March 1917, *Poetry Magazine* Papers, Regenstein Library, University of Chicago (hereafter cited as PM-C).

13. Williams, *Monroe*, 119–25, 190–91, PM-C. See also Conrad Aiken to Monroe, 30 October 1913, PM-C, objecting to her editing of "Decadence"; and William Carlos Williams to Monroe, 5 March 1913 and 26 October 1916.

14. The Lowell correspondence runs through folders 6–16 of the PM-C. See esp. Lowell to Monroe, 7 September 1912, 23 July 1913, 10 February 1914, several in early April 1914, 20 July 1914, 10 September 1914, 15 September 1914, 11 June 1915, 29 January 1916, and 4 May 1917.

15. Monroe, *Poet's Life*, 159, 212–13.

16. Margaret Anderson, *My Thirty Years' War* (New York, 1969, c.1930), 29, 88–89, 35; Tietjens, *World at my Shoulder*, 64–65.

17. Anderson, *Thirty Year's War*, 37, 35, 71–72.

18. *Ibid.*, 38–39.

19. The best biography is Richard Lingeman, *Theodore Dreiser at the Gates of the City 1871–1907* (New York, 1986).

20. Theodore Dreiser, *Dawn* (New York, 1931), esp. 10–15, 71–73; *A Book about Myself* (New York, 1922), esp. 457–58; *Twelve Men* (New York, 1919), ch.3.

21. *Book about Myself*, 132–33; Robert H. Elias, ed., *Letters of Theodore Dreiser* (3 vols., Philadelphia, 1959), 121; Thomas P. Riggio, ed., *Dreiser-Mencken Letters* (Philadelphia, 1986), 231–32.

22. See the primary materials in Thomas P. Riggio, ed., Theodore *Dreiser American Diaries 1902–1926* (Philadelphia, 1982); in Donald Pizer, ed., *Theodore Dreiser: A Selection of Uncollected Prose* (Detroit, 1977) and Yosinobu Hakutani,

ed., *Selected Magazine Articles of Theodore Dreiser* (Rutherford, NJ, 1985); and Stuart Sherman's article, reprinted from the *Nation* of 2 December 1915 in Alfred Kazin and Charles Shapiro, eds., *The Stature of Theodore Dreiser* (Bloomington, IN, 1955), 71–80.

23. Pizer, ed., *Dreiser*, 165, 181–82, 248–53, 281, 194, 221–23, 263–64; Dreiser, *Book about Myself*, 421–22; T.D. Nostwich, ed., *Theodore Dreiser Journalism* I (Philadelphia, 1988), 36–38, 55–62, 87–88, 146–61, 170–74, 188–206.

24. Pizer, ed., *Dreiser*, 200–03, from *New Republic*, III (12 June 1915), 155–56.

25. William A. Sutton, *The Road to Winesburg* (Metuchen, NJ, 1972), first established many of the factual materials for Anderson's life; the best biography is now Kim Townsend, *Sherwood Anderson* (Boston, 1987). On the earliest writing, see Karen-Elisabeth Mouscher, "Sherwood Anderson: The Early Advertising Years," Ph.D., Northwestern, 1986, DA# 8621837.

26. Hansen, *Midwest Portraits*, ch. 4, esp. 112, 116.

27. William A. Sutton, ed., *Letters to Bab; Sherwood Anderson to Marietta D. Finley 1916–33* (Urbana, 1985), 8–9, 15, 17, 27, 35, 49, 51.

28. Sherwood Anderson, *A Story Teller's Story* (New York, 1989, c.1924), esp. 3–6, 21, 26, 31, 75, 77, 94, 100, 123, 308, 352, 363.

BOOK II Chapter 3

1. Louis R. Harlan, "Desegregation in New Orleans Public Schools during Reconstruction," *American Historical Review* LXVII (April 1962), 663–75; and John W. Blassingame, *Black New Orleans 1860–1880* (Chicago, 1973), ch. 1, 5 and pp. 139, 167–68. For the history of white music in the city, see esp. Vernon Loggins, *Where the World Ends* (Baton Rouge, 1958); and Henry A. Kmen, *Music in New Orleans: The Formative Years 1791–1841* (Baton Rouge, 1966).

2. Alan Lomax, *Mister Jelly Roll* (Berkeley, 1973, c.1950), pp. xv, 102–03, 126, 154, 3, 11–18, 22–25, 47, 34, 75, 62–64.

3. The best introduction to the subject is Robert C. Toll, *Blacking Up: The Minstrel Show in Nineteenth-Century America* (New York, 1974); W.C. Handy, *Father of the Blues* (New York, 1970, c.1941), 19, 36, 72–73.

4. Rudi Blesh and Harriet Janis, *They All Played Ragtime* (New York, 1971, c.1950), 96, 100; see also "Cakewalk" in H. Wiley Hitchcock and Stanley Sadie, eds., *The New Grove Dictionary of American Music* (London, 1986), I:343. Debussy's "Minstrels," the twelfth of the *Préludes*, Book I, is another, less well-known example of American popular influence in Europe.

5. I have relied chiefly on Edward A. Berlin, *Ragtime* (Berkeley, 1980), 1–2, 37–38, and its condensation, in *New Grove*, IV:3–6. For Eliot, see *The Complete Poems and Plays: 1900–1950* (New York, 1952), 81, 41. The well-known black writer James Weldon Johnson wrote the words to "Under the Bamboo Tree." On the larger place of some of these themes in black cultural history, see especially Lawrence W. Levine, *Black Culture and Black Consciousness* (New York, 1977).

6. James Haskins with Kathleen Benson, *Scott Joplin* (New York, 1978), is my source for most specific Joplin material, but see also earlier work of Addison W. Reed, "The Life and Works of Scott Joplin," Ph.D., University of North Carolina, 1973, DA #74-5961. In addition to the works by Blesh and Janis and by Berlin, already cited, see Terry Waldo, *This is Ragtime* (New York, 1976).

7. Igor Stravinsky and Robert Craft, *Expositions and Developments* (London, 1981, c.1962), 92.

8. The New Grove Dictionary of American Music, I:241–48. I have throughout this section relied especially on Rudi Blesh, *Shining Trumpets: A History of Jazz* (New York, 1976, c.1946) and James Lincoln Collier, *The Making of Jazz* (New York, 1978). The chief source for most students of African music is A.M. Jones, *Studies in African Music* (2 vols., London, 1959); the best longer technical study of American jazz is Gunther Schuller, *Early Jazz* (New York, 1968).

9. Sandra R. Lieb, *Mother of the Blues: A Study of Ma Rainey* (Amherst, MA, 1981), ch. 1 and p. 67. An excellent interdisciplinary background work is Jeff Todd Titon, *Early Downhome Blues* (Urbana, 1977), although its focus is on the late 1920s.

10. Arbie Orenstein, *Ravel: Man and Musician* (New York, 1975), 198–205.

11. Collier, *Making of Jazz*, 24–27; see also Collier's condensation of his book in the *New Grove*, II:535–62.

12. Donald M. Marquis, *In Search of Buddy Bolden* (New York, n.d., c.1978); *Pops Foster: The Autobiography of A New Orleans Jazzman*, as told to Tom Stoddard (Berkeley, 1971), 16; Nat Shapiro and Nat Hentoff, eds., *Hear Me Talkin' to Ya* (New York, 1966, c.1955), 36–37.

13. James Lincoln Collier uses essentially the same language in the *New Grove* article on jazz, and in *Louis Armstrong* (New York, 1983), ch. 5–6.

14. Collier, *Armstrong*, ch. 4, 6. On Bechet's reputation, see Danny Barker, *A Life in Jazz* (New York, 1986), 29, 33–34.

15. Rudi Blesh, *Shining Trumpets*, ch. 9; Pops Foster, *Autobiography*, 63.

16. H.O. Brunn, *The Story of the Original Dixieland Jazz Band* (Baton Rouge, 1960) is standard if overly enthusiastic in its claims.

17. Darius Milhaud, *Notes Without Music* (New York, 1953), 75, 77, 98, 102, 119–20, 136–37, 148–49; Shapiro and Hentoff, *Hear Me Talkin' to Ya*, 391–92.

For other Europeans influenced by jazz, see Rollo H. Myers, *Erik Satie* (New York, 1968, c.1948); Milos Safránek, *Bohuslav Martinu* (London, 1962); S. Frederick Starr, *Red and Hot: The Fate of Jazz in the Soviet Union 1917–1980* (New York, 1983); Ronald Sanders, *The Days Grow Short: The Life and Music of Kurt Weill* (New York, 1980); Ernst Krenek, *Horizons Circled* (Berkeley, 1974).

18. I will be the first to admit that the discussion of jazz and its antecedents in this chapter is written entirely from a focus on white and largely European modernism. It pays scant heed to black perspectives and priorities. It also by necessity chooses sides in scholarly arguments that remain contentious and far from settled. Space considerations have also eliminated consideration of a number of issues: the role of James P. Johnson and the early stride piano; the pressures from Tin Pan Alley and the white economic power structure; the whole problem of vocal rags, which statistically remain a large majority of published rags; white ragtime composers; and the whole confusing story of how ragtime and jazz both shifted in meaning over time and in different contexts. The focus on Joplin is also problematic: he was himself anti-modernist in many ways, and not as central to the history of ragtime itself as he was to white perception of what was happening. I hope to reexamine many of these issues in a sequel volume on the years from 1917 to 1931.

BOOK II Chapter 4

1. For background see Kevin Brownlow, *The Parade's Gone By* (Berkeley, 1968), 30–31; Garth Jowett, *Film: The Democratic Art* (Boston, 1976); Benjamin B. Hampton, *History of the American Film Industry from its Beginnings to 1931* (New York, 1970, c.1931); David Bordwell, Janet Staiger, and Kristin Thompson, *The Classical Hollywood Cinema* (New York, 1985), Appendix B, 397–99; and Gordon Hendricks, *The Edison Motion Picture Myth* (Berkeley, 1961).

2. James Hart, ed., *The Man Who Invented Hollywood: The Autobiography of D.W. Griffith* (Louisville, 1972), 23; for most biographical detail, I have relied on Richard Schickel, *D.W. Griffith* (New York, 1984), ch. 1–4.

3. For scenarios see Lewis Jacobs, *The Rise of the American Film* (New York, 1939), ch. 3; on Méliès' and Porter's innovations, see A. Nicholas Vardac, *Stage to Screen: Theatrical Method from Garrick to Griffith* (New York, 1968, c.1949), esp. 184.

4. G.W. Bitzer, *Billy Bitzer* (New York, 1973), 54; for essential background I have relied on Robert M. Henderson, *D.W. Griffith: The Years at Biograph* (New York, 1970). There is some Bitzer material in the D.W. Griffith Papers, Museum of Modern Art, reels 2 and 35.

5. Bitzer, *Bitzer*, 104–05; Pickford is quoted in Henderson, *Griffith*, 97.

6. See especially Mrs. D.W. Griffith (Linda Arvidson), *When the Movies Were Young* (New York, 1968, c.1925), 66.

7. Karl Brown, *Adventures with D.W. Griffith* (New York, 1973), 39–41, 60–61.

8. Robert Sklar, *Movie-Made America* (New York, 1975), 55–56; Sergei Eisenstein, *Film Form* and *Film Sense*, ed. and trans. by Jay Leyda (New York, 1959, c.1949 and 1947), 204–05, 238.

9. Brown, *Adventures*, 61–62.

10. Lillian Gish with Ann Pinchot, *Lilliah Gish: The Movies, Mr. Griffith and Me* (Englewood Cliffs, 1969), 151–57; for a good assessment of Griffith's contributions, see Henderson, *Griffith*, ch. 7.

11. Kevin Brownlow, *Hollywood: The Pioneers* (New York, 1979), 70–72; Brown, *Adventures*, 173; William K. Everson, *American Silent Film* (New York, 1978), 90–92. The most detailed examination of some of these issues is Jordan Leondopoulos, "Still the Moving World: 'Intolerance,' Modernism, and 'Heart of Darkness,' " Ph.D., Columbia, 1985, DA# 85-23192.

12. Mack Sennett, *King of Comedy,* as told to Cameron Shipp (New York, 1954), 12, 28–29, 51–59.

13. Sennett, *King of Comedy,* 65; For background, see Robert Toll, *Blacking Up* (New York, 1974); Kalton C. Lahue and Terry Brewer, *Kops and Custards: The Legend of Keystone Films* (Norman, OK, 1968); and Everson, *American Silent Film*, ch. 15.

14. Jacobs, *Rise,* 210–13; Lahue and Brewer, *Kops and Custards,* 38–41.

15. Sennett, *King of Comedy,* 89; for Dreiser see George C. Pratt, *Spellbound in Darkness* (Greenwich, CT, 1973, c.1966), 39–40.

16. For details see Lahue and Brewer, *Kops and Custards,* 102–08 and *passim*.

17. Charles Chaplin, *My Autobiography* (New York, 1966, c.1964), 16; David Robinson, *Chaplin* (New York, 1985), conflating quotations from 1918 and 1917, pp. 18, 71–72.

18. Robinson, *Chaplin,* 93, 97–98 quoted sic; *Autobiography,* 144, 149–50.

19. *Autobiography,* 8, 137, 226; Robinson, *Chaplin,* 143–45, 154. See also Walter Kerr, *The Silent Clowns* (New York, 1975), ch. 9–10.

20. Hugo Münsterberg, *The Photoplay: A Psychological Study* (New York, 1916), 38–39, 95, 97.

21. Bordwell, Staiger, Thompson, *Classical Hollywood Cinema,* 9.

BOOK II Chapter 5

1. James B. Crooks, *Politics and Progress: The Rise of Urban Progressivism in Baltimore 1895 to 1911* (Baton Rouge, 1968), esp. 5–6, 14–15, 50–51, 160–61, 197.

2. Hugh Hawkins, *Pioneer: A History of the Johns Hopkins University 1874–1899* (Ithaca, 1960); Harvey Cushing, *The Life of Sir William Osler* (Oxford, 1925); Simon Flexner and James T. Flexner, *William Henry Welch and the Heroic Age of American Medicine* (New York, 1941).

3. Most accounts depend of necessity on Stein's memoirs, chiefly in *The Autobiography of Alice B. Toklas,* most conveniently available in Carl Van Vechten, ed., *Selected Writings of Gertrude Stein* (New York, 1962, c.1946), see 65 ff. The most reliable secondary source is James R. Mellow, *Charmed Circle* (New York, 1975, c.1974), 31 ff. See also Gertrude Stein, *Lectures in America* (Boston, 1985, c.1935), 110–16.

4. Leo Stein (hereafter LS) to Gertrude Stein (hereafter GS), Gertrude Stein Papers, Beinecke Library, Yale University (hereafter GS-YU); Hutchins Hapgood, *A Victorian in the Modern World* (New York, 1939), 120 and *passim;* Arthur Lachman, "Gertrude Stein as I Knew Her," unpublished memoir, GS-YU, 7–8. The best sketch of Leo Stein to date is that of Irene Gordon in *Four Americans in Paris* (New York, 1970), 13–33, a Museum of Modern Art exhibition catalog full of related material. For examples of GS's early writing see the reprinted material in Rosalind S. Miller, *Gertrude Stein: Form and Intelligibility* (New York, 1949).

5. Stein, *Autobiography,* 73–75; Lachman, "Gertrude Stein as I Knew Her." See Stein's "Normal Motor Automatism," *Psychological Review,* III #5 (September, 1896), 492–512, and "Cultivated Motor Automatism," *idem,* V #3 (May, 1898), 295–306.

6. Of the ten letters from Leon Solomons to GS that survive, GS-YU, see especially 26 October 1896, 5 April, and ? December 1897, and 4 January 1898 (misdated 1897).

7. William James to GS, 17 October 1900; LS to Mabel Weeks, 19 September 1902, 6 October 1909, 15 February 1910, and 3 October 1911, with addenda 12 October 1911; neither letter nor addenda sent at the time, but included with letter of 4 February 1913 and mentioned therein. LS to GS, undated but fall 1910; and LS to Trigant Burrow, 9 June 1941, all GS-YU. Some of these are excerpted in Edmund Fuller, ed., *Journey Into the Self: being the letters, papers & journals of Leo Stein* (New York, 1950), 12, 20, 22, 42, 216.

8. See the Stein chapter in Aline Saarinen, *The Proud Possessors* (New York, 1958) and Barbara Pollack, *The Collectors: Dr. Claribel and Miss Etta Cone* (New York, 1962).

9. All scholars are deeply indebted to Leon Katz, who first sorted out these problems in "The First Making of 'The Making of Americans': A Study Based on Gertrude Stein's Notebooks and Early Versions of her Novel (1902–1908),"

Ph.D., Columbia, 1963, DA#65-7458, and its subsequent appearances in article form, especially in the introduction to Stein's *Fernhurst, Q.E.D., and Other Early Writings* (New York, 1971).

10. LS to Mabel Weeks, 19–20 September 1902, excerpted in *Journey*, 10–13; the text of the early manuscript fragment of *The Making of Americans* is in Katz, ed., *Fernhurst*, etc., 137–72; quotations from 138, 137, 141, 143–5, 140, 151, 152.

11. Katz, ed., *Fernhurst*, etc., 48, 80, 71, 55, 59, 101, 108–09, 77, 132.

12. *Ibid.*, 4–5, 6–7, 11–12, 19.

13. Van Vechten, ed., *Selected Writings*, 31; GS to Mabel Weeks, ? May 1906, GS-YU. The standard literary reading is Richard Bridgman, *Gertrude Stein in Pieces* (New York, 1970): the most imaginative in tying literature to painting to psychology is Jayne L. Walker, *The Making of a Modernist: Gertrude Stein from Three Lives to Tender Buttons* (Amherst, 1984).

14. Roché first commented on *Three Lives* is a letter to GS of ? 15 June 1907; see also 20 December 1909, but chiefly 6 February and 9 February 1912, GS-YU.

15. Gertrude Stein, *Three Lives* (New York, 1909), Modern Library edition, 128–29.

16. GS to Mabel Weeks, n.d.; Nella Larsen Imes to GS, 1 February 1928, both GS-YU; Fuller, ed., *Journey*, 137. For Richard Wright, see Van Vechten, ed., *Selected Writings*, 338.

17. Leon Katz, "The First Making . . . ," provides a far more detailed account of her intentions, and supplies an extensive plot summary. My comments are based on the unabridged edition, republished as Gertrude Stein, *The Making of Americans being a history of a family's progress* (New York, 1966 c.1925).

18. Stein, *Lectures in America*, 137–38, 147, 176–77, 160–61.

19. See William M. Johnston, *The Austrian Mind* (Berkeley, 1972), 158–62 for a brief overview; and David Abrahamsen, *The Mind and Death of a Genius* (New York, 1946), a Norwegian psychobiography that speculates a great deal but prints useful letters; see esp. 54–55, 202, 207–08.

20. Otto Weininger, *Sex and Character* (New York, 1906), 3, 79, 104, 131, 148, 186, 189, 135, 303, 306. On the reception of the book in the Stein circle, see Katz, "The First Making . . . ," 266 ff.

21. Stein, Notebook C, 21, GS-YU.

22. All accounts of Mencken's life have to follow his own detailed suggestions, first written out for Isaac Goldberg in the early 1920s and the basis of his pioneering *The Man Mencken* (New York, 1925). This book thus has the authority of a primary source, despite its many shortcomings. Mencken reused much of this material in *The Days of H.L. Mencken* (New York, 1947), a rambling collection of three volumes, of which *Happy Days* (1940) is most relevant here; see esp. vii, 37–38. The best analyses of his ideas are Charles A. Fecher, *Mencken* (New York, 1978), here esp. p. 80; and Mark B. Ryan, "Mencken's Mind: The Intellectual Orientation of H.L. Mencken," Ph.D., Yale, 1974, #75-15, 386. The most entertaining biography is William Manchester, *Disturber of the Peace* (New York, 1950); the most reliable is Carl Bode, *Mencken* (Carbondale, IL, 1969). Neither adequately assesses Mencken's place in cultural history.

23. Carl Bode, ed., *The Young Mencken* (New York, 1973), 268–81; Goldberg, *The Man Mencken*, 7–10, quoting *Baltimore Evening Sun* for 16 February 1925.

24. H.L. Mencken, *George Bernard Shaw: His Plays* (New Rochelle, New York,

1969, c.1905), vii, x–xxix; the introduction is now more readily available in Bode, ed., *Young Mencken*, 63–77. But see also "The Ulster Polonius" in H.L. Mencken, *Prejudices*, I (New York, 1919), 181–90.

25. See esp. Carl R. Dolmetsch, *The Smart Set* (New York, 1966), both a history and an anthology; and Marilyn Claire Baker, "The Art Theory and Criticism of Willard Huntington Wright," Ph.D., University of Wisconsin, 1975, #75-28, 782.

26. D.D. Paige, ed., *The Selected Letters of Ezra Pound* (New York, 1950), esp. 40, 51, 56–60, 114–15; Bode, ed., *Young Mencken*, 175–77.

27. Guy J. Forgue, ed., *Letters of H.L. Mencken* (New York, 1961), 64–65, 73–74.

28. *Ibid.*, 37; William H. Nolte, ed., *H.L. Mencken's* Smart Set *Criticism* (Ithaca, N.Y., 1968), 104–05.

29. Nolte, ed., *Mencken's Criticism*, 147–51; Carl Bode, ed., *The New Mencken Letters* (New York, 1977), 101.

30. Mencken, *Prejudices*, I, 44.

31. Forgue, ed., *Letters*, 19. Mencken's chief contribution to Conrad's reputation was *A Book of Prefaces* (New York, 1917), 11–64.

32. Mencken, *Book of Prefaces*, 67–148, conveniently reprinted in Edmund Wilson, ed., *The Shock of Recognition* (New York, 1955); Thomas P. Riggio, ed., *Dreiser-Mencken Letters* (Philadelphia, 1986).

33. Goldberg, *The Man Mencken*, 178–83.

BOOK III London

1. Michael John King, ed., *Collected Early Poems of Ezra Pound* (New York, 1982), 34–35, 215–22 (hereafter cited as *CEP*); and EP to IP, 1909?, Paige carbons, EP-YU. All Pound scholars are deeply in debt to the indispensable Donald Gallup, *A Bibliography of Ezra Pound* (Charlottesville, VA, 1983). The most reliable study of this period is J.J. Wilhelm, *Ezra Pound in London and Paris 1908–1925* (University Park, PA, 1990).

2. Douglas Goldring, *Odd Man Out* (London, 1935), 92 ff., typographical error silently corrected. I have made much use in this section of the chronology established *in extenso* for Pound's years in London, by Robert Dale Schultz, in "Ezra Pound's Developing Poetics, 1908–1915: The Critical Prose," Ph.D., Cornell, 1981, DA #8110909, also available as "A Detailed Chronology of Ezra Pound's London Years, 1908–1920," *Paideuma*, XI #3 (Winter 1982), 456–72 and XII #2–3 (Summer–Fall, 1983), 357–73.

3. Notebook entries for 16 and 26 February 1909, in 1909, in Omar Pound and A. Walton Litz, eds., *Ezra Pound and Dorothy Shakespear: Their Letters, 1909–1914* (New York, 1984), 3–5. Hereafter cited as *Pound/Shakespear*.

4. EP to Viola Baxter, fall 1908? from 48 Lonighan St., London, EP-YU; "Masks," in *CEP*, from *A Lume Spento*, 34; EP to Burtron Hessler, 14 December 1908, EP-UT.

5. EP to Hessler, 14 December 1908, EP-UT; EP to IP, 19 September 1909, Paige carbons, EP-YU.

6. Ezra Pound, *The Spirit of Romance* (New York, n.d.), 13, 16, 22, 37–38, 33, 131, 82, 87, 154; on the larger subject see Robert Briffault, *The Troubadours* (Bloomington, 1965).

7. T.S. Eliot, ed., *Literary Essays of Ezra Pound* (New York, 1968, c.1935), 75; William Cookson, ed., *Selected Prose, 1909–1965* by Ezra Pound (New York, 1975, c.1973), 21–23.

8. *Literary Essays*, 367; EP to Floyd Dell, 20 January 1911 and n.d. but shortly thereafter, copies EP-YU; see also G. Thomas Tanselle, ed., "Two Early Letters of Ezra Pound," *American Literature*, XXXIV #1 (March 1962), 114–19; T.S. Eliot, "Ezra Pound," in Peter Russell, ed., *Ezra Pound* (London, 1950), 25.

9. EP to IP, 1 January 1910, Paige carbons, EP-YU; *Literary Essays*, 11–12. The most helpful secondary sources covering the material in these paragraphs have been N. Christoph de Nagy, *The Poetry of Ezra Pound: The Pre-Imagist Stage* (Berne, 1968, c.1960); Thomas H. Jackson, *The Early Poetry of Ezra Pound* (Cambridge, 1968); and Hugh Witemeyer, *The Poetry of Ezra Pound: Forms and Renewal, 1908–1920* (Berkeley, 1969).

10. Allan Wade, ed., *The Letters of W.B. Yeats* (New York, 1955), 543; *Letters*, 3–4; EP to ?, 30 June 1910, printed in George Bornstein, ed., *Ezra Pound among the Poets* (Chicago, 1985), 132–33; *Poetry*, IV (April 1914), 27; *Literary Essays*, 378–81. I am much indebted to A. Walton Litz, "Pound and Yeats; The Road to Stone Cottage," in the Bornstein volume, 128–48.

11. EP to Viola Baxter, 3 October 1909?, 10 January and 26 February 1910, and 1911? (from Swarthmore), EP-YU; EP to IP and EP to HP, different letters both dated 12 March 1910, Paige carbons, EP-YU; *Pound/Shakespear*, 32–34.

12. EP to Floyd Dell, 20 January 1911, copy EP-YU; Pound, "What I feel about Walt Whitman," fragment mss., probably 1909, EP-YU with copy in Charles Norman Papers, University of Texas (hereafter CN-UT). Pound never could spell "rhythm" properly or consistently and other odd spellings are his as well. See also Herbert Bergman, "Ezra Pound and Walt Whitman," *American Literature*, XXVII (March 1955), 56–61; and C.B. Willard, "Ezra Pound's Debt to Walt Whitman," *Studies in Philology*, LIV (October 1957), 573–81.

13. Pound, *Personae* (New York, 1949, c.1926), 89; *Letters*, 21.

14. EP to IP, 7 October, ? October and 11 November 1910; EP to John Quinn, 25 February 1915, all EP-YU; Bruce St. John, ed., *John Sloan's New York Scene* (New York, 1965), 339, 448.

15. EP to IP and HP, ? 1911; EP to IP, 27 February, 2 March, n.d., and ? August 1911; EP to HP, 22 July 1911?, Paige carbons; EP to Hashimura Togo, ? 1911, EP-YU, and EP to Dell, 20 January 1911, copy EP-YU, on illness; EP to Viola Baxter, 12 June 1911, EP-YU.

16. For factual matters, Ford Madox Ford's memoirs are notoriously unreliable (he changed his name in 1915), and I have relied chiefly on Arthur Mizener, *The Saddest Story: A Biography of Ford Madox Ford* (New York, 1971), quotation on 154. See also Brita Lindberg-Seyerstad, ed., *Pound/Ford: The Story of a Literary Friendship* (New York, 1982).

17. Ford Madox Ford, *Return to Yesterday* (London, 1931), 388; Douglas Goldring, *South Lodge: Reminiscences of Violet Hunt, Ford Madox Ford and the English Review Circle* (London, 1943), 47.

18. Pound, *Gaudier-Brzeska*, 115; Mizener, *Saddest Story*, 202; EP to IP, ? August 1911, Paige carbons, EP-YU; Pound, "En breu brisaral temps brau," *New Age*, X (1912), 370; EP to Alice Corbin Henderson (hereafter ACH), 8 and 9 August 1913, Alice Corbin Henderson Mss., University of Texas, Austin (hereafter ACH-UT).

19. Edward Nehls, ed., *D.H. Lawrence: A Composite Biography* (Madison, 1957), I: 123–24; Lawrence to Louie Barrows, 20 November 1909, in James T. Boulton, ed., *Lawrence in Love* (Nottingham, 1968), 46–47; Pound, *Letters*, 17.

20. Sam Hynes, ed., *Further Speculations* by T.E. Hulme (Minneapolis, 1955) supplies the best introduction to Hulme, vii–xxxi. See also Alun R. Jones, *The Life and Opinions of T.E. Hulme* (Boston, 1960), and Ezra Pound, "This Hulme Business," reprinted in Hugh Kenner, *The Poetry of Ezra Pound* (Norfolk, CT, n.d.).

21. *Pound/Shakespear*, 79, and EP to IP, ? December 1911, Paige carbons, EP-YU.

22. Thus Margaret Drabble omits Flint from the *Oxford Companion to English Literature* (1985) while having a significant entry on Hulme. Conrad Aiken, however, thought him "the nicest and most intelligent of the Imagist crowd"— in conversation with Charles Norman, 10 January, 1950; CN-UT. The Flint Papers are at the University of Texas, (hereafter cited as FSF-UT) a significant if not major collection, including a lot of mediocre poetry. One defender has been Christopher Middleton, as in "Documents on Imagism from the Papers of F.S. Flint," *The Review* XV (April 1965), 35–51, copy at Texas. On the Hulme-Flint relation see the Hulme to Flint letters, mostly brief notes from 1909 to 1913, especially 6 April and 9 August 1912.

23. EP to IP, 21 February 1912 and HD to IP, 26 February 1912, both Paige carbons, EP-YU; HD to F.S. Flint (hereafter FSF), various letters often of uncertain date, FSF-UT; Richard Aldington (hereafter RA) to Harriet Monroe (hereafter HM), 8 July 1914, *Poetry* Mss., University of Chicago (hereafter PM-C).

24. Numerous EP to FSF letters in 1912 and 1913 mention meals and small personal matters; EP to FSF, 24 July 1914, details the job efforts. Occasional letters from Gourmont and Barzun survive as well; all FSF-UT. For valuable documentation, see also Cyrena N. Pondrom, *The Road from Paris: French Influence on English Poetry 1900–1920* (Cambridge, U.K., 1974).

25. F.S. Flint, "The History of Imagism," *The Egoist* (1 May 1915), 70–71. See also "Imagism" and "Mr. Pound at that Time," fragmentary mss., FSF-UT.

26. EP to FSF, 2 & 7 July 1915, EP-UT; FSF to EP, 3 July 1913, FSF-UT.

27. EP to B. Hessler, 9 February 1915, EP-UT; *Letters*, 25; Joseph Hone, *W.B. Yeats* (London, 1971, c. 1943), 275–76.

28. Hone, *Yeats*, 276; Norman Jeffares, *W.B. Yeats: Man and Poet* (London, 1949), 167; Allan Wade, ed., *The Letters of W.B. Yeats* (New York, 1955), 585.

29. *Pound/Shakespear*, 302–03; *Gaudier-Brzeska*, 84–85; James Longenbach, "The Secret Society of Modernism: Pound, Yeats, Olivia Shakespear, and the Abbé de Montfaucon de Villars," in Warwick Gould, ed., *Yeats Annual No. 4* (London, 1986), 103–20. On Yeats' influence in general, see Terence Diggory, *Yeats and American Poetry* (Princeton, 1983).

30. *Pound/Shakespear*, 265; Donald Hall, interview with Pound, in George Plimpton, ed., *Writers at Work*, second series (New York, 1963), 49; Lawrence W. Chisholm. *Fenollosa: The Far East and American Culture* (New Haven, 1963).

31. Ezra Pound, ed., *The Chinese Written Character as a Medium for Poetry* by Ernest Fenollosa (London, 1936).

32. *Letters*, 82.

33. Pound did not work many of these details out until the 1930s, in *ABC of Reading* and *Guide to Kulchur*, books which, while beyond the time limits of this

volume, clearly owe a basic debt to Fenollosa. The best secondary source is Laszlo Géfin, *Ideogram: History of a Poetic Method* (Austin, 1982). See also Roy E. Teele, "Through A Glass Darkly: A Study of English Translations of Chinese Poetry," Ph.D., Columbia, 1949, 20, 107–08; Achilles Fang, "Fenollosa and Pound," *Harvard Journal of Asiatic Studies*, XX (1957), 213–38; and Hugh Gordon Porteus, "Ezra Pound and his Chinese Character," in Peter Russell, ed., *An Examination of Ezra Pound* (Norfolk, CT, 1950). On the other hand, one of my former graduate students, Dr. Chih-Ping Chang, tells me that Pound was in fact correct for the majority of Chinese characters, so perhaps the argument is not entirely over.

34. Ronald Bush, "Pound and Li Po: *What Becomes a Man,*" in George Bornstein, ed., *Ezra Pound Among the Poets* (Chicago, 1985), 38–39; Hugh Kenner, *The Pound Era* (Berkeley, 1971), 192–222; *Gaudier-Brzeska*, 68.

35. The best treatment is Wai-lim Yip, *Ezra Pound's Cathay*. Princeton, 1969).

36. Pound, "Chinese Poetry," *To-Day*, III (April–May 1918), 54–57 and 93–95, as cited in Hugh Witemeyer, *The Poetry of Ezra Pound* (Berkeley, 1969), 147–51.

37. T.S. Eliot, introduction to *Ezra Pound: Selected Poems*, (London, 1928).

38. EP to ACH, 27 January 1914, ACH-UT; *Letters*, 31; Yoko Chiba, "Ezra Pound's Versions of Fenollosa's Noh Manuscripts and Yeats's Unpublished 'Suggestions & Corrections,' " in Warwick Gould, ed., *Yeats Annual No. 4* (London, 1986), 121–43, which cites Eliot's "The Noh and the Image," *Egoist* IV: 7 (August 1917).

39. Yeats, "Certain Noble Plays of Japan," is now most readily available in *Essays and Introductions* (New York, 1961), 221–37; *Plays and Controversies* (London, 1923), 213.

40. Nobuko Tsukui, *Ezra Pound and Japanese Noh Plays* (Washington, 1983); Arthur Waley, *The No Plays of Japan* (New York, 1957); *Letters*, 102.

41. Wyndham Lewis, *Blasting and Bombadiering* (London, 1982, c.1937), 271–89.

42. Jeffrey Meyers, *The Enemy: A Biography of Wyndham Lewis* (Boston, 1980), 1–25.

43. Wyndham Lewis, *Time and Western Man* (New York, 1928), 38–40.

44. Walter Michel, *Wyndham Lewis Paintings and Drawings* (Berkeley, 1971), esp. 64–79.

45. Pound, *Gaudier-Brzeska*, 81–99; Douglas Goldring, *South Lodge*, 65.

46. *Wyndham Lewis and Vorticism* (London, 1956), 3; Walter Michel and C.J. Fox, eds., *Wyndham Lewis on Art* (New York, 1969), 74–75; Pound, *Letters*, 74. See also Reed Way Dasenbrock, *The Literary Vorticism of Ezra Pound and Wyndham Lewis* (Baltimore, 1985); and Richard Cork, *Vorticism and Abstract Art in the First Machine Age* (2 vols., Berkeley, 1976).

47. HD to IP, 4 December 1911, Paige carbons, EP-YU; all odd spellings sic.

48. RA to Amy Lowell (hereafter AL), 20 November 1917 and RA to Kreymborg, ca. 1921, copies in CN-UT; RA to CN, 5 February 1960, CN-UT. HD to EP, ?1929, EP-YU; Aldington, *Life for Life's Sake* (New York, 1941), 134–35.

49. Harriet Monroe, *A Poet's Life* (New York, 1938), 259 ff., and Pound, *Letters*, 9 ff. Roughly seventeen letters from EP to HM, some of indefinite date, are in PM-C for August, September, and October, 1912. Most of the significant passages have been printed in these volumes.

50. HD to HM, n.d., but marked "ansd October 24, 1914"; RA to HM, 24 November 1912, both PM-C. Fletcher, *Life is My Song*, 78–79. HD to IP, 5 December 1912, Paige carbons; HD, "Paris 1912" diary, quote p. 25 for 25 May 1912, HD-YU.

51. *Pound/Shakespear*, 226; EP to Viola Baxter Jordan, 27 January 1914, EP-YU. Doolittle also recalled the Paris visit and the suicide of their mutual friend, Margaret Cravens, in *The Cantos of Ezra Pound* (New York 1933), copy EP-UT. RA to EP, 10? May 1914, Paige carbons, EP-YU. For documentation of this period, see Omar Pound and Robert Spoo, eds., *Ezra Pound and Margaret Cravens, A Tragic Friendship 1910–1912* (Durham, NC, 1988).

52. In addition to Guest, *Herself Defined*, and Robinson, *H.D.*, see Paul Delany, *D.H. Lawrence's Nightmare* (New York, 1978); Peter E. Firchow, "Rico and Julia: The Hilda Doolittle–D.H. Lawrence Affair Reconsidered," *Journal of Modern Literature*, VIII #1 (1980), 51–76, and Alfred Satterthwaite, "John Cournos and 'H.D.,'" *Twentieth Century Literature*, XXII #4 (December 1976), 394–410; see also the novel John Cournos based on these events, *Miranda Masters* (1926). On Pound's attitude to Aldington and several others, see EP to ACH, 9 August 1915 and 8 March 1917, ACH-UT.

53. Aldington, *Life for Life's Sake*, 111–12.

54. *Letters*, 14, 19; EP to ACH, ? April 1913; EP to HM, 5 April 1913 and ? September 1913, all PM-C; EP to Samuel Putnam, 3 February 1927, EP-UT; EP to ACH, 14 October 1913, ACH-UT.

55. Robert P. Eckert, *Edward Thomas* (London, 1937), 140–41; Robert Frost (hereafter RF) to FSF, 21 January 1913, FSF-UT; Margaret Bartlett Anderson, *Robert Frost and John Bartlett* (New York, 1963), 75. For biographical background see Lawrance Thompson, *Robert Frost: The Early Years, 1874–1915* (New York, 1966).

56. FSF to RF, 3 July 1913, and RF to FSF, 16 July 1913, FSF-UT; William R. Evans, ed., *Robert Frost and Sidney Cox* (Hanover, NH, 1981), 30; and *Frost and Bartlett*, 44–45, 49–50.

57. Eckert, *Thomas*, 141; R. George Thomas, ed., *Letters from Edward Thomas to Gordon Bottomley* (London, 1968), 233.

58. Eleanor Farjeon, *Edward Thomas: The Last Four Years*, "The Memoirs of Eleanor Farjeon," I (London, 1958), 87–91; *Frost and Bartlett*, 44.

59. *Frost and Cox*, 34–35, 54–55; Farjeon, *Thomas*, 77–78.

60. *Frost and Bartlett*, 45; Lawrance Thompson, ed., *Selected Letters of Robert Frost* (New York, 1964), 84, 87; RF to FSF, 6 and 8 July 1913 and 24 August 1916, FSF-UT.

61. *Frost and Cox*, 19; RF to FSF, 10 December 1913, FSF-UT. The best brief introduction to Frost's place is David Perkins, *A History of Modern Poetry from the 1890s to the High Modernist Mode* (Cambridge, 1976), ch. 10–11.

62. Lawrance Thompson, *Robert Frost: The Years of Triumph, 1915–1938* (New York, 1970), ch. 1–2, pp. 114–15; Amy Lowell, *Tendencies in Modern American Poetry* (New York, 1971, c.1917), 81, 135.

63. Aldington, *Life for Life's Sake*, 139–42; Pound, *Letters*, 37–9, 48; AL to HM, 15 September 1914, PM-C, also printed in S. Foster Damon, *Amy Lowell* (Boston, 1935), 237–40.

64. Cyrena N. Pondrom, "Selected Letters from H.D. to F.S. Flint: A Commentary on the Imagist Period," *Contemporary Literature*, X #4 (Autumn 1969), 557–86; Lowell, *Tendencies*, 237–46. For background see Perkins, *History of*

Modern Poetry, ch. 15; and the still useful study, Stanley K. Coffman, Jr., *Imagism* (Norman, OK, 1951).

65. Such an examination, even restricted to Americans, would have to include not only the many printed letters now available, but also the uncollected materials in the Amy Lowell Papers at Harvard; the John Gould Fletcher Papers at the Universities of Arkansas and Texas; the Conrad Aiken Papers at the Huntington Library in California; the William Carlos Williams Papers at the State University of New York, Buffalo, Yale University, and the University of Texas; the Robert Frost Papers at Texas and Amherst College; and the Marianne Moore Papers at the Rosenbach Museum and Library in Philadelphia. It would also include the scattered materials of these and others in many other collections, and of course the incoming files for the Pound Papers at Yale, and the Harriet Monroe and *Poetry* Collections at the University of Chicago. Painters, sculptors and photographers, being less verbal, left fewer such materials, but such surviving letters as those which George Antheil sent to Ezra Pound during the 1920s remain suggestive. For Pound's own words, see the obvious sources: R. Murray Schafer, ed., *Ezra Pound and Music: The Complete Criticism* (New York, 1977); and Harriet Zinnes, ed., *Ezra Pound and the Visual Arts* (New York, 1980).

66. Joseph Killorin, ed., *Selected Letters of Conrad Aiken* (New Haven, 1978), 21–23.

67. Aiken, "The Place of Imagism," *The New Republic,* III (22 May 1915), 75–76; "Imagism or Myopia," *The Poetry Journal,* III (July 1915), 233–41.

68. Charles Norman, interview notes with Conrad Aiken, 10 January 1959, CN–UT; *Writers at Work,* 30; Aiken, *Ushant* (New York, 1952), 215, 205.

69. "Obituary in Bitcherel," in Aiken, *Collected Poems* (2nd edition, New York, 1970), 1012–14; Aiken, interview with Joseph Killorin, February, 1967, in *Selected Letters,* 4–5, *Ushant,* 302.

70. *Ushant,* 45, 72–74; *Writers at Work,* 27–29; Aiken, *The Clerk's Journal: Being the Diary of a Queer Man* (New York, 1971).

71. *Ushant,* 165–66, 278; 205; *Letters,* 13; *Clerk's Journal,* introduction.

72. *Clerk's Journal,* 6; *Collected Poems,* prefatory note, n.p.; *Earth Triumphant* (New York, 1914), vii–viii, 140; on Masefield, see "Fertilizing Poetry," *Poetry Journal,* IV (1915), 31–34, and "The Declining Masefield," V (1916), 74–77.

73. The best biographical sources are Edward Butscher, *Conrad Aiken: Poet of White Horse Vale* (Athens, GA, 1988), and Steven Eric Olson, "The Vascular Mind: Conrad Aiken's Early Poetry, 1910–1918," Ph.D., Stanford, 1981, DA#8202028; *Clerk's Journal,* 6.

74. *Letters,* 32–33; *Writers at Work,* 27, 38, 36; on Freud see also Frederick J. Hoffman, *Freudianism and the Literary Mind* (Baton Rouge, 1967, c.1945), 274–81.

75. Charles Norman interview with Conrad Aiken, 10 January 1959, notes CN-UT; T.S. Eliot (hereafter TSE) to CN, 10 June 1959, also CN-UT; EP to HM, 22 September 1914, PM-C; Pound, *Letters,* 40–41, 44–45, 50.

76. See especially Conrad Aiken, "King Bolo and Others," in Richard March and Tambimuttu, eds., *T.S. Eliot: A Symposium* (London, 1948) and "T.S. Eliot," *Life,* (15 January 1965), 92. The best sources for biographical detail are Herbert Howarth, *Notes on Some Figures Behind T.S. Eliot* (London, 1965); Lyndall Gordon, *Eliot's Early Years* (New York, 1977); and Peter Ackroyd, *T.S. Eliot* (New York, 1984). The recent publication of Valerie Eliot, ed., *The Letters of*

T.S. Eliot I, 1898–1922 (New York, 1988), has added little to the information in these volumes, but XIX–XXVI supply a useful chronology.

77. TSE to Herbert Read, 1928, quoted in *The Sewanee Review*, LXXIV (1966), 35, a special Eliot issue edited by Allen Tate; Martin D. Armstrong to Conrad Aiken, 11 October 1914, AIK 47, Conrad Aiken Papers, Huntington Library, as quoted in Louis Menand, *Discovering Modernism: T.S. Eliot and his Context* (New York, 1987), 5.

78. Plimpton, ed., *Writers at Work*, second series, 92–95.

79. Arthur Symons, *The Symbolist Movement in Literature*, ed. Richard Ellmann (New York, 1958), vii–xvi, 4–5, 56–62, 94–96. For useful background see Roger Lhombreaud, *Arthur Symons* (London, 1963), and Ruth Zabriskie Temple, *The Critic's Alchemy: A Study of the Introduction of French Symbolism into England* (New Haven, 1953), part 3.

80. Warren Ramsay, *Jules Laforgue and the Ironic Inheritance* (New York, 1953), esp. 80–81, 179–82.

81. In addition to the biographies of Gordon and Ackroyd, see Francis Scarfe, "Eliot and Nineteenth-century French Poetry," in Graham Martin, ed., *Eliot in Perspective* (New York, 1970), 45–61.

82. TSE to Sydney Schiff, "Wednesday" ca. 1920, British Museum 52918 775 B (I am grateful to Prof. G.S. Amur for this reference); TSE to Wilbur, 15 August 1963, in Robert Henry Hunter Wilbur, "George Santayana and Three Modern Philosophical Poets: T.S. Eliot, Conrad Aiken, and Wallace Stevens," Ph.D. Columbia, 1964, DA#65-10, 226, p. 102; Grover Smith, ed., *Josiah Royce's Seminar, 1913–1914: As Recorded in the Notebooks of Harry T. Costello* (New Brunswick, 1963), 73–74, 78, 83, 120. For background see Bruce Kuklick, *The Rise of American Philosophy: Cambridge, Massachusetts, 1860–1930* (New Haven, 1977).

83. F.H. Bradley, *Appearance and Reality* (Oxford, 1930), 406–07; TSE, *Knowledge and Experience in the Philosophy of F.H. Bradley* (New York, 1964), 17–18. See also for this and succeeding paragraphs Walter Benn Michaels, "Philosophy in Kinkanja: Eliot's Pragmatism," *Glyph* VIII (1981), 170–202, and Menand, *Discovering Modernism*.

84. TSE, *Knowledge and Experience*, 29–31, 10, 54, 132.

85. *Ibid.*, 165, 145; Smith, ed., *Royce's Seminar*, 175. The best recent discussion of many of these issues is William Skaff, *The Philosophy of T.S. Eliot: From Skepticism to a Surrealist Poetic, 1909–1927* (Philadelphia, 1986).

86. Ronald W. Clark, *The Life of Bertrand Russell* (New York, 1976), 231–32; TSE, *The Complete Poems and Plays, 1909–1950* (New York, 1950), 18.

87. Wyndham Lewis, *Blasting and Bombadiering*, 282–83; Goldring, *Odd Man Out*, 121; Robert Gathorne-Hardy, ed., *Ottoline at Garsington* (London, 1974), 101–02; Osbert Sitwell, *Laughter in the Next Room* (Boston, 1948), 38.

88. See the materials cited in Valerie Eliot, ed., *The Waste Land: A Facsimile and Transcript of the Original Drafts* (London, 1971), ix–xiv; and the following: Donald Gallup, "T.S. Eliot and Ezra Pound: Collaborators in Letters," (New Haven, 1970), a fifty-page pamphlet; Ronald Schuchard, "Eliot and Hulme in 1916: Toward a Revaluation of Eliot's Critical and Spiritual Development," *PMLA*, LXXXVII #5 (October, 1973), 1083–94; and "T.S. Eliot as an Extension Lecturer, 1916–1917," *The Review of English Studies*, n.s., XXV #98 (May, 1974), 163–73, and #99 (August, 1974), 292–304.

89. EP to HP, 30 June 1915, Paige carbons, EP-YU; Bertrand Russell (here-

after BR) to Lady Ottoline Morrell (hereafter OM), Ottoline Morrell Papers, University of Texas, Austin (hereafter OM-UT), n.d., #1301. The standard secondary sources are Clark, *Russell*, 309 ff., and Robert H. Bell, "Bertrand Russell and the Eliots," *American Scholar* (Summer 1983), 309–25, which corrects Clark in several vital matters.

90. Derek Patmore, ed., *My Friends When Young*, 84; Huxley to OM, 21 June 1917, in Gathorne-Hardy, ed., *Ottoline at Garsington*, 206–07.

91. Clark, *Russell*, 311–13; Bell, "Bertrand Russell and the Eliots," reports that Russell described the adultery in a letter to Lady Constance Malleson.

92. This matter is too vast to annotate, but see especially Robert Langbaum, "Pound and Eliot," in Bornstein, ed., *Pound among the Poets*, 168–94; and Marjorie Perloff, *The Poetics of Indeterminacy: Rimbaud to Cage* (Princeton, 1981).

93. TSE, "Ezra Pound," in Walter Sutton, ed., *Ezra Pound* (Englewood Cliffs, NJ, 1963), 20; this is reprinted from *Poetry*, LXVII (September, 1946), 326–38.

94. Pound, *Letters*, 26, 111; there is a small collection of Jacob Epstein letters at the University of Texas, Austin, correspondents including Henri-Pierre Roché and Bernard van Dieren, mostly undated but probably 1912–1920.

95. Jacob Epstein, *Let There Be Sculpture* (New York, 1940) is the basic source for Richard Buckle, *Jacob Epstein Sculptor* (Cleveland, 1963), the only biography; Hutchins Hapgood, *A Victorian in the Modern World* (Seattle, 1972, c.1939), 142.

96. Zinnes, ed., *Pound and the Visual Arts*, 5; Epstein to Quinn, 12 August 1912, John Quinn Papers, New York Public Library (hereafter JQ-NYPL); Quinn to EP, 25 February 1915, EP-YU. See also B.L. Reid, *The Man from New York: John Quinn and his Friends* (New York, 1968), 129, 191.

97. *Pound/Shakespear*, 270–71, 315; *Let There be Sculpture*, 38–39.

98. *The Sculptor Speaks: Jacob Epstein to Arnold L. Haskell* (New York, 1971, c.1932). 85–93.

99. Epstein to Quinn, 12 August 1914 and 20 July 1917, JQ-NYPL; Pound, *Letters*, 52, 74; *Let There Be Sculpture*, 42; see also Michael Holroyd, *Augustus John* (New York, 1973), 448–49.

100. *Sculptor Speaks*, 141, 146; italics in original.

101. Pound, *Letters*, 42–42, 45–53, 95, 104; Helmut and Alison Gernsheim, eds., *Alvin Langdon Coburn Photographer: An Autobiography* (New York, 1978, c.1966), 102, 104, plates #54–55. The best study of Coburn to 1912 is Alice A. Doner, "Alvin Langdon Coburn and the Politics of Modernist Photography," M.A., University of Texas, 1988. The best overall study is Mike Weaver, *Alvin Langdon Coburn: Symbolist Photographer, 1882–1966* (New York, 1986).

102. In addition to Coburn's *Autobiography*, 14–22, see Estelle Jussim, *Slave to Beauty: The Eccentric Life and Controversial Career of F. Holland Day* (Boston, 1981).

103. Alvin Langdon Coburn (hereafter ALC) to Alfred Stieglitz (hereafter AS), ? July 1904 and 1 September 1904, Alfred Stieglitz Papers, Yale University (AS-YU). Notations will not distinguish between postcards and letters. Coburn was also an erratic speller and I will silently correct obvious unimportant errors.

104. ALC to AS, apparently ? November 1905 but marked a year later; it logically precedes ALC to AS, 13 and 26 February 1906, AS-YU.

105. ALC to AS, 1906?, 3 December 1906, 7 October 1908, AS-YU.

106. George Davison to AS, 30 October 1903, 5 April 1907, 31 January 1908, 4 May 1909, AS-YU; Frederick Evans to AS, *passim,* esp. 14 May 1909, AS-YU; AS to R. Child Bayley, 11 December 1913, all AS-YU.

107. ALC to Max Weber, 2 October 1917, 26 February and 2 October 1918, 26 January 1919, all Max Weber Papers-Archives of American Art, reel N/69-85.

108. RA to AL, 21 September 1914, photostat in CN-UT.

109. Pound, *Letters,* 46–47; EP to ACH, 14 October 1916, ACH-UT.

110. MacLeish's remarks are in William Carlos Williams, "A Tribute to Ezra Pound," unpublished radio script of December 1955, copy in Williams Papers, University of Texas, Austin; EP to ACH, 9 August 1915, ACH-UT.

111. EP to HP, 19 October 1916, and EP to IP, 15 November 1916 and several others, all EP-YU.

112. EP to ACH, 5 May 1916, ACH-UT.

113. Pound, *Letters,* 106–07; HM to ACH, 19 March and 9 April 1917, ACH-UT, with two typos silently corrected.

114. ACH to HM, 9 June and 15 June 1917; HM to EP, copy to ACH, 3 July 1917, all ACH-UT.

115. EP to ACH, 9 August 1915, and EP to Milton Bronner, 21 September 1915, ACH-UT and EP-UT respectively.

116. EP to ACH, 26 August 1916, ACH-UT. Most of the material of importance in art and music falls after 1917 and is available in Harriet Zinnes, ed., *Ezra Pound and the Visual Arts* (New York, 1980) and R. Murray Schafer, ed., *Ezra Pound and Music* (New York, 1977). On the pseudonyms, see especially Ronald Bush, *The Genesis of Ezra Pound's Cantos* (Princeton, 1976), 161–67. Bush also prints the texts of the Ur-Cantos and their variants; I am much indebted to his book for material in the next few paragraphs.

117. "Affirmations: As for Imagisme," *The New Age* (28 January 1915), reprinted in *Selected Prose,* 374–77; and Bush, *Genesis,* ch. 2.

118. Pound, *Letters,* 180; *Pound/Joyce,* 90–91.

119. Pound, *Letters,* 115; Bush, *Genesis,* 184 ff. See also Myles Slatin, "A History of Pound's Cantos I–XVI, 1915–1925," *American Literature,* XXXV #2 (May 1963), 183–95; and John Foster, "Pound's Revision of Cantos I–III," *Modern Philology* LXIII #3 (February 1966) 236–45.

120. FSF to editor, *The Egoist,* 21 February 1917, copy FSF-UT.

121. Iris Barry, "The Ezra Pound Period," *The Bookman,* LXXIV #2 (October 1931), 159–71.

122. See especially William Pratt, "Ezra Pound and the Image," in Philip Grover, ed., *Ezra Pound: The London Years: 1908–1920* (New York, 1978), 15–30; Marjorie Perloff, "The Contemporary of Our Grandchildren: Pound's Influence," in Bornstein, ed., *Pound Among the Poets,* 195–229; and Donald Davie, *Ezra Pound: Poet as Sculptor* (New York, 1964).

BOOK IV Paris

1. All quotations and facts are from Edward Steichen, *Steichen: A Life in Photography* (New York, 1985, c.1963), part 1; this volume is unpaginated, but divided into fifteen parts. Parts one through four deal with his experience up to World War I.

2. *Ibid.,* pt. 2; A. Horsley Hinton to Alfred Stieglitz (hereafter AS), 2 Oc-

tober and 10 November 1900, 17 December 1901, 26 November and 22 December 1902, 8 June 1903 and 21 June 1904, all Alfred Stieglitz Papers, Beinecke Library, Yale University (hereafter cited as AS-YU). The elisions in one letter are Hinton's.

3. Eduard Steichen (hereafter ES) to AS, ? January 1901 and ? 1901, AS-YU. For background see William Innes Homer, *Alfred Stieglitz and the Photo-Secession* (Boston, 1983), 31–32, 85–97.

4. Steichen, *A Life*, pt. 2, which includes many pictures; and Gertrude Käsebier to AS, 21 August 1901, AS-YU. Frederic V. Grunfeld, *Rodin* (New York, 1987), adds nothing significant on these matters.

5. Steichen, *A Life*, pts. 3–4; J.T. Keiley to AS, 22 August 1904, AS-YU.

6. See the large Demachy file, especially letters #39, 40, and 60, Robert Demachy to AS, AS-YU. A wealthy man, fluent in English, a lover of music, especially that of Wagner, Demachy was finally divorced from his American wife, Julia Delano, in 1909. See Bill Jay, *Robert Demachy 1859–1936* (New York, 1974).

7. George Davison to AS, 11 September and 30 October 1903, 20 September, 17 October and 23 October 1906; Frederick Evans to AS, 17 October 1906; ES to AS, 29 October 1906; and J.T. Keiley to AS, 10 and 24 June 1907, all AS-YU.

8. Steichen, *A Life*, pts. 4, 5; AS to Samuel Halpert, 23 October 1914, AS-YU.

9. Edmund Fuller, ed., *Journey into the Self: being the letters papers & journals of Leo Stein* (New York, 1950), 3–66; Leo Stein, *Appreciation: Painting, Poetry and Prose* (New York, 1947), 139–208. These volumes contain most of the available primary material on Stein and are the sources for facts and brief phrases unless otherwise noted.

10. Ambroise Vollard, *Recollections of a Picture Dealer* (New York, 1978, c.1936) is not helpful; on Berenson, see Ernest Samuels, *Bernard Berenson* (2 vols., Cambridge, 1979, 1987).

11. Gertrude Stein (hereafter GS) to Mabel Weeks, n.d. (? late 1904), GS-YU.

12. Unless otherwise noted, all material from Sterne is from Charlotte Leon Mayerson, ed., *Shadow and Light: The Life, Friends and Opinions of Maurice Sterne* (New York, 1965), ch. 3. This book is chiefly autobiographical fragments in Sterne's words.

13. Hutchins Hapgood, *A Victorian in the Modern World* (New York, 1939), 120, 219, 245 and *passim.;* Agnes E. Meyer, *Out of These Roots* (Boston, 1953), 81–82; Samuels, *Berenson*, II, 61; Mabel Dodge Luhan, *European Experiences* (New York, 1935), 321–26.

14. In addition to previously cited published volumes, see the LS to GS file, GS-YU, with many, often undated letters about Leo's travels, opinions, and enthusiasms, 1909 on. He refers for example to Isadora Duncan, the "Eugene variety" of Christian Science, and his sustained interested in things Japanese.

15. For other American painters who were in and out of Paris, see Michael Klein, "The Art of John Covert," Ph.D., Columbia, 1972, DA#DDJ74-17874; Elizabeth McCausland, *A. H. Maurer* (New York, 1951); Van Deren Coke, *Nordfeldt the Painter* (Albuquerque, NM, 1972); Irma Jaffe, *Joseph Stella* (Cambridge, 1970); Theodore W. Eversole, "Abraham Walkowitz and the Struggle for an American Modernism", Ph.D., University of Cincinnati, 1976, DA#77-11,203;

and two volumes without editors, *Avant-Garde Painting and Sculpture in America, 1910–1925* (Wilmington, DE, 1975) and *The Advent of Modernism: Post-Impressionism and North American Art, 1900–1918* (Atlanta, GA, 1988). The list of painters should probably include Thomas Hart Benton, Jerome Blum, Patrick Henry Bruce, Arthur Carles, John Covert, Andrew Dasburg, Jo Davidson, Manierre Dawson, Arthur Dove, Preston Dickinson, Arthur B. Frost, Jr., Anne Goldthwaite, Samuel Halpert, Bernard Karfiol, Stanton Macdonald-Wright, John Marin, Alfred Maurer, Carl Newman, B.J.O. Nordfeldt, Walter Pach, Morgan Russell, Henry Lyman Saÿen, Morton Schamberg, Charles Sheeler, Lee Simonson, Eduard Steichen, Joseph Stella, Maurice Sterne, Abraham Walkowitz, Max Weber, Marguerite and William Zorach.

16. See especially Holger Cahill, *Max Weber* (New York, 1930), 4, 7ff.; the text of this book is also available on reel NY59-6, Max Weber Papers, Archives of American Art. The reels in this collection also contain several biographical sketches compiled by the artist for exhibitions. In general, Weber's letters are not informative, but see "The Reminiscences of Max Weber" which Carol Gruber compiled in 1958 for the Columbia Oral History project, here esp. pp. 6–7. For the best biography, see Phylis Burkley North, "Max Weber: The Early Paintings (1905–1920)," Ph.D. Delaware, 1975, DA#75-6389.

17. Sandra E. Leonard, *Henri Rousseau and Max Weber* (New York, 1970), 12–15. I rely heavily on this book for the next few paragraphs.

18. Cahill, *Weber,* 14; autobiographical notes, reel 59–65, MW-AAA.

19. Roger Shattuck, *The Banquet Years* (New York, 1961, c.1958), 110–11 and *passim.;* the quarter of this book devoted to Rousseau remains the best introduction to both his life and art.

20. Weber, Oral History, 201–42 and *passim.*

21. Lucile M. Golson, "The Michael Steins of San Francisco: Art Patrons and Collectors," *Four Americans in Paris* (New York, 1970), 35–49.

22. Alfred H. Barr, Jr., *Matisse: His Art and His Public* (New York, 1951), 116–118, and for a transcript of Sarah Stein's notes, 550–52.

23. Max Weber, "The Matisse Class," read 19 November 1951, MW-AAA reel NY59-6. See also Pierre Schneider, *Matisse* (New York, 1984), 732.

24. Max Weber, "The Fourth Dimension from a Plastic Point of View," *Camera Work,* XXXI (July 1910), 25; John R. Lane, "The Sources of Max Weber's Cubism," *Art Journal,* XXXV #3 (Spring 1976), 231–36; and the definitive treatment of the larger context, Linda Henderson, *The Fourth Dimension and Non-Euclidean Geometry in Modern Art* (Princeton, 1983), 167 ff. and *passim.*

25. I regret that lack of space and primary source material have prevented any detailed discussion of either Patrick Henry Bruce or American participation in Orphism. The best sources are William C. Agee and Barbara Rose, *Patrick Henry Bruce,* (New York, 1979), and Virginia Spate, *Orphism: The Evolution of Non-Figurative Painting in Paris, 1910–1914* (Oxford, 1979).

26. My account closely follows that in Gail Levin, *Synchromism and American Color Abstraction, 1910–1925* (New York, 1978), 9–16; a picture of the "Synchromie en vert" is figure 8, p. 13. The correspondence between Russell and Dasburg is in the Syracuse University Library; I have used Levin's excerpts. See also William C. Agee, *Synchromism and Color Principles in American Painting, 1910–1930* (New York, 1965).

27. Thomas Hart Benton, *An Artist in America* (New York, 1937), 34–39; Lee

Simonson, *Part of a Lifetime: Drawings and Designs, 1919–1940* (New York, 1943), 18–19.

28. All excerpts quoted from Levin, *Synchromism*, 17–27, sic; and 128–32. See also color plates #8, 10, 11, 12.

29. Harriet Lane Levy, *920 O'Farrell Street* (New York, 1947), 23; many of Levy's notes to Gertrude Stein survive, GS-YU. For biographical detail, I have relied chiefly on Linda Simon, *The Biography of Alice B. Toklas* (New York, 1978).

30. Alice B. Toklas, *What Is Remembered* (New York, 1963), 23.

31. Simonson, *Part of a Lifetime*, ch. 2; Toklas, *What Is Remembered*, 46, 125.

32. Fernande Olivier, *Picasso and his Friends* (New York, 1964), 82–83; for biographical details I have relied on Roland Penrose, *Picasso* (3rd ed., Berkeley, 1981).

33. Gertrude Stein, *Picasso* (New York, 1984, c.1938), 8; Pierre Daix, *Picasso: The Cubist Years, 1907–1916* (Boston, 1979), 11–12.

34. Marianne Tauber, "William James and Picasso's Cubism," abstract of paper presented at Fourth European Conference on Visual Perception, Paris, September, 1981; "New Sources for Cubism or Pablo Picasso and William James," paper presented to Cheiron Society, Newport, RI, 22–26 June 1982; "Formvorstellung und Kubismus oder Pablo Picasso und William James," in S. Gohr, ed., *Kubismus* (Köln, 1982), 9–57. I am grateful to Ulla Dydo for copies of these works.

35. I have relied heavily on the best brief introduction to the subject, Edward Fry's introduction to his anthology, *Cubism* (New York, 1978), 11–41.

36. In addition to works already cited, see especially the revisionist work of Leo Steinberg, "The Philosophical Brothel," Parts 1 and 2, in *ARTnews*, LXXI #5 (September, 1972), 20–29, and #6 (October, 1972), 38–47. Alfred H. Barr, Jr., *Picasso: Fifty Years of his Art* (New York, 1966, c.1946), remains a useful starting point. Most of the important documentation is available in Fry's *Cubism* and in Gert Schiff, ed., *A Picasso Anthology: Documents, Criticism, Reminiscences* (London, 1981); and Herschel B. Chipp, ed., *Theories of Modern Art* (Berkeley, 1968), 193–280. On the continuities from Cézanne, see William Rubin, ed., *Cézanne: The Late Work* (New York, 1977), 151–202.

37. The chief primary sources for Hartley's early years are his "Somehow A Past," which exists in several drafts, and several letters to Richard Tweedy in 1900–01, all Marsden Hartley Papers, Beinecke Library, Yale University (hereafter MH-YU). Hartley's memoirs deserve to be used with more caution than is always the case. They are not only incomplete and disorganized, but whoever did the typing did not understand either the German language or cultural history; and Hartley, writing no earlier than the middle 1930s, seems to "remember" some events that he only read about. For biographical details I have followed Barbara Haskell, *Marsden Hartley* (New York, 1980), an account closely dependent on "Somehow A Past."

38. Marsden Hartley (hereafter MH) to AS, ? July 1911, AS-YU. All Hartley's writing idiosyncracies have been preserved, as if with "sic" following, and not corrected as in many scholarly citations. Hartley did not usually include accent marks in names like Cézanne, nor did he capitalize "french," "german," etc.

39. MH to AS, 20 August, ? September, 14? October 1911, AS-YU; MH to Norma Berger, 18 September 1911, MH-YU.

40. MH to AS, 24 April and 8 May 1912, AS-YU. Most of Hartley's letters are postal cards, sometimes several a day, usually numbered. I will not distinguish these in annotations.

41. MH to AS, 20 June 1912, AS-YU.

42. MH to AS, 2 and 12 July 1912, AS-YU.

43. Arnold Rönnebeck, "Journals" in 3 volumes, 1910–1912, Arnold Rönnebeck Papers, Beinecke Library, Yale University (hereafter AR-YU). These journals contain frequent references to sculptors and their ideas. Other documents in the collection seem to be drafts of speeches or articles that elaborate these interests and make occasional reference to Picasso, Pound, Stravinsky, and others.

44. MH to AS, continuing the extraordinarily long letter of 12 July 1912 cited in note 42, sic, AS-YU.

45. MH to AS, 30 July 1912, AS-YU.

46. MH to AS, 19 August and ? September 1912, sic, AS-YU.

47. MH to AS, ? September 1912, AS-YU.

48. MH to AS, 27 September, 2, 30, and 31 October 1912, AS-YU.

49. MH to AS, ? November 1912, AS-YU.

50. MH to AS, 20 November 1912, AS-YU; MH to Norma Berger, 30 December 1912, MH-YU.

51. MH to AS, 20 November 1912, briefly, and then a letter marked as being received 20 December 1912, AS-YU; the typed copy of this second letter has several erroneous transcriptions; I have as usual tried to follow the original, sic.

52. MH to AS, 14 January 1913, AS-YU.

53. MH to AS, 1 February and ? February 1913, AS-YU. This second letter continues for eight more pages, and one of the 13 March 1913 contains many of the same themes for six more. For confirmation and additional detail, see Rönnebeck, Journals III, AR-YU, esp. entry for 24 January 1913. On the larger topic, see Peg Weiss, *Kandinsky in Munich: The Formative Jugendstil Years* (Princeton, 1979), and Johannes Eichner, *Kandinsky und Gabriele Münter, von Ursprüngen moderner Kunst* (München, 1957).

54. MH to AS, 13 March, 9, 11, and 29 April, and ? April or May 1913, AS-YU; MH to "Dear People," meaning Gertrude Stein and Alice Toklas (hereafter cited as GS, since he was clearly addressing most remarks to Stein), 29 April and 3 May 1913, GS-YU.

55. MH to AS, ? May 1913, AS-YU. In addition to books cited elsewhere, see especially Peter Jelavich, *Munich and Theatrical Modernism: Politics, Playwrighting, and Performance, 1890–1914* (Cambridge, 1985); Frederick S. Levine, *The Apocalyptic Vision: The Art of Franz Marc as German Expressionism* (New York, 1979); and Peter Selz, *German Expressionist Painting* (Berkeley, 1957), part 5. On Albert Bloch, see Sandra Gail Levin, "Wassily Kandinsky and the American Avant-Garde, 1912–1950," Ph.D. Rutgers, 1976, DA#76-27, 019, ch. 5; see also Hans K. Roethal, *The Blue Rider* (New York, 1971), 138; and Max Putzel, *The Man in the Mirror: William Marion Reedy and his Magazine* (Cambridge, 1963), 143–4, Reedy having been the man who supported Bloch during this period. On Konrad Cramer, see Levin, "Kandinsky," ch. 3; and Van Deren Coke, *Andrew Dasburg* (Albuquerque, 1979), 25. On Covert, see Michael Klein, *John Covert 1892–1960* (Washington, 1976), the quote originally coming from Rudi Blesh, *Modern Art USA* (New York, 1956), 90–93. On Feininger, see Hans Hess,

Lyonel Feininger (New York, 1961); and Ernst Scheyer, *Lyonel Feininger: Caricature & Fantasy* (Detroit, 1964).

56. Will Grohmann, *Wassily Kandinsky* (New York, 1958?), is my chief biographical source; see also Jonathan Fineberg, *Kandinsky in Paris 1906–1907* (Ann Arbor, 1984), 49–51, *passim*.

57. Wassily Kandinsky, "Reminiscences," most readily available in Robert L. Herbert, ed., *Modern Artists on Art* (Englewood Cliffs, 1964), 19–44. See also Kenneth C. Lindsay and Peter Vergo, eds., *Kandinsky Complete Writings on Art* I (1901–1921), (Boston, 1982), 355–82.

58. as quoted in Grohmann, *Kandinsky*, 67. Weiss, *Kandinsky in Munich*, is now the standard survey of these years.

59. Wassily Kandinsky, *Concerning the Spiritual in Art*, trans. M.T.H. Sadler (New York, 1977), 2, 11, 6, 16–17, 24, 30, 34, is the most available English edition. The text is problematic and has variants of little concern in this context. It is also available in Lindsay and Vergo, eds., *Kandinsky: Complete Writings* I, 114–219. See also John E. Bowlt and Rose-Carol Washton Long, eds., *The Life of Vasili Kandinsky in Russian Art: A Study of On the Spiritual in Art* (Newtonville, MA, 1980); and Rose-Carol Washton Long, *Kandinsky: The Development of an Abstract Style* (Oxford, 1980).

60. MH to AS, ? late May 1913, AS-YU.

61. GS to AS, n.d., sic, AS-YU. An edited version is printed in Donald Gallup, "The Weaving of a Pattern: Marsden Hartley and Gertrude Stein," *Magazine of Art* XLI (November 1948), 256–61.

62. MH to GS, 9 May 1913, GS-YU.

63. MH to AS, ? May and ? June 1913, AS-YU.

64. MH to GS, ? June 1913, GS-YU.

65. MH to GS, 23 July and 8 August 1913, GS-YU; MH to AS, ? August 1913, AS-YU.

66. MH to AS, 22 and 28 September and 18 October 1913; AS to MH, 20 October 1913, AS-YU; MH to GS, ? 15 September and 18 October 1913, GS-YU.

67. MH to AS, 22 October 1913, AS-YU.

68. MH to GS, 28 or 29 October and ? 7–10 December 1913, 2 January (2 cards) and 16 January 1914, GS-YU.

69. MH to GS, ? February 1914, GS-YU, and MH to AS, ? February 1914, AS-YU.

70. MH to AS, ? May and ? June 1914, AS-YU; MH to GS, 14 and 30 April 1914, GS-YU.

71. MH to AS, 29 July, 2 August, 2 September, ? 20 September 1914, AS-YU. See also Hartley's "Somehow a Past," MH-YU, where he recalls the war months, finding "a sexual immensity" in all the energy.

72. MH to AS, 23 October and 12 November 1914, AS-YU.

73. MH to AS, 28 June and ? August 1913, AS-YU; MH to GS, ? June and ? August, 1913, GS-YU; Gallup, "Weaving of a Pattern," 257–58.

74. "1916 Catalogue Statement, 291," in Gail R. Scott, ed., *On Art* Marsden Hartley (New York, 1982), 67.

75. Arnold Rönnebeck to Duncan Phillips, probably late 1944, in two differently worded drafts, Arnold Rönnebeck Papers, Beinecke Library, Yale University.

76. MH to AS, chiefly 5 August and 8 November 1915, AS-YU.

77. For what was in the Paris air, see esp. Henderson, *The Fourth Dimension and Non-Euclidean Geometry in Modern Art,* and Stephen Kern, *The Culture of Time and Space, 1880–1918* (Cambridge, 1983).

78. Edmund Wilson, *The Shores of Light* (New York, 1952), esp. 581, 586. See also Richard Bridgman, *Gertrude Stein in Pieces* (New York, 1970), 94–102.

79. *Selected Writings of Stein,* 472–73, 476.

80. Stein, *Lectures in America,* 14–15, 24, 56, 65, 74, 70–71, 79.

81. *Ibid.,* 150, 182–84, 93–95.

82. *Ibid.,* 191, 210, 212, 227, 231.

BOOK V Chapter 1

1. The subject is too vast to annotate, but see for background Perry Miller, *The Raven and the Whale* (New York, 1956) and Thomas Bender, *New York Intellect* (New York, 1987).

2. B.L. Reid, *The Man from New York: John Quinn and His Friends* (New York, 1968) is a mine of relevant information.

3. The scrapbooks in the Alfred Stieglitz Papers, Beinecke Library, Yale University (hereafter AS-YU), provide ample documentation for Stieglitz' interests. For family detail, I have relied on the memoir/biography by a grandniece, Sue Davidson Lowe, *Stieglitz* (New York, 1983). Edward Abrahams has a good brief introduction in *The Lyrical Left* (Charlottesville, VA, 1986), 93–203.

4. Thomas Craven, "Stieglitz—Old Master of the Camera," *Saturday Evening Post,* CCXVI (8 January 1944), 14; Gary Richard Pearce-Moses, "The Early Photographs of Alfred Stieglitz, 1883–1902: Evolution of A Modernist Aesthetic," M.A., University of Texas, Austin, 1987, 37; and see the reproductions in Dave Oliphant and Tom Zigal, *Perspectives on Photography* (Austin, TX, 1982), 83, 88.

5. Nancy Newhall, *P.H. Emerson: The Fight for Photography As A Fine Art* (Millerton, NY, 1978), 34 ff., 76 and *passim;* Emerson's thirty-seven letters to Stieglitz survive, but not Stieglitz' answers: see 111–36 for substantial excerpts.

6. Pearce-Moses, "The Early Photographs . . . ," 33–38; Stieglitz later changed the titles of some of his pictures to make them conform to retrospective changes in attitude.

7. While the opinions are my own, they often follow those of Pearce-Moses, *op.cit.,* or in conversation. For other revisionist views, see Richard John Kent, "Alfred Stieglitz and the Maturation of American Culture," Ph.D., Johns Hopkins, 1974, DA#77-16, 562; and James S. Terry, "Alfred Stieglitz: The Photographic Antecedents of Modernism," Ph.D., S.U.N.Y., Stony Brook, 1980, DA#80-11, 073.

8. Estelle Jussim, *Slave to Beauty: The Eccentric Life and Controversial Career of F. Holland Day* (Boston, 1981); see also the 56 letters from Day to AS; and the following AS to Day letters: 6 October 1902, 15 July 1903, 14 April and 26 November 1906, and 21 May 1910, all AS-YU.

9. Robert Redfield to AS, 18 February 1898, AS-YU; AS, "Painters on Photographic Juries," *Camera Notes* (hereafter *CN*), IV (July 1902), 27–30.

10. See especially William I. Homer, *Alfred Stieglitz and the Photo-Secession* (Boston, 1983), 44–48.

11. Eva Watson-Schütze to AS, 21 April 1901, AS-YU.

12. Charles H. Caffin, *Photography As A Fine Art* (New York, 1971, c.1901),

49, 90–91, and *passim.* See also Sandra Lee Underwood, *Charles H. Caffin, A Voice for Modernism, 1897–1918* (Ann Arbor, 1983).

13. AS, Scrapbooks, III, AS-YU. See especially Leila Mochlin, "The Camera's Work," from *The Washington Star* and two notices by Sidney Allan (pseud. Sadakichi Hartmann), "The Exhibition of the Photo-Secession," *The Photographic Times-Bulletin,* XXXVI #3 (March 1904), and "Advance in Artistic Photography," *Leslie's Weekly* (28 April 1904); and the Eduard Steichen reprint, *CN,* VI (July 1902), 22–24. On conditions abroad, the best books in English are Peg Weiss, *Kandinsky in Munich* (Princeton, 1979); Carl E. Schorske, *Fin-de-Siècle Vienna* (New York, 1980); and Peter Paret, *The Berlin Secession* (Cambridge, 1980).

14. See especially Harry W. Lawton and George Knox, eds., *The Valiant Knights of Daguerre* (Berkeley, 1978), a collection of articles by Sadakichi Hartmann, pp. 49, 173–79; and Homer, Stieglitz and Photo-Secession, 97–101.

15. AS to Heinrich Kühn, 1 March 1909, AS-YU; Peter C. Bunnell, "Gertrude Stanton Käsebier," *Notable American Women* (Cambridge, 1971), II, 308–09; Lawton and Knox, *Valiant Knights,* 48, 198–201; Homer, *Stieglitz and Photo-Secession,* 58–69; Barbara L. Michaels, "Rediscovering Gertrude Käsebier," *Image,* XIX #2 (June 1976), 20–32.

16. AS to George Davison, 10 April 1909; AS to Frederick H. Evans, 12 August and 26 December 1910; Clarence H. White to AS, 15 May 1912 and AS to White, 23 May 1912; many letters to and from Cornelia Sage and others at the Albright are also marginally relevant, AS-YU. For most material on White, see the thorough biography by his grandson, Maynard P. White, Jr., "Clarence H. White: A Personal Portrait," Ph.D., Delaware, 1975, DA#76-22,572; for Lange see Dorothea Lange, *Dorothea Lange* (Berkeley, 1968), 42.

17. AS, Scrapbooks, IV, has the announcement, 14 October 1905; for a list of shows, see William I. Homer, *Alfred Stieglitz and the Avant-Garde,* (Boston, 1973), 295–98.

18. Homer, *Stieglitz and Avant-Garde,* 70–75, 52–55; Willard Bohn, "The Abstract Vision of Marius de Zayas," *The Art Bulletin,* LXII #3 (September 1980), 434–52; Craig R. Bailey, "The Art of Marius de Zayas," *Arts Magazine,* LIII #1 (September 1978), 136–44. These sources continue useful for succeeding paragraphs.

19. Marius de Zayas (hereafter MZ) to AS, 28 October 1910, all odd usages and spellings here and in future quotes, sic, AS-YU.

20. MZ to AS, 22 December 1910, 25 January, 7 March, and 6 April 1911, AS-YU.

21. MZ to AS, 6 and 21 April, 14 and 26 August 1911, and 14 September 1912, AS-YU.

22. AS to Hartmann, 22 December 1911, printed in the letters section of Sarah Greenough and Juan Hamilton, *Alfred Stieglitz: Photographs & Writings* (Washington, n.d.), 193.

23. See the letters, notebooks, and diaries on reel D242, Walt Kuhn Papers, Archives of American Art (hereafter WK-AAA). Some are quoted in Philip Rhys Adams, *Walt Kuhn, Painter* (Columbus, OH, 1978).

24. Walt Kuhn (hereafter WK) to Vera Kuhn (hereafter VK), sic, 12 and 15 December 1911, WK-AAA, reel D240.

25. Brooks Wright, *The Artist and the Unicorn: The Lives of Arthur B. Davies (1862–1928)* (New City, New York, 1978).

26. Arthur Davies to WK, 2 September 1912; WK to VK, 25, 29, and 30 September, 2 and 4 October 1912, WK-AAA, reel D240. There is also a brief 1912 summer diary on reel D242.

27. WK to VK, 15, 16, 18, and 23 October 1912, WK-AAA, reel D240.

28. Davies to WK, 1 October and ? October 1912, WK-AAA, reel D240.

29. WK to VK, 26, 28, and 31 October 1912, and especially 6 November 1912, WK-AAA, reel D240; WK to Walter Pach, 12 December 1912, WK-AAA, reel D72; Milton Brown, *The Story of the Armory Show* (New York, 1963), ch. 2, esp. 49–51.

30. WK to VK, 11 and 17 November, and 14 December 1912; "Monday," summer 1913; ? January and 2 February 1914. See reels D72 and D73 for Armory Show documentation, all WK-AAA. The Walter Pach Papers, AAA, are thin and unhelpful. WK to Pach, 12 December 1912, is printed both in Brown, *Armory Show*, 55–6, and Adams, *Kuhn*, 52.

31. WK to VK, ? January and 2, 5, and 11 February 1914, WK-AAA, reel D240. Reid, *Man from New York*, see index entry under John Quinn; anti-Semitism.

32. AS to Kandinsky, cc of draft, AS-YU, 26 May 1913.

33. Unless otherwise indicated my chief sources for Picabia are Maria Lluïsa Borràs, *Picabia* (New York, 1985), here esp. 87 and 98; and William Camfield, *Francis Picabia* (Princeton, 1979). On Gleizes, see Daniel Robbins, "The Formation and Maturity of Albert Gleizes: A Biographical and Critical Study, 1881 through 1920," Ph.D., NYU, 1975, DA#76-1760.

34. AS to Arthur Carles, 11 April 1913, AS-YU.

35. Most of Gabrielle Buffet-Picabia, *Aires Abstraites* (Genève, 1957), is included in the expanded *Rencontres* (Paris, 1977), see esp. 175–86.

36. MZ to AS, 22 and 26/7 May 1914, AS-YU; on Kahnweiler, see Pierre Assouline, *An Artful Life* (New York, 1990).

37. MZ to AS, 11 June 1914; R. Child Bayley to AS, 11 June 1914, AS-YU.

38. MZ to AS, 30 June 1914, sic. He is also the author of *A Study of the Modern Evolution of Plastic Expression* (1913), with Paul Haviland.

39. MZ to AS, 30 June and 13 August 1914; 23, 27, and 30 August, 1 September (twice), 4 September, 8 September (twice), and 14 September 1915, all AS-YU. See also Douglas K.S. Hyland, "Agnes Ernst Meyer, Patron of American Modernism," *American Art Journal* XII (Winter 1980), 64–81.

40. The two chief sources for biographical data are Ann Lee Morgan, "Toward the Definition of Early Modernism in America: A Study of Arthur Dove," Ph.D., Iowa, 1973, DA#74-7406; and Sherrye Cohn, *Arthur Dove: Nature As Symbol* (Ann Arbor, 1985). The letters are available as Ann Lee Morgan, ed., *Dear Stieglitz, Dear Dove* (Cranbury, NJ, 1988), but focus on the years after 1917. Morgan's *Arthur Dove* (Newark, DE, 1984) is a catalog raisonné with a lengthy introduction based on her dissertation. Frederick S. Wight, *Arthur G. Dove* (Berkeley, 1958) is a brief overview.

41. Dove to Arthur Jerome Eddy, ? November 1913, quoted in Eddy's *Cubists and Post-Impressionism* (Chicago, 1919, c.1914), 48; and the final phrase from Dove's undated writings, Cohn, *Dove*, 37.

42. The letter, from the Stieglitz/Dove letters, AS-YU, is also printed in Cohn, *Dove*, 58, and Wight, *Dove*, 36–37.

43. See Laurie Lisle, *Portrait of an Artist* (New York, 1980) and Roxana Robinson, *Georgia O'Keeffe* (New York, 1989). On futurism, see Margaret R.

Burke, "Futurism in America, 1910–1917," Ph.D., Delaware, 1986, DA#8629258. Except for an interest in Severini in 1916–17, those in the 291 circle paid little attention to futurism.

44. See Georgia O'Keeffe (hereafter GO'K) to Anita Pollitzer (hereafter AP), 25 August and 1 September 1915? and 21 February 1916, AS-YU. Catalog statement quoted from Robinson, *O'Keeffe*, 257.

45. GO'K to AP, 11 October 1915, AS-YU.

46. AP to GO'K, 1 January 1916; GO'K to AP, 4 January and ?early 1916; she was more enthused about Texas in ?25 February 1916, all AS-YU.

47. GO'K to AP, ?21 June, ? September and 30 October 1916, 17 January and 19 February 1917, all six AS-YU.

48. AS to Mitchell Kennerley, 17 May 1917; GO'K to AP, 20 June 1917, AS-YU.

49. GO'K to AP, 20 June 1917, AS-YU. Paul Strand, "Photography to Me," *Minicam Photography*, VIII #8 (May 1945), 42–47, 86–90; Elizabeth Mc-Causland, "Paul Strand," *U.S. Camera Magazine* #8 (February–March 1940), 21–24 ff; Alden Whitman, obituary for Strand, *New York Times* (2 April 1976), 36. William I. Homer has important primary interview material in *Stieglitz and Avant-Garde*, 242–54, esp. 245–46. Copies of articles are in AS-YU.

50. Homer, *Stieglitz and Avant-Garde*, 249–51; AS to R. Child Bayley, 17 April 1916, sic, AS-YU.

51. Strand to AS, ?late July 1917, AS–YU. Benita Eisler, *O'Keeffe and Stieglitz: An American Romance* (New York, 1991) covers the sexual entanglements in copious detail.

52. See especially the claims made in Ileana B. Leavens, "From '291' to Zurich: The Birth of Dada," Ph.D., University of Washington, 1980, DA#DDJ81-09745; and the more moderate suggestions in Dickran Tashjian, *Skyscraper Primitives: Dada and the American Avant-Garde 1910–1925* (Middletown, CT, 1975). For an example of the connections between modernism and decadence, see Benjamin de Casseres, "Modernity and the Decadence," *Camera Work*, XXXVII (January 1912), 17–19.

53. "French Artists Spur on an American Art," *New York Tribune*, 24 October 1915.

54. Gabrielle Buffet-Picabia, "Some Memories of Pre-Dada: Picabia and Duchamp," (1949), in Robert Motherwell, ed., *The Dada Painters and Poets: An Anthology* (New York, 1951), 255–67.

BOOK V Chapter 2

1. Mabel Dodge Luhan, *Intimate Memories: Background* (New York, 1933), 5, 48, 55, and *passim*. For some factual material I will also be using Lois Palken Rudnick, *Mabel Dodge Luhan* (Albuquerque, 1984), the only scholarly biography.

2. Mabel Dodge Luhan, *Intimate Memories: European Experiences* (New York, 1935), 134–35, 139, 167, and *passim*.

3. *Ibid.*, 183–84, 327.

4. *Ibid.*, 445–53.

5. Mabel Dodge Luhan, *Intimate Memories: Movers and Shakers* (New York, 1936), 3–5, 9–13, 83–84; Max Eastman, *Enjoyment of Living* (New York, 1948), 524–25; Mabel Dodge (hereafter MD) to AS, 24 May 1913, AS–YU.

6. Hutchins Hapgood, *A Victorian in the Modern World* (New York, 1939), 67–70, 97–99, 138–39, 145, 154–55, 213, 277–78, 332, 377, 395, 436, 446, and *passim*. A brief scholarly study of the family is Michael D. Marcaccio, *The Hapgoods* (Charlottesville, VA, 1977).

7. In addition to works mentioned in other notes, the Dodge Salon appears at least fleetingly in a wide range of primary and secondary sources. These include the Lippmann/Dodge Correspondence, MDL-YU, with related material in the Lippmann/Alfred Kuttner Correspondence, Walter Lippmann Papers, Sterling Library, Yale University; the Dodge/Stein Correspondence, GS-YU; the Reed/Dodge, Goldman/Dodge, and Berkman/Dodge Correspondence, all MDL-YU.

Relevant books include Ronald Steel, *Walter Lippmann and the American Century* (New York, 1980); Robert A. Rosenstone, *Romantic Revolutionary: A Biography of John Reed* (New York, 1975); Justin Kaplan, *Lincoln Steffens* (New York, 1974); James A. Reed, *From Private Vice to Public Virtue* (New York, 1978); Paul Avrich, *The Modern School Movement* (Princeton, 1980); and Laurence Veysey, *The Communal Experience* (Chicago, 1973). See also the Will Durant novel *Transition* (New York, 1927), and his autobiography with Ariel Durant, *A Dual Autobiography* (New York, 1977). Dodge appears as well in the novels and letters of Carl Van Vechten. Two relevant dissertations are Kate E. Wittenstein, "The Heterodoxy Club and American Feminism, 1912–1930," Ph.D., Boston University, 1989, DA#8905708; and Ann Uhry Abrams, "Catalyst for Change: American Art and Revolution, 1906–1915," Ph.D., Emory, 1975, DA#76-1607.

8. Luhan, *Early Experiences*, 321–33.

9. *Ibid.*, 325; GS to MD, n.d., ? March 1912, ? February 1913, ? March or April 1913, all MDL-YU.

10. MD to GS, 24 January 1913, GS-YU; AS to Gabrielle Picabia, 15 January 1914, AS-YU; *Movers and Shakers*, 25–37, 84, 249–54; Van Deren Coke, *Andrew Dasburg* (Albuquerque, 1979), 1–41; Dasburg, "Cubism—Its Rise and Influence," collected in Gert Schiff, ed., *Picasso* (Englewood Cliffs, NJ, 1976), 61–2.

11. They were often apart, divorcing in 1921; see the heavily emotional, relentlessly domestic Dodge/Sterne file, starting 1915, MDL-YU; *Movers and Shakers*, 350–51, 362, 390–91, 394, 399, 406; MD, "Doctors: Fifty Years of Experience," typed manuscript signed, obviously written late in life and not published, 33–34, MDL-YU. Charlotte Leon Mayerson, ed., *Shadow and Light: The Life, Friends, and Opinions of Maurice Sterne* (New York, 1965), 111–32.

12. *Movers and Shakers*, 282, 341–43. The closest thing to a history of the area is Mary Heaton Vorse, *Time and the Town* (New York, 1942).

13. Hapgood, *Victorian*, 393–94.

14. Lawrence Langner, *The Magic Curtain* (New York, 1951), esp. 67–73, 83–85, 90–104; Robert Károly Sarlós, *Jig Cook and the Provincetown Players* (Amherst, MA, 1982), ch. 1–2. For lists of members, see Keith N. Richwine, "The Liberal Club: Bohemia and the Resurgence in Greenwich Village, 1912–1918," Ph.D., Pennsylvania, 1968, DA#69-15,111, pp. 117–18, 143 n.28.

15. See *The Provincetown Plays*, published as pamphlets by Frank Shay but with no editor, first, second, and third series (New York, 1916) and George Cram Cook and Frank Shay, eds., *The Provincetown Plays* (Cincinnati, 1921).

16. Hapgood, *Victorian*, 199, 360, 368–71.

17. My source for most matters of biography is Louis Sheaffer, *O'Neill: Son and Playwright* (Boston, 1968) and *O'Neill: Son and Artist* (Boston, 1973); see esp.

102–05, 122–23 of the former. Much of the material is also available in the more popular work, Arthur and Barbara Gelb, *O'Neill* (New York, 1973), which in its 1962 edition was the pioneering modern study. Of the many useful critical works on O'Neill, I learned the most from Travis Bogard, *Contour in Time* (New York, 1972). On Nietzsche, see also Agnes Boulton, *Part of a Long Story* (London, 1958), 57.

18. Michael Meyer, *Ibsen* (London, 1974, c.1967 & 1971), 124, 162–63, and *passim*.

19. O'Neill, "Strindberg and Our Theatre," reprinted in Travis Bogard, ed., *The Unknown O'Neill: Unpublished or Unfamiliar Writings of Eugene O'Neill* (New Haven, 1988), 386–88. For Strindberg, I have found the most material in the best biography, Michael Meyer, *Strindberg* (New York, 1985), the best critical treatment in English, Olof Lagercrantz, *August Strindberg* (New York, 1984), and the pioneering treatment of his religious crisis, Gunnar Brandell, *Strindberg in Inferno* (Cambridge, 1974). See also Sheaffer, *O'Neill*, I, 252–53, and *passim*.

20. Eugene O'Neill, *Complete Plays 1913–1920* (New York, 1988), 537–38 and *passim;* Sheaffer, *O'Neill*, I, 383, quoting David Karsner; O'Neill to George Pierce Baker, 30 June 1919.

21. Glaspell, *The Road to the Temple*, (New York, 1927) 253–54.

BOOK V Chapter 3

1. Most of the relevant Arensberg material in archives is in the Francis Bacon Library in Claremont, California; I am indebted to Naomi Sawelson-Gorse for her helpful advice concerning it. Scholars can consult the most important items by asking for reels 3570 and 3571 of the Arensberg Papers, Archives of American Art. Most of the material on the first reel is an exchange between Arensberg and Duchamp, beginning in 1917, but heaviest for the 1940s. The second has brief material concerning painter John Covert and psychiatrist Elmer E. Southard. I found nothing useful on reels 1609, 1610, and 1611.

I have therefore relied chiefly on materials by Francis Naumann, a few hints supplied in conversation, the rest in article form. The chief of these is "Walter Conrad Arensberg: Poet, Patron, and Participant in the New York Avant-Garde, 1915–20," *Philadelphia Museum of Art Bulletin*, LXXVI: #328 (Spring 1980), 2–32; I remain grateful to Linda Henderson for giving me a copy of this as well as many useful suggestions and criticisms.

2. See especially Francis Naumann, "Cryptography and the Arensberg Circle," *Arts Magazine*, LI #9 (May 1977), 127–33.

3. Frederick P. Gay, *The Open Mind* (Chicago, 1938), 33–34, 43, 50–52, 196–97, 251–53, 286, and *passim*, on Southard.

4. The Walter Pach Papers, Archives of American Art, reels 4216 and 4217 for this period, are thin, and have only one note, of 1 March 1914, from Arensberg. See also Milton W. Brown, *The Story of the Armory Show* (New York, 1963), 101–05, *passim*.

5. In addition to Naumann's articles, see "Autobiographical Notes of Louis Bouché," reel 688, frames 679–868, Archives of American Art, quote from frame 755. I regret that considerations of space in this volume, the accidents of history, and the scarcity of extant works have prevented me from an examination of the role of the Arensberg salon in classical music in America. Edgard Varèse is the vital figure here, but most of his work before 1917 perished in

Berlin due to his absence during the war, or due to his own destruction of it. The music of Charles Tomlinson Griffes and Leo Ornstein also deserve mention; I hope to deal in detail with all three in a sequel volume.

6. Alfred Kreymborg, *Troubadour* (New York, 1957, c.1925), 169–73, 64–66, 101, 112–13, 128–29, 154–58, 161–62, 189, and *passim; Our Singing Strength* (New York, 1929), 339–40.

7. For biographical detail, see especially Paul Mariani, *William Carlos Williams* (New York, 1981), 107–08 and *passim.*

8. William Carlos Williams, *I Wanted to Write A Poem* (New York, 1978, c.1958), 15. Compare this to Charles Steinmetz, *Four Lectures on Relativity and Space* (New York, 1923), which Mike Weaver does ably in *William Carlos Williams* (Cambridge, Eng., 1971), 48–49. Another important treatment is J. Hillis Miller, *Poets of Reality* (Cambridge, 1965), ch. 7.

9. *The Autobiography of William Carlos Williams* (New York, 1951), 134–37. In addition to Miller's essay, the best criticism of Williams for my purposes was James Guimond, *The Art of William Carlos Williams* (Urbana, 1968). See also Williams' essay, "The Work of Gertrude Stein," (1930), now most readily available in Webster Schott, ed., *Imaginations* (New York, 1970), 344–51.

10. Man Ray, *Self Portrait* (Boston, 1963), 45, 54–55, and *passim;* Neil Baldwin, *Man Ray* (New York, 1988) is the best introduction for factual material. Like most studies appearing after the autobiography, it is heavily dependant on it. See Carl I. Belz, "The Role of Man Ray in the Dada and Surrealist Movements," Ph.D., Princeton, 1963, DA#64-1321, for an independent analysis.

11. Arturo Schwarz, *New York Dada: Duchamp, Man Ray, Picabia* (Munich, 1973), 90–91.

12. Ray, *Self Portrait,* 66–68.

13. Arturo Schwarz, *Man Ray: The Rigour of Imagination* (New York, 1977), 39.

14. Ray, *Self Portrait,* 72–73.

15. Beatrice Wood, *I Shock Myself* (San Francisco, 1988, c.1985), 3, 22–27, and *passim.* Naumann, "Arensberg," pictures the salon, using photos by Charles Sheeler taken in 1918, on pp. 8–10. Among other artists on the walls were Cézanne, John R. Covert, Morton Schamberg, Renoir, Joseph Stella, Derain. For the full collection, see Philadelphia Museum of Art, *The Louise and Walter Arensberg Collection* (2 vols., Philadelphia, 1954).

16. Reconstructing Duchamp's life and opinions presents a nice historical problem. Few contemporary manuscripts survive, and he had a charming habit of joking and fabricating his way through newspaper and magazine interviews, often with journalists who knew little French. After World War II, more responsible individuals conducted the interviews which form the basis of scholarly treatments. Such materials also deserve skepticism, but they inevitably form the basis for my comments. Chief among them are Pierre Cabanne, *Dialogues with Marcel Duchamp* (New York, 1971), here esp. 43–44; and Michel Sanouillet and Elmer Peterson, eds., *Salt Seller: The Writings of Marcel Duchamp (Marchand du Sel)* (New York, 1973), chiefly 123–37 and 141–59. The best biographical sources are Alice Goldfarb Marquis, *Marcel Duchamp: Eros c'est la vie* (Troy, NY, 1981), here 98, 142; Arturo Schwarz, *The Complete Works of Marcel Duchamp* (New York, 1970), and Robert Lebel, *Marcel Duchamp* (New York, 1959).

17. Marquis, *Duchamp,* 122, 8, 36; Cabanne, *Dialogues,* 22–27, 37.

18. Cabanne, *Dialogues,* 24, 89; Schwarz, *Duchamp,* 30.

19. *Salt Seller,* 124; Cabanne, *Dialogues,* 18–19. On the Jarry connections, see

esp. Linda Henderson, *The Fourth Dimension and Non-Euclidean Geometry in Modern Art* (Princeton, 1983), 50.

20. Cabanne, *Dialogues*, 30, 124; *Salt Seller*, 124.

21. See, for example, Gertrude Stein to Mabel Dodge on Duchamp, in an undated note of summer, 1913, GS-YU. All my discussions of these matters depend heavily on Henderson, *Fourth Dimension*.

22. Cabanne, *Dialogues*, 39, 23–24; *The Brothers Duchamp* (Boston, 1976), 93.

23. See esp. Arturo Schwarz, ed., *Notes and Projects for the Large Glass* (London, 1969), 36–42; and *Marcel Duchamp Letters to Marcel Jean* (Müchen, 1987), 74, where he mentions seeing works of Kandinsky and others in windows, but had no personal contacts.

24. Cabanne, *Dialogues*, 38–39; *Salt Seller*, 125.

25. Thus the inherent logic in Calvin Tomkins' approach, in *The Bride and the Bachelors* (New York, 1965), where Duchamp is godfather to John Cage, Jean Tinguely, Robert Rauschenberg and Merce Cunningham; and the obvious affinities between artist and writer in Octavio Paz, *Marcel Duchamp* (New York, 1981, c.1978). See also Cabanne, *Dialogues*, 41.

26. Cabanne, *Dialogues*, 88, 33, 30.

27. Cabanne, *Dialogues*, 31; Schwarz, *Duchamp*, has each item pictured in roughly chronological order, which is useful if falsely linear, since Duchamp was developing in three directions at once.

28. The best introduction to the show is the collection of articles in *Dada/ Surrealism*, XIV (1985), the New York Dada issue, and XVI (1987), a Duchamp issue. I have relied especially on the contributions by Craig Adcock and William Camfield. The issues later became books: Rudolf E. Kuenzli, ed., *New York Dada* (New York, 1986), and Rudolf Kuenzli and Francis M. Naumann, eds., *Marcel Duchamp: Artist of the Century* (Cambridge, 1989). The fullest version of Camfield's work is *Marcel Duchamp Fountain* (Houston, 1989), an exhibition catalog. See also Francis M. Naumann, "Affectueusement, Marcel: Ten Letters from Marcel Duchamp," *Archives of American Art Journal*, XXII #4 (1982), 2–19; Beatrice Wood, *I Shock Myself*, 29–31, and the Wood Papers, Archives of American Art, reel 1236; and Alfred Stieglitz to Henry McBride, 19 April 1917, McBride Papers, Archives of American Art, reel 12.

29. Holly Stevens, ed., *Letters of Wallace Stevens* (New York, 1966), 185; hereafter cited as WS, *Letters*.

30. For my purposes, the best critical studies were J. Hillis Miller, *Poets of Reality*, 217–84; Joseph N. Riddel, *The Clairvoyant Eye: The Poetry and Poetics of Wallace Stevens* (Baton Rouge, 1965); Robert Buttel, *Wallace Stevens: The Making of Harmonium* (Princeton, 1967); A. Walton Litz, *Introspective Voyager: The Poetic Development of Wallace Stevens* (New York, 1972); Adalaide Kirby Morris, *Wallace Stevens: Imagination and Faith* (Princeton, 1974).

31. Wallace Stevens, *The Collected Poems of Wallace Stevens* (New York, 1954), 120; hereafter cited as WS, *Poems*. For most readers, the best biographical introduction of reasonable length will be George S. Lansing, *Wallace Stevens: A Poet's Growth* (Baton Rouge, 1986), 3–157; the standard biography for details is Joan Richardson, *Wallace Stevens: The Early Years 1879–1923* (New York, 1986); for the fullest treatment of the Arensberg milieu, see Glen S. MacLeod, *Wallace Stevens and Company: The Harmonium Years* (Ann Arbor, 1983).

32. WS, *Opus Posthumous* (New York, 1989, c.1957), 187; *Letters*, 820.

33. WS, *Letters*, 136; "Sunday Morning" is in WS, *Poems*, 66–70.

Index